PERSIAN PAINTING

FROM THE MONGOLS TO THE QAJARS

PEMBROKE PERSIAN PAPERS

Series Editor: Charles Melville

VOLUME 1

History and Literature in Iran

edited by Charles Melville

ISBN 1 85043 652 5 – hardback

VOLUME 2

Rituals in Babism and Baha'ism

Denis MacEoin

ISBN 1 85043 654 1 – hardback

VOLUME 3

Persian Painting: From the Mongols to the Qajars

Studies in honour of Basil W. Robinson

edited by Robert Hillenbrand

ISBN 1 85043 659 2 – hardback

VOLUME 4

Safavid Persia: The History and Politics of an Islamic Society

edited by Charles Melville

ISBN 1 86064 023 0 – hardback
ISBN 1 86064 086 9 – paperback

PERSIAN PAINTING

FROM THE MONGOLS TO THE QAJARS

Studies in honour of Basil W. Robinson

EDITED BY ROBERT HILLENBRAND

I.B.Tauris *Publishers*

LONDON • NEW YORK

in association with
The Centre of Middle Eastern Studies
University of Cambridge

Published in 2000 by I.B.Tauris & Co Ltd
Victoria House, Bloomsbury Square, London WC1B 4DZ
175 Fifth Avenue, New York NY 10010
website: http://www.ibtauris.com
in association with the Centre for Middle Eastern Studies, University of Cambridge

In the United States and Canada distributed by St. Martin's Press
175 Fifth Avenue, New York NY 10010

ISBN 1 85043 659 2

A full CIP record for this book is available from the British Library
A full CIP record for this book is available from the Library of Congress

Library of Congress catalog card: available

Designed and typeset in Venetian by Karen Stafford, London

TABLE OF CONTENTS

Preface and Acknowledgements vii
Foreword ix
Note on Transliteration x
List of Illustrations xi

1. B.W. Robinson at the Victoria and Albert Museum 1
CLAUDE BLAIR

2. A Copy of the Divan *of Mir 'Ali Shir Nava'i* 3
of the Late Eighteenth Century in the Lund University Library and
the Kashmiri School of Miniature Painting
KARIN ÅDAHL

3. On the Attribution of Persian Paintings and Drawings of the Time of Shah 'Abbas I: 19
Seals and Attributory Inscriptions
ADEL T. ADAMOVA

4. Beyond the Pale: 39
Meaning in the Margin
BARBARA BREND

5. The Ahmed Karahisari Qur'an in the Topkapi Palace Library in Istanbul 57
FILIZ ÇAĞMAN

6. The Pen or the Brush? 75
An Inquiry into the Technique of Late Safavid Drawings
SHEILA CANBY

7. The Qajar Court Painter Yahya Ghaffari: 83
His Life and Times
LAYLA S. DIBA

8. Gold in the Pictorial Language of Indian and Central Asian Book Painting 97
LARISA DODKHUDOEVA

9. Ibrahim-Sultan's Anthology of Prose Texts 101
ERNST J. GRUBE

10. The Hundred and One Paintings of Ibrahim-Sultan 119
ELEANOR SIMS

11. *Images of Muhammad in al-Biruni's Chronology of Ancient Nations* 129
ROBERT HILLENBRAND

12. *The Name of a Painter who Illustrated the World History of Rashid al-Din* 147
ANATOLI IVANOV

13. *The Anthology of a Sufi Prince from Bokhara* 151
ASSADULLAH SOUREN
MELIKIAN-CHIRVANI

14. *The Chester Beatty Süleymânnâme Again* 187
MICHAEL ROGERS

15. *The Illustrated Manuscripts of Athar al-Muzaffar:* 201
A History of the Prophet
KARIN RÜHRDANZ

16. *A Reconstruction and Preliminary Account of the 1341 Shahnama* 217
With Some Further Thoughts on Early *Shahnama* Illustration
MARIANNA SHREVE SIMPSON

17. *Ghiyath al-Din 'Ali-yi Naqshband and an Episode in the Life of Sadiqi Beg* 249
ROBERT SKELTON

Supplement: The Sins of Sadiqi's Old Age 264
GAUVIN ALEXANDER BAILEY

18. *The Ann Arbor* Shahnama *and its Importance* 267
PRISCILLA P. SOUCEK

19. *Habib Allah* 283
MARIE L. SWIETOCHOWSKI

20. *Worldly and Otherworldly Love in Safavi Painting* 301
ANTHONY WELCH

21. *Two Eminences Observed:* 319
A Drawing by Mirza-'Ali
STUART CARY WELCH

Index 325

Preface and Acknowledgements

My first debt of gratitude is to Dr Charles Melville for his alacrity in accepting this book for inclusion in the *Pembroke Persian Papers* series, of which he is the general editor. This made it possible to proceed quickly with inviting contributions from scholars scattered over three continents. Dr Melville also kindly corrected a set of proofs.

Next, my thanks go to Iradj Bagherzade for the offer to co-publish and for his enthusiastic efforts to ensure that the book should be worthily and indeed lavishly illustrated. It will surprise no one that this ambition proved very difficult to fulfil, and it proved necessary to launch a serious fund-raising campaign. That all the difficulties were finally overcome – after several years of effort, and thanks also to further diplomatic initiatives by Iradj Bagherzade and William Robinson – is due to the generosity of many donors. Pride of place goes to a munificent donor who wishes to remain anonymous, but whose gift met the remaining shortfall in full. I should also like to single out two other supporters who made all the difference: the Max van Berchem Foundation, whose very generous contribution was made at the very beginning of the campaign, and thus helped to encourage other donors; and the Iran Heritage Foundation, which also gave very substantial and timely help. The other donors are, in alphabetical order, Professor James Allan, the Ashmolean Museum, the Barakat Trust, the Bodleian Library, the British Institute of Persian Studies, Mr Edmund de Unger, Dr David Khalili, the Lund University Library and the Royal Asiatic Society. Further help of a very practical kind came from Christie's: the firm generously undertook to provide the colour separations for the colour plates, and this offer was a key element in the decision to illustrate the volume as fully as possible.

Warm thanks go to Dr Barry Flood for compiling the index and for suggesting substantial improvements to the volume.

Finally, a heartfelt word of thanks to the contributors for showing their affection for Basil Robinson, the dedicatee of this *Festschrift*, in such a practical way. It is their achievement that this volume covers the whole range of Islamic painting in Persia and thus reflects his own interests so exactly.

ROBERT HILLENBRAND

Foreword

Among those currently active in the study of Persian painting, Basil Robinson occupies a unique position. By general consent he is the father figure of the field. This is not a role that he has sought but one freely accorded to him by his colleagues by virtue of his lifetime of unobtrusive labour and also his benevolent personality. It is a simple and touching index of his popularity that he is so widely known by the affectionate nickname of Robbie.

It is fortunate that Robbie himself has left an absorbing and often amusing account of his life and times in the preface to his two volumes of collected articles, published recently by the Pindar Press, and by his reminiscences of undergraduate life at Oxford in the early thirties, published in the magazine of Corpus Christi College, *The Pelican* (1988–89, pp. 37–46). The former sketch tells the story of how he gradually came to love Persian painting while still a little boy and then, by a series of fortunate conjunctions, to meet some of the great names of Persian studies, especially in the context of the great Persian Art exhibition of 1931. He subsequently read for a postgraduate degree at Oxford in 1935–36 – a happy year spent cataloguing the Bodleian collection of Persian paintings 'in the medieval peace and seclusion of Duke Humfry's Library'. Eventually, further happy chances enabled him to make his career in that field when, in 1939, he was appointed to the Victoria and Albert Museum. Though transferred to the Department of Metalwork, he was able nonetheless vigorously to pursue his speciality of Persian painting.

A milestone of these studies was the *Loan Exhibition of Persian Miniature Paintings from British Collections* held at the V. & A. in 1951, whose catalogue (price 1s.0d.net) of 150 items contains – despite its small size and lack of illustrations – much solid information in the way of dates, provenances and signatures. The work for this exhibition, with over a score of lenders, pointed the way for his future work, especially his great 1967 exhibition, also at the V. & A., of *Persian Miniature Painting from Collections in the British Isles*. Perhaps not surprisingly, private collectors were quick to recognise Robbie's qualities in the wake of the 1951 exhibition, and his work on the Chester Beatty collection was sumptuously published in three volumes (with Robbie making major contributions to volumes 2 and 3). The very useful Kevorkian catalogue of 174 pages in typescript, completed in 1953, has, however, remained unpublished (though there is happily a copy on deposit in the V. & A. Library).

Over the years this has been followed by a galaxy of published catalogues of major collections, among which those of the Bodleian, the India Office Library, the John Rylands Library in Manchester, the Keir Collection in Richmond and the Pozzi Collection in Geneva are of outstanding importance. It is good to know that Robbie's catalogue of the Persian paintings in the Royal Asiatic Society collection has now also appeared, and one may hope that he will find time to publish the extensive material which he has steadily assembled over some decades on the remaining British collections of Persian painting, and thus round off his life's work. These catalogues, then, with their sober factual tone, their careful identification of the subject matter, their close focus on date and provenance and on the artists themselves, their lists of manuscripts for comparison and their copious indices, have transformed the field and laid a solid foundation for scholars who have tried many other kinds of approaches to the material.

Side by side with these lengthy catalogues research is a series of brief introductions to the subject, often with very well chosen illustrations; in their various ways they epitomise Robbie's frank delight in these paintings and reveal much about his approach to them. Of quite a different character again are his separate studies in book and article form, dealing with significant periods and manuscripts. Here too he has broken much ground – whether in analysing key masterpieces like his beloved Juki *Shahnama*, proposing new affiliations in fifteenth-century painting or publishing little-known material from private collections. He has also done much to identify hitherto unrecognised or inadequately defined schools, such as royal Turkman painting, the Sultanate style in India or the Astarabad school in the Safavid period. Nor should his championship of Qajar art, including especially painting on enamel and lacquer, be forgotten. In all these domains he has been a pioneer, decisively re-routing the directions that scholarship was taking.

How Robbie has managed to maintain this steady output over the decades – while also making a name for himself as an expert on Japanese prints (see his 1961 monograph on Kinyoshi and his prize-winning *Kuniyoshi. The Warrior Prints*, 1982), Japanese swords (he wrote the standard handbook on the subject in 1961) and English glees (yet another book!) defeats the imagination. Yet this is no driven man. He wears his honours – Fellow of the British Academy, past President of the Royal Asiatic Society – lightly, and work does not spoil the capacity of this unobtrusively devout man to enjoy family life, the pleasures of drinking beer and making an Indian chutney that packs a formidable punch.

What comes out of the numerous anecdotes in his autobiographical sketches is Robbie's huge enjoyment of what he does. He responds instinctively to the storytelling aspect of Persian painting, and is himself no mean storyteller, as his rollicking account of Rustam, the legendary Persian hero, reveals. His delicate sensibility engages with the full range of formal qualities in these paintings, though he has been careful to keep that persona of the admiring connoisseur on a tight rein. Too tight, perhaps: one would welcome an analysis from his pen of the scene of Rustam lassoing Kamus from an early sixteenth-century *Shahnama*, his favourite example of Persian painting. Is it that seductive combination of derring-do and refined fantasy? Or the pageantry, the intricate massing of the composition, the saturated colours? Let us hope he finds the opportunity to put it all on paper and thus satisfy the curiosity of his colleagues.

The adage 'you can't take it with you' applies not only to our belongings but also to the information we hold. Very few scholars take that warning seriously. Robbie does, and for decades he has been an absolute model of generosity in sharing his wide and curious erudition. He makes available with equal freedom to senior and junior colleagues alike his slides, his notes and his insights – and all without fuss. I know; I have been a beneficiary. In doing so he has saved those colleagues from making countless mistakes and has thus quietly, anonymously, pushed back the frontiers of knowledge.

Retirement has fuelled rather than reduced Robbie's energies; he has published no fewer than eight major books in that time and has plans for more. Yet that has spelt no diminution to his zest for singing glees, cataloguing Japanese prints and extending his customary unstinting hospitality to colleagues and friends from far and near. His genial presence hovers as benignly over the field as ever it did. His colleagues ask him to accept this *Festschrift* as a celebration of the Persian part of his many-sided scholarly career and as a token of their abiding affection.

ROBERT HILLENBRAND

Note on Transliteration

The individual authors have been free to choose their preferred system of transliteration from among the standard options available. Diacritical signs, however, have not been used in the transliteration of Arabic, Persian and Turkish in this volume, with the exception of Dr Çagman's article; in this case, both the editor and the publishers considered that the extensive citations of archival material made their use imperative.

List of Illustrations

CHAPTER 2

1. *Divan* of Mir 'Ali Shir Nava'i,
 Lund University Library, Prov.450, fol. 8 v.

2. *Divan* of Mir 'Ali Shir Nava'i,
 Lund University Library, Prov.450, fol. 144 v.

3. *Divan* of Mir 'Ali Shir Nava'i,
 Lund University Library, Prov.450, fol. 63 r.

4. *Divan* of Mir 'Ali Shir Nava'i,
 Lund University Library, Prov.450, fol. 48 v.

5. *Divan* of Mir 'Ali Shir Nava'i,
 Lund University Library, Prov.450, fol. 54 v.

6. *Divan* of Mir 'Ali Shir Nava'i,
 Lund University Library, Prov.450, fol. 136 v.

7. *Divan* of Mir 'Ali Shir Nava'i,
 Lund University Library, Prov.450, fol. 142 v.

8. *Divan* of Mir 'Ali Shir Nava'i,
 Lund University Library, Prov.450, fol. 44 r.

9. *Divan* of Mir 'Ali Shir Nava'i,
 Lund University Library, Prov.450, fol. 159 v.

10. *Shahnama* by Firdausi,
 British Library, Add.18804, fol. 2 r.

11. *Shahnama* by Firdausi,
 British Library, Add.7763, fol. 21 r.

12. *Hamla-i Haidari* by Bazil,
 British Library, Or.2936, fol. 376 r.

13. *Mahbub al-Qulub* by Barkhudar
 ibn Mahmud Turkaman Farahi,
 Bibliothèque Nationale, Sup.pers.1151,
 fol. 119 v.

14. *Hamla-yi Haidari*, Mir Ghulam
 'Ali Khan Azad,
 Bibliothèque Nationale, Sup.pers.1030,
 fol. 6 b.

15. *Hamla-yi Haidari*,
 Bibliothèque Nationale, Sup.pers.1030,
 fol. 257 b.

CHAPTER 3

1. CAMEL AND KEEPER.
 The Freer Gallery of Art, Smithsonian
 Institution, Washington, D.C., 37.21.
 Gouache painting, inscribed (in the cartouches
 at the top and below the picture) *"musavvir va
 muharrir Shaykh Muhammad fi shuhur sanat 964"*, i.e.
 "painter (author of the miniature) and
 designer (of the whole album page) Shaykh
 Muhammad, in the months of the year 964"
 (1556–57). For other readings of the
 inscription see the following publications: Atil,
 p. 49 and FIG. 16A; Dickson-Welch, I, p. 166B
 and FIG. 226; Simpson, "Shaykh Muhammad",
 p. 105–107 and FIG. I.
 *Commentary: this is evidently either the lower
 half of a composite album page or a recto page
 with the picture arranged horizontally on a
 leaf to be mounted into the vertical format of
 the album, its lower edge towards the spine
 (and lacking only the left edge of the folio).*

2. TWO CAVALIERS.
 Fogg Art Museum, Cambridge, Mass.,
 1948.60.
 Drawing in black ink with gold and
 watercolour, mounted with calligraphy and
 illuminated squares.
 Simpson, APP, No. 23: "Qazvin. 2nd half of
 the 16th-century" (p. 70), "attributable to
 Muhammadi of Herat" (p. 10).
 *Commentary: part of an album page which
 once belonged to a 16th-century album.*
 *Compare: Stchoukine, SA, pl. XXXVI;
 A. Welch, "Shah 'Abbas", ill. 4.*

3. DANCING SUFIS
 The Freer Gallery of Art, 46.15.
 Drawing in black ink with gold, tinted with
 red, inscribed 'amila ustad Muhammadi Haravi.
 PRIMROSES.
 Gouache painting, inscribed 'amila ustad Murad,

 mounted with samples of calligraphy and
 illuminations. Atil, No. 15.
 *Commentary: the seal impression is only on
 the drawing.*

4. LOVERS.
 Museum of Fine Arts, Boston, No. 14. 588.
 Gouache painting, inscribed '"amila ustad
 Muhammadi". Stchoukine, MS, p. 116, No. 137
 (without illustration): "miniature de l'école de
 Shiraz, vers 1570"; Robinson, PD, pl. 46:
 "The attribution to Muhammadi may be
 confidently accepted, ca. 1575". Reproduced
 in: Marteau et Vever, pl. 124; Schulz II, pl.
 157; Coomaraswamy, pl. XXII; Sakisian, FIG.
 160.

5. PORTRAIT OF AN ARTIST.
 Museum of Fine Arts, Boston.
 Gouache painting, inscribed '"amila
 Muhammadi", "surat-i Muhammadi".
 Stchoukine, MS, p. 116, No. 140 (without
 illustration): "l'école de Shiraz, vers 1575".
 Reproduced in: Schulz II, pl. 159;
 Coomaraswamy, pl. XXIII; Sakisian, FIG. 131;
 Kaziev, p. 252.
 *Commentary: the upper part of the seal has
 been trimmed off.*

6. HUNTING SCENE.
 Topkapi, Istanbul, *muraqqa'* H. 2155, f. 20b.
 Drawing, inscribed 'amila ustad Muhammadi.
 PORTRAIT OF 'ALI QULI KHAN.
 Gouache painting, "done in 992/1584 by
 Muhammadi at Herat" (in attributory
 inscription), mounted with calligraphy and
 illuminations.
 A. Welch, "Shah 'Abbas", p. 502, ill. 4 and p.
 469.
 *Commentary: the seal appears on both works;
 on the miniature its upper part has been
 trimmed off.*

7. SEATED YOUTH LEANING ON A
 CUSHION.
 Topkapi, Istanbul, *muraqqa'* H. 2155, f. 20a.
 Gouache painting.
 A RUSSIAN IN A FUR CAP.

Gouache painting.

Both paintings are mounted with samples of calligraphy. Grube-Sims, p. 213, ill. 26: "ca. 1610" for the first one, "1625–1650" for the second.

Commentary: on the first miniature the seal impression is faint, while on the second the upper part of the seal impression has been trimmed off.

8. PORTRAIT OF A RUSSIAN AMBASSADOR.

Topkapi, Istanbul, *muraqqa'* H. 2155, f. 19b. Gouache painting, inscribed *surat-i ilchi-yi urus hasb-i al-amr-i navvab-i ashraf agdas a'la Shah 'Abbas samt tahrir yaft* ("portrait of the Russian ambassador done according to the wish of the noble, most holy, superior Shah 'Abbas") Topkapi, No. 123.

9. YOUNG MAN IN A BLUE COAT.

Arthur M. Sackler Museum, Harvard University, Cambridge, Mass., 1935. 27. Gouache painting, inscribed *mashaqahu kamtarin Aqa Riza*; mounted on later album page and also incorrectly (see note 45).

Published many times: Stchoukine, *SA*, p. 100: "1590 environ"; Gray, *Persian Painting*, p. 161: "c. 1590"; Simpson, *APP*, No. 29: "ca. 1587"; A. Welch, *Artists*, p. 101, 129, pl. 6: "c. 1587"; Canby, ill. 1: "c. 1587".

Commentary: the lower part of the seal has been trimmed off.

10. WOMAN WITH A FAN.

The Freer Gallery of Art, 32.9. Gouache painting, inscribed *mashaqahu Aqa Riza*, mounted with illuminated bands.

Published many times; see, for example: Stchoukine, *SA*, p. 99–100: "vers 1590", Atil, No. 19A: "ca. 1590"; A. Welch, *Artists*, pl. 7: "c. 1587".

Commentary: fragment of an album page of the 16th century.

11. YOUTH AND AN OLD MAN

Arthur M. Sackler Gallery, Smithsonian Institution, Washington DC S.86.0292. Gouache, gold and ink on coloured paper, inscribed *mashaqahu Aqa Riza*, mounted with

samples of calligraphy and illuminations. Stchoukine, *SA*, p. 102: "entre 1605–1615"; Canby, FIG. 11: "c. 1602–03"; Lowry-Beach, No. 365, p. 312: "c. 1605".

Commentary: an album page of the 16th century very similar in its design to the page with Reclining Nude, inscribed mashaqahu Riza, *with rubbed paper near the right edge (perhaps the seal itself is rubbed?) (Atil, No. 19B; Canby, ill. 2).*

12. HUNTER ON HORSEBACK.

Victoria and Albert Museum, London. Ink drawing, tinted with watercolours, inscribed *raqimuhu Riza-yi 'Abbasi*.

YOUTH IN A FUR-LINED COAT.

Gouache painting, inscribed *'amila ustad Muhammad Qasim*; mounted with samples of calligraphy and illumination. Canby, fig 7: "c. 1595" for the drawing by Riza.

Commentary: both works bear seal stamps.

13. PORTRAIT OF A CALLIGRAPHER.

British Library, London. 1920-9-17-0271(1). Tinted drawing on brown-toned paper inscribed *mashaqahu Riza*.

Stchoukine, *SA*, pl. XLa, p. 121: "dessin faussement attribué à Reza", "debut du XVIIe siècle"; B.W. Robinson, *Persian Miniature Painting from collections in the British Isles*, London, 1967, No. 65: "beginning of the 17th century"; Titley, *Index*, Cat. 396 (38), ill. 41: "seventeenth cent."

14. A STANDING WOMAN.

Arthur M. Sackler Gallery, Smithsonian Inst., Washington, D.C., S.86.0305. Gouache painting, inscribed "Sadiqi"

A STANDING YOUTH.

Gouache Painting, inscribed *ustad Muhammad Qasim*; mounted with samples of calligraphy. Lowry-Beach, p. 306, No. 356: "Iran (Qazvin?), ca. 1590.... While the attribution to Sadiqi seems plausible, Robinson has suggested that *A Standing Youth* may be by Riza Abbasi rather than by Muhammad Qasim".

Commentary: the seal is on both of the paintings, but on the right one it is faint.

15. AN INDIAN FEEDING A GAZELLE.

Gulistan Library, Tehran, *Muraqqa'-yi Gulshan*. Gouache painting.

AN ANTELOPE.

Gouache painting.

D.N. Wilber, *Four Hundred and Forty-six Kings of Iran*, Tehran, 1972, ill. 46, depicted personage identified as "Shah Tahmasp".

Commentary: the seal is only on the upper painting.

16. A RELIGIOUS DIGNITARY

Collection of the Calouste Gulbenkian Foundation. Gouache painting, mounted on an album leaf. Inscribed: (above) *hasb-i al-amr-i navvab-i kamiab ashraf agdas a'la/Shah 'Abbas?/samt-i tahrir yaft. Surat-i Mir Kamal al-Din Husain Vaiz* (?) (below) *mashaqahu Riza-yi musawwir*. See *L'Art de L'Orient islamique. Collection de la Fondation Calouste Gulbenkian*. Lisboa, Maio, 1963, No. 135: "vers 1590".

17. SEATED YOUTH WITH A GUN.

Museum Czartoryski, Cracow, Ms. Czart. 3456, fol. 5r. Gouache painting. S. Komornicki, in: *Bull. de la Soc. Franc. de reprod. de peintures*, 18e année (1934), p. 173 and pl. XXXVIII: "les premières années du XVIIe siècle".

18. YOUTH IN A GOLD HAT.

Collection of Sadruddin Aga Khan, Geneva, Ir.M.73. Tinted drawing, mounted with samples of calligraphy and illuminated panels. A. Welch, *Aga Khan*, v. III, p. 104: "Qazvin, c. 1587".

Commentary: the drawing is mounted on a later album page.

Fig. 1. YOUTH HOLDING A FOLIO.

Istanbul University Library, Ms. 1426, fol. 6b. Signed *mashaqahu Riza*. Stchoukine, SA, pl. XXXVI

Fig. 2. GIRL SMOKING.

Topkapi, Istanbul, *Muraqqa'* H.2137, fol. 21b. Signed *Raqam-i Kamine Khaksar Muhammad Qasim*.

CHAPTER 4

1. Manuchihr kills Tur, *Shahnama*, c. 1300.
 Dublin, Chester Beatty Library, Ms. 104, No. 4. Reproduced by kind permission of the Trustees of the Chester Beatty Library, Dublin.

2. The infant Rustam slays the elephant *div*, *Shahnama*, c. 1440–44.
 London, Royal Asiatic Society, Ms. 239, 32b. Courtesy of the Royal Asiatic Society.

3. Chingiz Khan fighting the Chinese, *Epics*, 800/1397.
 London, British Library, Or. 2780, 49b. Courtesy of the Trustees of the British Library.

4. Marginal fragments, *Sharafnama*, c. 1405.
 London, British Library, Or. 13529, 44. Courtesy of the Trustees of the British Library.

5. Conversation of Iskandar and Nushaba, *Sharafnama*, c. 1405.
 London, British Library, Or. 13529, 49. Courtesy of the Trustees of the British Library.

6. Failaqus carrying the infant Iskandar, *Sharafnama*, c. 1405.
 London, British Library, Or. 13529, 12. Courtesy of the Trustees of the British Library.

7. Zangi champion, *Sharafnama*, c. 1405.
 London, British Library, Or. 13529, 17. Courtesy of the Trustees of the British Library.

8. Gifts for Nushaba, *Sharafnama*, c. 1405.
 London British Library, Or. 13529, 53. Courtesy of the Trustees of the British Library.

9. Iskandar entertained by the Khaqan, *Sharafnama*, c. 1405.
 London, British Library, Or. 13529, 74. Courtesy of the Trustees of the British Library.

10. Battle of Dara and Iskandar at Mosul, *Sharafnama*, c. 1405.
 London, British Library, Or. 13529, 32. Courtesy of the Trustees of the British Library.

11. Iskandar comforts the dying Dara, *Sharafnama*, c. 1405.
 London, British Library, Or. 13529, 35, c. 1405. Courtesy of the Trustees of the British Library.

12. Iskandar at the tomb of Kai Khusrau, *Sharafnama*, c. 1405.
 London, British Library, Or. 13529, 59. Courtesy of the Trustees of the British Library.

13. Khusrau sees Shirin bathing, *Miscellany*, 814/1411.
 London, British Library, Add. 27261, 538b. Courtesy of the Trustees of the British Library.

14. Bahram Gur in the Black Pavilion, *Khamsa* of Nizami, 886/1481–2.
 Dublin, Chester Beatty Library, Ms. 162, 200a. Reproduced by kind permission of the Trustees of the Chester Beatty Library, Dublin.

15. Shirin visits Farhad, *Khamsa* of Nizami, 849/1445.
 Manchester, John Rylands University Library, Persian Ms. 36, 62a. Reproduced by courtesy of the Director and University Librarian, the John Rylands University Library of Manchester.

16. Jibra'il visits the worshipping Christian, *Mantiq al-Tair*, c. 1490–1500.
 London, British Library, Add. 7735, 75b. Courtesy of the Trustees of the British Library.

17. Amir Ahmad flies on his father's turban, *Amir Ahmad u Mahsati*, 867/1462–3.
 London, British Library, Or. 8755 (three anonymous romances), 104a. Courtesy of the Trustees of the British Library.

18. The worship of fire, *Suz u Gudaz*.
 Dublin, Chester Beatty Library, Ms. 268, 8a, c. 1640–50. Reproduced by kind permission of the Trustees of the Chester Beatty Library, Dublin.

19. Astronomer, *Nustratnama* of Mustafa 'Ali, 992/1584.
 Istanbul, Topkapi Sarayi Kütüphanesi, H. 1365. Courtesy of Topkapi Sarayi Kütüphanesi.

20. The marriage palanquin, *Pemnem*, c. 1590–1600.
 London, British Library, Add. 16880, 213b. Courtesy of the Trustees of the British Library, London.

CHAPTER 5

FIG. 1 Topkapı Saray Museum Library H.S.5, Binding.

FIG. 2 Topkapı Saray Museum Library H.S.5, Endowment Notation, fol. 1b.

FIG. 3 Topkapı Saray Museum Library H.S.5, Frontispiece, fols. 2v and 3r.

FIG. 4 Topkapı Saray Museum Library H.S.5, fols. 220v and 221r.

FIG. 5 Topkapı Saray Museum Library H.S.5, fols. 53v and 54r.

FIG. 6 Topkapı Saray Museum Library H.S.5, fols. 289v and 290r.

FIG. 7 Topkapı Saray Museum Library H.S.5, fols. 299v and 300 r.

CHAPTER 6

1. Cloth Merchant, from the "Rida-yi 'Abbasi Album"
Iran, early 17th century, black ink on paper, 17.1 x 11.5 cm., Freer Gallery of Art, 53.43.

2. Bird, Butterflies and Flowers, attributed to Muhammad Shafi' 'Abbasi
Iran, mid-17th century, 11.7 x 18.3 cm., British Museum, OA 1922 3–16 01.

3. A Scribe, signed by Rida
Iran, ca. 1600, ink, gold, and colours on paper, 10 x 7 cm., British Museum, 1920 9–17 0271(I).

4. Portrait of Fani (or Mani)
Iran, ca. 1610 or later, ink and colours on paper, 13.2 x 8.5 cm., British Museum, Gift of Sir Bernard Eckstgein Bt., OA 1948 12–11 011.

5. Shafi' 'Abbasi, detail, from the "Rida-yi 'Abbasi Album"
Iran, second quarter of the 17th century, ink and colours on paper, 10.4 x 6 cm., Freer Gallery of Art, 53.17.

6. Detail of FIG. 2, x6.

7. Detail of FIG. 2, x25.

8. Detail of FIG. 2, x25.

9. Signature of Muhammad Shafi' 'Abbasi, detail x25
from the "Shafi' 'Abbasi Album", Iran, ca. 1640–75, ink on paper, British Museum, OA 1988 4–23 035.

10. Detail of a flower, x25, from the "Shafi' 'Abbasi Album"
Iran, ca. 1640–75, colours on paper, British Museum, OA 1988 4–23 013. Note the single stroke that runs from 6:00 to 9:00.

CHAPTER 7

1. Abu'l-Hasan Khan Ghaffari. A RIOT IN ISFAHAN.
Watercolour; Signed and dated: ...raqam-i chakar-i dargah-i Shahanshahi Abu'l-Hasan-Ghaffari Naqqashbashi Kashani dar bist va shishum-i mah-i mubarak-i Ramazan surat itmam pazir yaft sana 1268/August 1852.

2. F. Colombari. PORTRAIT OF MUHAMMAD SHAH.
Watercolour on paper. Ca. 1840. Private collection.

3. Abu'l-Hasan Khan Ghaffari. THE QUEEN IN CONVERSATION.
Illustration to the manuscript of 1001 Nights. Gulistan Palace Library, no. 2240 (folio numbers not available). ca. 1269/1852–3.

4. Yahya Ghaffari. PORTRAIT OF A LADY.
Watercolour on paper. Signed and dated: raqam-i Yahya, 1278/1862. Art Market, London.

5. Abu'l-Hasan Ghaffari. PORTRAIT OF KHURSHID KHANUM.
Signed and dated: mashq-i Abu'l-Hasan-Thani Ghaffari sana 1259/1843–44. Private collection, Paris.

6. Yahya Ghaffari. YOUTH AND MAIDEN BY A STREAM.
Illustration to a manuscript of the Masnavi of Jalal al-Din Rumi. Book IV, folio 3. Signed: raqam-i Yahya. Dated 1279–80/1863–4. Private collection, London.

7. Yahya Ghaffari. PHARAOH WITH HIS CONSORT, ASIYA.
Illustration to a manuscript of the Masnavi of Jalal al-Din Rumi. Book IV, folio 76. Dated 1279–80/1863–4. Private collection, London.

8. Abu'l-Hasan Ghaffari. A WOMAN STONED BY HER BROTHER-IN-LAW.
Illustration to a manuscript of the 1001 Nights. Ca. 1269/1852–3. Gulistan Palace Library, no. 2240 (folio numbers not available).

9. Yahya Ghaffari. THE ELEPHANT LOOKING AT THE MOON.
Illustration to a manuscript of the Masnavi of Jalal al-Din Rumi. Book III, folio 78. Dated 1279–80/1863–4. Private collection, London.

10. Yahya Ghaffari. PORTRAIT OF HIS FATHER, ABU'L-HASAN.
Watercolour on paper. Signed and dated: Abu'l-Hasan-i Thalith, 1293/1876. Private collection, Tehran.

11. Yahya Ghaffari. PORTRAIT OF A MAN.
Watercolour on paper. Signed and dated: Hunar az khanazad Abu'l-Hasan-i Thalith, 1294/1877. Private collection.

12. Yahya Ghaffari. THE ALI QAPU PORTAL, AND PALACE SQUARE.
Oil on canvas. Signed and dated: raqam-i khanazad mirza Abu'l-Hasan Khan pasar-i Sani' al-Mulk fi sana 1303/1885-6. Gulistan Palace Museum, Tehran.

13. Muhammad Ghaffari. A GARDEN COURTYARD IN THE GULISTAN PALACE.
Oil on canvas. Signed and dated: durnama-yi 'Imarat-i Gulistan hasb al-amr-i A'lahazrat-i aqdas khassa tamam shud amal-i Muhammad Ghaffari Kashani. 1303/1886–87. Gulistan Palace Museum, Tehran.

14. Yahya Ghaffari. THE DIAMOND HALL OF THE GULISTAN PALACE.
Oil on canvas. Signed and dated: hasb al-amr-i bandigan-i A'lahazrat-i Shahanshah-yi al-'alamin fadah utaq-i mubarak-i birilian, bi dast-i khanazad Abu'l-Hasan Khan tashshakul yaft. 1305/1888. Gulistan Palace Museum, Tehran.

15. Muhammad Ghaffari.
THE DIAMOND HALL OF THE
GULISTAN PALACE.
Oil on canvas. 1305–10/1888–93. Gulistan
Palace Museum, Tehran.

CHAPTER 9

Text I *MARZUBAN-NAMA*

1. (Pl. 1) Folio 13v: Hanbui Before
Zahhak
10.5 x 9 cm
Levy, *Marzuban* (1968), pp. 16–17.

2. (Pl. 2) Folio 54r: The Two
Highwaymen Killing Their Companion
8.3 x 9 cm
Levy, *Marzuban* (1968), p. 74.

3. (Pl. 3) Folio 153v: The Battle of the
Elephants and the Lions
10.5 x 9 cm
Levy, *Marzuban* (1968), pp. 208–211.

4. (Pl. 4) Folio 161r: The Weaver and the
Serpent
8.3 x 9 cm
Levy, *Marzuban* (1968), pp. 222–227.

Text II *KALILA U DIMNA*[13]

Chapter I. *Burzuya's Biography*

5. (Pl. 5) Folio 239v: The Perils of Life
(B.13)
11.5 x 8.3 cm
Atasoy, "Süleymaniye" (1979), p. 426,
fig. 1.

Chapter II. *The Lion and the Bull*

6. (Pl. 6) Folio 242v: The Monkey and
the Carpenter (C.3)
9 x 8.3 cm
Gray, "Shiraz" (1979), p. 137, fig. 77.

7. (Pl. 7) Folio 246v: Dimna Presents
Himself to the Lion (B.15.4)
6.5 x 8.3 cm

8. (Pl. 8) Folio 251r: Dimna Leads
Shanzaba to the Lion
(B.15.11)
5.5 x 8.3 cm

9. (Pl. 9) Folio 260v: The Lion and the
Hare at the Well (C.7.3)
9.5 x 8.4 cm

10. (Pl. 10) Folio 274v: The Killing of the
Camel (C.10.8)
9 x 8.3 cm

11. (Pl. 11) Folio 277v: The 'Flying
Tortoise' (D.2.2)
9 x 8.3 cm

12. (Pl. 12) Folio 279v: The Lion Attacks
Shanzaba (B.15.21)
8.4 x 8.3 cm

13. (Pl. 13) Folio 283v: The 'Testimony
of the Tree' (C.13.7)
8.5 x 8.4 cm

Chapter III. *The Doves, the Crow, and Rat, the
Tortoise, and the Gazelle*

14. (Pl. 14) Folio 307v: The Doves
Caught by the Fowler (B.16.2)
8.4 x 8.4 cm

Chapter IV. *The Owls and the Crows*

15. (Pl. 15) Folio 335v: Firuz and the
King of the Elephants at the Lake of the
Moon (D.5.5)
8.1 x 8.3 cm

16. (Pl. 16) Folio 343r: The Plot of the
Thief and the *Div* Against the Pious
Man (C.23.3)
8.4 x 8.4 cm
marg 1991, p. 94, fig. 100.

Chapter V. *The Monkey and the Tortoise*

17. (Pl. 17) Folio 357r: The King of the
Monkeys Dropping Figs Into the Lake
(B.18.2)
9.1 x 8.4 cm

18. (Pl. 18) Folio 361r: The King of the
Monkeys Riding Across the Lake on the
Tortoise's Back (B.18.6)
7.5 x 8.3 cm

Chapter VI. *The Pious Man and the Faithful
Weasel*

19. (Pl. 19) Folio 369r: The Pious Man
Kills the Faithful Weasel (B.19.5)
6.4 x 8.3 cm

Chapter VII. *The Cat and the Rat*

20. (Pl. 20) Folio 371r: The Cat in the
Trap, the Rat, the Weasel, and the Owl
in the Tree (B.20.2)
6.5 x 8.3 cm

Chapter VIII. *The King of India and the
Treacherous Brahmans*

21. (Pl. 21) Folio 420v: Kibayrun
Interprets the King's Dreams (B.23.4)
7.4 x 8.3 cm

22. (Pl. 22) Folio 422v: The King and
Irakht (B.23.13)
8.7 x 8 cm

23. (Pl. 23) Folio 432v: The Execution of
the Treacherous Brahmans (B.23.14)
10 x 9 cm

Text III *SINDBAD-NAMA*

24. (Pl. 24) Folio 473v: The Astronomers
Casting the Horoscope of the King's
Son
10 x 9 cm
Bogdanovic, *Sendbadnameh* (1975), p. 37.

25. (Pl. 25) Folio 503r: The Prince
Pursues the Onager of Marvellous
Allure
9.5 x 12.5 cm
Bogdanovic, *Sendbadnameh* (1975), p.
111.

26. Pl. 26) Folio 520v: The Beautiful
Youth in Love With the Maiden
10 (19) x 12.5 cm

Bogdanovic, *Sendbadnameh* (1975), pp. 145–147.

27. (Pl. 27) Folio 525r: The Old Woman, With the Help of Her Crying Dog, Persuades the Maiden to Accept the Love of the Beautiful Youth
10 x 9 cm
Bogdanovic, *Senbadnameh* (1975), pp. 154–158.
Atasoy, "Sülemaniye" (1979), p. 427, fig. 2

28. (Pl. 28) Folio 556v: The King Asks His Son How to Punish the Woman Who Had Falsely Accused Him
10.5 x 9.9 cm
Bogdanovic, *Sendbadnameh* (1975), p. 262.

Fig. 1. The Plot of the Thief and the *Dīv* Against the Pious Man
(C.23.3)
'Abu'l-Ma 'ālī Naṣr Allāh, *Kalila u Dimna*
Persia, probably Tabriz, about 1370 Istanbul, University Library, Album Farsca 1422, fol. 7r

Fig. 2. The Plot of the Thief and the *Dīv* Against the Pious Man
(C.23.3)
'Abu'l-Ma 'ālī Naṣr Allāh, *Kalila u Dimna*
Persia, MS Herat, 834/1431, paintings probably Tabriz, about 1400
Istanbul, TKS, H. 362, fol. 95r

Fig. 3. The Plot of the Thief and the *Dīv* Against the Pious Man
(C.23.3)
Ḥusayn ibn 'Alī al-Vā'iẓ al-Kāshifī, *Anvār-i suhavli*
India, Mughal court atelier, 22 Rabi' II, 978/September 23, 1570
London, University of London, School of African and Oriental Studies, MS 10102, fol. 174r

Fig. 4. The Plot of the Thief and the *Dīv* Against the Pious Man
(C.23.3)
Ḥusayn ibn 'Alī al-Vā'iẓ al-Kāshifī, *Anvār-i suhavli*
Persia, Qazvin, 13 Safar 1002/November 8,

1593 Collection of Prince Sadruddin Aga Khan (Ex Bute MS 347), fol. 190v

Fig. 5. The Plot of the Thief and the *Dīv* Against the Pious Man
(C.23.3)
'Abdallah ibn al-Muqaffa, *Kalila u Dimna*
Syria, early 7th/13th century
Paris, BN, MS Arabe 346, fol. 103v

Fig. 6. Dimna Presents Himself to the Lion (B.15.4)
'Abu'l-Ma 'ālī Naṣr Allāh, *Kalila u Dimna*
Baghdad or Tabriz, Jala 'irid atelier, 744/1343–44
Cairo, National Library, MS Adab farsi 61, fol. 17v

Fig. 7. The Weaver and the Serpent
(B.15.4)
Sa's al-Dīn Varāvinī, *Marzubān-nāma*
Persia, Yazd, 810/1407
Istanbul, TKS, H. 796, fol. 261r

CHAPTER 11

1. Rashid al-Din,
Jami' al-Tawarikh, f.149v: *bismillah*

2. Rashid al-Din,
Jami' al-Tawarikh, f.48v: early converts to Islam undergo torture

3. Rashid al-Din,
Jami' al-Tawarikh, f.54r: the Quraish consult about the proscription of their kinsmen who support Muhammad

4. Rashid al-Din,
Jami' al-Tawarikh, f.42r: the birth of Muhammad

5. Al-Biruni,
Al-Athar al-Baqiya, f.6v: Muhammad forbids intercalation

6. Al-Biruni,
Al-Athar al-Baqiya, f.10v: Isaiah's prophecy about Muhammad

7. Rashid al-Din,
Jami' al-Tawarikh, f.45r: Muhammad arbitrates over lifting the Black Stone into position in the Ka'ba

8. Rashid al-Din,
Jami' al-Tawarikh, f.52r: the Negus of Abyssinia refuses to yield up the Muslims who sought asylum with him

9. Rashid al-Din,
Jami' al-Tawarikh, f.57r: Muhammad, Abu Bakr, the herdswoman and the goats

10. Rashid al-Din,
Jami' al-Tawarikh, f.55r: the Night Journey of Muhammad on Buraq

11. Rashid al-Din,
Jami' al-Tawarikh, f.43v: the young Muhammad is recognised by the monk Bahira

12. Al-Biruni,
Al-Athar al-Baqiya, f.92r: Muhammad with the envoys of Musailama

13. Al-Biruni,
Al-Athar al-Baqiya, f.162r: The investiture of 'Ali at Ghadir Khumm

14. Al-Biruni,
Al-Athar al-Baqiya, f.161r: The Day of Cursing

15. Rashid al-Din,
Jami' al-Tawarikh, f.45v: Muhammad receives his first revelation through the angel Jibra'il

16. Al-Biruni,
Al-Athar al-Baqiya, f.1r: title page

17. Rashid al-Din,
Jami' al-Tawarikh, f.149r: *shamsa*

18. Rashid al-Din,
Jami' al-Tawarikh, f.41r: 'Abd al-Muttalib and al-Harith about to discover the well of Zamzam

CHAPTER 13

1. Ni'matullah Khalife, as a Sufi master, presenting his book to the literati of the age.

2. 'Attar, *Manteq ot-Teyr.*
Sheykh San'an sees a Greek beauty in a palace – inscribed to 'Abdullah Khan.

3. 'Attar, *Manteq ot-Teyr.*
Sheykh San'an attends a party given by the Greek beauty. 'Abdullah Khan is named in the frieze.

4. 'Attar, *Manteq ot-Teyr.*
The Greek beauty expires in the presence of Sheykh San'an and his disciples.

5. 'Attar, *Manteq ot-Teyr.*
Sheykh San'an's disciples watch the scene depicted in fig. 4.

6. Sa'di, *Bustan.*
A travelling dervish is led to the king. His arms in the *lam-alif* position identify him as a Sufi.

7. Sa'di, *Bustan.*
A compassionate man who found a thirsty dog in the desert pulls up water.

8. Sa'di, *Bustan.*
One of two beggars, whose disparaging remarks King Saleh overheard, addresses the ruler.

9. Nezami, *Khosrow va Shirin.*
Farhad is taken by emperor Shapur to Shirin's palace.

10. Nezami, *Khosrow va Shirin.*
A proverb about the wolf's tale is illustrated in rebus form.

11. Jami, *Tohfat ol-Ahrar.*
The dervish thrown off the roof of a palace is named over the door: this is Ni'matullah Khalife.

12. Jami, *Tohfat ol-Ahrar.*
The two figures relate to Jami's verses celebrating God as an object of human love.

13. Jami, *Yusof va Zoleykha.*
Zoleykha sends Yusof off to the park. Only one pool is visible, instead of the two in the story.

14. Jami, *Yusof va Zoleykha.*
Yusof receiving a ewer and the Egyptian women raving about his beauty.

15. Jami, *Yusof va Zoleykha.*
Yusof invites Zoleykha to take her place in a house of worship and thank God.

16. 'Arefi, *Guy-o Chowgan.*
A young king becomes aware that a dervish is attracted by his good looks.

17. 'Arefi, *Guy-o Chowgan.*
The king holds a book (the *Anthology*) facing a dervish, meant here as Ni'matullah.

18. Hatefi, *Leyla va Majnun.*
Majnun sits in the desert amidst wild beasts, as his companions approach his retreat.

19. Hatefi, *Leyla va Majnun.*
Majnun, taken to the encampment of Leyla, sees her peeping out of a tent.

20. Hatefi, *Leyla va Majnun.*
Majnun retreats to the mountains. Paradoxically, the image is composed as a dyptich.

21. Helali, *Shah va Darvish.*
A servant hands the king a seal that he had given to the dervish.

22. Helali, *Shah va Darvish.*
The dervish arrives at the royal precinct and the King receives a seal.

23. The young prince makes the *lam-alif* gesture, suggesting his Sufi allegiance to Ni'matullah.

24. Jami, *Yusof va Zoleykha.* Note the inscription over the arched door mentioning Tanish Bey.

CHAPTER 14

1. SOLOMON ENTHRONED, Firdevsî Burûsevi, *Süleymânnâme,* c. 1505–12,
Dublin, Chester Beatty Library MS 406, f. 2b.

2. THE ANGEL POURING THE VIALS OF WRATH ON THE CITY OF BABYLON/THE RUIN OF BABYLON,
Beatus of Liébana. *Commentary on the Apocalypse,* made for Ferdinand I of Castile and León, 1047, Madrid, Biblioteca Nacionál, vit. 14–2, folio 234a.

3. Firdevsî Burûsevi, *Süleymânnâme* THRONE OF BILQIS,
Dublin, Chester Beatty Library. MS. 406, f. 2a

4. LUIS DE GUZMAN,
25th Master of the Order of Calatrava, Bible of the House of Alba, Toledo, 1422–30. madrid, Palacio de livia vit. 1.

Fig. 1. Firdevsî Burûsevi, *Süleymânnâme,* THRONE OF SOLOMON.
Dublin, Chester Beatty Library, MS. 406, f. 1b.

Fig. 2. Firdevsî Burûsevi, *Süleymânnâme,* THRONE OF SOLOMON.
Dublin, Chester Beatty Library, MS. 406, F. 1b (detail).

Fig. 3. Firdevsî Burûsevi, *Süleymânnâme,* THRONE OF BILQIS.
Dublin, Chester Beatty Library, MS. 406, f. 2a.

Fig. 4. Firdevsî Burûsevi, *Süleymânnâme,* DEMONS BELOW THE THRONE OF BILQIS.
Dublin, Chester Beatty Library, MS. 406, f. 2a.

CHAPTER 15

1. THE SACRIFICE OF 'ABD AL-MUTTALIB, 1568
 Istanbul, Topkapi Saray Museum, H. 1233, fol. 13b

2. MUHAMMAD UND 'ALI DURING THE BATTLE OF BADR, 1568
 Istanbul, Topkapi Saray Museum, H. 1233, fol. 96b

3. 'ALI FIGHTING TO TAKE THE FORTRESS OF QAMUS, 1568
 Istanbul, Topkapi Saray Museum, H. 1233, fol. 158b

4. 'ALI FIGHTING TO TAKE THE FORTRESS OF QAMUS, 1567
 Dublin, Chester Beatty Library, Pers. 235, fol. 132a. Reproduced by courtesy of the Trustees of the Chester Beatty Library, Dublin

5. MUHAMMAD AND 'ALI NEAR GHADIR KHUMM, 1567
 Dublin, Chester Beatty Library, Pers. 235, fol. 152a. Reproduced by courtesy of the Trustees of the Chester Beatty Library, Dublin

6. MUHAMMAD PREACHES AFTER THE BATTLE OF THE DITCH, 1567
 Opaque watercolour, ink, and gold on paper, S1986.282. Courtesy of the Arthur M. Sackler Gallery, Smithsonian Institution, Washington, D.C.

7. 'ABD AL-MUTTALIB PRAYING AT THE KA'BA, 1567
 Courtesy of the Pierpont Morgan Library, New York (G. 72b)

8. THE PURSUERS OF MUHAMMAD BEING DECEIVED, 1573/74
 St. Petersburg, Russian National Library, Dorn 456, fol. 50b

9. 'ALI DESTROYING THE IDOLS, 1573/74
 St. Petersburg, Russian National Library, Dorn 456, fol. 124a

CHAPTER 16

pls. 1–2
1341 *Shahnama*, folios [5b–6a]: Dedicatory rosette
Courtesy, Arthur M. Sackler Gallery, Smithsonian Institution, Washington, D.C. (S1986.110, verso and S1986.111, recto)

pl. 3
1341 *Shahnama*, folio [321/322b]: Colophon and finispiece
Collection of Prince Sadruddin Aga Khan, Geneva (IR.M.6/I, verso)

pl. 4
1341 *Shahnama*, folio 317a: *Shahnama* text
Worcester Art Museum, Worcester, Massachusetts (1953.21, recto)

pl. 5
1341 *Shahnama*, folio 317b: Sa'd-i Vaqqas slays General Rustam
Worcester Art Museum, Worcester, Massachusetts (1953.21, verso)

pls. 6–7
1341 *Shahnama*, folios [1b–2a]: Double frontispiece
Courtesy, Arthur S. Sackler Gallery, Smithsonian Institution, Washington, D.C. (S1986.113, side 2 and S1986.112, recto)

pls. 8–9
1341 *Shahnama*, folios [2b–3a]: Double folios with beginning of old preface to *Shahnama*
right half: Courtesy, Arthur M. Sackler Gallery, Smithsonian Institution, Washington. D.C. (S1986.112, verso)
left half: Chester Beatty Library, Dublin (MS 110.I, recto)

pl. 10
1341 *Shahnama*, folio 4b: Old preface and illustration of Firdausi and the court poets of Ghazna
Collection of Prince Sadruddin Aga Khan, Geneva (IR.M. 56, verso)

pl. 11
1341 *Shahnama*, folio [5a]: Old preface
Courtesy, Arthur M. Sackler Gallery, Smithsonian Institution, Washington, D.C. (S1986.110, recto)

pls. 12–13
1341 *Shahnama*, folios [6b–7a]: Beginning of the *Shahnama*
Courtesy, Arthur M. Sackler Gallery, Smithsonian Institution, Washington, D.C. (S1986.111, verso and S1986.109, recto)

pl. 14
1341 *Shahnama*, folio [216a]: Mihrak's daughter converses with Shapur at the well
Courtesy of The Arthur M. Sackler Museum, Harvard University Art Museums, Cambridge, Massachusetts. Bequest of Abby Aldrich Rockefeller (1960.192)

pl. 15
1341 *Shahnama*, folio [187b]: Rustam and Isfandiyar meet and parley
The Metropolitan Museum of Art, New York. The Cora Timken Burnett Collection of Persian Miniatures and Other Persian Objects, Bequest of Cora Timken Burnett (57.51.36)

pl. 16
1341 *Shahnama*, folio [191a]: Rustam and Isfandiyar test each other
Albright-Knox Art Gallery, Buffalo, New York, Sherman S. Jewett Fund (35:15.2)

pl. 17
1341 *Shahnama*, folio [59a]: Fire ordeal of Siyavush
McGill University Libraries, Montreal, Department of Rare Books and Special Collections (1977.4)

pl. 18
1341 *Shahnama*, folio 125a:

Rustam rescues Bizhan
from the pit
Courtesy, Freer Gallery of Art, Smithsonian
Institution, Washington, D.C. (45.7)

pl. 19
1330 *Shahnama*, folio 91b:
Rustam rescues Bizhan
from the pit
Topkapi Sarayi Müzesi, Istanbul (H. 1479)

pl. 20
1341 *Shahnama*, folio
[310/311]: Musician Barbad
plays for Khusrau Parviz
Art and History Trust Collection, courtesy of
the Arthur M. Sackler Gallery, Smithsonian
Institution, Washington, D.C.

pl. 21
1330 *Shahnama*, folio 272b:
Musician Barbad plays for
Khusrau Parviz
Topkapi Sarayi Müzesi, Istanbul (H. 1479)

pl. 22
1341 *Shahnama*, folio 37a:
Rustam catches Afrasiyab
by the belt and lifts him from
the saddle
Courtesy, Freer Gallery of Art, Smithsonian
Institution, Washington, D.C. (52.35)

pl. 23
1330 *Shahnama*, folio 28a:
Rustam catches Afrasiyab by the
belt and lifts him from the
saddle
Topkapi Sarayi Müzesi, Istanbul (H. 1479)

pl. 24
1341 *Shahnama*, folio 34a:
Zal joins Mihrab in battling
Turanians
Walters Art Gallery, Baltimore (10.677d)

pl. 25
1341 *Shahnama*, folio 154a: Kay-
Khusrau sees marvels of the sea
Courtesy, Freer Gallery of Art, Smithsonian
Institution, Washington, D.C. (42.12)

CHAPTER 17

1. LAILA AND MAJNUN IN THE
DESERT WITH BEARS SEATED ON
ROCKS.
Satin lampas signed: *'amal-i Ghiyath*.Yazd or
Isfahan, late 16th century. Courtesy of the
Textile Museum, Washington (TM3.312)

2. THE ANNUNCIATION TO THE
VIRGIN.
Watercolour on paper signed by Sadiqi
Beg.Yazd, c.1580–5.
PRIVATE COLLECTION ON LOAN TO FOGG ART
MUSEUM 418.1983

3. THE ANNUNCIATION TO THE
VIRGIN.
Engraving on paper by the Master of the
Banderoles.
Flemish, c.1450–70.
After Lehrs. *Kritischer Katalog*.

4. STUDY OF A ROSE MOUNTED
WITH CALLIGRAPHY.
Watercolour on paper inscribed "Work of
Sadiqi".
Isfahan or perhaps Yazd, c.1580–1609.
PRESENT WHEREABOUTS UNKNOWN.

5. A SYBIL.
Watercolour on paper. Signed by Sadiqi
Kitabdar.
Isfahan, 1609 A.D.
PRESENT WHEREABOUTS NOT KNOWN.

6. TWO SYBILS.
Engraving on paper. By Goltzius after Polidoro
da Caravaggio, 1592.

7. OLD MAN AND CHILD.
Ink and watercolour on paper.
Signed by Sadiqi. Isfahan, early 17th century.
By courtesy of the Chester Beatty Library,
Dublin.

8. DERVISH LEADING A DOG.
Ink and water-colours on paper. Signed by
Sadiqi. Isfahan, early 17th century.
By courtesy of the Walters Art Gallery,
Baltimore.

CHAPTER 18

1. TUR KILLS IRAJ.
The University of Michigan, Museum of Art,
1963/1.41, fol. 22.

2. TUR KILLS IRAJ.
Istanbul, Topkapi Sarayi Museum, H. 1496,
fol. 30b.

3. TAHMINA ENTERS RUSTAM'S
CHAMBER.
The University of Michigan, Museum of Art,
1963/1.46, fol. 81a.

4. TAHMINA ENTERS RUSTAM'S
CHAMBER.
Harvard Art Museums (Arthur M. Sackler
Museum), gift of Mrs. Elsie Cabot Forbes and
Mrs. Eric Schroeder and purchase from the
Annie S. Coburn Fund, 1939, 225.

5. TAHMINA ENTERS RUSTAM'S
CHAMBER.
Geneva, Château de Belle Rive, fol. 85a.

6. TAHMINA INTRODUCES HERSELF
TO RUSTAM.
Istanbul, Topkapi Sarayi Museum, H. 1496,
fol. 103a.

7. RUSTAM THROWS A ROPE TO
BIZHAN.
The University of Michigan, Museum of Art,
1963/1.54, fol. 202b.

8. RUSTAM THROWS A ROPE TO
BIZHAN.
The Chester Beatty Library, Persian Ms. 157,
fol. 214b.

9. ARDASHIR MOUNTS THE THRONE
IN BAGHDAD
The University of Michigan, Museum of Art,
1963/1.67, fol. 367a.

10. ARDASHIR MOUNTS THE
THRONE IN BAGHDAD
Istanbul, Topkapi Sarayi Museum, H. 1496,
fol. 459a.

11. BUZURJMIHR ADVISES
ANUSHIRVAN
The University of Michigan, Museum of Art,
1963/1.71, fol. 440b.

12. BURZUYAH BEFORE
ANUSHIRVAN.
Tehran, Gulistan Palace Library.

CHAPTER 19

1. A STALLION.
The Metropolitan Museum of Art, New York.
1992.51 (H14)

2. YOUNG HUNTSMAN LOADING A
MATCHLOCK.
Topkapi Saray Museum Library, Istanbul, H.
2165, fol. 54b. (H2)

3. A SEATED LADY IN AN ORANGE
DRESS AND GREEN MANTLE.
Topkapi Saray Museum Library, Istanbul, H.
2165, fol. 54v. (H3)

4. A SEATED LADY.
Private Collection, London (H4)

5. YOUNG MAN WITH A BOW.
Art and History Trust Collection, courtesy of
the Arthur M. Sackler Gallery, Smithsonian

Institution, Washington, D.C.

6. A YOUNG LADY HOLDING A SPRIG
OF WHITE FLOWERS.
The Hans P. Kraus Collection, New York
(H7)

7. A CHAINED DROMEDARY.
The Medelhavsmuseet, Stockholm (H12)

CHAPTER 20

1. Harvard University Art Museums,
Alpheus Hyatt Fund, 1952.7.

2. Collection of Prince Sadruddin Aga Khan,
Ir. M. 81.

3. Museum of Fine Arts, Boston, 14.614.

4. Collection of Prince Sadruddin Aga Khan.

5. Collection of Prince Sadruddin Aga Khan, M.
193.

6. Collection of Prince Sadruddin Aga Khan, M.
109.

7. Museum of Fine Arts, Boston, 14.495.

8. Istanbul University Library.

9. Collection of Prince Sadruddin Aga Khan, Ir.
M. 91.

10. Museum of Fine Arts, Boston, 14.595.

11. Private Collection.

12. Collections of Prince Sadruddin Aga Khan,
Ir. M. 77.

13. Nelson-Atkins Gallery, Kansas City, no.
34–224.

14. Institute of Art, Detroit, 44.274.

15. Musée Guimet.

16. Private Collection.

17. Topkapi Saray Museum, Istanbul.

18. Collection of Prince Sadruddin Aga Khan, Ir.
M. 89.

19. Collection of Prince Sadruddin Aga Khan, Ir.
M. 71.

CHAPTER 21

1. A drawing by Mirza-'Ali.

1

B.W. Robinson at the Victoria and Albert Museum

CLAUDE BLAIR

I FIRST MET ROBBIE IN 1947, AND WE BECAME COLLEAGUES IN 1956 when I joined the V. &. A. as an Assistant Keeper in the Department of Metalwork, of which he was then Deputy Keeper under the late C.C. Oman. So when I was asked to write something about him in the context of the V. &. A. for this *Festschrift* my first reaction was to think that I could do it not only with pleasure, but also with ease. On coming to attempt it, however, and after consulting various former colleagues, it has been borne in on me that there is very little to say, and certainly nothing sensational, or even more than mildly amusing! His life, like all our lives during his time in the Museum, was tranquil to an extent that now seems hardly possible looking back from the present unhappy period of incompetent "restructuring" and commercialisation of museums.

During all the time I worked with Robbie he followed an almost unvarying routine. He would arrive in the morning at about 9.45 and settle down in his office, which soon became filled with the smoke from one of the selection of pipes he kept on his desk. He would then work steadily at answering letters — always in his characteristic script since he eschewed the typewriter — or some other writing, until 12.30, when he would go out to lunch, which normally started with a visit to a favourite pub where he would down a couple of pints of draught beer or Guinness. He would return at 2.30 and continue as before until he went home at 5.30. In normal times this routine was disturbed only by the telephone and the many visitors who came to him for opinions on oriental metalwork, especially, of course, Japanese swords and sword-mounts, Japanese prints and Persian miniatures. The last two groups of objects came his way because there was then nobody capable of dealing with them in the department that was officially responsible.

One anecdote about Robbie and the giving of opinions is worth recounting. In common with many other people in museums in the 50s, 60s and 70s he suffered his share of persecution from the eccentric Mrs. Hull Grundy. She was a wealthy collector of jewellery and netsuke whose other hobby — or rather one version of it — was to use half-promises of bequeathing or presenting her collection to certain museums as a means of making their officials dance to her tune. In middle age she had developed an undiagnosed illness — which enabled her to make those round her dance too — and had taken to her bed at her home in Stockbridge, Hampshire, from which she communicated with the world by telephone and telegram. Despite her reputation, Robbie, with his usual amiability, acceded to a summons to visit her to advise about her Japanese collection, unwisely as it turned out. During the course of his visit a netsuke allegedly disappeared, and her reaction was to demand that he should be stripped and searched. The more ribald of his colleagues suggested that the presence of so attractive a man at her bedside after years of repression had been too much for her, and that she had hidden the netsuke herself! He has never revealed to me whether or not she succeeded in getting her way.

Robbie was, of course, involved in the organisation of a number of important loan exhibitions in the Museum, amongst which one remembers with particular pleasure the Kuniyoshi exhibition of 1961 and, above all, the superb Persian miniature exhibition of 1967.

Also worth recording as an example of Robbie's many-sided talents is the splendid poster he designed for the "Art of the Armourer" exhibition held in the Museum in 1963.

Robbie held the office of Keeper of Metalwork from 1966 until his retirement in 1972. These last six years of his museum career were less happy than they might have been because they were largely overlapped by the directorship of Sir John Pope-Hennessy (1967–1973). Pope-Hennessy was not noted for his kindness to his subordinates, but he was particularly unkind to Robbie, no doubt because he mistook amiability and courtesy for weakness. Some years after Robbie had retired I asked him how he had been able to put up with it. His reply was that he had adopted the principle early in life of always asking himself in a crisis "What is the worst that can happen?", and had nearly always found that this was never as bad as he had first thought!

Robbie's popularity in the Museum matched his popularity everywhere. He is one of the very few people I have known about whom I have only heard good spoken. On my first day at the V. & A., in September, 1956, a Museum Assistant of some seniority – whose identity I have regrettably forgotten – was detailed to take me round the place to carry out various administrative rituals that were required and generally show me the basic ropes. I mentioned to him that I already knew Robbie and he replied "Ah, Mr. Robinson. Now he is a *real* gentleman". What more is there to say?

2

A Copy of the Divan of
Mir 'Ali Shir Nava'i

of the Late Eighteenth Century in the Lund University Library and the Kashmiri School of Miniature Painting

KARIN ÅDAHL

THE HISTORY OF MINIATURE PAINTING IN KASHMIR IS STILL a relatively unknown field of research and has not been the subject of much study. In 1976 two Russian scholars, Ada Adamova and T. Grek, published a still unique monographical study based on a collection of 17 illustrated manuscripts of possible Kashmiri origin in collections held in St. Petersburg.[1] An additional five manuscripts from other collections in the former Soviet Union and Germany, the origin of which appears uncertain, were added separately to the first group for further study.[2]

Only 10 of this total of 22 manuscripts are dated, the earliest date being 1111 A.H./1699–1700 A.D. and the latest 1287 A.H./1870–71 A.D.[3] The accuracy of these dates is extremely uncertain, since, according to Adamova and Grek, it appears to have been common practice to change the dates in the manuscripts when this appeared convenient.[4] The miniatures illustrating the texts were most likely produced within a shorter period than the one indicated by these dates.

The attribution to Kashmir of the miniature paintings was based on the style of the miniatures with the support of the few manuscripts where mention is made of a Kashmiri origin. This is the case with a *Mahbub al-Qulub* by Barkhurdar ibn Mahmud Turkman Farahi (Adamova and Grek, no. 1) with a note on fol. 1a saying "created in Rabi' II of 1112 in the land of Kashmir" and a *Matla' al-Sa'dain wa*

Majma' al-Bahrain by 'Abd al-Razzaq ibn Mawlana Jalal al-Din Ishaq al-Samarqandi (Adamova and Grek, no. 3) with an inscription on fol. 583b saying "This book, *Timur-nama*, belongs to Mawlana Nazar-Muhammad Farghani, bought in Kashmir".[5] The stylistic analysis of the manuscripts, the illumination and the miniatures of these two manuscripts, and a group of manuscripts that could be associated with these two, indicates a production of illustrated manuscripts in Kashmir in the eighteenth and nineteenth centuries. Evidence for a school of miniature painting in Kashmir, however, has had to be based mainly on stylistic criteria and on a comparative analysis of Persian and Indian miniature painting.

Bearing in mind the relatively short period of twenty to thirty years during which it can be supposed that most of the miniatures of the 17 manuscripts were produced, Adamova and Grek have drawn certain tentative conclusions from the St. Petersburg material, dividing the paintings of the 17 main manuscripts into two groups. Twelve manuscripts (Adamova and Grek, nos. 1–12) belong to the first group and five manuscripts (nos. 13–17) to the second. The distinction between the two groups was again based on a stylistic analysis which indicated two different styles, one more influenced by Persian painting, and the other with a closer relation to Indian painting. According to Adamova and Grek, the manuscripts in Persian style are of an earlier date than those in Indian style.

An attempt to draw the outlines of a history of miniature paint-ing after the Muslim conquest of Kashmir in the fourteenth cen-tury is still difficult, since little is known about the production of miniatures and the manuscripts are insufficiently documented. However, during the reign of Sultan Zain al-'Abidin (1420–1470) Persian became the official language in Kashmir and artists were invited there from Central Asia and Iran.[6] The inaccessibility of the valley of Kashmir and Srinagar itself, situated on a high plateau and surrounded by mountain ranges, did not prevent trade and com-munication and Kashmir was connected with Central Asia as well as the Indian subcontinent through well-established trade routes. Only political conditions temporarily complicated these relations.

The few manuscripts illustrated with miniatures produced in Kashmir during the fifteenth and sixteenth centuries are car-ried out in a style strongly influenced by contemporary Persian paint-ing, particularly of the Shiraz school, as is evident in many details and elements in the miniatures as well as in their composition. This fact was observed by H. Goetz in 1962 in the article "Two illus-trated Persian manuscripts from Kashmir", where Goetz writes that "Islamic painting under the sultanate of Kashmir seems to have been a mere variety of Persian painting, in contrast to contemporane-ous architecture".[7] Goetz's article is one of the first to focus on the history and development of miniature painting in Kashmir.

The Persian influence in Mughal India, particularly during the time of Akbar, was later examined by P. Soucek, though she paid no special attention to Kashmir.[8] D. Barrett and B. Gray, when writing about the schools of the Panjab hills in the sev-enteenth to nineteenth centuries, say that "Kashmir and its old dependencies between the Indus and the Chenab have little part to play in the development of Hill painting," and further, "From the small group of Buddhist miniatures of the tenth century, mentioned in an earlier chapter, to a manuscript painted in Basholi in the last decade of the seventeenth century, there is not a single piece of real evidence to indicate the survival of a tradition of painting in the Hill region".[9]

In an analysis of the importance of the Shiraz school in rela-tion to early Mughal painting A.S. Melikian-Chirvani, however, has observed that "Nous avons....la preuve qu'en l'année même où Akbar montait sur le trône il y avait une école Shirazi dans le nord de l'Inde et qu'elle eut à cette date tardive des disciples dans le pays même".[10] Melikian-Chirvani is referring to the article by H. Goetz, where miniatures in a pure Shirazi style but also miniatures in a style which could be attributed to a Kashmiri painter appear together in a man-uscript produced in Kashmir. This is a *Khamsa* of Nizami dated 977 A.H./1569 A.D. which, according to Goetz, is believed to have belonged to the library of the sultans of Kashmir.[11] After the conquest by Akbar in 1589, artists were brought from Kashmir to the Mughal court, a fact which indicates not only the presence of a certain qual-ity among the artists but most likely also that production in Kashmir itself was affected.

Referring to two detached miniatures in the Keir collection, attributed to Kashmir or Bukhara and dated to the end of the seventeenth century, R. Skelton has also enriched the picture of the relation between Persian and Kashmiri painting in this period.[12] He writes: "the mixture of style seen in this manuscript is character-istic of a group of artists who appear to have gone from India (prob-ably Kashmir) to Bukhara in about the middle of the seventeenth century."[13] The style of the two miniatures, which originate from the same manuscript, could be connected with two copies of the *Khamsa* of Nizami completed in Bukhara in 1037 A.H./1628 A.D. and 1081 A.H./1671 A.D.[14]

The development of book painting in Kashmir from the sev-enteenth and until the late eighteenth century is still little known. It is to be expected that the invasion by Nadir Shah in 1739 and, after 1752, Afghan rule over Kashmir might have brought new influ-ences. There is, however, still no evidence for this. In his book, includ-ing a catalogue, which accompanied the exhibition of Indian miniature painting in the British Museum in 1982, J.P. Losty states that "the Kashmiri style of painting has an obscure origin not yet properly fathomed. It is found only in eighteenth and nineteenth century manuscripts and is there fully formed."[15] Losty thereby refers to an indigenous Kashmiri style of the character identified and analysed by Adamova and Grek.

Losty included one manuscript from the British Library in his book. It is dated 1211 A.H./1796–97 A.D. but has no reference to Kashmir in the colophon.[16] The attribution to Kashmir was made by Losty on the basis of the criteria set up by Adamova and Grek.

In his analysis of the Kashmir school in the chapter on "Delhi and the provinces, 1600–1850", Losty writes "Throughout the cen-turies in which Muslim and Hindu book production had continued side by side, there had been scarcely any rapprochement between the two until the 18th century" and, further on, "It has scarcely been necessary in this discussion of Kashmiri painting to distinguish between Muslim and Hindu styles, for here in Kashmir there occurred in the eighteenth century a spontaneous synthesis, in which Hindu manuscript illumination came closest to Muslim."[17]

The Kashmiri manuscripts from this period in British col-lections had already in 1977 been included in N. Titley's catalogue of the miniatures from Persian manuscripts in the British Library and the British Museum.[18] In the pages dedicated to painting in Kashmir in her *Persian Miniature Painting*, published in 1983, Tit-ley again refers to Kashmiri manuscripts in the British collec-tions and the history of miniature painting in Kashmir in the late eighteenth century, giving much of the same historical back-ground already outlined by Drs. Adamova and Grek as well as Goetz.

By virtue of their important documentation of the British Library collection of manuscripts, Miss N. Titley and J.P. Losty have added most substantially to the knowledge of miniature painting in Kashmir, insofar as conclusions could be made and the history of this art traced on the basis of the collections in the British Library and the Hermitage.

Attention has, however, not yet been paid to the collection of illustrated Kashmiri manuscripts in the Bibliothèque Nationale in Paris. It is my intention to bring these miniatures as well as a few more manuscripts from different collections into the picture. The perspective will thereby be broadened and subsequently a new explanation will be proposed concerning the different styles found in the miniatures painted in Kashmir.

My attention was originally attracted to this problem by an unpublished manuscript by Mir ʿAli Shir Navaʾi in the Lund University Library.[19] This manuscript will be examined and an attempt will be made on the basis of observations made from the Lund Navaʾi to establish more substantial evidence for the existence of a school of miniature painting in Kashmir as well as more firmly established criteria for the identification of different schools of Kashmiri miniature painting between ca. 1760 and 1830.

The *Divan* of Mir ʿAli Shir Navaʾi

A few years ago Professor Gunnar Jarring, during his work of composing a new catalogue of the collection of Oriental manuscripts in the Lund University Library (the present catalogue dates back to 1850), drew my attention to an unpublished manuscript by Mir ʿAli Shir Navaʾi, illustrated with 35 miniatures.[20] The manuscript had been bought for the library in 1937 by Professor Jarring himself from Fritze's antiquarian booksellers in Stockholm. In a letter to Professor Jarring, Fritze's confirmed that the manuscript had been brought to Sweden from Russia around 1920 by a Swedish businessman.[21] The manuscript is the only one of its kind in Sweden.

The collections of oriental manuscripts in the University Libraries of Lund and Uppsala and in the Royal Library in Stockholm are well documented, since the first catalogues were prepared and printed in the nineteenth century.[22] Most of the manuscripts – Qurʾans, religious, poetical and scientific works – are not illustrated, but a number of Persian and Turkish manuscripts of poetry as well as scientific treatises are illuminated as well as illustrated. Two of the most important of the poetical works have been published in monographical studies, the famous *Dastan-i Jamal u Jalal* by Muhammad Asafi dated 909 A.H./1503–04 A.D. and 910 A.H./1504–05 A.D. and a *Khamsa* of Nizami dated 849 A.H./1439 A.D.[23] The *Divan* by Mir ʿAli Shir Navaʾi is for obvious reasons not included in the printed catalogue of the Lund University Library.

The Navaʾi volume appears to have been rebound in a lacquer cover, decorated with flower patterns, arranged as a bouquet in a vase in the shape of a pointed medallion. The composition as well as the dominating red and orange colours are typical of Kashmiri lacquerwork. The back is of simple, black leather. Damage on the front cover has been repaired with a piece of marbled paper.

The size of the manuscript is 34 cm x 19 cm.

The text has been copied on thin, highly polished, slightly darkened, but probably originally white paper which has become dry and brittle with much damage. There are several blank pages in the manuscript, which appears to be unfinished.

According to the description made by Jarring, the *Divan* is written in Chagatai on 465 pages. After seven blank pages, prepared for writing by a division of the folios into two columns, delineated and framed with the help of a *mastar*, the *Divan* begins with a preface on fol. 8b to fol.14a and ends on fol.174a.[24] The colophon of the *Divan*, found on fol.174a, includes the year 886/1481–82 which, according to Jarring "agrees with the approximate date of the composition of the *Divan*", and not the date when the manuscript was copied and illuminated. There is no indication of where the manuscript was produced, nor who was the calligrapher, the miniature painter, or the owner of the volume. A note in Chinese in 12 characters has been added on fol.461b, which may be interpreted as giving the number of pages and illustrations.[25]

The manuscript is written in a clear and elegant *nastaʿliq*. The text is organized in two columns with surrounding text in oblique lines on three sides, and a thumb-piece decorated with an arabesque ornament in red outline and gold paint. The text columns are surrounded by frames in pale green and red.

The illumination is completed only in the *ʿunwan* on fol.8b and a *sarlawh* on fol.14b (pl. 1). The *ʿunwan* covers almost the whole page,

1. *Divan* of Mir ʿAli Shir Navaʾi,
Lund University Library, Prov.450, fol. 8 v.

framing the two columns of text with thin marginal borders of lotus-buds in pink and green. The surrounding ornamental motifs, strongly curved and expanding into the margins, are carried out in a high-quality blue and gold with gem-like knot ornaments in black, green and red. The decoration is typical of Kashmiri manuscripts of the period.

Only the first *divan* is illuminated and illustrated. The thirty-five miniatures are found on fols. 22a, 24a, 32b, 33b, 34b, 40b, 42a, 44a, 46b, 48b, 53a, 54b, 60a, 63a, 70a, 77b, 80a, 84b, 87a, 91b, 98b, 102b, 104a, 108b, 114a, 116b, 135b, 136b, 142b, 144b, 148b, 155a, 159b, 162b and 172b. The large number of miniatures in relation to the text is a characteristic feature of Kashmiri manuscripts of the period.

There is no indication in the text of the Kashmiri origin of the manuscript. As will be demonstrated later, however, it may be presumed that the manuscript as well as the illumination and the miniatures were, to judge by the style, produced in Kashmir. Although carried out with some care, the miniatures appear to have been drawn and painted with a rather swift hand, indicating that the miniatures might have been added to the manuscript mainly for commercial reasons.

In the remarks that follow, the miniatures of the Lund Nava'i will be compared with miniatures in Russian collections, the British Library and the Bibliothèque Nationale in Paris, and an attempt will be made to establish more firmly a theory about the development

of miniature painting in Kashmir during the latter part of the eighteenth century until ca. 1830.[26]

The Miniatures

Throughout the manuscript the miniatures cover only part of the page and do not extend into the margins. Thirty-four of the altogether 35 miniatures appear to have been painted by the same hand or in the same atelier, while the miniature on fol. 144b differs in style. In my opinion it was painted before the rest of the miniatures were added to the manuscript. It is well carried out in a style more influenced by contemporary Persian painting than the others and is more sophisticated in its composition and drawing (pl. 2). It is drawn in grey, black, gold and a thin wash of pale red in a linear style influenced by late Safavid painting, and shows a couple seated under a tree. However, single elements are of a kind often found in Kashmiri painting, such as the tree with radiating leaves, the square fountain in the foreground and the line of pointed cypresses showing behind the hilly horizon.

The other 34 miniatures may be divided into two groups, those with a single motif and those where two or more motifs are represented on two, or even three, different base lines but within the same context. All scenes show outdoor events except four depicting interior, more intimate scenes. A common and characteristic motif is a reception taking place in a small pavilion or on a terrace with a pavilion and a canopy stretched from the wall in the background (pl. 3).

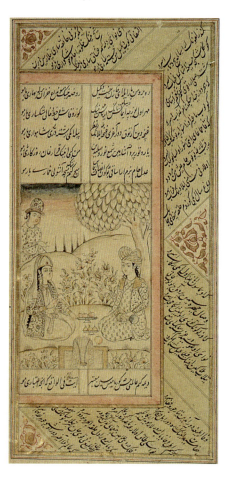

2. *Divan* of Mir 'Ali Shir Nava'i, Lund University Library, Prov.450, fol. 144 v.

3. *Divan* of Mir 'Ali Shir Nava'i, Lund University Library, Prov.450, fol. 63 r.

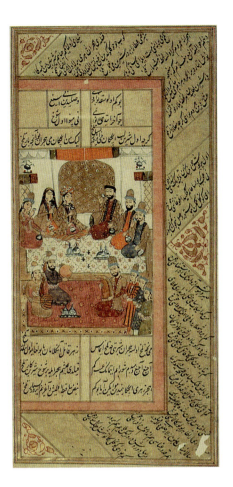

The wall of the pavilion is usually decorated with niches adorned with blue and white porcelain or simply with blue ornaments (pl. 4). This characteristic detail often appears in Kashmiri miniatures with architectural motifs. A small, square fountain is often depicted in the foreground, serving as a repoussoir.

The composition is generally centred around two main characters and developed almost symmetrically from the central group whether in a circular composition or in an aligned group of courtiers or attendants. The horizontal line of men represented in several miniatures is a characteristic influence from fifteenth-century Shiraz painting (pl. 5). In some cases the composition moves diagonally from the central person, always sitting to the right in the picture. It can therefore be concluded that the picture is "read" from right to left.[27] This pattern is repeated also in the exterior scenes, where the direction in most cases moves from right to left.

Garden scenes, court scenes with a tent or a pavilion, or scenes centred around a carpet spread on the floor or the ground are repeated frequently.

The conclusion to these observations is that the artist appears to have had at his disposal a set of compositions or a repertoire of spatial representations taken from the classical Persian miniature. The interior, the pavilion or tent in the open air, and the open landscape with a high horizon recall Shiraz compositions from the mid- and later fifteenth century, although here used in much simplified versions. In the Kashmiri paintings of the eighteenth century

these models are used freely in combinations of twos or threes in the same picture. They are divided by repeated baselines, usually a hilltop border painted in a mauve outline, in a manner unlike Persian, Mughal Indian or Turkish miniature painting (pl. 6). It should perhaps be pointed out that the white marble pavilion belongs in an Indian context rather than in the Persian tradition. In this way the representations are multiplied by two or sometimes three on the same page, adding to the richness of the manuscript but sometimes also diminishing its aesthetic value.

According to J.P. Losty, "recession in the landscape is attempted by drawing various horizons across it, each of the sections being differently coloured, and usually with purple rocks on top of each horizon."[28] There is, however, in spite of the different colours of the sections, no obvious attempt to create foreground or background. A closer examination of the miniatures also leads to the conclusion that the different episodes represented in the same picture are not related to each other in time and sometimes do not even relate to the same passage of the story.

Thus the horizontal division should be seen not as an attempt to create a perspective but rather as a mode of concentrating the action and of using the surface of the page.

The landscape is simple, in most cases a green, grassy plain with a high, often a saddle-back mountain horizon, sometimes with a rocky outline painted in mauve. Spread over the green grass are small tufts of white and red flowers; in many miniatures a rose-bush appears

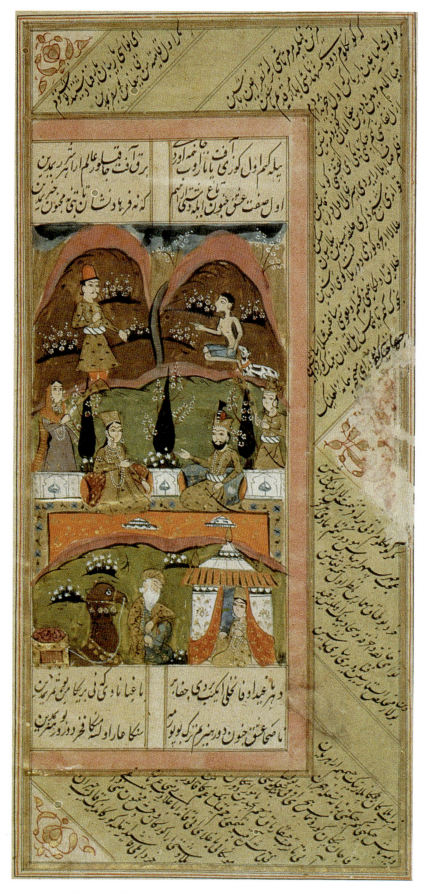

6. *Divan* of Mir 'Ali Shir Nava'i, Lund University Library, Prov.450, fol. 136 v.

7. *Divan* of Mir
'Ali Shir Nava'i,
Lund University
Library, Prov.450,
fol. 142 v.

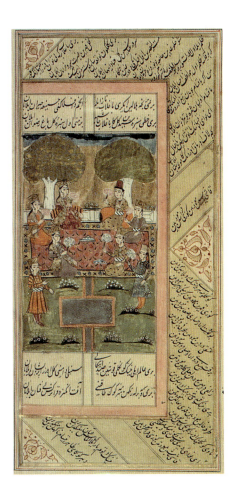

8. *Divan* of Mir
'Ali Shir Nava'i,
Lund University
Library, Prov.450,
fol. 44 r.

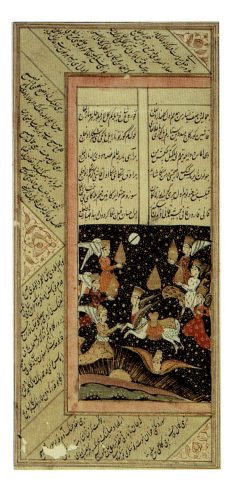

in the background (pl. 7). Behind the horizon may be a line of thin, pointed cypresses. These elements, like the composition or outline of the landscape in general, point to a Shirazi influence and particularly the commercial, simple manuscripts produced in the middle and later part of the fifteenth century.

Typical for the Lund Nava'i, as for all Kashmiri illustrated manuscripts, is a tree with concentrically arranged large leaves as well as a weeping willow with thin, hanging branches, as also seen in Safavid painting and in eighteenth-century provincial Mughal miniatures.

Women are dressed in Persian fashion with a long dress covered by a gown open in front, or a short coat, tight trousers and high boots and a high cap or hat, round and slightly flaring. Most women, and sometimes also men, wear long pearl necklaces, and jackets too may be decorated along the borders by pearls. In the Lund Nava'i, as in most Kashmiri manuscripts, men and women have long, curling sidelocks. Young men may have well-trimmed black beards while old men often wear important white beards. The faces are drawn in the Persian manner in three-quarter profile, occasionally in profile. The faces are long and fine, with small, narrow noses and elongated eyes.

A frequent element of Indian origin, and generally associated with female servants, is a long fly-whisk, made probably from the hairs of a horse-tail or the feathers of a peacock's tail.

The colours are somewhat subdued, with a predominance of green, shades of orange and red and a pale blue. Gold, both polished and unpolished, is frequently used all through the manuscript. Silver, unpolished and still with a silvery sheen, also appears in some details. There is an unusual presence of deep black, covering surfaces like the night sky as well as details in the picture, sometimes in contrast to a bright white giving an even covering.

There is little movement or expression of emotion in the pictures and poses are fixed. So too is the constant smile on the faces, in spite of the often dramatic episodes being illustrated.

A frequently depicted scene, appearing in two variations in the Lund Nava'i, is Buraq ascending through the black and starry sky. Fol. 44r shows Buraq surrounded by houris, represented as full-sized women in long coats and wearing the typical high, cylindrical hat or crown (pl. 8). This motif appears in many contemporary Kashmiri manuscripts in almost identical versions and indicates a common stereotype and prototype. A similar scene is represented on fol. 159 where Buraq ascends from right to left surrounded by what appear to be male houris; only the heads with hair cut short and attached wigs are represented (pl. 9). Buraq is seen surrounded by houris above a small black lake in the lower part of the picture. Over, or rather behind, the lake is a tree with houris, sitting like birds among the leaves of the tree. Their bare heads with short black hair are an unusual feature, with an alien, almost European character.

9. *Divan* of
Mir 'Ali
Shir Nava'i,
Lund University
Library,
Prov.450,
fol. 159 v.

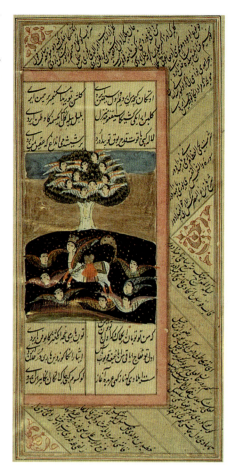

10. *Shahnama* by
Firdausi,
British Library,
Add.18804, fol. 2 r.

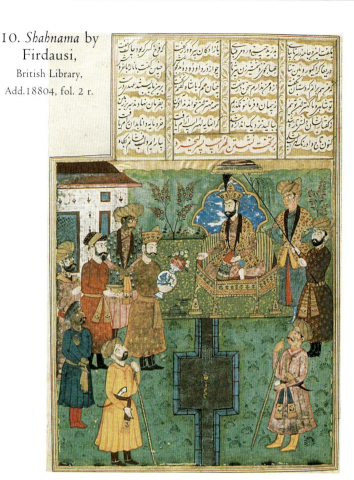

The characteristic elements which may be traced back to the Shiraz school of the mid- and late fifteenth century are easily distinguished in the Lund Nava'i, as in the related manuscripts in other collections. Nevertheless these elements have been transformed into stereotyped shapes, lacking the original expression and elegance and used simply in their most basic forms or added as decorative details with little relation to the composition as such. This indicates that reminiscences of a former Shirazi influence have been preserved and repeated with little knowledge of or feeling for the original form or value. In the late eighteenth century this Shirazi influence was mixed with features of the late Safavid and even early Qajar styles.

It should be pointed out that the iconography of Kashmiri miniatures differs considerably from the iconography of Persian and Mughal miniatures and will need more in-depth study. It is my intention to make a future study of all the episodes illustrated in the Lund Nava'i as well as the iconography of the miniatures.

In conclusion it may be repeated that the Lund Nava'i paintings show most of the compositional features and details which are characteristic of miniature painting in Kashmir in the late eighteenth century. There is no doubt that the miniatures belong to the Kashmiri school. It is also my assumption that it may be concluded, from the stylistic analysis, that they were painted before 1800.

The St. Petersburg and Tashkent collections

The publication by Adamova and Grek on the manuscripts of Kashmiri origin is a comprehensive documentation of the collections in Russia and represents the first attempt to analyse and to shed light on miniature painting in Kashmir in the eighteenth and nineteenth centuries.[29] In their detailed analysis the Kashmiri style is carefully mapped, and there can be no doubt about the unique and characteristic style of miniature painting in Kashmir during this period. Among the twenty-two manuscripts of the three groups referred to above are seven copies of the *Divan* of Hafiz, five copies of the *Khamsa* of Nizami and five copies of Jami's *Yusuf and Zulaikha*. The popularity of these poems will be confirmed when manuscripts of presumably Kashmiri origin in other collections are considered.

A comparison between the manuscripts in the Hermitage and the Lund Nava'i points to resemblances particularly between this manuscript and the first group identified by Adamova and Grek, who suggest that all the manuscripts were produced before 1800. A close resemblance appears particularly between the Lund Nava'i and no. 9, a copy of Nizami's *Laila and Majnun* (Saint Petersburg Branch of the Institute of Oriental Studies, IOS, N 3678).

However, the analysis by Adamova and Grek is limited to the Russian collections and no comparative study of manuscripts in collections outside Russia has yet been made. The Lund Nava'i

Consequently the eleven manuscripts in the British Library may be divided into two main groups according to whether their dominant style is Persian or Indian. One manuscript in the collection is unique and distinguishes itself from the others by its early date of 1131 A.H./1719 A.D. as well as by the style of the miniatures. It is a *Shahnama*, copied and illustrated in Rajaur in the Punjab, on the trade route to Kashmir (British Library Add.18804): see pl.10. Elements in the miniatures, however, indicate an important relation to the later Kashmiri school.[31]

The first group is more closely related to the Persian tradition; the drawing is finer and the colours less brilliant, although gold may be abundantly used (pl.11). The second group is more Indian in character: the figures are squat, with disproportionately big heads, the composition simple and the colours bright and saturated with dominating red, orange and mauve shades (pl.12). Elements from provincial Mughal painting dominate, although there appears to be an influence also from Hindu painting, particularly in the colour scheme.

The dates of the manuscripts range from 1211 A.H./1796 A.D. until 1231 A.H./1815 A.D., although only six manuscripts are dated. The two styles cannot be separated chronologically; it appears that they existed side by side, whether produced in different workshops, by different artists or otherwise related to different locations.

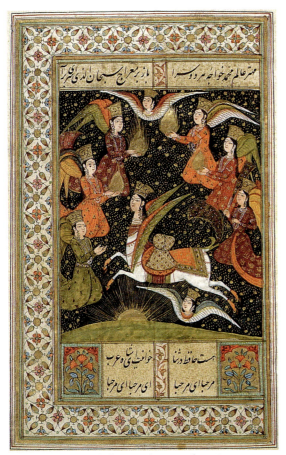

11. *Shahnama* by Firdausi,
British Library, Add.7763, fol. 21 r.

could not, for obvious reasons, have been known to the two Russian scholars.

A more interesting picture emerges, however, when Kashmiri manuscripts in other collections are added to the Russian material.

The British Library manuscripts

In the British Library twenty-seven manuscripts may be distinguished as of supposedly Kashmiri origin.[30] Sixteen of the manuscripts contain Indian texts while eleven are copies of Persian poetry. Only this latter group will be included in the present analysis. As in the Russian collections, there is a notable predominance of copies of the *Divan* of Hafiz and Jami's *Yusuf and Zulaikha*.

The Kashmiri "school" when commented upon by Norah Titley and Jeremiah Losty has been regarded as a uniform style mainly developed under Persian and Hindu influence. An examination of the British Library manuscripts, however, leads to the conclusion that a Persian influence, and probably a later Hindu as well as a provincial Mughal influence, had produced two parallel styles, each clearly distinguishable from one another and executed in varying styles of pronounced Persian or Indian character. The difference in style was remarked upon already by Adamova and Grek but with less clear indications than the ones it is possible to make on the basis of the enlarged body of material.

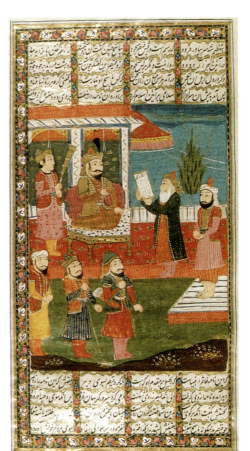

12. *Hamla-i Haidari* by Bazil, British Library, Or.2936, fol. 376 r.

The group with a more Persian character, here called A, includes the following manuscripts:

> Add.7034, Hafiz's *Divan*, probably 18th century,
> 35 miniatures (Titley 1977, no. 166).[32]
> Add.7763, *Shahnama* by Firdausi, probably 18th century,
> 112 miniatures (Titley 1977, no. 157, Rieu vol. 2, p. 630).[33]
> Add.7764, *Shahnama* by Firdausi, dated 1215/1801,
> 16 miniatures (Titley 1977, no. 158, Rieu vol. 2, p. 631).

The miniatures of these manuscripts are painted in a style strongly influenced by Persian painting, mainly of the Safavid and early Qajar period. Figures are slender and the faces are of a Persian character. The outline of the figures, the architecture, and the details of the landscape are rather sketchy and the colour is sometimes laid on thin and imperfectly.

The second group, which is more provincial Indian in character, is here called B and includes the following manuscripts:

> Or.7039, *Yusuf and Zulaikha* by Jami, 18th century,
> 19 miniatures (Titley 1977, no. 217).
> Or.5599, *Divans* of Hilali, Sa'di, Ahmad-i Jami and Mu'in,
> dated 1231/1815, 19 miniatures.
> Or.12564, *Yusuf and Zulaikha* by Jami, 17th–18th century,
> 26 miniatures (Titley 1977, no. 220).
> Or.1632, *Vaqi'at-i Kashmiri* by Muhammad A'zam, dated
> 1148/1735–6, 27 miniatures, probably of the 19th century
> (Titley 1977, no. 272).
> Or.2936, *Hamla-yi Haidari* by Bazil, no date, 82 miniatures
> (Titley 1977, no. 96).

The composition of landscapes as well as interiors in this group are in general of a simple character; the figures, although short and squat, are big in proportion to the space and colours are bright and clear, dominated by shades of red and a pale green. The simple composition and the representation of men and women, particularly the faces, indicate influences from neighbouring schools of miniature painting, especially of the Basholi and the Guler styles.

Add.7771, a *Yusuf and Zulaikha* by Jami with 76 miniatures, dated 1177/1764 (Titley 1977, no. 220, Rieu vol. 2, p. 689) although in general belonging to group B, is of a different character, with simple compositions and a dominating brown pigment appearing also in other manuscripts but more often in the manuscripts with Indian texts. The miniatures are of a poor quality. Titley has compared the miniatures of this manuscript with the rather exceptional miniatures of the Rajaur *Shahnama* (Add.18804) and arrived at the conclusion that "even in details common to both, the liveliness and originality of the Rajaur artist's work has made no impact on later Kashmiri painting". The example may be a badly chosen one, since the miniatures of Add.7771 are not typical.[34]

A character common to both groups, evident in the composition as well as in details of the architecture and the landscape, may be traced to the Shiraz school of the fifteenth century. The difference, however, becomes apparent in the rendering of human beings; in the first group a Persian influence and character is maintained, while in the second group, an Indian influence dominates.

The quality of the miniatures varies from very simple and badly carried-out compositions and paintings – according to N. Titley, "so bad they can hardly be true"[35] – to fairly accomplished miniatures, technically well made and with some originality in the iconography. A general characteristic of the period is however the stereotyped composition of landscape and interiors, with few actors on the "scene".

Bibliothèque Nationale, Paris

The Kashmiri manuscripts in the Bibliothèque Nationale, Paris, however, contribute more interesting and even surprising material to this study. When these manuscripts are taken into account the picture of a school of miniature painting in Kashmir becomes more complex.[36]

The quality of the miniatures is in general higher than in the collections in Russia, Tashkent and in the British Library. The holdings include an amazing copy of *Hamla-yi Haidari* written for Hasan Khan in Kashmir and dated 1223 A.H./1808 A.D. (Suppl.pers.1030) which is an outstanding example of the artistic capacity of Kashmiri artists. There is, however, as might perhaps be expected, no obvious relation in the iconography between the *Hamla-yi Haidari* of the British Library and the copy in the Bibliothèque Nationale.

The material in the Bibliothèque Nationale may also be divided into two main groups according to the same criteria as have been applied to the British Library manuscripts.

Manuscripts in the same style as group A of the British Library include:

> Suppl.pers.1647, Hafiz, *Divan*, no date (Blochet 1622).[37]
> A small manuscript written in a good *nasta'liq* in two
> columns and illustrated with miniatures of a very mediocre
> quality. Fols. 428b and 492a lavishly illuminated in high
> quality pigments and gold in Kashmiri style.
> Suppl.pers.1151, *Mahbub al-Qulub* by Barkhurdar ibn
> Mahmud Turkman Farahi, dated 1158(?) A.H./1745 A.D.,
> 65 miniatures.[38] This is a large-size manuscript written in
> Indian *nasta'liq* with a lacquerwork binding. (pl. 13)

Manuscripts belonging to group B are:

> Suppl.pers.1078, *Hamla-yi Haidari* by Bazil (Muhammad
> Rafi Khan), copied in *nasta'liq* by Mir Sayyid Riza, dated
> 1169 A.H./1756 A.D., 44 miniatures.
> Suppl.pers.1927, *Yusuf and Zulaikha* by Jami, written in
> *nasta'liq*, dated 1227 A.H./1812 A.D., 29 miniatures.
> Suppl.pers. 2176, *Suluk al-Talibin* by Abu Talib b. Nizam al-

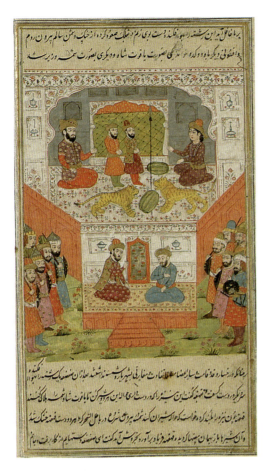

13. *Mahbub al-Qulub* by Barkhudar ibn
Mahmud Turkaman Farahi,
Bibliothèque Nationale, Sup.pers.1151, fol. 119 v.

Din, probably around 1225 A.H./1810 A.D., 8 miniatures in
a very mediocre Kashmiri style.

Smith-Lesouf 225, *Iskandar-nama*, no date, 14 miniatures in
late 18th-century style.

Suppl.pers.1030, *Hamla-yi Haidari* continued by Mir
Ghulam 'Ali Khan Azad, dated 1223 A.H./1808 A.D., 226
miniatures of an extraordinary type. Although of an
undeniably Kashmiri character, it cannot be closely
associated with any of the manuscripts in other collections.
Details of the paintings and the style in general may be
associated with the style of group A, but the elaborate and
complex compositions as well as single motifs are of a
unique character and make a distinction from the rest of the
group evident (pls. 14 and 15).

Most of the manuscripts in the Bibliothèque Nationale are superior
in quality to the Lund Nava'i but a comparison can be made with
the *Mahbub al-Qulub*, Suppl.pers.1151, whose 65 miniatures are in
a style close to that of the Lund Nava'i.

Manuscripts in other collections

Six manuscripts in the catalogue by I. Stchoukine, B. Flemming,
P. Luft and H. Sohrweide on the illuminated Islamic manuscripts in
the Staatsbibliothek Stiftung Preussischer Kulturbesitz und Deutsche
Staatsbibliothek in Berlin belong to the group of Kashmiri manu-
scripts.[39] They are a copy of Hafiz's *Divan* (Heinz, no. 233),
dated 995 A.H./1587 A.D., with thirty-three miniatures from the early
nineteenth century; Firdausi's *Shahnama* (Pertsch, no. 700), dated
1245 A.H./1830 A.D., with 95 miniatures;[40] Nizami's *Iqbal-nama*
(Heinz, no. 277), no date, fourteen miniatures probably from the
early nineteenth century; an *Anthology* (*safina*) (Pertsch, no. 671), no
date, sixteen miniatures, probably early nineteenth century; and finally
two copies of *Yusuf and Zulaikha* by Jami (Heinz, no. 214 and
Ms.or.oct.980), the first dated 1215 A.H./1800 A.D., with 25 minia-
tures in eighteenth century style, the second undated, with 33 minia-
tures, possibly from the middle of the eighteenth century.

The main part of this total of 216 miniatures was, accord-
ing to Stchoukine, Flemming, Luft and Sohrweide painted around
1830 in the characteristic style of the Kashmiri school. It seems pos-
sible, however, that the miniatures, when compared with dated minia-
tures in the British Library and Bibliothèque Nationale, might turn
out to be some twenty years older.

Since I have not been able to see the manuscripts in Berlin and
the catalogue does not include illustrations of the Kashmiri
manuscripts except in one case (Ms. Minutoli 134, f.230b, ills.
2416 and 2452), it has not been possible to analyse the style and
attribute these miniatures to the "Persian" or the "Indian" group.

An unfinished *Shahnama* with distinctive miniatures painted
in rather dark, saturated shades in the Indian style, is found in
the collection of the Royal Asiatic Society, no. 243.

A single manuscript of Kashmiri origin is found also in the
Royal Library in Copenhagen. It is a copy of Jami's *Yusuf and Zulaikha*
with 27 miniatures.[41] The lacquer cover is decorated with a vase
motif in the red, rose and mauve colours typical of Kashmir. The
miniatures are almost full-page and of a rather simple quality;
they are painted in the Indian style.

It should be mentioned that no manuscripts of Kashmiri
origin have been identified in the Topkapi collection.

Altogether there are in the six collections mentioned above 49
manuscripts including more than 1200 miniatures, produced within
a short period of maybe thirty years – a definite time limit can
only be estimated since the dates of the manuscripts might have been
changed and in most cases are missing.

While the *Shahnama* produced in Rajaur may indicate an early
predecessor to the Kashmiri style of the late eighteenth and early
nineteenth centuries, the Persian influence may be traced back to
the Shiraz school. The Indian influence could be related to local
Mughal schools, and was brought most likely through the trade
routes connecting Kashmir with the sub-continent. The *Hamla-yi
Haidari* of 1808 in the Bibliothèque Nationale (Suppl.pers. 1030)

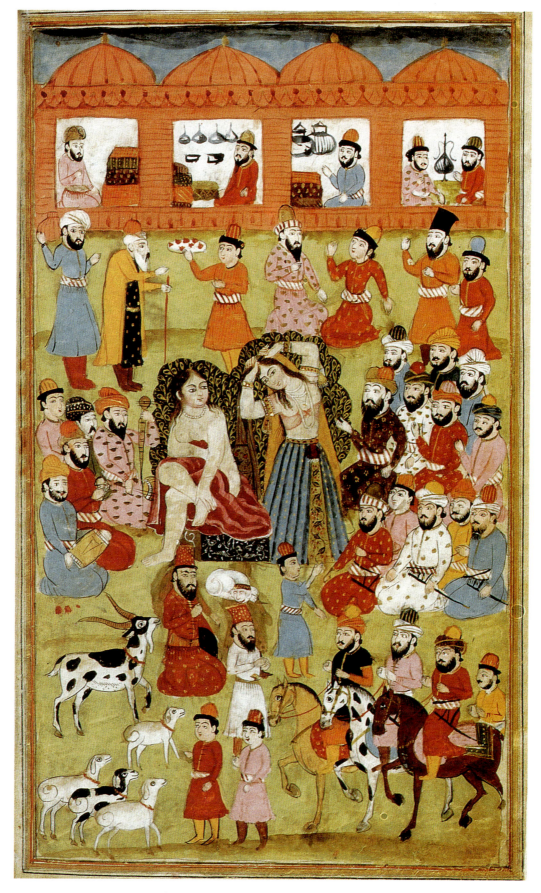

14. *Hamla-yi Haidari*, Mir Ghulam 'Ali Khan Azad,
Bibliothèque Nationale, Sup.pers.1030, fol. 6 b.

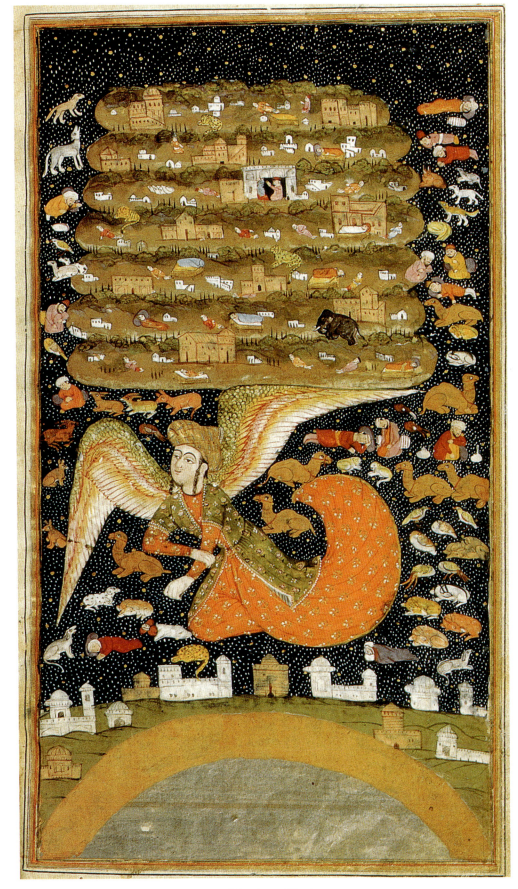

15. *Hamla-yi Haidari,*
Bibliothèque Nationale, Sup.pers.1030, fol. 257 b.

gives evidence of a certain maturity and refinement, as well as a development of the Kashmiri style which is still enigmatic. It was ordered for a certain Hasan Khan ibn Allahyar Khan ibn Pir Sultan of the Shahsavan tribe, residing in Kashmir. Who was the artist, and where could he have been trained to produce more than 200 full-page miniatures in a manuscript of 581 folios, developing a surprising and original iconography as well as a quality superior to any other manuscript produced in Kashmir during this period?

An analysis of the miniatures shows, however, that most likely several artists were involved in creating this volume, which was not only lavishly illustrated but also illuminated on every page. One master, several artists and also some apprentices appear to have worked on the miniatures, which towards the end of the volume, however, are of a less remarkable quality. A separate study of this manuscript may contribute new insights about miniature painting in Kashmir around 1800.

Conclusion

It would not be surprising to find that artists with different backgrounds were working in Srinagar during the same period and that they were employed in the commercial production of manuscripts. It is, however, evident that the Kashmiri school of miniature painting may have more to offer than what can be deduced from the 49 manuscripts included in this study. Systematic research in collections in Europe, the United States and India, may contribute further to the knowledge of this late phase of Indo-Persian miniature painting beyond the mere commercial aspects of many less successful manuscripts.

There is, as has already been pointed out, a remarkable difference in quality between most of the manuscripts in the material known so far and a few manuscripts illustrated with far higher ambitions. This is evident from the *Hamla-yi Haidari* in the Bibliothèque Nationale as well as the more traditional, but well-executed *Hamla-yi Haidari* (Or.2936), the *Divan* of Hafiz (Add.7763) in the British Museum and the *Divan* of Mir 'Ali Shir Nava'i in the Lund University Library.

In the collections which are included in this study it has been possible to distinguish 49 manuscripts as of probably Kashmiri origin. The conclusion must be that within a limited period of maybe 40 years at most there appears to have been considerable demand for illustrated manuscripts in the Kasmir valley and most likely in Srinagar itself. The demand obviously ranged from patrons or customers who possessed a certain connoisseurship, with artists and workshops corresponding to that demand, as well as groups of customers who were interested in Persian or Hindu manuscripts but less demanding and who could find satisfaction in commercially produced miniatures. What seems to be important is that although it flourished, this market was not limited to the latter type of production but proved in the above-mentioned cases to possess a hitherto unknown and surprising creativity and originality.

It has thus been possible, so far, to enlarge the group of manuscripts belonging to the late eighteenth century family by an additional 27 manuscripts. At the same time the group evidently contains a wider range of characteristics than previous classification has identified.

Notes

I would like to express my thanks first of all to B.W. Robinson, who has always given me the best of support in my work, to Gunnar Jarring, Ada Adamova at the Hermitage in St. Petersburg, Francis Richard and Annie Berthier at the Bibliothèque Nationale, and Muhammad Waley and Jeremiah P. Losty at the British Library, who have all generously shared their knowledge with me. Without their invaluable help and advice this article could not have been written.

1 A. Adamova and T. Grek, *Miniatures from Kashmirian Manuscripts* (ed. L.T. Giuzalian), Leningrad, 1976. The catalogue, following the introductory text of the book, includes twenty-two manuscripts mainly from the M.E. Saltykov-Shchedrin State Public Library and the State Hermitage Museum in St. Petersburg and the St. Petersburg branch of the Institute of Oriental Studies of the Academy of Sciences. Four of the manuscripts formerly belonged to the Emir of Bukhara.

2 Four of the five manuscripts which, according to Adamova and Grek, "may be attributed to Kashmir" (p. 83), belong to the Institute of Oriental Studies of the Academy of Sciences of the former Uzbek SSR. Three of these manuscripts were later published in *Oriental Miniatures of Abou Raihon Beruni Institute of Orientology of the UzSSR Academy of Sciences*, Tashkent, 1980. The reference to the fifth manuscript is not quite clear but the latter appears to be the *Vamiq va Azra* of Mirza Ibrahim Kirmani in the Staatsbibliotek Stiftung Preussischer Kulturbesitz, Berlin und Deutsche Staatsbibliothek Berlin (Ms. or. quart 1158), see I. Stchoukine, B. Flemming, P. Luft, H. Sohrweide, *Illuminierte Islamische Handschriften* (*Verzeichnis der orientalischen Handschriften in Deutschland*, Band XVI) Wiesbaden, 1971, p. 190, no. 69.

3 Adamova and Grek, no. 5 and no. 17.

4 In several cases this change of date has been done in a most obvious way, see e.g. Adamova and Grek, 1976, no. 5 and no. 10 and further comments by Adamova and Grek, 1976, p. 7.

5 Adamova and Grek, p. 70 and p. 73.

6 According to N. Titley, Zayn al-'Abidin also sent Kashmiri craftsmen to Iran, where they learnt to make paper and the art of lacquer book binding, see N. Titley, *Persian Miniature Painting*, London, 1983, p. 211.

7 H. Goetz, "Two illustrated Persian manuscripts from Kashmir", in *Arts Asiatiques*, IX (1962–63), p. 61–72.

8 P. Soucek, "Persian Artists in Mughal India: Influences and Transformations", in *Muqarnas*, 4 (1987), pp. 166–181.

9 D. Barrett and B. Gray, *Painting of India*, Geneva 1963, p. 161.

10 A.S. Melikian-Chirvani, "L'école de Shiraz et les origines de la miniature moghole", in *Paintings from Islamic Lands*, (ed. R. Pinder-Wilson), Oxford, 1969, p. 137.

11 Goetz 1962–63, p. 63.

12 B.W. Robinson, E.J. Grube, G.M. Meredith-Owens, R.W. Skelton, *The Keir Collection, Islamic Painting and the Arts of the Book*, London, 1976, nos. V.90 and V.91, detached leaves of a *Shahnama*, Kashmir or Bukhara, third quarter of the 17th century.

13 *Ibid.*, p. 266.

14 *Khamsa* of Nizami dated 1037 A.H./1628 A.D., "with miniatures added later", *Sotheby and Co. Catalogue of Fine Western and Oriental Manuscripts and Miniatures*, 5th July 1965, lot 1977; and *Khamsa* of Nizami, 1081 A.H./1671 A.D., Chester Beatty Library, Persian MS, No. 276, see *Keir 1976*, pp. 266 and 267.

15 J.P. Losty, *The Art of the Book in India*, London, 1982, p. 119.

16 *Ibid.*, pp. 143–44. Losty notes that the manuscript was acquired in India before 1808. "Fine quality manuscripts from Kashmir in the 18th century exhibit some of the richest illuminations ever attempted in India" and further, "The paper is of the thinnest, finest quality, burnished and gold-sprinkled, a speciality of Kashmir, for it is found nowhere else at this time" (Losty, p. 143).

17 *Ibid.*, pp. 119–120.

18 N. Titley, *Miniatures from Persian Manuscripts. Catalogue and Subject Index of Paintings from Persia, India and Turkey in the British Library and the British Museum*, London 1977, nos. 49, 84a, 96, 100, 157, 158, 210, 213, 217, 272, and 318.

19 *Divan* of Mir 'Ali Shir Nava'i, Lund University Library. The temporary inventory number of the Nava'i manuscript is Jarring, Prov. 450.

20 Professor Gunnar Jarring's catalogue, still in manuscript, includes 543 items, described on more than one thousand handwritten pages.

21 I am greatly indebted to Professor Jarring, who has put at my disposal his handwritten information pertaining to the manuscript. A copy of the catalogue entry of the *Divan* is with the present author. A note signed H.Hbg and dated 3.1.34 (Harald Holmberg, former librarian at the Royal Library in Stockholm), written in Swedish, accompanies the Nava'i manuscript with comments on the author, the subject, the Uzbek language in which the book is written and the miniatures, and concludes "a very beautiful book!"

22 The oldest catalogue still in use is Carl Johan Tornberg, *Codices orientales Bibliothecae Regiae universitatis Lundensis*, Lund, 1850. The catalogue of the oriental manuscripts in the Royal Library in Stockholm was produced by Wilhelm Riedel: *Katalog över Kungl. Bibliotekets orientaliska handskrifter*, Stockholm, 1923, and the catalogue of the Uppsala University Library by K.V. Zetterstéen: *Arabische, persische und türkische Handschriften der Universitätsbibliothek zu Uppsala verzeichnet und beschrieben*, Teil 1–2, Uppsala, 1930.

23 For the *Jamal and Jalal* and the *Khamsa* by Nizami see K.V. Zetterstéen and C.J. Lamm, *Muhammed Asafi. The story of Jamal and Jalal*, Uppsala, 1948 and K. Ådahl, *A Khamsa of Nizami of 1439*, Uppsala, 1981.

24 From page 178 the sequence is *Rubayyat* (pp. 178b–186a), *Divan* (188b–405b), *Rubayyat* (406a–410a), *Mathnavi* (410a–422a), *Qasida* (422a–423b), *Maqamat* (423b–430a) and *Mathnavi* (430a–441b). This part of the manuscript is not illustrated.

25 The characters have been read by P.O. Leijon, curator of Chinese art at the Museum of Far Eastern Antiquities in Stockholm. The meaning of the note is not clear but may be interpreted to give the number of pages and illustrations. There is no indication when or where the note was written.

26 In 1989 I had the opportunity to discuss the miniatures with Ada Adamova in St. Petersburg. I am very grateful for her most valuable opinion on the miniatures in the Lund Nava'i.

27 See Adamova and Grek, 1976, p. 26, where this movement is observed in the order in which the different episodes are illustrated within the frame of the painting.

28 Losty 1982, p. 119.

29 Adamova and Grek, p. 83–84. It should be mentioned that Oriental manuscripts from collections in the former U.S.S.R. have been published since the book by Adamova and Grek was published. The manuscripts of presumably Kashmiri origin are the same as those published by Adamova and Grek, nos. 18–22. See *Oriental Miniatures of Abou Raihon Beruni Institute of Orientology of the UzSSR Academy of Sciences*, Tashkent, 1980: Hafiz, *Divan* (10042, C.O.M.VIII, No. 5734), ca. 1780, ill. 57–59; Farid al-Din 'Attar, *Lives of Saints* (21033 C.O.M. III, No. 2200), dated 1211/1797, ill.

60–64; Hafiz, *Divan* (1420, C.O.M.II, No. 1087) undated, ill. 68–79; Jami, *Seven Poems* (9397, C.O.M.IX, No. 6207), undated, ill. 71–73.

30 As indicated above, it may be concluded from Titley 1982 which manuscripts in the British Library could be assumed to be of Kashmiri origin. I am also most grateful to J.P. Losty for sharing with me his documentation on the Kashmiri manuscripts with Persian as well as Indian subjects.

31 The *Shahnama*, dated 1131 A.H./1719 A.D. was copied in Rajaur for the patron Raja Azumat Allah Khan. Titley notes, concerning the name of Rajaur, "Also called Rampur, it lies in the modern state of Jammu and Kashmir, on the road to Srinagar from Sialkot via the Pir Panjal pass, the regular route taken by the Mughal emperors when they went to Kashmir" (Titley 1983, p. 211).

32 Titley 1977, 59.

33 Charles Rieu, *Catalogue of the Persian manuscripts in the British Museum*, London, 1879–83.

34 Titley states that the miniatures of the Rajaur *Shahnama* were forerunners of the later Kashmiri style (Titley 1983, p. 210), and that the manuscript, in combining Persian and Mughal features, is an important link in the development of the Kashmiri style. She also points out that "many of the details in the *Shahnama* miniatures occur again in the considerably simpler Kashmiri book illustrations of the late 18th and the 19th centuries" (Titley 1983, p. 211). But cf. *ibid.*, p. 212.

35 The dated manuscripts are Add.7763, *Divan* of Hafiz, dated 1796; Add.7764, *Divan* of Hafiz, dated 1801; Or.5599, *Divans* of Hilali, Hafiz and Sa'di, dated 1815; Or.1632, *Vaqi'at-i Kashmir*, dated 1735 and Add.7771, *Yusuf and Zulaikha* by Jami, dated 1764, both with later miniatures.

36 I am greatly indebted to Francis Richard and Annie Berthier in the department of Oriental manuscripts in the Bibliothèque Nationale in Paris for their invaluable help in tracing the manuscripts presumably from Kashmir.

37 E. Blochet, *Bibliothèque Nationale, Catalogue des Manuscrits persans*, III, Paris 1928, no. 1924; see also *Revue des Bibliothèques* 8, 1898, pp. 446–455, continued in vol. 9, 1899, pp. 35–40.

38 Blochet, no. 1622.

39 Blochet, no. 2116; see also *Revue des Bibliothèques* 9, 1899, p. 405.

40 Blochet, no. 1923; see also *Revue des Bibliothèques* 9, 1899, p. 405.

41 Blochet, no. 1902.

42 See I. Stchoukine, B. Flemming, P. Luft, H. Sohrweide, *op. cit.*, nos. 71, 73, 74, 75, 79 and 80.

43 Acc. no. D.1/1980.

On the Attribution of Persian Paintings and Drawings of the Time of Shah 'Abbas I:

Seals and Attributory Inscriptions

ADEL T. ADAMOVA

IN HIS ARTICLE ON THE MINIATURES OF THE *SHAHNAMA* OF Muhammad Juki (RAS. MS 239) B.W. Robinson writes: "The game of attributing the miniatures in a fine manuscript like this to a series of hypothetical artists is a favourite one, played with enthusiasm from time to time by most writers on the subject… But when it has been attempted on the same manuscript by more than one scholar the measure of agreement reached is often so negligible as to cast some doubt on the usefulness of such an exercise".[1] This is true not only of manuscript illustrations but also of separate paintings and drawings. There is no doubt that the method of stylistic analysis which prevails in the study of Persian paintings is of primary importance, but there is always a wish to confirm the results achieved thereby by non-art-historical research, in other words to find more objective criteria for defining any given work. To evidence of this kind belong, in my opinion, seal stamps and the various inscriptions on paintings and drawings, as well as the precise place which they occupy on folios mounted in albums (*muraqqa'*).

This article discusses miniatures and drawings from various sources which have one feature in common: all of them bear impressions of the seals of Shah 'Abbas I (1587–1629), showing that they belonged to the library of this Safavid ruler.

All these miniatures and drawings have been preserved by being mounted on folios which were once integral parts of albums (see the list of folios at the end of this article). The majority of them, however, now exist only as separate pages dispersed among various collections throughout the world. Happily three of the folios of

this group are still mounted in *muraqqa'* H.2155 in the library of the Topkapi Saray Museum in Istanbul. All the works (five in total) mounted on these three leaves bear the impressions of 'Abbas I's seal. Perhaps there are stamps on the other works included in this *muraqqa'*, but in that case they have not been published.

The art of *muraqqa'*-making in the sixteenth and seventeenth centuries has not yet been studied; the successive cycles of works in the albums still preserved have not been described or even published, though now there is no doubt that the study of albums and of their contents as unities of some kind is the key to understanding them. Moreover, the close study of the works they contain, not as isolated items but in connection with each other, could become an important source for determining the time and place of creation both of the albums and of the individual works which they contain.

The majority of the folios in the group we are considering here (pls. 1, 3, 6–8, 10–12) seem, to judge by their decoration and composition, to be original pages from sixteenth- and early seventeenth-century albums.[2] Characteristic for the albums of this time are the folios which could be called "composite", because usually they combine specimens of calligraphy, painting, drawing, ornamental panels and medallions, and the whole composition is set within ornamental frames and decorated margins. The intact folios of the group under consideration demonstrate artfully planned and carefully balanced compositions. These have their own artistic value. The style of illumination on these folios, as far as we know them

from illuminated manuscripts, also points to the sixteenth and early seventeenth century. Signed and dated specimens of calligraphy mounted on the pages belong to the sixteenth century (it is worth noting that there are no seal impressions on these). Evidently in the albums made in the time of Shah 'Abbas I the device of two facing pictures alternating with two facing calligraphy pages, as well as mirror symmetry in the decoration of the pages, had not been practised as it was to be in later albums; it is possible that these devices appeared in India in the albums made for Jahangir (1605–1627)[3] and were accepted in Iran about the middle of the seventeenth century.[4]

Seals

There are the impressions of four different seals of Shah 'Abbas I on the folios considered here: a small rectangular seal with the date 995/1586–87, the year of 'Abbas's accession to the throne[5] (pls. 1–6); a very similar stamp but with the upper left corner cut and with the date 996/1587–88[6] (pls. 7–16); one more rectangular seal with the date 1010/1601–02 (pl. 17); and a small round seal[7] (pl. 18).

On all the seals one and the same inscription can be read Bandah-yi Shah-i Vilayat 'Abbas ("The servant of the King of Holiness [i.e. the Imam 'Ali] 'Abbas").[8] Though this Shi'ite term was the one most frequently used in Safavid royal titulature,[9] it was evidently 'Abbas I, proud of his descent from 'Ali, who used it especially often. This formula – Anthony Welch calls it "the standard 'signature' of the great Shah" – is seen on the coins of 'Abbas I, it is inlaid in gold on his sword, cut out on seals, and impressed on his firmans[10] as well as on all the above-mentioned seals.

On eighteen folios there are twenty-two paintings and drawings, whose entry into the royal library was evidently "registered" with stamps of the Shah's seals. Moreover, Basil Gray mentions the Hadiqat al-Uns, dated 1573, in the Museum of Fine Arts in Boston, with eight illustrations of "late Tahmaspi work" which bear 'Abbas's seal (judging from the context, this bears the date 995).[11]

It is clear now that independent miniatures and drawings existed in Iran (parallel with the art of book-illustration and other forms of painting) throughout the entire known time-span of Persian painting, but it looks as if it was only in the time of 'Abbas I that they became an art-form in their own right, with a defined style and aesthetic principles. All the paintings and drawings with stamps of the monarch's seal are finished works of high quality executed in various techniques: gouache paintings, pen and ink drawings, drawings tinted with watercolour, gold, gouache, and so on. Many of these works have been studied and published many times. The fact of the presence of 'Abbas's seal has been generally noted, but it has been interpreted in different ways. Ivan Stchoukine in 1964 describing the miniature "Woman with a Fan" (pl. 10) remarks: "Notons que l'année qui figure sur le cachet est celle de l'avènement du souverain au trône, et ne se rapporte pas à l'exécution de la peinture,

qui pourrait lui être postérieure. Le cachet indique que l'image faisait parti de la bibliothèque royale, rien de plus".[12]

Later many scholars admitted that the seal indirectly points to the date of a work. Shreve Simpson writes that the stamp on "Young Man in a Blue Cloak" and "Woman with a Fan" (pls. 9 and 10) "helps establish the dating for Riza's early style".[13] E. Atil notes that on the miniature "Woman with a Fan" the seal "helps to date the painting" and on the drawing "Dancing Sufis" (pl. 3) "the date on the seal must refer to the year in which the album was compiled, since the style of the drawing indicates that it was executed in Kazvin in the 1570s".[14] Anthony Welch suggests, à propos 'Abbas's seal on the drawing "Youth in a Gold Hat" (pl. 18): "it is likely that this excellent work entered the royal library shortly after 'Abbas's accession in 1587 in Qazvin".[15]

What do the folios with stamps show in general? We may say definitely that the seals were stamped on the miniatures and drawings before their inclusion into albums: in some cases the stamp appears twice on each piece (pls. 6, 7, 12 and 14). On several folios the impressions were trimmed off when the paintings were mounted (pls. 5, 6, 7 and 9). Moreover, on the miniatures mounted on three folios from muraqqa' H. 2155 we see two different seals (pls. 6–8).

One and the same seal looks as if it were used throughout the course of several years. The mechanics of how one seal replaced another in the royal library are not clear, but the seal with the date 995 appears on the earlier works: on the miniature by Shaykh Muhammad dated 964/1556–57, that is a work painted thirty years before the making of the seal (pl. 1); on the miniature "Portrait of 'Ali Quli Khan", painted by Muhammadi in 992/1584 (pl. 6); on a drawing by an anonymous artist, "Two cavaliers" (pl. 2), which is also apparently older than the seal; and on several works by Muhammadi (pls. 3–6), whose career was within the 16th century. It may be as well to remember that the above-mentioned manuscript of the Hadiqat al-Uns had been copied in 1573, before the accession of 'Abbas I to the throne.

The seal with the date 996 is stamped on the later works, mainly with inscriptions ascribing them to Riza (pls. 9–13), the artist who in 1587 had presumably just entered the royal atelier reconstructed by Shah 'Abbas I in Qazvin and who continued to work for 'Abbas I in the new capital, Isfahan, in the seventeenth century under the name of Riza-yi 'Abbasi. But his works discussed in this article are generally ascribed to the last ten to thirteen years of the sixteenth century (see the notes in the list at the end of the article).

The following suggestions can be made: the seal dated 996 was introduced as a substitute for the earlier seal when the court atelier reconstructed by 'Abbas I in Qazvin had started to function. Only one work is known stamped with the seal dated 1010/1601–02 and we may suggest that this is the year when the court atelier of 'Abbas I began to work in Isfahan; he had proclaimed the city as his capital in 1598.

Thus the paintings and drawings which bear seals dated 995/1586–87 could not have been created later than 996/1587–88, and all the works bearing the seal dated 996/1587–88 could have been created at this date, earlier or later, but no later than 1010/1601–02.

Inscriptions

The majority of the works considered here bear inscriptions, but only one of them may be taken as an indubitable signature (pl. 1); all the others are apparently attributions. In a recently published book, *Fifteenth-Century Persian Painting. Problems and Issues*, Basil Robinson writes, concerning the problem of signatures and attributions to the fifteenth-century masters Siyah Qalam and Shaykhi: "However much Western scholars may quibble at these, the fact remains that they were written by men of the same culture as the artists, at a period much nearer to the artists' than our own, and they are therefore worthy of respectful consideration".[16]

Now we do have some grounds for accepting the trustworthiness of some attributory inscriptions on the works under discussion. A long inscription in the upper part of the miniature "Portrait of 'Ali Quli Khan" (pl. 6) identifies the person depicted and notes that the portrait was painted by Muhammadi at Herat in 992/1584. It evidently postdates the seal, for it is written as it were around it. 'Ali Quli Khan played such an important role in the life of Prince 'Abbas, being his *lalah* in Herat and one of those who helped him to ascend the throne, that the information given in this inscription is beyond doubt. Furthermore the miniature is preserved in an album compiled apparently in the sixteenth century.

The inscription on the "Portrait of the Russian ambassador" on f. 19a of the same album (pl. 8) records that the portrait was painted at the order of Shah 'Abbas. These lines had been written before the miniature was mounted on the album folio; the words "Shah 'Abbas" were found above the main lines, and while composing the folio these two words were carefully preserved: the magnificent golden frame breaks its even line at this place and makes a curve.

The same inscription, undoubtedly written by the same hand, is seen in the upper part of the portrait of a religious dignitary (pl. 16), but in this case the words "Shah 'Abbas" were obviously cut off in the mounting of the miniature on a later album leaf (no doubt after the death of Shah 'Abbas).

All this shows that the inscriptions were written by a competent, knowledgeable person (perhaps a librarian of Shah 'Abbas I), who pointed out the names of his contemporaries. It looks as if the same person made a note on the "Hunting Scene" drawing mounted on the same folio as the "Portrait of 'Ali Quli Khan" (pl. 6). This note – *'amila ustad Muhammadi* – is undoubtedly not a signature, but an attribution, which is clear from the use of the word *ustad* (master), a word not used in miniatures whose signatures are unquestionably those of the artists themselves, but one often added to the name of an artist in literary and historical sources.

The same hand inscribed the attributions to Muhammadi on two other works – the tinted drawing "Dancing Sufis" and the miniature "Lovers" (pls. 3 and 4). Moreover we recognize the same handwriting in the attributory inscriptions mentioning *ustad Murad* on the miniature "Primroses"[17] mounted on one folio with "Dancing Sufis" (pl. 3) and (a matter to emphasise) Muhammad Qasim, on two miniatures showing standing youths (pls. 12 and 14). The latter was an artist whose activity is usually ascribed to the middle and the second half of the seventeenth century.

Let us now see how these attributory inscriptions have been accepted by scholars. The attributions to Muhammadi[18] on the drawings "Hunting scene" and "Dancing Sufis" (pls. 6 and 3) are generally accepted, but there has been no such agreement about the "Lovers" and "Portrait of an artist" miniatures (pls. 4–5). Stchoukine, admitting that the miniature "Lovers" "est pleine de grâce et de charme juvéniles" rejects the attribution to Muhammadi, writing "le style de la miniature n'est pas celui de Muhammadi, mais des peintres de Shiraz, vers 1570".[19] To the same school, about 1575, Stchoukine ascribes also the portrait of an artist, noting "la raideur du personnage représenté, qui diffère des figurines pleines de naturel et d'aisance du maître".[20] Other authors writing after Stchoukine, however, accepted Muhammadi's authorship of these works.[21]

There are many works with attributory inscriptions to Muhammadi, a well-known artist of the second half of the sixteenth century. Among them, and especially famous, is a tinted drawing – "Pastoral Scene" (Musée Guimet, Paris)[22] – with an inscription in the lower right-hand corner. This, to judge by its formula, is an author's signature: *qalam-i faqir al-da'i Muhammadi musavvir. Fi shuhur sanat 986* "brush of the poor suppliant Muhammadi the painter. In the months of the year 986" (1578–79). This drawing was until recently the only known work of Muhammadi with a date, but after the publication by Anthony Welch of the page from the *muraqqa'* H. 2155, the portrait of 'Ali Quli Khan painted in 1584 can now be added.[23] The publication of this folio (pl. 6) with two of Muhammadi's works, attested by the Shah's own seal and by perfectly credible attributions, is very important, because it casts new light on the problem of the differences between two arts – gouache painting and ink drawing. Here on the same folio we see two works made in two different techniques and demonstrating absolutely different approaches. Anthony Welch explains that Muhammadi has long been associated with a rather "lyrical genre style of drawing, which flourished in late sixteenth century Iran" and adds "were these drawings all we knew of his work, it would be relatively easy to define his style and his role in late sixteenth century painting". "But", he says, "a number of other works survive, which also bear his name and which reveal a different character and in many respects a different style". Thus Anthony Welch noticed exactly how much the miniatures of Muhammadi differ from his drawings.[24]

In fact miniature painting, with the opaque covering of a specially prepared ground by bright pigments, and drawing, executed directly on paper, are different arts, each with its own aims and specific methods. The first is more academic. It had a highly finished and classical look and as such it was less subject to change and thus more conservative. Line plays an important but subsidiary role in miniatures, outlining contours for the application of bright colours. In drawing, line is of primary importance; often transparent watercolour is used, which not only does not hide lines but accentuates them. In the drawings an artist was free, natural and ready to capture immediate impressions. His hand and his individual manner are more easily recognized in drawings.

When Muhammadi's "Lovers" and "Portrait of an artist", themselves miniatures, are compared not with his drawings, but with the miniature portrait of 'Ali Quli Khan, they can be unquestionably recognised as works of this artist.

Muhammad Qasim

We have already mentioned that on two miniatures (pls. 12 and 14) of the group under consideration, attributory inscriptions ascribing them to Muhammad Qasim are written by the same person who so exactly identified the authorship of Muhammadi. Both miniatures are stamped with the above-mentioned seal dated 996/1587–88 and, according to the argument outlined above, could not have been created later than 1010/1601–02.

The most comprehensive study of Muhammad Qasim is still that in the book by Stchoukine (1964).[25] But the career of this master now has to be reassessed. Stchoukine wrote about the works of Muhammad Qasim: "Exécutés dans un style qui est une interprétation originale des principes de Reza-yi 'Abbasi, les peintures et les dessins de Muhammad Qasim se distinguent par leurs belles qualités artistiques et s'échelonnent entre la cinquième et la dernière décade du XVIIᵉ siècle".[26] Of signed works of Muhammad Qasim known at that time only one had the date and even that was given in shortened form. It was the drawing "Chastisement of a Pupil" from the Metropolitan Museum of Art, signed *raqam-i khaksar Muhammad Qasim. Sanat 114.* The date on this expressive drawing executed in calligraphic line, vivid, changing its thickness, was read by Stchoukine as 1104/1692–93, noting his disagreement with Schulz, who understood it as 1014/1605.[27] M.L. Swietochowski and S. Babaie, who published this drawing in 1989, wrote that "the style of Muhammad Qasim and of two other mid-seventeenth-century artists, Muhammad 'Ali and Muhammad Yusuf, derived from the, at that time, innovative style of Reza 'Abbasi". About the date they noted: "… the equivalent, if another digit is added, to 1692–93, rather late in the long span of productivity of this artist".[28] Apparently they took into account the miniature acquired by the Louvre in 1975 (No. MAO. 494), showing 'Abbas I embracing his young page who is serving him wine. The verses written on the right side of the figures finish with the information that the

work was done on Friday 24 Jumada al-Thani 1036/ 10 February, 1627 by the miserable Muhammad Qasim *musavvir*.[29] Muhammad Qasim, who painted this rather large miniature, (25.5 x 15cm) must have been a court painter of Shah 'Abbas especially near to the monarch and enjoying his favour. As to the work itself, it shows that by 1627 its author had reached his mature style. Many features show that this painter is that very Muhammad Qasim who is mentioned in the attributory inscriptions on the two miniatures discussed above (pls. 12 and 14). For example the thick-trunked tree with flat quadrangular stylized foliage occupying the upper part of the Louvre miniature, and crossing the composition diagonally behind the figures, seems to be a favourite motif of this artist, being present in almost all his known works.[30] It is also represented in the above-mentioned scene of the chastisement of a pupil. We may also note that this work is not characteristic of Persian paintings and drawings of the end of the seventeenth century, when a Europeanized style became the prevailing stylistic trend in the Isfahan school. On the other hand, if we accept the date 1014/1605, then this work does not integrate into the traditional scheme of "Riza-yi 'Abbasi and his followers". All the contradictions are removed if we admit that the period of Muhammad Qasim's activity was the first half of the 17th century and not the second. Then this painter becomes not a "student" and "follower" of Riza-yi 'Abbasi (who died in 1635), but his (probably somewhat younger) contemporary; that is, a painter who worked at the same time, in the same style, but in an absolutely different manner. In that case artistic life of the first half of the seventeenth century in Isfahan is no longer to be interpreted in relationship to the one personality of Riza-yi 'Abbasi, but proves to have been as varied and rich in masters with a strong personal style as was artistic life in the second half of the sixteenth century when such personalities as Muhammadi, Siyavush, Sadiqi and Riza worked.

The miniature "Standing Youth" (pl. 14) is one of the earliest known works of Muhammad Qasim. It is executed in the style typical of the end of the sixteenth century, and still closely connected with the traditions of the Qazvin school. The early style of the master looks to be very close to that of Riza and Sadiqi: this goes for the posture, the silhouette and the treatment of the youth's figure, shown against a background of landscape painted in gold. One may compare this work with Sadiqi's miniature mounted on one folio together with Muhammad Qasim's work, and with many works of Riza ascribed to the last decade of the 16th century.[31]

The miniature "Youth in a fur-lined coat" (pl. 12), though also executed under the influence of Riza (it is especially similar to the "Youth with an ewer" from the Hermitage collection,[32] one of Riza's masterpieces) shows to a greater degree the personal manner of Muhammad Qasim: his liking for carefully rendered, many-layered rich clothing for his personages, a recognizable type of face which can be traced in his works, and his favourite tree, crossing the background diagonally. The same features are visible in his miniature "Girl smoking" (Topkapi, *muraqqa'* H. 2137, f. 21b), signed *raqam-i kamine khaksar*

Muhammad Qasim,[33] probably of the end of the sixteenth or the beginning of the seventeenth century (fig. 2); and in an apparently somewhat later work "Young woman in European dress" (Victoria and Albert Museum),[34] signed *raqam-i kamtarin Muhammad Qasim musavvir*. It is worth noting that there exists a mirror-reversed variation on the first of these miniatures, painted by Mu'in Musavvir in 1084/1673–74 (Topkapi, *muraqqa*' H. 2143, f. 12).[35]

The miniature showing a standing woman holding a waterpipe and a wine cup is dated by Massoumeh Farhad c. 1640–50.[36] The high horizon with sharp rocks and small trees, the dark foreground executed in pointillistic technique with reserved small rocks and bushes – all this appears in the drawing "The chastisement of a pupil" in 1605, where these elements have already been mastered. They are used in the illustrations of the 1648 *Shahnama*, the best paintings of which Basil Robinson has ascribed to this master.[37]

In *Qisas al-Khaqani* by Wali Quli Shamlu the date of Muhammad Qasim's death is given as 107. Massoumeh Farhad, citing this information, suggests that it means the year 107(0)/1659.[38]

If Muhammad Qasim, who died in 1659, was already working at the end of the 16th century (this is the period to which we ascribe two miniatures with 'Abbas's seal) then he must have been born not later than 1575 and he must have had a long life – about 85–90 years.[39]

Riza

Six works of the group under consideration bear short notes ascribing them to Riza (pls. 9–13). They are well-known works by the celebrated master whose working life coincided almost exactly with the reign of 'Abbas I (the painter outlived his patron by five years). When the court moved to the new capital of Isfahan, Riza was already a famous painter respected for his art.[40] His earliest dated work "Girl in a fur cap", in the Hermitage collection, is signed *raqam-i kamine Riza-yi 'Abbasi. 1011* (1602–03).[41] This formula, with "'Abbasi" added to the name, is met on almost all his later works, usually in combination with highly detailed and precise dates.

Of all the works with 'Abbas's seal only one – the drawing showing a hunter (pl. 12) – includes this honorific addition. On the other works his authorship is noted in short form: *mashaqahu Riza* (pls. 11a and 13) and *mashaqahu Aqa Riza* (pls. 9–11). It is generally accepted that these two formulae were the signatures of the painter used by him before he received the honorific 'Abbasi. It is worth remarking that there are no dates on the works with such notes.

Possibly *mashaqahu Riza* really was his signature. There is a drawing showing a boy holding a folio (Istanbul, University Library),[42] mounted on an album page (presumably of the sixteenth century), whose decoration resembles that of the drawing "Two cavaliers" (pl. 2) with its similar calligraphic bands and ornamental panels. The folio in the boy's hands has the verses ending with *mashaqahu Riza* written in the same hand (see fig. 1). The posture of the boy's figure, facial type and treatment of the folds of his dress are very similar to those in the miniatures "Girl with a fan" and "Youth in a blue cloak" (pls. 9–10), which are considered to be the earliest works by Riza, and to have been painted about 1587–90. The drawing "Boy holding a folio" belongs, in my opinion, to the same period. Its more "vivid" line in comparison with the calmer line in the miniatures is due to the different character and role of line in paintings and drawings, as stressed above.[43]

As to the inscriptions of the type *mashaqahu Aqa Riza*, they are connected with the problem if the word "Aqa" is part of the name, as some authorities suppose, or if it means honorific "sir", as is the opinion of other authors.[44] The inscription on the miniature "Youth in a blue cloak" (pl. 9) – *mashaqahu kamtarin Aqa Riza* – might give a definite answer to this question, because only the painter could use the humiliating word *kamtarin* about himself. Unfortunately this miniature, unlike the majority of the others, is preserved on the late album folio mounted wrongly[45] and we cannot be sure that it was inscribed in the sixteenth century.

Qadi Ahmad, writing in 1596–97, and later Iskandar Munshi call this painter "Aqa Riza".[46] One may suggest that they would have added *ustad* or some such word (as they always do when speaking of other masters) if "Aqa" had been part of his name. Perhaps the inscriptions using "Aqa" are attributions written on the works of Riza when he had already become a celebrated artist, that is nearer to the end of the sixteenth century.

Five works of Riza with seals created in the last decade of the sixteenth century (two gouache miniatures, a tinted ink drawing, a drawing in gold line tinted with bright gouache and a drawing on colored paper) show an extremely wide range of artistic capabilities of the master, who is compared by Qadi Ahmad with Mani and Bihzad.

I shall conclude with some remarks – absolutely hypothetical – on several miniatures in the group under discussion which have no inscriptions and which are known to me only through reproductions.

The miniature "Youth with a gun" (pl. 17), the only work in the group whose seal is dated 1010/1601–02, was ascribed by S. Komornicki to the early seventeenth century. To this we may add only that the motif of a man with a gun is not frequent in Persian painting; some depictions of this kind currently known were created by a court painter of 'Abbas I named Habiballah.[47] It is worth remarking that in the miniature "Concourse of the birds" which he contributed to the manuscript *Mantiq al-tair* he shows a man with a gun, a detail which has no connection with the subject.[48]

At present it is difficult to explain how the depiction of an Indian very much resembling the young prince Salim, later to be the Mughal Emperor Jahangir (born in 1569, ruled 1605–1627) (pl. 15), got into Shah 'Abbas's library and was later included in the *Muraqqa'-yi Gulshan*, decorated between 1599 and 1609.[49] We can only say that depictions of Indians are not rare in the works by

Persian masters of the sixteenth and seventeenth centuries; there are also repetitions of Indian paintings by Persian artists (for example, "Lovers" by Riza-yi 'Abbasi in the *muraqqa'* Dorn 489 in the St. Petersburg Public Library).[50]

Very intriguing are the portraits of the Russian ambassadors (pls. 7 and 8), one of which is dated, without commentary, by Ernst Grube and Eleanor Sims to 1625–1650.[51] Basil Robinson thinks that the authors of these portraits are the two main painters of 'Abbas

I – Sadiqi and Riza.[52] The portraits are placed in *muraqqa'* H. 2155, ff. 19b–20a, facing each other. The garments of the ambassadors are very similar – fur-lined caftans and fur caps – but one of them is dark-bearded, and the second light-bearded. Both portraits are stamped with the above-mentioned seal dated 996/1587–88 and, according to the argument already presented, were created not later than 1010/1601–02. Only two Muscovite ambassadors to the court of 'Abbas I are relevant to this discussion – Grigorii

The seal with date 995

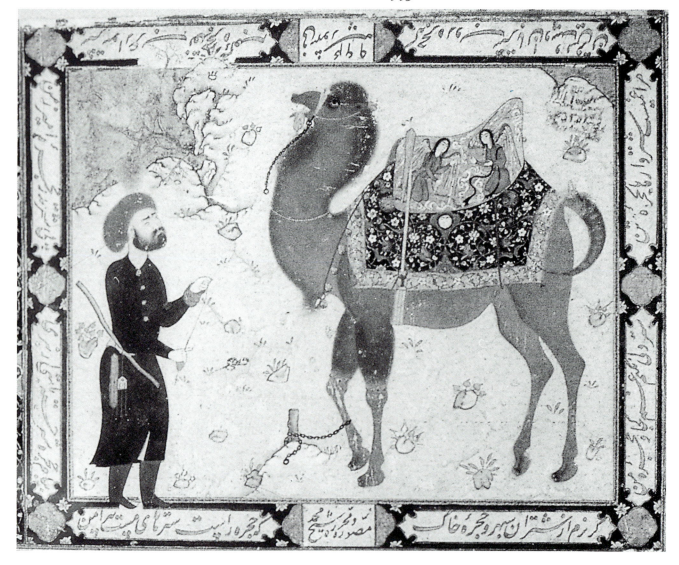

I. CAMEL AND KEEPER
The Freer Gallery of Art, Smithsonian Institution, Washington, D.C., 37.21.
Gouache painting, inscribed (in the cartouches at the top and below the picture) *"musavvir va muharrir Shaykh Muhammad fi shuhur sanat 964"*, i.e. "painter (author of the miniature) and designer (of the whole album page) Shaykh Muhammad, in the months of the year 964" (1556–57). For other readings of the inscription see the following publications: Atil, p. 49 and FIG. 16A; Dickson-Welch, I, p. 166B and FIG. 226; Simpson, "Shaykh Muhammad", p. 105–107 and FIG. I.
Commentary: this is evidently either the lower half of a composite album page or a recto page with the picture arranged horizontally on a leaf to be mounted into the vertical format of the album, its lower edge towards the spine (and lacking only the left edge of the folio).

Borisovich Vasilchikov, head of the embassy of 1588–89, and Andrei Dmitrievich Zvenigorodsky – head of the embassy of 1594–95.[53]

The survey of the whole group of paintings and drawings bearing the stamps of 'Abbas I's seals helps to verify the attributions and datings of some outstanding works of the second half of the sixteenth century. The evidence presented here suggests that the Qazvin court atelier became the place where Muhammad Qasim began his activity at the end of the sixteenth century.

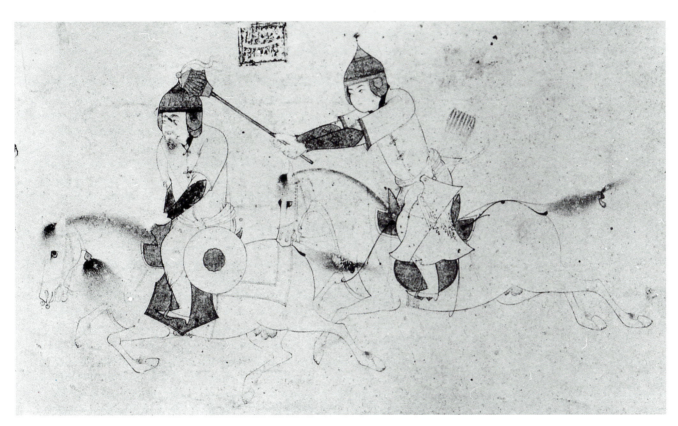

2. TWO CAVALIERS
Fogg Art Museum, Cambridge, Mass., 1948.60.
Drawing in black ink with gold and watercolour, mounted with calligraphy and illuminated squares.
Simpson, APP, No. 23: "Qazvin. 2nd half of the 16th-century" (p. 70), "attributable to Muhammadi of Herat" (p. 10).
Commentary: part of an album page which once belonged to a 16th-century album. Compare: Stchoukine, SA, pl. XXXVI;
A. Welch, "Shah 'Abbas", ill. 4.

3. DANCING SUFIS
The Freer Gallery of Art, 46.15.
Drawing in black ink with gold, tinted with red, inscribed 'amila ustad Muhammadi Haravi.
PRIMROSES
Gouache painting, inscribed 'amila ustad Murad, mounted with samples of calligraphy and illuminations. Atil, No. 15.
Commentary: the seal impression is only on the drawing.

4. LOVERS
Museum of Fine Arts, Boston, No. 14. 588.

Gouache painting, inscribed "'amila ustad Muhammadi". Stchoukine, *MS*, p. 116, No. 137 (without illustration): "miniature de l'école de Shiraz, vers 1570"; Robinson, *PD*, pl. 46: "The attribution to Muhammadi may be confidently accepted, ca. 1575". Reproduced in: Marteau et Vever, pl. 124; Schulz II, pl. 157; Coomaraswamy, pl. XXII; Sakisian, FIG. 160.

5. PORTRAIT OF AN ARTIST
Museum of Fine Arts, Boston.

Gouache painting, inscribed "'amila Muhammadi", "surat-i Muhammadi". Stchoukine, *MS*, p. 116, No. 140 (without illustration): "l'école de Shiraz, vers 1575". Reproduced in: Schulz II, pl. 159; Coomaraswamy, pl. XXIII; Sakisian, FIG. 131; Kaziev, p. 252.
Commentary: the upper part of the seal has been trimmed off.

6. HUNTING SCENE
Topkapi, Istanbul, *muraqqa'* H. 2155, f. 20b.

Drawing, inscribed *'amila ustad Muhammadi*.
PORTRAIT OF 'ALI QULI KHAN

Gouache painting, "done in 992/1584 by Muhammadi at Herat" (in attributory inscription), mounted with calligraphy and illuminations.
A. Welch, "Shah 'Abbas", p. 502, ill. 4 and p. 469.
Commentary: the seal appears on both works; on the miniature its upper part has been trimmed off.

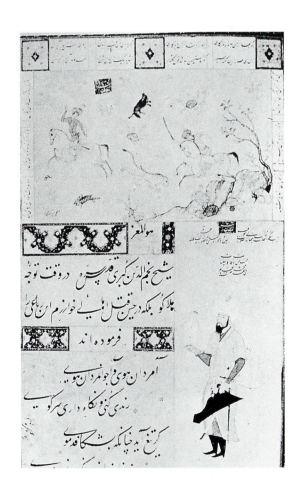

The seal with the date 996 (with cut upper left corner)

This seal can be distinguished from that bearing the earlier date even when its impression has been trimmed off or is faint, because on all the impressions of this seal there is a distinct vertical line which crosses *vav* in the upper line and *sin* in the lower one.

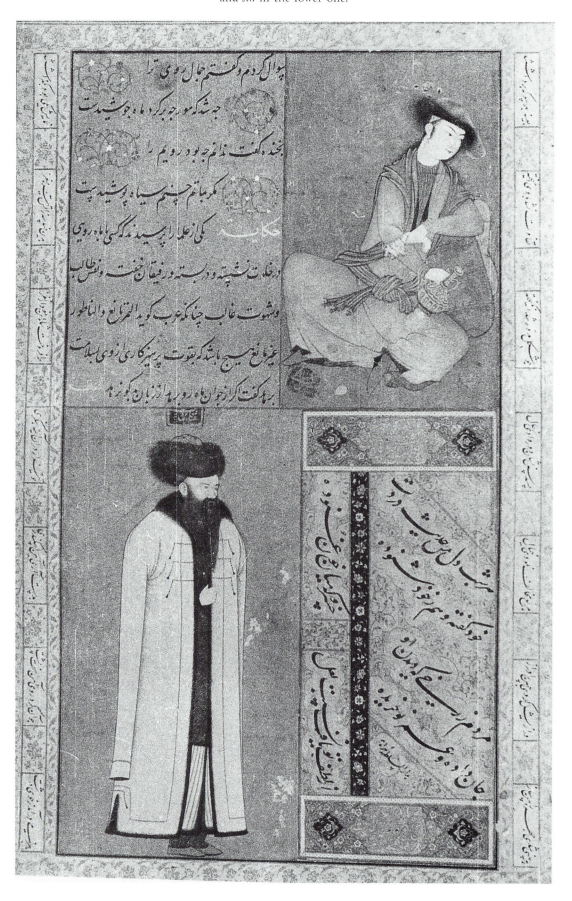

opposite 7. SEATED YOUTH LEANING ON A CUSHION
Topkapi, Istanbul, *muraqqa'* H. 2155, f. 20a.

Gouache painting.

A RUSSIAN IN A FUR CAP

Gouache painting.

Both paintings are mounted with samples of calligraphy. Grube-Sims, p. 213, ill.
26: "ca. 1610" for the first one, "1625–1650" for the second.
*Commentary: on the first miniature the seal impression is faint, while on the
second the upper part of the seal impression has been trimmed off.*

right 8. PORTRAIT OF A RUSSIAN AMBASSADOR
Topkapi, Istanbul, *muraqqa'* H. 2155, f. 19b.

Gouache painting, inscribed *surat-i ilchi-yi urus hasb-i al-amr-i navvab-i ashraf agdas a'la
Shah 'Abbas samt tahrir yaft* ("portrait of the Russian ambassador done according to
the wish of the noble, most holy, superior Shah 'Abbas") Topkapi, No. 123.

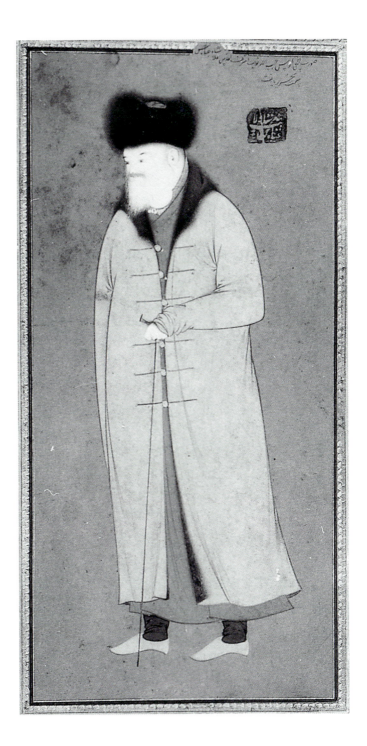

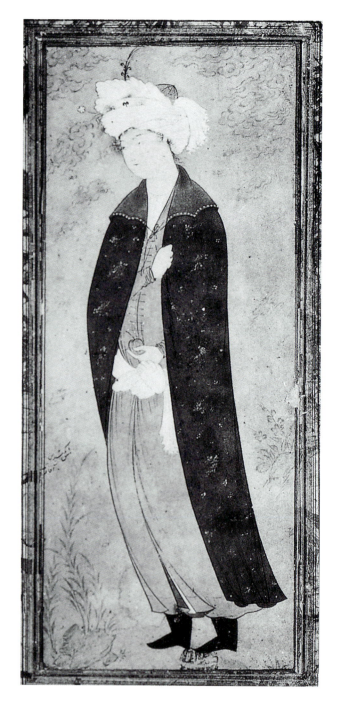

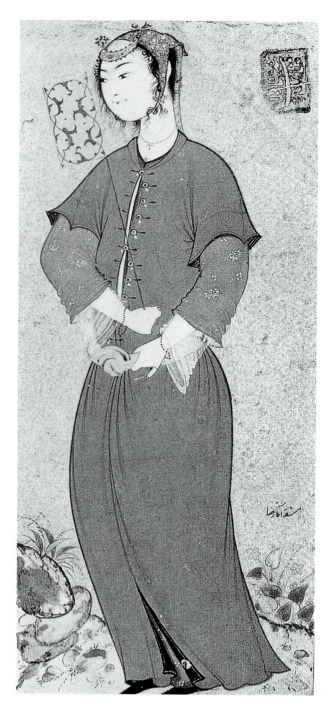

9. YOUNG MAN IN A BLUE COAT
Arthur M. Sackler Museum, Harvard
University, Cambridge, Mass., 1935. 27.
Gouache painting, inscribed *mashaqahu kamtarin Aqa Riza*; mounted
on later album page and also incorrectly (see note 45).
Published many times: Stchoukine, *SA*, p. 100: "1590 environ";
Gray, *Persian Painting*, p. 161: "c. 1590"; Simpson, *APP*, No. 29:
"ca. 1587"; A. Welch, *Artists*, p. 101, 129, pl. 6: "c. 1587";
Canby, ill. 1: "c. 1587".
Commentary: the lower part of the seal has been trimmed off.

10. WOMAN WITH A FAN
The Freer Gallery of Art, 32.9.
Gouache painting, inscribed *mashaqahu Aqa Riza*, mounted with
illuminated bands.
Published many times; see, for example: Stchoukine, *SA*, p.
99–100: "vers 1590", Atil, No. 19A: "ca. 1590";
A. Welch, *Artists*, pl. 7: "c. 1587".
Commentary: fragment of an album page of the 16th century.

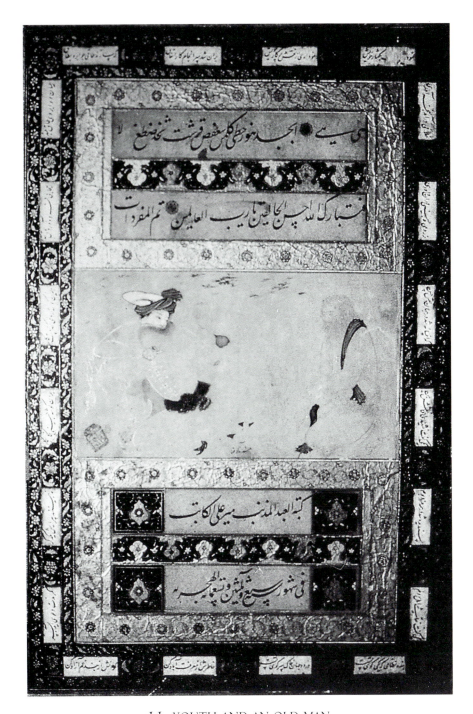

11. YOUTH AND AN OLD MAN
Arthur M. Sackler Gallery, Smithsonian Institution, Washington DC S.86.0292.
Gouache, gold and ink on coloured paper, inscribed *mashaqahu Aqa Riza*, mounted with samples of calligraphy and illuminations.
Stchoukine, *SA*, p. 102: "entre 1605–1615"; Canby, FIG. 11: "c. 1602–03"; Lowry-Beach, No. 365, p. 312: "c. 1605".
Commentary: an album page of the 16th century very similar in its design to the page with Reclining Nude, inscribed
mashaqahu Riza, *with rubbed paper near the right edge (perhaps the seal itself is rubbed?) (Atil, No. 19B; Canby, ill. 2).*

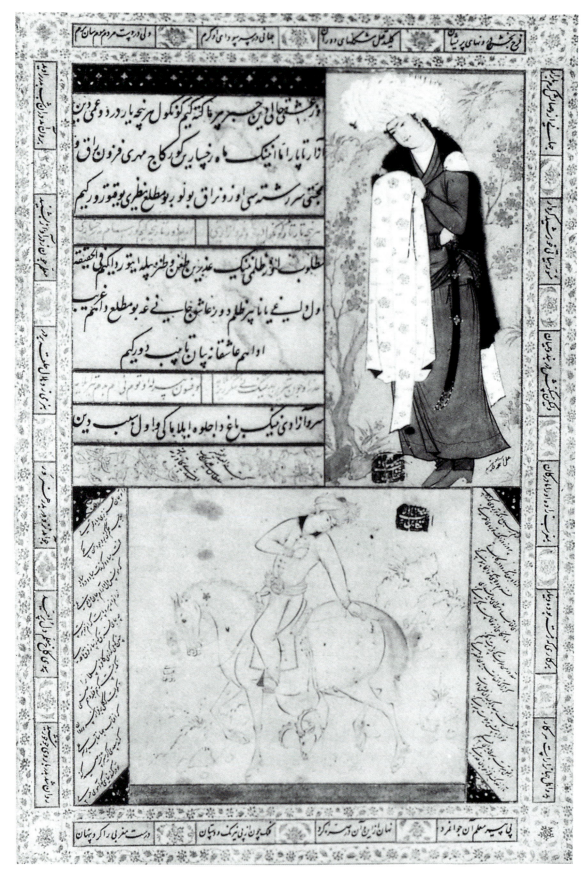

12. HUNTER ON HORSEBACK
Victoria and Albert Museum, London.
Ink drawing, tinted with watercolours, inscribed *raqimuhu Riza-yi ʿAbbasi*.
YOUTH IN A FUR-LINED COAT
Gouache painting, inscribed *ʿamila ustad Muhammad Qasim*; mounted with samples of calligraphy and illumination. Canby, fig 7:
"c. 1595" for the drawing by Riza.
Commentary: both works bear seal stamps.

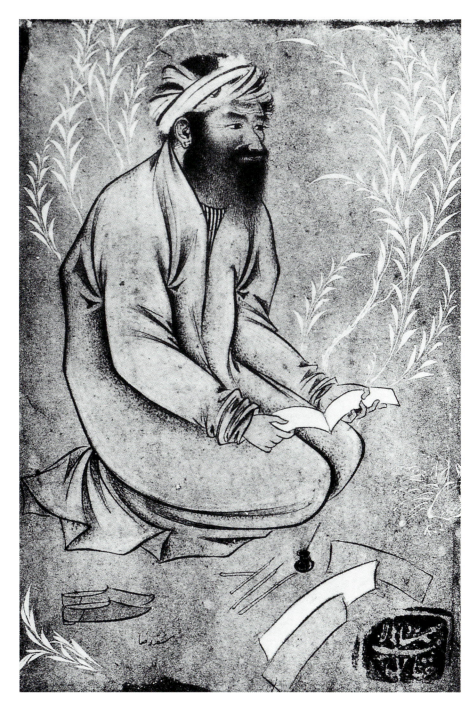

13. PORTRAIT OF A CALLIGRAPHER
British Library, London. 1920-9-17-0271(1).
Tinted drawing on brown-toned paper inscribed *mashaqahu Riza*.
Stchoukine, *SA*, pl. XLa, p. 121: "dessin faussement attribué à Reza", "début du XVIIe siècle";
B.W. Robinson, *Persian Miniature Painting from collections in the British Isles*, London, 1967, No. 65:
"beginning of the 17th century"; Titley, *Index*, Cat. 396 (38), ill. 41: "seventeenth cent."

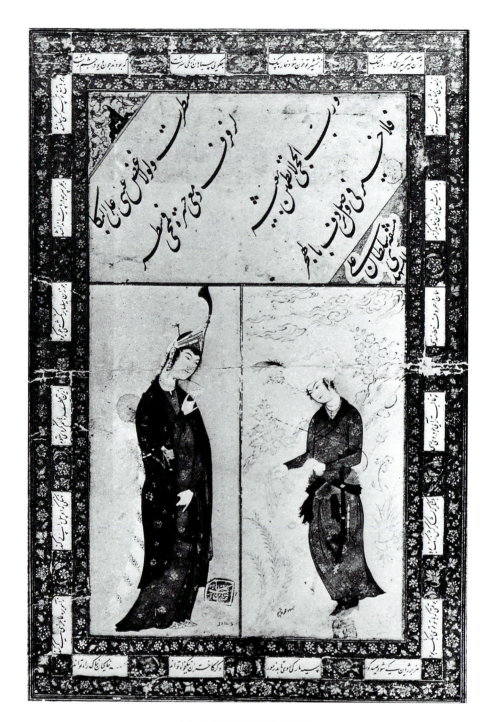

14. A STANDING WOMAN
Arthur M. Sackler Gallery, Smithsonian Inst., Washington, D.C., S.86.0305.
Gouache painting, inscribed "Sadiqi"
A STANDING YOUTH
Gouache Painting, inscribed *ustad Muhammad Qasim*; mounted with samples of calligraphy.
Lowry-Beach, p. 306, No. 356: "Iran (Qazvin?), ca. 1590.... While the attribution to Sadiqi seems plausible,
Robinson has suggested that *A Standing Youth* may be by Riza Abbasi rather than by Muhammad Qasim".
Commentary: the seal is on both of the paintings, but on the right one it is faint.

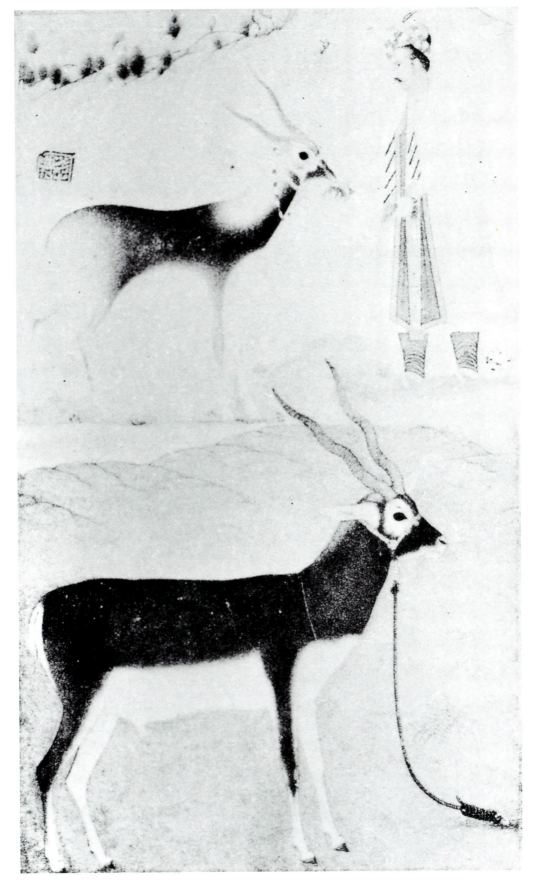

15. AN INDIAN FEEDING A GAZELLE
Gulistan Library, Tehran, *Muraqqa'-yi Gulshan.*
Gouache painting.
AN ANTELOPE
Gouache painting.
D.N. Wilber, *Four Hundred and Forty-six Kings of Iran*, Tehran, 1972, ill. 46, depicted personage identified as "Shah Tahmasp".
Commentary: the seal is only on the upper painting.

16. A RELIGIOUS
DIGNITARY
Collection of the
Calouste Gulbenkian
Foundation.
Gouache painting, mounted on an
album leaf. Inscribed: (above) *hasb-i
al-amr-i navvab-i kamiab ashraf agdas
a'la/Shah 'Abbas?/samt-i tahrir yaft. Surat-
i Mir Kamal al-Din Husain Vaiz* (?)
(below) *mashaqahu Riza-yi musawwir.*
See *L'Art de L'Orient islamique.
Collection de la Fondation Calouste
Gulbenkian.* Lisboa, Maio, 1963, No.
135: "vers 1590".

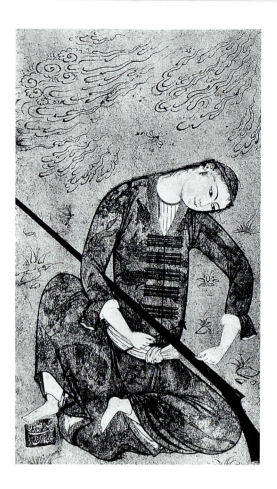

Seal with date 1010

17. SEATED YOUTH WITH A GUN
Museum Czartoryski, Cracow, Ms. Czart. 3456,
fol. 5r.
Gouache painting. S. Komornicki, in: *Bull. de la Soc. Franc. de reprod. de peintures,*
18e année (1934), p. 173 and pl. XXXVIII: "les premières années du
XVIIe siècle".

Round seal

18. YOUTH IN A GOLD HAT
Collection of Sadruddin Aga Khan, Geneva, Ir.M.73.
Tinted drawing, mounted with samples of calligraphy and illuminated panels.
A. Welch, *Aga Khan,* v. III, p. 104: "Qazvin, c. 1587".
*Commentary: the drawing is mounted on a later
album page.*

YOUNG WOMAN HOLDING A FLOWER
(Unillustrated here)
The Israel Museum, Jerusalem, 561.69.
Gouache painting. R. Milstein, *Islamic Painting in the Israel Museum,*
Jerusalem, 1984, No. 21, FIG. on p. 46.
*Commentary: only the upper edge of the stamp is visible (under the feet of
the woman); it is possibly the seal with the date 996.*

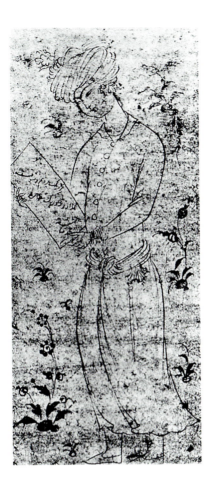

Fig. 1. YOUTH HOLDING A
FOLIO
Istanbul University Library,
Ms. 1426, fol. 6b.
Signed *mashaqahu Riza*. Stchoukine,
SA, pl. XXXVI

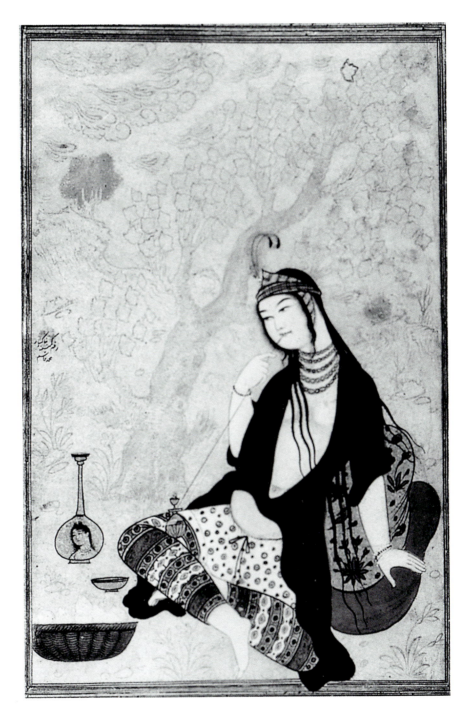

Fig. 2. GIRL SMOKING
Topkapi, Istanbul, *Muraqqa'* H.2137, fol. 21b.
Signed *Raqam-i Kamine Khaksar Muhammad Qasim*.

Notes

Abbreviations

Atil, E. Atil, *The Brush of the Masters: Drawings from Iran and India*, Washington, D.C., 1978.

Canby, Sheila R. Canby, "Age and Time in the work of Riza", in: *Persian Masters. Five Centuries of Painting*, ed. Sheila R. Canby, Marg Publications, Bombay, 1990, pp. 99–113.

Dickson-Welch, M.B. Dickson and S.C. Welch, *The Houghton Shahnameh*, Cambridge, Mass., and London, 1981.

Grube-Sims, E.J. Grube and Eleanor G. Sims, "Painting", in: *The Arts of Persia* ed. R.W. Ferrier, New Haven and London, 1989, pp. 200–225.

Lowry-Beach, G.D. Lowry and M.C. Beach, *An Annotated and Illustrated Checklist of the Vever Collection*, Washington, D.C., 1988.

Robinson, *PD* B.W. Robinson, *Persian Drawings from the 14th through the 19th century*, New York, 1965.

Simpson, *APP* M.S. Simpson, *Arab and Persian Painting in the Fogg Art Museum*, Cambridge, Mass., 1980.

Simpson, "Shaykh Muhammad" M.S. Simpson, "Shaykh Muhammad", in: *Persian Masters. Five centuries of Painting*, ed. Sheila R. Canby, Marg Publications, Bombay, 1990, pp. 99–113.

Stchoukine, *MS* I. Stchoukine, *Les peintures des manuscrits Safavis de 1502–1587*, Paris, 1959.

Stchoukine, *SA* I. Stchoukine, *Les peintures des manuscrits de Shah 'Abbas I à la fin des Safavis*, Paris, 1964.

Titley, *Index* M. Titley, *Miniatures from Persian Manuscripts. A Catalogue and Subject Index of Paintings*, London, 1977.

Topkapi J.M. Rogers, F. Çağman, Z. Tanındı, *The Topkapi Saray Museum. The Albums and Illustrated Manuscripts*, London, 1986.

A. Welch, *Artists* A. Welch, *Artists for the Shah*, New Haven and London 1976.

A. Welch, *Aga Khan* A. Welch, *Collection of Islamic Art* (collection of Prince Sadruddin Aga Khan). 4 volumes, Geneva 1972–78.

A. Welch, "Shah 'Abbas" A. Welch, "Painting and Patronage under Shah 'Abbas I", in: *Studies on Isfahan. Iranian Studies* 7 (1974), pt 2, pp. 458–507.

1 B.W. Robinson, "The Shahnama of Muhammad Juki. RAS. MS 239", In *The Royal Asiatic Society, its History and Treasures*, ed. S. Simmonds and S. Digby, London, 1979, p. 94.

2 For the albums made for 'Abbas I, see A. Welch, *Artists*, 1976, p. 69 and n. 51 on p. 90.

3 See for example the description of an album for Jahangir in M.C. Beach, *The Imperial Image. Paintings for the Mughal Court*, Washington, D.C., 1981, p. 25.

4 For the albums of the 17th–19th centuries see: A.A. Ivanov, T.V. Grek and O.F. Akimushkin, *Album of Indian and Persian miniatures of the 15th–18th centuries*, Moscow, 1962 (in Russian); S.C. Welch et al., *The Emperors' Album*, New York, 1987.

5 L.-L. Bellan, *Chah 'Abbas I*, Paris, 1932, p. 19, gives the date of 'Abbas's coronation in Qazvin as May 1587 (i.e. 995).

6 In the scholarly literature the date on this seal is sometimes given as 995, sometimes as 996. I have chosen the reading of the date 996/1587–88 as given in: Topkapi, No. 123, p. 182.

7 A. Welch, *Aga Khan*, III, p. 104 does not inform us whether there is any date on the seal; in the reproduction he gives it is indistinguishable.

8 For two seals of 'Abbas I taking other forms, one of them with the date 996/1587–8, the second dated 999/1590–91, but with the same formula, see H.L. Rabino, *Coins, Medals and Seals of the Shahs of Iran 1500–1941*, Hertford, 1945, pl. 48.

9 This titulature was used by Shah Tahmasp. See A. Welch, *Treasures of Islam*, London and Geneva, 1985, No. 67.

10 A. Welch, *Shah 'Abbas and the Arts of Isfahan*, Cambridge, Mass., 1974, p. 144, Nos. 45, 17. The reverse side of the *firman* where the seal is stamped is not reproduced, and the author does not say what kind of seal was used.

11 B. Gray, *Persian Painting*, Geneva, 1961, p. 156.

12 Stchoukine, *SA*, p. 100.

13 Simpson, *APP*, N. 29, p. 82.

14 Atil, Nos. 19A, 15, pp. 44 and 55.

15 A. Welch, *Aga Khan*, III, p. 104.

16 B.W. Robinson, *Fifteenth-century Persian Painting. Problems and Issues*, New York, 1991, p. 37.

17 For the identity of handwriting, see Atil, *Brush*, No. 15; for the artist Murad, see Stchoukine, *SA*, p. 73; Atil, *Brush*, No. 15.

18 For Muhammadi see Stchoukine, *MS*, p. 41–42, 94–97; B.W. Robinson, *Persian Painting in the India Office Library*, London, 1976, Nos. 52–154; Welch, *Shah 'Abbas*, p. 466–470.

19 Stchoukine, *MS*, p. 116, No. 137.

20 Stchoukine, *MS*, p. 116–7, No. 140.

21 Robinson, *PD*, pl. 46, p. 136; Gray, *op. cit.*, p. 156.

22 Robinson, *PD*, pl. 40, p. 135.

23 A. Welch, *Shah 'Abbas*, p. 469, Fig. 4.

24 *Ibid.*, p. 466–467. See also M.L. Swietochowski and S. Babaie, *Persian Drawings in the Metropolitan Museum of Art*, New York, 1989.

25 Stchoukine, *SA*, p. 53–56.

26 *Ibid.*, p. 53.

27 *Ibid.*, p. 56.

28 M.L. Swietochowski and S. Babaie, *op. cit.*, No. 34 (p. 78).

29 *L'Islam dans les collections nationales*, Paris, 1977, No. 249.

30 Martin, v. II, pl. 165c; E. Kühnel, *Miniaturmalerei im Islamischen Orient*, Berlin, 1922, Abb. 91; Stchoukine *SA*, pl. LXXI.

31 Presumably this is why B.W. Robinson suggested that "A standing youth" may be by Riza 'Abbasi rather than Muhammad Qasim. See: Lowry-Beach, No. 356, p. 306.

32 Stchoukine, *SA*, pl. XXXIIb.

33 Topkapi, No. 124.

34 Stchoukine, *SA*, pl. LXXVIII.

35 *Ibid.*, pl. LXXVI.

36 M. Farhad in A. Welch (ed.), *Treasures of Islam*, Geneva, 1985, No. 89.

37 Robinson, *PD*, pl. 62 and p. 137.

38 See note 36.

39 All this casts doubt on the existence of Muhammad Qasim "l'Ancien"; see Stchoukine, *SA*, p. 53.

40 For Riza see: Stchoukine, *SA*, p. 85–133; A. Welch, *Artists*; A. Welch, "Shah 'Abbas", p. 478–482; Canby, p. 71–84.

41 Robinson, *PD*, fig. 3.

42 Stchoukine, *SA*, pl. XXXVI.

43 It is dated by Stchoukine to "la première quinzaine du XVIIe siècle" (Stchoukine, *SA*, p. 103 and pl. XXXVI ("vers 1610")).

44 T.W. Arnold, *Painting in Islam*, Oxford, 1928, pp. 145–147; Stchoukine, *SA*, pp. 95, 107; O. Akimushkin and A. Ivanov, *Persian Miniatures of the XIV–XVIIth centuries*, Moscow, 1968 (in Russian), p. 28.

45 This folio is recto, but had to be verso so that the youth's regard would be turned to the inner and not the outer margin.

46 Qadi Ahmad, *Calligraphers and Painters*, tr. V. Minorsky, Washington, D.C., 1959, p. 192; Iskandar Munshi in Arnold, *Painting in Islam*, pp. 143–44.

47 Robinson, *PD*, pl. 59; A. Welch, "Shah 'Abbas", p. 482.

48 *The Metropolitan Museum of Art Bulletin*, May, 1967, p. 343.

49 S.C. Welch et al., *The Emperors' Album*, p. 45.

50 Akimushkin and Ivanov, *op. cit.*, pl. 65.

51 Grube-Sims, p. 212, fig. 26.

52 B.W. Robinson, "A Survey of Persian Painting", in: *Art et Société dans le Monde Iranien*, ed. C. Adle, Paris, 1982, p. 65.

53 P.P. Bushev, *The History of Embassies and Diplomatic Relations between the Russian and Iranian States in 1588–1612*, Moscow, 1976 (in Russian).

4

Beyond the Pale:

Meaning in the Margin

BARBARA BREND

THE FIELD OF PERSIAN PAINTING PRESENTS AN ENCHANTED landscape which, for all its enticements, it is by no means simple to enter. Mr. Robinson has opened up many of its pathways, enabling others to follow.[1]

A tree leans sideways, swaying beyond the space ostensibly allocated to illustration, outcrops of rock lap over the rulings; domes, minarets, *badgir*s and balconies break through the upper lines; persons enter from the margins. Painters and connoisseurs of the past have left no statement as to the intention which guides this usage, and so we are obliged to divine that from its apparent results, as both Cowen and Hillenbrand have done to good effect.[2] This essay is based on the view that Islamic painting, and especially its Persian branch, tends to convey meaning diagrammatically, so that, in addition to enjoying the colours and lines of paintings sensuously, we should try to read them. The use of any feature which catches the eye may be a casual trick of style, but we are not entitled to assume that it is meaningless until we have tried to find sense in it. To read pictures in this way a glancing familiarity with comic-books may be useful, since these are under the same necessity of telling their tale in the most telling way. More generally, any illustrated book shares the condition that, within the limits of the page size, the space allowed for an illustration is arbitrary and can be exceeded, in a way that a canvas usually cannot. When the picture is extended over its notional limits the most general comment to be made is that it is asserting itself and vying with the text for our attention, and the most basic message of the painter is that the scene portrayed is more extensive than he is able to show, given the limitations imposed on him. Thus the extension seems always to carry some implication of space, but this is scarcely surprising since its raw mate-

rial is the extra centimetre or two that it takes from the margin. Its most frequent use is to enhance the description of landscape or architecture. But space is rarely the sole concern, since the background elements in an illustration are selected to serve the narrative: a garden which suggests love; a looming mountain which images a threat; a high palace which reflects the status of its inhabitants. Furthermore, in addition to its scenic role, the extension may be used to draw attention to particular items of information: for the intimately connected themes of time and dramatic action; for effects of pathos or comedy; to characterize various personages. Nor does any one usage necessarily exclude another.

The scenic use is intimately connected with Chinese influence in the fourteenth century, but to understand the device as a whole we need to seek further back. With the Paris *Kitab al-Diryaq* of 595/1199,[3] we break in upon a period when the practice of enclosing both the illumination and text of a manuscript in ruled lines is gaining ground, but is not yet universal. It seems that the painter here meets this problem with two solutions. On the one hand, the figures casually infringe the neat red rulings with their elbows and haloes, as though they had no intention of bowing to newly-imposed restrictions. On the other hand, in *Andrumakhus watches agricultural activities* a mule is bisected vertically by the ruling, its forequarters only portrayed. This is a clear admission that the picture has to stop somewhere, with the *quid pro quo* that the viewer is required to imagine – or to admit the notional existence of – the half of the mule which is not shown. Among the early illustrated manuscripts of the Arab school where rulings are not used, it might seem that extensions would be excluded by logic, but this is not the case. Many of the pictures are contained in implied limits, perhaps

in the form of grassy rims or architectural frames. One of the most celebrated and sophisticated pictures, *The Village*, which illustrates the forty-third *Maqama* in the al-Hariri of 634/1237 in the Bibliothèque Nationale, employs both landscape and architectural boundaries and makes very clear extensions beyond them.[4] On the left, a palm-tree asserts its independence from the line dictated by the minaret, its angle striking but botanically credible, while on the right, a man dangles his spindle over a void. These strong shapes may owe something to the shadow-theatre which Ettinghausen has invoked as an influence on Arab painting.[5]

Other illustrations in the Paris *Maqamat* favour banners, dark and narrow, projecting into the text area, and similarly in the Saljuq *Varqa u Gulshah*, of c. 1225, many of the items which break the rulings – spears and swords, but also the occasional horsetail – are slim and dark.[6] It may be suggested that these projecting elements hold the clue to the freedom with which Islamic painters use extensions, for they can be compared to the letters in Arabic script. It is accepted generally that calligraphic forms condition the flowing lines of Islamic drawing, and why should not the grouping of letters, with occasional ascenders rising above the line or descenders flicking below it, have conditioned the feeling for what is permissible in composition? It is, furthermore, not unknown for a letter to break out of the rectangle allotted to a text.[7] Nor is this all that unillustrated manuscripts can tell us: if we take a step beyond the script and consider the organization of Qur'anic pages, we see that the margins are full of meaning. Already by the ninth century *'unvans* have *ansae* (sometimes in the form of trees), which both call attention to the commencement of a *sura* and honour it with decoration. By the period of Ibn al-Bawwab, 391/1000-1, the margins of Qur'ans are busy with a variety of signifiers.[8] This tradition must encourage the painter to locate in the margin a visual gloss on the picture.

Together with the weaponry, *Varqa u Gulshah* contains a number of minor extensions, such as haloes, tent-finials, hooves, and streams of blood. Most appear to be almost accidental, perhaps the consequence of the recent introduction of framing lines in manuscripts. If the work owed much to a wall-painting tradition it is probable that this would have imposed a firm discipline on the framing, though the possibility of extensions of a "baroque" character could not be ruled out entirely; nor is it likely that the stucco tradition, which evidently did play a part in some of the pictures, licensed the extensions since stucco usually avoids projections as technically hazardous. Clearly of the arts of the book is an extension, of a different character, noted by Cowen:[9] it is the tree which rises centrally between the two text columns in the scene of the lovers' farewell. The limbs of the tree are entwined like those of the lovers, and they form tiers of branches which, with the escaping bird, suggest their sighs, perhaps even to the extent of mimicking the rhythm of the line: *bi-zari su-yi asman kard sar* ("groaning he raised to heaven his head"). There is no manner of doubt that

the scene is to be read symbolically, since it is so effective and since, as Daneshvari has shown, the painter al-Khuyi was experimenting with visual metaphors.[10] As this extension is internal to the text space and its position is governed by the text columns, it must originate in manuscript illustration, indeed, in the illustration of manuscripts in verse. It is probable that we shall never know whether this is the first example of its type, but in conception it seems advanced beyond anything else of its time; it is interesting that it is not until the sixteenth century that it becomes widely fashionable to extend landscape between the text columns.

In the Il-Khanid period, the extension is more often exploited for its dramatic than for its affective potential. The small *Shahnamas*, which otherwise employ a relatively naturalistic Chinese style, include vastly elongated banners which rise from low in the page to the upper margin. The general purpose must be to signal conflict, but more particularly there is sometimes an appeal to the partisan view, showing that "our side" in whatever engagement is at grips with "the enemy". This is demonstrated in the Chester Beatty picture *Manuchihr kills Tur*, where it is evident that the banner of Turan succumbs to that of Iran (pl. 1).[11] Banners continue to appear in later manuscripts. In a folio from the "Big Head" *Shahnama* of 899/1493–4 in the Sackler Gallery, Washington, D.C.,

1. Manuchihr kills Tur, *Shahnama*, c. 1300.

there is a rather similar scene in which, in addition, the defeated foe has literally dropped out of the picture.[12] The sprightly but martial élan of the small *Shahnama*s also owes much to the projecting hoof, used to greater purpose than in *Varqa u Gulshah*. This feature too reappears in later works, a deceptively simple example being the *Polo players* in a *Mihr u Mushtari* of 881/1476–7 in the Walters Art Galley, Baltimore.[13] Here the more extended legs of the horse coming at an angle from the right show that, though it started further off, it is galloping faster, and hence its rider gets the ball. The *Jami' al-Tawarikh* manuscript of 1314 prefers the menace of projecting spears to the banners of the small *Shahnama*s; the hooves of horses barely clip the rulings, but a sword upraised over the head of Firuz Shah recalls the calligraphic tradition.[14] These features apart, there would seem to be a deliberate avoidance of extensions, since numerous figures bow their heads to avoid transgressing the limits. A different solution to the problem of what to put in the picture, however, is used for *The Buddha's tree* in which, under Chinese influence, the painter shows the lower part of the trunks only – as though the bisected mule of the *Kitab al-Diryaq* had lost his head rather than his tail.[15] This visual synecdoche well-nigh compels us to believe that the trees continue beyond the rulings.

Of the utmost importance for the evolution of the extension is the great mid-fourteenth-century *Kalila wa Dimna* of the Istanbul University Library, now in a fragmentary state but, as Cowen and Grube have shown, capable of reconstruction with the help of the Rampur copy.[16] The *Kalila wa Dimna* manuscript appears to be the origin of a rich legacy of devices used in particular by painters in fifteenth-century Herat, whether for that text or another. In it, apparently for the first time, rocks and trees overflow in turmoil from the picture space, architecture gains ancillary elements, and figures are placed largely or entirely outside the picture. In Cowen's discussion of the use of these margins four modes can be distinguished: as a secondary, or second, field of action; as an image of critical transitions; as a wider area of space; and as the locus of metaphor.[17] The categories are not necessarily discrete, and the subject would bear extensive analysis.

The modes will here be considered in ascending order of complexity. The last, the metaphor indicating the situation of the character in the drama, is not much developed in the *Kalila wa Dimna*. Cowen quotes entwined flowers as indicating lovers, but there are also examples of flower-vases which seem to mean little more than a human rather than an entirely animal context. However, Cowen also notes the use of a bowed tree to show "the reversal of the natural order". It is in this area that the device was to become most usefully expressive, acting as the signifier of a conception akin to the pathetic fallacy: the mode is well exemplified in the British Library's Nizami of 900/1494–5 where the painter – probably Bihzad – suggests the emotional climate of the *Death of Farhad* with a frail, bent and dead tree.[18]

Cowen's third category concerns exits into the greater space of the margin, an effect which might best be expressed by the archaic sense of enlargement. The *Kalila wa Dimna* illustrates in *The hunter pursues the tortoise* a gradual passage into the margin, which evokes space, time and individual destiny.[19] The crow is safely into the margin and shown without background; the mouse and gazelle, at the junction of picture and extension, are about to escape; the tortoise, still within the picture, is on the point of capture. The tripartite scheme is taken up in a rather academic manner in the portrayal of a man falling from a camel in the British Library's Nizami with pictures of 1490, in which the shield touches the rulings, the sleeve is almost through, and the turban-end is into the margin.[20]

Examples of figures coming inwards over the rulings are noted by Cowen as her second category. With regard to the arrival of the ox, Shanzaba, before the Lion, she aptly introduced the notion of crossing a threshold.[21] However, most later instances differ from this *Kalila wa Dimna* scene in emphasizing physical action, whereas here the entry into psychological subjection is more important. In the *Kalila wa Dimna*, figures on the point of leaving a picture are provided with a small peninsula of rock to help them on their way. By the fifteenth century the rocky excrescence is often associated with fast movement and may be read in much the same way as the combination of scuffled dust and after-image that often represents this in strip cartoons. Muhammad Juki's *Shahnama* of the 1440s uses this for comic effect in *The infant Rustam slays the elephant div* (pl. 2). So energetic is the young hero that a rocky exten-

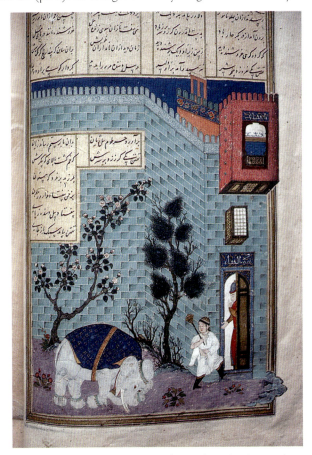

2. The infant Rustam slays the elephant *div*,
Shahnama, c. 1440–44.
London, Royal Asiatic Society, Ms. 239, 32b. Courtesy of the Royal Asiatic Society.

sion – of suitably small scale – precedes him out of the picture. The *Shahnama* also uses rock to mark entrances from the margin, such as the exceptionally dramatic onslaught of Gushtasp on the dragon.[22] In this the hero is shown just as he crosses the rulings, and where two qualities of rock meet: he is literally at a moment of crisis. It is surely to the tradition of the *Kalila wa Dimna* that the *Shahnama* painter owes his awareness of the dramatic potential of such a moment of transition.

Cowen's first grouping, the provision of a second area of space, embraces a range of effects. The addition may be truly secondary, as when the eponymous jackals watch the battle of the Lion and Shanzaba, as from a box in the dress circle.[23] Spectators in later manuscripts are more often beyond a horizon than in a margin. In a few *Kalila wa Dimna* pages picture and margin have an equal importance, as in the vertiginous *Attack of the owls on the crows*, where we seem to participate in a crow's view.[24] Another example shows, in the central picture, a *qadi* who contemplates, in the margin, a man trapped in a burning tree:[25] in a poignant "threshold" effect the doomed man's hands reach into the picture which he is desperately trying to re-enter. The imitation of such complex examples seems to have been confined to the succeeding *Kalila wa Dimna* tradition; it is of course found in the Rampur manuscript. In another subdivision of this mode the central picture becomes subsidiary or disappears altogether. The centre has virtually vanished in the illustration which shows a man who has entered a hazardous well to escape a mad camel; here the long vertical of the fore-edge margin is exploited to represent the well.[26] Outside the *Kalila wa Dimna* tradition, the absent centre is rarely used for narrative illustration, though a remarkable series will be discussed latter; it may perhaps also be said to occur where certain marginal ornaments verge on a narrative character. On the other hand, the portrayal of wells or pits was already a matter of interest to painters, as Hillenbrand has shown, with reference to a *Shahnama* of the Inju school.[27] A comparable use of the fore-edge channel, which evokes height and depth combined with movement, is preserved in the Rampur illustration of the loquacious tortoise who plummets to his death, while the centre contains mere watchers.[28] Such pictures taught the general lesson that the margin could carry the main message, and the particular lesson that the fore-edge was good for a sharp descent. The lesson is taken up in a *Shahnama* of 845/1441 in the Soudavar collection in which an angel dives upon a *div*.[29] Curiously, most copies of *Kalila wa Dimna* prefer to show the tortoise airborne with the fall down the fore-edge still in a potential state, but similarly, in the Juki *Shahnama* we see the moment before Rustam is cast into the Caspian by the *div* Akvan, though rock in the fore-edge margin delineates the space through which he will fall and the splash he will make.[30]

Chinese influence is of overwhelming importance in the *Kalila wa Dimna*, and the use, in some extensions, of clouds to veil the transition to the void of the margin points to the heritage of scroll paint-

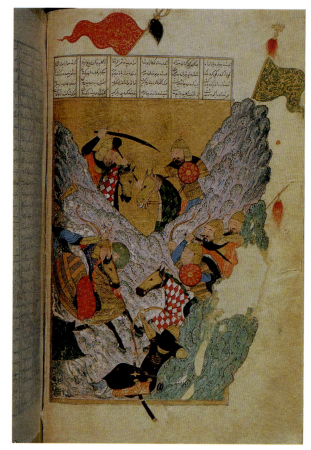

3. Chingiz Khan fighting the Chinese, *Epics*, 800/1397.

ing, in which scenes emerge from a misty continuum. However, the use of strong shapes in the margin, such as the phalanx of crows which attacks the owls, black almost to the point of silhouette,[31] recalls rather the Islamic tradition of Qur'anic signifiers or the banners of the small *Shahnama*s. Perhaps also related is the concentrated emphasis, in some extensions, on small details, hands or mouths, as expressive features. The pale hands of the man trapped in the tree are a case in point. Similarly, the horror of the tortoise's fall lies not so much in the action imaged by the flame-like swirl, but in the gaping mouth and splayed digits which show that the creature is conscious of falling. Other examples are the mouth of the anguished lioness who has lost her cubs, picked out by colour and form, and, at a less emotive level, the slack jaw of the ass.[32] This technique is taken up in the Nizami of 1494–5 where, as Hillenbrand has noted, in *Mourning for Laila's husband* a potent and almost auditory effect is suggested by the wailing figure who breaks the upper line.[33]

The challenge presented by the Chinese scroll format is still evident in the classical manuscripts of the late fourteenth century. The problem of how to divide what the Chinese did not feel called upon to divide is seen in the *Mathnavis* of Khvaju Kirmani of 798/1396.[34] *The combat of Humay and Humayun* takes place as it

were in a cloud of rock hanging in space – or non-space, as though every side were an extension, with an external ruling which is almost incidental. *Humay at Humayun's gate* is similarly free on three sides, though an attempt – possibly later? – has been made to stabilize the bottom line with a dark filling between rock and ruling. The British Library's *Epics* of 800/1397 and its companion *Shahnama* in the Chester Beatty Library have a more cautious approach to rock extensions, which are used once in each volume to convey movement.[35] In the London picture of *Chingiz Khan fighting the Chinese* (pl. 3) the tall formation of knobby rock on the right suggests the advance of a host more numerous than the painter can conveniently portray. Other extensions are also used: as in *Manuchihr kills Tur*, the banners tell their story. More often than not a hero, or "our side", comes – like writing – from the right, but here the banner on the left, higher and red, will be victorious, while the dipping green banner on the right will be defeated. The requirement to read the banners symbolically is evident from the fact that they are logically extraneous to the action, the green raised behind the hill, and the red unsupported. There is also a skilful "calligraphic" extension into the lower margin where the scabbard of the foreground archer grapples into the space beyond the picture, drawing him towards us and creating space for the diagonal rush of the attacking rider.

The *Epics*, generally assumed to have been produced in Shiraz, have often been attributed to the patronage of Timur's grandson Iskandar, but were more probably for the latter's eldest brother Pir Muhammad, since Iskandar was removed from Shiraz to Samarqand on the death of his father in 1394.[36] The earliest commission for Iskandar may well have been the British Library's pocket-sized copy of the *Sharafnama* section of Nizami's *Iskandarnama*, which Robinson published in 1957 with the suggestion that it was made for the eponymous prince.[37] It seems very probable that this is correct; Robinson's dating of the manuscript to 807/1404–05 would place it in the year in which Iskandar was established as governor

of Yazd. A feature noted by Robinson is the resemblance of the full-page picture *Iskandar visits the hermit* in the *Sharafnama* to that subject in the *Miscellany* produced for Iskandar in 814/1411.[38] The latter picture evokes the splendour of kingship, and it may be suggested that it is intended as a portrait of the patron-prince; it would thus be probable that the Iskandar of the *Sharafnama* was intended as his portrait also. The face of Nizami's hero, where it appears in the *Sharafnama* in the finer hand of the margin painter (pl. 4), has an appreciable resemblance to the long and moustached face of the Iskandar of the *Miscellany*. It may be, then, that these tiny fragments contain the earliest surviving Timurid portraits.

The little manuscript would have been relatively economical in paper and pigments, but it is rich in invention. The majority of its illustrations are confined to margins hardly more than a centimetre wide; unlike many marginal paintings they are narrative in character, and they constantly refer to the central space, as though they were extensions of pictures partly screened by the text. The margin painter is an exquisite draughtsman, his most elegant scene being the *Conversation of Iskandar and Nushaba* (pl. 5) which makes a virtue of its diagonal alignment. He is also witty. By drawing a

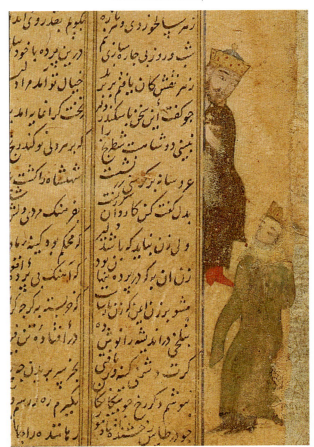

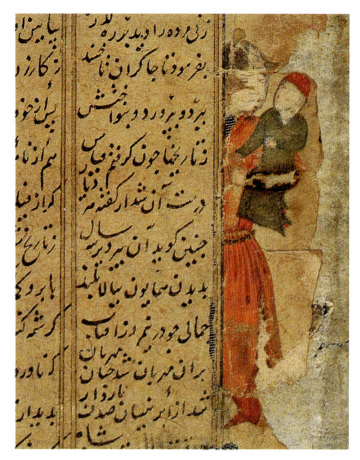

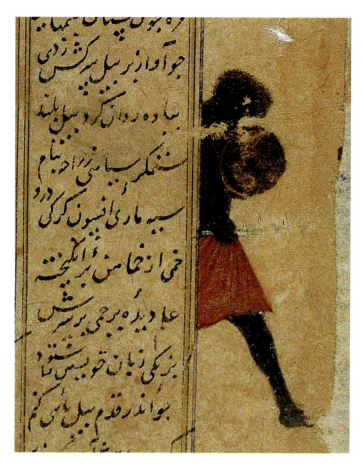

6. Failaqus carrying the infant Iskandar, *Sharafnama*, c. 1405.
London, British Library, Or. 13529, 12. Courtesy of the Trustees of the British Library.

7. Zangi champion, *Sharafnama*, c. 1405.
London, British Library, Or. 13529, 17. Courtesy of the Trustees of the British Library.

minute child in *Failaqus carrying the infant Iskandar* (pl. 6), he signals that he could work to a yet smaller scale; while the semi-silhouette of the half-revealed *Zangi champion* seems to cry "peekaboo" at the viewer (pl. 7). The painter displays great ingenuity in manipulating the available space. He presents *The combat of Gupal and Zarivand* on steeply raked ground and with one figure hunched, as though to emphasize the difficulty of fitting them in,[39] or the *Gifts for Nushaba* in close-up (the detail of a fine blue-and-white jar plainly visible), as though this were the only solution to the problem posed by their quantity (pl. 8). But he is in fact able to conjure space from nowhere in *Iskandar entertained by the Khaqan*, which shows the hero, an accumulation of gear, and a kneeling repoussoir figure who manages to add another mite of dimension by tipping his head back so that his face is visible (pl. 9). Another *jeu d'esprit* is to negate the relation to the central page space by directing our attention outwards to the edge of the page. Thus, the *Pursuit of a Rumi by a Rus* takes place almost detached from the text area, and cut by the lower edge of the folio. Similarly, those who acclaim Iskandar stand, clipped by the rulings and much like tortoise-watchers from a *Kalila wa Dimna*, but looking towards a king who must be imagined beyond the fore-edge.[40]

The margin painter is also well-versed in the achievements of his predecessors. There is parody of traditional battle-pictures, with the action represented solely by the tokens which usually penetrate the margin: spear, banner, horse's head, limb and fallen rider (pl. 10); and perhaps rock-painting is also teased where Iskandar gazes at a rocky extension with studied interest.[41] We have the part for the whole, where one of two musicians is represented solely by his hand which plays a mere two-thirds of a tambourine; conversely, as Iskandar enters the portal of Sarir, he is seen from the back, complete but for the not-unimportant detail of his head.[42] Three scenes are particularly interesting as they seem to be intended to provide the viewer with the pleasure of recognition of an existing composition. In one we see the upper body of Iskandar, as he reclines on his elbow on a bed between two candles, a format more familiar to us as *Rustam visited by Tahmina* in the Juki *Shahnama*.[43] The other, slightly more complex, is the group of *Iskandar and the dying Dara*, dignified with half a royal umbrella (pl. 11); the painter has divided the unit very punctiliously so as to include a small unattached loop of green which must be the gown over Dara's bent left knee. The third picture is *Iskandar enters the tomb of Kai Khusrau* (pl. 12). Framed in a doorway, wearing red and biting the finger of

8. Gifts for
Nushaba, *Sharafnama*,
c. 1405.

London British Library, Or.
13529, 53. Courtesy of the
Trustees of the British
Library.

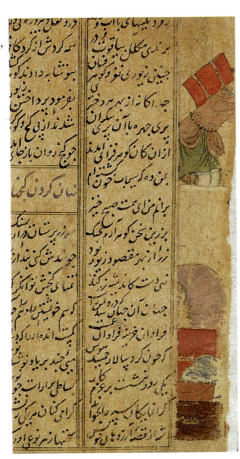

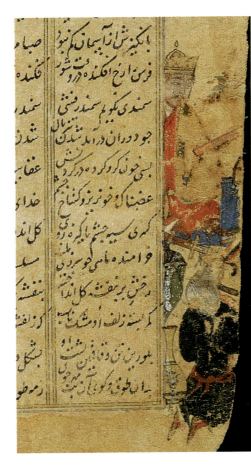

9. Iskandar
entertained by the
Khaqan,
Sharafnama, c.
1405.

London, British Library,
Or. 13529, 74. Courtesy
of the Trustees of the
British Library.

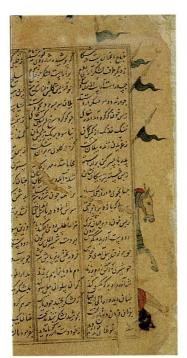

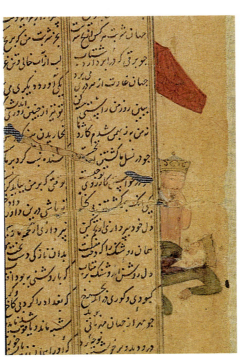

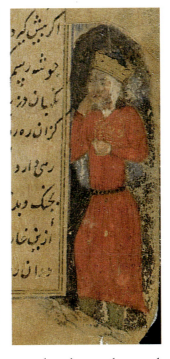

10. Battle of Dara and
Iskandar at Mosul,
Sharafnama, c. 1405.

London, British Library, Or.
13529, 32. Courtesy of the
Trustees of the British Library.

11. Iskandar comforts the dying
Dara, *Sharafnama*, c. 1405.

London, British Library, Or. 13529, 35, c. 1405.
Courtesy of the Trustees of the British Library.

12. Iskandar at the tomb
of Kai Khusrau,
Sharafnama, c. 1405.

London, British Library, Or. 13529,
59. Courtesy of the Trustees of the
British Library.

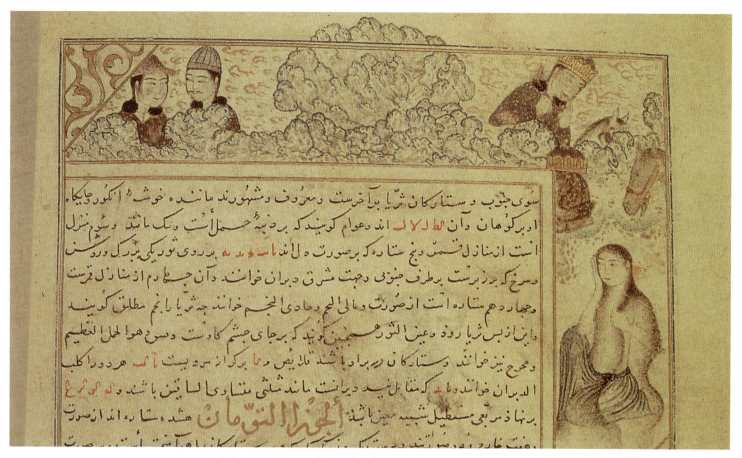

13. Khusrau sees Shirin bathing, *Miscellany*, 814/1411.
London, British Library, Add. 27261, 538b. Courtesy of the Trustees of the British Library.

surprise, Iskandar is remarkably similar to the Bahman who comes upon heroes in their coffins in the *Epics* of 1397.[44] If the viewer knows the *Epics* he can visualize Kai Khusrau's tomb. This connection to the *Epics* tends to support Iskandar as patron of the *Sharafnama*, though, as proposed above, it is more probable that his elder brother, rather than he himself, was patron of those volumes.

A manuscript whose margins seem to show a late tribute to the *Sharafnama* is a *Kulliyyat-i Ahli Shirazi* of 991/1583 in the Salar Jang Museum, Hyderabad; this is perhaps a consequence of the sojourn of the *Sharafnama* in India, where it surfaced in 1919.[45] Evidently a more immediate successor is Iskandar's *Miscellany* of 1411, amongst whose predominantly decorative marginal drawings is the narrative scene *Khusrau sees Shirin bathing*, published by Robinson in 1965.[46] The main elements of this composition seem to derive from the type used in the British Library's *Khamsa* of 790/1388 (Or. 13297);[47] however, the upper line of the text area contributes to the rocky barrier between the future lovers, while an outer set of rulings creates a margin to the margin into which the rock extends (pl. 13). The early-fifteenth-century *Divan* of Sultan Ahmad also has marginal drawings, and Klimburg-Salter has argued that they represent narrative, but their diverse and decorative character

suggests that this is less than certain; in particular, the extensions into an outer margin are so general as to appear purposeless.[48] The *Divan* may have been available to the draughtsmen of the *Miscellany* and have influenced them towards decoration and away from full colour, but this is unsure. Later in the century, delicate marginal figures, without background, but used as adjuncts to a central picture, are occasionally found in Herat, but seem to be more favoured in the western lands. Where West and East meet, in the *Kalila wa Dimna* of the 1460s, which Robinson has suggested was made for Pir Budaq,[49] the nobility of the standing Bilal contributes to the dignity of the seated Prophet and his companions. Other attendants in Turkman manuscripts, both in the Chester Beatty Library, are a groom, who crouches attentively with a horse while a prince picnics, in a *Divan* of Hidayat for Sultan Khalil,[50] and, in a Nizami of 886/1481–2 in "brownish" style, the guards whose lack of attention adds a comic aside throughout the *Haft Paikar* pavilion scenes (pl. 14).[51] In the sixteenth century, *divs* which extend from central fields into the margins may still be distant reflections of the *Sharafnama*'s Zangis.[52]

Some middle-ranking manuscripts of western Iran use engaging extensions which go beyond what is strictly required to illus-

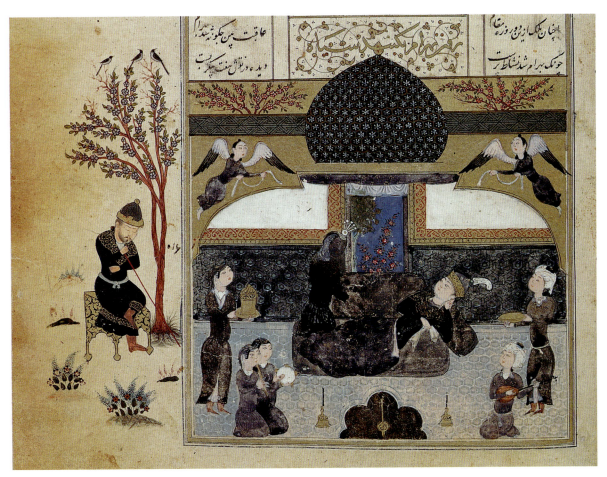

14. Bahram Gur in the Black pavilion, *Khamsa* of Nizami, 886/1481–2.
Dublin, Chester Beatty Library, Ms. 162, 200a. Reproduced by kind permission of the Trustees of the Chester Beatty Library, Dublin.

trate their narrative. A Nizami of 849/1445 in the John Rylands Library, published by Robinson, has in *Shirin visits Farhad* the scene-stealing detail of a shepherd who is trying to save one of his flock from a crag (pl. 15).[53] It is possible that the painter intends a comment on Farhad's dangerous situation, but in the process he amuses himself, and hence us. Similarly, it could be said that the painters' fascination with mechanisms almost runs away with them in the depiction of a loaded siege-engine in a *Shahnama* of 924/1518, in the Sackler Museum, Washington, D.C.,[54] and the ox-powered draw-well of a *hammam* in a Nizami of 936/1529 in the Chester Beatty Library.[55]

A use of the extension which emerges in the course of the fifteenth century is as a means of conveying the miraculous.[56] Portents had appeared before. Already in the Inju *Shahnama* of 1330 the *simurgh* in combat with Isfandiyar has plumes projecting slightly through the rulings, as though it were a force too great to be contained.[57] Fifteenth-century manuscripts make a larger use of the margin to convey the beauty and power of the *simurgh*, an example being the same combat in the ex-Dufferin and Ava copy of 841/1437, published by Robinson, where the tail feathers are echoed by an extension of rock.[58] In a late sixteenth-century *Shahnama* of the Chester

Beatty Library, published by Robinson, the other-wordly nature of the *simurgh* is indicated by its nest above the upper rulings; and in the same manuscript, as late as 1087/1676 Muhammad Zaman, for all his interest in realistic treatment, uses the traditional symbolic and diagrammatic mode when he shows the *simurgh* entering from the margin to assist at the *Birth of Rustam*.[59]

The most sustained presentation of the meeting of the human and the angelic is in the *Mi'rajnama* copied in Herat 840/1436.[60] The illustrations, intended to excite awe, use extensions in two ways. Firstly, perhaps in part influenced by the *simurgh* tradition, the many-headed angels and the white cock are shown as too vast and powerful to be encompassed within the picture, or the flames of hell are shown as too terrible. Secondly, the Prophet, travelling through these scenes on the *buraq*, is sometimes shown leaving or entering the margins, an indication both of his movement and of his otherness. Where the two types are used in succession, now the Prophet and now the angels extended beyond the picture, a sense of disorientation is created which serves the subject admirably.[61] In other subject matter angels visit the earth. Illustrations to two works of 'Attar in the British Library show different levels of sophistication. In a *Divan* of 877/1472 an angel hovers above the enthroned

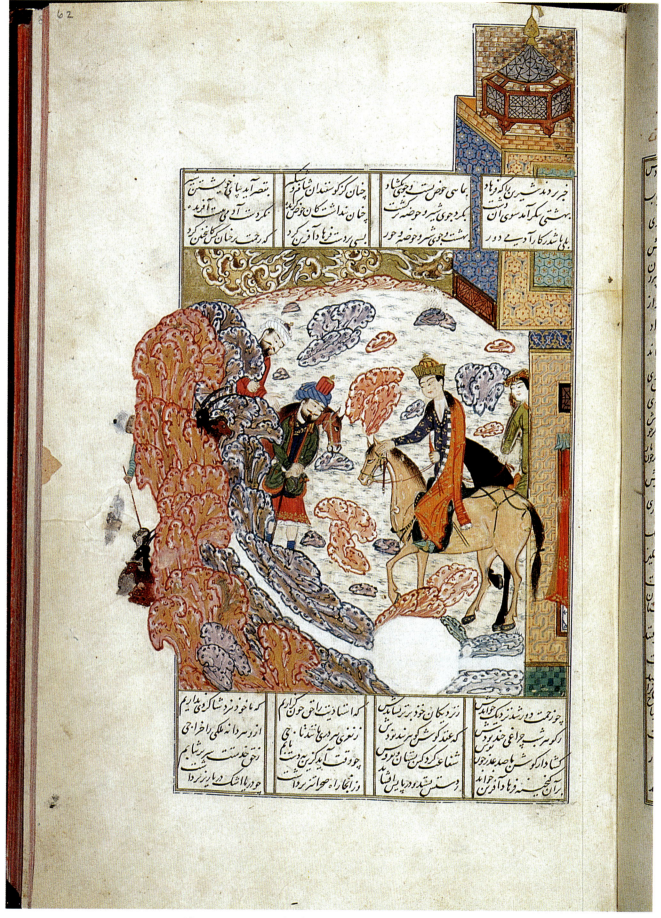

15. Shirin visits Farhad, *Khamsa* of Nizami, 849/1445.
Manchester, John Rylands University Library, Persian Ms. 36, 62a. Reproduced by courtesy of the Director and University Librarian, the John Rylands University Library of Manchester.

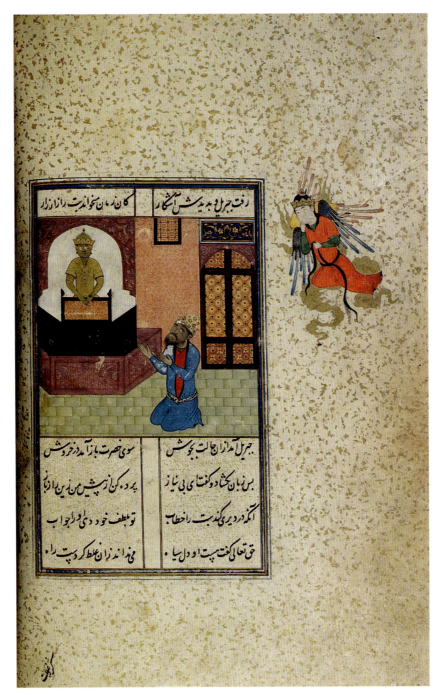

16. Jibra'il visits the worshipping Christian, *Mantiq al-Tair*,
c. 1490–1500.

Sulaiman and Bilqis on an extended patch of gold sky, rather as
though a piece of the picture below it had broken off.[62] By contrast,
in a *Mantiq al-Tair*, datable to the 1490s, Jibra'il, descending to inves-
tigate a Christian's prayer, is entirely detached from the central pic-
ture, so that the impression of his coming from another world is
greatly enhanced (pl. 16). Another miraculous event, involving
no angelic presence, is portrayed with great economy in the appar-
ently unique *Amir Ahmad u Mahsati* of 867/1462–3 in the British
Library.[63] The father throws his prayer carpet on water and floats,
but the son throws his father's turban into the air and flies (pl. 17).

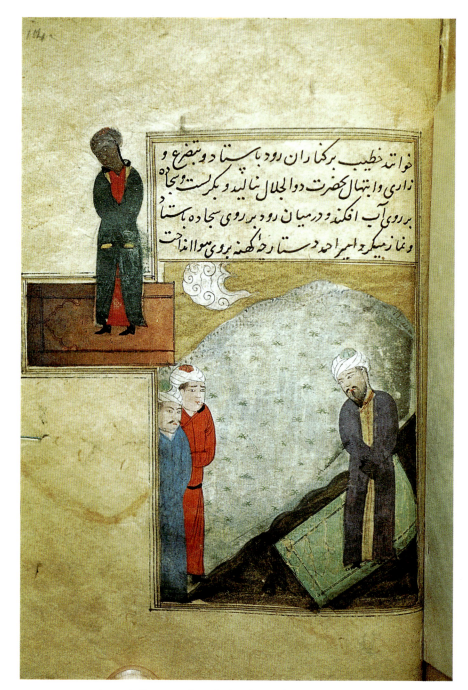

17. Amir Ahmad flies on his father's turban, *Amir Ahmad u Mahsati*, 867/1462–3.

The son's position confirms that his is the greater miracle – the painter, having exchanged the textiles, shows perhaps the only Islamic flying carpet?

From the late sixteenth century, there is a tendency to a dissolution of the rulings, and in consequence extensions become less meaningful. However, the Chester Beatty's *Suz u Gudaz*, which Robinson dates to the mid-seventeenth century,[64] is able to exploit this style with illustrations showing rulings consumed by fire,

the central motif of the romance. In the narrative an object of worship, fire represents the ecstatic love of the *sati*, which in turn symbolizes the soul's search for God (pl. 18). In subsequent Persian painting the pursuit of realism is inimical to the diagrammatic mode.

Ottoman painting, though often realistic in content, tends to stylization in treatment, and thus it makes some use of marginal figures and extensions. A particularly evocative example in a

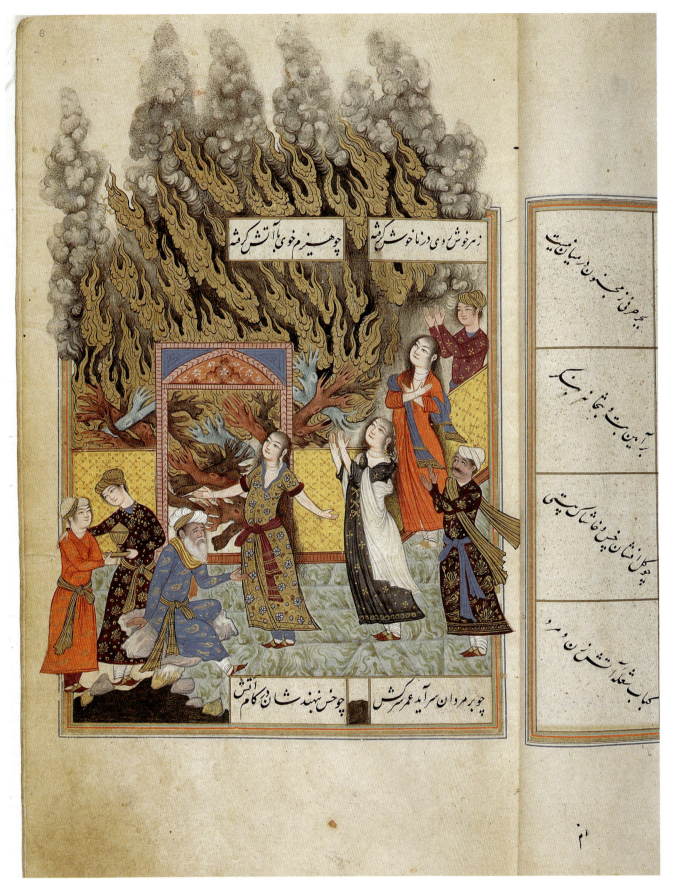

18. The worship of fire, *Suz u Gudaz*. Dublin, Chester Beatty Library, Ms. 268, 8a, c. 1640–50.

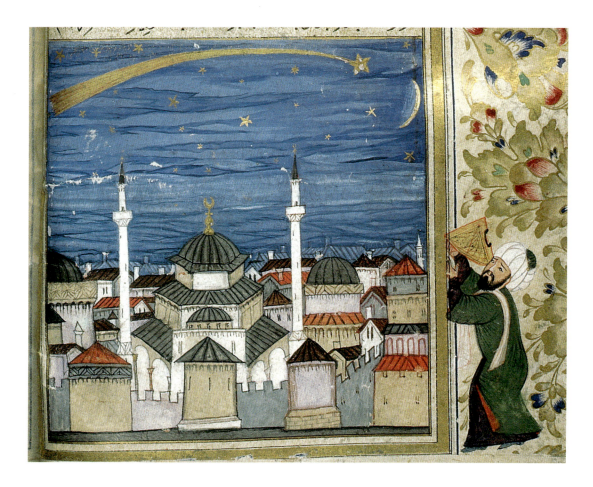

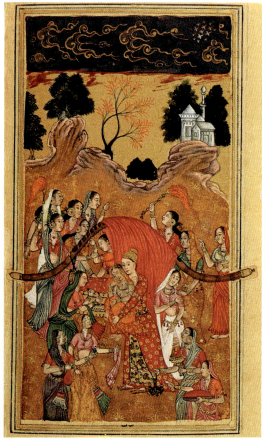

19. Astronomer, *Nustratnama* of
Mustafa 'Ali, 992/1584.
Istanbul, Topkapi Sarayi Kütüphanesi, H. 1365.
Courtesy of Topkapi Sarayi Kütüphanesi.

20. The marriage palanquin, *Pemnem*,
c. 1590–1600.
London, British Library, Add. 16880, 213b. Courtesy
of the Trustees of the British Library, London.

Nusratnama of 992/1584, in the Topkapı Sarayı Kütüphanesi, has, in the margin, an astronomer who observes, in the centre, a comet crossing the night-sky above city roofs (pl. 19).[65] A more conventional painter, with angels in mind, might have put the comet in the margin and been admired for it. The actual arrangement suggests that we put ourselves beside the astronomer, and reflect upon the relative importance of man and the cosmos. Another picture demonstrating a lively approach to established tradition is a *Battle of the crows and the owls*, in a *Kalila wa Dimna* of c. 1600, in which flames are made to seem dangerously out of control since they run through the usually sacrosanct area of the text.[66] A conceit exploiting the inner margins, which may be peculiar to the Ottomans, is to consider the unpainted gutter between two folios as the image of a watercourse; this is found in two manuscripts of the British Library, a *Nusratnama* 990/1582 for a mountain torrent, and an 'Ata'i of 1151/1738–9 for the Bosphorus.[67]

Though not entirely absent, extensions are not an important feature of Mughal painting. This may be because the majority of painters, being of Hindu origin, were relatively uninfluenced by the conventions of the Islamic page, and beyond this by Islamic conceptions of order and abstraction. Instead, rooted in a more realistic Hindu tradition, they would be confident that the mundane or miraculous, any action or shade of mood could be represented without resort to any particular graphic conventions. In spite of stronger Persian influence, the extension is not frequently found in the Deccan either, though a delightful example appears in the romance *Pemnem*, whose illustrations are probably of the 1590s (pl. 20).[68] The poles of the marriage palanquin of the hero and heroine yoke together the side rulings, symbolizing both matrimony and the mechanics of the vehicle.

Though marginal figures are an important feature of Mughal album pages, and though they are sometimes thematically linked to a central picture, they are usually not related spatially to that centre, and so are not part of the present topic. However, occasionally decorative work may pretend to be so related, as when, in the Jahangir Album of the Staatsbibliothek zu Berlin, a crouching hunter leans his haunch against the central spread of calligraphy.[69] Instructive, if slightly disturbing, is another album page, of c. 1640, in the Chester Beatty Library.[70] In its margin Laila on camel-back advances from a landscape in perspective; her space will almost match that of the central picture, but not quite: she is in an alternative world.

Notes

1 Reference will be made to the following works by B.W. Robinson: "The earliest illustrated Nizami?", *Oriental Art*, N.S. III, Autumn, 1957, pp. 96–103; *A descriptive catalogue of the Persian Paintings in the Bodleian Library*, Oxford, 1958; M. Minovi, B.W. Robinson, J.V.S. Wilkinson, *The Chester Beatty Library: a catalogue of the Persian Manuscripts and Miniatures*, II, Dublin, 1960; A.J. Arberry, B.W. Robinson, E. Blochet, J.V.S. Wilkinson, *The Chester Beatty Library: a catalogue of the Persian Manuscripts and Miniatures*, III, Dublin, 1962; *Persian Drawings from the 14th through the 19th century*, Boston and Toronto, 1965; "The Turkman School to 1503", in *Arts of the Book in Central Asia*, ed. B. Gray, Paris and London, 1979, pp. 215–47; *Persian Paintings in the John Rylands Library: a descriptive catalogue*, London, 1980; "Persian Epic Illustration: A 'Book of Kings' of 1436–37", *Apollo*, September 1982, pp. 170–3.

2 J.S. Cowen, *Kalila wa Dimna: an animal allegory of the Mongol court*, New York and Oxford, 1989, pp. 22–4; R. Hillenbrand, "The uses of space in Timurid painting", in *Timurid Art and Culture: Iran and Central Asia in the Fifteenth Century*, ed. L. Golombek and M. Subtelny, Leiden, 1992, pp. 84–92. The present essay derives from a paper given in Edinburgh in 1990.

3 R. Ettinghausen, *Arab painting*, Geneva, 1962, p. 84.

4 Ettinghausen, *Arab painting*, p. 116.

5 Ettinghausen, *Arab painting*, p. 81.

6 A.S. Melikian-Chirvani, *Le roman de Varqe et Golšāh, Arts Asiatiques*, XXII, 1970.

7 M. Lings and Y.H. Safadi, *The Qur'an*, London, 1976, p. 33.

8 D.S. Rice, *The unique Ibn al-Bawwab manuscript in the Chester Beatty Library*, Dublin, 1955.

9 Melikian-Chirvani, *AA*, 1970, p. 231, H. 841, 33b; M.S. Ipsiroglu, *Islamda Resim*, Istanbul, 1971, pl. 21; Cowen, *KwaD*, p. 23.

10 A. Daneshvari, *Animal symbolism in Warqa wa Gulshah*, Oxford, 1986.

11 A.J. Arberry, M. Minovi and E. Blochet, *The Chester Beatty Library: a catalogue of the Persian Manuscripts and Miniatures*, 1, Dublin, 1959, No. 104.

12 G.D. Lowry and M.C. Beach, *An Annotated and Illustrated Checklist of the Vever Collection*, Washington, D.C., 1988, No. 107.

13 E.J. Grube, *Muslim Miniature Paintings from the XIII to XIX Century*, Venice, 1962, No. 51.

14 B. Gray, *The World History of Rashid al-Din*, London, 1978, p. 22.

15 B. Gray, *Persian painting*, repr. Geneva, 1977, p. 24; Gray, *Rashid al-Din*, pl. 26.

16 Cowen, *KwaD*, p. vii; E.J. Grube, "The Istanbul University Library *Kalilah wa Dimnah* and other 14th-Century Persian Manuscripts", in *A Mirror for Princes from India*, ed. E.J. Grube, Bombay, 1991, p. 59.

17 Cowen, *KwaD*, p. 22–4.

18 Cowen, *KwaD*, pls. 16, 30, 38a; T.W. Lentz and G.D. Lowry, *Timur and the Princely Vision*, Los Angeles and Washington, D.C., 1989, No. 140.

19 Cowen, *KwaD*, pl. XX.

20 *ABCA*, pl. LXV.

21 Cowen, *KwaD*, p. V.

22 J.V.S. Wilkinson and L. Binyon, *The Shah-namah of Firdausi*, London, 1931, pl. XIV; see also B. Brend, "Rocks in Persian Miniature Painting", *Landscape in Asia* (Colloquies on Art & Archaeology in Asia No. 9), London, 1980, p. 117, pl. 2b.

23 Cowen, *KwaD*, pl. VII.

24 Cowen, *KwaD*, pl. X.

25 Cowen, *KwaD*, fig. 24.

26 Cowen, *KwaD*, figs. 6a and 6b.

27 Hillenbrand, *TAC*, p. 87 (the *Shahnama* of 741/1340–41 is presumably older than the fragmentary *Kalila wa Dimna*, but, were it not, it represents an older tradition).

28 E.J. Grube, "The Early Illustrated *Kalilah wa Dimnah* Manuscripts", in *Mirror for Princes*, fig. 27.

29 A. Soudavar, *Arts of the Persian Courts*, New York, 1992, 27c.

30 *Mirror for Princes*, pls. 28, 29; Gray, *Persian painting*, p. 90.

31 Cowen, *KwaD*, pl. IX.

32 Cowen, *KwaD*, pls. XXII and XIX.

33 Gray, *Persian painting*, p. 122; Hillenbrand, *TAC*, pp. 87–90, fig. 16.

34 Gray, *Persian painting*, pp. 46–47.

35 *Chester Beatty: Persian*, I, No. 114, 38a.

36 Sharaf al-Din 'Ali Yazdi, *Sharaf ud-Din 'Ali Yazdi: Zafarnama*, ed. A. Urunbayev, Tashkent, 1972, p. 528, with mention of the youth of Iskandar.

37 Robinson, *OA*, 1957, especially p. 99.

38 I. Stchoukine, *Les peintures des manuscrits Timurides*, Paris, 1954, pl. XX.

39 Robinson, *OA*, 1957, fig. 19.

40 Or. 13529, 14.

41 Robinson, *OA*, 1957, fig. 6.

42 Robinson, *OA*, 1957, figs. 20, 13.

43 Robinson, *OA*, 1957, fig. 12; Lentz and Lowry, *Timur*, No. 45.

44 Norah M. Titley, *Persian Miniature Painting*, London, 1983, pl. 3.

45 Salar Jang Museum, Hyderabad, A.P., No. 725, appears to be of the Deccan and is not published to my knowledge. Robinson *OA*, 1957, p. 96, notes that the *Sharafnama* was purchased in Bombay in 1919.

46 Robinson, *Persian Drawings*, pl. 9.

47 Norah Titley, "A fourteenth-century Khamseh of Nizami", *British Museum Quarterly*, XXXVI, 1971–72, p. 9. Picture not published to my knowledge.

48 D.E. Klimburg-Salter, "A Sufi theme in Persian Painting: the *Divan* of Sultan Ahmad Galair in the Freer Gallery of Art, Washington", *Kunst des Orients*, XI/1–2, 1976–77, pp. 43–44; E. Atil, *The Brush of the Masters*, Washington, D.C., pp. 14–17, Nos. 1–7.

49 Robinson, *ABCA*, p. 217, pl. 128.

50 V. Minorsky, *The Chester Beatty Library: A catalogue of the Turkish Manuscripts and Miniatures*, Dublin, 1958, No. 401; Robinson, *Persian Drawings*, pl. 80.

51 *Chester Beatty: Persian*, II, No. 162.

52 *Chester Beatty: Persian*, III, pl. 24, No. 256; A. Welch, *Artists for the Shah*, New Haven and London, 1976, fig. 12.

53 Robinson, *Rylands*, No. 411.

54 Lowry and Beach, *Vever*, p. 105, No. 112, 550a.

55 *Chester Beatty: Persian*, II, pl. 23, No. 195, 33a.

56 Cowen, *KwaD*, p. 23, suggests the margin may mean eternity in the Istanbul University *Kalila wa Dimna*.

57 Ipsiroglu, *Islamda Resim*, pl. 29.

58 Robinson, *Apollo*, 1982; Sotheby's catalogue, 11.10.82, Lot 214.

59 *Chester Beatty: Persian*, III, pls. 41 and 38, No. 277; Robinson, *Persian Drawings*, pl. 52.

60 M.-R. Séguy, *The miraculous journey of Mahomet: Miraj Nameh*, London, 1977.

61 Séguy, *Miraj Nameh*, pls. 28 and 29, 30b and 32(a?).

62 Titley, *PMP*, fig. 32, Or. 4151, 92b.

63 G. Meredith-Owens, "A rare illustrated Persian manuscript", *Forschungen zur Kunst Asiens, In Memoriam Kurt Erdmann*, Istanbul, 1970, pp. 172–81, with a reference to Robinson, *Bodleian*, p. 59.

64 *Chester Beatty: Persian*, III, pl. 27, No. 268; Titley, *PMP*, fig. 47, 31b.

65 I. Stchoukine, *La peinture turque d'après les manuscrits illustrés*, Paris, 1966, No. 44, H. 1365; S.H. Nasr, *Islamic Science: an illustrated*

study, London, 1976, pl. 83. For another Ottoman example see B. Brend, *Islamic Art*, London, 1991, fig. 132.

66 E. Sims, "16th-Century Persian and Turkish Manuscripts of Animal Fables in Persia, Transoxiana and Ottoman Turkey", in *Mirror for Princes*, p. 120, pl. 126.

67 N.M. Titley, *Miniatures from Turkish Manuscripts*, London, 1981, No. 9, Add. 22011,

103b–104a, not illustrated; Titley, *PMP*, fig. 55, Or. 13882, 68b–69a. With regard to continuity over the gutter see Hillenbrand, *TAC* p. 87; also, I am indebted to Marcus Fraser for the observation, 30.10.92, that in a *Maqamat*, Ms. 677, John Rylands Library, a blue garment is distributed over both folios of a double-page picture.

68 J.P. Losty, *The Art of the Book in India*, London, 1982, No. 52.

69 E. Kühnel and H. Goetz, *Indische Buchmalerei aus dem Jahangir-Album der Staatsbibliothek zu Berlin*, Berlin, 1924, pl. 24.

70 A. Okada, *Imperial Mughal Painters*, tr. D. Dusinberre, Paris, 1992, pl. 243, Ms. 7, No. 27.

5

The Ahmed Karahisari Qur'an

In the Topkapı Palace Library in Istanbul

FILIZ ÇAĞMAN

THE QUR'AN KNOWN AS THE "AHMED KARAHISARI Mushaf-i Şerifi" (the Ahmed Karahisari Qur'an) is possibly the most important manuscript produced by the Ottoman court artisans of the arts of the book. It bears the accession number 5 in the Hırka-ı Saadet section at the Topkapı Palace Library in Istanbul.[1] It is the largest Qur'an ever produced in the Ottoman world, and has a stamped and gilded black leather binding with a flap; it measures 62.5cm. x 43.5cm. It consists of 300 folios, each measuring 61.5cm. x 42.5cm. The written surface within the marginal rulings in each page measures 40.3cm. x 24.3cm. All the pages are margined (vassale) except one folio, 265, where both the written surface and the margins are from the same sheet of paper. The book contains an endowment notation (fol. 1v), an illuminated roundel on its opening folio containing appropriate Qur'anic verses (fol. 2r), a richly illuminated double frontispiece (serlevha), two pairs of illuminated double pages, 112 illuminated Sura headings, 2360 illuminated rectangular panels (koltuk), illuminated 'ashara and cüz signs and a richly illuminated double endpiece.

Its frontispiece contains the Fatiha Sura on folio 2v and the beginning of the Bakara Sura on folio 3r. These are written in muhakkak and reyhani (fig. 3). The first pair of illuminated double pages following the frontispiece on fols. 3v–4r have a line of large calligraphy on the top and bottom, and reyhani calligraphy in a roundel in the middle. The second pair of illuminated double pages on fols. 4v–5r have the same arrangement, but this time without a roundel. After this variety in the beginning, the rest of the pages starting from fol. 5v are all written in the classical calligraphical organization known as that of Yakut. This consists of one line of muhakkak, five lines of nesih, one line of sülüs, five more lines of nesih, and one more line of muhakkak on the bottom (figs. 4 and 5).

The rectangular space prepared for the text of the colophon on the last page of the Qur'an was left empty (fig. 7). The reason why it is known as the Ahmed Karahisari Qur'an, even though it is not signed, is connected to the endowment notation found on folio 1b (fig. 2). To summarize briefly, this notation states that this Qur'an is the Ahmed Karahisari Mushaf-i Şerifi, that it was preserved in the personal treasury of the Sultan and that Sultan Mustafa presented it to the Hırka-ı Saadet room in the year 1107/1696 as a religious endowment to be read daily in religious rites (tilavet).

According to Müstakimzade, Ahmed Karahisari, also called Şemsaddin, was from Karahisar.[2] It seems that he was born around 873/1468, and died in 963/1556 in his late eighties or early nineties.[3] He was buried in Sütlüce in the vicinity of the Ca'fer Agha Tekke, near the tomb of his own Shaykh, Cemal Halife. Müstakimzade states that Ahmed Karahisari studied nesih and sülüs with Yahya Sofi and later took lessons from Asadullah Kirmani (died 892/1486).[4] It can indeed be deduced from the colophons of extant manuscripts signed by Ahmed Karahisari that he obtained his diploma (icazet) from Asadullah Kirmani.[5] According to these dates, Ahmed Karahisari must have earned his diploma before he was eighteen years old, while it seems highly unlikely that he was ever Yahya Sofi's student, as Yahya died in 1477.

Ahmed Karahisari must have developed his art during the reigns of Bayezid II and Selim I. Although it is not known when he joined the corps of the calligraphers of the Palace Ehl-i Hiref organization (the institution of court artisans), he must have started working there from the beginning of Süleyman the Magnificent's reign. The earliest payroll register of the Ehl-i Hiref to mention the corps of the calligraphers is dated Masar 952/March–May 1545.[6]

Here, his is the sixth name on the list and is given as Ahmed Karahisari while his daily wage is recorded as 14 *akçes*. Karahisari had rightfully become famous because of his expertise in *celi-sülüs* and *celi-muhakkak* scripts known as *müsenna*. However, he was most successful in his aesthetic approach to the organization of each individual page. It can be clearly seen in his output that for Ahmed Karahisari the proportion of the calligraphy to the rest of the page was just as important as the proportions of the calligraphy within itself.

The most accomplished extant manuscripts dated and signed by Ahmed Karahisari date from the years 1545 to 1555, the last years of his life.[7] This suggests that he wrote the Topkapı Qur'an, Hırka-ı Saadet 5, during the reign of Süleyman the Magnificent and after the year 1545 when he reached his artistic maturity. It is highly surprising that Karahisari did not sign his name in this, possibly the most magnificent manuscript he had ever written, especially since he seems to have signed his other output. Moreover, he was clearly an extremely famous calligrapher, accepted as the most talented of his time, according to the Ottoman sources.[8] This suggests that he did not complete the manuscript, either because of his extreme old age or death.

This view is supported by an *in'am defteri* (a register for palace expenses), one of the two highly important documents related to the Ahmed Karahisari Qur'an. An entry dated 12 Ramazan 992/17 September 1584 in this register states that a second scribe was paid 500 gold pieces for finishing the Qur'an which was started by Ahmed Karahisari (*Karahisārī hattı ile mushaf-ı şerīf muhimmātiyçün be marifet-i hüdāvendigār beş yüz filūri ihrac olunub başkaca hattata olundu levazımı içün harc olunur 500*).[9] The fact that it was not completed by Karahisari is even more clearly understood from an entry dated twelve years later (27 Ramazan 1004/ May 1596), in the same expense register. This entry lists the sums given by the Sultan Mehmed III to the persons who were instrumental in the completion of the Ahmed Karahisari Qur'an and refers to the manuscript as "the Qur'an which was started (*ibtidā*) by the hand of the famous calligrapher known as Karahisari".[10]

When the manuscript is studied in the light of these entries, it also becomes evident that there is a difference in the quality of its script beginning from fol. 221r, towards the end of the thirty-seventh Sura, even though the rich illumination seen in every page disguises this fact to a certain degree. Thus, it is clear that a second calligrapher who wrote in the style of Ahmed Karahisari but who could not quite reach his expertise completed this hitherto unfinished Qur'an (fig. 4). This calligrapher must understandably have hesitated to sign his own name in the rectangular space clearly reserved for the colophon, which was not only left empty but was also completely gilded, possibly as a sign of respect for Karahisari.

What was the identity of this scribe who was given 500 gold pieces for completing the manuscript and who did not sign his name? It is highly probable that he was Hasan Çelebi whose signature usu-

ally reads either Hasan b. 'Abdullah or Hasan b. Ahmed Karahisari. He was both a freed slave and the adopted son of Ahmed Karahisari.[11] He also belonged to the corps of the calligraphers of the Palace *Ehl-i Hiref* organization and followed the style of Ahmed Karahisari. His name does not appear in the *Ehl-i Hiref* payroll register for *Masar* 952/March–May 1545. In the *Muharrem* 965–966/ October 1557–October 1558 yearly register, his name is given as *Hasan gulam-i Karahisari* (Hasan, slave of Karahisari) and his daily wage as 13 *akçes*.[12] Eleven years later, in *Masar* 974/ July–September 1566, he is recorded as Hasan b. Karahisari.[13] Although Evliya Çelebi says that Hasan Çelebi became blind in both his eyes as a result of an accident which happened when he was working on the monumental calligraphic inscriptions in the centre of the dome of the Edirne Selimiye Mosque, this information need not necessarily be completely correct. According to this story, one of Hasan Çelebi's eyes became blind when a piece of lime accidentally fell into it. Then, his second eye also got affected from lime when he mistakenly tried to wash his face with water which had lime in it.[14] Thus, one of his eyes might still have retained part of its sight. On the other hand, there are no extant manuscripts signed by Hasan Çelebi after the completion of the Selimiye Mosque (1574). But Müstakimzade states that he saw a verse written by Hasan Çelebi dated 1002/1593 when he was already an old man.[15] Although the exact date of his death is not known, he must have died, according to Müstakimzade, soon after this year.

The Topkapı Palace Library owns a prayer book dated 974/1566–67 transcribed by Hasan Çelebi, who signed himself as Hasan b. Karahisari.[16] This manuscript shows a marked similarity to the Ahmed Karahisari Qur'an in the organization of its pages. When Hasan Çelebi's hand in this prayer book is compared with the last section of the Ahmed Karahisari Qur'an written after 1584, it can be seen that the latter does not have the same quality. However, this might have been because Hasan Çelebi had become quite old and partially blind by the time that the Ahmed Karahisari Qur'an was completed. The main reason why it seems highly probable that Hasan Çelebi was given such an important commission as completing the Ahmed Karahisari Qur'an, in spite of his old age and bad eyesight, could have been because he was the most famous and most talented student of Ahmed Karahisari as well as being his adopted son.

The second highly important document in the Topkapı Palace archives relating to the Ahmed Karahisari Qur'an is entitled "Karahisari Mushaf-i Şerif-i masraf defteri" (the Karahisari Qur'an account book) and dates from the reign of Murad III (1574–1595) (see Appendix II). This account book reveals that the duration of material purchases for the completion of the manuscript was nine years, starting from 12 Ramazan 992/ 17 September 1584 and lasting till 25 Receb 1001/ 27 April 1593 since these are the first and last dates for material expenses for this task.[17] The first expense was for the purchasing of paper; on the 12th day of the month of

Ramazan thirty pieces of paper were bought for 930 *akçe*s and given to a scribe, who was most probably Hasan Çelebi. Paper purchases were continued in the following days and throughout the month. Additionally, *kitre* (gum tragacanth), saffron and henna were also bought. The last purchase of paper was on 29 July 1585.

Through these expenses it is possible to follow the progress made on the completion of the Qur'an. They indicate that the margining process of the folios which had already been transcribed by Ahmed Karahisari was most probably the first task taken in hand. For this process, the sheets of paper were pasted together, dyed, varnished and polished using the above-mentioned materials. Thus, the new paper used for the margins would match the paper of the folios which had been transcribed by Karahisari about three decades earlier. Although it is not possible to decide exactly when the entirety of the folios transcribed by Karahisari was margined, it is possible that part of this process took place during the reign of Süleyman the Magnificent. The expenses related to paper purchases from this account book show that the margining process most probably began at the same time as the transcribing of the Qur'an. Two entries dated 13 Muharrem 995/ 24 December 1586 and 28 Rebi'ül evvel 995/ 8 March 1587 recording the paper polishing expenses indicate that this process was also continuing alongside the transcribing of the manuscript. The transcription was most probably completed some time in the year 1587 (See Appendix II).

The extraordinarily rich illumination of this manuscript seems to have been designed as a single programme. Thus, it seems highly probable that all the illumination was done in this later period of 1584–1596 when the transcription of the Qur'an was being completed. The account book of 1584–1593 reveals when the illumination and the marginal rulings were begun. The initial expense is dated 24 Ramazan 992/ 29 September 1584 and is for the purchase of some gold leaf from green and yellow gilding (see Appendix II, items 4, 6). More entries specifying expenses for the illumination follow this with differing dates; *neft dudesi* (black soot) and lapis lazuli were purchased, the *nakkaşbaşı* was paid for preparing the colour *la'l* (ruby red), and forty reed pens were purchased, most probably for the painter-designers. The expenses from October 1584 to February 1585 indicate that some headway was made with the preparations for illuminating the Qur'an in this year. Additional illumination-related expenses, for the purchase of paints, paint materials and the preparation of gilding, were recorded until the beginning of 999/1591. Apart from green and yellow gold leaf, the colours listed in the book were lapis lazuli, black, vermilion (*sürh*), ruby red (*la'l*), red lead or minium (*sülügen*), yellow, green, white lead (*üstübeç*) and light green (*silū*) and *simār* (the colour for this could not be determined).[18] Half tones like pink and light blue were obtained from these colours.

Additional material for the illumination was purchased in July and August 1592 (see Appendix II, items 43, 44). The most interesting of these was the "good quality" lapis lazuli for the frontispiece (fig. 3). 3,600 *akçe*s were paid for this purpose at 200 *akçe*s for a *miskal*. This record indicates that the frontispiece was among the last sections of the Qur'an to be illuminated and that better-quality, more expensive material was used for its illumination. The very last expense recorded for material purchases for the Qur'an on 10 and 25 Receb 1001/ 12 and 27 April 1593 was again related to its illumination. Green and yellow liquid gold was purchased for the illumination of a section of the Qur'an. The liquid gold was most probably required for illuminating the borders of the double endpiece, where an extraordinary amount of gilding was used (fig. 7). Indeed, it seems that the total expense for gilding on these two pages was 2,200 *akçe*s. The total amount spent on various paints and paint materials for the illumination of the entire Qur'an was 13,690 *akçe*s.

The account book of 1584–1593 does not give any names for the artists who designed and executed the illumination of the manuscript. However, it refers to four painter-designers in relation to purchases of material or allocation of funds; the Nakkaşbaşı, Master Ca'fer, 'Ali Çelebi and Nakkaş Hasan from the Has Oda (Privy Chamber). In addition to this, the above-mentioned Ramazan 1004/ May 1596 entry in the register for palace expenses (*in'am defteri*) lists seven painter-designers who were remunerated for their efforts in the completion of the Ahmed Karahisari Qur'an; Nakkaş Hasan from the Has Oda (Privy Chamber), four students (*şagird*) of Mustafa Nakkaş, the *nakkaşbaşı*, and the Steward (*kethüda*) of the corps of the painter-designers (See Appendix I).

In these circumstances, Nakkaş Hasan from the Has Oda (Privy Chamber), who is mentioned in both of these sources, must have worked on this project. Nakkaş Hasan was an artist from the Enderun who held various duties in the Has Oda. He was later removed from the Has Oda and made an Agha of the Janissaries in 1603. Later on he became the *Kubbealtı* Vizier and died in 1623. Although he is better known as a miniaturist, he must also have been a skilled illuminator, since the Topkapı Palace Library owns a large illuminated *tugra* of Ahmed I signed by Nakkaş Hasan Paşa.[19]

According to the 1004 Ramazan/ May 1596 entry in the register for palace expenses (*in'am defteri*), it was only the four students (*şagird*) of Mustafa Nakkaş who were paid, while their master is not mentioned as having received any payment. The name Mustafa Nakkaş does not exist in the extant *Ehl-i Hiref* payroll registers from October 1592 on. The name Mustafa, which belonged to a *nakkaş* who was said to have been an illuminator (*müzehhib*), does exist, however, in the 1545, 1557–58 and 1566 payroll registers from the reign of Süleyman the Magnificent. In the 1557–58 payroll register this artist's name is mentioned as Mustafa Müzehhib and his daily wage is given as 8 *akçe*s. This is repeated in the 1566 register while the 1545 register states that he was Kara Memi's student (*şagird*). It is highly probable that Mustafa Müzehhib was indeed one of the illuminators working on the Ahmed Karahisari

Qur'an. The absence of his name in the sources from 1592 on can be explained by the probability that he had died by then. On the other hand, it may be that he never worked on this project and it was only his four students mentioned by the 1596 entry who actually worked on the Ahmed Karahisari Qur'an.

The Nakkaşbaşı who was mentioned in both the account book of 1584–1593 and entry of 1596 from the register for palace expenses must have been the Lütfi 'Abdullah, since he was the Nakkaşbaşı in this period. However, Lütfi 'Abdullah's contribution to the Ahmed Karahisari Qur'an was most probably in the capacity of an organizer. He had gone to Mecca in Safer 994 (the beginning of 1586)[20] and during his absence, in the years 1586 and 1587, it can be seen in the account book that the sums for the expenses for the manuscript were given to Nakkaş 'Ali Çelebi. An extant document dated 1591–92 refers to 'Ali Çelebi as the halife-i nakkaşin (leading assistant of the head of the corps of the painter-designers).[21] However, since this title primarily refers to his capacity as an administrator, it cannot really be ascertained whether or not he was one of the illuminators who actually worked on the execution of the illuminations. The same account book reveals that in the years 1000 and 1001/1592–93 the sums for the expenses for the manuscript were given to Master Ca'fer Nakkaş. Ca'fer Nakkaş is mentioned in the 1004/1596 Ehl-i Hiref payroll register as Ca'fer b. 'Abdullah and as the kethüda (steward) for the corps of the painter-designers.[22] Another document dated 972/1565 refers to him as Ca'fer b. 'Abdullah şagird-i ser nakkaşan ("Ca'fer, the son of 'Abdullah, the student of the head of the corps of the painter-designers").[23] The head of the corps of the painter-designers in 1565 was Kara Memi, who was an illuminator. This would necessarily imply that Ca'fer Nakkaş was also trained as an illuminator. However, again it cannot be ascertained whether Master Ca'fer worked on the actual execution of the illuminations or not. On the other hand, according to the 1596 entry, both the Nakkaşbaşı Lütfi 'Abdullah and the Steward (kethüda) of the corps of the painter-designers, Ca'fer Nakkaş, were rewarded financially by the Sultan for their work on the Ahmed Karahisari Qur'an.

Thus, from the above sources and study of the Ahmed Karahisari Qur'an itself, it can be concluded that the manuscript was probably illuminated in varying degrees by Nakkaş Hasan, Mustafa Müzehhib, and by four court painter-designers trained by the latter, 'Ali Çelebi and Master Ca'fer under the organization of the Nakkaşbaşı Lütfi 'Abdullah.

With its extensive illumination, the importance of this manuscript in the field of Ottoman decorative arts is beyond dispute. In addition to the richly illuminated pages at the beginning and at the end of the manuscript, and the more usual illuminated Sura headings, 'ashara and cüz signs, every single page contains four illuminated rectangular panels (koltuk) each measuring 9cm. x 4.5cm. and flanking the two blocks of nesih calligraphy.

Special care was given to the organization of these rectangular panels. The illuminators decorating this, the largest Qur'an ever produced in the Ottoman world, seem to have displayed all the expertise they could, all the motifs which existed in their decorative vocabulary, and all the decorative compositions which could possibly have been used in these rectangles. The motifs were combined and recombined in as many variations as needed, often appearing similar but almost never the same. Out of the 2360 illuminated rectangles, approximately 500 give totally different impressions. Although the differences are sometimes very slight, one can clearly see more than 100 different compositions. For example, the designs in some rectangular panels had unpainted backgrounds creating a subdued appearance. This could be negative imprint hatayi blossoms on spiral scrolls, a combination of different motifs painted only in gold, or naturalistic garden flowers. Others had bold and contrasting colours to create an immediate, sensuous impact. Sometimes the designs were repeated in opposite rectangular panels (figs. 4 and 6) and sometimes in diagonal ones, while at other times each of the four rectangles had a different design. However, the rectangular panels in each page were almost always repeated on the facing page with the same designs like mirror images, thus creating a harmonious double-page composition at every opening (fig. 5). The purpose of this variety of design in these rectangles was most probably to save the reader of the Qur'an from monotony while demonstrating the extreme importance given to the word of God written in this peerless calligraphy.

However, the most interesting aspect of the illuminations of these rectangular panels was their approach to composition, where the same motif was used over and over again but at different degrees of magnification. This was sometimes taken to such a pitch that the motif itself was hardly recognizable, though sometimes it produced truly interesting designs. This most unusual approach to book illumination appears to have been employed to achieve harmony between the large calligraphy and the oversized pages. These bold magnified patterns produced an immediate vibrant effect from a distance through the use of contrasting radiant colours and blended perfectly with the large calligraphy, thus reflecting the sensuous immediacy of the Ottoman decorative aesthetic, which could be appreciated in its own terms while being in complete harmony with its surroundings.

The above-mentioned 1584–1593 account book also gives some information about the production of the binding of the manuscript (fig. 1). It states that 5040 akçes and 12,000 akçes were paid for the binding materials on 15 Receb 999/ 9 May 1591 and on 16 Zi'l-hicce 999/3 October 1591 respectively. A later 1596 entry in a register for palace expenses (in'am defteri) states that the mücellidbaşı (head binder) and two of his students were remunerated for their work on the completion of the manuscript.

The head binder of this period was Süleyman b. Mehmed while the two binders who were trained by him must have been 'Abdi Şaban and Kara Mehmed, since these were the two master bookbinders

whose signatures are seen on other important contemporary bindings as well.²⁴ The binding seems to have been completed within these five years, that is between 1591 and 1596.

The same 1596 entry from the register for palace expenses (in'am defteri) also reveals that for the task of completing this extremely important manuscript, a special workshop was constructed by the palace carpenters (dülgerler).²⁵ It states that some carpenters were also remunerated for their services to the Ahmed Karahisari Qur'an.

The study of these two important documents, the 1584–1593 account book and the 1596 entry from the register for palace expenses (in'am defteri), thus makes it possible to calculate the sums spent for the completion of the Qur'an in the twelve years from 1584 to 1596

during the combined reigns of Murad III and Mehmed III. Accordingly, the total expenses recorded for the manuscript for the duration of this time come to 1237 gold pieces and 45,064 akçes.

To summarize, then, 220 folios of the Ahmed Karahisari Qur'an were transcribed by Ahmed Karahisari during the reign of Sultan Süleyman the Magnificent, between the years 1545–1555; the rest of this Qur'an could not be completed owing to the death of its calligrapher. The remaining 80 folios were probably written by Karahisari's student and adopted son Hasan Çelebi between the years 1584–87 for Murad III. The manuscript was totally completed, with the margining, marginal rulings, and illumination of all of its 300 folios as well as the binding, between the years 1584 and 1596.

FIG. I

Topkapı Saray Museum Library H.S.5, Binding.

FIG. 2

Topkapı Saray Museum Library H.S.5, Endowment Notation, fol. 1b.

FIG. 3 Topkapı Saray Museum Library H.S.5, Frontispiece, fols. 2v and 3r.

FIG. 4 Topkapı Saray Museum Library H.S.5, fols. 220v and 221r.

FIG. 5 Topkapı Saray Museum Library H.S.5, fols. 53v and 54r.

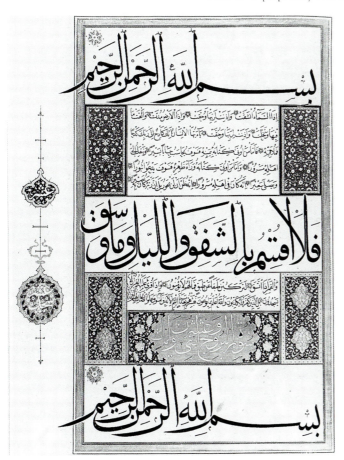
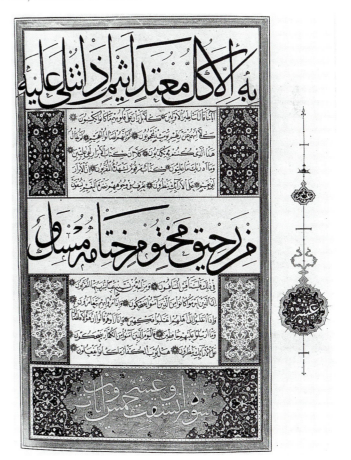

FIG. 6 Topkapı Saray Museum Library H.S.5, fols. 289v and 290r.

FIG. 7

Topkapı Saray Museum Library H.S.5, fols. 299v and 300 r.

Appendix I

Topkapı Sarayı Müzesi Arşivi. D. 34 y. 196b.

Sene 1004 Ramazān
Def'a māh-i Ramazan'ın fi 27.
Karahisārī dimek ile meşhūr ve nāmdār kātibiñ haṭṭı ile ibtidā olunan muṣḥaf-ı şerīfiñ hiḍmetinde bulunanlara virilen in'ām ṣūretidir ki ẕikrolunur.

Odada Nakkāş Ḥasan'a	ḥasene 200
taşrada Muṣṭafā Nakkaşa dört nefer şagirdlerine	fi 50. ḥasene 200
mücellidbaşıya	ḥasene 60
nakkaşbaşıya	ḥasene 50
nakkāşlar kethüdāsina	ḥasene 40
altuncuya	ḥasene 20
iki nefer mücellidbaşı şagirdlerine	fi 10. ḥasene 20
dülgerbāşı	ḥasene 35
dülger ustası Semender'e	ḥasene 20
dülger Meḥmed'e	ḥasene 15
dört nefer dülgerlere	fi 10. ḥasene 40
Meblağı mezbūr bī-ma'rifet-i pādişāh-ı	
'ālem-penāh kethüdā yedinden teslīm	Cem'an 685. ḥasene.

The Archives of the Topkapı Palace Museum. D.34, folio 196b

Ramazan, 1004 A.H.

On the 27th of the month of Ramazan (25 May 1596). The following is a copy of the benefactions bestowed upon those working on the Holy Qur'an begun in the hand of the renowned calligrapher known as Karahisārī.

to Nakkāş Ḥasan in the Has Oda (Privy Chamber): 200 gold pieces
to the 4 apprentices of Nakkāş Muṣṭafā outside of the Palace: at 50 apiece, 200 gold pieces
to the head of the book binders: 60 gold pieces
to the head of the painter designers (Nakkaşbaşı): 50 gold pieces
to the steward of the painter designers: 40 gold pieces
to the gold gilder: 20 gold pieces
to two apprentices of the head of the book binders: at 10 apiece, 20 gold pieces
to the head of the carpenters: 35 gold pieces
to the carpenter Master Semender: 20 gold pieces
to the carpenter Meḥmed: 15 gold pieces
to four other carpenters: at 10 pieces apiece, 40 gold pieces.

The above amounts were paid by the Steward with the approval of the Sultan.

Total 685 gold pieces

Appendix II

Topkapı Sarayı Müzesi Arşivi. D. 9628
Karahisārī Muṣḥaf-i Şerīfī Masraf Defteri, sene 992

[1] Defʿa māh-ı Ramażān-ı Şerīfin fi 12.
Bā ḫattı-ı Karahisār Muṣḥaf-ı Şerīfüñ mühimmāti
ḫuṣuṣiyçün otuz dāne kāğıt şatūn alınūb ḳîymetleri ṭoḳuz
yüz otuz akçe olduḳta be-maʿrifet-i Ḫudāvendigār
Teberdārlar Bölükbāşının yedinden kātibe teslīm
akçe 930

[2] Defʿa Māh-ı mezbūrun fi 13.
mezkūr Muṣḥaf-ı Şerīfüñ mühimmātıyçün baʿżī kāğıd
alınub kıymetleri sekiz yüz ṭoḳsan akçe olduḳta
Ḫazīnedārbaşı yedinden bāyiʿa teslīm
akçe 890

[3] Defʿa Māh-ı mezbūrun fi 16.
mezkūr Muṣḥaf-ı Şerīfüñ mühimmātıyçün on deste kāğıd
alınub beher deste üç yüz yigirmişer akçe olduḳda gelüb
Teberdārlar Bölükbāşısı aldı ve yed-i mezbūrdan bāyiʿa
teslīm
akçe 3200

[4] Defʿa māh-ı mezbūrun fi 24.
mezbūr Muṣḥaf-ı Şerīfüñ mühimmātıyçün sarı altūn varaḳ
olmaḳ içün dört filori verildi.
ḥasene 4

[5] Defʿa māh-ı mezbūrun yevm-i mezkūrunda.
mezkūr Muṣḥaf-ı Şerīfüñ mühimmātıyçün yeşil altūn varaḳ
almaḳ ḫuṣūṣiyçün dört dāne filori verildi.
ḥasene 4

[6] Defʿa māh-ı mezbūrun fi 28
mezkūr Muṣḥaf-ı Şerīfüñ mühimmātıyçün otuz bir tabaḳ
kāğıd yapışdırmasına ve mühresine ve gitre ve zaġferān
ḥınnā içün üç yüz elli iki akçe virilüb Hazine ketḫüdāsı
yedinden kātibe teslīm.
akçe 352

[7] Defʿa māh-ı mezbūrun fi 16
mezkūr Muṣḥaf-ı Şerīfüñ mühimmātıyçün baʿżı rengler
alınub kıymetleri iki biñ seksen akçe olmağın gelüb
Teberdār Mūsa aldı Ḫazīnedārbaşı yedine ve yed-i
mezkūrdan Naḳḳāşbaşına teslīm
akçe 2080

[8] Defʿa māh-ı mezbūrun fi yevm-i mezkūrunda
lāʿlīn reng yapılmaḳ ḫuṣūṣiyçün Naḳḳāşbaşıya üç yüz akçe
verilmeğin Ḫazīnedārbaşı yedinden mezbūra teslīm.
akçe 300

[9] Defʿa māh-ı Şevvālüʾl-mükerremin fi 8
baʿżı kāğıdların ḫarcı ḫuṣūṣiyçün üç yüz yigirmi altı akçe
virilüb Ḫazīnedārbaşı yedinden kātibe teslīm
akçe 326

[10] Defʿa māh-ı mezbūrun fi 14
Muṣḥaf-ı Şerīfüñ mühimmātıyçün kırk dāne kalem alınub
kıymetleri yigirmi iki akçe olmağın Ḫazīnedārbaşı yedinden

bāyiʿa teslīm
akçe 22

[11] Defʿa māh-ı mezbūrun fi 24
mezbūr Muṣḥaf-ı Şerīfüñ mühimmātıyçün lāʿlīn reng
yapılmak için iki yüz akçe virilüb Ḫazīnedārbaşı yedinden
Naḳḳāşbaşıya teslīm
akçe 200

[12] Defʿa māh-ı mezbūrun fi 26
mezkūr Muṣḥaf-ı Şerīfüñ mühimmātıyçün on sekiz mişḳāl
lāciverd beher mişḳāl yigirmi ṭoḳuz akçeden beş yüz yigirmi
iki akçe olmağın Ḫazīnedārbaşı yedinden Naḳḳāşbaşıya
teslīm
akçe 522

[13] Defʿa māh-ı Ziʾl-ḳaʿdeniñ fi 3
mezbūr Muṣḥaf-ı Şerīfüñ mühimmātıyçün altūn şūyu
olmağa dört dāne filori verildi
ḥasene 4

[14] Defʿa māh-ı Ziʾl-ḥiccenin fi 10
ṭoḳuz dāne kāğıd beher kāğıd otuzar akçeden iki yüz
yetmiş akçe olduḳda getirilmesine daḫi doksan virilüb ki
cemʿan üç yüz altmış akçe olmağın Ḫazīnedārbaşı yedinden
kātibe teslīm
akçe 360

[15] Defʿa māh-ı Muharremüʾl-haramın [sene 993] evaḫirinde
üç buçuk neft dudesi satun alınub ḳıymeti dört yüz yigirmi
akçe olmağın Ḫazīnedārbaşı yedinden Naḳḳāşbaşına teslīm
[akçe 420]

[16] Defʿa māh-ı Saferüʾl-muzafferiñ fi 7
üç mişḳāl neft dūdesi satun alīnub beher mişḳāl yüzer
akçeden üç yüz akçe olduḳda Serḫāzin yedinden
Naḳḳāşbaşıya teslīm
akçe 300

[17] Defʿa māh-ı Rebiʾüʾl-ahırın fi 2
mezbūr baʿżı levāzımı için kātibe iki biñ akçe virildi
akçe 2000

[18] Defʿa māh-ı mezbūrun fi 17
mezbūr Muṣḥaf-ı Şerīfüñ mühimmātıyçün altūn şuyu
olmaḳ içün sekiz altūn virildi
ḥasene 8

[19] Defʿa māh-ı Şaʿbanʾın gurresinde
kırk iki ṭabaḳa kāğıd alınub beher ṭabaḳı fi cümlesi biñ yüz
altmış akçe olduḳda Serḫāzin yedinden kātibe teslīm
akçe 1176

[20] Defʿa yevm-i mezkūrda
Muṣḥaf-ı Şerīfüñ baʿżı levāzîmîna dört yüz akçe virilüb
Serḫāzin yedinden kātibe teslīm
akçe 400

[21] Defʿa māh-ı Şevvālin fi 25
Muṣḥaf-ı Şerīfüñ mühimmātıyçün iki dirhem silū alınub
dirhemi altmış akçeden yüz yigirmi akçe olup ve üç dirhem
dūde-i siyāh alınub her bir dirhemi yüzer akçeden cemʿan

dört yüz yigirmi akçe olduḳda Naḳḳāşbaşıya teslīm
akçe 420

[22] Def'a māh-ı Ẕi'l-ḳa'de'nin fi 6
sarı varaḳ olmak içün altūncuya dört filori ve yeşil varaḳ
olmak içün daḫi dört filori virilüb Teberdar Mūsa yedinden
Altūncuya teslīm-i şehr
ḥasene 8

[23] Def'a māh-ı Rebī'ü'l-evvel fi 13 [Sene 994]
Muṣḥaf-ı Şerīf varaḳ ḥarci içün Altūnṣuyucuya sekiz yüz
ḳırḳ yidi akçe virilmiştir
akçe 847

[24] Def'a māh-ı mezbūrun fi 19
Muṣḥaf-ı Şerīf içün otuz akçe sürh boya ve on dört akçalık
sülegān ve on dört akçalık şaru boya alınduḳda bahāları
Naḳḳāş 'Ali Çelebiye teslīm
akçe 58

[25] Def'a māh-ı Cumade'l-aḫirin fi 17
altūn şuyu olmak içün sekiz dāne filori ve yeşil altūn şuyu
olmak içün dört filori verildi
ḥasene 12

[26] Def'a māh-ı Sa'banın fi 9
altūn şuyu olmak ḥarci içün iki yüz ḳırḳ akçe virilüb
Ḫazīnedārbaşı yedinden teslīm
akçe 240

[27] Def'a māh-ı Ẕı'l-ḳa'de'nin fi 24
Muṣḥaf-ı Şerīf içün on mişḳāl silū alınub mişḳāli yüz
yigirmişer akçeden bin iki yüz akçe 'Ali Çelebiye teslīm
akçe 1200

[28] Def'a māh-ı Muharremin fi 13 [Sene 995]
ba'ẓi varaḳ olduḳda ḥarcları içün yüz altmış akçe verildi
akçe 160

[29] Def'a māh-ı Rebī'ü'l-evvel'in fi 28
ḳāğıdlar mühresi içün altmış dört akçe verildi
akçe 64

[30] Def'a māh-ı mezbūrun fi 30
bir divid sürh alındıḳda yüz elli akçe verildi
akçe 150

[31] Def'a māh-ı Recebü'l-müreccebin fi 28.
elli dirhem dūde-i siyāh alınub beher dirhemi onar akçeden
beş yüz akçe Naḳḳāş 'Ali Çelebi'ye teslīm
[akçe 500]

[32] Def'a māh-ı Ẕi'l-ḳa'de'nin fi 5
altı dirhem silū alınub beher dirhemi yüz yigirmiden altı
yüz altmış akçe 'Ali Çelebiye teslīm
akçe 660

[33] Def'a māh-ı Ẕi'l-ḥicce fi 16
ḳırḳ dāne deste altūn şuyu ḥarcı iki yüz ḳırḳ akçe teslīm
akçe 240

[34] Def'a māh-ı Rebī'ü'l-aḫır fi 13 [sene 996]
On dirhem silū fi yüz yigirmişerden ve iki yüz otuz akçalık
sürh alınub Naḳḳāş Ḥasan'a teslīm
akçe 1430

[35] Def'a māh-ı Ẕi'l-ḳa'de'nin fi 22
işlenen altūn varaḳ ḥarcı içün Altūncuya teslīm

akçe 300

[36] Def'a māh-ı Ẕi'l-ḥicce 19
Muṣḥaf-ı Şerīf içün alınan üstübec bahāsı için
Naḳḳāşbāşıya teslīm
akçe 100

[37] Def'a māh-ı Rebi'ü'l-evvelin fi 12 [sene 997]
Muṣḥaf-ı Şerīf içün Altūncuya teslīm
akçe 120

[38] Sene 998 Def'a māh-ı Recebin fi 13
Muṣḥaf-ı Şerīf içün Altūncuya on iki sikke teslīm
ḥasene 12

[39] Def'a māh-ı Muharremin fi 22 [Sene 999]
Muṣḥaf-ı Şerīf harcıyçün yüz altmış bir akçe Güğümbāşı
yedinden teslīm
akçe 161

[40] Def'a māh-ı Rebī'ü'l-evvelin fi 30
Muṣḥaf-ı Şerīf mühimmātıyçün sekiz mişḳāl ile üç denk
yeşil boya alındıḳda üç yüz elli akçe Naḳḳāş Ḥasan'a teslīm
akçe 350

[41] Def'a māh-ı Receb fi 15
mezkūr Muṣḥaf-ı Şerīfün cild ḥarcıyçün ḥarc beş biñ ḳırḳ
akçe virilüb Bölükbaşı yedinden teslīm
akçe 5040

[42] Def'a māh-ı Ẕi'l-ḥicce fi 16
on iki biñ akçe Muṣḥaf-ı Şerīf cild ḥarcıyçün mücellidbāşı
oğluna Ḫazīnedārbāşı yedinden teslīm
akçe 12000

[43] Def'a māh-ı Şevvālin fi 13
mezkūr Muṣḥaf-ı Şerīf içün yigirmi mişḳāl silu alîndîḳda
beher mişḳāl yitmişden ketḫudā yedinden Usta Ca'fer
Naḳḳāşa teslīm
akçe 1400

[44] Def'a māh-ı Şevvālin fi 30
. mezkūr Muṣḥaf-ı Şerīfün ser-levhası içün on sekiz mişḳāl
eyüce lāciverd ikişer yüz akçeden alınub üç biñ altı yüz akçe
Usta Ca'fer'e teslīm
akçe 3600

[45] Def'a māh-ı Receb'in fi 10 [Sene 1001]
mezkūr Muṣḥaf-ı Şerīfün bir yerleri tezhibi içün otuz bir
deste yeşil altūn şuyu alînub fi 35, cümle biñ ṭoḳsan akçe
olub ba'żi ḳāğıtlar gitralanmaḳ içün daḫi mezkūr akçeden
verülüb ki cümle biñ üç yüz yigirmi akçe olduḳda Usta
Ca'fer'e teslīm
akçe 1320

[46] Def'a māh-ı Receb'in fi 25
mezkūr Muṣḥaf-ı Şerīf içün otuz deste altūn şuyu alınūb
ḳıymeti ṭoḳuz yüz akçe olmağın Usta Ca'fer'e teslīm
akçe 900

(on an inserted sheet, unbound)
*Üçüncü def'ada alınan iki deste ḳāğıdın tutḳal ve ḥınna ve
za'firān ve ücret-i üstadiyye için
akçe 326

Appendix III

The Archives of the Topkapı Palace Museum. D.9628

The Account Book of the Ḳaraḥisārī Holy Qur'an, 992 A.H.

1- On the 12th of Ramażān (17 September 1584) paid 930 akçe by the Teberdarlar Bölükbaşısî (Head of the Cops of Halberdiers) to a scribe for 30 sheets of paper for the Holy Qur'an in Ḳaraḥisārī's hand with the Sultan's approval.
Total amount 930

2- On the 13th day of the same month (18 September 1584) paid 890 akçe by the Chief Treasurer to the seller for some paper for the aforementioned Holy Qur'an.
Total amount 890

3- On the 16th day of the same month (21 September 1584) paid by the Teberdarlar Bölükbaşı to the seller 320 akçe per pack (deste) for 10 packs of paper for the aforementioned Holy Qur'an.
Total amount 3200

4- On the 24th day of the same month (29 September 1584) paid 4 gold florins for sheets of yellow gold for the aforementioned Holy Qur'an.
Gold pieces 4

5- On the same day of the same month (29 September 1584) paid 4 gold florins to buy green gold sheet for the aforementioned Holy Qur'an.
Gold pieces 4

6- On the 28th day of the same month (3 October 1584) paid 352 akçe by the steward of the Treasury to a scribe for the pasting and polishing of 31 sheets of paper and for henna, saffron and gum arabic (kitre) for the aforementioned Holy Qur'an.
Total amount 352

7- On the 29th day of the same month (4 October 1584) paid 2080 akçe to Terberdar Musa who gave it to the Chief Treasurer who delivered it to the Naḳḳāşbaşı for certain pigments for the aforementioned Holy Qur'an.
Total amount 2080

8- On the same day of the same month (4 October 1584) paid 300 akçe by the Chief Treasurer to the Naḳḳāşbaşı for making a ruby pigment.
Total amount 300

9- On the 8th day of Şevval (13 October 1584) paid 326 akçe by the Chief Treasurer to the scribe for the expenses of certain sheets of paper.
Total amount 326

10- On the 14th day of the same month (19 October 1584) paid 22 akçe by the Chief Treasurer to the seller for 40 brushes.
Total amount 22

11- On the 24th day of the same month (29 October 1584) paid 200 akçe by the Chief Treasurer to the Naḳḳāşbaşı to make a ruby pigment for the aforementioned Holy Qur'an.
Total amount 200

12- On the 26th day of the same month (31 October 1584) paid 522 akçe by the Chief Treasurer to the Naḳḳāşbaşı for 19 miskāls of lapis lazuli at 29 akçe per miskal for the aforementioned Holy Qur'an.
Total amount 522

13- On the 3rd day of the month of Ẕi'l-ḳa'de (6 November 1584) paid four florins for liquid gold for the aforementioned Holy Qur'an.
Gold pieces 4

14- On the 10th day of the month of Ẕi'l-ḥicce (13 December 1584) paid 360 akçe by the Chief Treasurer to the scribe for nine sheets of paper at 30 akçe per sheet and 90 akçe to procure them.
Total amount 360

15- On the last day of the month of Muḥarrem (3 January 1585) paid 420 akçe by the Chief Treasurer to the Naḳḳāşbaşı to buy 3.5 miskāls of naphta soot (neft dudesi, black soot).

16- On the 7th day of the month of Safer (8 February 1585) paid 300 akçe by the Chief Treasurer (Serḥāzın) to the Naḳḳāşbaşı to buy 3 miskāls of naphta soot (neft dudesi) at 100 akçe apiece
Total amount 300

17- On the 2nd day of the month of Rebi'ü'l-ahir (4 March 1585) paid 2000 akçe to the scribe for certain materials needed for the aforementioned Holy Qur'an.
Total amount 2000

18- On the 17th day of the same month (19 March 1585) paid 8 gold pieces for liquid gold for the above-mentioned Holy Qur'an.
Gold pieces 8

19- On the first day of the month of Şa'ban (26 August 1585) paid 1160 akçe by the Chief Treasurer to the scribe for 42 sheets of paper at 28 akçe apiece.
Total amount 1176

20- On the same day (26 August 1585) paid 400 akçe by the Chief Treasurer to the scribe for certain materials needed for the Holy Qur'an.
Total amount 400

21- On the 25th day of the month of Şevval (20 October 1585) paid 420 *akçe* to the Naḳḳāşbaşı for two *dirhems* of *silū* (light green) at 60 *akçe* per *dirhem* and three *dirhems* of black soot (*dude-i siyah*) at 100 *akçe* per *dirhem*.
Total amount 420

22- On the 6th day of the month of Ẕi'l-ḳa'de (30 October 1585) paid by Teberdar Mūsa to the gold dealer 4 florins for yellow gold foil and 4 florins for green foil delivered in the city ("*teslīm-i şehr*"?).
Gold pieces 8

23- On the 13th day of the month of Rebi'ü'l-evvel (4 March 1586) paid 847 *akçe* to the liquid gold maker for expenses for the Holy Qur'an.
Total amount 847

24- On the 19th day of the same month (10 March 1586) paid to the Naḳḳāş 'Ali Çelebi 30 *akçe* for vermilion pigment and 14 *akçe* for red lead and 14 *akçe* for yellow pigment for the Holy Qur'an.
Total amount 58

25- On the 17th day of the month of Cumade'l-ahir (5 June 1586) paid 8 florins for liquid gold and 4 florins for green liquid gold.
Gold pieces 12

26- On the 9th day of the month of Şa'ban (26 July 1586) paid 240 *akçe* by the Chief Treasurer for expenses for liquid gold.
Total amount 240

27- On the 24th day of the month of Ẕi'l-ḳa'de (6 November 1586) paid 1200 *akçe* to 'Ali Çelebi for ten *miskals* of *silū* (light green) at 120 *akçe* per *miskal* for the Holy Qur'an.
Total amount 1200

28- On the 13th day of the month of Muḥarrem (24 December 1586) paid 160 *akçe* for the expenses for some sheets of paper.
Total amount 160

29- On the 28th day of the month of Rebi'ü'l-evvel (8 March 1587) paid 64 *akçe* for paper polish.
Total amount 64

30- On the 30th day of the same month (10 March 1587) paid 150 *akçe* for a *divid* of vermilion pigment.
Total amount 150

31- On the 28th day of the month of Receb (4 July 1587) paid 500 *akçe* to the Naḳḳāş 'Ali Çelebi for 50 *dirhems* of black soot (*dude-i siyah*) at 10 *akçes* apiece.

32- On the 5th day of the month of Ẕi'l-ḳa'de (7 October 1587) paid 660 *akçe* to Ali Çelebi for six *dirhems* of *silū* (light green) at 120 *akçe* apiece.
Total amount 660

33- On the 16th day of the month of Ẕi'l-ḥicce (17 November 1587) paid 240 *akçe* for the expenses of liquid gold for 40 packs.
Total amount 240

34- On the 13th day of the month of Rebi'ü'l-ahir (11 February 1588) paid for 10 *dirhems silū* (light green) at 120 *akçe* apiece and 230 *akçe* worth of vermilion pigment delivered to the Naḳḳāş Ḥasan.
Total amount 1430

35- On the 22nd day of the month of Ẕi'l-ḳa'de (13 October 1588) paid to the gilder for the expenses for gold foil.
Total amount 300

36- On the 19th day of the month of Ẕi'l-ḥicce (9 November 1588) paid to the Naḳḳāşbaşı for white lead purchased for the Holy Qur'an.
Total amount 100

37- On the 21st day of the month Rebi'ü'l-evvel (7 February 1589) paid (120 *akçes*) to the gilder.
Total amount 120

38- 998 A.H. On the 13th day of the month of Receb (18 May 1590) paid 12 gold pieces to the gilder for the expenses of the Holy Qur'an.
Gold pieces 12

39- On the 22nd day of the month of Muḥarrem 999 (20 November 1590) paid 161 *akçe* by the Güğümbaşı for the expenses of the Holy Qur'an.
Total amount 161

40- On the 30th day of the month of Rebi'ü'l-evvel (26 January 1591) paid 350 *akçe* to the Naḳḳāş Ḥasan for 8 *miskals* and 3 *denk* of green pigment for materials for the Holy Qur'an.
Total amount 350

41- On the 15th day of the month of Receb (9 May 1591) paid 5040 *akçe* by the Bölükbaşı for the expenses for the binding of the aforementioned Holy Qur'an.
Total amount 5040

42- On the 16th day of the month of Ẕi'l-ḥicce (5 October 1591) paid 12000 *akçe* by the Chief Treasurer to the son of the Head of the Binders for the expenses for the binding of the Holy Qur'an.
Total Amount 12000

43- On the 13th day of the month of Şevval (23 July 1592) paid by the Steward to the Master Ca'fer Naḳḳāş for 20 *miskāl* of *silū* (light green) for the aforementioned Holy Qur'an at 70 *akçe* per *miskāl*.

Total amount 1400

44- On the 30th day of the month of Şevval (8 August 1592) paid 3600 *akçe* to Master Ca'fer for 18 *miskāl* of good quality lapis lazuli at 200 *akçe* per *miskal* for the frontispiece of the aforementioned Holy Qur'an.
Total amount 3600

45- On the 10th day of the month of Receb (12 April 1593) paid a total of 1320 *akçe* to Master Ca'fer, 1090 *akçe* for 31 packs of green gold gilt at 31 *akçe* per pack for the illumination of certain parts and some more *akçe* for the pasting of certain pages for the aforementioned Holy Qur'an.
Total amount 1320

46- On the 25th day of the month of Receb (27 April 1593) paid 900 *akçe* to Master Ca'fer for 30 packs of gold gilt for the aforementioned Holy Qur'an.
Total amount 900

(on an inserted sheet, unbound)
* "for the glue, saffron, henna, and workmanship of two packs of paper acquired in the third purchase".
Total amount 326 *akçe*

Notes

1 F.E. Karatay, *Topkapı Sarayı Müzesi Arapça Yazmalar Kataloğu*, vol. I, Istanbul 1962, no. 823; O. Aslanapa, *Turkish Art and Architecture*, London 1971, pl. XXXII; U. Derman, "Kanuni Devrinde Yazı Sanatımız," *Kanuni Armağanı*, Ankara 1970, 260–310, fig. 10; U. Derman, "Hat Sanatında Türklerin Yeri," *Islam Sanatında Türkler*, 53–6, pl. 16; U. Derman, *Türk Hat Sanatının Şaheserleri*, Istanbul 1982, no. 8; *The Anatolian Civilizations III*: Seljuk/Ottoman, Istanbul 1983, E.192.

2 Müstakimzade, Süleyman Saadeddin Efendi, *Tuhfe-yi Hattatin*, Istanbul 1926, p. 94. In the related literature some scholars think that this may refer to Afyon Karahisar in Turkey.

3 *Ibid.*

4 *Ibid.*

5 The colophons of the following are all signed by Ahmed Karahisari as "Ahmed Karahisari min talamidh Sayyid Asadullah al-Kirmani": Qur'an dated 933/1526/7, TIEM 400 (see *Soliman Le Magnifique, 15 fevrier au 14 mai 1990 Galéries Nationales du Grand Palais*, Paris 1990, no. 126, pp. 120–121);
Qur'an dated 953/1546–47, TSM Y.Y.999 (E. Atil, *The Age of Sultan Süleyman the Magnificent*, Washington D.C. and New York 1987, pl. 9a, p. 48–9; J.M. Rogers and R.M. Ward, *Süleyman the Magnificent*, London 1988, p. 66);
Calligraphic specimens c. 1550, TIEM 1443 (Atil, *op. cit.*, fig. 10, p. 50; Rogers and Ward, *op. cit.*, no. 16, p. 71);
Suras from a Qur'an dated 945/1547, TIEM 1438 (*Soliman le Magnifique*, no. 211, p. 196); Album of calligraphy dated 960/1552–3, TSM A. 3654 (Atil, *op. cit.*, fig. 11, p. 52; Rogers and Ward, *op. cit.*, no. 17, p. 71)
Suras from a Qur'an dated 961/1554, TSM 416 (*Soliman le Magnifique*, no. 213, p. 197).

6 TSMA, D. 9706/4.

7 See 5 above.

8 Mustafa 'Āli refers to Ahmed Karahisari as one of the most famous seven scribes of Rum (i.e. Turkish scribes). Mustafa 'Āli, Gelibolulu, *Menakib-i Hünerveran*, Istanbul 1926, p. 25. See also Appendix I.

9 TSMA, D. 34, fol. 84r.

10 *Ibid.*, fol. 196v. See also Appendix 1.

11 Müstakimzade, *op. cit.*, p. 94.

12 TSMA, D.9612.

13 Başbakanlık Arşivi, M.M.6196, p. 154.

14 Evliya Çelebi, *Seyahatname*, vol. III, Istanbul 1314, p. 440.

15 Müstakimzade, *op. cit.*, p. 155.

16 Topkapı Palace Library, E.H. 1077. See also Atil, *Age of Sultan Süleyman*, pl. 12, p. 53; Derman, *Türk Hat Sanatının…*, nos. 9–10.

17 TSMA, D.9628. Also published by R.M. Meriç, *Türk Nakış San'atı Tarihi Araştırmaları I; Vesikalar*, Ankara 1953, no. CXV, pp. 66–8.

18 V. Minorsky, *Calligraphers and Painters: A Treatise by Qadi Ahmad, son of Mir-Munshi (circa A.H. 1015/A.D. 1606)* Washington 1959, p. 196.

19 Z. Akalay, "XVI. Yüzyıl Nakkaşlarından Hasan Pasa ve eserleri", in *I. Milletlerarası Türkoloji Kongresi*, Istanbul 1979, p. 607–26; *The Anatolian Civilizations III*, Cat. no. E.193.

20 TSMA D.34, fol. 94v.

21 Başbakanlık Arşivi, M.M. 750. See also G. Necipoglu, *Architecture, Ceremonial, and Power: The Topkapı Palace in the Fifteenth and Sixteenth Centuries*, New York 1991, p. 241.

22 Meriç, *Türk Nakış*, no. VI, p. 7.

23 Başbakanlık Arşivi, K. Kepeci 7099, 13r.

24 R.M. Meriç, *Türk Cild San'atı Tarihi Araştırmaları I; Vesikalar*, Ankara 1964, no. VII, pp. 5–6; Z. Tanındı, "Islam'da Kitap Kapları ve Ustaları," *Yeni Boyut Dergisi* (May, 1984), p. 21.

25 F. Çağman, "Saray Nakkashanesinin yeri üzerine düsünceler", *Sanatta Doğudan Batiya, Ünsal Yücel anîsîna Sempozyum Bildirileri*, Istanbul, 1989, p. 38. See Appendix I.

6

The Pen or the Brush?

An inquiry into the technique of late Safavid drawings

SHEILA R. CANBY

ONE OF THE GREAT PRIVILEGES OF LIVING IN LONDON IS the opportunity of meeting B.W. Robinson from time to time to discuss Persian painting. With his characteristic good humour and economy of words he brings almost forgotten artists to life and suggests lines of inquiry that one might not otherwise have pursued. In response to one such comment: "Were not some Persian drawings done with a pen?",[1] I decided to investigate a seventeenth-century drawing and related works in the British Museum using various levels of magnification as well as the naked eye. I hoped to find evidence of brushstrokes or at least an obvious contrast between the strokes of the pen and those of the brush. As I looked through the microscope, I realized that the pen and the brush are only one aspect of a larger set of variables that determine how late Safavid drawings look. The ink, the paper, and, of course, the artist's skill all contribute to the versatility of his implement, whether pen or brush.

Several sixteenth-century Persian writers, most notably Qadi Ahmad and Sadiqi Beg, discuss the making of pens, brushes, and ink.[2] The processes they describe must have been familiar to their artistic contemporaries, but also represent the continuation of traditional methods enumerated at length as early as the eleventh century by the Arab writers Abu Hayyan al-Tawhidi and al-Mu'izz Ibn Badis.[3] The Arab texts merit attention because of their detailed accounts of the preparation of the reed pen and numerous recipes that demonstrate the array of choice available to anyone who wished

to make or use ink. Since Qadi Ahmad's text deals primarily with the artists and calligraphers themselves, the three ink recipes he mentions were presumably the most commonly used calligraphers' inks. However, even a cursory review of late sixteenth-century drawings shows that artists used inks of different colours and consistency often in the same work. As for paper, Ibn Badis describes several methods of production,[4] echoed in abbreviated form by Qadi Ahmad.[5]

This article will first review and summarize the written record of pens, brushes, inks and paper used to produce Persian drawings. A brief discussion of the pictorial record, namely portraits of artists at work, will follow. Finally, in the light of this technical information a mid-seventeenth-century drawing and related works will be discussed.

The Qalam: Pen and Brush

The naming of a chapter of the Qur'an after the pen, or *qalam*, underscores the special significance of the pen as the vehicle for writing and spreading the word of Islam. Thus, both Ibn Badis and Qadi Ahmad preface their description of the pen's physical attributes with praise and the acknowledgement of its religious importance. According to Ibn Badis, "The most beautiful and best of the properties [of the reed pen] is the goodness of the average one – between the long and the short, the thin and the thick, the diagonal and straight... The best of the reeds is that which is proportioned in its length, its body, and its hardness. The chosen is that which has a redness

within it and is more oily."[6] To prepare the reed, the pith was removed from its core at the nib end and a split was usually but not always cut up the centre of the nib.[7] In the medieval period the obliquely cut point was preferred,[8] though by the late fifteenth century the sides of the point were cut even.[9] This change of preference may reflect the suitability of the latter pens for writing in *nasta'liq* script, which was developed in late fifteenth-century Iran. In the eleventh century Abu Hayyan al-Tawhidi noted four ways of cutting nibs: "oblique, even, upright, and inclined",[10] and despite the advent of *nasta'liq* Timurid and Safavid calligraphers and artists apparently continued to use pens with a variety of points.[11]

Seventeenth-century drawings of scribes usually include more than one pen with noticeably different nibs (pl. I). Yet the sources are woefully silent on which pens suited which styles of writing, and of course no one mentions using the reed pen for making drawings. Qadi Ahmad, however, does differentiate between the animal *qalam* and the plant *qalam*, namely the brush and the reed pen.[12] Although he specifies that the brush is made of hair (*qalam-i mu*),

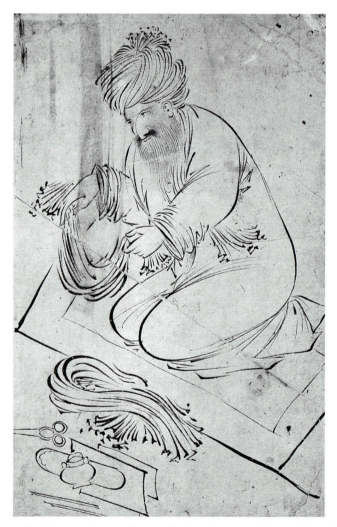

1. Cloth Merchant, from the "Rida-yi Abbasi Album"
Iran, early 17th century, black ink on paper, 17.1 x 11.5 cm.,
Freer Gallery of Art, 53.43.

he does not say whether the hairs are attached to a reed or a quill. In the eleventh century Ibn Badis had described the "brush pen" as follows: "The hair of a weasel is taken and the thin part bundled... The hair is prepared around the head after fish glue has been smeared on it... It is tied with silk thread." Cat's or squirrel's hair could be used as a substitute.[13] By the sixteenth century the technique of making brushes had developed, perhaps under the influence of Europeans who used quills instead of reeds for pens. Sadiqi Beg describes sorting soft squirrel's tail hairs and binding them with three knots, not "so loose that the hairs will easily pull out of the quill (*parghazeh*)."[14]

Qadi Ahmad treats the two types of *qalam*, the pen and the brush, as equally important, which indicates the Safavid acceptance of the legitimacy of the graphic arts as well as the traditional high regard for calligraphy.[15] In a slightly earlier work of another sixteenth-century writer, Mir Sayyid Ahmad, the distinction between the two types of *qalam* is at times blurred. Discussing Bihzad, he says, "The brush attains such heights because it/takes its place between his two fingers./ When the pen/brush boldly begins *tash'ir*,/the hair is raised on the lion's back."[16] While one can assume from the context that the author means "brush", one wonders if Safavid writers ever wished to signify "reed pen" when they mentioned an artist's tool while discussing his work. Furthermore, did late sixteenth- and seventeenth-century patrons of the pictorial arts make the distinction between pen drawings and brush drawings or was the difference of importance only to the artists themselves? Perhaps to the Safavids the division of uses for the two types of *qalam* was so obvious that it did not warrant consideration.

Ink

The extensive discussion of ink by the eleventh-century writer Ibn Badis and the detailed recipes of Qadi Ahmad provide a helpful point of departure for determining what type of inks Safavid draughtsmen were using. Without actually taking samples of different inks for scientific analysis, a procedure beyond the scope of this paper, one can at best attempt to match what one sees with the types of ink described in the sources. In addition to coloured inks, the two primary types of black ink in Ibn Badis' treatise are soot inks and gallnut or tannin inks.[17] The soot for the former is taken from the charred remains of various plants or from the black film left on the cover of the vessel in which oil has been cooked. Although he does not mention lampblack, it was certainly the most common ingredient of soot ink. Gallnut ink derived from the pulverized gallnuts of various plants, such as tamarisk, mixed with vitriol and water and boiled. Gum arabic was the customary binder, though egg white was added on occasion. Some exotic inks included additives of perfume or crushed glass, while yoghurt or vinegar counteracted mould.

Quoting Sultan 'Ali al-Mashhadi, Qadi Ahmad describes a

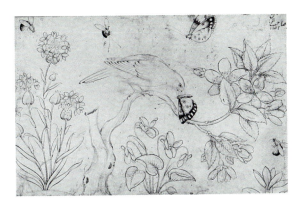

2. Bird, Butterflies and Flowers,
attributed to Muhammad Shafi' 'Abbasi
Iran, mid-17th century, 11.7 x 18.3 cm., British Museum,
OA 1922 3–16 01.

Paper

Despite Adam Olearius's contention that the Persians made paper from rags of cotton and silk,[22] linen appears to have been by far the most common source, as recent tests have proven conclusively.[23] Yet, even though the raw material of Persian paper was more or less uniform, its smoothness, durability, and porosity depend on sizing and burnishing. Heavily sized paper reveals tiny lumps of starch under high magnification. Highly burnished sheets appear smoother, shinier, and less spongy than those with little or no burnishing. Royal Safavid manuscripts of the sixteenth century such as the Shah Tahmasp *Shahnama* contain superb examples of highly burnished paper, whereas the paper of seventeenth-century drawings is far more porous and matte in appearance.

Artists at Work

While portraits of Safavid artists and scribes reveal little about the paper they used, they do shed light on how scribes' working methods differed from those of artists. A portrait of a "Scribe" by Rida (pl. 3) of about 1600 depicts the figure holding two

compound ink in which soot and gallnut are combined with gum arabic and either vitriol or alum.[18] Qadi Ahmad presents his own recipes in greater detail and with added ingredients such as indigo, aloe, musk, saffron, and rosewater or with starch substituted for gum.[19] However, these, too, are compound inks of greater complexity than those enumerated by Ibn Badis. On seventeenth-century Persian drawings variations in colour and thickness of ink are visible to the naked eye. Even a black and white reproduction of the "Bird, Butterflies and Flowers" (pl. 2) reveals the contrast between the pale, watery ink in which the bird and tree stump are drawn and the sharp black ink of the flowers, leaves and insects. The brownish colour of the bird and tree stump derives from gallnut ink whereas the black drawing of the rest of the picture could either be soot or compound ink.

What magnification shows that neither the naked eye nor photography can capture is the variable degree to which the ink is absorbed into the paper. The amount of sizing in the paper may account for this,[20] as may the effects of burnishing, which would cause the paper fibres to bind together more tightly.[21] Also, the greater the amount of ink applied to the paper, the more likely it is to form a slight relief above the surface of the paper or at least not to sink entirely below the surface. Yet, even when the variables of the paper and quantity of ink are taken into account, the inks employed for the drawings in question differ noticeably from those used by calligraphers for pages of poetry typically found in albums. Fine examples of the latter are written in ink that adheres to the surface of the paper in the same way that paint does. Perhaps such ink corresponds to the type described by Qadi Ahmad as containing starch. In any event, the ink of Safavid draughtsmen appears by contrast to be a far thinner substance, but one which allows for tonal modulation and generally versatile treatment. With the numerous recipes available it is not surprising that Safavid artists should have singled out inks better suited to their own purposes than to those of the scribe.

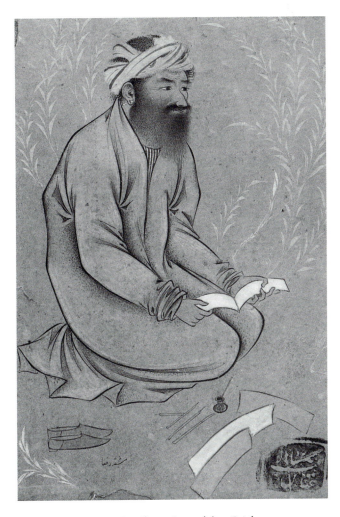

3. A Scribe, signed by Rida
Iran, ca. 1600, ink, gold, and colours on paper, 10 x 7 cm., British Museum,
1920 9–17 0271(1).

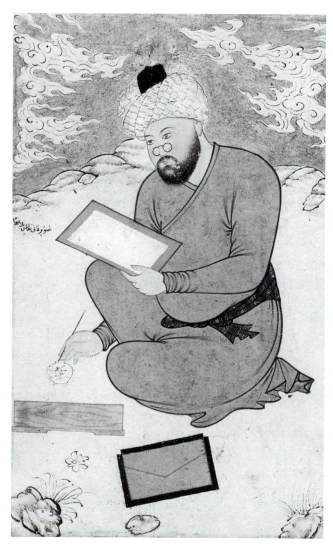

long narrow white sheets of paper joined at the short edge. Albums or books of this format, known as *safina*, are fairly common in portraits of young men reading poetry. In the foreground lie three more sheets of paper, one white, one pink and one tan. Next to them a tiny, wide-mouthed blue ink jar holds a pen, while a pen-knife, two reed pens and a *maqta'* or perhaps another pen lie to the side. Unlike figures portrayed in the act of writing,[24] this scribe holds neither a board nor another form of support for his paper.

A portrait of Mani (which appears to read "Fani") the Painter (*naqqash*) (pl. 4) may depict an artist embarking on a drawing, not a painting. The tip of his *qalam* is obscured by the pot into which it is inserted, thus making it impossible to determine whether he holds a brush or a pen. Nonetheless, the white paper on a red-edged board, the red album in the foreground and the low wooden table beside the artist all resemble the accoutrements to be found in two of the best-known portraits of a Persian artist, namely Mu'in Musavvir's portraits of Rida.[25] Like Mani, Rida wears pince-nez spectacles and he sits in the midst of albums and the tools of his trade. In the later portrait of Rida an inkwell and a low table with a small bowl and shallow saucers on top of it are visible at the lower left. Rida is depicted drawing with a reed pen, held between his thumb and forefinger.[26] Unlike Mani, he has dipped the pen in a shallow saucer which probably contains gold paint, the customary pigment Rida used for vegetation. Most likely the other saucers and the bowl on the table contain paint, whereas the small round pot with another *qalam* in it holds ink. If this distinction is valid, then Mani would be dipping his pen into an inkwell, while an artist in

4. Portrait of Fani (or Mani)

Iran, ca. 1610 or later, ink and colours on paper, 13.2 x 8.5 cm., British Museum, Gift of Sir Bernard Eckstgein Bt., OA 1948 12–11 011.

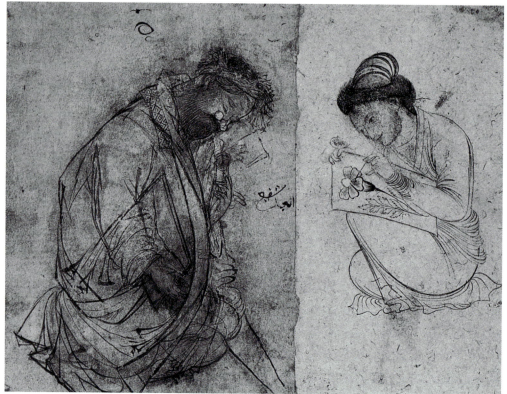

5. Shafi' 'Abbasi, detail, from the "Rida-yi 'Abbasi Album"

Iran, second quarter of the 17th century, ink and colours on paper, 10.4 x 6 cm., Freer Gallery of Art, 53.17.

a drawing in the Metropolitan Museum of Art[27] would be engaged in painting. Likewise, the portrait thought to be that of Shafi' 'Abbasi (pl. 5) shows the young artist painting a pink flower with a tool that appears from its wide tip to be a brush. Possibly the sketchy oval object on his right hand is a dish of paint attached somehow to the back of his hand rather than held by his fingers. Naturally, one cannot conclude from these scraps of evidence that all Safavid artists made drawings only with reed pens, but certainly some of them did do so some of the time.

The Brush or the Pen?

The drawing (pl. 2) of a "Bird, Butterflies and Flowers" (with a false date of 1152/1739–40 and ascription to Muhammad Zaman, based on the invocation "Ya Sahib al-zaman") begs the question of whether it was executed with the pen, the brush or both. Attributed on the basis of style and subject matter to Muhammad Shafi' 'Abbasi, the mid-seventeenth-century artist and son of Rida, the drawing most likely derives from a European pattern book or herbal. Such books were the prototypes of many of the drawings in an album containing several signed works by Shafi' 'Abbasi.[28] Shafi' himself was a noted painter of birds and flowers and may have supplied designs for textiles.

In the centre of the drawing a bird perched on the branch of a flowering shrub grasps a butterfly in its beak while another flutters above them. Below the bird a cyclamen grows out of a low mound of earth. To the right the branch divides into two clumps of flowers and foliage. A flowering plant of another variety blooms at the left, while at the lower right the broad leaves of another plant,

perhaps of the lily family, are visible above the border. Bees seen from various vantage points home in on the inviting blossoms.

The composition conforms to the type adapted by Safavid artists from European floral pattern books. Each plant contains flowers in various stages of maturity from bud to fully open blossom. The addition of birds and insects is standard in both the European and Persian versions. However, in this drawing the bird, the tree stump and the branch up to the butterfly's wing are executed in brown ink in a loose and painterly fashion in contrast to the sharp, steady draughtsmanship of the areas drawn in black ink. One wonders firstly if the brown ink section was drawn at the same time as the rest of the composition and secondly if the bird, branch and tree stump were rendered with a brush while pen and ink were used for flowers and insects.

One can well imagine an artist putting aside his sketch of a bird and branch and later resuscitating and adding to it. Since Shafi' 'Abbasi acknowledged finishing works begun by Rida,[29] he must have had no misgivings about "completing" pre-existing works, whether by another artist or himself. The use of two distinctly different inks – thin brown gallnut ink and black soot ink – could also indicate two different dates of execution. An inspection of the butterfly in the bird's beak (pl. 6) under magnification reveals that the ink of the butterfly's leg (pl. 7) and belly lie on top of the bird's beak. Yet the brown ink to the left of the base of the tree rests on top of the black lines defining a small mound of earth. Therefore, one can surmise that the bird and branch were drawn at the same time as the rest of the picture. Most likely the bird and branch were drawn first with the rest of the composition in

6. Detail of FIG. 2, x6.

7. Detail of FIG. 2, x25.

8. Detail of FIG. 2, x25.

9. Signature of Muhammad Shafi' 'Abbasi,
detail x25

from the "Shafi' 'Abbasi Album", Iran, ca. 1640–75, ink on paper, British
Museum, OA 1988 4–23 035.

mind, and then, after finishing the bulk of the drawing, Shafi' 'Abbasi added a few touches in brown ink.

The question remains, however, of which *qalam* the artist employed, the pen or the brush. To the naked eye the bird and branch appear to be rendered in a wash technique consisting of the wide, short strokes of a brush on the tree stump, and possibly a pen on the bird. By contrast the insects and the flowers growing from the earth and from the extension of the branch on which the bird stands have continuous contours and details formed by parallel lines unquestionably produced by a pen. A comparison of a detail of the branch at the right (pl. 8) with a detail of Shafi' 'Abbasi's signature on an album page (pl. 9) reveals a similar thickening at the end of his strokes on the branch and on the *dal* of "Muhammad". Other stroke endings on the branch are angular, squared or hooked, resulting as one might expect from the pressure applied to the angled cut of the nib.

Shafi' 'Abbasi has used numerous faint striations to draw the bird's head and stronger lines terminating in triangular hooks for its wings and tail. This calligraphic use of line was almost certainly achieved with a pen. Thus, only the tree stump remains as a candidate for brush and ink. Unlike the bird, the tree stump consists of three layers of ink. The first, most thoroughly absorbed into the paper, is a very pale wash employed for shading in the centre of the tree trunk and branch. Over this Shafi' 'Abbasi has

drawn short strokes to indicate bark. Some of these overlap the wider strokes of the contours of the tree stump. Finally the artist has drawn over the brown ink lines of the branch near the bird's claws and the butterfly with swift strokes of black ink.

Although many of the individual strokes of wash seem simply to fade away, one or two terminate in angled or blunt ends characteristic of the pen. Possibly the wash areas were produced by smudging the wet ink strokes with a finger or cloth. On closer inspection the broader strokes that form the outline of the tree also reveal the occasional angled or squared terminus typical of pen strokes. The dots and dashes of darker brown ink added as accents to the outline of the trunk also bear the hallmarks of the pen.

Despite what one observes through a magnifying lens, one receives the distinct impression from a normal distance that the tree stump has been painted with a brush. Because of the extremely fluid pigments and seamless style of Persian painting, individual brush strokes are almost never visible. The paint forms a flat surface on the paper and thus the hairs of the brush do not leave minute ridges. In a few instances, however, the end of a brushstroke will divide slightly as if the hairs of the brush had splayed (pl. 10). No such strokes are visible on the tree stump or bird. Thus one must conclude that the artist purposely drew the bird and tree stump with a pen to look as if they were executed with a brush. This demonstration of artistic sleight-of-hand conforms to the Persian notion

10. Detail of a flower, x25, from the
"Shafi' 'Abbasi Album"

Iran, ca. 1640–75, colours on paper, British Museum,
OA 1988 4–23 013. Note the single stroke that runs
from 6:00 to 9:00.

of artists as magicians or masters of illusion, able to convince the
viewer that he sees things that are not actually there.[30] In addi-
tion to showing his ability to copy or adapt the composition of a
European flower print, Shafi' 'Abbasi has revealed his skill in ren-
dering part of his picture in the style of a European watercolour.

By the third quarter of the seventeenth century, the period
in which this page was produced, the European style was becom-
ing increasingly influential in Iranian painting. Not only did artists
such as Muhammad Zaman copy European paintings and prints
outright, but also some attempted to reproduce European illusionist
techniques such as perspective and modelling. The artist of an album
made in Isfahan for Engelbert Kaempfer in 1684–85 signed his
work "Jani farangi saz", that is "Jani, [painter in the] European style".
Presumably the ability to reproduce the style and subject matter
of European prints enhanced the status of Persian artists in this
period. Shafi' 'Abbasi succeeded in creating a composition that is
Europeanizing in its style, subject matter and layout. Whether
his patrons or only his fellow artists appreciated his use of tradi-
tional Persian implements to produce a European-looking pic-
ture, we will never know. Most likely, though, they admired his
virtuosity and cleverness in making the work of the pen appear to
be that of the brush.

Notes

I would like to thank Sue La Niece of the British Museum Department of Scientific Research for allowing me to use her microscope and camera and for helping me photograph the works under magnification.

1 B.W. Robinson, letter to the author, 16 June, 1992.

2 Qadi Ahmad, son of Mir Munshi, *Calligraphers and Painters*, trans. V. Minorsky [Freer Gallery of Art Occasional Papers, vol. 3, no. 21], Washington, D.C.: 1959, pp. 111–114, 199–200. Sadiqi Beg in Martin Bernard Dickson and Stuart Cary Welch, *The Houghton Shahnameh*, Cambridge, MA: 1981, p. 262.

3 F. Rosenthal, "Abu Hayyan at-Tawhidi on Penmanship", *Four Essays on Art and Literature in Islam*, Leiden: 1971, pp. 24–26. Al-Mu'izz ibn Badis, "Staff of the Scribes and Implements of the Discerning with a Description of the Line, the Pens, Soot Inks, *Liq*, Gall Inks, Dyeing, and Details of Bookbinding" in Martin Levey, "Mediaeval Arabic Bookmaking and its Relation to early Chemistry and Pharmacology", *Transactions of the American Philosophical Society*, N.S. vol. 52, pt. 4, 1962, pp. 13–15.

4 Ibn Badis, *op. cit.*, pp. 39–40.

5 Qadi Ahmad, *op. cit.*, pp. 113–114.

6 Ibn Badis, *op. cit.*, p. 14. Likewise, Qadi Ahmad, *op. cit.*, pp. 111–112, quotes Sultan 'Ali al-Mashhadi as stating, "The reed must be ruddy coloured,/It must not be hard like stone,/nor black, nor too long either."

7 Rosenthal, *op. cit.*, p. 25.

8 *Ibid.*, and ibn Badis, *op. cit.*, p. 14.

9 Qadi Ahmad, *op. cit.*, quoting Sultan 'Ali al-Mashhadi, p. 115.

10 Rosenthal, *op. cit.*, p. 25.

11 Qadi Ahmad, *op. cit.*, p. 154, notes that the sixteenth-century musician and calligrapher Maulana 'Abd al-Hadi Qazvini cut "his *qalam* at a slant", implying that this was an unusual practice.

12 Qadi Ahmad, *op. cit.*, p. 50.

13 Ibn Badis, *op. cit.*, pp. 38–39.

14 Sadiqi Beg in Dickson and Welch, *op. cit.*, p. 262.

15 B.N. Zakhoder in Qadi Ahmad, *op. cit.*, p. 23.

16 Mir Sayyid Ahmad in W.M. Thackston, *A Century of Princes: Sources on Timurid History and Art*, Cambridge, MA: 1989, p. 356. He was writing in 1560–65, about thirty years before Qadi Ahmad.

17 Ibn Badis, *op. cit.*, pp. 15–16. Monique Zerdoun Bat-Yehouda, *Les Encres Noires au Moyen Age*, Paris: 1983, p. 127 ff.

18 Qadi Ahmad, *op. cit.*, p. 112.

19 Qadi Ahmad, *op. cit.*, pp. 199–200.

20 As suggested by Don Baker in conversation.

21 Janet G. Snyder, "Study of the Paper of Selected Paintings from the Vever Collection" in Glenn D. Lowry and Milo Cleveland Beach, *An Annotated and Illustrated Checklist of the Vever Collection*, Washington, DC: 1988, pp. 433–434, 439.

22 Adam Olearius, quoted in Qadi Ahmad, *op. cit.*, p. 113, n. 365.

23 Snyder, *op. cit.*, pp. 434, 437–440. Ibn Badis, moreover, *op. cit.*, p. 39, describes papermaking from flax. Cf. J. von Karabacek, "Das Arabische Papier", *Mitteilungen aus der Sammlung der Papyrus Erzherzog Rainer 2/3*, Vienna: 1887, trans. Don Baker and Suzy Dittmar: *Arab Paper*, London: 1991. Von Karabacek's exhaustive study also reaches the conclusion that flax was the most common source of Arab paper.

24 For example, the very early Mughal portrait of Shah Abu'l-Ma'ali in Stuart Cary Welch, *Wonders of the Age*, Cambridge, MA: 1979, cat. no. 75, p. 195.

25 Abolala Soudavar, *Art of the Persian Courts*, New York: 1992, p. 264, figs. 45 and 46. Soudavar believes both portraits are authentic and that, in accordance with their inscriptions, the one with two dates, 1635 and 1673, is in the style of the first half of the seventeenth century, whereas the one dated 1673 represents the style of the latter part of the century.

26 Soudavar, *op. cit.*, p. 265 notes that Rida used a reed pen but does not specifically connect this observation with the pen in Mu'in's portrait.

27 Marie Lukens Swietochowski and Sussan Babaie, *Persian Drawings in The Metropolitan Museum of Art*, New York: 1989, cat. no. 29, p. 69.

28 British Museum, Department of Oriental Antiquities, 1988 4–23 01–056; Basil Gray, "An Album of Designs for Persian Textiles", *Aus der Welt der islamischen Kunst: Festschrift für Ernst Kühnel*, ed. Richard Ettinghausen, Berlin: 1959, pp. 219–225.

29 B.W. Robinson, ed., *Islamic Painting and the Arts of the Book*, London: 1976, cat. no. III. 387, pp. 208–210, pl. 88.

30 Qadi Ahmad, *op. cit.*, p. 174 ff.

The Qajar Court Painter Yahya Ghaffari: His Life and Times

LAYLA S. DIBA

WE ARE EXTREMELY PRIVILEGED TO HAVE FOR LATE nineteenth-century Persian art the kind of documentation rarely available for the study of Persian painting and painters in previous centuries. Literary and historical sources, biographical information, court journals, legal documents as well as oral histories and testimony from living family members are among the resources available and these have been used extensively in recent years in the works of Iranian scholars.[1]

On the other hand, from the seventeenth century onwards, European travellers to Persia left invaluable records as well, and provided a firm historical background for B.W. Robinson's seminal articles on Qajar painting and art.[2] The following study is in small part a response to Robinson's own recognition of the importance of using both types of sources for a balanced appreciation of Qajar painting.

The considerable evidence for the artistic contribution of the Ghaffari family over the course of more than 250 years had previously led to an investigation of their role in the development of Persian painting in the eighteenth and nineteenth centuries.[3] The prominent role played by Abu'l-Hasan Ghaffari and Muhammad Ghaffari during the reign of Nasir al-Din Shah (1848–96) is quite well documented. However, the career of Yahya, son of Abu'l-Hasan Khan Ghaffari, also known as Abu'l-Hasan the Third, a minor figure in this artistic pantheon, is little known and may shed new light on late nineteenth-century painting.

The Ghaffari family originated in Kashan. They rose to prominence in political and bureaucratic positions in the eighteenth century during the reign of Nadir Shah (1736–47), although they trace their roots back to the early centuries of Islam.[4] Thus, they actively discouraged one of their members, Abu'l-Hasan-i Avval,

Abu'l-Hasan the First, from exercising the lowly profession of painter and encouraged him to follow family tradition by becoming court scribe and historian to Karim Khan Zand (1750–1779), the *de facto* ruler of Persia. His enthusiasm for painting is recorded in the introduction to his *History of the Zand Dynasty*, completed in 1796 after his death by his son. Surviving watercolours show that he had a distinct talent for depicting historical and family figures and events as well as those of his own day.[5]

The artistic inclination of this talented family again reappeared in the mid-nineteenth century when his grand-nephew, Abu'l-Hasan-i Thani, Abu'l-Hasan the Second, began his meteoric rise to court painter (*naqqashbashi*) first under Muhammad Shah (1834–48) and then under his successor, Nasir al-Din (1848–96).[6] Abu'l-Hasan's talents were so striking that he was sent to Europe for a period of study in 1848–9. It was there that he perfected a talent for realistic portraiture inherited from his uncle and probably inspired by the family portraits and documents still preserved in the Ghaffari family collections. While in Europe he most probably became acquainted with two technological innovations that were changing the face of European art and culture in the nineteenth century and were to do the same in Iran: lithography and photography.

On his return, he resumed his career as court portraitist *par excellence* and by 1852 was being given commissions to illustrate a six-part manuscript of the *One Thousand and One Nights* for Nasir al-Din Shah and a monumental wall painting of the ruler and his court for the Nizamiyya palace of the prime minister Aqa Khan Nuri. The large number of painters needed to execute these projects under Abu'l-Hasan's supervision were trained by him in a special academy devoted to painting and lithography on the palace grounds, which

was modelled on European prototypes. By 1861, he had been awarded the title Sani' al-Mulk ("Craftsman of the Kingdom") in recognition of his services, including director and chief illustrator of the court newspaper, the *Ruznama Dawlat-i 'Aliya-yi Iran*. He was also appointed Under-Secretary to the Minister of Science. These positions he filled admirably until his death some time after 1866.

Sani' al-Mulk was a gifted Persian manuscript illustrator (pl.3) in the traditional style and yet had tremendous expressive power as well (pls.1 and 8). These qualities were coupled with an understanding of modelling and perspective far superior to that of his contemporaries. He was also among the few to have a familiarity with the new processes from Europe, and he knew how to use them to full advantage. His illustrations for the *Ruznama* recall Daumier in their gift for psychological caricature and Goya in their expressiveness and drama. Additionally, he inherited generations of family expertise in court politics, while his administrative talents were far beyond the abilities of other painters of his day, and he used these advantages to reach the highest court positions of his time.

Abu'l-Hasan had a brother, Mirza Buzurg, who was a talented artist as well, although perhaps not the prolific genius his brother was, as can be seen in the portraits of court dignitaries he executed for the *Ruznama*.[7] Mirza Buzurg's sons, Abu Turab Ghaffari and Muhammad Ghaffari, Kamal al-Mulk ("Perfection of the Kingdom"), were also trained as painters and had important careers at court. Abu Turab was a respected artist, primarily known for his illustrations for another court newspaper, *Sharaf*. He died an untimely death under tragic circumstances to be described further on.[8]

Kamal al-Mulk was to surpass even his uncle Sani' al-Mulk and is considered by many contemporary writers to be Persia's greatest painter and the father of modern painting. An immensely dedicated and talented painter, he completely assimilated Western academic painting standards and techniques to produce works of unsurpassed photographic realism. Besides his royal commissions he attempted to introduce themes of a more popular or national character. He also founded an Academy of Painting which trained artists who were to continue his style of nineteenth-century academic painting in a purely derivative manner until after World War Two.[9]

Other cousins, 'Ali Reza and Mas'ud Ghaffari, also painted for the court in the third quarter of the nineteenth century. Mas'ud left an illustrated geographical manuscript and a number of illustrated lithographic books.[10]

Sani' al-Mulk himself had three sons, all of them scribes, according to a number of sources: at least two of them, Asadallah and Yahya Khan, became painters. Although both seem to have had active careers, neither reached the fame or stature of their father, Abu'l-Hasan, or their cousin Muhammad; the latter confirmed that Asadallah was a painter and there are a handful of works ascribed to him, including a drawing in the "Churchill" album.[11]

The careers of these artists thrived thanks to extensive court patronage of the arts. Such patronage, especially that of poetry and painting, flourished in Persia whenever the political or economic situations were favourable and particularly when the rulers themselves were artists or *amateurs d'art* such as in late fifteenth-century Herat, sixteenth-century Tabriz or seventeenth-century Isfahan. This patronage sometimes expressed itself in intimacy and friendship with the poets, calligraphers and painter-courtiers themselves – such as the relationship between Shah Tahmasp and the painters Sultan Muhammad and Aqa Mirak. Royal workshops were established in the palace grounds and contributed to the superior quality and also to the standardization of Persian painting and decorative arts.[12]

In the nineteenth century, the Qajar rulers and their powerful families and courtiers revived these same traditions after the more limited interest in such matters shown earlier in the eighteenth century, as a result of the fall of the Safavid empire in 1722. An important school of life-size mural painting appeared, primarily due to the patronage of Fath 'Ali Shah (1797–1834) and the building programmes undertaken during his reign. While his successor, Muhammad Shah (1834–48) showed less interest in painting, it was during his reign that the foundations were laid for the artistic revival that was to follow in the second half of the nineteenth century during the reign of his son and heir Nasir al-Din Shah. These foundations included the presence of European painters and the introduction of photography.

If not a gifted artist himself, Muhammad Shah nevertheless is said to have taken lessons from the English painter Sir Robert Ker Porter, who visited Iran in 1817–20,[13] and to have sat for his portrait with various European diplomats, artists, and adventurers who travelled to Iran at the time: these included F. Colombari, Eugene Flandin, the Russian prince Alexis Soltykoff and perhaps the most talented, Jules Laurens, who accompanied the French archaeologist Hommaire de Hell on his mission during the years 1846–48.[14]

Even members of the harem were instructed to sit for their portraits by the European painters.[15] Soltykoff notes that he executed three portraits of the young crown prince Nasir al-Din: one for the Queen Mother, one for Muhammad Shah and one for himself.[16] The young prince also exercised his talents with a pencil portrait of Colombari and a sketch of a small mausoleum after the latter, dated 1261/1845.[17]

It does seem likely that these European artists, who were all admitted to the royal court and socialized freely with its members, must have had some influence on the development of the school of portraiture which flourished in the following reign. And yet already Soltykoff notes that he heightened the colours and added more detail to conform to Persian taste, for which he was amply rewarded. The accommodation to Persian taste can be clearly seen in a watercolour portrait of Muhammad Shah by Colombari (pl.2), one of three works varnished in the Persian manner.[18]

Another factor which was to be instrumental in the method and style of the school of Nasiri painting is the art of photography. Recent research has clearly shown that it was already introduced at the court of Muhammad Shah in the 1840s by Jules Richard, a teacher at the *Dar al-Funun* College. During the same period, the Qajar prince Mirza Qasim Malik was an enthusiast for photography and painting. An ink drawing, after a photograph of him, was sketched by the painter Aqa Bala in 1275/1858–9. For the history of painting, more important is that a number of daguerrotypes of court figures which Richard produced were used as models for portraits by Muhammad Ghaffari in the 1880s, according to inscriptions on the works themselves, still in the Gulistan Palace collection.[19] These examples provide the first firm evidence of the direct influence of photography.

A very significant passage in the *Ma'athar va'l-Athar* ("Good Works and Monuments") written in 1307/1889–90 by the contemporary courtier and observer, 'Itimad al-Saltana, notes: "Since photography was discovered, it has been of great service to the art of design (*san'at tasvir*). The art of landscape rendering (*durnamasazi*), of portraiture (*shabihkashi*), of light and shade (*vanamudan-i saya rushan*) and the use of the laws of perspective as well as other aspects of this technique: all have found their originality and have been perfected".[20]

Tellingly, while he emphasizes the importance of photography in the emergence of illustrated newspapers, he adds that no-one could equal Sani' al-Mulk in the art of portraiture (*shabihsazi va chahra pardazi*) without it.

Thus, the presence of European painters spurred the development of a major school of portraiture under the leadership of Sani' al-Mulk in the first half of Nasir al-Din Shah's reign. Artists of this school used photography to a greater or lesser extent according to their talents, either as a model or to complete portraits of impatient sitters. Likewise the aesthetics and technical requirements of photography were to influence portraiture in the poses, background and fixed gazes of the sitters. It is an irony that the perceived intensity and heightened expression of the portraiture of this period may merely be due to the uncomfortably long and immobile poses required by early photography.

Photography was to be even more crucial first to the development and then to the predominance of the art of cityscape and landscape painting in the second half of Nasir al-Din Shah's reign. Photography had finally given Iranian painters the means with which to render nature in an absolutely faithful manner, an aesthetic ideal that had always been present in Iranian painting connoisseurship since the Timurid period, and which underlay the immediate acceptance and rapid dissemination of photography.

It is remarkable that realistic painting flourished as it did in the last decades of the nineteenth century and the early decades of the twentieth, in spite of the popularity of photography. Its success can undoubtedly be attributed to the talents and traditional training of Persian painters. Indeed, it has been noted that the lack of

success of European painters in Persia was due to a very active local school of portraiture, which did not exist in other lands of the Middle East.[21]

Royal patronage was of crucial importance in this artistic revival. Nasir al-Din Shah remains a controversial figure to historians. He was a complex man, torn between East and West, tradition and innovation, curious about the superficial aspects of Western culture and anxious to incorporate them into court life, yet maintaining the life-style and political approach of an oriental autocrat.[22]

He was, for instance, an amateur photographer and an enthusiastic Sunday painter.[23] His interest in photography was undoubtedly stimulated by the expensive gifts of photographic material sent by both British and Russian monarchs. Numerous albums of his photography are housed in the Gulistan Palace library collection and provide a vivid record of court life of the period.[24] More importantly, the Gulistan palace was considerably enlarged during his reign with a number of new palaces, such as the Shams al-'Imarat.[25]

He even created a European-style museum in the Gulistan Palace to display his gifts and treasures; he himself enjoyed directly supervising the hanging and installation of his paintings in various areas of the palace, including the halls of the Shams al-'Imarat.[26]

Yet it is his patronage of *Persian* painting that concerns us here. Without his direct involvement, enthusiasm, connoisseurship, and creation of institutions to train a school of painters on the premises of the Palace itself, this late nineteenth-century school of portraiture would not exist. European observers noted the great potential of Persian painters if they were properly trained and supported,[27] a potential that was largely realized, but which still remains to be recognized. Specific examples of his direct effect include annual visits to the Dar al-Funun to view exhibitions of the students' paintings, and his ability to select the best artists, such as Sani' al-Mulk, Kamal al-Mulk and Yahya. Numerous instances are noted of his generosity and support of painting with the distribution of titles and *padash*. His touching attempts to gather together all the works of Sani' al-Mulk after his death in a tribute to his favourite painter are also recorded by contemporary witnesses.[28]

Most importantly, the major commissions stemmed from him and in turn stimulated further sub-royal patronage: the previously mentioned manuscripts of the *One Thousand and One Nights*, the recording of palace interiors, printing and lithographic projects gave a whole new focus to painters' talents.[29]

These aspects of his personality were of course part of the traditional princely image and attainments expected of a Persian monarch: his training as a painter, the interest in recording historic events, particularly portrait painting, the close imitation of nature, the copying of European works so that they could not be distinguished from the originals – all are familiar traits of royal patronage since the Safavid period.

This lavish patronage attracted a considerable number of artists to the court, whose names and biographies are recorded: most espe-

cially, 16 or 17 major painters working at the court are listed in a contemporary source;[30] to this may be added at least another 10 from surviving works, 30–40 painters recorded as having been trained during the seven-year *One Thousand and One Nights* project and the Nizamiyya palace project, and annual graduates of the *Dar al-Funun* school.

This, then, was the artistic climate into which Yahya was born, a situation full of possibilities for any painter, and doubly so for one with his family background. His period of activity, established by his dated works and contemporary references, ranges from the 1860s to the 1880s and he died some time after that (between 1313/1895 and 1324/1906). While the exact date of his birth is unknown, a date in the 1840s seems probable.[31] Two contemporaries, Kamal al-Mulk and Furughi, note that he was the youngest of three sons, all painters, born to Abu'l-Hasan, and that he worked at the court of Nasir al-Din Shah.[32]

It is most probable that he obtained his initial training with his father, perhaps even working as an apprentice on some of his important commissions, such as the *One Thousand and One Nights* and the Nizamiyya portraits. He certainly would have had an informal apprenticeship with his father, with access to Sani' al-Mulk's studies.[33] He may have attended formal classes in painting at the *Dar al-Funun* College, founded in 1851. What is clear is that he had at an early age assimilated the rudiments of his father's style and the artistic vocabulary of the period, as can be seen in a watercolour sketch of a lady (pl.4) dated ten years after the *One Thousand and One Nights*, which recalls in feeling if not in exact composition Abu'l-Hasan's portrait of Khurshid Khanum (pl.5).

It is perhaps in this early period that Yahya exercised his talent for copying European paintings in the school founded by his father and that he used lithographs and plaster casts of the works of Michelangelo and Raphael: contemporary scholars record the existence of a copy of a painting of a fire by Raphael, undoubtedly the *Fire in the Borgo*, from the Stanza dell' Incendio in the Vatican Museum.[34]

His next important commission is a manuscript of the *Masnavi* of Jalal al-Din Rumi,[35] dated 1279–80/1863–64 on fol. 11v. (end of part II), for which he executed 56 miniatures. It is not impossible that this commission, certainly inspired by Sani' al-Mulk's success with the *One Thousand and One Nights* project and most probably made for a patron connected with the court, may have been passed on to his son, during a period when Sani' al-Mulk himself was too occupied with his duties at the *Ruznama* to accept other projects. The manuscript also contains a number of explicit erotic scenes, perhaps requested by the patron, a request that Sani' al-Mulk may have preferred to have had carried out by another painter.

The miniatures are certainly a delightful example of the adaptation of his father's manuscript illustration style, such as the illustration of a youth and a maiden by a stream (pl.6), one of four in the manuscript which are inscribed *raqam-i Yahya*. The for-

mat of the paintings is a simplified version of that adopted by his father, as are many compositions (for comparison see pl.7). However, the colour scheme selected for the *Masnavi* is much more pastel and Yahya lacks the expressionistic abilities of his father, such as in this riveting scene from the *One Thousand and One Nights* of a woman being stoned (pl.8). Yahya also shows a tendency to greater exaggeration of perspective and height, which give many of these paintings a very distinctive character.

However, a number of the illustrations of the episodes are not based on any known prototypes, since illustrated manuscripts of the *Masnavi* are exceedingly rare. Yahya therefore had to call on his own powers of invention. This was a task which he performed with some charm and simplicity, as in a night-time scene of an elephant looking at the moon (pl.9), reminiscent of Douanier Rousseau.

Sani' al-Mulk's death occurred shortly after this commission. His presence must have been sorely missed by Nasir al-Din Shah, if we are to credit the evidence of Furughi and Kamal al-Mulk who both maintain that the title Abu'l-Hasan the Third was given to Yahya by Nasir al-Din Shah both to encourage Yahya and to perpetuate his father's memory.[36] A portrait of his father (pl.10) executed according to the inscription in 1298/1876 after a self-portrait, is the first work signed with the honorific accorded him by Nas-r al-Din Shah, Abu'l-Hasan-Thalith, and shows how thoroughly Yahya could work in his father's style.[37] A portrait of an unidentified grandee (pl.11), a year later in date and signed in the same manner, again recalls his father's work, such as the famous study for the portrait of Khusraw Khan Kirmani, who may have sat for this painting as well.[38]

Finally, two surviving oil paintings in the Gulistan Palace collection attest to Yahya's continuing career as a court painter. The earlier is dated 1303/1886 and is a carefully rendered perspectival view of the Palace square (pl.12). It is painted in the naturalistic style rendered fashionable by the European paintings brought on his return from his trips by the Shah and as taught by 'Ali Akbar Khan, Muzayyan al-Dawla, chief teacher at the *Dar al-Funun*. A comparison with a similar subject by his cousin Kamal al-Mulk (pl.13) painted in the same year shows a parallel yet far superior approach. Yahya also painted a view of the Diamond Hall (Utaq-i Birilian) (pl.14) on the orders of Nasir al-Din Shah, in 1305/1888. A comparison with one of Kamal al-Mulk's most famous paintings of this same subject, done over the course of *five* years, 1305–10/1888–1893,[39] (pl.15) points out Yahya's limitations when compared with a painter of the first rank.[40]

Now this rather dry sketch of a typical late nineteenth-century court painter's career is dramatically altered by the evidence of two contemporaries about his private life: the kind of evidence so rare in Persian sources. Furughi comments: "Yahya did not live to fulfil the promise of his early career or the responsibilities of his name".[41] Indeed it appears that, like a number of his contem-

poraries, he became addicted to wine, opium and other intoxicants. The strange perspectives and distortions sometimes characterizing Yahya's works may thus be due in part to these habits.

But even more tragically, Yahya was to be involved in the suicide of his more talented cousin, Abu Turab, who visited Yahya on the day of his death. I'timad al-Saltana, who was Abu Turab's superior at the royal printing house, records the event vividly and with great sadness in his *Diaries*, or *Khatirat*, for Tuesday, 19 Rajab 1307/ 1 March 1890.[42] He somehow holds Yahya responsible for his cousin's death, even though after having taken a lethal dose of opium which he had provided himself, Abu Turab had been returned to his own home and had resisted all efforts to save him. It was, as so often, an *affaire du coeur*. According to I'timad al-Saltana, Abu Turab had determined to die because his wife had dishonoured him; Furughi is less specific and refers to differences with family members, from which Kamal al-Mulk was more protected, because of his privileged position at court, with lack of funds and depression as contributing factors.

He was even accorded the title of *pidarsukhta* (knave) by I'timad al-Saltana, not really an objective observer here, as he lost an excellent employee by this tragic act. That this was one title he did not deserve seems obvious, but the clouded circumstances surrounding this death are probably partly responsible for Yahya's absence in the roster of famous Nasiri painters[43] and undoubtedly contributed to his decline from drug abuse.

Yahya may be discussed as a typical example of a painter of modest talent but interesting connections whose work mirrored the two most important developments in later Persian painting attributable, ironically, to his own father and cousin: a flowering of the art of portraiture and the introduction of academic landscape and cityscape painting in a western style. Nevertheless, this seemingly minor painter became of major interest with the recent discovery of his wonderful illustrated *Masnavi*, a truly impressive achievement. It suggests that Yahya has been seriously overshadowed by his more famous family members and concomittantly underestimated by his contemporaries and later writers.

But more importantly, the re-discovery of this *Masnavi* allows us to reconstruct a corpus of later illustrated manuscripts. This group shares one common characteristic: unusual and curious subject matter, or some form of novelty, of a type absolutely typical of nineteenth-century interests. Included in this group are: a manuscript of *Shirin and Farhad* of Vahshi Bafqi with 5 miniatures by Sani' al-Mulk, a translation of the *Travels in Africa* of Dr. George Shonfort with copies of the original illustrations by Mas'ud Khan Ghaffari in 1291/1874–5, and a translation of the *Tour Du Monde* of the year 1300/1878 with illustrations after photographic originals by Hasan ibn Ahmad.[44]

While the preceding analysis has emphasized the importance of portrait and landscape painting in the second half of the nineteenth century, the *Masnavi* may very well inspire a reconsideration of the continuing importance of manuscript illustration in this later period and thus fundamentally change the current understanding of the course of later Persian painting.

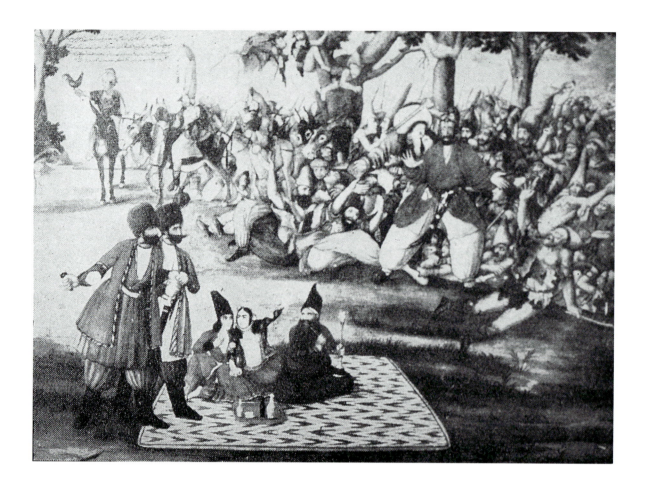

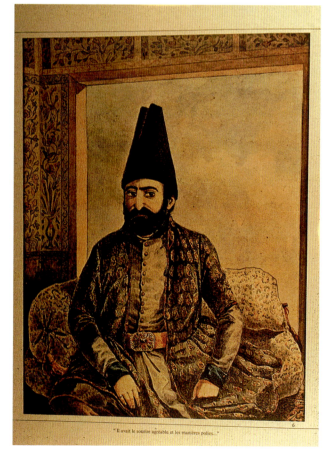

1. Abu'l-Hasan Khan Ghaffari.
A RIOT IN ISFAHAN.
Watercolour; Signed and dated: *...raqam-i chakar-i dargah-i Shahanshahi Abu'l-Hasan-Ghaffari Naqqashbashi Kashani dar bist va shishum-i mah-i mubarak-i Ramazan surat itmam pazir yaft sana 1268*/August 1852.

2. F. Colombari.
PORTRAIT OF MUHAMMAD SHAH.
Watercolour on paper. Ca. 1840. Private collection.

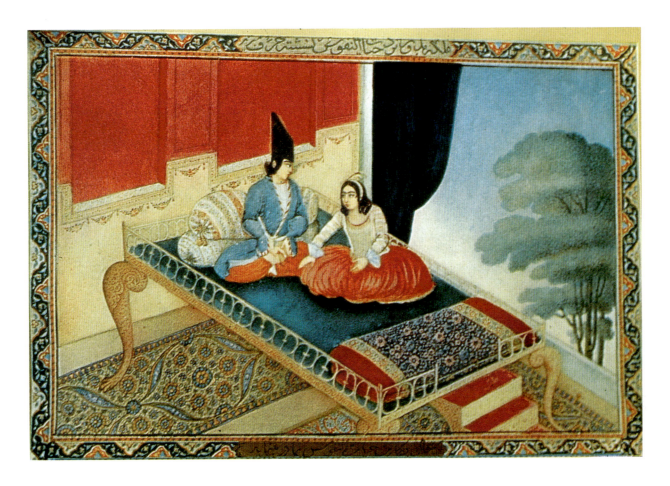

3. Abu'l-Hasan Khan Ghaffari.
THE QUEEN IN CONVERSATION.
Illustration to the manuscript of *1001 Nights*. Gulistan
Palace Library, no. 2240 (folio numbers not available).
ca. 1269/1852–3.

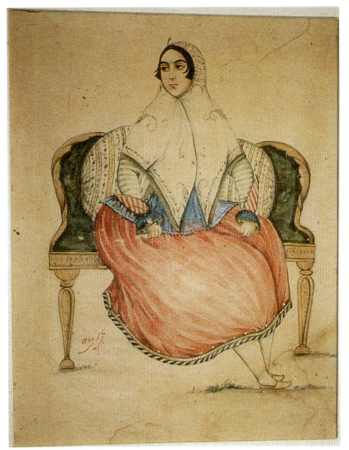

4. Yahya Ghaffari.
PORTRAIT OF A LADY.
Watercolour on paper. Signed and dated: *raqam-i Yahya,
1278/1862*. Art Market, London.

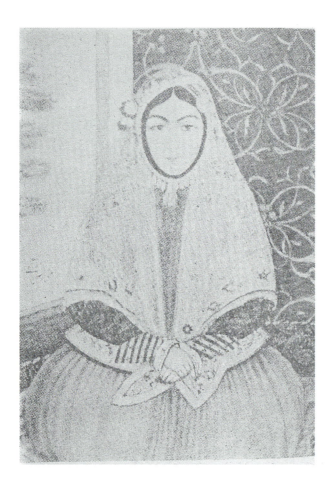

5. Abu'l-Hasan Ghaffari.
PORTRAIT OF KHURSHID KHANUM.
Signed and dated: *mashq-i Abu'l-Hasan-Thani Ghaffari sana
1259/1843–44*. Private collection, Paris.

6. Yahya Ghaffari.
YOUTH AND MAIDEN BY A STREAM.
Illustration to a manuscript of the *Masnavi* of Jalal al-
Din Rumi. Book IV, folio 3. Signed: *raqam-i Yahya*.
Dated 1279–80/1863–4. Private collection, London.

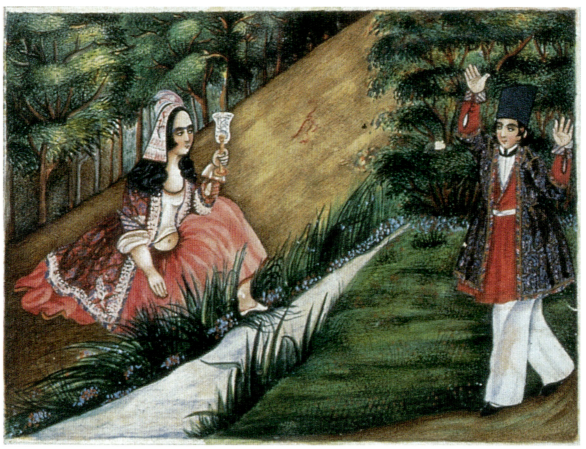

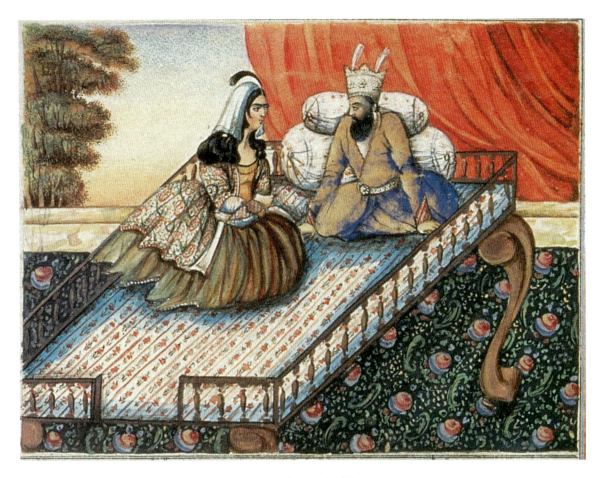

7. Yahya Ghaffari.
PHARAOH WITH HIS CONSORT, ASIYA.
Illustration to a manuscript of the *Masnavi* of Jalal al-Din Rumi. Book IV, folio 76. Dated 1279–80/1863–4. Private collection, London.

8. Abu'l-Hasan Ghaffari.
A WOMAN STONED BY HER BROTHER-IN-LAW.
Illustration to a manuscript of the *1001 Nights*. Ca. 1269/1852–3. Gulistan Palace Library, no. 2240 (folio numbers not available).

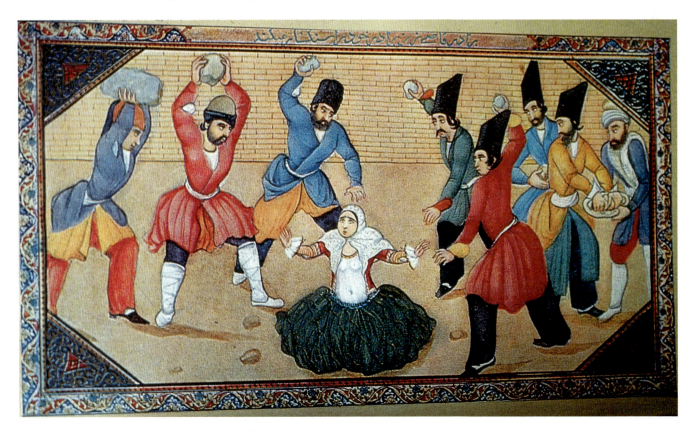

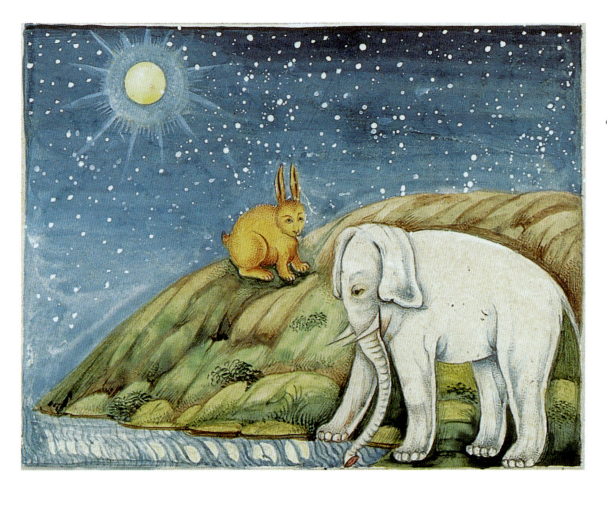

9. Yahya Ghaffari.
THE ELEPHANT
LOOKING AT THE
MOON.

Illustration to a manuscript of the *Masnavi* of Jalal al-Din Rumi. Book III, folio 78. Dated 1279–80/1863–4. Private collection, London.

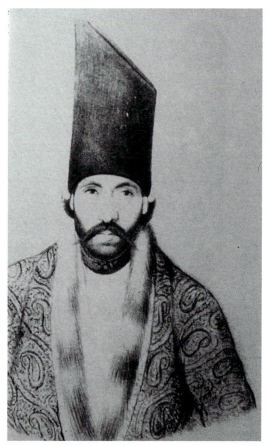

10. Yahya Ghaffari.
PORTRAIT OF HIS
FATHER, ABU'L-
HASAN.

Watercolour on paper. Signed and dated: *Abu'l-Hasan-i Thalith, 1293/1876.* Private collection, Tehran.

11. Yahya Ghaffari.
PORTRAIT OF A MAN.

Watercolour on paper. Signed and dated: *Hunar az khanazad Abu'l-Hasan-i Thalith, 1294/1877.* Private collection.

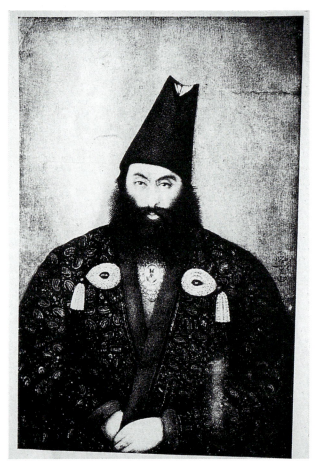

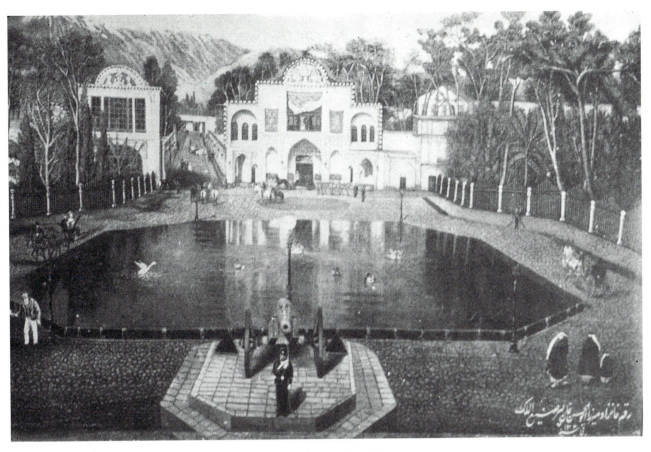

<div style="text-align:center">

12. Yahya Ghaffari.
THE ALI QAPU PORTAL, AND PALACE SQUARE.

Oil on canvas. Signed and dated: *raqam-i khanazad mirza Abu'l-Hasan Khan pasar-i Sani' al-Mulk fi sana 1303/1885-6.* Gulistan Palace Museum, Tehran.

13. Muhammad Ghaffari.
A GARDEN COURTYARD IN THE GULISTAN PALACE.

Oil on canvas. Signed and dated: *durnama-yi 'Imarat-i Gulistan hasb al-amr-i A'lahazrat-i aqdas khassa tamam shud amal-i Muhammad Ghaffari Kashani. 1303/1886–87.*
Gulistan Palace Museum, Tehran.

</div>

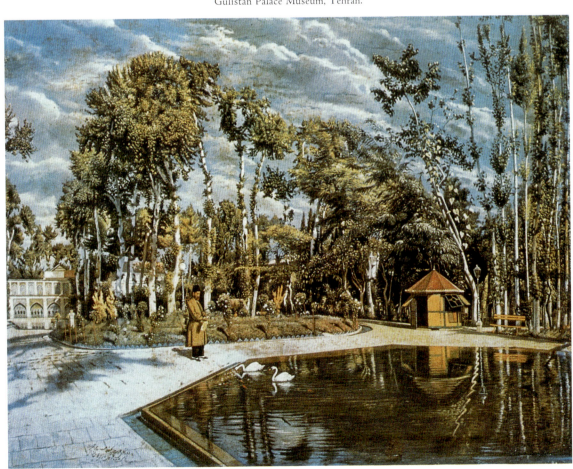

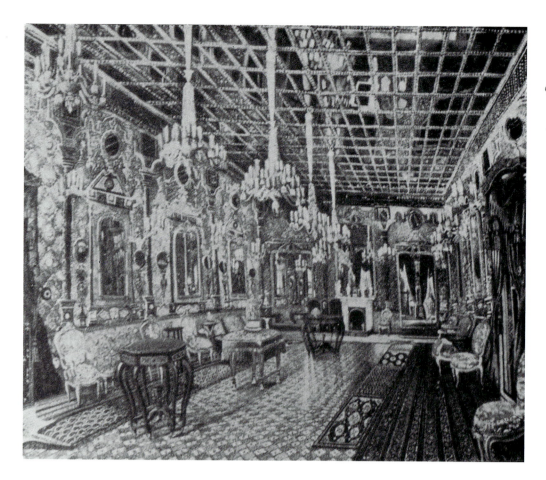

14. Yahya Ghaffari.
THE DIAMOND HALL OF THE
GULISTAN PALACE.
Oil on canvas. Signed and dated: *hasb al-amr-i*
bandigan-i A'lahazrat-i Shahanshah-yi al-'alamin
fadah utaq-i mubarak-i birilian, bi dast-i khanazad
'Abu'l-Hasan Khan tashshakul yaft. 1305/1888.
Gulistan Palace Museum, Tehran.

15. Muhammad Ghaffari.
THE DIAMOND HALL OF THE
GULISTAN PALACE.
Oil on canvas. 1305–10/1888–93.
Gulistan Palace Museum, Tehran.

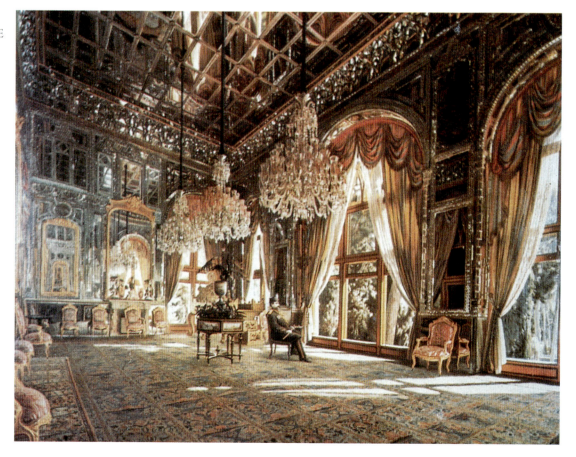

Notes

I wish to take this opportunity to thank Farrokh Ghaffari for his comments and for permission to publish works from his collection. The transliteration of living authors' names follows that adopted in their published works in Western languages; otherwise the standard system has been maintained.

1 See: Yahya Zoka, "Mirza Abu'l-Hasan Khan Ghaffari", *Hunar va Mardum*, 1963, series 8, no. 10, part 1, pp. 14–27; no. 11, part 2, pp. 16–33; Muhammad 'Ali Karimzada-Tabrizi, *Ahval va Athar-i Naqqashan-i Qadim-i Iran*, 3 vols., London, 1363 S/1985 ff.; Farrokh Ghaffari, "Abu'l-Hasan-i Mostowfi", *Encyclopaedia Iranica*, ed. Ehsan Yarshater, vol. 1, London, 1983, fasc. 3, p. 211; Ahmad Suhayli-Khwansari, *Kamal-i Hunar, Ahval va Athari-i Muhammad Ghaffari, Kamal al-Mulk*, Tehran, 1990.

2 Basil W. Robinson, "Qajar Art", *Highlights of Persian Art*, Boulder, Colo. 1979, pp. 330–61; *idem*, "The Court Painters of Fath 'Ali Shah", *Eretz-Israel*, Jerusalem, 1963, VII, pp. 94–105; *idem*: "Art in Iran: Qajar 2", *Encyclopaedia Iranica*, ed. Ehsan Yarshater, vol. 2, London, 1987, pp. 637–40.

3 L.S. Diba, "Persian Painting in the 18th century: Tradition and Transmission", *Muqarnas* VI, 1989, pp. 147–159.

4 From H. Naraqi and F. Ghaffari, *Khandan-i Ghaffari*, Kashan and Tehran, 1974, first noted in: Zoka, *Hunar*, part 1, p. 15, note 3; see also G.P. Churchill, *Biographical Notices of Persian Statesman and Notables*, Calcutta, 1906, p. 21. I wish to thank Maryam Mass'udi for this reference.

5 Diba, "Persian Painting", p. 156.

6 See Zoka, "Abu'l-Hasan", for his complete biography, and works.

7 Cf. Suhayli-Khwansari, *Kamal*, p. 3 and illus. p. 5.

8 Mahdi Bamdad, *Tarikh-i Rijal-i Iran*, vol. 1, Tehran, 1347–51 S/1968–72, pp. 71–2; Basil W. Robinson, "The Tehran Nizami of 1848 and other Qajar lithographed books", *Islam in the Balkans. Persian Art and Culture of the 18th–19th Centuries*, ed. Jennifer M. Scarce, Edinburgh, 1979, p. 73; Karimzada-Tabrizi, *Ahval*, vol. 1, pp. 19–20; and nn. 40–41 below.

9 Isma'il Ashtyani, "Shahr-i Hal-i Tarikh-i Kamal al-Mulk", *Hunar va Mardum*, year 1, 1342 S/1963, no. 7, pp. 8–19; G.R. Scarcia, "Qajar School", *Encyclopedia of World Art*, New York, 1959–68, vol. 1, col. 819; Karimzada-Tabrizi, *Ahval*, vol. 3, pp. 1031–59; Karim Emami, "Art in Iran: Post-Qajar", *Encyclopaedia Iranica*, ed. Ehsan Yarshater, vol. 2, London, 1987, pp. 640–46; Suhayli-Khwansari, *Kamal*, plate facing p. 368 for an illustration of a painting of *Three Attendants at the Hunt*, painted by Kamal al-Mulk in 1302/1885, Gulistan Palace, Tehran and *Maktab-i Kamal al-Mulk*, Nashr-i Abgina, Tehran, 1986, pl. facing p. 96 for an illustration by a later follower of Kamal al-Mulk, Husayn Shaykh, the *Haft-Sin*.

10 See Badry Atabay, *Fihrist-i Tarikh-i Safar-Nama-Siyahat-Nama, Ruznama va Jughrafiyya-yi Khatti-yi Kitabkhana-yi Saltanati*, Tehran, 2535 S/1976, vol. 2, no. 237, pp. 58 ff.; also Robinson, "The Tehran Nizami", p. 73.

11 Qasim Ghani, *Yaddashtha-yi Duktur Qasim Ghani*, London, 1981, vol. 5, p. 27; and Basil W. Robinson, *Persian Miniature Painting from Collections in the British Isles*, London, 1967, p. 82, no. 102/13; Karimzada-Tabrizi, *Ahval*, vol. I, p. 64.

12 Anthony Welch, *Artists for the Shah: late 16th Century Painting at the Imperial Court of Iran*, London, 1976; S. Cary Welch and Martin B. Dickson, *The Houghton Shah-Nameh*, Cambridge, Mass., 1981; Thomas W. Lentz and Glenn D. Lowry, *Timur and The Princely Vision. Persian Art and Culture in the 15th Century*, Washington, 1989.

13 Lynne Thornton, *Images de Perse, Le Voyage du Colonel F. Colombari à la Cour du Chah de Perse de 1833 à 1848*, Paris, 1981, p. 7.

14 See Thornton, *Images*, for a bibliography of the publications of their travels.

15 Thornton, *Images*, p. 24.

16 Thornton, *Images*, p. 45, no. 45, ill. p. 29.

17 See Thornton, *Images*, p. 19 for an illustration with the following pencil notation in the crown prince's hand: *az ruyi kar-i Musiu Kulumbari vali 'ahd kashida fi shahr zi qa'd sana 1261.*

18 Contrast this with the simplicity of effect of the sketch by Mme. Labat, the wife of Léon Labat, the Shah's French doctor, illustrated in Thornton, *Images*, p. 18.

19 The above is condensed from Chahryar Adle and Yahya Zoka, "Notes et Documents sur la Photographie Iranienne et son Histoire", *Studia Iranica*, 20, 1983, pp. 249–80; also Donna Stein, "A Persian Harem as it Really Was", (unpublished lecture); and Scarcia, "Qajar", col. 819 for a discussion of a portrait by Kamal al-Mulk painted from a photographic likeness.

20 First noted by Adle and Zoka, "Notes", p. 274–5.

21 Philippe Julien, *The Orientalists*, Oxford, 1977, pp. 160–61.

22 See Abbas Amanat, *The Pivot of the Universe. Nasir al-Din Shah and the Iranian Monarchy, 1831–1871*, Berkeley, Los Angeles and London, 1997.

23 Karimzada-Tabrizi, *Ahval*, vol. 3, pp. 358–59; Bamdad, *Tarikh-i Rijal-i Iran*, vol. 3, p. 336 for a sketch of I'timad al-Saltana by the Shah.

24 Badry Atabay, *Fihrist-i Albumha-yi Kitabkhana-yi Saltanati*, Tehran, 2537/1978.

25 Yahya Zoka, *Tarikhcha-yi Arg-i Saltanati*, Tehran, 1349 S/1970; see also Dr. Feuvrier, *Trois Ans à la Cour de Perse*, Paris, 1906, p. 401 for a map of the palace grounds.

26 Dust 'Ali Khan Mu'ayyir al-Mamalik, *Rijal-i 'Asr-i Nasiri*, reprint, Tehran, 1361 S/1982, chapter 29, p. 289. This important source for 19th-century Persian painting will be the subject of a forthcoming study by the author.

27 S.G.W. Benjamin, *Persia and the Persians*, London, 1887, pp. 319–20; Jacob Polak, *Persien, das Land und Seine Bewohner*, Leipzig, 1863, vol. 1, p. 290–91.

28 Dust 'Ali Khan, *Rijal*, p. 275.

29 See for instance a frontispiece illustration of Nasir al-Din Shah as the King Khusraw Parviz from a *Khamsa* of Nizami lithographed in the royal printing house (1299–1314/1881–96).

30 Dust, 'Ali Khan, *Rijal*, pp. 273–80; see also Robert Hillenbrand, *Imperial Images in Persian Painting. A Scottish Arts Council Exhibition. August–September, 1977. Catalogue.* Edinburgh, 1977, pp. 43–46 for a discussion of this school.

31 Yahya Zoka and M.H. Semsar, *Tehran dar Tasvir*, Tehran, 1369 S/1990, p. 75 propose 1264–1313/1847–1895; and Karimzada-Tabrizi, *Ahval*, vol. 1, pp. 21–22 and vol. 3, p. 1437, for his biography and works.

32 Ghani, *Yaddashtha*, vol. V. pp. 27 and Furughi, *apud* Ghani, vol. 9, pp. 786–7.

33 See Robinson, *Persian Miniature Painting*, p. 82, no. 102/17.

34 Karimzada-Tabrizi, *Ahval*, vol. 1, p. 22.

35 First published in: *Christie's. Important Islamic, Indian, and South-East Asian Manuscripts*, 24 April, 1990, p. 91, no. 140; also Karimzada-Tabrizi, *Ahval*, vol. 3, p. 1437 for his biography and works.

36 Ghani, *Yaddashtha*, vol. 5, p. 284 and vol. 9, 286–7.

37 Zoka, "Mirza Abu'l-Hasan Khan", part 1, p. 15 and Karimzada-Tabrizi, *Ahval*, vol 3, p. 1573 for an illustration of this work.

38 Basil W. Robinson, *Persian Drawings from the 14th through the 19th century*, Boston, 1965, p. 125, pl. 97.

39 Reproductions of this work do not show an

inscription. The reading is taken from Karimzada-Tabrizi, *Ahval*, vol. 3, p. 1056, no. 86.

40 References to works not yet identified include: a watercolour of his uncle and an unidentified painting in the Art School of Kamal al-Mulk in Karimzada-Tabrizi, *Ahval*, vol. 1, pp. 21–22; and a painting in the garden of the Kamraniyya palace (oral communication of Ahmad Suhayli-

Khwansari to Farrokh Ghaffari).

41 Ghani, *Yaddashtha*, vol. 9, p. 286.

42 I'timad al-Saltana, *Ruznama-yi Khatirat*, Tehran, 3rd. edition, 2536 S./1977, p. 686.

43 Yahya is not included in Dust 'Ali Khan's list and is dismissed in a recent study, Ahmad Suhayli-Khwansari's "Panj Abu'l Hasan-i Naqqash dar yak Qarn", *Hunar va Mardum*, 2535 S./1978, series 5, no. 169–70, Aban-

Azar, pp. 61–65.

44 See for Bafqyi: Badry Atabay, *Fihrist-i Divanha-yi Khatti va Kitab-i Hazar va Yak Shab*, Tehran, 2535 S./1978, no. 538, pp. 1334 f.; for Shonfort and the *Tour du Monde*, see: Badry Atabay, *Safarnama*, no. 237, pp. 558 f. and no. 239, pp. 562 f. respectively.

Gold in the Pictorial Language of Indian and Central Asian Book Painting

LARISA DODKHUDOEVA

THE EMPLOYMENT OF GOLD IN MEDIEVAL PAINTING IS conditioned by a class of ancient mythological, religious doctrines, especially by Islam and Sufism and by the aesthetic conceptions of this period. Gold was selected as an essential element of book decoration owing to its peculiarities – its strength, durability, flickering light and luminescence. The hardness of gold made miniatures truly everlasting. Today some of them remain as fresh as ever.

The spiritual and formal characteristics of this precious metal, including its different reflections, tints and the possibilities it offered of combining with every colour, were the source of its original and expressive language. The different kinds of gold – gold leaf, its powder and paste – were all known to the Oriental world.

Sometimes one composition employing various gilded surfaces used different types of gold ranging from a green tone to a bright yellow one. The craftsmen used a wide range of gilding techniques. They decorated a gold surface with tiny needle punctures to make its texture shine like velvet, or they polished gilded paper until it acquired a frosted lustre. *Tash'irsazi* (graphic linear outline) and *'aks-sazi* (zoomorphic, floral themes) were popular methods of gold decoration.[1]

There are two classical ways in which gold was employed in Islamic miniature painting. It served as a background, or it was used for design or to delineate contours. A comparison of miniature painting with the art of gold embroidery (*zar-duzi*) permits us, in some instances, not just to refer to a similarity in general but to identify two common ways in which gold was used: *zamin-duzi* (background for embroidery) and *gul-duzi* (gold design on a plain space).

Thus gold, that widespread method of decoration as background or design in the applied arts, in painting and in architectural ornamentation, was one of the most characteristic expressions of the spiritual and aesthetic conceptions of the medieval world, and brought its own enrichment to a visual language which denied depth and in which space was flat.

The duty of gold was to give a distinctive, almost semantic, meaning to every element of the page and to accent the more significant parts of the book as a whole. The Muslim religious formula *bismillah* ("In the name of Allah, the Merciful, the Compassionate"), epithets of God, the names of saints and even the diacritical dots of individual letters are written in gold in medieval manuscripts.

The sun (the so-called *shams*) with its rays; the text, which is gold-sprinkled and is set into a beautiful cartouche of gilded arabesque scrolls; the spaces between lines of the script in the so-called "clouds"- all these are part of the idiosyncratic use of gold in medieval books.

The Oriental masters emphasized a metrical system of ornamentation by the gold framing lines of the binding itself, text subdivisions, *'unwans*, *sarlauhs* and illustrations. The metallic glitter of the elements and contours of the book made both the general forms and the small details of the design clear and firm; it ensured that they did not disappear into the composition as a whole.

Gilt borders and marbled paper *abri* made from gold and tragacanth were a symbol of the absolute, a metaphor of light or of the "Light of Lights" (*nur al-anwar*) and of the divine itself. We could say with J. Huizinga[2] that through the medium of gold a sense of divine grandeur came into everything that could be perceived by the senses.

The virtuosity displayed in the employment of gold in the fine arts suggests the existence of an old and stable tradition going back many centuries. References to the bright, glittering and shining metal in the *Avesta* and the *Rigveda* are worthy of special interest. According to these ancient texts, a cosmic golden egg, or an egg of shining metal, was the first essential element of the world.[3] Its peak reached the Infinite Light itself. The sun and moon were created from atoms of light and the jubilant man Gayumarth was shining like a sun, according to the *Avesta*.

The god Mitra, who was the personification of the sun for Parthian and Sogdian Manichaeans, had a special link with concepts of light. Some Indo-Iranian and Central Asian divinities also possessed peculiar characteristics of radiance and light. Heathen myths are often endowed with magical and astrological significance, e.g. the Avestan Hauma (Hari in the *Rigveda*) had innumerable hypostases. This divinity was gilded (*zari-guna*). The goddess Anahita had a gold crown and gold jewellery, and her shoes and mantle were gilded. Subsequently, Muslim artists too painted such golden accessories of personages in their miniatures.

The sun was the torch of God's sovereignty.[4] We know the various ancient centres of sun worship in India, Central Asia and Iran. Numerous sacred hymns and rituals in praise of the sun were an essential part of the common Indo-Iranian and Central Asian heritage.

Numerous other myths and legends refer to light, the sun and gold. Thus Vishnu was a personification of the sun, and the Indian Sisodia dynasty claimed descent from the sun.[5]

The foundation of all these conceptions and their depictions in art lie in the aesthetic of light as a manifestation of various ancient and medieval religions. We find the tenets and themes of such beliefs in various early texts from Iran, Central Asia, Buddhist and Hindu India, as well as in the Bible and the Qur'an — the latter referring to itself "as light or as being radiant with light".[6]

The spiritual and practical influence of the aesthetic of light in India, Iran and Central Asia was due to philosophers, Sufis, scientists, artists and poets. The Philosophy of Light (*Hikmat al-ishraq*) of the twelfth-century Sufi, Shihab al-Din Suhrawardi, was particularly prominent at the court of the Mughal emperor Akbar, whose collaborators were much influenced by doctrines of *ishraq* ("the sunrise", or "illumination").[7]

Akbar's contribution of the ritualistic association of the sun and fire to the solar monotheism of the *Din-i Ilahi* "Divine Faith" was on the whole more Sufi and Zoroastrian than Hindu. Sufi elements must have helped Akbar in his homage to the sun, such as the emphasis on the destructive glory of light in the Suhrawardiyya order, the constant use of the imagery of the sun in Rumi's *Divan-i Shams-i Tabrizi* and the exaltation of the divine attribute *Jalal*, which was part of Akbar's own name, with the sun as its symbol.[8]

According to Suhrawardi's philosophy of light (*ishraq*) there are three dwelling places of Pure Light — the sun, fire and the soul of man. God, angels and the soul of man are the substantive Light, but fire and celestial bodies represent accidental Light. It is not surprising that these elements of Surawardi's theory appear in gilt form in medieval miniatures of Central Asia, India and Iran as gold, sun, moon, stars and fire.

Angels and sages, saints and prophets with flaming gilded haloes, nimbi or flaming shoulders symbolized the Light of grandeur, and their own enlightened nature. The medieval illustrations of canonical religious texts describing the prophets are executed entirely within the bounds of traditional iconography, where attributes are minutely defined. The doctrine of *al-nur al-Muhammadi* "The Light of Muhammad" reflected the idea which proclaimed that Muhammad embodied the Light of Divinity, and that this Light showed itself in the world in Adam and in other prophets. For this reason Muslim saints and prophets had their own gold referents — the nimbus, the halo or fire — which were symbols of light, divinity and the sun. These indications were as much decorative as they were symbolic and spiritual elements of composition.

There is reason to suppose that anthropomorphic images of the flame-bearing Buddha appeared in the Buddhist oases of Central Asia (Bactria and Tokharistan) from the second to seventh centuries; this type is not quite characteristic of Indian art.[9]

Probably the iconographic image of the flame-enveloped Buddha was later reflected in the paintings of Muslim saints and prophets — Muhammad, Musa, Ibrahim, 'Isa and so on. Yusuf had the same nimbus, but in works of the Mughal school, influenced to some extent by European prints and paintings, not only Yusuf, but also the Mughal rulers and other saints, are depicted with the disc halo.

S. Averincev considers that gold is the ideal emblem to express the biblical conception of glory[10] and we could say that gold is similarly the ideal symbol to express the Iranian and Central Asian conception *hwarna* (*farn, farrah, farr*), which means "splendour". According to ancient Iranian mythology the *hwarna* entered into Zoroaster's body and became a part of the prophet. Corbin notes that the concept of Suhrawardi's *hwarna* had been especially distinctly expressed in the iconography of Christ's halo in the West and in the nimbate icons of the Buddha and bodhisattvas in the Orient.[11]

Muslim painters probably followed this iconography. It is, however, very important to know what parts of the composition are gilded. The use of gold idealized the miniature and therefore there was no interest in the natural colours of objects. The gold helped to reduce the surface of the miniature to flatness, making it consist of one or two planes, and thereby fitting it for the two-dimensional quality which suited it to the needs of Islamic book illustration. Its spatial emphasis shifted from physical and optical phenomena to a more metaphysical conception.[12]

Bihzad and other masters of Khurasan, Mawarannahr and India of the second part of the fifteenth century often painted the sky gold in their miniatures so that the upper layer of the landscape

stands out against the gilt sky and forms the horizon. Thus the golden heavens brightened gardens, palaces and mosques as though a rising sun were bathing the landscape in light.

Bukharan miniaturists of the sixteenth century frequently painted golden hills or mountains in the centre of the composition so that the gold gave greater emphasis to the landscape, and thus the living beings included in the composition were propelled from the background to the foreground. The tradition of this image of the gold sun, which originated in the countries of the ancient world, can also be observed in schools of the medieval period. Sometimes Bihzad, Indian and Central Asian masters painted the sun as a golden anthropomorphic image with rays.

Light is also a dominant feature of Iranian, Central Asian and Indian architecture "not only as a physical element but also as a symbol of the Divine Intellect and also of Being".[13] And it is not accidental that many elements of Islamic architecture are shown as gilded in the medieval miniatures from this region: domes, minarets, doors, roofs, windows, walls and so on. However, some representatives of Islamic orthodoxy, for example Ibn Ukhuwwa (sixteenth century), protested against the employment of gold in architecture.[14]

One characteristic feature of the interior was a window looking onto a garden or park. As a rule the window's aperture, which was a symbol of light, as well as a source of splendour and blessing, was painted in gold. Its gilt flat surface could be interpreted as a hollowness, a synonym for the sacred manifestation of divinity.[15]

Gold was thus an imaginative medium much used in the medieval painting of Central Asia, Iran and India. But in the course of time the links between the spatial arrangements and the colouring in miniatures changed, because the representation of nature became the great rival of gold as a space-filler. Sometimes in the painting of the seventeenth to nineteenth centuries gold was replaced by yellow, which like gold was a symbol of knowledge, because the religious basis of art, in which the theological associations of gold were prevalent, changed. Landscape in miniatures began to be represented in a more descriptive and naturalistic fashion.[16]

Economic circumstances, moreover, did not always permit artists to paint their miniatures in gold. Therefore they sometimes had to work in yellow or bronze.[17] Yet despite the ample evidence pointing to the original supremacy of gold in miniature painting, its splendour was supported by other colours, especially by white, which was also a symbol of light.

Sometimes the traditional colour pattern was based on a composition combining white with gold, and each served as a foil for the other. White dots were also introduced into certain golden borders to represent pearls — resembling in this a favourite technique of Central Asian and Indian jewellery.

The use of white, which harmonised so well with gold and lent a considerable brightness to it, was also a general means of introducing religious ideology into art.[18] Blue, which was the colour of the infinite, and gold were opposite enough to enhance each other greatly and contribute to the total effect of holiness.[19]

Thus the depiction of light was an essential feature of Persian, Indian and Central Asian miniature painting and gold was the prime visual characteristic of its nature. Thus one sees in medieval painting of the region a continuation of many of the features of a common tradition rooted in ancient times.

Notes

1 A. Kaziev, *Khudozhestvennoe oformlenie azherbaidzhanskoi rukopisnoy knigi XII–XVIII vv.,* Moscow, 1977, p. 136.

2 J. Huizinga, *Osen srednevekovia,* Moscow, 1988, p. 226.

3 F.B.T. Knipper, *Ancient Indian Cosmogony,* New Delhi, 1983, pp. 99–100; *Mifologii drevnego mira,* Moscow, 1977, pp. 345–50.

4 A. Aziz, *Studies in Islamic culture in the Indian environment,* Oxford, 1964, p. 178.

5 E. Binney, 3rd, ed., *Persian and Indian miniatures from the Collection of Edwin Binney exhibited at the Portland Art Museum, Sept.–Nov. 1962,* Portland, Oregon, 1962, p. 34.

6 M. Lings, *The Quranic art of calligraphy and illumination,* London, 1976, p. 74.

7 H. Corbin, *Oeuvres philosophiques et mystiques de Sohrawardi,* Tehran and Paris, 1952, p. 304; A. Schimmel, *The Triumphal Sun,* London, 1980, pp. 61–74.

8 Aziz, *op. cit.,* p. 178.

9 B. Staviski, *Kushanskaya Baktria: problemi istorii i kulturi,* Moscow, 1977, p. 127.

10 S. Averincev, "Zoloto v systeme symvolov rannevizantiskoi kulturi" – *Vizantiya, Yuzhnie slaviane, Drevnya Rus. Zapadnaya Evropa,* Moscow, 1973, p. 11.

11 Corbin, *op. cit.,* p. 36.

12 M. Dworzhak, *Ocherki po iskusstvu srednevekovia,* Moscow, 1934, p. 34.

13 N. Ardalan and L. Bakhtiar, *The Sense of Unity, The Sufi Tradition in Persian Architecture,* Chicago and London, 1973, p. xiii.

14 R.A. Jairazbhoy, *Art and cities of Islam,* Bombay, 1964, p. 43.

15 S. Shukurov, *"Shah-nameh" Firdawsi i rannya izobrazitelnaya traditsia,* Moscow, 1983, p. 130.

16 M. Sokolov, "Ot zolotogo fona k zolotomu nebu", *Sovetskoe iskusstvoznanie* 76 (1977, no. 2), p. 46.

17 H. Kotaian. "Kvet v izobrazitelnom yazike srednevekovoy zivopsi", *Sovetskoe iskusstvoznanie* 79, (1980, no. 1), p. 65.

18 Sokolov, *op. cit.,* p. 46.

19 Lings, *op. cit.,* p. 77.

9

Ibrahim-Sultan's 'Anthology of Prose Texts'

ERNST J. GRUBE*

P ERUSING THE LIST OF ILLUSTRATED MANUSCRIPTS OF THE animal fables *Kalila u Dimna*,[1] one is struck by the fact that there seems to be no complete illustrated copy of this popular text made for Ibrahim-Sultan ibn Shah Rukh, who governed Fars province from Shiraz between 817/1414 and 838/1435. This is particularly curious, as his brother Baysunghur, with whom he appears to have engaged in a kind of fraternal literary competition, commissioned two copies of this text, both sumptuously adorned and illustrated.[2] There is, however, a manuscript in the Süleymaniye Library in Istanbul, an *Anthology of Prose Texts* that contains an abbreviated version of the *Kalila u Dimna* as well as selections from two other such texts, the *Marzuban-nama* and the *Sindbad-nama*.[3] The manuscript is not dated, as the colophon has been lost with the last folios, but on folio 1r a *shamsa* has been partly preserved in which the name "abu'l-fath" can still be made out; and on folio 205v is a prayer or eulogy in which the name "abu'l-fath ibrahim-sultan" appears. These details, and the style of the paintings that illustrate the texts, make an attribution to Ibrahim-Sultan's ateliers in Shiraz virtually certain.[4]

It may be well, before describing the manuscript and setting its pictures into their iconographical context, to define briefly the special quality of this manuscript within the general history of the genre. The *Kalila u Dimna* is part of a vast literature, often referred to as the "Mirror for Princes", to which both the *Marzuban-nama* and the *Sindbad-nama* belong.[5] A manuscript which combines these texts, therefore, is fully in keeping with the literary and "philosophical" traditions of the Muslim world, and it would not be astonishing to find such an anthology in the library of a Timurid prince, especially one who ruled from Shiraz. For illustrated anthologies made in this city abound, those made for Iskandar-Sultan ibn 'Umar Shaykh being the most famous.[6] Indeed, the manuscript whose contents most closely parallel Ibrahim-Sultan's *Anthology of Prose Texts* is a volume of both prose and poetry, (including selections from the *Khamsa* of Amir Khusrau Dihlavi, the *Gul u Nauruz* of Khwaju Kirmani, the *Khurshid u Jamshid* of Salman Savaji, the *Shah-nama* of Firdausi, and the *Marzuban-nama* of al-Varavini), and it is probably no coincidence that it was produced in Yazd, a city also in Fars province, in the early ninth/fifteenth century.[7]

THE MANUSCRIPT

The manuscript has 579 folios, which measure 21.8 x 14.1 cm; the three different texts are written in a fairly large and rigid *naskh*, with 19 lines to the page, on which the written surface measures 15 x 8.4 cm. Sa'd al-Din Varavini's *Marzuban-nama*[8] is on folios 1v–205r; Nasr Allah's *Kalila u Dimna* on folios 206r–445v (it is incomplete, the text at the beginning starting in mid-sentence);[9] and Shams al-Din Muhammad al-Daqa'iqi al-Marvazi's *Sindbad-nama* on folios 445v–479v.[10] All three texts are illustrated, although the *Kalila u Dimna* text has the lion's share of paintings – 19 out of 28; four paintings illustrate the *Marzuban-nama*, and five the *Sindbad-nama*. All 28 miniatures are in the style of Ibrahim-Sultan's atelier, a style well documented by two illustrated manuscripts made for him: the *Shah-nama* in Oxford[11] and the dispersed *Zafar-nama* of 839/1436.[12]

**To be read with Eleanor Sims' "The Hundred and One Paintings of Ibrahim-Sultan", pp. 126–34. All plates are shared. For the particulars of the paintings. see pp. 113–114. For a list of the works which are abbreviated in both articles, see p. 115.*

COMMENTS ON THE ICONOGRAPHY

Studying this manuscript from the point of view of its position within the iconographical development of the three texts it contains, it becomes apparent that only the *Kalila u Dimna* text exists in sufficient illustrated copies to make such a study possible. Only two earlier illustrated *Marzuban-nama* manuscripts[14] have so far come to light, and only one other illustrated copy of the *Sindbad-nama*; as it dates from the Safavid period[15] it is of little relevance to Ibrahim-Sultan's manuscript (although it does have 70 paintings, indicating the existence of an earlier iconographic tradition on which later illustrators might have relied).

Beginning with the *Kalila u Dimna* cycle, it is interesting to note that none of the episodes chosen for illustration are unique or even unusual. Instead, most of them appear in the majority of both Arabic and Persian manuscripts of this text,[16] and it is the more surprising that the painter who illustrated this text for Ibrahim-Sultan appears to have been remarkably independent of established iconographical traditions. Comparing his paintings with earlier versions of the same subjects, one is struck both by their originality and by their truly "strange" quality, largely the result of disregard for the pictorial setting the text would require.

Perhaps the most striking example is the depiction of "The Plot of the Thief and the *Div* against the Pious Man" (Pl. 16). An interior – or at least the indication of one – is required by the text and it is generally represented in other Persian paintings of the subject, but here it is absent, as is the stable in which the pious man's cow is sheltered. The most elaborate rendering of this scene is found in the fragment of the celebrated *Kalila u Dimna* manuscript datable in the second half the fourteenth century (Fig. 1).[17] The painting in the *Kalila u Dimna* manuscript made for Baysunghur (the manuscript in which earlier paintings are re-used and some additional figures are painted in the margins) is unusually thorough in its "translation" of text into picture (Fig. 2).[18] The pious man is seated upright in his bed greeting the neighbours who answer his call for help against the intruders, the thief and the *div*, and his cow rests in the foreground below. The thief and the *div* are actually set outside the original picture, in the left-hand margin, the thief half hidden by the text panel as if he is about to enter the pious man's dwelling and the *div* turning away, as if to flee the scene. These marginal figures are clearly later additions made at the time the manuscript was prepared for the prince to "house" an earlier set of paintings; they must have been depicted in the same manner in the original painting but they were probably too damaged to be "rescued". Unusual is the inclusion of both the thief and the *div* at the pious man's door *and* the neighbours who come to the pious man's rescue. So far as can be documented at present, so different an interpretation of this episode seems unique for this period. Only in much later painting is the subject treated in this manner, as in a Mughal *Anvar-i Suhayli* of 978/1570, in which the pious man's compound is shown with his cow and her calves in the fore-

ground, while the neighbours chase the thief and the *div* away (Fig. 3).[19] The earliest rendering of this subject, in a Persian manuscript of the thirteenth century,[20] dedicates two facing paintings to this story. In the first, the pious man is shown sleeping in the upper story of a building, his cow sheltered in the stable below to the left, while two men, inside the building in the lower right-hand side, apparently in discussion, must be the thief and the *div* (though oddly enough, the *div* is rendered as human rather than as a horned monster). The second painting has the same setting but the pious man, apparently disturbed by the noise of the quarrelling thief and *div*, raises himself up in his bed. It is notable that his position and gesture also occurs, reversed, in Baysunghur's *Kalila u Dimna* of 834/1431 (Fig. 2). To complete this survey of remarkable renderings of this episode, yet another version should be recalled, in a Safavid copy of this text dated 1002/1593, where the thief and the *div* are also placed in the margin, quarrelling at the door (not depicted) of the pious man's house, while in a niche, the pious man sits on what would appear to be his prayer mat, and the cow stands, largely hidden by the text panel, in the neutral foreground below the niche (Fig. 4).[21]

It would seem that the interior setting for this episode called for by the text appears only in Persian manuscripts, while the earliest Arabic manuscript follows a different tradition: the pious man rests on the ground under a tree, his cow to the right of this tree (and more like a goat, feeding off its lower leafy branches), while the thief and the *div*, further to the right, are engaged in the heated argument the text describes (Fig. 5).[22] One may wonder whether the painting in Ibrahim-Sultan's manuscript was not inspired by such a painting, possibly in an Arabic, rather than a Persian, illustrated manuscript of this text, particularly as other idiosyncrasies of this set of Shiraz paintings are also most closely paralleled by other paintings in Arabic manuscripts.

The other strange aspect of the paintings that illustrate Ibrahim-Sultan's *Anthology of Prose Texts* is the reduction of the principal element – that is, the actors in the scenes, be they animal or human figures – to almost incidental minor components in paintings that seem to be principally images of elaborate landscapes. This characteristic also has close parallels in the illustrations in Arabic copies of the *Kalila u Dimna*. For instance, in the painting of Dimna's first "official" encounter with the lion (Pl. 7), the two animals are separated by a monumental tree in an open landscape, and no other figures are represented; while in the majority of paintings of this subject, other members of the lion's court witness this crucial encounter (Fig. 6).[23] The same is true in the painting showing Shanzaba led to the lion by Dimna (Pl. 8), though the landscape element is not quite so predominant. Landscape has a prominent role in the next painting, "The Lion and the Hare at the Well" (Pl. 9), as in "The Killing of the Camel" (Pl. 10). This is also the painting in which the decorative quality of the typical Shirazi landscape comes into full play for the first time. Around the

group of the animals (one – the wolf/jackal – is missing, not a unique feature but noteworthy nevertheless), the spaces are deliberately filled with floral elements: a tree and star lily in the upper left of the painting, and in the lower right an elaborate flowering shrub with long, undulating branches. This decorative elevation of what should be secondary elements into principal – truly predominant – features of the designs of Ibrahim-Sultan's pictures reaches its extreme in "The Monkey Dropping Figs into the Lake" (Pl. 17). The "actors" are almost totally lost in the nervously agitated foliage of the fig-tree and the floral shrub, both depicted against the sandy hillside that fills the upper two-thirds of the painting. Somewhere between these two pictures stands "The Doves Caught by the Fowler" (Pl. 14). Apart from the fact that the fowler holds the end of the net (a detail at odds with the text, which says that the doves escape by fluttering together inside the net, lifting it out of the fowler's reach), what should be the main element of the painting – the rising net with the doves inside it – has again become an almost secondary feature in a picture dominated by the typical Shiraz lancet-leaf tree, here intertwined with a blossoming fruit tree so that the two function together, as an elaborate central floral motif. Perhaps not quite so dramatic, but similar in its pictorial attitude, is "The Cat in the Trap" (Pl. 20). Underneath a large tree whose branches fill the better part of the painting, the cat's rear legs are caught in the trap; the other animals – the rat, the weasel and the owl (looking more like a sparrow) perched on an upper branch – are literally dwarfed by the tree. One must know the story very well to understand what actually happens.

Lastly, another aspect of the "strangeness" of the illustrations in Ibrahim-Sultan's *Prose Texts* is the reduction of the number of players in these dramas of life to the absolute minimum. The most striking example is "The Lion Attacks Shanzaba" (Pl. 12), one of the major images in the *Kalila u Dimna* cycle. The text would certainly require the presence of Dimna who, after all, is the cause of this unnecessary confrontation and, consequently, of the death of the bull, which in turn brings about his trial and his own death. And as the two jackals are engaged in telling each other a series of important stories during the fight of the two beasts, in the majority of paintings illustrating this episode at least one of the jackals is represented, and in many both are. Still, this is a singular picture. The lion is shown astride the bull who has collapsed, dying. The

forms of the two animals create a central oval with a continuous outline interrupted only by the trailing tail of the bull; this oval is framed by the larger oval of the convex horizon of the hill above, and the concave outline of the lower foreground – as if the animal group were set in the centre of an almost complete oval "medallion." Despite its highly dramatic subject, this painting has the static quality of an icon rather than the narrative, dramatic quality the subject would seem to demand, and actually has, in most of the other paintings of this episode.[24]

Little can be said about the paintings that illustrate the other two texts, other than that they appear to be by a different painter – perhaps the same who might have done two of the *Kalila u Dimna* paintings (Pls. 21, 23). He is considerably less mannered, and his figures especially are more solid, truly the subjects of the paintings in which they appear. The secondary features, landscapes or architectural interiors are just that – secondary and complementary elements that provide an appropriate setting.

The first illustrated *Marzuban-nama*, dated 698/1299, has practically no true text illustrations, using paintings only to emphasize the royal quality of the codex,[25] and it affords no comparison, whereas the second of the earlier *Marzuban-nama* manuscripts, in the Yazd *Anthology* of 810/1407, illustrates one episode (Fig. 7)[26] also found in Ibrahim-Sultan's manuscript. Comparing "The Weaver and the Serpent" (Pl. 4) suggests that both painters appear to have followed an earlier model. In both paintings the weaver's figure is placed at the right to strike the serpent on the ground to the left, but there are differences in the figural details. In the earlier manuscript the weaver's staff strikes the serpent's head, although the text specifies that the serpent, realizing the weaver's treacherous intent, turns to escape and is only hit on the tail. In Ibrahim-Sultan's manuscript, the painter may have intended to depict this exact detail; yet the position of the snake, rising as if about to attack the weaver – again similar in both paintings – makes such attention to the detail of the story by either painter unlikely.

None of the other paintings in the Yazd *Anthology* are repeated in Ibrahim-Sultan's manuscript, nor is there an earlier illustrated *Sindbad-nama* with which the paintings in this last of Ibrahim-Sultan's illustrated manuscripts may be compared. For the moment, then, the iconographical tradition which undoubtedly stands behind these paintings remains unidentified.

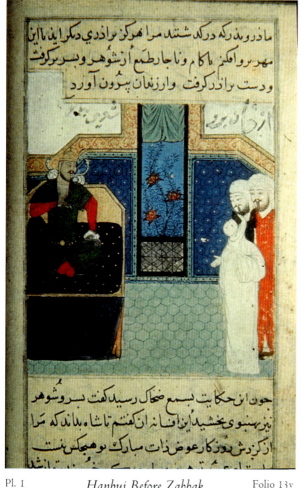

مادرو بدرك در كه شته شد مرا هوكر مراد ديكر بايد با اين
مهر سرواكن ماكلام و ناجادطمع از شوهر و بسر بركرفت
و دست برادركرفت و ارزنهان بيرون آورد

جون اين حكايت بسمع ضحاك رسيد كفت بسروشهر
نير سنيوي بخشيد اين افسان ان كفتم تا شاه ما كند كه مرا
ازكردش دوركار عوض ذات مبارك نو هيكس نيست

Pl. 1 *Hanbui Before Zahhak* Folio 13v

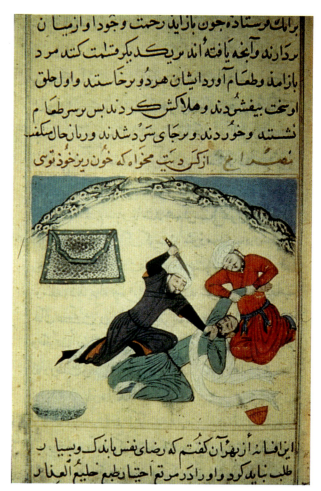

مراملك فرستاده جون بازايد رحت وجود و از ميان
مردارند و آنجه ان مرد يكدير بكرد قسمت كند مرد
باز امد و طعام آورد و ايشان هردو برخاستند و او لحلق
او سخت بيفشردند و هلاك شكردند يس بر سرطعام
نشسته و خوردند و برجاى سرد شدند و در ان حال سكفت
مصراع از كرد يت محواه كه خون ريز خود توى

اين افسانه ازبهر ان كفتم كه رضاى نفس بايد كه وبسيا ب
طلب نبايد كرد و او رادر مرتم احتيارطمع حليم العذاب

Pl. 2 *The Two Highwaymen Killing* Folio 54r
 Their Companion

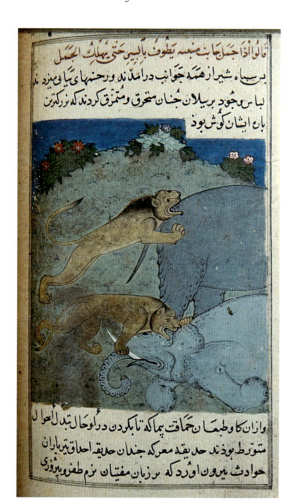

قالوا و اذا جمل جاء ت منيه يطوف بالسير حتى يهلك الجمل
درسبا شيران از همه جوانب در آمدند و درحنهاى تيز بى بردند
لباس وجود بريلان جان متحرق و متمزق كردند كه بركن
بان ايشان كوش نبود

و از ان كا وطبايع ن حماقت بماكه تا بكردند در او وحال تبدل احوال
متورط بودند تا حد بقد معركه جندان حديقه احداق تبارن
حوادث نمودن آورد كه بر زبان مفتيان نرم طفرة ببرورى

Pl. 3 *The Battle of the Elephants* Folio 153v
 and the Lions

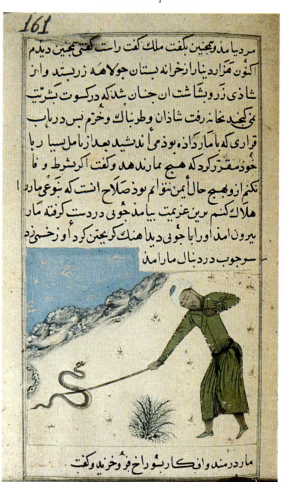

161

سردياً مذ و نجمين بكفت ملك كفت راست كفتى نجمين ديدم
اكنون هزار دينار از خزانه خواند بستان جولاهه زربستد و ان
شادى زردوبشاشت ان جان شد كه دركوت بثرتيب
بنى كنجيه بخانه رفت شادان و طربناك وختم نس در باب
قدارى كه مامار داده بود و ميا ندشيد بعد از امل بسيا ربا
خود مقرّركرد كه هيج مار ندهد و كفت اكرشط و فا
نكنم از وهيج حال ايمن نتوام بود صلاح ان است كه بنوعى مار ا
هلاك كنم مين عزيمت بيا مذ جوى بياه مذ در دست كرفته مار
بيرون آمد و او را با جوى ديلا هنك كرد نجن كرد او را زخمى زد
سوجوب در دنبال ماراً مد

ماردرمند و انكار شو داخ فرونيد د وكفت

Pl. 4 *The Weaver and the Serpent* Folio 161r

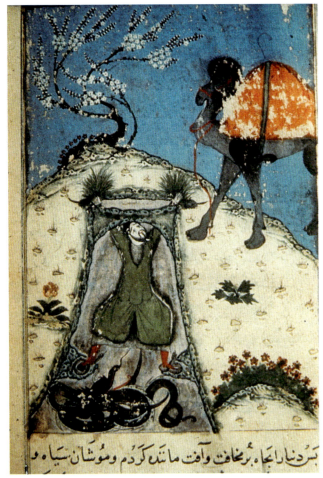

بر دینار اجاره برخاطر واقف ماند کردم و موشان سیاه و

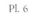

در پیش نهاد هرگاه که لختی بکوفتی دیگر براکه دکا رود براور دی
بر وود کار یجاجتی برخاست نورنه یامد و رجوب نشست
و بویدردکرد کزان جانب که نزیب بود خصیتن او میان
شکاف چوب فروورفت وپیش از لک مچ بکوفتی ایک دکار
بود براور هرود تخته چوب واهی امذ و دوخایه محکم
بکوفت جامک ازدودینقرار کشت و دود کرربسید واورا
دست بردی نموذ خالک دران هلاک شد واین حکایته اند
که دود کری کار نورنه نیست

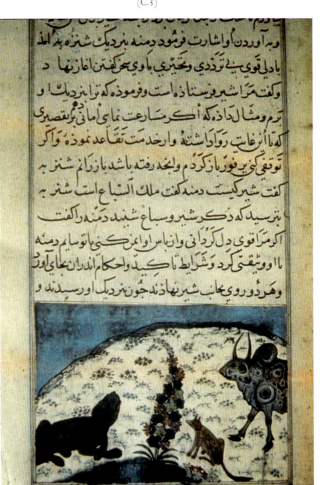

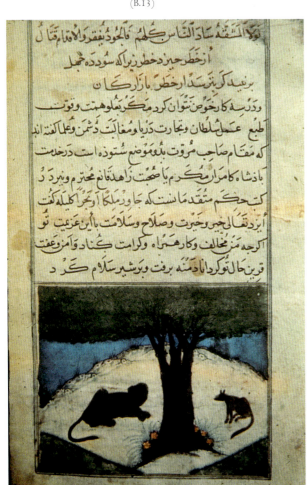

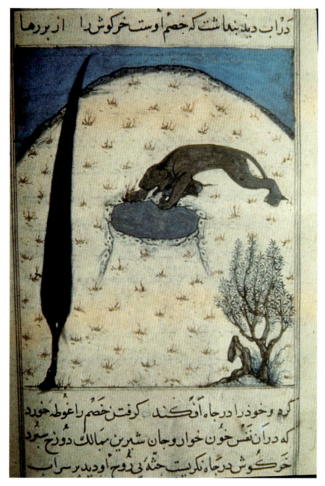

درابِ دیدنیاشت که خصم او ست خرگوش را از بردها

که وخودرا درجاه اوکند گرفتن خصم را غوطه خورد
که دران نفس خون خوار وجان شیرین مبالک دوزخ ببود
خرگوش درجاه نگریست جثه ی دوم او دیدبرسراب

Pl. 9 *The Lion and the Hare at the Well* Folio 260v
(C.7.3)

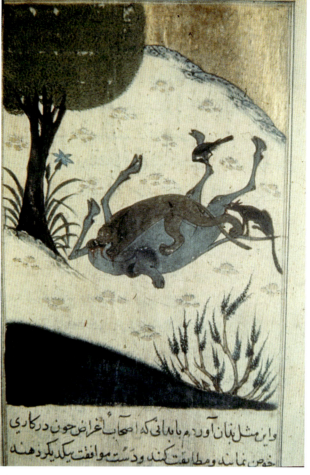

وایر مثل بنان آورد ه بابانی که اصحاب اغراض چون درکاری
خصم نمابند ومطابقت کنند ودست موافقت یک دیکرزهنه

Pl. 10 *The Killing of the Camel* Folio 274v
(C.10.8)

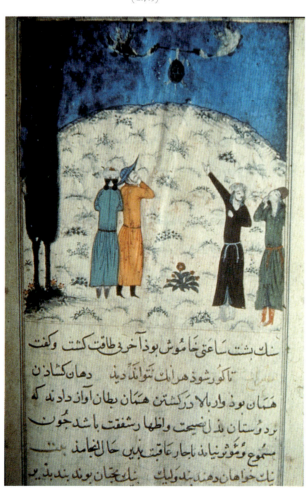

یک پشت ساعتی خاموش بود آخری طاقت کشت وکفت
تاکورشود هراک نتوانند دید دهان کشاد ن
همان بود واربلا درکشتن همان بطان آواز دادند که
پردوستان بلا نصیحت واظها رشفقت باشد چون
مجموع ومؤ منینا بد باجار عاقبت بدین حال الخامذ
یک خواهان دهند ه ولیک یک جان بوند بند بذی یو

Pl. 11 *The 'Flying Tortoise'* Folio 277v
(D.2.2)

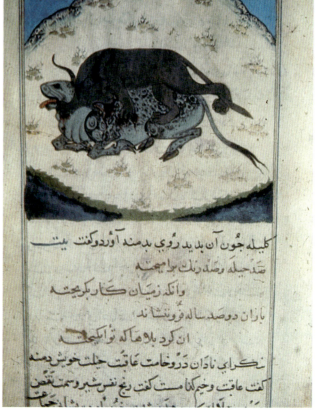

کلیله چون آن بلا بد روبی بد مند آورد وکنت یتن
صد حیله وصد دلک واجمته
وانکد زمیان کار برجته
باران دوصد ساله قوریشاه ند
ان کرد بلا ماکه نوایکجله
نکرای نادان درد وخامت عاقبت جله خویش بمند
کفت عاقت وخم کامست کفت نفس شیر وحمت نقص

Pl. 12 *The Lion Attacks Shanzaba* Folio 279v
(B.15.21)

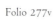

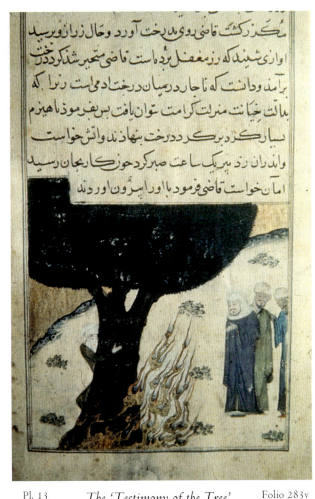

بكرزكشت قاضى بدى بدرخت آورد وحال زيارپرسيد
اوارى شنيده كه رزمعقل بوده است قاضى متحير شد ذكردرخت
برآمد ودانست كه ناجاردرميان درختادمى هاست رزا كه
بناكت خيانت منزلت كرامت توان يافت بسفرموذها هيزم
بسيار كرد بركرد درختۍ نهاذند وآتش خواست
واندران رذ بريك ساعت صبركرد جون كاربجان رسيد
امان خواست قاضى فرمود با اورا برون آوردند

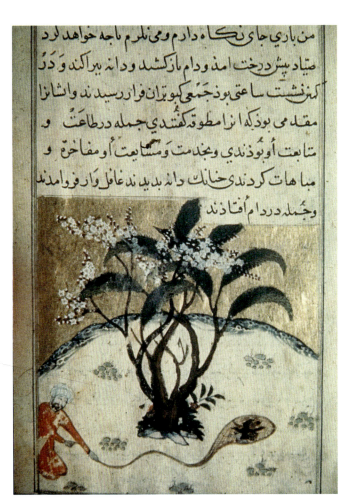

من بارى جاى زنكاه دادم ومى نلرم باجه خواهد كرد
صياد بيش درخت امد ودام بازكشد ودانه بيرا كند و دَرِ
كنشست ساعتى بود كه كبوتران فرا رسيدند واشانرا
مقدمى بو دكه انرا مطوقه كفتندى جمله درطاعت و
متابعت او بودندى وبجدمت ومشايعت او مفاخرة و
مباهات كردندى خانك دام بديد ند غافل وار فروامدند
وجمله در دام افتادند

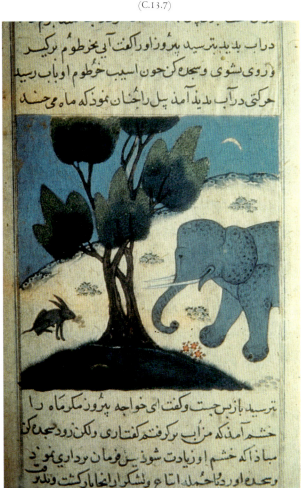

در آب بديد پرسيد بيروز او كفت آبى مخزطوم بريكسر
وروى بشوى وبسجد كن جون اسيب خطوم او باب رسيد
حركتى در آب بديد آمد پيل راجان نمود كه ماه مى جنبد
ترسيد باز بجست وكفت اى خواجه بيروز مكرماه را
خشم آمده كه مزاب بركرفتم كفتارى ولكن زود سجده كن
مبادا كه خشم او زيادت شود بس زمان مرد ارينمود
وبجد اور داجمله ابنا ولشكر ارا انجا بارك كشت وبلند

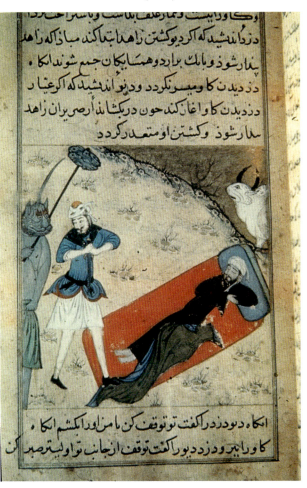

دزدانشنيد كه آكر ديو كشتن زاهد ابتدا كند مبادا كه راهد
بيدار شود وبانك براورد وهمسايكان جمع شوند انكا
دز ديدن كا و ميسر نكردد وديو انديشيد كه آكر زاهد
دز ديدن كا واغان كند جون دركشاند او رصبى ران زاهد
سلار شود وكشتن او متعدد كردد

انكه ديو دزد را كفت توقف كن تا من اورا بكشم انكا و
كا ورا بير ودزد ديو را كفت توقف كن از انجانب توابيت صبر كن

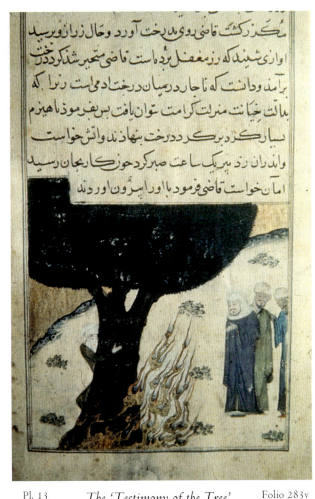
Pl. 13 *The 'Testimony of the Tree'* Folio 283v
(C.13.7)

Pl. 14 *The Doves Caught by the Fowler* Folio 307v
(B.16.2)

Pl. 15 *Firuz and the King of the Elephants at the Lake of the Moon* (D.5.5) Folio 335v

Pl. 16 *The Plot of the Thief and the Div Against the Pious Man* (C.23.3) Folio 343r

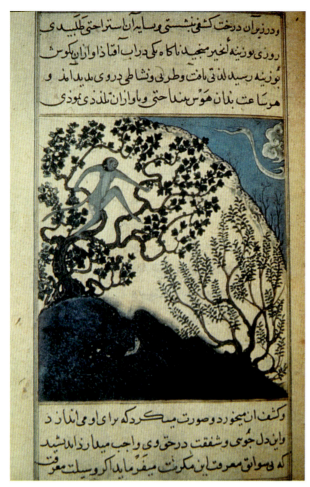

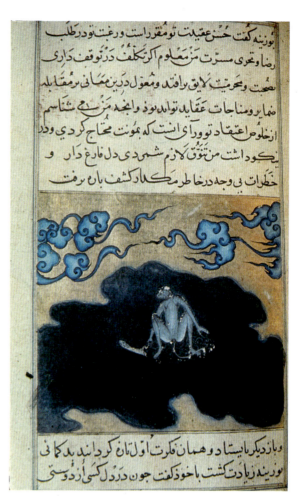

ود زیر آن درخت کشو بنشستی و بسایر آن استراحتی طلبیدی
روزی بوزینه بتغییر مجیدناگاه کی درآب افتاد وآواز بکوش
بوزینه رسید دل یافت و طربی و نشاطی دروی پدیدآمد و
هوساعت بدان هوس سرحتی و با واز ان لذذی بودی

حسن عقیدت تو و مقر راست و رغبت تو در طلب
رضا و نحوی مسرت من معلوم اگر تکلف در تو قف داری
نعمت و محوبت لایق پافت و مشعول دین معانی و مقابله
مهابر و مناجات عقاید تو باشد بود و انجه مرتبع شناسم
از خلوص اعتقاد تو و برای است که بمونت محتاج کردی و در
بکو داشت من متوق کازم شمردی دل فارغ دار و
خطرات بی وجد در خاطر ملک دکشف بان برفت

وکشف این میخورد و صورت میکرد که برای او می انداخت د
واین دل جوی و شفقت در حق وی واجب میداند شد
که بی سوای معروف این مکرمت میفر ماید اکرو سیلت معرفت

و بازدیگر بایستاد و همان فکرت اول بآن کرداند بد کا نی
بوزینه زیادت کشت با خودکفت چون در دل کسی از دوستی

Pl. 17 *The King of the Monkeys Dropping* Folio 357r
Figs Into the Lake (B.18.2)

Pl. 18 *The King of the Monkeys Riding* Folio 361r
Across the Lake on the Tortoise's Back (B.18.6)

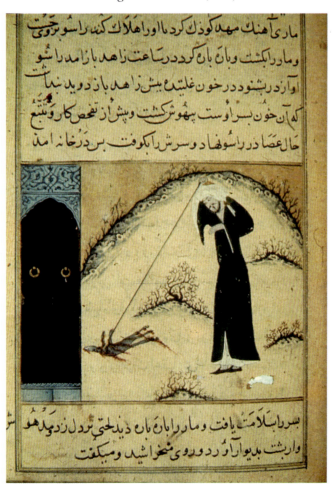

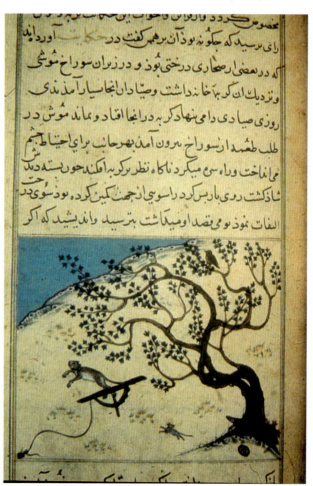

ماری آهنک مهد کودک کرد ما او را هلاک کند راسو برجوی
و ماررا بکشت و بان بان کرد در ساعت زاهد بازآمد را شو
آورد ریشون ود در خون غلیده بیش زاهد دوید ببنا ست
که آن خون بسر او ست بیهو شرکشت و پش از تفحص کارو سبع
حال عصا در راسو فتاد و سرش را بکوفت برد رخانه امد

ر سیده که جکو به نوآن ر هرکفت در حک لا آورداند
در بعضی ر حجاری درختی بود و در زیر آن سوراخ موشی
و نزدیک آن کر به خانه داشت و صیادان انجا بسیار آمدندی
روزی صیادی دامی نهاد و کر به در انجا افتاد و ماند موش در
طلب طعمه از سوراخ برون آمد هر جانب برای احتیا طم
می انداخت وده سو میکرد ناکاه نظر برکر به افکن خون بشسته دل
شاد کشت روی بار بر کرد راسوی از جهت کین کرده بودسوی در
الفات بود و می قصد او میکاشت برتر سید و ماند بیشید که اگر

Pl. 19 *The Pious Man Kills the Faithful Weasel* Folio 369r
(B.19.5)

Pl. 20 *The Cat in the Trap, the Rat,* Folio 371r
the Weasel, and the Owl in the Tree (B.20.2)

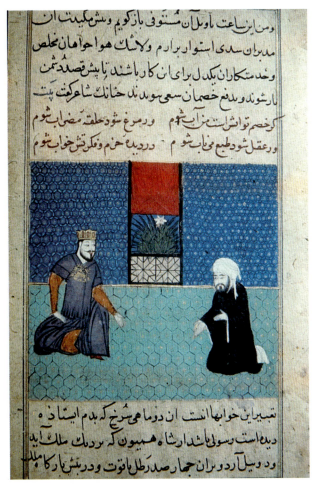

ومن این ساعت ماول ان مستوفی بازکویم وشرط کنیم ان
مدیوان سدی استوار دارم ولاشک هواخواهان مخلص
وخدمتکاران یکدل برای این کار باشند تا پیش قصد دشمن
بار شوند و دفع خصمان سعی نمود مک خانک شاعر گفت پت
کرخصم توانست مرا بشم و مرغ شود حلقه مضارب شوم
و عقل شود طمع مویاب شوم در دیده خم وفکر ترخواب شوم

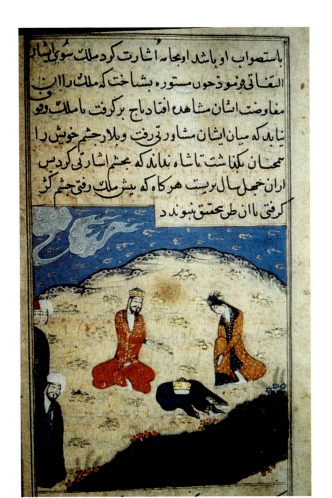

باستصواب او باشد او بجاء اشارت کرد ملک سوی ایشار
النفاق ونمو دخون مستوره بشناخت که ملک را اب ان
مفاوضت ایشان مشاهده افتاد داج برکوفت مالک و و
نیابد که میان ایشان مشاور نوفت وبلاد جشم خویش را
سمجان نگنانشت تاشاء نماند که جشم اشاری کردس
اران خجل سال بریست هرگاه که پیش ملک وفی جشم کت
کرفتی بان طریحقتق نبوند د

تعبیر این خوابها انست ان دوماهو شرخ که بدم استاده
دیداست رسولی پادشدارشاه همیون که مردیک ملک آید
ود بیل آرد و ران جمار صدرطل یاقوت ودرشتیمار کا مهمله

Pl. 21 *Kibayrun Interprets the King's* Folio 420v
 Dreams (B.23.4)

Pl. 22 *The King and Irakht* (B.23.13) Folio 422v

TEXT III *Sindbad-nama*

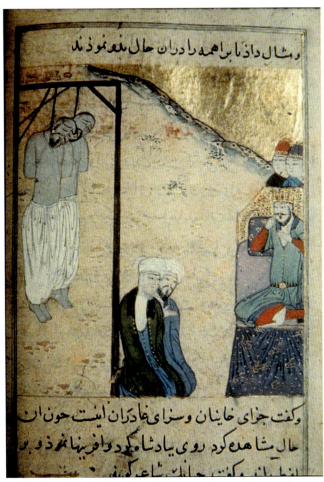

ومثال داذ با براهمه را دران حال بنع نمود ند

وکفت جزای خاینان وسزای غادران اینست جون ان
حال مشاهده کرد روی یاد شاه کرد واقربنافو ذو ب

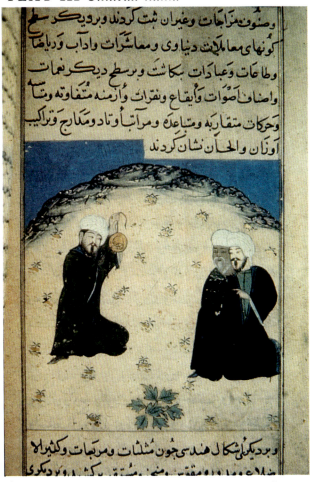

وصنوف مزاجات وغیران ثبت کردند وبر دیگر سطح
کونهای معالگبت دیناوی ومعاشرات واداب و دیاظا
وطاعات وعبادات بکاشت وبرسطح دیگر نغمات
واصناف اصوات وایقاع ونقرات وارمنه متفاوته ونسا
وحرکات متقاربه ومتباعده ومراتبا و نثاد ومدارج وتراکیب
اونان والحان نشان کردند

وبردیگر شکال هندسی جون مثلثات ومربعات وکثیرالا

Pl. 23 *The Execution of the Treacherous* Folio 432v
 Brahmans (B.23.14)

Pl. 24 *The Astronomers Casting the* Folio 473v
 Horoscope of the King's Son

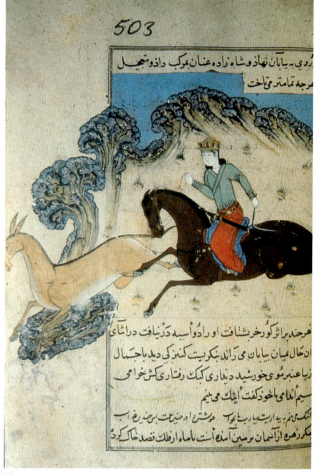

Pl. 25 *The Prince Pursues the Onager of* Folio 503r
Marvellous Allure

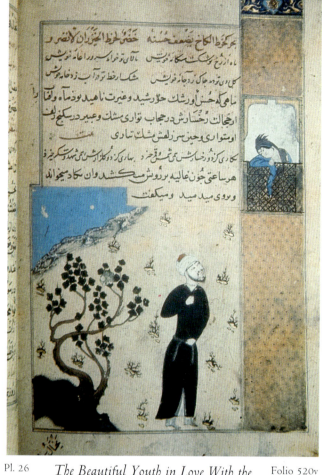

Pl. 26 *The Beautiful Youth in Love With the* Folio 520v
Maiden

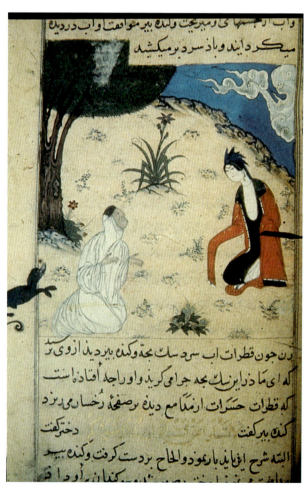

Pl. 27 *The Old Woman, With the Help of* Folio 525r
Her Crying Dog, Persuades the
Maiden to Accept the Love of the Beautiful Youth

Pl. 28 *The King Asks His Son How to* Folio 556v
Punish the Woman Who Had Falsely Accused Him

Fig. 1. The Plot of the Thief and the *Div* Against the Pious Man (C.23.3)

Abu'l-Ma'ali Nasr Allah, *Kalila u Dimna*

Persia, probably Tabriz, about 1370 Istanbul, University Library, Album Farsca 1422, fol. 7r

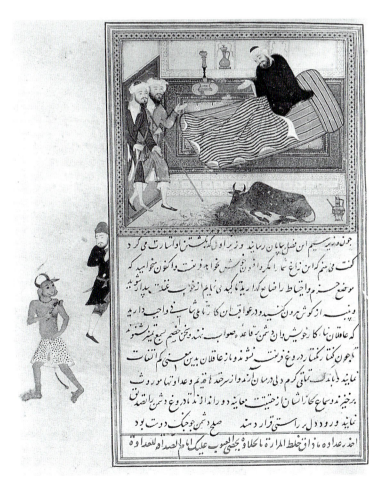

Fig. 2. The Plot of the Thief and the *Div*
Against the Pious Man (C.23.3)

Abu'l-Ma'ali Nasr Allah, *Kalila u Dimna*

Persia, MS Herat, 834/1431, paintings probably Tabriz, about 1400

Istanbul, TKS, H. 362, fol. 95r

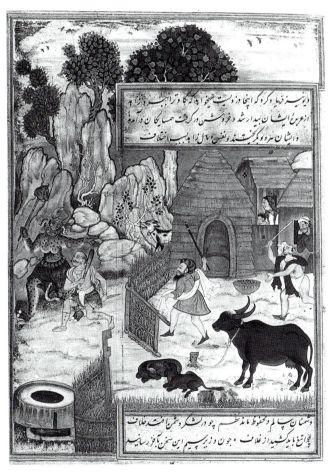

Fig. 3. The Plot of the Thief and the *Div* Against
the Pious Man (C.23.3)

Husayn ibn 'Ali al-Va'iz al-Kashifi, *Anvar-i suhayli*

India, Mughal court atelier, 22 Rabi' II, 978/September 23, 1570

London, University of London, School of African and Oriental Studies,

MS 10102, fol. 174r

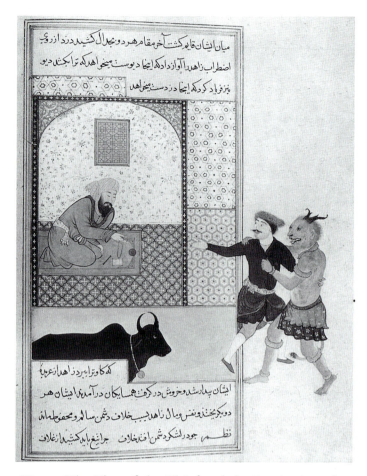

Fig. 4. The Plot of the Thief and the *Div* Against the
Pious Man (C.23.3)

Husayn ibn 'Ali al-Va'iz al-Kashifi, *Anvar-i suhayli*

Persia, Qazvin, 13 Safar 1002/November 8, 1593 Collection of Prince

Sadruddin Aga Khan (Ex Bute MS 347), fol. 190v

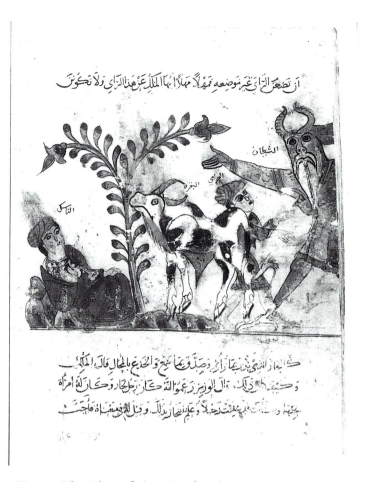

Fig. 5. The Plot of the Thief and the *Div* Against the
Pious Man (C.23.3)

'Abdallah ibn al-Muqaffa, *Kalila u Dimna*

Syria, early 7th/13th century

Paris, BN, MS Arabe 346, fol. 103v

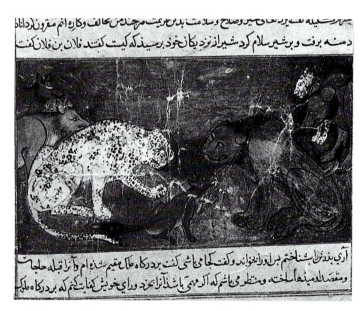

Fig. 6. Dimna Presents Himself to the Lion (B.15.4)

Abu'l-Ma'ali Nasr Allah, *Kalila u Dimna*

Baghdad or Tabriz, Jala'irid atelier, 744/1343–44

Cairo, National Library, MS Adab Farsi 61, fol. 17v

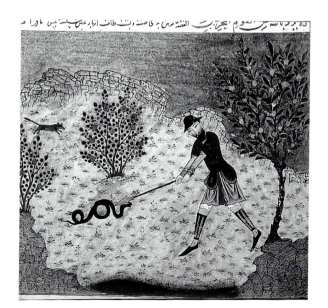

Fig. 7. The Weaver and the Serpent (B.15.4)

Sa'd al-Din Varavini, *Marzuban-nama*

Persia, Yazd, 810/1407

Istanbul, TKS, H. 796, fol. 261r

List of Paintings

Text I *MARZUBAN-NAMA*

1. (Pl. 1) Folio 13v: Hanbui Before Zahhak
10.5 x 9 cm
Levy, *Marzuban* (1968), pp. 16–17.

2. (Pl. 2) Folio 54r: The Two Highwaymen Killing Their Companion
8.3 x 9 cm
Levy, *Marzuban* (1968), p. 74.

3. (Pl. 3) Folio 153v: The Battle of the Elephants and the Lions
10.5 x 9 cm
Levy, *Marzuban* (1968), pp. 208–211.

4. (Pl. 4) Folio 161r: The Weaver and the Serpent
8.3 x 9 cm
Levy, *Marzuban* (1968), pp. 222–227.

Text II *KALILA U DIMNA*[13]

Chapter I. *Burzuya's Biography*

5. (Pl. 5) Folio 239v: The Perils of Life (B.13)
11.5 x 8.3 cm
Atasoy, "Süleymaniye" (1979), p. 426, fig. 1.

Chapter II. *The Lion and the Bull*

6. (Pl. 6) Folio 242v: The Monkey and the Carpenter (C.3)
9 x 8.3 cm
Gray, "Shiraz" (1979), p. 137, fig. 77.

7. (Pl. 7) Folio 246v: Dimna Presents Himself to the Lion (B.15.4)
6.5 x 8.3 cm

8. (Pl. 8) Folio 251r: Dimna Leads Shanzaba to the Lion (B.15.11)
5.5 x 8.3 cm

9. (Pl. 9) Folio 260v: The Lion and the Hare at the Well (C.7.3)
9.5 x 8.4 cm

10. (Pl. 10) Folio 274v: The Killing of the Camel (C.10.8)
9 x 8.3 cm

11. (Pl. 11) Folio 277v: The 'Flying Tortoise' (D.2.2)
9 x 8.3 cm

12. (Pl. 12) Folio 279v: The Lion Attacks Shanzaba (B.15.21)
8.4 x 8.3 cm

13. (Pl. 13) Folio 283v: The 'Testimony of the Tree' (C.13.7)
8.5 x 8.4 cm

Chapter III. *The Doves, the Crow, and Rat, the Tortoise, and the Gazelle*

14. (Pl. 14) Folio 307v: The Doves Caught by the Fowler (B.16.2)
8.4 x 8.4 cm

Chapter IV. *The Owls and the Crows*

15. (Pl. 15) Folio 335v: Firuz and the King of the Elephants at the Lake of the Moon (D.5.5)
8.1 x 8.3 cm

16. (Pl. 16) Folio 343r: The Plot of the Thief and the *Div* Against the Pious Man (C.23.3)
8.4 x 8.4 cm
marg 1991, p. 94, fig. 100.

Chapter V. *The Monkey and the Tortoise*

17. (Pl. 17) Folio 357r: The King of the Monkeys Dropping Figs Into the Lake (B.18.2)
9.1 x 8.4 cm

18. (Pl. 18) Folio 361r: The King of the Monkeys Riding Across the Lake on the Tortoise's Back (B.18.6)
7.5 x 8.3 cm

Chapter VI. *The Pious Man and the Faithful Weasel*

19. (Pl. 19) Folio 369r: The Pious Man Kills the Faithful Weasel (B.19.5)
6.4 x 8.3 cm

Chapter VII. *The Cat and the Rat*

20. (Pl. 20) Folio 371r: The Cat in the Trap, the Rat, the Weasel, and the Owl in the Tree (B.20.2)
6.5 x 8.3 cm

Chapter VIII. *The King of India and the Treacherous Brahmans*

21. (Pl. 21) Folio 420v: Kibayrun Interprets the King's Dreams (B.23.4)
7.4 x 8.3 cm

22. (Pl. 22) Folio 422v: The King and Irakht (B.23.13)
8.7 x 8 cm

23. (Pl. 23) Folio 432v: The Execution of the Treacherous Brahmans (B.23.14)
10 x 9 cm

Text III *SINDBAD-NAMA*

24. (Pl. 24) Folio 473v: The Astronomers Casting the Horoscope of the King's Son
10 x 9 cm
Bogdanović, *Sendbâdnameh* (1975), p. 37.

25. (Pl. 25) Folio 503r: The Prince Pursues the Onager of Marvellous Allure
9.5 x 12.5 cm
Bogdanović, *Sendbâdnameh* (1975), p. 111.

26. Pl. 26) Folio 520v: The Beautiful Youth in Love With the Maiden
10 (19) x 12.5 cm
Bogdanović, *Sendbâdnameh* (1975), pp. 145–147.

27. (Pl. 27) Folio 525r: The Old Woman, With the Help of Her Crying Dog, Persuades the Maiden to Accept
the Love of the Beautiful Youth
10 x 9 cm
Bogdanović, *Senbâdnameh* (1975), pp. 154–158.
Atasoy, "Sülemaniye" (1979), p. 427, fig. 2

28. (Pl. 28) Folio 556v: The King Asks His Son How to Punish the Woman Who Had Falsely Accused Him
10.5 x 9.9 cm
Bogdanović, *Sendbâdnameh* (1975), p. 262.

The following works are abbreviated in both articles.

ABCA, 1979 *The Arts of the Book in Central Asia*, ed. Basil Gray, UNESCO/Serindia, Paris/London, 1979

Atasoy, "Sülemaniye" (1979) Nurhan Atasoy, "Persian Miniatures of the Sülemaniye Library Istanbul," *Akten des VIII. Internationalen Kongresses für Iranische Kunst und Archäologie, München 7.–10. September 1976*, Berlin, 1979, pp. 425–430

Bogdanović, *Sendbâdnameh* (1975) Zahiri de Samarkand, *Le Livre des sept vizirs, Sendbâdnameh*, translated from the Persian by Dejan Bogdanović, Paris, (second edition) 1975

BWG, 1933 Laurence Binyon, J.V.S. Wilkinson, and Basil Gray, *Persian Miniature Painting, Including a Critical and Descriptive Catalogue of the Miniatures Exhibited at Burlington House, January–March, 1931*, Oxford, 1933

Enderlein, 1970 Volkmar Enderlein, *Die Miniaturen der Berliner Baisonqur-Handschrift*, Frankfurt, 1970

Gray, "Shiraz" (1979) Basil Gray, "The School of Shiraz from 1392 to 1453," in *ABCA* 1979, pp. 121–145

Grube, "K&D", 1991 Ernst J. Grube, "Prolegomena for a Corpus Publication of Illustrated *Kalilah wa Dimnah* Manuscripts," *Islamic Art*, IV, 1990–1991, pp. 301–481, and Colour Plate XVI

Kühnel, "Handschrift" 1931 Ernst Kühnel, "Die Baysonghur-Handschrift der Islamischen Kunstabteilung," *Jahrbuch der Preussischen Kunstsammlungen*, 52, 1931, pp. 133–52

Lentz & Lowry, 1989 Thomas W. Lentz and Glenn D. Lowry, *Timur and the Princely Vision: Persian Art and Culture in the Fifteenth Century*, Los Angeles County Museum of Art, 1989; catalogue to the exhibition organized by the Arthur M. Sackler Gallery, Smithsonian Institution, Washington, DC, and the Los Angeles County Museum of Art in 1989

Marg, 1991 *A Mirror for Princes from India, Illustrated Versions of the Kalilah wa Dimnah, Anvari-i Suhayli, Iyar-i Danish, and Humayun Nameh*, Edited by Ernst J. Grube, Marg Publications, Bombay, 1991

Robinson, *Bodl.*, 1958 B.W. Robinson, *A Descriptive Catalogue of the Persian Paintings in the Bodleian Library*, Oxford, 1958

Sims, "Shahnama", 1993 Eleanor Sims, "The Illustrated Manuscripts of Firdausi's *Shahnama* Commissioned by Princes of the House of Timur," *Ars Orientalis*, XXII, 1993, pp. 43–68

Sims, "Zafar-nameh", 1991 Eleanor Sims, "Ibrahim-Sultan's Illustrated *Zafar-nameh* of 839/1436," *Islamic Art*, IV, 1990–1991, pp. 177–217

Stchoukine, *MT*, 1954 Ivan Stchoukine, *Les peintures des manuscrits Timurides*, Paris, 1954

TAC, 1992 *Timurid Art and Culture: Iran and Central Asia in the Fifteenth Century*, Studies in Islamic Art and Architecture: Supplements to Muqarnas, VI, 1992, ed. by Lisa Golombek and Maria Subtelny

Thackston, 1989 *Century A Century of Princes: Sources on Timurid History and Art*, selected and translated by W.M. Thackston, Cambridge, Mass., 1989

V&A, 1967 B.W. Robinson, *Persian Miniature Painting from collections in the British Isles* (Catalogue to the Exhibition at the Victoria and Albert Museum), London, 1967

Notes

1 See Grube, "K&D", 1991, pp. 360–69, Appendix I: Checklist.

2 See Cat. 16 and Cat. 24 in the Checklist (Note 1).

3 Fatih 3682. See Cat. 25 in the Checklist (Note 1), where the *Sindbad-nama* is, however, erroneously identified as a work by al-Samarqandi; it is actually the version by Shams al-Din Muhammad al-Daqa'iqi al-Marvazi, see Jan Rypka, *History of Iranian Literature*, Dordrecht, 1968, pp 223, 225, n. 15. I must thank a number of people for their help with the study of this manuscript: my former students, Dr. Stefano Carboni and Dr. Anna Contadini; Professor Nurhan Atasoy; and most especially Professor Güner Inal, who identified the author of the *Sindbad-nama* and has provided us with the most recent bibliography on the manuscript: Nezihe Seyhan, *Süleymaniye Kütüphanesi'ndeki Minyatürlü Yazma Eserlerin Kataloğu*, Istanbul (forthcoming publication of a thesis presented to Istanbul University in 1986), Nos. 28, pp. 352ff, 32, pp. 367ff, and 39, pp. 82ff.

4 Nurhan Atasoy, "Persian Miniatures of the Süleymaniye Library Istanbul," *Akten des VII. Internationalen Kongresses für Iranische Kunst und Archäologie, München, 7.–10. September 1976*, Berlin, 1979, pp. 425–430; Basil Gray, "The School of Shiraz from 1392 to 1453," *ABCA*, 1979, pp. 121–145, p. 137, fig. 77; and Grube, in *Marg*, 1991, p. 89, and p. 94, fig. 100, colour.

5 See Charles-Henri de Fouchécour, *Moralia, Les notions morales dans la littérature persane du 3e/9e au 7e/13e siècle*, Institut Français de Recherche en Iran, Bibliothèque Iranienne No 32, Editions Recherche sur les Civilisations, "Synthèse" no. 23, Paris, 1986. Chapter 4, pp. 357–440, of de Fouchécour's study is dedicated to "Les Miroirs des Princes".

6 Lisbon, The Gulbenkian Foundation, LA 161, and London, BL, Add. 27261. See Stchoukine, *MT*, 1954, pp. 40–41, MSS XIX–XV, pls. XVI–XX; Priscilla P. Soucek, "The Manuscripts of Iskandar Sultan," *TAC*, 1991, pp. 116–131; and Norah Titley, *Miniatures from Persian Manuscripts: Catalogue and Subject Index of Paintings from Persia, India, and Turkey in the British Library and the British Museum*, London, 1977, p. 39, no. 98. Neither has yet been published adequately nor have their many illustrations – 20 full-page miniatures in the London manuscript, in addition to innumerable drawings, and 35 originally in the Lisbon manuscript – been completely reproduced.

7 Istanbul, TKS, H. 796, *Majmu'a-i ash'ar*, copied and illustrated in Yazd in 810/1407; see Fehmi

E. Karatay, *Topkapi Sarayi Müzesi Kütüphanesi, Farsça Yazmalar Kataloğu*, Istanbul, 1961 (Topkapı Sarayı Müzesi Yayınları, No. 12), pp. 309–10, No. 887, and Ivan Stchoukine, "La peinture à Yazd au début du XVe siècle," *Syria*, XLIII, 1966, pp. 99–104, and pls. VII–X, with illustrations of 8 of the 16 paintings in the manuscript. See also Grube, "K&D", 1991, p. 402, II.1.2, and *ibid.*, II.1.1 for another, earlier, illustrated *Marzuban-nama* in the Library of the Archaeological Museum, Istanbul, MS 216, produced in Baghdad in 698/1299.

8 For the text of the *Marzuban-nama*, written by Sa'd al-Din Varavini, and dedicated to Khwaja Abu'l-Qasim Rabib al-Din Harun, vizir of the Eldigüzid prince of Azarbayjan, Muzaffar al-Din Özbek (607/1210–622/1225), and according to de Fouchécour (*Moralia* [1986], p. 431, quoted in Note 5) based on a late 4th/10th century Persian source rather than the "texte primitif en tabaristanais," see *The Marzuban-nama, a Book of Fables originally compiled in the dialect of Tabaristan, and translated into Persian by Sa'd'd-Din-i-Warawini, The Persian text edited by Mirza Muhammad ibn 'Abdu'l-Wahhab of Qazwin*, London, 1909 (E.J.W. Gibb Memorial Series, Vol. VIII). This edition was revised and re-edited in 2 volumes by M. Roshan, Tehran 1355/1976. See also David M. Lang, "Parable and Precept in the Marzuban-name," *W.B. Henning Memorial Volume* (ed. Mary Boyce and Ilya Gershevitch), London, 1970, pp. 231–237.

9 For text versions of the *Kalila wa Dimna*, see now Grube, "K&D", 1991, Appendix IV, pp. 426ff.

10 I have not been able to locate another manuscript of al-Daqa'iqi's text (or a reference to such a manuscript), nor a modern edition or translation; the text-references following the descriptions of Pls. 24–28 are therefore to al-Samarqandi's version as translated by Dejan Bogdanovic, *Zahiri de Samarkand, Le Livre des sept vizirs, Sendbadnameh*, Paris, 1975 (second edition). For the text of the *Sindbad-nama* composed by Muhammad ibn 'Ali al-Zahiri al-Katib al-Samarqandi, dedicated to the Qara-Khanid Qilij Tamghaj Khaqan ibn Mas'ud shortly after the middle of the 6th/12th century, see *Sindbad-name, yazan* Muhammad b. 'Ali az-Zahiri as-Samarqandi, *Arapça Sindbad-name ile birlikte mukaddime ve haşiyelerle neşreden* Ahmed Ateş, Istanbul, 1948. See also *The Book of Sindibad; or, The Story of the King, His Son, the Damsel, and the Seven Vazirs. From the Persian and Arabic. With Introduction, Notes, and Appendix*, by W.A. Clouston, Privately Printed, 1884; on p.

xlvi, he notes Nöldeke's suggestion that Muhammad ibn 'Ali al-Zahiri al-Samarqandi and Shams al-Din Muhammad ibn 'Ali al-Daqa'iqi may be one and the same person; see also Ateş, p. 14; and now also B.E. Perry, *The Origin of the Book of Sindbad*, Berlin 1960, (offprint from *Fabula, Zeitschrift für Erzählforschung*, Vol. 3, 1/2, 1959), pp. 63–64: discussing the Persian textual tradition of the *Sindbad-nama*, he remarks that manuscripts of two of the versions, including that of Daqaqi (*sic*) of Marv, are not extant. The entry on "Daqa'iqi Marvazi" from the Persian encyclopaedia, *Farhang-i Dihkhuda*, graciously translated for me by Manijeh Bayani, reads as follows: "Shams al-Din Muhammad ibn 'Ali, the learned theologian and poet of the late 6th [12th] century; he lived to the end of the 6th century and he is the one who wrote a *Sindbad-nama* in *masnu'* [rhymed prose style]; and this is apparently the same as the *Bakhtiyar-nama* or *The Story of the Ten Vazirs*; and ... he has written various types of poems which have appeared in different *tazkiras* ..." See, further, Zabihollah Safa's *Tarikh-i 'Adabiyat dar Iran*, II, Tehran, 1336sh, pp. 999–1003, who says that the *Sindbah-nama* is one of the books of Baha al-Din/Zahir al-Din Muhammad ibn 'Ali Zahiri, and it is probably one of the old Indian stories translated into Pahlavi; that it must have been very famous in the pre-Islamic period in Persia; and that al-Mas'udi refers to *The Book of Seven Wazirs* and attributes it to a certain Sindbad, "a wise man of Kush[an?] of India." The most recent (but inconclusive) discussion of the problems of the *Sindbad-nama*'s author is in J.T.P. de Bruijn's entry, "Daqayeqi," in the *Encyclopaedia Iranica*. Finally, François de Blois has kindly given me a copy of his forthcoming entry on "Sindbad (Book of)," in the *Companion to Arabic Literature*, in which he notes that al-Nadim, speaking in the *Fihrist* of Indian books known to Persians, refers to two versions of the *Sindbad-nama*; de Blois' suggestion is that the work was originally written in Middle Persian, in the Sassanian period, and is not a translation of a pre-existing Sanskrit work. In the end, it must be noted that the relevant text in Süleymaniye Library MS 3682 has not yet been studied by a literary historian and the attribution to Daqa'iqi has thus not been confirmed. Should it, however, prove to be Daqa'iqi's, and not Samarqandi's, *Sindbad-nama*, this little anthology made for Ibrahim may turn out to be as interesting to literary historians as it is to art historians.

11 Ouseley Add. 176 (Ethé 501), see Robinson,

Bodl., 1958, pp. 16–22, nos. 81–132; and Sims, "*Shahnama*", 1993, and the following article, pp. 125–133.

12 Sims, "*Zafar-nameh*", 1991, and the following article, pp. 125–133.

13 The episode numbers that appear in parentheses after the subject-identifications refer to the text synopsis in Grube, "K&D", 1991, Appendix IV, pp. 428–453.

14 For illustrated manuscripts of the *Marzuban-nama*, see Note 7.

15 MS 3214 in the India Office Library, London, (see Hermann Ethé, *Catalogue of Persian Manuscripts in the India Office Library*, I, Oxford, 1903, pp. 714–715, no. 1236), is listed by Ivan Stchoukine, *Les Peintures des manuscrits safavis de 1502 à 1587*, Paris, 1959, p. 137, MS 196, and pls. LXXVIII–LXXIX, and attributed to a southern Persian provincial atelier of about 1575. Robinson exhibited it in 1951 (see B.W. Robinson, *Catalogue of a Loan Exhibition of Persian Miniature Paintings from British Collections*, Victoria and Albert Museum [London, 1951], p. 34, No. 143), attributing it to a southern Persian provincial atelier and dating it to the mid-16th century; by 1967, he had changed his mind and placed the manuscript in India (V&A, 1967, p. 113), an attribution accepted by Jeremiah P. Losty, *The Art of the Book in India*, The British Library, London, 1982, pp. 70–71, No. 48, and illustrations on p. 54. It was thus, understandably, not included in Robinson's *Persian Paintings in the India Office Library, A Descriptive Catalogue*, Sotheby Parke Bernet, London, 1976, and its 70 paintings have therefore not yet been studied nor their subjects identified.

16 For a concordance of the episodes illustrated in this manuscript with those in other *Kalila wa Dimna* manuscripts, see Grube, "K&D", 1991, Appendix III; p. 407: "The Perils of Life" (B.13); p. 408: "The Monkey and the Carpenter" (C.3); "Dimna Presents Himself to the Lion" (B.15.4); and "Dimna Leads Shanzaba to the Lion" (B.15.11); p. 410: "The Lion and the Hare at the Well" (C.7.5); p. 411: "The Killing of the Camel" (C.10.8); "The 'Flying Tortoise'" (D.2.2); "The Lion Attacks Shanzaba" (B.15.21); p. 412: "The Quarrelling Men, the Judge, and the 'Testimony of the Tree'" (C.13.7); p. 414: "The Doves [Pigeons] Caught by the Fowler" (B.16.2); p. 416: "Firuz and the King of the Elephants at the Lake of the Moon" (D.5.5); p. 417: "The Plot of the Thief and the *Div* Against the Pious Man" (C.23.3); p. 418: "The Monkey Dropping Figs Into the Lake" (B.18.2); "The Monkey Riding Across the Lake on the Tortoise's Back" (B.18.6); p. 419: "The Pious Man Kills the Faithful Weasel" (B.19.5); pp. 419–420: "The Cat in the Trap, the Rat, the Weasel, and the Owl in the Tree" (B.20.2); p. 422: "Kibayrun (Karidun) Interprets Hilar's Dreams" (B.23.4); p. 423: "Iladh Restores Irakht (Irandukht) to King Hilar" (B.23.13); "The Execution of the Treacherous Brahmans" (B.23.14).

17 Istanbul University Library, Farsça 1422, fol. 7r, see Grube, "K&D", 1991, p. 346, Fig. 57A.

18 Istanbul, TKS, H. 362, fol. 95r, see Sims, in *Marg*, 1991, p. 111, fig. 119.

19 London, Library of the School of Oriental and African Studies, MS 10102, dated 978/1570, see Khandalavala and Desai, in *Marg* 1991, p. 134, fig. 132.

20 Istanbul, TKS, H. 363, fols. 134v and 135r. For the manuscript see Grube, "K&D," 1991, p. 378, MS 8.

21 Geneva, Collection of Prince Sadruddin Aga Khan, see Sims, in *Marg* 1991, p. 110, fig. 118.

22 Paris, BN, Ar. 3465, fol. 103v; Syria or Egypt, 13th century; see Grube, "K&D", 1991, p. 374, MS 1.

23 The earliest renderings of this subject, in Ar. 3465, on fol. 49v (often illustrated, see Richard Ettinghausen, *Arab Painting*, Geneva, 1962, p. 63) show Dimna and the lion alone, and the same is true for the Rabat manuscript, fol. 24v (see Marianne Barrucand, "Le *Kalila wa Dimna* de la Bibliothèque Royale, Un manuscrit illustré il-khanide," *Revue des Études Islamiques*, LIV, 1986: *Mélanges offerts au Professeur Dominique Sourdel*, p. 34, fig. 3). But in Paris, BN, Ar. 3647, on fol. 22r (illustrated by Tharwat 'Ukasha, *Al-taswir al-islami*, 5, *Al-dini wa'l-'arabi*, Beirut, 1977, p. 446, fig. 174), and Munich, N.B., Ar. 616, fol. 45r (illustrated by H.C. von Bothmer, *Kalila und Dimna. Ibn al-Muqaffa's Fabelbuch in einer mittelalterlichen Bilderhandschrift Cod. arab. 616 der Bayerischen Staatsbibliothek München*, Wiesbaden, 1981, p. 130), and also in Oxford, the Bodleian Library, Pococke 400, fol. 41v (illustrated by Esin Atil, *Kalila wa Dimna, Fables from a Fourteenth-Century Arabic Manuscript*, Washington, D.C., 1981, fig. 18), the lion's mother is represented; and in Cambridge, Corpus Christi, MS 578, fol. 32v (not published), Dimna *and* Kalila appear at the lion's court although no other animal-courtiers are present. In TKS 362, the earliest (presently known) Persian manuscript, on fol. 42r (not yet published) the leopard, the lion's advisor, is present, symbolizing the entire court; while in Cairo, N.L., Adab Farsi 61, fol. 17v, a considerable number of the lion's entourage, including the leopard, is shown (see Fig. 6).

24 A series from seven manuscripts is illustrated in *Marg*, 1991, pp. 40–41, figs. 31–37.

25 Marianna S. Simpson, "The Role of Baghdad in the Formation of Persian Painting," *Art et société dans le monde Iranien*, ed. Chahryar Adle (Institut Français d'Iranologie de Téhéran, Bibliothèque Iranienne, No. 26, Editions Recherche sur les civilisations), Paris, 1982, (pp. 94–106 on this manuscript), illustrates all three miniatures, figs. 49–51.

26 For the manuscript, see Grube, "K&D", 1991, p. 402, MS II.2.

10

The Hundred and One Paintings
of Ibrahim-Sultan

ELEANOR SIMS

ABU'L-FATH IBRAHIM-SULTAN IBN SHAHRUKH IBN TIMUR IS
a Timurid prince whose position as a patron and sponsor
of fine painting is anomalous. He is connected with four illus-
trated manuscripts of the first third of the Timurid century, and yet
the painting in them – and thus that associated with his name –
is usually considered provincial in style, remarkable more for its
divergencies from the classical Timurid canon of his younger brother
Baysunghur than for its intrinsic aesthetic merits.

What is, today, known about this third son of Shah Rukh as
a figure connected with fine manuscript painting is largely due to
the honouree of this volume, who has done more than anyone else
in our field to place the name of Ibrahim-Sultan on the "map" of
Timurid painting, and to characterize the distinctive stylistic fea-
tures of the painting now connected with him. Few can have ben-
efited so much from B.W. Robinson's work on Shiraz at the time of
Ibrahim-Sultan as have I, and thus it seems highly appropriate for
me to offer to Robbie's Festschrift these comments on Ibrahim-Sul-
tan's sponsorship of Timurid manuscript painting, and an assess-
ment of the legacy that is peculiarly his.

Ibrahim-Sultan would not be the Timurid prince who comes
first to mind as a patron of good illustrated manuscripts. But he did
have bibliophilic interests; and that he was an accomplished cal-
ligrapher is noted by the Timurid historians Khwandamir and Daulat-
shah and repeated by later writers, principally Qadi Ahmad, and
Mustafa 'Ali.[1] From these, and other sources, a list of projects
and objects Ibrahim-Sultan sponsored or executed himself has recently
been compiled, in the form of a Preliminary Index of Timurid
cultural patronage.[2] However incomplete it will eventually prove
to be, it does appear to suggest that writing, both monumental

and in manuscripts, was of primary interest to this prince and
pictures were less so.

The Preliminary Index lists six building inscriptions written
by Ibrahim-Sultan, six Qur'an manuscripts in his hand, and six sur-
viving manuscripts of other texts (but see below, and Note 14);
only three of these have illustrations. It is curious, and worth
noting, that all three are in notably different hands and must
have been copied by different scribes (although the colophon of only
one survives to document this assumption),[3] as were the three
unillustrated volumes with Ibrahim-Sultan's ex-libris that are
also listed in the Preliminary Index.

The earliest illustrated manuscript associated with him, the
"Baysunghur Anthology" in the Islamic Department of the Berlin
State Museums, is not even listed in the Preliminary Index under
his name but that of Baysunghur.[4] This manuscript was copied in
Shiraz in 823/1420, where Ibrahim-Sultan governed from late sum-
mer 817/1414 until his death in 838/1435,[5] yet it bears an illu-
minated *shamsa* with the name of *abu'l-ghazi baysunghur bahadur khan*.[6]
It contains a large selection of poetic texts, a good deal of deli-
cate illumination together with several double-page pairs of illu-
minated pages, and 29 illustrations executed in as many as eight
styles. These in no way relate to any of the paintings and draw-
ings connected with Baysunghur but instead recall Shiraz paint-
ing of the previous three decades, in various ways and not always
at the highest level of quality. The exception is represented by
only two pictures (pages 21 and 245)[7] that are remarkable for their
large and muscular figures, the exclusion of extraneous details,
the energy of the forms, and even the irregular shapes of the two
pictures themselves. Not only are the paintings visually quite strik-

ing; they are also the earliest examples of the fully developed pictorial style that would come to exemplify the illustrated manuscripts that issued from Ibrahim-Sultan's ateliers in Shiraz.

The Berlin "Baysunghur" *Anthology* of Persian *belles-lettres*, however, is a curious and hybrid creation, and we should recall that its connection with Ibrahim-Sultan, however evident it seems today in the light of pragmatic observation and the fact of his governance in Shiraz, remains – strictly speaking – inferential.[8] Nonetheless, its Shiraz origin seems perfectly secure: the scribe says so (in a colophon on p. 175); and its calligraphy, layout, and illumination all confirm its Shirazi locale. The ornament is in the "minute, unoutlined" Shiraz style of illumination, as Robbie has characterized it, and its illuminated double-page index-folios and opening text pages are different in composition, but similar in quality, to the celebrated *Anthology* now in the Gulbenkian Foundation in Lisbon that was completed in Shiraz for Ibrahim-Sultan's cousin Iskandar-Sultan a decade earlier, in 813/1411.[9] The Berlin manuscript was copied by the same Shiraz scribe as the Gulbenkian manuscript, Mahmud al-Husayni, and in the same format: selections of illustrated texts written horizontally within the *jadwal*, or ruling, of the rectangular written surface, the *matn*, and enclosed within wide margins, the *hashiyya*, in which other texts are written on the diagonal. The manuscripts even share folios and written surfaces of similar size.[10] But pictorially, the Berlin *Anthology* is very different from the fine, large, and quite original illustrations of the Gulbenkian *Anthology*: the Berlin manuscript's plethora of pictorial styles is both puzzlingly broad and surprisingly bad. Almost surely conceived as an exercise in the Shiraz manner of Iskandar-Sultan and presumably commissioned by Ibrahim-Sultan as a gift for his younger brother Baysunghur,[11] to me this manuscript has always seemed ambiguously placed in the *oeuvre* of either prince.[12] Its dependence on the form of Iskandar-Sultan's large *Anthology* – pictorial quality notwithstanding – and its early date both suggest the experimental nature of this manuscript within the larger *oeuvre* of the illustrated volumes sponsored by the sons of Shah Rukh.

We may well wonder whether the pictorial aspect of the art of the book occupied Ibrahim-Sultan at all in the years between 823/1420 and about 1430 or so. He copied Qur'ans: five of the six recorded in the Preliminary Index have dates between 826/1422–23 and 837/1434.[13] He executed monumental inscriptions for buildings in Shiraz and its environs, and at Persepolis. And he commissioned unillustrated volumes, at least five *Khamsa*s of Nizami and of Amir Khusrau Dihlavi, a Rumi, a *Jami' al-Sahih*, and a complete *divan* of Amir Khusrau Dihlavi, which have dates of completion between 822/1419 and 834/1430–31.[14] This last is of interest for several reasons, one being that Daulatshah reports correspondence among Baysunghur, Ibrahim-Sultan, and Ulugh Beg on the subject of which Persian poet was the superior, Nizami or Amir Khusrau Dihlavi; Baysunghur preferred Amir Khusrau, while Ibrahim-Sultan's opinion is not recorded.[15] Amir Khusrau's *Khamsa*, and

other selections of his poetry, are among the many texts in the *Anthology* of 820/1423, and in 1427 and 1428, the scribe Bayazid *al-tabrizi* was copying *Khamsa*s of both Nizami and Amir Khusrau for Sultan-Ibrahim; so perhaps he shared his brother's opinion, given the commission of the unillustrated volume of Amir Khusrau's *Divan* of 834/1430–31.[16] It has illuminations of spectacular design and beauty, leading Lentz to comment on the "qualitative disparity between illumination and manuscript illustration" in Ibrahim-Sultan's manuscripts.[17] The earlier dates by which these unillustrated volumes were completed would seem to suggest that Ibrahim-Sultan's pictorial interests were slow to develop.

The earliest illustrated manuscript unquestionably connected with Ibrahim-Sultan is a copy of Firdausi's *Shahnama* in the Bodleian Library of Oxford University. It was Robbie who "offered" this once fine but now very damaged manuscript to his colleagues in 1958, with the publication of his expanded and reworked thesis, a *Descriptive Catalogue of the Persian Paintings in the Bodleian Library*.[18] His discussion of its entire illustrative programme provided fundamental details – the number and location of miniatures, their subjects, parallels and publications, and remarks on their condition; and his comments on the "stark" and "farouche" style of the paintings have firmly fixed the features of Ibrahim-Sultan's very particular figural style in our collective eye.

Robbie has also called Ibrahim-Sultan's *Shahnama* "one of the most splendid Timurid manuscripts,"[19] with "sumptuous" ornamentation;[20] indeed its original splendour resides as much in these aspects as in its illustrations. To begin with, Ibrahim-Sultan's *Shahnama* is almost identical in size to the Berlin *Anthology*.[21] The quantity of its illumination almost rivals that of Baysunghur's *Shahnama*,[22] although stylistically it draws on both Shiraz and Herat models: a large, lobed Shirazi *shamsa* in which appears Ibrahim-Sultan's name (folio 12r); two splendid *'unwans*, one Shirazi (folio 12v) and the other Herati (folio 16r); and three splendid double-page *sarlauhs* in Herati style (folios 16v–17r, 17v–18r, 237v–238r), one actually signed by the illuminator, "Nasr *al-sultani*" (folio 17v, at the very bottom of the composition). It also contains five pages of finely-drawn and humorous fantasies, some in the manner of chinoiserie and others more Jalayirid in flavour; these are heightened with gold and faint touches of colour, about which Wright has now commented (see p.134).

As for illustrations, Ibrahim-Sultan's *Shahnama* has 47 paintings, more than twice as many as Baysunghur's.[23] They are not all by the same hand but far more than the Berlin *Anthology* they are stylistically cohesive, notwithstanding divergencies of conception and model, size and finish. In conception, they range between old-fashioned small, horizontal formats and quite large full-page images. Among them are a number of imaginative compositions that interweave text and picture over the entire page in a highly dramatic and effective manner never seen before nor so effectively used since.

Despite these compositional variations, the paintings in Ibrahim-

Sultan's *Shahnama* give us a clear picture of the state of painting in his atelier in Shiraz by about 1430. Essentially, it is distinguished by an aesthetic of minimalism that seems almost diametrically opposed to Baysunghur's complex and carefully constructed pictures filled with depictions of Timurid material culture.

Ibrahim-Sultan's figures are quite large and occasionally somewhat attenuated, with large oval heads, and they move in a series of simplified settings, the landscapes with high, curving or hilly horizons, sometimes organized in overlapping planes of differing colours, and the interiors with a minimum of furnishing and little articulation. The fine, and finely-painted, details of Jalayirid and earlier Shiraz painting, whether garments or architecture or gardens, are almost entirely absent, and the colour-schemes are, consequently, almost entirely without subtlety. A characteristic feature is the use of figures in multiples placed "in unison" to compose groups, or crowds. Attendants around a prince or princess, and armies of mounted soldiers or foot-soldiers are the usual function of such repeated groups, whose pictorial origin again lies in certain earlier Shiraz pictures of Iskandar-Sultan's patronage, for instance, one half of "Khusrau Administers Justice," from the Lisbon *Anthology*.[24] Two other mannerisms mark the depiction of natural elements: towering, upright, apparently "exploding" masses of rock with frothing tops and wriggling internal lines of articulation, and shrubs with clumps of dark-green foliage rendered as thick curving spade-like shapes that give the impression of being tossed in a strong wind. Some miniatures in Ibrahim-Sultan's *Shahnama* are extremely vivid and memorable, while others are basic, and simple in the extreme. Collectively, however, they exemplify that highly individual and mannered version of Timurid painting seen in just two of the illustrations in the Berlin *Anthology*.

To these they add a number of variant pictorial possibilities. Among the more striking is the use of two adjoining pages for an illustration that should properly be understood as one picture: Ibrahim-Sultan's *Shahnama* has four such double-page compositions, a feature matched in earlier or contemporary Persian painting only by the Lisbon *Anthology*.[25] Ibrahim-Sultan's are significant for many reasons, the first being that none illustrate Firdausi's text at all. Instead, the first three embody the most ancient of Iranian themes in contemporary Timurid garb, and they are among the more aggressively crowded of (presently known) Shiraz paintings from Ibrahim-Sultan's ateliers. Their subjects are contemporary Timurid renderings of ancient Persian themes particularly prevalent in the *Shahnama* — battle, hunting, and feasting: in short, the *bazm u razm* of Persian literature. In each case in this *Shahnama*, Ibrahim-Sultan himself is the "hero": he displays his prowess on the battle-field and at the hunt and then holds a celebratory banquet in a garden. At present, these paintings are placed in the first seven folios of the manuscript, the reverse of each folio bearing either a contemporary drawing or left blank; thus whatever may have been their original position they seem to be a unit distinct from the

other parts of the "front matter" — a genealogical table, an explanation of ancient words to be encountered in reading the *Shahnama*, and the Baysunghuri preface, which begins on folio 12v. That there should be three such illustrations, whereas in those of Baysunghur's manuscripts having double-page frontispieces such images of princely prerogative are single — an outdoor feast in the *Kalila va-Dimna* of 833/1429,[26] a hunting scene in the *Shahnama* of 833/1430[27] — suggests that Ibrahim-Sultan's notion of the function of illustrations in a manuscript was evidently both more personal and less distilled than was his brother's.

This seems borne out by the fourth double-page painting, as unusual — if in a different way — as the first three. It occurs on folios 239v–240r, at the beginning of the second "half" of Firdausi's text, with the reign of Gushtasp, and it is preceded by the third of the double-page illuminations, on folios 237v–238r. The settings are again contemporary: a crowned Ibrahim-Sultan holds court in a palace interior, and his consort stands with attendants on a balcony overlooking a garden in which a gardener works.[28] Each picture, therefore, depicts Ibrahim-Sultan and his consort in his own sphere of activity, but it is also clear that the pictorial means of Shiraz painters lag well behind their pictorial intentions, for the "picture" hardly functions as a unified image.[29]

Finally, all four of these double-page compositions are quite large, extending noticeably beyond the ruling of the written surface. In this they stand apart from any of the other text illustrations in the manuscript, even the most audaciously composed, such as "Rustam Flees up the Mountain from Isfandiyar," or "Rustam Rescues Bizhan from the Pit."[30]

Precisely when this extraordinarily personal copy of Firdausi's epic poem was completed is not known, for the manuscript is defective and no longer has its colophon. Thus, the name of the calligrapher remains unknown, and the date of its completion conjectural — within a short span of years, to be sure: it can be no earlier than 829/1426, when Baysunghur composed his new Preface, and no later than 839/1436, the date of Ibrahim-Sultan's death, and is surely well before this date. It is, furthermore, a manuscript distinguished by a particular "charge" that has nothing to do with the stylistic accomplishment of its paintings: indeed, I would venture to say that the special value of the few illustrated manuscripts Ibrahim-Sultan must have supervised personally lies in the meaning conveyed by the subjects of their pictures rather than the joint effect of superior aesthetic quality and meaningful subject.

We have already seen that he seized upon the notion of the manuscript frontispiece, in the classical tradition depicting the patron in a dignified or ennobling activity and then reinterpreted by his brother Baysunghur, in contemporary Persian usage, as a unique double-page picture at the head of a manuscript. The significance of such an image was thus exaggerated — whether by Ibrahim-Sultan or by his painters is probably not possible to say — by the

rejection of a single, formal, almost iconic image in favour of three compositions verging on the narrative and crammed with figures, many shown "in unison," whose purpose is to emphasize Ibrahim-Sultan's role as a hero in the ancient Iranian manner.

Ibrahim-Sultan also chose to emphasize certain themes by his choice of *Shahnama* illustrations, and they are remarkably different from Baysunghur's sober and restrained *Shahnama* with its images of princely duties and responsibilities to governed peoples. Ibrahim-Sultan's *Shahnama* stresses personally heroic deeds but accords as much weight to family connections, confronting the difficult issues that may arise between blood relations.[31] This is not surprising, given the family feuds that marked the period after Timur's death, and the fact that he had himself attained his position in Shiraz because of his cousin Iskandar-Sultan's continuous insubordination. Moreover, he had been concerned with the presentation of his family's dynastic history since very shortly after settling in Shiraz, having begun as early as 822/1419–20 to rework the chronicles kept daily by his grandfather.[32]

The result of Ibrahim-Sultan's reordering of dynastic history was the elaborate panegyric biography called the *Zafarnama*, commissioned from the noted prose stylist Sharaf al-Din ʿAli Yazdi. The text had been finished in 828/1424–25, but the earliest copy surviving today is a manuscript of over a decade later, completed in Dhuʾl-Hijja 839/May–June 1436. It is the third of the illustrated volumes to issue from Ibrahim-Sultan's atelier. Again it was Robbie who firmly set these paintings in Ibrahim-Sultan's Shiraz orbit, and he did so even earlier than for the *Shahnama*: in 1952.[33] Although its illustrations have been widely dispersed, the text block and its final folios have been kept together. Now "reconstructed",[34] the *Zafarnama* can be appreciated for a number of reasons that have nothing to do with the history of Timurid art but rather with Timurid politics. Not only does it pay visual tribute to the accomplishments of the ostensible subject of the text, Timur – presenting him as a conqueror as well as a builder, and also as a pious and observant Muslim – but it also focuses on the accomplishments of Ibrahim-Sultan's father, Shah Rukh, and translates into visual propaganda some of the dynastic concerns of this prince who had only with some difficulty established himself as Timur's successor.

As a document in the history of Timurid painting, however, Ibrahim-Sultan's *Zafarnama* may now also be described in the same terms as Ibrahim's other manuscript. The manuscript originally had 24 illustrations, almost all full-page in size, of which a particularly large number – 13 – are double-page compositions.[35] The pictorial style of these paintings is, again, that of the two pictures in the Berlin *Anthology* and many of the *Shahnama* illustrations, but it is far more unified in the conception of the pictures, and their scale, colouring and draughtsmanship. Its figures are uniformly elongated; its landscape settings all similarly shaped and clad in desert foliage with an occasional shading tree; and the *Shahnama*'s

exaggerations of foliage and rocky landscape are usually avoided save for episodes that actually occur in the mountains, such as "Timur Besieges the Abkhazis in Caves".[36]

It is sobering to realize that Ibrahim-Sultan did not live to see it finished: the copying was completed in the spring of 839/May–June 1436, but Ibrahim-Sultan had died a year earlier, on 4 Shawwal 838/15 May 1435, "when treacherous fate and the unjust celestial spheres drew the line of annihilation through the daybook of that exalted prince's life".[37] I am virtually certain that had Ibrahim-Sultan lived to see the completion of what was intended as the first of a trilogy of panegyric histories (of Timur, Shah Rukh, and himself), the volume would have been illuminated as sumptuously as was his *Shahnama*. Instead, it has only two contemporary ʿunwans, one at the head of the text and the second just before the first pictures in the manuscript, "Timur Holds an Accession-Audience in Balkh, 12 Ramadan 771/9 April 1370."[38]

That the programme of illustration was a careful selection of key moments in the lives of Timur and Shah Rukh meant that contemporary history was depicted in contemporary settings. It also meant that there were relatively few models for these episodes other than the most generic of pictures. I suspect that the double-page paintings of Ibrahim-Sultan's *Shahnama* now stood the *Zafarnama* painter in very good stead, since representations of battles, of hunts, and of feasts held both indoors and outdoors, in gardens or by streams, comprise many of the generic settings of this illustrated piece of dynastic propaganda. A particularly good example is Timur's invasion of Delhi in Rabiʿ II 801/December 1398.[39] The text vividly recounts the success of the battle and comments on the impression made on the Timurids by the Indian army mounted on its war-elephants, yet the painting is composed entirely of elements from which *any* Timurid scene of combat might be composed; moreover, it shows no elephants! Their absence, where the text calls for them, might be explained by the fact that the particular painter had never actually seen such a beast – and then again it might not, since elephants do figure in other of Ibrahim-Sultan's pictures (see Pls. 3, 15).[40] The same generic, non-specific treatment accounts for some *Zafarnama* illustrations, such as "Timur Receives Guests at the Marriage of his First-Born Son Jahangir in 775/1374", or "The Building of Aq Saray in 781/1379".[41] Yet other *Zafarnama* paintings translate the text quite specifically into images, as do "The Attack on Aleppo in 803/1400", and "The Capitulation of Baghdad in 803/1401".[42] The left half of the double-page painting in which the gift of the Sultan of Egypt is presented to Timur perfectly sums up the Shiraz pictorial achievement under Ibrahim-Sultan's aegis: pictures consisting of a standard setting with a minimum of generic pictorial elements and details but with one specific essential – the exotic giraffe. The result is a compressed but usually memorable image.[43]

The fourth illustrated manuscript connected with Ibrahim-Sultan's patronage in Shiraz, now in the Süleymaniye Library in

Istanbul,[44] is illustrated with twenty-eight miniatures in the Shiraz style that are nothing if not compressed (Pls. 1–28). In the old Shiraz tradition, the volume is again an anthology (although perhaps "compilation" is more apt), this time of selections of prose texts, all of which belong to the genre of the "Mirror for Princes": the *Marzuban-nama* of Sa'd al-Din Varavini, Nasr Allah's *Kalila va Dimna*, and Shams al-Din Daqa'iqi's *Sindbad-nama*. The manuscript is fully described in the best Robinsonian fashion, in the preceding article, by Ernst J. Grube, and its contents commented upon (pp. 111–125), and I shall dwell but briefly on those features which place Ibrahim-Sultan's *Anthology of Prose Texts* – as we have been provisionally calling this manuscript – in the broader context of all of his illustrated manuscripts.

The volume lacks its colophon, but other "iconographical" aspects – the partly effaced *shamsa* on folio 1r that still allows the words *"abu'l-fath"* to be read, the eulogy (at the end of folio 205v) in which Ibrahim-Sultan is mentioned, and the fascinatingly mannered style of its illustrations – leave no doubt that it was copied and illustrated for him in Shiraz. When, however, is again impossible to say, in the absence of the colophon. A peculiar feature is that the manuscript is much smaller than those just discussed.[45] This, and the style of its illustrations, the work of probably no more than two different Shiraz painters, convey the impression that it was planned, and probably also completed, later than the *Zafarnama*.

Both in size and subject, it presents a notable parallel with his brother Baysunghur's *Chahar Maqala*, which is also a small illustrated copy of a text in the same "Mirror for Princes" genre and was completed in 835/1431, coincidentally also late in *his* lifetime.[46] In other features, however – the style of its illustrations and its *naskh* calligraphy, particularly clear and upright – what the Istanbul anthology most resembles is the well-known dispersed Timurid copy of Juvayni's *Ta'rikh-i Jahan Gushay*.[47] This was finished in 841/1438, the work of the scribe Abu Ishaq ibn Ahmad al-Sufi al-Samarqandi.[48] Reflecting on its content and the style of its illustrations (in which history is presented in the guise of *belles-lettres*, as was the *Zafarnama*, which I suggest must be seen as a specific innovation of Ibrahim-Sultan) within the context of its date, we might well wonder who commissioned it, and whether the fact of Baysunghur's two (unillustrated) copies of the same text might be in any way germane.[49] I would venture the suggestion that Ibrahim-Sultan's *Anthology* predates the *Ta'rikh-i Jahan-Gushay* (for reasons whose confirmation must await its reconstruction).

From the preceding article, it will be evident that the *Anthology's* illustrations have a deceptive simplicity as well as an apparent similarity, and also that they were devised from quite divergent pictorial sources, just as the iconographic history of the texts they illustrate is divergent. The *Kalila u Dimna* pictures (Pls. 5–23) draw on a long and complex illustrative tradition, which numbers at least 14 surviving earlier Persian manuscripts of Nasr Allah's text, not to speak of at least nine earlier copies of Ibn al-Muqaffa''s Arabic

version.[50] The illustrations in the other two texts, rare before this date and having little or no iconographical tradition on which to draw (see Grube, pp. 101–117, and Pls. 1–4, 24–28), are a fascinating adaptation of both Shiraz and Herat models, both contemporary as well as of slightly earlier date. What ties them all together is that they have all been reinterpreted by Ibrahim-Sultan's Shiraz artists: adapted, often by simply reversing images, and subjected to that simplifying, compressing, almost "scouring" treatment we have already seen in Ibrahim-Sultan's other – three – manuscripts.

What I have not yet been able to deduce is the purpose, the "charge" of Ibrahim-Sultan's *Anthology of Prose Texts*: why were these texts, in particular, chosen for this volume, and what might be signified by their illustrations, over and above what they *appear* to illustrate? For I have virtually no doubt that such a purpose was intended, one that would have become evident had Ibrahim-Sultan lived to see the completion of this manuscript. In the process of studying his illustrated *Zafarnama* and his illustrated *Shahnama*, I have come to believe that Ibrahim-Sultan held certain ideas about the use of an illustrated text of classical Persian poetry that were uniquely his own. When he commissioned an illustrated manuscript, he did so with a very specific purpose that was other than aesthetic, one that did not require the distillation, the transmutation of meaning into the perfection of timeless, fixed, frozen formal images that was Baysunghur's pictorial achievement. Ibrahim-Sultan, instead, used the illustrative aspect of the texts he commissioned sparingly, and always with a very personal intention; and that the style and finish of these pictures rarely equalled those of his brothers' manuscripts was, I venture to suggest, irrelevant to him.

What is astonishing to contemplate is the impact that Ibrahim-Sultan's Shiraz-style of painting had in later decades, not only in Timurid Persia but elsewhere in the Eastern Islamic world. For the illustrated manuscripts produced at Ibrahim-Sultan's personal commission in Shiraz, in the years of his governance between 817/1414–15 and 838/1435 (or shortly thereafter) – at least, to the best of our present knowledge – number only four, and the paintings in them only 101, a number which must include the earliest pictures, the two from the anthology of 823/1420 that so splendidly adumbrate the later paintings of his atelier. Their impact, however, was to be found everywhere in the Eastern Islamic world during the next century: it was enormous.

At the time of the publication of the Bodleian catalogue in 1958, Robbie could already document 25 post-Ibrahim-Sultan Shiraz-style manuscripts; and others continue to emerge.[51] Seventeen post-Ibrahim-Sultan Shiraz-style copies of the *Shahnama* alone are listed in a recent preliminary gathering of fifteenth-century *Shahnama* volumes, of which two of the most interesting have come to light since 1958, one quite recently.[52] Mannerisms typical of Ibrahim-Sultan's style can also be found in metropolitan manuscripts

from around 1440 as well as in Turkman-style manuscripts of the rest of the century, testifying to the strength of this pictorial tradition in the hands of painters who plied their trade at the service of other Timurid princes after Ibrahim-Sultan's death.[53]

The style travelled east and west of Timurid Persia. Certain post-Ibrahim-Sultan Shiraz-style manuscripts are, for the moment, considered products of workshops in Western India;[54] and which among them will eventually prove to be so is less important, to this argument, than that their most significant sources also lie in post-Ibrahim-Sultan Shiraz painting. The post-Ibrahim-Sultan Shiraz manner is present in some of the 62 miniatures in a Mamluk translation of the *Shahnama* completed in Cairo in 916/1510 for a functionary of Sultan al-Ghauri.[55] And it underlines most of the illustrations in three (presently known) manuscripts made in the second half of the fifteenth century in Ottoman Turkey, of which one, a copy of Ahmedi's *Iskandar-nama*, has 66 illustrations.[56] In this case, the means of transmission westward may be a *Khamsa* of Nizami dated 846/1442, which has 41 pictures in three styles that all recall different Timurid Persian manners of the period, one being clearly post-Ibrahim-Sultan Shiraz,[57] although the *shamsa* on folio 1v carries a dedication to "Muhammad ibn Murad Khan", Sultan Mehmet II.[58] From Istanbul to the Indian Ocean is an impressive reach for a provincial version of a princely mode for visualizing the content of classical Persian literature!

I submit, moreover, that the forging of the pictorial instrument to illustrate manuscripts of the most popular texts for a wider Persian-reading public, in what I have elsewhere proposed calling "the scribal" manner,[59] was not intended but instead occurred, unplanned, in the aftermath of Ibrahim-Sultan's death at the relatively young age of 42. Given his predilection for "charging" his illustrated manuscripts not by the combination of carefully chosen text and significant image enhanced by a supremely balanced, polished pictorial aesthetic, but by the highly personal choice of text and picture alone, even the best of his Shiraz manuscript illustrations – forceful and dynamic and immensely attractive to the contemporary eye though they may be – have a somewhat primitive appearance compared to the formal and theatrical perfection of the images in Baysunghur's Herat manuscripts. I further suspect that the "charge" of Ibrahim-Sultan's illustrated manuscripts proved impossible to recreate, once he who had ordained the "charge" was no longer there to do so. What did remain was the shell that

had contained the "charge" – the traditions of laying out and illuminating manuscripts, the workshop drawings, the habits of the painters who had executed these images: all constituting a pictorial dialect that would continue to be spoken throughout the Eastern Islamic world for at least a century to come.

Even Shiraz manuscripts with a princely connection "spoke" in this dialect, as do the emphatically post-Ibrahim-Sultan illustrations of a *Shahnama* completed in 848/1444.[60] Robbie has recently reminded me that its scribe signs himself "Muhammad *al-Sultani*" (as did the illuminator of Ibrahim-Sultan's *Shahnama*), and was, thus, presumably in the service of some princely personage: Robbie's candidate is Ibrahim-Sultan's son 'Abdallah.[61] The impressive double-page painting of an outdoor feast in a garden in the Cleveland Museum of Art (but acquired at different dates) is usually considered the frontispiece to this manuscript, and its composition clearly derives from both the double-page *razm* "Frontispiece" in Ibrahim-Sultan's own *Shahnama* and the first double-page illustration in the *Zafarnama*, although it is more aggressively peopled than either.[62]

The 101 paintings that can, at the moment, be securely connected with Abu'l-Fath Ibrahim-Sultan ibn Shahrukh ibn Timur echo through at least a century of manuscript production in the Muslim East. He, and his painters, were fortunate in having inherited a broad-based Shiraz tradition of making manuscripts, with well-developed notions of layout and adornment and illustration, that predated the arrival of the Timurids, although this tradition tends to be overshadowed by the brilliant achievements in the first period of Timurid governance in Shiraz, especially during the time of Iskandar-Sultan's peripatetic rule, between 813/1410 and 817/1414. Some of Iskandar-Sultan's craftsmen had left Shiraz after his deposition, and those who remained to serve Ibrahim-Sultan quite naturally effected changes in what had briefly but so brilliantly come to represent the Timurid-Shiraz pictorial canon. They adapted its compositions and simplified its style, "streamlined" it, so to speak, with inevitable aesthetic consequences. But Ibrahim-Sultan's Shiraz canon spoke to other, and perhaps wider, audiences than the circles of his brothers in Herat, and it was to have an impact on posteriority that was based on qualities other than the aesthetic. And in the end, this is perhaps as great a legacy as could be wished by any patron of the arts whose daybook had been prematurely closed by treacherous fate and the unjust celestial spheres.

Notes

* The full titles of works abbreviated will be found on p. 115, at the beginning of the notes to the article of Ernst J. Grube, pp. 101–117, with whom all illustrations are also shared.

1 Daulatshah, translated from Muhammad 'Abbasi's Tehran edition of 1337 (*sic*), in Thackston, *Century*, 1989, pp. 33–34; *Calligraphers and Painters: A Treatise by Qadi Ahmad, Son of Mir-Munshi (circa A.H. 1015/A.D. 1606)*, tr. Vladimir Minorsky, with an introduction by B.N. Zakhoder, (Freer Gallery of Art Occasional Papers, 3, number 2), Washington, D.C., 1959, pp. 69–71; Mustafa 'Ali, quoted by Thackston, *Century*, 1989, in his own translation, p. 34 (for source of edition, see p. 392).

2 Lentz & Lowry, 1989, Appendix II, pp. 366–74: on Ibrahim-Sultan, pp. 369–70.

3 That of the *Zafarnama*, see below, Note 34; it is in a hand remarkably like his own, if we may judge from the 2-volume Qur'an manuscript of 830/1427, cf. Lentz & Lowry, 1989, p. 84 and p. 105, for example.

4 J. 4628. Kühnel, "Handschrift", 1931, pp. 133–52; also Enderlein, 1970.

5 The usually accepted date, given by Sharaf al-Din, and also by Khwandamir, *Habib al-Siyar*, as in Thackston, *Century*, 1989, pp. 138–39; Daulatshah, *Tadhkirat al-Shu'ara*, gives a later date, Rajab 819/September 1416 again, see Thackston, *Century*, p. 33.

6 Kühnel, "Handschrift", 1931, p. 18, in Arabic characters, and fig. 1; a larger reproduction in colour in Enderlein, 1970, p. 1.

7 Enderlein, 1970, pp. 3, 11, in colour.

8 Lentz & Lowry, 1989, as already noted, list it as a work of Baysunghur (p. 368); I have, myself, always considered it as a work of Ibrahim-Sultan's patronage, since everything about the manuscript is fundamentally characteristic of Shiraz in the earliest years of his residency there: Sims, "*Zafar-Nameh*", 1991, n. 20, pp. 182–83; and "Ibrahim Sultan's Illustrated *Zafarnama* and its Impact in the Muslim East," *TAC*, 1992, p. 132, and n. 6, p. 141.

9 Stchoukine, *MT*, 1954, pp. 40–41, MS XIV; cf. Kühnel, "Handschrift", 1931, fig. 2, with Priscilla P. Soucek, "The Manuscripts of Iskandar Sultan: Structure and Content", *TAC*, 1992, pp. 116–31, figs. 1 and 2.

10 The Berlin folios measure 280 mm in height and approx. 190–200 mm in width, with a written surface measuring 236 by 158 mm; the Lisbon folios measure approx. 272–3mm in

height and 172–181 mm in width, with a written surface measuring 235 by 146 mm. These values, however, are imprecise, since published data on the size of this important manuscript do not accord with notes made personally (in 1971); and Soucek's otherwise useful study does not include the measurements of folios or the sub-divisions of layout.

11 As suggested first by Kühnel: "C. History of Miniature Painting and Drawing", *A Survey of Persian Art From Prehistoric Times to the Present*, ed. Arthur Upham Pope and Phyllis Ackerman, London, 1938–39, 6 vols.: V, p. 1847.

12 No illustrated manuscript connected with the patronage of Baysunghur at this date survives to compare the features that comprise the profile of each of these princes' illustrated manuscripts, but the idea is intriguing!

13 Lentz & Lowry, 1989, p. 370: one of the six is undated.

14 The last three listed *ibid.*, pp. 369–70; the first is noted in *The Catalogue of the All-Union Exhibition on the Arts of the Timurid Period*, the exhibition accompanying the Timurid Symposium sponsored by UNESCO in Samarqand in 1969, pp. 7, 30, and 52, no.39. This volume of Nizami's *Khamsa* was completed in Shawwal 831/July–August 1428 by the scribe Bayazid al-Tabrizi *al-sultani* for Ibrahim-Sultan and consists of 338 folios measuring 242 by 155 mm (thus a bit wider than the Bodleian *Shahnama*, see Note 21 below). It has no illustrations but "unwans, headpieces, illuminated colophon" in the Shiraz style. The manuscript is numbered P-458 in the Institute of Manuscripts of the Academy of Sciences of what was, in 1969, the Georgian SSR. The *Khamsa* of Amir Khusrau was shown in 1940 in New York, at the Iranian Institute, *Exhibition of Persian Art*, New York, 1940 (Second Edition, May), p. 211 (Case 106–A); it measures approximately 241 by 165 mm, almost exactly the size of the same scribe's Nizami. The manuscript was then in the possession of Hagop Kevorkian but has since disappeared.

15 Daulatshah's *Tadkhirat al-Shu'ara*, in Thackston, *Century*, pp. 23–24; correspondence regarding the *Khamsa*s of these two poets is also mentioned by V.V. Barthold, in *Four Studies on the History of Central Asia: Ulugh Beg* (Volume II), tr. V. and T, Minorsky, Leiden, 1963, pp. 134–35, likewise quoting Daulatshah, from E.G. Browne's edition of 1901.

16 Lentz & Lowry, 1989, cat. 18, and p. 370, ill. in colour pp. 72–73 and 138.

17 Lentz & Lowry, 1989, p. 338, cat. 18.

18 Ouseley Add. 176. Robinson, *Bodl.*, 1958, pp. xxiii, xxv, 13–22, cat. 81–132, pls. I, IV. It had been lent to the Persian Exhibition in Burlington House in 1931, cat. 538A, and was later published in BWG, 1933, pp. 55, 67–68, cat. 46, pls. XXXVIII–XLB and frontispiece (in the reprint, in colour, following p. 16). Finally, Sims, "*Shahnama*", 1993, pp. 43–68, *passim*, especially n. 6, p. 59 (where the BWG reference should read "46").

19 V&A, 1967, p. 91.

20 Robinson, *Bodl.*, 1958, p. 16.

21 The *Shahnama* has a folio less than a centimetre longer and a written surface slightly shorter: its folios measure approx. 285–7 mm in height and approx. 200 mm in width; the *Anthology*, as noted in Note 10 above, has dimensions of approx. 280 by 190–200 mm; the *Shahnama*'s written surface varies between 221 and 230 mm in height and 147–8 mm in width, compared with the *Anthology*'s written surface of 236 mm by 158 mm.

22 Sims, "*Shahnama*", 1993, n. 4, pp. 58–59, for the earliest reference; the most thorough recently published bibliography remains that in Thomas W. Lentz's unpublished doctoral dissertation at Harvard University, *Painting at Herat under Baysunghur ibn Shahrukh*, 1985, pp. 385–421.

23 Sims, "*Shahnama*", 1993, Appendix A, pp. 65–66.

24 Basil Gray, *Persian Painting*, Geneva, 1961, p. 77.

25 Soucek, *TAC*, 1992, pp. 129–30.

26 Lentz & Lowry, 1989, pp. 110–11, in colour.

27 BWG, 1933, pl. XLIV; and in colour but not as facing plates, in *Iran: Miniatures Persanes – Bibliothèque Impériale*, Paris, 1956, pls. I–II (also in English), and in the "miniature" paperback edition, in English, with the same plate-numbers.

28 BWG, 1933, separately: colour-frontispiece (in the reprint in colour following p. 16), and pl. XXXVIII; Sims, "*Shahnama*", 1933, fig. 2 together.

29 BWG, 1933, p. 55, seem to suggest that the two "halves" of this composition are mistakenly bound together, cf. Sims, "*Shahnama*", 1993, pp. 46–47, for the opposing view.

30 Sims, "*Shahnama*", 1993, Appendix A, pp. 65–66, fols. 186r (illustrated Stchoukine, *MT*, 1954, pl. XXV), and 280v (illustrated Robinson, *Bodl.*, 1958, pl. I).

31 Sims, "*Shahnama*", 1993, pp. 47–48, and Appendix A, pp. 65–6.

32 Sims, "Zafar-nameh", 1991, p. 175.

33 B.W. Robinson, *The Kevorkian Collection: Islamic and Indian Illustrated Manuscripts, Miniature Paintings, and Drawings*, unpublished typescript catalogue prepared for the Trustees of the Kevorkian Foundation at the Metropolitan Museum of Art, 1953, p. 24, no. XXI.

34 Sims, "Zafar-nameh", 1991.

35 That these paintings had been so widely dispersed and for so long, and that the double-page pictures are often not specifically recognizable as such, had imposed a strictly pragmatic system of recording them as they emerged; it gave rise to an initially separate numeration that was retained in publications prior to 1992. But by the standards usually applied in this field, the number of illustrations in Ibrahim's *Zafarnama* is better expressed as "24" and will be so rendered in this, and any future, publications.

36 Sims, "Zafar-nameh", 1991, fig. 31, cat. 31, pp. 208–9.

37 Thackston, *Century*, 1989, again quoting Daulatshah, p. 34 (and again the date – 834/1430–31 – is at variance with the usually accepted one of 838/1435).

38 The first is now on folio 73v, the second on folio 127v, after the addition of a *muqaddima*, or introduction, of 72 folios, in 885/1480, in Herat; Sims, "Zafar-nameh", figs. 40, 42.

39 Sims, "Zafar-nameh", 1991, fig. 14, cat. 14, p. 202; most recently discussed, and reproduced in colour, by the writer, in *Eredità dell'Islam: Arte Islamica in Italia*, (Exhibition Catalogue), Venice, 1993, cat. 218, p. 363.

40 In the *Shahnama*'s "Rustam Pulls the Khaqan of Chin from his Elephant," fol. 164r, Sims, "Shahnama", 1993, fig. 10; twice in the *Anthology*, in "The Battle of the Elephants and the Lions," fol. 153v, and "Firuz and the King of the Elephants at the Lake of the Moon," fol. 335v, see Pls. 3, 15; whether this implies different painters, or something that remains to be deduced, is uncertain.

41 The former also reproduced, most recently, in colour in *Eredità dell' Islam*, cat. 220, p. 365; and also Sims, "Zafar-nameh", 1991, fig. 3, cat. 3, p. 197; the latter *ibid.*, fig. 5, cat. 5, p. 198.

42 Sims, "Zafar-nameh", 1991, figs. 21–22, cat. 21–22, pp. 205–206.

43 Sims, "Zafar-nameh", 1991, figs. 34–35, cat. 34–35, pp. 209–210; pls. XII–XIII.

44 Fatih 3682. Nurhan Atasoy, "Persian Miniatures of the Süleymaniye Library Istanbul," *Akten des VII. Internationalen Kongresses für Iranische Kunst und Archäologie, München, 7.–10. September 1976*, Berlin, 1979, pp. 425–30, figs. 1–2; *ABCA*, 1979, fig. 77, p. 140 (the description is, however, incorrect); *Marg*, 1991, fig. 100; and Grube, "K&D," 1991, cat. 25, pp. 385–86; Nezihe Seyhan, *Süleymaniye Kutuphanesi'ndeki Minyatürlü Yazma Eserlerin Katalogu*, Istanbul, (forthcoming), no. 28, pp. 352ff; no. 32, pp. 367ff and no. 39, pp. 382ff. We are extremely grateful to Professor Nurhan Atasoy, of Istanbul University, and Professor Güner Inal, formerly of Hacettepe University, for immense help in graciously providing pictures and bibliography, and checking details of this manuscript, which neither of us has yet been able to study in detail.

45 Its folios measure only 218 x approx. 135 to 141 mm, and its written surface only 150 x 84.

46 Istanbul, TIEM, 1954: Eleanor Sims, "Prince Baysunghur's *Chahar Maqaleh*," *Sanat Tarihi Yilliği*, VI, 1974–5, pp. 375–409.

47 Paris, B.N., Suppl. pers. 206. 6 paintings remain in the parent MS, and possibly as many as 8 were removed and are now widely dispersed. Stchoukine, *MT*, 1954, p. 44, MS XXII, pl. XXXIII; Clément Huart, *Les Calligraphes et les miniaturistes de l'Orient musulman*, Paris, 1908, pls. 1–3 (and photomechanical reprint, Osnabruck, 1972, with plates unnumbered): pl. 1 has been in Worcester (Mass., 1935.10), since 1935, the whereabouts of pl. 2 remain unknown, and pl. 3 is now in the collection of Prince Sadruddin Aga Khan, Ir. M. 10, see Anthony Welch, *Collection of Islamic Art (Prince Sadruddin Aga Khan)*, privately printed, 1972, Vol. I, pp. 103–105; two are in the British Museum, 1948-12-11 05, -06, see V&A, 1967, cat. 121, p. 93; and at least three more are in two private collections in New York City. I have been working on a reconstruction which will appear in due course.

48 A scribe whose name does not – yet – otherwise appear in any other recorded Shiraz manuscripts or documents; as usual, it is Manijeh Bayani who has confirmed my reading of various sources, and to whom it is a pleasure to direct my thanks.

49 These two manuscripts, dated 833/1430 and 835/1431–32 respectively, are listed in the Preliminary Index, Lentz & Lowry, 1989, pp. 368–69, that dated 835 having been in the Keir Collection since 1972: Basil W. Robinson *et al.*, *Islamic Painting and the Arts of the Book*, London, 1976, p. 296, VII.62, and pl. 42 in colour.

50 These have now been documented in an extraordinarily useful study, Grube "K&D," 1991, see Appendices I, especially pp. 360–62, and II, especially pp. 374–86.

51 Robinson, *Bodl.*, 1958, pp. 23–25 *passim*.

52 Sims, "Shahnama", 1993, Appendix B, pp. 67–68; the two are: the Dufferin and Ava *Shahnama*, dated 839/1436 and 841/1437, with 58 illustrations, see Christie's 19 June 1968, Lot 8, pp. 8–22, and Sotheby's, 11 October 1982, Lot 214, pp. 90–94 and colour frontispiece; and yet again, at Sotheby's, 16 October 1996, Lot 47, colour cover and pp. 50–54; and the Soudavar *Shahnama*, dated 844/1441, with 24 illustrations: A. Soudavar, *Art of the Persian Courts: Selections from the Art and History Trust Collection*, New York, 1992, cat. 27a-i, pp. 71–77. These two manuscripts, and the 17 listed in appendix B of Sims, "Shahama", 1993, form the Appendix of this writer's "Towards a Study of Shirazi Illustrated Manuscripts of the Interim Period": The Leiden *Shahnama* of 840/1447", *Oriente Moderno*, N.S., XV (LXXVI), 2, 1996: *La Civiltà Timuride Come Fenomeno Internazionale*, ed. Michele Bernardini, Vol. II, pp. 611–25, pls. XXI–XXIII.

53 Among the most notable instances being the Royal Asiatic Society *Shahnama* of Muhammad Juki, as Robinson had pointed out as early as 1951: "Unpublished Paintings from a XVth Century 'Book of Kings'", *Apollo Miscellany*, 1951, pp. 17–23, and also, with illustrations of telling details, "The Shahnama of Muhammad Juki, RAS. MS 239", *The Royal Asiatic Society: Its History and Treasures*, ed. Stuart Simmonds and Simon Digby, Leiden & London, 1979, pp. 83–102, pls. III–X.

54 "As early as the late 1960s, Robinson had been developing the hypothesis that Sultanate India might be the origin of a group of unlocalized Persian manuscripts whose unusual characteristics left them uneasily placed in an Iranian milieu" (Sims, "Shahnama", 1993, n. 18, p. 61). For the essence of the argument, the following are key statements and documents: A.S. Melikian Chirvani (*sic*), "L'école de Shiraz et les origines de la miniature moghole", *Paintings from Islamic Lands*, ed. R. Pinder-Wilson (Oriental Studies IV), Oxford, 1969, pp. 124–41; B.W. Robinson, *Persian Paintings in the John Rylands Library*, London, 1980, esp. "Timurid Painting in Western India", pp. 95–96, concerning Rylands Pers. MS 933, datable between 1430 and 1440; Robinson also summarized the arguments of Irma L. Fraad and Richard Ettinghausen, whose "Sultanate Paintings in Indian Style", *Chhavi: Golden Jubilee Volume*, ed. Anand Krishna, Banaras, 1971, pp. 48–66, had set forth the problem a decade earlier and listed the manuscripts and dispersed leaves (pp. 49–51)

they then thought might be Indian. In close succession were then published Karin Ådahl's doctoral dissertation, discussing a *Khamsa* of Nizami dated 843/1439, O. Vet. 82 in the Uppsala University Library, *A Khamsa of Nizami of 1439: Origin of the miniatures – a presentation and analysis*, Uppsala, 1981, in which she reproduces as Appendix III (p. 104) Robinson's 1967 list of "possibles" but declines to accept that the Uppsala *Khamsa* (No. 8) belongs with this group; and Barbara Brend's study of B.L., Or. 1403, dated 841/1438, "The British Library's *Shahnama* of 1438 as a Sultanate manuscript," *Facets of Indian Art: A symposium held at the Victoria and Albert Museum*, London, 1986, pp. 87–93, in which she reiterates the key manuscripts (p. 87) and analyses the B.L. manuscript, concurring with Fraad and Ettinghausen on the Indian origin of this "linchpin" in their argument, and refining the attribution by proposing a Bahmanid attribution for it. See also Grube (above), Note 15 (p. 117).

55 TKS, H. 1519. Fehmi Edhem Karatay, *Topkapî Sarayî Müzesi Kütüphanesi, Türkce Yazmalar Kataloğu*, Istanbul, 1961, II, 2155, pp. 58–9; Nurhan Atasoy, "Un manuscrit mamluk illustré du Šahnama," *Revue des Études Islamiques*, 1969/1, pp. 151–58 and pls. I–XIV.

56 Venice, Biblioteca Marciana, Cod. Or. XC. Ernst J. Grube, "The Date of the Venice Iskandar-Nama," *Islamic Art*, II, 1987, pp. 187–95; all presently-known pre-1500 Turkish manuscripts are listed in Appendix II, pp. 191–95, those referred to in my text being 6, 7, 8. See now also Grube's entry for the *Iskandar-nama* in the Venice catalogue (Note 39 above), cat. 261, pp. 407–9.

57 Istanbul, TKS, H. 862. Grube, *Islamic Art*, II, 1987 (Note 56 above), Appendix II, 5; also illustrated by Filiz Cağman and Zeren Tanındı, *The Topkapi Saray Museum: The Albums and Illustrated Manuscripts*, translated, expanded and edited by J.M. Rogers, Boston, 1986, fig. 56 in colour, and Ivan Stchoukine, *Les peintures des manuscrits de la "Khamseh" de Nizami au Topkapi Sarayi Müzesi d'Istanbul*, Paris, 1977, pl. VIII.

58 Illustrated by Stchoukine, *ibid.*, pl. VII.

59 In an essay arising from a symposium sponsored by the Royal Asiatic Society of Great Britain and Ireland in March 1991, entitled "Timurid Manuscript Painting and its Legacy", building – as we all so often may – on Robinson's conception of the material, proposed as "metropolitan" and "local," in 1965 (*Persian Drawings from the 14th through the 19th Century [Drawings of the Masters]*, New York), pp. 16–30, *passim*; the terms restated as "metropolitan" and "provincial," in the continuously useful catalogue to V&A, 1967, pp. 32–33.

60 Paris, B.N., Suppl. pers. 494. Stchoukine, *MT*, 1954, p. 46, MS XXVII, pls. XXXVIIII–XL; and C.M.A., 45.169 and 56.10, illustrated in colour by Basil Gray, *Persian Painting*, Geneva, 1961, pp. 102–3.

61 Letter of 4 October 1993; my only objection would be the very late date of this manuscript, completed at least a decade later than Ibrahim-Sultan's *Shahnama*. What might be deduced from its illustrative programme must await an analysis of the manuscript itself, which has at least 5 lacunae, and the 13 illustrations still unpublished.

62 I have counted 38 persons (using Gray's illustration in colour [Note 60 above]), in addition to two horses and two hunting-cheetahs, in the Cleveland [Paris] paintings, almost twice as many as in either of the earlier compositions. The *Zafarnama* includes perhaps 31 figures, and the pairs of horses and hunting-cheetahs (but the paintings have been badly smudged, and also cut away, at the outer sides), see Sims, "*Zafar-nameh*", 1991, figs. 1–2, and also Glenn D. Lowry, Milo Cleveland Beach, *et al.*, *An Annotated and Illustrated Checklist of the Vever Collection*, Washington D.C./Seattle/London, 1988, pp. 252–53; the *Shahnama* composition, now folios 1v and 4r, is badly damaged and repainted and has never been reproduced, but I count in it 35 figures, and the obligatory pairs of animals.

Postscript

Since this article was written, the Bodleian *Shahnama* has been the subject of further reflection by Elaine Wright. In a public lecture in London in October 1995, she proposed a fascinating explanation for some of the additional components in a manuscript that constitutes Ibrahim-Sultan's response to his brother Baysunghur's magisterial *Shahnama*. She suggests that the five pages of drawings touched with gold, on the backs of which are painted the three large double-page compositions featuring Ibrahim-Sultan as the "hero" of the scenes of princely hunt, battle, and feast, were included to enhance still further the prestigious appearance of Ibrahim-Sultan's own manuscript. The same can be said of the fourth large double-page painting set into the middle of the volume, which show (on facing pages) Ibrahim-Sultan holding court and his consort overseeing the work of a gardener; her argument is given weight by the fact that the poetry on the folios preceding this pair of paintings is not from Firdausi but instead an additional insert, consisting of an anonymous encomium praising Allah, and an unnamed ruler – probably to be understood as Ibrahim-Sultan, and commenting on the *Shahnama* and the reasons for the commission of this copy of it.

11

Images of Muhammad in al-Biruni's Chronology of Ancient Nations

ROBERT HILLENBRAND

AL-BIRUNI, PERHAPS THE SINGLE MOST OUTSTANDING Muslim polymath,[1] wrote *The Chronology of Ancient Nations* in c.1000 A.D.[2] To judge by surviving evidence, the text was never a favoured vehicle for illustration; among the manuscript versions known,[3] only two are illustrated, of which the second and later one (Paris, Bibliothèque Nationale, ms. arabe 1489, datable to the seventeenth century and probably of Ottoman provenance) copies the earlier version in Edinburgh.[4] This Edinburgh manuscript (Edinburgh University Library, Ms. Arab 161), dated 707/1307–8 and copied by a certain Ibn al-Kutubi,[5] (there is no indication as to where the work was produced)[6] has in fact a greater claim to attention than merely the circumstance that it is the earliest illustrated copy of this text (pls. 5–6, 12–14, 16), for – with the images in the Edinburgh copy of the *World History* of Rashid al-Din, dated to 714/1314 (pls. 1–4, 7–11, 15, 17–18),[7] which have an extra public dimension – it contains the earliest set of images of the Prophet Muhammad in Islamic art.[8]

An obvious question to arise at this point is why this long-dead text should have been resuscitated at this particular time, and why it should have had conferred on it the extra *éclat* of illustrations (pls. 5–6, 12–14) and illumination (pl. 16). Here the content of the text is plainly crucial. It deals with the various systems of computing time known to al-Biruni's world, and backs this up with a complement of astronomical calculations. There were two grounds on which such a text could arouse interest in Ilkhanid Iran. One was the focus on astronomy. The Ilkhan Hulegu had built a state-of-the-art observatory at Maragha,[9] and subsequently, under the Ilkhan Abaqa, there was completed in 667/1265 or 670/1271–2 the preparation of a set of astronomical tables known as the *Zij-i Ilkhani*.[10] Other Ilkhans

shared this fascination with the lore of the stars.[11] The second focus of the text, equally well calculated to appeal to Mongol taste, was the well-nigh ecumenical scope of al-Biruni's material. He ranged very widely in time and space, commenting not only on the calendars but also on the history, festivals and customs of many exotically remote nations.[12] In his tolerance and open-minded curiosity – which was evidenced by his decision to live in India for many years, learn Sanskrit and write a book about the non-Islamic part of the country[13] – al-Biruni was centuries ahead of his time. Not for him the instinctive conviction that his own culture, and all that it entailed, was simply the best. And this lack of dogmatism, this willingness to learn about other cultures and other systems of belief, seems to have struck a chord with the unknown Ilkhanid patron of this manuscript. There can be no question that al-Biruni's text was uncannily relevant in the Ilkhanid period. It presents a remarkable array of systems of belief, and this inevitably brings to mind the farrago of religious practices in Ilkhanid times.[14] Nevertheless, since the text itself remained a production of the period c.1000, the task of making it specifically relevant to the fourteenth century devolved upon the person who selected the subjects for illustration, and on the illustrator himself. They could, of course, have been one and the same person. Thus the text and its illustrations are not necessarily at one; indeed, the content of the illustrations can change the emphasis of the text. A prime example of this process is given by the last two images. Admittedly, al-Biruni seems to have had Shi'ite sympathies,[15] yet that is not enough to account for the spirit of intense religious particularism which animates these two paintings. While it would be too strong to maintain that they put the text and the illustrations virtually at cross pur-

poses, they certainly show how paintings can place in the forefront of attention ideas which are only latent in the text itself, and how this heightening of emphasis can be used to affect the reader. Thus the fact that the pictorial cycle begins and ends with images of Muhammad places the whole book as it were under his protection, and sanctifies its contents.

The point of departure of al-Biruni's book was revolutionary within its own society because the author in some respects implicitly placed Islam on a level with other religions rather than in a category all by itself, while still writing as a Muslim.[16] The Edinburgh manuscript drives home this point by means of its illustrations. This is not to say, of course, that the mindset of al-Biruni was that of the Mongols. He displays a genuinely broad mind; his tolerance is based on wide knowledge and careful observation. That of the Mongols was based, it seems, on a profound lack of commitment to any single body of religious dogma. Nevertheless, despite these fundamental differences of approach, a freak of history saw to it that al-Biruni found his real audience for this book some three centuries after his death and among people who had done much to destroy the culture he had helped to build.

The pervasive emphasis on false prophets, and on false religion generally, attains such prominence in the paintings that it must be recognised as one of the driving forces behind the entire cycle of illustrations. The images of Muhammad fit well into this programme, for they include scenes where he is set against representatives of other systems of belief and is shown to be superior to them. To that extent there is a proselytising flavour to the images of Muhammad; but there can be no doubt that Jesus and the prophets of the Old Testament are also objects of veneration in these paintings.[17] This particular emphasis, which of course recurs in the *World History* of Rashid al-Din, corresponds very closely to the spirit of the generation before c.1300, which saw Christians and Jews rise to positions of power and influence unparalleled in the earlier history of Iran.[18] The religious tolerance of the Mongol elite, and their readiness to espouse a variety of faiths, helps to explain this ecumenical spirit, while the conversion to Islam of the Ilkhan Ghazan and his *amirs*[19] gives an apt context for the unprecedented emphasis on Muhammad. But it was precisely in a milieu of such religious ferment that accounts of some of the discredited sects and systems of belief in past ages or in distant lands would arouse a lively interest. Hence the number of illustrations devoted to false prophets; and orthodoxy could be appeased by sandwiching these images between pictures asserting the supremacy of Muhammad and thus of Islam. Thus, seen as a whole, the 25 illustrations of the Edinburgh al-Biruni manuscript propel to the forefront of the reader's attention themes that are only latent in the text itself. The overwhelmingly scientific, and specifically astronomical, emphasis of al-Biruni's book has been ousted by themes more in sympathy with the religious trends of the Ilkhanid realm around 1300. In that sense the text has been turned upside down and furnishes a striking example of how a cycle of pictures can go much further than merely illustrating the major themes of the accompanying text, or even providing a sub-plot; they can give it an entirely new and unexpected twist, rendering it relevant for contemporary concerns.

Clearly, then, this text is an unlikely one to serve as a basis for a set of images of Muhammad. The *sine qua non* for any iconographic cycle, namely continuity, is simply not there. The images showing Muhammad, though totalling only 5 out of the 25 in the book, span the entire text, from beginning to end. Thus the whole book, and its illustrations, is presented within an overall Islamic context. But even so, it is more appropriate to speak of a set of images rather than of a cycle. Such a cycle would have had to be fashioned in the teeth of the text's undeclared opposition. Nor does this group of images respect any chronological continuity; indeed, the very first scene, which depicts the Prophet forbidding intercalation (pl. 5), renders an event which occurred at the very end of his life, during his farewell pilgrimage.[20] It would be more accurate to explain the choice of images as the result of the desire of the painter (or whoever else dictated the selection of episodes for illustration) to pounce on any event which involved the Prophet. Since the life of the Prophet was very far from being the concern of al-Biruni in writing his book, there were very few such events. On occasion even a relatively insignificant episode is chosen to exalt the Prophet, as in the case of the watchman and the two riders (pl. 6). That this somewhat undramatic event rated a painting points to the desire to use the text as a vehicle for images of the Prophet, and it seems that few opportunities were missed.[21] There is no evidence that any attempt was made to impose unity on the scenes from his life that were selected for illustration. That would have demanded at least some rearrangement of the text. As it is, these scenes plainly have no inherent unifying theme apart from the person of Muhammad. In short, no-one seriously attempting to create a connected cycle of images of Muhammad would have chosen either this particular combination of scenes or their present order. Hence these images can be called a cycle by default. The images of Muhammad in the *World History* of Rashid al-Din (pls. 4, 7, 9–11, 15)[22] are far more carefully selected to tell a continuous story and they focus on some of the major events of Muhammad's life; but they have the advantage, unlike al-Biruni's text, of being based on a coherent historical narrative which focusses closely on his life and respects the chronology of events.

In no sense, then, can this be regarded as a cycle of deliberately religious images, like the *Siyar-i Nebi* for instance.[23] After all, this is emphatically a secular manuscript. Hence any orthodox opposition to these images – assuming that such opposition voiced itself in the Ilkhanid period – could have been deflected by the argument that there was no question of these images having any religious function at all, least of all worship. In both these books, then, the religious image enters as it were by the back door: under cover of history in the case of the text of Rashid al-Din, and of

calendrical issues in the case of al-Biruni's text. Once these images had taken shape, the way was open for a genuinely religious cycle, and the fragmentary Istanbul *Mi'rajnama* of c.1350[24] shows that it was not long in coming.

Since the guiding thread between the images of Muhammad is not absolute chronology but the sequence dictated by the text, this is the most convenient order to follow in discussing the paintings.

The first picture (pl. 5), on f.6b (dimensions: 67 by 134 mm.) depicts the Prophet forbidding intercalation.[25] This may sound an abstruse subject, and it certainly does not lend itself naturally to illustration; but for an Islamic author, the Prophet's own views on time as they affected Muslims were a natural place to begin a disquisition on that subject. Hence, perhaps, the choice of this scene for the first painting in the book. Its immediate context is the controversy about observing a sacred month. Some argued that it could be postponed in a given year and then reinstated in a later year. In the *Sira*'s version of Muhammad's last address to his people – in which he ranged widely over the practices to be followed by pious Muslims – Muhammad is reported as saying "Time has completed its cycle and is as it was on the day that God created the heavens and the earth. The number of months with God is twelve; four of them are sacred…"[26] This is a more circumstantial account than that given by al-Biruni. In the same section, according to the *Sira*, he quoted Sura 9:37 in which postponement of a sacred month and making up the total later is roundly condemned. The importance of Muhammad's stand on this matter may be gauged from the fact that two of the Five Pillars of Islam – fasting and pilgrimage – are involved in this ruling. Intercalation, then, was a practice with very serious repercussions[27] and justified a pronouncement by the Prophet *ex cathedra*. Hence the location of the scene in a mosque setting and the presence of a *minbar*, whereas according to tradition the event occurred in the open air and Muhammad was seated on his camel.[28] Thanks to the plain white ground, the scene acquires a certain universality, as is indeed fully appropriate for an image dealing with the enunciation of doctrine. Here the *minbar* adds – and neatly blends – secular and religious authority, the latter aspect reinforced by the mosque environment. That environment is also suggested by the hanging lamp, which could also be interpreted as a symbol of religious enlightenment.[29] It certainly sanctifies the scene. As for the *minbar*, its form is unmistakably anachronistic, for it has much more in common with the developed 'Abbasid type as at Qairawan[30] than with the version known in the seventh century, of which Umayyad coins seem to preserve an echo.[31] Muhammad is shown grasping one of the posts,[32] painted red, at the top of the *minbar*, perhaps in order to support himself since at this time he was close to his final illness.

The source of this image is presumably one of the series of enthroned *qadi*s, *khatib*s and rulers which are so frequently encountered in Mesopotamian painting of the thirteenth century, especially in *Maqamat* scenes.[33] Such images were probably part of this artist's own training and background. The artist contents himself with isolating Muhammad from the rest of the congregation (again as in *Maqamat* scenes), and although he depicts the Prophet as slightly bigger than the men listening to him, he does not distinguish him further by giving him a special head-dress, colour or other clothing. All the figures have haloes, thereby depriving this feature of any meaning, and four wear the same turban as Muhammad. Indeed, this painting is full of information about turban fashions and it suggests that certain hierarchical principles were followed in this item of dress.[34] Thus the turbans of the two youngest figures have no loops under the chin, which suggests that the loop is an adult fashion, and the central cross-band of the turban is undecorated, whereas the turbans of the older men, including the tailpiece, have panels decorated with a lozenge grid.[35] Two other figures have a different type of turban with a central red conical cap round which the folds of the material are wound. Yet in the scene depicting the Prophet's family with the envoys of Musailima, Hasan and Husain do have the loop under their chins even though they are both clearly children.

The tight, expressive grouping of the figures, the simple and dramatic spatial relationships – fully legible even though they are technically all awry – owe much to the formulae worked out during the previous century in the illustrated *Maqamat* manuscripts.[36]

The next scene to be illustrated, (f.10b; dimensions: 87 by 133 mm.)[37] though not strictly about calendrical systems, takes up what might be called the other leitmotif of al-Biruni's text: false religion (pl. 6). Ostensibly it is directed against Babylon and its idols, for it illustrates a passage in Isaiah 21:6–9 in which a watchman hears the news that "Babylon has fallen, has fallen! All the images of its gods lie shattered on the ground!" In the Biblical version, this message is given by "a man in a chariot with a team of horses" (Isaiah 21:9). The artist here, however, has preferred to depict an earlier verse, in which the watchman is admonished "when he sees chariots with teams of horses, riders on donkeys or riders on camels, let him be alert, fully alert" (Isaiah 21:7). Even so, he has removed any visual reference to chariots, or to multiple riders, and has compressed the image into one rider on a camel and one on a donkey. Thus the emphasis in the Biblical account, which is on the destruction of Babylon's idols,[38] has been subtly altered to stress the pre-eminence of the man on the camel, and, more generally, the contrast between him and the rider on the donkey. The complexities of numerical calculation and the symbolism of numbers which characterise al-Biruni's text[39] would of course have appealed to the author's mathematical, astronomical, astrological and generally scientific interests, but they emphatically do not lend themselves to visual depiction. This is not enough, however, to explain the form which the picture has taken, and in particular its references to Muhammad and "the Messiah", which are made explicit in a later marginal note.

The starting point for any interpretation must be the text itself. It mentions that Babylon has fallen, and that is a phrase that would

have resounded in the ears of a contemporary reader of the Edinburgh manuscript, by whom the trauma of the fall of Baghdad — itself a great capital in the tradition of Babel, and located near the site of its great predecessor[40] — in 1258 would not easily have been forgotten. The aftermath of that cataclysmic event, an event like the sack of Rome or the capture of Constantinople, was precisely a recrudescence of Christian influence and political power in Iran.[41] Only after the mass conversions of 1295 did this situation end; and that was a still fresher memory. Seen in this light, then, the picture is a commentary on recent events, a sigh of relief that Islam is back in the saddle again. And there is little doubt that the picture has personalised this issue by depicting Muhammad and Jesus together. It is a message that could scarcely be more contemporary.[42]

It is instructive to see how the artist puts this message across. Visually speaking, the camel — the Muslim beast *par excellence*[43] — shoulders out the donkey, the Christian beast, and its head held high contrasts with the submissive drooping of the donkey's head. Muhammad, who is slightly the larger figure, occupies the foreground, relegating Jesus to the next plane and overlapping him; he has a slightly more elaborate turban than Jesus, complete with decorated tailpiece, cross-band and loop under the chin. For his part, Jesus indicates Muhammad in a way that broadly recalls John the Baptist indicating Jesus in Christian images. The cloud above underlines this gesture. Muhammad alone wears green, which was to be the colour of sanctity in Islam and may already have taken on that meaning. Muhammad's halo is above that of Jesus. Nor can there be any doubt that Jesus is making way for Muhammad.

What of the watchman? Certainly he fits rather uneasily into the rest of this picture. He wears the cowl of a Christian monk, and that might suggest that his tower is a Christian hermitage (*saumi'a*). One is irresistibly reminded of a comparable scene in Rashid al-Din's *World History* where the Christian monk Bahira, again looking out of a tower, recognises Muhammad as a prophet (pl. 11).[44] It is hard to doubt that these two contemporary scenes are related. Jesus, on the other hand, wears a turban, presumably because he is reckoned to be a Muslim whereas the watchman is not. As in the scene from the *World History* which has just been quoted, it is a Christian who (like Jesus himself) acknowledges the supremacy of Islam. It is not hard to believe that a message to contemporaries is contained in this scene.

It would be mistaken, however, to interpret the juxtaposition of Muhammad and Jesus here in a spirit hostile to Christianity.[45] The close parallelism of pose encourages the idea that the two religions are intimately linked, though with Islam having a distinct edge. It was not yet time for a persecution of Christians, what with the intense diplomatic and commercial activity at this period between the Ilkhanids and Western Europe,[46] not to mention the probable survival of Christians and Christian sympathisers at the Ilkhanid court.

The next image to depict Muhammad (f.92a; dimensions 83 by 133 mm.) is located well over half-way through the book, at such a distance from its predecessor that it is hard to defend the notion that they are intended as part of a connected cycle. It shows Muhammad, surrounded by his family, receiving the envoys of the false prophet Musailima (pl. 12).[47] The two figures at his own right hand have presumably been added for symmetry to counterbalance 'Ali and his two sons. The resultant compositional format is clearly derived from a standard audience scene of the kind familiar from the frontispieces of thirteenth-century book painting and related images.[48] But this visual cliché is used to excellent effect here to suggest instead — mainly by the body language of 'Ali and his children — the solidarity and intimacy of the Prophet's family, and how they revere him, for all of them gaze at him. Al-Husain is placed closest to Muhammad, presumably a reference to his favoured status. All in all, the exclusiveness of the *ahl al-bait* is introduced into a scene in which it has no place, for the standard account of this episode, an account also followed by al-Biruni, mentions merely the Prophet himself and the two envoys from the rival prophet Musailima. By thus transforming an official ceremonial scene into an intimate family portrait, the artist has injected into the image an unmistakable hagiographical fervour. He has, so to speak, raised the emotional temperature and brought a Shi'ite emphasis (of which the original text is innocent) to an otherwise neutral ceremonial image.

There is no sign of the letter which the envoys brought, in which Musailima proposed that he and Muhammad should divide half of Arabia between them, leaving the other half to the Quraysh. Ibn Hisham in his *Sira* or *Life of the Prophet* states that Muhammad was so incensed with this message — to which the envoys, on being asked their opinion, subscribed — that he said to them, "By God, were it not that heralds are not to be killed I would behead the pair of you!"[49] The artist's rendition of this scene makes it clear that there was no discussion with the envoys. Muhammad's rigid pose bespeaks a stern and fixed resolve to yield no ground. He ignores the pleading hands of the ambassadors, silhouetted for extra effect in mid-air, and stares straight ahead. His own left hand makes an ambiguous gesture, denoting perhaps his dismissal of what they are saying, unless indeed he is dictating an answer to them.[50] A narrow but critical gap has opened up between the envoys and the people clustered around Muhammad. As already noted, the gazes of 'Ali and his two sons are fixed on the Prophet and away from the envoys, on whom they pointedly turn their backs. Musailima's men are isolated and alienated at the edge of the picture — space is used aggressively to diminish and indeed to marginalise them. The issue is already settled. Indeed, 'Ali's sword, Dhu'l-Faqar, juts into the ankle of the foremost ambassador, perhaps an allusion to the coming campaign in which Musailima's followers were defeated by the Muslims and he himself killed.[51] Illustrating (and perhaps initiating) the iconography that was to become standard, though

mistaken, the sword has two points, though in fact it was merely double-edged.[52]

Muhammad is the only personage among the eight figures here who is depicted frontally, and this uncompromising pose helps to drive home his authority. The Chinese cloud (*tai*) motif – for motif it is, since it is unrelated to any attempt to create a landscape setting for this image – is used to double as an honorific canopy over Muhammad's head. The Prophet is clothed in green, but clearly this was not yet a colour especially associated with sanctity, for one of the envoys also wears a robe of this colour. Similarly, as in the two previous scenes featuring Muhammad, all the figures – not just the Prophet and his family – are haloed. Given the Prophet's pronouncements against the use of silk unless one sat on it, it is intriguing to note that the patterns of the throne covering on which he is seated identify this as a piece of Chinese silk.[53]

The infusion of an extra degree of emotion and seriousness, noted already in the scene with the envoys, is taken still further in the next two images depicting Muhammad. These strike a note of exaltation and veneration of the *ahl al-bait* which sets them apart as expressions of intense Shi'ite sentiment. In some respects they are the key to the whole iconographic cycle, and they offer incontrovertible evidence as to how the text of al-Biruni was made to serve new purposes in the specific circumstances of the contemporary political situation in the Ilkhanid realm.

These are grandiose claims and of course they require substantiation. The evidence is in fact manifold. First, these two pictures are the last illustrations and they come near the end of the book,[54] thus constituting a kind of *khatima*, in other words saying in visual form that Muhammad and 'Ali are the seal of the prophets, the last in line. They have been saved for the end of the volume, thereby creating a lasting impression that the reader takes away from the book. Second, these images appear on successive folios (ff.161a and 162a), a practice found several times in the book[55] and normally used for two scenes of very similar import.[56] This suggests that the two Shi'ite images are intended to support each other and thus to intensify the impact of the message they transmit. Third, they are physically the largest images in the entire book (dimensions: 105 by 136 mm. and 128 by 176 mm.). This alone sets them apart from all the rest of the paintings, and is a silent warning that something extraordinary is afoot here. To the reader of the book it comes as a dramatic surprise. Fourth, their colour scheme dramatically intensifies the palette employed for most of the other images. In particular, they use a striking indigo blue, a deep purplish black and a blazing orange – shades that are employed from f. 129b onwards, but never before on this dramatic scale.[57] Finally, both images have a much more fully realised landscape setting – i.e., involving both the earth and the sky – than all but two of the other 22 images.[58] And their pronounced emphasis on the skyscape, with its lowering, threatening clouds, big with meaning, is unique in the book. It has a more thoroughly Chinese flavour than any other

landscape in the cycle, even though the putative Chinese model has been thoroughly re-interpreted. This marshalling of portentous forces in the sky is a signal that something of moment is happening, and that the heavens themselves are involved in it. Chinese landscape elements are thus manipulated to drive home a polemical religous message, a novel and unexpected reuse of borrowed material.[59] All this points to the hand of another artist who was employed especially, though not, perhaps, exclusively, for these more significant scenes – and was certainly given (or took) more leeway in these last two paintings in the book.

But of course all these factors, important and diagnostic as each of them is, are secondary to the actual content of these two scenes; and it is the content which clinches the matter. Folio 160a depicts the imminent prayer contest (*mubahala*, sometimes rendered as "mutual ritual cursing") between Muhammad and the Christians of Najran (pl. 14). On this occasion, Muhammad formally recognised his own grandchildren in lieu of his sons, Fatima in lieu of his wives and 'Ali as his closest friend.[60] While the other three Muhammad scenes discussed so far, and all the 13 scenes in the Muhammad cycle in the Edinburgh and London manuscripts of Rashid al-Din's *World History*, follow in their essentials the classical account of the relevant events in the *Sira* of Ibn Hisham, this scene does not figure at all in that source. Its presence here is an indication of al-Biruni's Shi'ite proclivities. He has of course drawn on a Shi'ite source for this event; Sunnis regard the Shi'ite versions of this and the next scene as outright falsifications of historical reality.[61]

On the other hand, Ibn Hisham does say in the *Sira* that three of the Najranis entered into a theological dispute with Muhammad, and that is exactly what the painting in the Biruni manuscript depicts – except that it adds Muhammad's family to the *dramatis personae*, and thereby fundamentally changes the configuration and meaning of the image.[62] This is the clue which reveals that the painting is based on a Shi'ite version of this event, such as that of Shaikh al-Mufid. Here the Najranis engage Muhammad in a dispute about the nature of the Messiah; he thereupon recited Sura 3:61 to them, which contains the statement that God created Jesus from earth and if there is any dispute about this, each party should call their sons and women and then "call on God to witness against each other, and let…the curse of God fall on those who lie". Muhammad then challenged the Najranis to a contest of prayer to God (*mubahala*) and states that God has informed him "that dread torment will come down on him who has spoken falsely after the contest of prayer". In the account of Shaikh al-Mufid, the key factor which causes the Najranis to make up their minds is the presence of Muhammad's family. The Najrani bishop, Abu Haritha,[63] reasons that if Muhammad enters the contest alone, they should proceed with the *mubahala*. But if he is prepared to expose his own family to the outcome of such a contest, he must have right on his side and conflict with him should be avoided. Sure enough, "the next morning, the Prophet, may God bless him and his family, came and took 'Ali b.

Abi Talib by the hand, while al-Hasan and al-Husayn, peace be on them, were walking in front of him and Fatima, peace be on her, walked behind him"[64]. When the members of Muhammad's family — each of them described in turn as being the dearest of creatures to him — are identified for the bishop, he advised the three principal Najranis (the 'aqib or deputy, the sayyid or chief, and 'Abd al-Masih) to make peace with Muhammad. They duly did so, and Shaikh al-Mufid then gives the details of the treaty,[65] which broadly conform with those related in the standard Sunni sources.[66] At the end of the narrative, Shaikh al-Mufid provides a brief commentary on the entire episode,[67] stressing that it shows 'Ali to have been equal in stature to the Prophet, that it is a miracle which indicates Muhammad's prophethood, and that it conferred on Muhammad's family "a merit which no one else of the community shares with them, nor even approaches them in it, nor has anything like it in significance. It is associated with the outstanding special qualities of the Commander of the Faithful".[68]

How, then, is this story depicted? The painting, the largest so far in the whole manuscript, deploys the full resources of landscape in favour of Muhammad and his family. Thunderous clouds — harbingers, perhaps, of the "dread torments" with which the Najranis are threatened — hover over Muhammad's head and indicate that the heavens are on Muhammad's side.[69] The fire and smoke in these clouds recall the experiences of Moses on Mount Sinai, where his role as a prophet to whom God spoke was underlined by these same phenomena.[70] Two tongues of fire point balefully at the Christians, like emissaries of divine wrath. Quite aside from the portentous landscape, however, the scene projects a powerful sense of family solidarity that is quintessentially Shi'ite in feeling. This sense of 'asabiyya is underlined by the alarmingly wide gap that has opened up between Muhammad and his opponents, as in the scene depicting Musailima's envoys. Fatima's arched eyebrows meet at the bridge of her nose, a diagnostic sign of beauty.[71] Hers are the only eyebrows in the picture to form this gracefully joined double arch or bow (Persian kaman). Her hand is laid protectively on al-Husain's shoulder, as is 'Ali's, and once again, as in the scene with Musailima's envoys, al-Husain is closest to Muhammad. His hands are so positioned as to be a reverse echo of Muhammad's own hands. The disparity in size is enough to differentiate al-Husain from his elder brother, al-Hasan, who functions as the link figure between the two groups; the two landscape planes point from him to the Najranis, while his gaze turns away from them to encounter that of his younger brother.[72] The tension in the image is palpable as the opposing sides eye each other up; something awesome is about to occur. Presumably it is the very moment that the Prophet challenges the Najranis to the prayer contest. Colour is used to dramatic effect in distinguishing Muhammad's family, who wear an array of intense deep colours, from the plain white worn by the Najranis. Muhammad, who on folios 6b, 10b and 92a is attired more or less like the other fig-

ures in these scenes, now wears his prophet's burqa, its radiating patterns reminiscent of a rayed nimbus,[73] though he already has a halo. This, as in the next picture, is of a specific type: it encircles the head but not the turban, which seems to swallow it up so that the halo is reduced to a pair of golden ear-muffs. In the earlier paintings of the manuscript, where Mesopotamian influence is strong, the halo encircles the turban as well as the head. The largely obliterated halo is a signature of the second painter.

There remains the pressing question of why this particular episode was selected for illustration, and treated in this emotionally charged style. The crucial factor here seems to have been that Muhammad's opponents were Christians, and that — by the transparent device of a theological debate — they were challenged head-on as to the Prophet's claims about his mission. As with the three previous Muhammad scenes, then, the issue of a rival to Islam is raised, and once again, in the person of Muhammad, Islam is presented as triumphing over its enemies. Clearly Christianity is the principal enemy to be overcome, for two of the five pictures involving Muhammad deal with it. As before, the theme of Islam victorious takes on an extra resonance in the religious context of the Ilkhanid realm c.1300, and the very recent triumph of Islam over rival faiths. But an extra dimension is added here in the form of a Shi'ite emphasis that was first detectable in the scene with Musailima's envoys but is now much more pronounced — for whereas in that scene 'Ali and his sons are not integral to the story, but serve merely to give the Prophet moral support, here their presence, now reinforced by Fatima, is crucial to the immediate victory over the Christians. This victory, as Shaikh al-Mufid's tafsir explains, sets the seal on the unique status of the ahl al-bait in the Muslim community.

The very last painting in the book (pl. 13; f. 162a) is also the largest (128 by 176 mm.) — with only three lines of text beneath it, it is almost a full-page illustration — and of course its power is intensified by its proximity to the previous image. It is as if the artist had reserved the most important and eloquent image to act as a fitting climax for the whole book. Al-Biruni's text does not lend itself to anything like this degree of manipulation,[74] yet another reminder that illustrations and text do not necessarily follow the same agenda. The theme depicted here is of critical importance in Shi'ite belief, for it is the culminating moment in a long sequence of statements made by the Prophet to indicate that 'Ali was his designated successor. Shaikh al-Mufid gives four separate stories in this vein,[75] adding that many more could be cited.[76] But he reserves a lengthy separate section for the episode illustrated here, when in the course of his farewell pilgrimage Muhammad, in obedience to a revelation he had received, stopped at a place called Ghadir Khumm[77] to make a formal announcement acknowledging 'Ali as his heir: "The time has come for me to depart from you. I leave behind me among you two things which, if you cleave to them, you will never go astray — that is the Book of God and my offspring from my family" (ahl al-bait)… "taking both arms of the Commander of the faith-

ful, peace be on him, and raising them so that the white of his armpits could be seen, he said 'Whoever I am the master (*maula*) of, this man, 'Ali, is his master. O God, befriend whoever befriends him, be hostile to whoever opposes him, support whoever supports him and desert whoever deserts him.'"[78]

The setting is briefly evoked by Shaikh al-Mufid: Ghadir Khumm "lacked water and pasturage",[79] "it was a scorching day of intense heat" and Muhammad ordered 'Ali "to go and stand under a great tree"[80] – as indeed is shown in the painting, though the effect is vitiated by a second smaller tree to the left – and "the travellers to be gathered in that place and to be put in (rows) one after another".[81] Muhammad made 'Ali stand at his right hand,[82] but here 'Ali is shown at Muhammad's left hand. Moreover, Muhammad lays his left hand on 'Ali's shoulder instead of raising both of 'Ali's arms. Similarly, the gathering of many Muslims in rows has been reduced to three bystanders. 'Umar is mentioned as one of those present at Ghadir Khumm – indeed, he congratulates 'Ali[83] – and given that the faces of the three attendant figures have been comprehensively obliterated while those of Muhammad and 'Ali have remained untouched, it is possible that they were interpreted as, and may even have been intended by the painter to represent, the other three Rashidun caliphs[84]. No matter what the identity of the bystanders might be, there is no mistaking the solemnity of the moment, with Muhammad and 'Ali regarding each other intently and the secondary figures pressing close.

The way the landscape is used in this investiture image recalls the technique employed in the Temptation scene on f. 48b.[85] In both cases a double landscape is developed, though the technique has evolved further in the investiture scene. Here the artist uses the lower plane to give his scene an *ambiente* and the upper plane to crown it. But there is no middle plane; it is left entirely white so that it does not get in the way of the action. As with the previous picture and the scene with Musailima's envoys, one may note an effective and dramatic use of a caesura of empty space, in this case to underline the scene's significance.

The clothing chosen for Muhammad differs from that employed in the previous image. Over a pure white robe, seemingly spangled with rosette designs in its lower part, he wears a dark brown combination of cowl and mantle, perhaps his *burda*. As in f. 161a, the effect is to single him out. Perhaps the choice of different clothing in the two cases is due to the fact that sacred iconography was still at that time in the making, and standard images had not yet evolved. Again as in f. 161a, the side figures have their hands muffled in their deep, full sleeves in true Chinese fashion. Both Muhammad and 'Ali are dark-complexioned, as if the artist had carefully observed the colouring of certain Arabians.

These last two images were to remain exceptional in cycles of Muhammad's life and their presence here is an obvious example of pictures with a message. They were painted at a time when the current Ilkhan, Oljeitu, who definitively embraced Shi'ism three years later,[86] in 1309, was possibly already turning over in his mind the possibility of conversion. With their fervid religiosity they are prophetic of the *ghulat*. Did the painter perhaps exceed his brief? Admittedly the scenes depicting both figure in al-Biruni's text, but the author himself did not write as a partisan Shi'ite and did not highlight them in the way that the painter did. It is not even certain that the patron, whoever that was, intended this particular emphasis; for, as already suggested, it is entirely possible that the book was ordered because the unprecedentedly wide horizons of the Mongol empire made at least some people unusually ready to interest themselves in other systems of belief. But whereas the images illustrating Rashid al-Din's *Jami' al-Tawarikh* are appropriately integrated with the historical text which they accompany, three of the five Muhammad images in the Biruni manuscript are already permeated by strong sectarian feeling. Thus the polemical potential of such subject matter is there right at the beginning of religious painting in Islam: proof, if any were needed, that it was a sound instinct which had steered earlier painters away from such themes.

1. Rashid al-Din,
Jami' al-Tawarikh, f.149v: *bismillah*

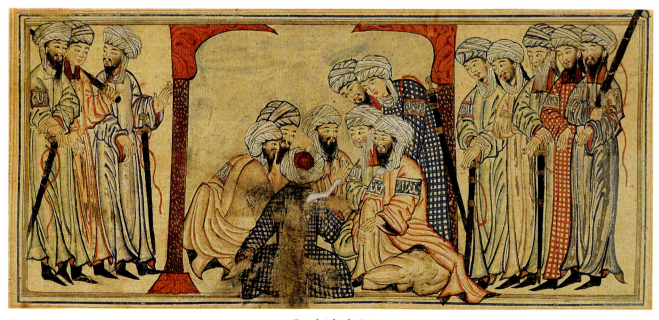

2. Rashid al-Din,
Jami' al-Tawarikh, f.48v: early converts to Islam undergo torture

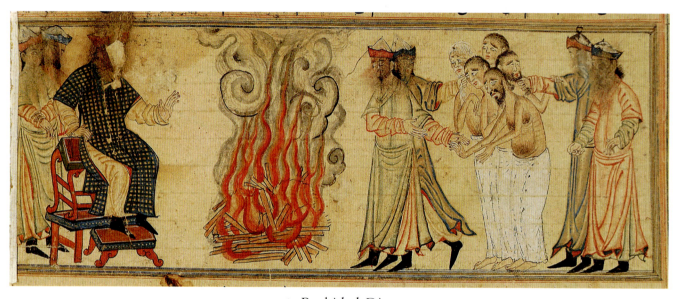

3. Rashid al-Din,
Jami' al-Tawarikh, f.54r: the Quraish consult about the proscription of their kinsmen who support Muhammad

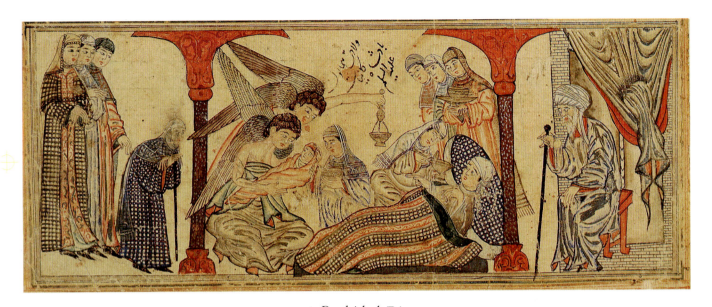

4. Rashid al-Din,

Jami' al-Tawarikh, f.42r: the birth of Muhammad

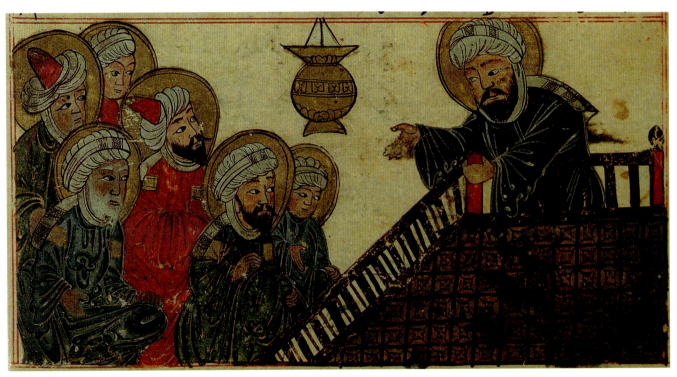

5. Al-Biruni,

Al-Athar al-Baqiya, f.6v: Muhammad forbids intercalation

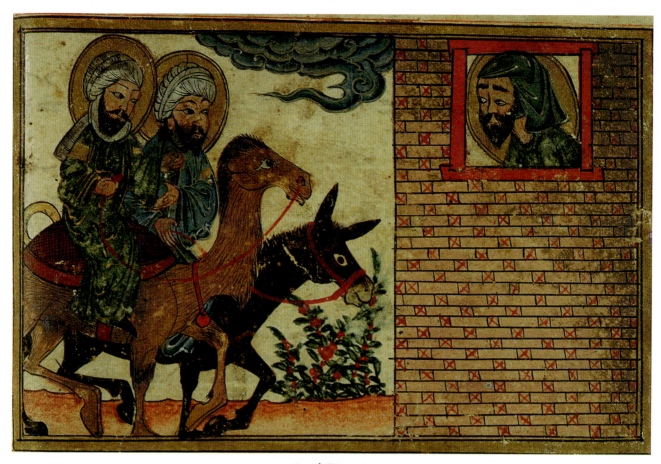

6. Al-Biruni,

Al-Athar al-Baqiya, f.10v: Isaiah's prophecy about Muhammad

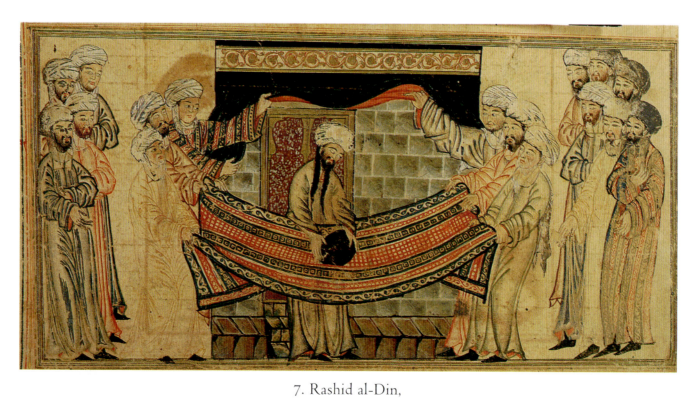

7. Rashid al-Din,

Jami' al-Tawarikh, f.45r: Muhammad arbitrates over lifting the Black Stone into position in the Ka'ba

8. Rashid al-Din,

Jami' al-Tawarikh, f.52r: the Negus of Abyssinia refuses to yield up the Muslims who sought asylum with him

9. Rashid al-Din,

Jami' al-Tawarikh, f.57r: Muhammad, Abu Bakr, the herdswoman and the goats

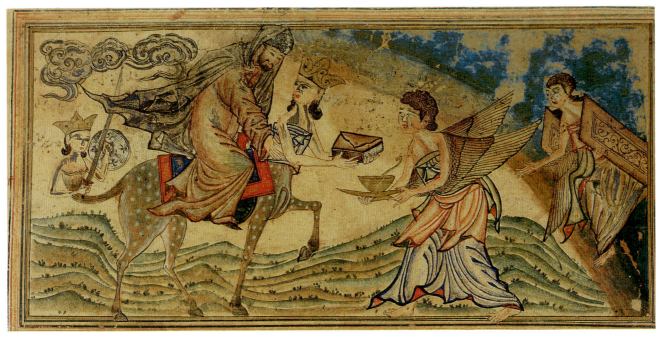

10. Rashid al-Din,

Jami' al-Tawarikh, f.55r: the Night Journey of Muhammad on Buraq

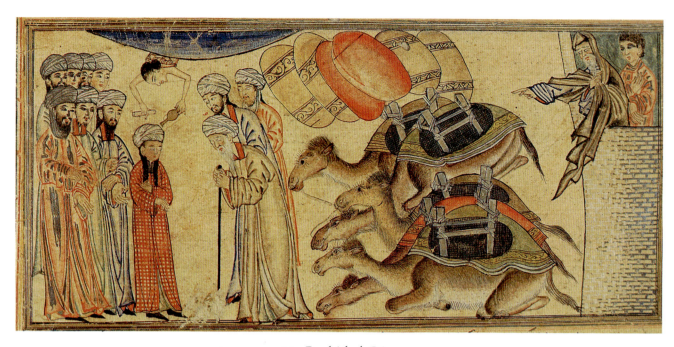

11. Rashid al-Din,

Jami' al-Tawarikh, f.43v: the young Muhammad is recognised by the monk Bahira

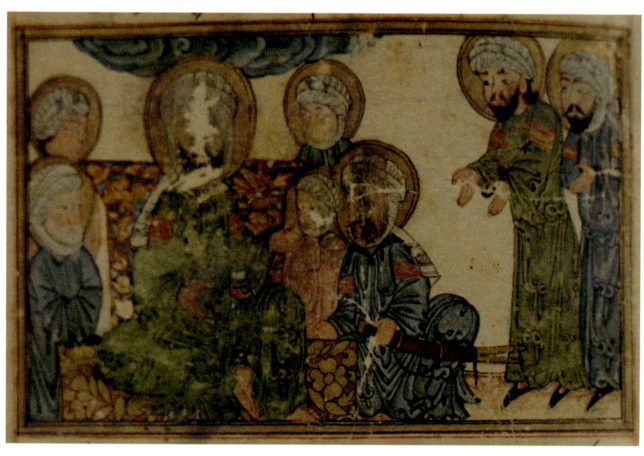

12. Al-Biruni,

Al-Athar al-Baqiya, f.92r: Muhammad with the envoys of Musailama

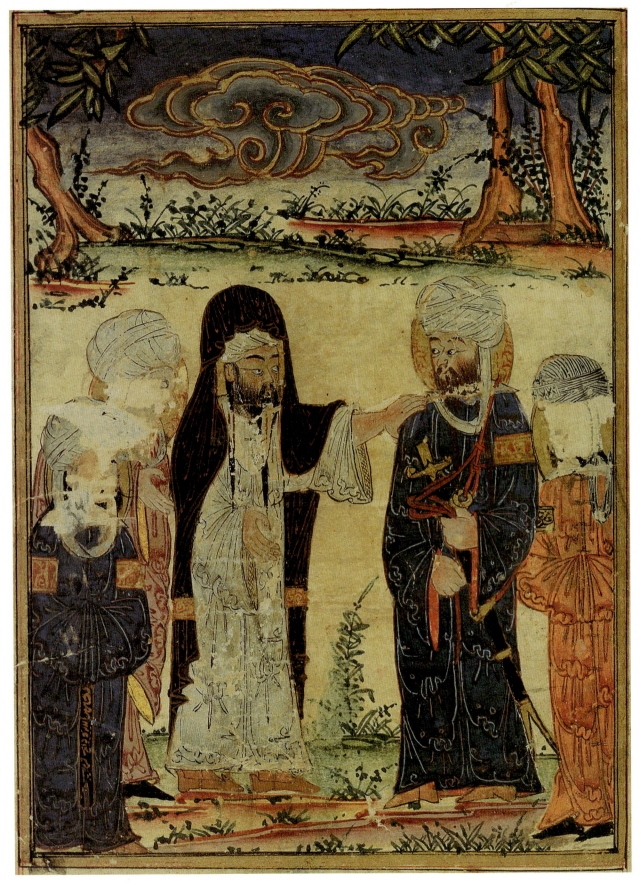

13. Al-Biruni,

Al-Athar al-Baqiya, f.162r: The investiture of 'Ali at Ghadir Khumm

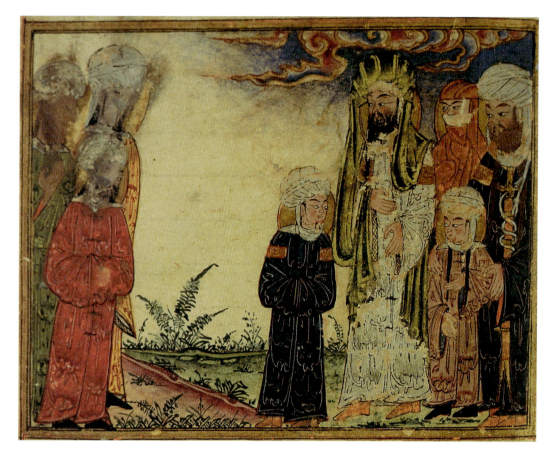

14. Al-Biruni,

Al-Athar al-Baqiya, f.161r: The Day of Cursing

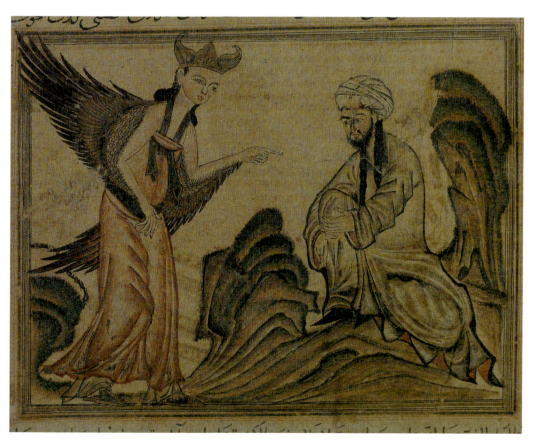

15. Rashid al-Din,

Jami' al-Tawarikh, f.45v: Muhammad receives his first revelation through the angel Jibra'il

16. Al-Biruni,

Al-Athar al-Baqiya, f.1r: title page

17. Rashid al-Din,

Jami' al-Tawarikh, f.149r: *shamsa*

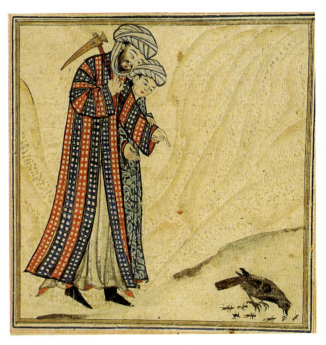

18. Rashid al-Din,

Jami' al-Tawarikh, f.41r: 'Abd al-Muttalib and al-Harith about to

discover the well of Zamzam

Notes

1 See *The Encyclopaedia of Islam* (1st ed.), s.v. (C. Brockelmann) and *The Encyclopaedia of Islam* (2nd ed.), s.v. (D.J. Boilot).

2 C.E. Sachau, *The Chronology of Ancient Nations. An English version of the Arabic text of the Athar-ul-Bakiya of Albiruni, or "Vestiges of the Past", collected and reduced to writing by the author in A.H. 390–1, A.D. 1000* (London, 1879), viii.

3 Which number at least five, namely the three used by Sachau (*Chronology*, xiv) plus the illustrated versions in Paris and Edinburgh.

4 Sir T.W. Arnold and A. Grohmann, *The Islamic Book. A Contribution to its Art and History from the VII-XVIII Century* (n.p., 1929), pl. 40.

5 M. Ashraful Hukk, H. Ethé and E. Robertson, *A Descriptive Catalogue of the Arabic and Persian Manuscripts in Edinburgh University Library* (Hertford, 1925), 136–7.

6 There is no indication of where the work was produced. The traditional ascription is to Tabriz; more recently, Dr Stefano Carboni has suggested Mosul (see his paper "The London Qazwini: an early 14th-century copy of the '*Aja'ib al-Makhluqat*", *Islamic Art* III [1989], 17).

7 D. Talbot Rice, *The Illustrations to the 'World History' of Rashid al-Din* (Edinburgh, 1976), 2.

8 Though not the earliest image of him *per se*; for a discussion of this issue, see my paper "Images of the Prophet Muhammad in the *World History* of Rashid al-Din", in *Islamic Iconography: the Royal and the Religious. Proceedings of a symposium held in Edinburgh, October 1990*, ed. R. Hillenbrand (in press).

9 For the physical remains of this observatory, see P. Vardjavand, "La découverte archéologique du complexe scientifique de l'observatoire de Maraqe", in *Akten des VII. Internationalen Kongresses für Iranische Kunst und Archäologie. München 7.–10. September 1976*, ed. W. Kleiss (Berlin, 1979), 527–36.

10 *Ibid.*, 527.

11 *Ibid.*, 528; E.S. Kennedy, "The exact sciences in Iran under the Saljuqs and Mongols", in *The Cambridge History of Iran. 5. The Saljuq and Mongol Periods*, ed. J.A. Boyle (Cambridge, 1968), 668–70, 672–3; B. Spuler, *Die Mongolen in Iran. Politik, Verwaltung und Kultur der Ilchanzeit 1220–1350* (Berlin, 1955), 192–3.

12 P.P. Soucek, "An Illustrated Manuscript of al-Biruni's *Chronology of Ancient Nations*", in *The Scholar and the Saint. Studies in Commemoration of Abu'l-Rayhan al-Biruni and Jalal al-Din Rumi*, ed. P.J. Chelkowski (New York, 1975), 103–68. This excellent study contains much information on the miniatures discussed in this paper. I owe much to it, as to the comments of generations of students in Edinburgh with whom I have discussed these images.

13 See the translation by C.E. Sachau: *Alberuni's India* (London, 1910). Cf. also A.T. Embree, "Foreign Interpreters of India: The Case of al-Biruni", in Chelkowski, *op. cit.*, 1–16; F.E. Peters, "Science, History and Religion: Some Reflections on the *India* of Abu'l-Rayhan al-Biruni", *ibid.*, 17–27; and B.B. Lawrence, "The Use of Hindu Texts in al-Biruni's *India* with Special Reference to Patanjali's Yoga-Sutras", *ibid.*, 30 and 44.

14 Spuler, *op. cit.*, 198–249.

15 Sachau, *Chronology*, xiii says "he inclined towards the Shi'a", and the book ends with the author calling down the mercy and blessing of God on the Prophet "and upon his holy family" (*ibid.*, 365).

16 Embree, *op. cit.*, 2, 4–8; cf. Peters, *op. cit.*, 21 and 25 and Lawrence, *op. cit.*, 30.

17 T.W. Arnold, *The Old and New Testaments in Muslim Religious Art* (London, 1932), *passim* but especially 15, 17, 22 and 35–6.

18 Spuler, *op. cit.*, 207–10, 212–8 and 246–9.

19 J.A. Boyle, "Dynastic and Political History of the Il-Khans", in *CHI 5*, 378–80; A. Bausani, "Religion under the Mongols", *ibid.*, 541–3; and, above all, C. Melville, "*Padshah-i Islam*: The Conversion of Sultan Mahmud Ghazan Khan", in *Pembroke Papers I. Persian and Islamic Studies In honour of P. W. Avery*, ed. C. Melville (Cambridge, 1990), 159–77.

20 A. Guillaume, *The Life of Muhammad. A translation of Ibn Ishaq's* Sirat Rasul Allah (repr. Karachi, 1980), 620.

21 Al-Biruni interprets Deuteronomy xxxiii:2 as referring to Muhammad rather than to Jehovah (Sachau, *Chronology*, 23); gives the lineage of Muhammad (*ibid.*, 46); describes the efforts of "those Muslims who try to derive mystical wisdom from the comparison of the name of Muhammad…with the human figure. According to them the Mim is like his head, the Ha like his body, the second Mim like his belly, and the Dal like his two feet" (*ibid.*, 293); and refers to a pair of white stones in the Mosque at Jerusalem with inscriptions mentioning Muhammad (*ibid.*, 294). None of these four references to Muhammad lend themselves to depiction.

22 Pending the appearance of the article mentioned in note 8 above, see Talbot Rice, *op. cit.*, 95–113; B. Gray, *The World History of Rashid al-Din. A Study of the Royal Asiatic Society Manuscript* (London, 1978), 24–5; and P.P. Soucek, "The Life of the Prophet: Illustrated Versions", in *Content and Context of Visual Arts in the Islamic World. Papers from a Colloquium in Memory of Richard Ettinghausen. Institute of Fine Arts, New York University, 2–4 April 1980. Planned and organized by Carol Manson Bier*, ed. P.P. Soucek (Philadelphia and London, 1988), 199–206, prefaced by a brief discussion of images of the Prophet and 'Ali in the Edinburgh Biruni manuscript on pp. 198–9. Most recently, see S.S. Blair, *A Compendium of Chronicles. Rashid al-Din's Illustrated History of the World* (London and Oxford, 1995), 69–72.

23 Z. Tanindi, *Siyer-i Nebi, Islam Tasvir Sanatinda Hz. Muhammed'in Hayatı* (Istanbul, 1984).

24 R. Ettinghausen, "Persian ascension miniatures of the fourteenth century", *Accademia Nazionale dei Lincei, XII Convegno "Volta", promosso dalla classe di scienze morali, storiche e filologiche. Tema: Oriente e Occidente nel Medioevo* (Rome, 1957), 360–83, repr. in *Richard Ettinghausen. Islamic Art and Archaeology. Collected Papers*, ed. M. Rosen-Ayalon (Berlin, 1984), 244–67.

25 Sachau, *Chronology*, 14.

26 Ibn Ishaq, 651; *The History of al-Tabari (Ta'rikh al-rusul wa'l-muluk). Volume IX. The Last Years of the Prophet*, tr. I.K. Poonawala (Albany, 1990), 112–3.

27 One may compare the reaction of a British mob to an eighteenth-century attempt at calendar reform: they rioted, shouting "Give us back our eleven days!"

28 T. Andrae, *Mohammed. The man and his Faith*, tr. T. Menzel (New York, Hagerstown, San Francisco and London, 1960), 170.

29 A. Shalem, "Fountains of Light: The Meaning of Medieval Islamic Rock Crystal Lamps," *Muqarnas* 11 (1994), 5–8, 10–11.

30 K.A.C. Creswell, *Early Muslim Architecture. II. Early 'Abbasids, Umayyads of Cordova, Aghlabids, Tulunids, and Samanids. A.D. 751–905* (Oxford, 1940), pl.89.

31 B. Spuler and J. Sourdel-Thomine, *Die Kunst des Islam* (Berlin, 1973), pl.71b. For the early history of the *minbar*, see C.H. Becker, "Die Kanzel im Kultus des alten Islam", *Islamstudien* (Leipzig, 1924), 450–71.

32 Such posts can be seen on the *minbar* at Qairawan.

33 See R. Ettinghausen, *Arab Painting* (Geneva, 1962), 106–7. The iconography continued in use after this period; one may cite the *Epics* of 1397 in the British Library – Or. 2780, f.61a

– where Chingis Khan, holding a sword, replaces Muhammad (see I. Stchoukine, *Les Peintures des Manuscrits Timurides* [Paris, 1954], pl.XIII).

34 Cf. L.A. Mayer, *Mamluk Costume* (Geneva, 1952).

35 For information on the turban, see Björkman, *EI* (1st ed.), *s.v.*

36 E.g. Ettinghausen, *AP*, 113, 118–9. Cf. D. James, "Space-forms in the work of the Baghdad *Maqamat* illustrators, 1225–58", *Bulletin of the School of Oriental and African Studies* XXXVII/2 (1974), 305–20.

37 Sachau, *Chronology*, 22.

38 And the artist could perfectly well have tackled such a scene, for there is in fact a scene in the Biruni manuscript in which Abraham destroys the idols of the Sabians, f.88b; compare too the destruction of the Temple of Jerusalem by Bukhtnassar/Nebuchadnezzar, f.134b. For illustrations, see Soucek, "Illustrated manuscript", figs. 5 and 20.

39 E.g. Sachau, *Chronology*, 21–2.

40 Cf. *EI* (1st ed.), *s.v.* "Babil" (G. Awad).

41 Spuler, *Mongolen*, 205–24; D.O. Morgan, *The Mongols* (Oxford, 1986), 159–60.

42 Perhaps the images of Nebuchadnezzar and Eli, with their message of tragedy for the Jews, drive home the idea that for the Jews too the year 1295 marked a new and less favourable dispensation.

43 See in general R.W. Bulliet, *The Camel and the Wheel* (Cambridge, Mass., and London, 1975), especially 105–10. See too the use of the camel to symbolise Muslims in defeat on the coronation robe of Roger II of Sicily (W. Hartner and R. Ettinghausen, "The conquering lion, the life cycle of a symbol", *Oriens* 17 [1964], 164–5 and fig.2). Since the animal normally shown under attack by the lion is the bull, its replacement by a camel in this case can be seen as a deliberately topical detail. Why the victorious feline is shown as a tiger rather than a lion remains obscure.

44 Talbot Rice, *op. cit.*, pl.30 (f.43b).

45 Nor can one easily detect any hostile flavour in the scenes of the Annunciation and the Baptism in this same manuscript, for all that these scenes are thoroughly Islamic (D. Talbot Rice, "Two Islamic manuscripts in the Library of Edinburgh University", *Scottish Art Review* VII/1 [1959], 4). Note, however, the implications of choosing for depiction the moment *after* the Baptism.

46 Spuler, *Mongolen*, 224–35; Morgan, *op. cit.*, 183–7.

47 Sachau, *Chronology*, 192.

48 Such as the scene depicting the Queen of Waqwaq enthroned with her attendants (al-Qazwini, *'Aja'ib al-Makhluqat*, Munich, Staatsbibliothek, cod. arab. 464, 678/1279, f.60b [Arnold and Grohmann, *op. cit.*, pl.35c]) or the frontispieces of the *Rasa'il Ikhwan al-Safa* in the Süleymaniye Mosque Library, Istanbul (Esad Efendi 3638, 686/1287, ff.3b and 4a [Ettinghausen, *AP*, 98–9]) and the *Kitab al-Hasha'ish fi Hiyuli al-'Alaj al-Tibbi* of Dioscurides in the Ayasofya Library, Istanbul (No. 3704, 7th/13th century, f.1b [E.J. Grube, "Materialien zum Dioskurides Arabicus", in R. Ettinghausen, ed., *Aus der Welt der islamischen Kunst. Festschrift für Ernst Kühnel zum 75. Geburtstag am 26.10.1957* (Berlin, 1959), fig.6]).

49 Ibn Hisham, *op. cit.*, 649; al-Tabari, *History, Volume IX*, tr. Poonawala, 106–7. Al-Biruni has a slightly terser version of these events, without the *isnad*.

50 Soucek, "Illustrated Manuscript", 120; but there is no sign of a scribe.

51 Ibn Ishaq, *op. cit.*, 377.

52 H. Halm, *Shiism* (Edinburgh, 1991), 27, n. 20.

53 One may recall the *hadith* which recounts how 'A'isha had a patterned figural silk which the Prophet permitted her to keep only on condition that it was used for cushions (T.W. Arnold, *Painting in Islam. A Study of the Place of Pictorial Art in Muslim Culture*, repr. Toronto and London, 1965, 7).

54 There remains the very last chapter, XXI (16 folios long), which deals with the lunar stations and is unillustrated, though it contains numerous subjects that would have been suitable for illustration (e.g. Sachau, *Chronology*, 338 and 343–50). The colophon occurs on f.178a.

55 Namely ff. 91a, 92a, 92b and 93b (all about false prophets); 94a and 95a (both execution scenes); 100a and 101a (Sasanian kings enthroned); 103a and 103b (Feast of Sada); 133b and 134b (disasters for the Jews); and 140b and 141b (Christian scenes).

56 But not 101a and 101b or 103b and 104b.

57 Clearly a second artist was responsible for the last eight images.

58 Namely, ff. 48b and 140b.

59 This is a foretaste of how landscape was employed only a generation later in the Great Mongol *Shahnama*.

60 Under 4 Shawwal, al-Biruni summarises the whole story very concisely: "Muhammad and the Christians of Najran argued with each other. Muhammad installed Hasan and Husain in the right of sons of his, and Fatima in the right of his wives, and 'Ali b. Abi Talib he made his intimate friend, complying with the order of God in the *verse of the cursing*"

(*Chronology*, 332).

61 Thus Ibn Ishaq (*op. cit.*, 270–77) places the deputation from the Christians of Najran before the first raid, while the Shi'ite Shaikh al-Mufid dates it to the last year of Muhammad's life (*Kitab al-Irshad. The Book of Guidance into the Lives of the Twelve Imams*, tr. I.K.A. Howard [Horsham and London, 1981], 116). Andrae, *op. cit.*, 170. quotes Ibn Sa'd, *Tabaqat*, i, 2, 84, who says that the Najranis sent *an emissary* in the last year of Muhammad's life to make a treaty. But this is not the formal ritual exchange in which the two groups are about to engage in the Biruni painting. Ibn Ishaq's account of the deputation simply records that the Najranis consulted their *'aqib* or chief adviser on whether to resort to *mubahala* with Muhammad. He advised them not to do this but to make their peace with him, which they did (Ibn Ishaq, *op. cit.*, 277).

62 Ibn Ishaq in fact seems to contradict himself; first he states that there were 60 men (Shaikh al-Mufid says there were 30) in the Najrani delegation, very elegantly dressed, (Shaikh al-Mufid, *op. cit.*, 116, relates that "they were wearing robes of silk and crosses"; of this there is no sign in the painting) and these included their 14 principal men, of which three spoke to Muhammad (Ibn Ishaq, *op. cit.*, 271). But a paragraph later (p. 272), he mentions only "two divines [who] spoke to the apostle."

63 Not the *'aqib* who advises the Najrani delegation in Ibn Ishaq's text.

64 Shaikh al-Mufid, *op. cit.*, 117.

65 Shaikh al-Mufid, *op. cit.*, 118.

66 For his text, see W.M. Watt, *Muhammad at Medina* (Oxford, 1956), 359–60; for a discussion of it, see *ibid.*, 127–8.

67 Shaikh al-Mufid, *op. cit.*, 118–9.

68 To Shi'ites, 'Ali is the only person who can legitimately bear this title; see Halm, *op. cit.*, 9.

69 Soucek notes that certain Shi'ite sources mention that there was thunder and lightning on this occasion ("Illustrated Manuscript", 154; cf. 168, n. 188).

70 They are faithfully depicted in the corresponding illustration of the *World History* of Rashid al-Din. See Talbot Rice, *op. cit.*, pl.10, f. 8a.

71 J. Nurbakhsh, *What the Sufis say* (New York, 1980), 57–8.

72 Does this perhaps point to a certain ambiguity in his status?

73 One may compare the curious combination of a halo and drapery in one of the frontispieces to a multi-volume copy of the *Kitab al-Aghani* made for Badr al-Din Lu'lu' in c.614/1218–19 (Ettinghausen, *AP*, 65).

74 Sachau, *Chronology*, 333. As usual, this is a compressed narrative. Even so, it adds a detail not reflected in the painting itself: "He (Muhammad) gave orders to collect the saddles and all the riding-instruments into one heap; this he ascended, supported by the arm of 'Ali b. Abi-Talib…" The painting shows Muhammad standing on a flat piece of ground.

75 *Kitab al-Irshad*, 27–9.

76 *Ibid.*, 29.

77 This place was chosen because it was the last spot before "many of the people would separate from his party (heading) for their towns, homes and valleys" (*Kitab al-Irshad*, 123).

78 *Kitab al-Irshad*, 124.

79 *Ibid.*, 123.

80 *Ibid.*, 124.

81 *Ibid.*

82 *Ibid.*

83 *Ibid.*, 125.

84 But the subsequent fate of these images, once the painter had completed them, is a treacherous guide to their significance. How, for example, is one to explain the defacement of the Prophet and his family in the scene with Musailima's envoys, when their images escape unscathed on ff. 161a and 162a? The original aspect of the damaged painting can perhaps be reconstructed with the aid of the later (perhaps Ottoman, 11th/17th century) copy in Paris whose illustrations seem to be based on those of the Edinburgh manuscript (Bibliothèque Nationale, fonds arable 1489, f. 87 [Arnold and Grohmann, *op. cit.*, pl.40]). Professor Marianne Barrucand is preparing a detailed study of this cycle of paintings. Cf. too M. V. Fontana, *Iconographica dell' Ahl al- Bayt. Immagini di arte persiana dal XII alXX secolo*, Istituto Universario Orientale, Annali 54/1 (1994), Supplemento 78, figs. 6 and 8; for the Biruni manuscript, see *ibid.*, 15–17.

85 Since this double-tiered landscape depicts Paradise, is it possible that a similar meaning is indirectly suggested in f. 162a (Soucek, "Illustrated Manuscript", fig. 4)?

86 M. van Berchem, "Une inscription du sultan mongol Uldjaitu", in *Mélanges Hartwig Derenbourg. Recueil de travaux d'érudition dédiés à la mémoire d'Hartwig Derenbourg par ses amis et ses élèves* (Paris, 1909), 374–5, repr. in his *Opera Minora*, II (Geneva, 1978), 680–1; see also S.S. Blair, "The coins of the later Ilkhanids: a typological analysis", *Journal of the Economic and Social History of the Orient* XXVI/III (1982), 297.

12

The Name of a Painter who Illustrated the World History of Rashid al-Din

ANATOLI IVANOV

THE MINIATURES OF TWO MANUSCRIPTS OF THE *JAMI'* *al-tawarikh* of Rashid al-Din (one dated 706 A.H./1306 A.D. in the Library of the University of Edinburgh and the second dated 714 A.H./1314 A.D., formerly in the Royal Asiatic Society and now in the N.D. Khalili collection) have long drawn the attention of specialists and have even had monographs devoted to them.[1]

But the problem of the names of the painters of these manuscripts has remained open, because there are no signatures on the miniatures. The authors of both monographs have devoted some space to this question.[2] Only one name of a painter of this period is known – "Qutluqbuga", a man mentioned in the *Waqfnama* of Rashid al-Din.[3] Some new information about a painter who worked on Rashid al-Din's book was published in the 1960s, but specialists in miniature painting were apparently unaware of it, because it occurred in a book in Arabic on *adab* – the work of Ibn al-Fuwati entitled *Talkhis majma' al-adab fi mu'jam al-alqab* ("The shortened collection of knowledge in the dictionary of titles").

Kamal al-Din Abu'l-Fadl 'Abd al-Razzaq ibn Taj al-Din Ahmad, better known as Ibn al-Fuwati al-Shibani al-Hanbali, was born on 17 Muharram 642 A.H./ 25 June 1244 A.D. at Baghdad. His biography was given briefly by Prof. F. Rosenthal in *The Encyclopaedia of Islam*,[4] and, in Russian, in articles by Prof. Diya M. Buniyatov[5] and Dr. Mariam G. Sayyidbeily.[6] Further details are provided by Dr. Mustafa Jawad, the editor of the fourth part of Ibn al-Fuwati's work.[7]

Ibn al-Fuwati was well educated. He was captured by the Mongols in 1258, but after two years he escaped and found shelter with Nasir al-Din Tusi in Maragha. He lived here many years and was for ten years the librarian of the observatory in Maragha, where almost 400,000 volumes of manuscripts were collected. He returned to Baghdad in 1280, but visited Azarbaijan and other parts of Iran many times thereafter. Ibn al-Fuwati died on 2 Muharram 723 A.H./11 January 1323 A.D.[8]

Ibn al-Fuwati wrote many works, but of particular interest for us is his 50-volume study *Majma' al-adab al-murattab 'ala mu'jam al-asma' fi mu'jam al-alqab* ("Collection of knowledge, composed in alphabetical order of the names in the 'Dictionary of titles'"). It is sad that only a shortened version of this work has survived, namely the above-mentioned *Talkhis majma' al-adab*, and even of this work only the fourth and fifth parts survive: the titles (*laqabs*) beginning with the letters *'ain, ghain, fa* and *qaf* are included in the fourth part[9] and the titles with the letters *kaf, lam* and *mim* are in the fifth part.[10]

This particular work of Ibn al-Fuwati contains very interesting information. Prof. D.M. Buniyatov published in 1970 information about 154 inhabitants of Azarbaijan, whose names feature in the fourth part of Ibn al-Fuwati's work, but he omitted the name of the painter who is the subject of this article. Prof. F. Rosenthal, however, did not fail to mention this fact in his short article in 1971, in which he notes the "...enormous amount of informa-

tion collected by an alert and open-minded scholar, who did not fail to observe a painter illustrating the *World History* of Rashid al-Din".[11] Since Prof. Rosenthal was here concerned principally with the biography of our author, he could not consider the implications of this fact in detail – implications which are very important for specialists in Iranian book painting.

This minor but very valuable text was published for the first time in Russian translation in the article of Dr. M.G. Sayyidbeily as follows: "'Afif al-Din Muhammad ibn Mansur ibn Muhammad ibn Bumuya al-Qashi, an engraver. I saw him in Arran in the sultan's headquarters. He was engraving the book *Jami' al-tawarikh* of the maula, vizir, philosopher Rashid al-Din in 705 A.H./24. VII. 1305–12.VII.1306 A.D."[12] Dr. M.G. Sayyidbeily adds no commentary to this sentence which is strange, because the words "engraving the book" are not understandable in Russian.

When one studies the actual text of Ibn al-Fuwati, it becomes apparent that there are some differences between the Arabic text and the Russian translation of Dr. M.G. Sayyidbeily. I would offer the following translation of this text: "'Afif al-Din Muhammad ibn Mansur ibn Muhammad (ibn) Bumuya al-Qashi, al-naqqash, a skillful master (*ustadh*) in the craft of painting (*san'at al-naqqash*) and drawing (*al-taswir*). And he writes verses in Persian. I saw him in Arran in the sultan's headquarters (*muqim*). And he is painting (*yan-qash*) in the book of the lord, the vazir, the doctor (*al-hakim*) Rashid al-Din, in the year 705".[13]

As we can see, the text uses the word *al-naqqash*, which Dr. M.G. Sayyidbeily translates as "an engraver (a carver)". But while the verb *naqasha* has its prime meaning in Arabic "to engrave/carve an inscription", on Iranian soil the word "*al-naqqash*" meant "a painter" in the broad sense, because it was also used by potters and coppersmiths, though not very often. Prof. D.M. Buniyatov also translated the term *al-naqqash* as an Arabist would, namely as "an engraver (a carver)", when in 1988 he edited the translation of a Turkish *defter* of 932 A.H./1526 A.D. about the members of court ateliers in Istanbul, where "all the painters" *jama'at-i naqqashan* has been transformed into "engravers (carvers)".[14] Apparently Dr. M.G. Sayyidbeily followed this tradition of translation; hence the term "engraving the book" in her article.

What conclusions do this report of Ibn al-Fuwati suggest?

1. There is no direct indication of the *Jami' al-tawarikh* in the text. This is merely a personal additional comment in the translation published by Dr. M.G. Sayyidbeily. The editor of Ibn al-Fuwati, Dr. M.

Jawad, made the supposition, but only in a footnote, that the reference concerns the two above-mentioned illustrated manuscripts of the *Jami' al-tawarikh*.[15] Of course, this supposition is very likely (particularly in the case of the Edinburgh copy), because examples are known of folios of long manuscripts being illustrated before the transcription of the manuscript's text has come to an end. That has indeed happened here, and some miniatures must be earlier than the date in the colophon, for we have the report of Ibn al-Fuwati with the date 705 A.H./24.VII.1305–12.VII.1306 A.D., whereas the copying of the Edinburgh manuscript was in 706 A.H./13. VII.1306–2.VII.1307 A.D.[16]

We can specify the period when Ibn al-Fuwati might have seen 'Afif al-Din Muhammad al-Qashi in Arran: it was in Sha'ban – Dhu'l -Qa'da 705 A.H., when the sultan's court was in the Mughan steppe according to the *Tarikh-i Uljaytu*.[17] Consequently, it was in the period from February to the beginning of May 1306 A.D.

2. It is very interesting that the painter was with the court and Rashid al-Din in Arran, working on miniatures, and that he did not stay in Tabriz during this period.

3. The question of the authorship of the miniatures in the manuscripts of the *Jami' al-tawarikh* (if only for the Edinburgh copy) arises once more at this point. Now we know the actual name of one painter who illustrated a book of Rashid al-Din (we may hope that it was the *Jami' al-tawarikh*); but specialists in miniature painting are inclined to the opinion that several painters worked on the miniatures of the Edinburgh copy.[18] Prof. Z.V. Togan expressed the view that several Mongol painters, whose names are mentioned in the *Waqfnama* of Rashid al-Din, illustrated the *Jami' al-tawarikh*.[19] Unfortunately, I cannot verify this statement of Prof. Z.V. Togan, because there are no editions of the *Waqfnama* in the libraries of St. Petersburg; at all events, the context of these names is very important. True, Prof. D. Talbot Rice and Basil Gray also quoted evidence from the *Waqfnama*, but both mention only the name Qutluqbuga *naqqash*.[20] They do not cite the other names mentioned by Prof. Z.V. Togan in his article.

There is no particular urgency in this question and it is certainly premature to propose any final conclusions on the basis of Ibn al-Fuwati's report, important though it is. Nevertheless, it is very interesting to contemplate the possibility that an illustrator of the *Jami' al-tawarikh* (even though only of the Edinburgh copy) was the Persian 'Afif al-Din Muhammad ibn Mansur ibn Muhammad (ibn) Bumuya al-Qashi.[21] One may hope that the names of other painters are waiting to be discovered.[22]

Notes

1 D. Talbot Rice, *The illustrations to the 'World History' of Rashid al-Din*, edited by B. Gray, Edinburgh, 1976; B. Gray, *The World History of Rashid al-Din. A Study of the Royal Asiatic Society Manuscript*, London, 1978. [Ed.: see S.S. Blair, *A Compendium of Chronicles*, London, 1995, with new discussion of the relationship between these manuscripts and their date.]

2 Talbot Rice, *op. cit.*, pp. 5–9; Gray, *op. cit.*, p. 20.

3 Talbot Rice, *op. cit.*, p. 3; Gray, *op. cit.*, p. 20.

4 F. Rosenthal, "Ibn al-Fuwati", *The Encyclopaedia of Islam*, 2nd edition, III, Leiden and London, 1971, pp. 769–770.

5 D.M. Buniyatov, "Vidayustchiyesia lichnosty Azarbaijana v sochneniyi Ibn al-Fuwati "Talkhis majma' al-adab fi mu'jam al-alqab" ["Outstanding personalities of Azarbaijan in the work of Ibn al-Fuwati"], *Izvestiya Akademii Nauk Azerbaijanskoy SSR. Seriya istorii, filosofii i prava*. Baku, 1970, Nos. 3–4, pp. 157–173 (henceforth Buniyatov 1970); *idem*, "Svedeniya Kamal al-dina ibn al-Fuwati o predstaviteliyakh semyi Sanjara ibn Abdallaha an-Nakhichevani" ["Information from Kamal al-Din ibn al-Fuwati about the members of the family of Sanjar ibn Abd Allah al-Nakhichivani"], *Doklady Akademii Nauk Azerbaijanskoy SSR*, Baku, 1978, vol. XXXIV, No. 5, pp. 77–80.

6 M. Sayyidbeily, "Ibn al-Fuwati I yego sochineniye "Talkhis majma' al-adab fi mu'jam al-alqab"" ["Ibn al-Fuwati and his work....."], *Drevniy i srednevekovyi Vostok*, Moskva, 1985, chast 2, pp. 327–330 (henceforth Sayyidbeily 1985); *eadem*, "Nekotorye svedeniya o vidayustchikhsiya lichnostiyakh Azarbaijana v sochinenii Ibn al-Fuwati "Talkhis majma' aladab fi mu'jam al-adab"" ["Some information about outstanding personalities of Azarbaijan in the work of Ibn al-Fuwati...."], *Materialy nauchnoy konferenzii aspirantov Akademii Nauk Azerbaijanskoy SSR*, Baku, 1987, kniga 2, pp. 43–44; *eadem*, "Vidniye deyateli Azarbaijana v sochinenii Ibn al-Fuwati "Talkhis majma' al-adab fi mu'jam al-adab"" ["Prominent figures of Azarbaijan in the work of Ibn al-Fuwati...."], *Istoriya i filologiya srednevekovogo Vostoka*, Moskva, 1987, pp. 159–181 (henceforth Sayyidbeily 1987–I); *eadem*, "Svedeniya o deyateliyakh Azarbaijana XIII – nachala XIV veka v sokhranivsheysiya chasti sochineniya Ibn al-Fuwati (1244–1326) "Talkhis majma' al-adab fi mu'jam al-alqab"" ["Information about people from Azarbaijan from the XIIIth to the beginning of the XIVth century in the surviving part of the work of Ibn al-Fuwati (1244–1326)....."], *Izvestiya Akademii Nauk Azerbaijanskoy SSR. Seriya istorii, filosofii i prava*,
Baku, 1987, No. 1, pp. 79–90 (henceforth Sayyidbeily 1987–II).

7 I was not able to see this article and I know about it only from the article of Dr. M. Sayyidbeily 1985, n. 2.

8 Prof. F. Rosenthal mentions that Ibn al-Fuwati died at the beginning of Muharram 723 A.H./January 1323 A.D. (Rosenthal, *op. cit.*), but Prof. D. Buniyatov (Buniyatov 1970, p. 158) and Dr. M. Sayyidbeily (Sayyidbeily 1985, p. 329), while giving the exact date of his death as 2 Muharram 723 A.H., give as the equivalent in the Christian calendar 28 November 1326 A.D. This seems to be an error for 11 January 1323 A.D.

9 Ibn al-Fuwati, *Al-juz' al-rabi' min "Talkhis majma' al-adab fi mu'jam al-alqab": al-qism al-awwal*, Damascus, 1962; *Al-qism al-thani*, Damascus, 1963; *al-qism al-thalith*, Damascus, 1965.

10 Ibn al-Fuwati, *Talkhis majma' al-adab fi mu'jam al-alqab. Al-juz' al-khamis*, Lahore, 1932. This edition is not to be found in the libraries of St. Petersburg.

11 Rosenthal, *op. cit.*, but the page must be 528 in the edition of "Talkhis".

12 Sayyidbeily 1987–I, p. 168, No. 52 (528).

13 Ibn al-Fuwati, *Al-qism al-thani*, No. 768.

14 D.M. Buniyatov, "Remeslenniki-vykhodtsy iz Azarbaijana, drugikh oblastey Kavkaza, Rossii i Moldavii na sluzhbe v pridvornikh masterskikh osmanskikh sultanov" ["The craftsmen – natives from Azarbaijan, other regions of the Caucasus, Russia and Moldavia – in the service of the court ateliers of the Ottoman sultans"], *Izvestiya Akademii Nauk Azerbaijanskoy SSR. Seriya istorii, filosofii i prava*, Baku, 1987, No. 1, pp. 72–78.

15 Dr. M. Jawad went so far as to suggest that the scribe of the book was Fakhr al-Din Ibrahim ibn Hasan al-Baghdadi, who was also mentioned by Ibn al-Fuwati (see Ibn al-Fuwati, *Al-qism al-thalith*, p. 57, No. 1900): here his name is given as Fakhr al-Din Abu Ishaq Ibrahim ibn Hasan ibn 'Abd Allah al-Baghdadi, and it is further mentioned that he had transcribed works of Rashid al-Din. But to assert that he had been the scribe of two copies of the *Jami'al-tawarikh*, or even of one, is to go too far, however interesting that speculation may be for art historians.

16 It is not clear whether the Edinburgh copy has a colophon with the date 706 A.H. or whether the basis for this is a note on f.107r, where the title of the manuscript is given erroneously as *Tarikh-i Tabari* and it is stated, equally erroneously, that the copy is in the handwriting of the author in the year 706 A.H. The catalogue of the manuscripts of the Library of
Edinburgh University is not to be found in our libraries. [Ed.:the Edinburgh Rashid al-Din manuscript has no colophon; on the date, see Blair *Compendium*, pp.21 and 23].

17 Abu'l-Qasim 'Abd Allah ibn Muhammad al-Qashani, *Tarikh-i Uljaytu* Tehran, 1348, pp. 49–50.

18 Talbot Rice, *op. cit.*, pp. 5–9.

19 A.Z.V. Togan, "The composition of the History of the Mongols by Rashid al-Din", *Central Asiatic Journal*, VII, No. 1, 1962, p. 71. The names of the painters given here are: Buylum Buga, Mogoltay, Toqtemur, Ayaz, Tuylum-gur, Altin-Buqa, Tugay-Temir.

20 See n. 3 above.

21 It is possible that he had the son who was the painter-illuminator (*mudhahhib*) Muhammad ibn 'Afif al-Din al-Qashi, whose name is in the margin of the frontispiece of the manuscript of the works of Rashid al-Din in Paris (Bibliothèque Nationale, Arabe 2324). See E. Blochet, *Les enluminures des manuscrits orientaux – turcs, arabes, persans – de la Bibliothèque Nationale*, Paris, 1926, pl. XCIX.

22 I know from the translation of Prof. D.M. Buniyatov and Dr. M.G. Sayyidbeily that Ibn al-Fuwati mentions two further artists called "*al-naqqash*": a) 'Izz al-Din Abu'l-Fadl al-Hasan ibn Yusuf al-Mawsili *al-naqqash* was born in Shawwal 648 A.H./27.XII.1250– 24.I.1251 A.D. in Mosul; he lived in Tabriz and died there in 710 A.H./31.V.1310–19.V.1311 A.D. (Buniyatov 1970, p. 159; Sayyidbeily 1987–I, p. 160; Ibn al-Fuwati, *Al-qism al-awwal*, p. 70, No. 79); b) 'Izz al-Din Abu Muhammad al-Hassan ibn 'Abd Allah ibn Ibrahim al-Rumi lived in Baghdad, where he died in Shawwal 599 A.H./13.VI.1203–11.VII.1203 A.D. But a very strange story is connected with his name: Dr. M. Jawad points out in a footnote that 'Izz al-Din Abu Muhammad al-Hasan was invited by Ghazan Khan to Azarbaijan to help with the decoration of architectural monuments. But Ghazan Khan reigned in 694–703 A.H./1295–1304 A.D. – 92 years after the death of this 'Izz al-Din! (Buniyatov 1970, p. 159; Sayyidbeily 1987–I, p. 161; Ibn al-Fuwati, *Al-qism al-awwal*, p. 70, No. 79). Prof. D.M. Buniyatov and Dr. M.G. Sayyidbeily did not perceive this chronological contradiction. Perhaps the date given as that of the painter's death (699 A.H.) was in the manuscript of Ibn al-Fuwati? In that case he did live in the reign of Ghazan Khan; but in the printed text of Ibn al-Fuwati we see the date as "*mat biha fi shawwal sanat tisa' wa tis'in wa khamsamiat*" (599 A.H.).

13

The Anthology of a Sufi Prince from Bokhara

ASSADULLAH SOUREN MELIKIAN-CHIRVANI

PERSIAN ILLUMINATED MANUSCRIPTS PROVIDE A WEALTH OF information on cultural trends in the Iranian world that has yet to be tapped by historians. A volume of Persian poetry comprising 103 folios which turned up in a Paris auction held at the Hôtel Drouot on 17 November, 1992[1] illustrates the case by throwing new light on literary and artistic intercourse between Bokhara, in Mavara an-Nahr, the "Lands Beyond the River", and the more southern centres of Iranian culture in the tenth/sixteenth century. Ascribed by the auction house expert to the Qazvin school despite explicit evidence to the contrary, it was actually copied in Bokhara in 972/9 August 1564–28 July 1565 and illuminated with 23 miniatures. Their number alone places the volume in the top range of those that were produced under the reign of Sultan Abu'l-Ghazi 'Abdullah Bahadur Khan[2] whose name and titles appear several times in the miniatures.

The text belongs to a literary genre – the anthology – which, to the best of my belief, has never been seriously studied as such, let alone considered in a historical perspective. This anthology is of the particular type that consists of a selection of allegorical narratives, called in Persian "assembled [texts]" (*majmu'e*). Referred to in the preface as the "Selections from the Treasure of Kindness" (*Montakhab-e Ganjine-ye Letafat*), it was compiled by Ni'matullah known as Khalifa. No other detail regarding the author's identity is given in the text.

Some useful indications about his position can be gleaned here and there. The way in which his name is calligraphed within one of the miniatures (below pl. 11) points to a man belonging to the King's inner circle. The preface reveals him to have been a highly literate man, at home in the difficult art of "ornate prose" (*nasr-e mozayyan*). In the complex counterpoint between image and text, visual allusions are made to the author as a spiritual master. These in turn echo the selected texts which are thus turned into allegories of Khalifa as a *darvish* in the King's entourage. The interplay of text and image further shows Khalifa to have been endowed with a sense of fun, and to display vivid self-incriminating irony. All this however would not be sufficient to place him in history.

Fortunately, one major contemporary source on the reign of 'Abdullah Khan fills in the gaps and bears out all the hints dropped in the *Anthology*. This is the "Book of 'Abdullah" (*'Abdullah-Nama*) written by Tanish b. Mir Muhammad al-Bukhari.[3] There, what was mere inference is confirmed as fact. The writer's full names are given as "Nizam ud-Din *Amir* Ni'matullah known as Mir Khalifa". In the *'Abdullah-Nama*, Khalifa comes across as a figure of great dignity, an elderly prince from the king's inner circle who saw himself as the disciple of Sufi masters (the *'Abdullah-Nama* says that in so many words). The prince was immersed in the Persian culture common both to the native Iranians of Bokhara, one of the oldest centres of Persian letters, and to the Uzbeks who totally adhered to Iranian culture. These were grimly determined to build up Bokhara into a second Harat, whether in art or literature, as this book demonstrates afresh.

The influence of Naqshbandi Sufism, which was deeply felt in Bokhara, its home town,[4] permeates the book. Indeed, the *Anthology* would appear to have been conceived as an instrument of spiritual teaching from a princely Sufi master to his younger disciples. Mystical allegories, all by Sufi writers, succeed each other, following the chronological order of their authors.

The collection of parables opens with *Sheykh* 'Attar's story of

Sheykh San'an drawn from the "Discourse of the Birds" (*Manteq ot-Teyr*). It continues with three stories from Sa'di's "Garden of Scents" (*Bustan*) and extracts from "Khosrow and Shirin" by Nezami. After that, passages from three of the romances gathered by Jami under the title "The Seven Thrones" (*Haft Owrang*) take up the largest section of the *Majmu'e*, namely: "The Present of the Spiritually Free" (*Tohfe-ye Abrar*), "The illumination of the Pious" (*Sobhat ol-Abrar*) and finally Jami's romance most admired in Sufi circles, "Yusof and Zoleykha". The book concludes with three shorter passages from 'Arefi's "The Polo Ball and the Mallet" (*Guy va Chowgan*), Hatefi's *Leyla va Majnun* and Helali's "The Shah and the Dervish" (*Shah va Geda*).

The succession of the parables has a striking pace to it, which yet again points to Ni'matullah Khalifa's feel for literature. Its long beginning borrowed from *Sheykh* 'Attar has the resonance of a grand overture. Not only has the author's name been omitted as is the case with the other stories, but so has any identifying line. The panel that would normally enclose it is filled instead with an abstract scrolling pattern. This silent heading, as it were, is highly unusual. Is this because the parable contains passages that could be read as more specific allusions to the writer's own plight in their allegorical garb? Extensive research is needed to determine whether the details of Ni'matullah Khalifa's life warrant such an assumption. Sa'di's story after that reads like the first part of a short movement in a simple mode, and so does the second part of the same movement, Nezami's parable of royal love. The *Anthology* then moves on to its second phase. The mood of Jami's three stories is vibrant and profound. They form the central triptych of the *Anthology*. The selection is concluded with three shorter parables by 'Arefi, Hatefi, and Helali characterized by a return to a simple limpid style. The rhythm is faster, more clipped. The "editing" of the extracts is remarkable. It is brisk, sometimes abrupt. One can hear the voice of a writer who knows his text backwards and, as likely as not, knows long passages by heart. The claim put out without the faintest trace of personal vanity that he has created another *Golestan* is not entirely without justification even if the texts are not the writer's own. If only for that reason, the discovery of the Sufi *Anthology* of a Shaybanid Prince throws new light on the cultural life of this Iranian metropolis of Central Asia.

That importance is magnified by the cycle of miniatures. It is the richest hitherto recorded from the Bokhara royal studio under 'Abdullah Khan. More importantly, while the Harat legacy can be seen to be maintained in somewhat stereotyped form, the manuscript betrays a blatant strain of Western Iranian influence that was coming in from Safavid Iran. This happened while the two states were waging war against each other in the name of Sunnism against Shi'ism,[5] further demonstrating that the two states were both integral parts of the Iranian world where culture was concerned.

PART ONE:
The Elderly Sufi Prince and the Youthful King

Despite the rough handling to which the volume has been subjected in the course of time, the volume retains its last folio. There, the colophon (*khateme*) yields essential information on the year in which it was copied and the calligrapher's name (pl. 23). The colophon is tersely written in Arabic rhyming prose:

تم الكتاب بعون الملك الوهاب

على يد الفقير المذنب على رضاى الكاتب

سنة اثنى سبعين و تسعماته من الهجرية النبوية

عليه السلام والتحية ٩٧٢

The book was completed
With the help of the Bestowing King
By the hand of the poor, sinful 'Ali Reza the calligrapher
In the year nine hundred
And seventy two of the Prophet's era
May salvation descend upon him
And wishes of eternal life 972

The addition of the letter "ya" to Reza transcribes the Persian *ezafe* as pronounced if it were read in the Persian fashion. This is typical of the style of 'Ali Reza who has a tendency to persianize his Arabic here and there.

The signature 'Ali Reza al-katib, "'Ali Reza *Scriptor*", is known from a number of manuscripts. In his *Dictionary of Nasta'liq Calligraphers*, Mehdi Bayani gathered under a single entry all the signatures reading "'Ali Reza *katib*" (in Persian fashion) or "'Ali Reza al-katib" (in Arabic fashion) that he could find.[6] He noted that they differ in style and spread over "centuries". It seems clear, however, that the manuscripts signed "'Ali Reza al-katib" with dates ranging from Rabi' II 963/13 February–12 March 1556 to Sha'ban 983/5 November–3 December 1575 must be by the same copyist. Of these, one which was in the Royal Library in Tehran under Fath 'Ali Shah and has since found its way into the Türk ve Islam Eserleri Müzesi in Istanbul is of special interest. It reproduces the text of "Leyla and Majnun" by Hatefi, a romance from which one of the passages included in the manuscript studied here has been excerpted. It was also written in the year 972 and is signed in a colophon which, according to Bayani's notes, reads as follows:

كتبه العبد الفقير المذنب على رضاء الكاتب غفر

ذنوبه ببلدةُ فاخرةُ بخارا فى اواسط شهر جميدى

الثانيه اثنى و سبعين و تسعماته من الهجرية

النبوية

Written by the slave, the poor sinful 'Ali Reza *al-katib*, may his faults be forgiven, in the magnificent city of Bokhara in the middle of the month of Jumida [sic] II [of the year] nine hundred and seventy two of the Prophet's *hijra*/mid-January 1565.[7]

The rare noun form *Jumida* betrays the tendency in Mavara an-Nahr to change "a" into "i" (actually, into "e", a long vowel which survives to this day in Eastern Persian but no longer does in Western Persian). The lapse into what I have called Persian Arabic,[8] i.e. Arabic constructed according to Persian grammar, which can be observed in the colophon of the volume in Istanbul, is well in line with the Arabic style found in the *Anthology* manuscript. The two manuscripts were undoubtedly copied by the same man, in the same year. That alone would suggest that the *Anthology*, although no location is mentioned, was copied in Bokhara.

The inference is fully borne out by the prominence given to the name and title of Abu'l-Ghazi 'Abdullah Bahadur Khan, which appears three times in the miniatures. As has been noted, the Shaybanid ruler had entered the city after defeating the other contender for the Sheybanid Sultanate, Darvish Khan.[9] In 972/9 August 1564–28 July 1565, 'Abdullah Khan, as he is called in Eastern historiography, had not yet taken Samarqand. A manuscript such as the Drouot *Anthology* could only have been executed in the royal atelier located in the capital, which at that time was Bokhara.

As in all Bokhara school manuscripts, which continue earlier Harat usage in this respect as in many others, the royal protocol is calligraphed in white on blue at the top of palatial facades. This reflects architectural decoration in which glazed tile friezes were common in the ninth/fifteenth century and later. The first frieze occurs in miniature 2, folio 7B (pl. 2):

في ايام الدولة الخاقان الزمان ابوالغازي عبدالله
بهادرخان خلد الله تعالى ملكه و سلطانه

In the days of the rule of the Khaqan of the Age Abu'l-Ghazi 'Abdullah Bahadur Khan,
May God the Exalted perpetuate his kingship and his domination.

The "negligence" of the Arabic wording, which follows accepted usage from the eighth/fourteenth century for royal titulatures, may be noted.

The second calligraphic band appears in miniature 3 (pl. 3):

في ايام دولة الخاقان الزمان ابوالغازي عبدالله
بهادرخان خلد الله تعالى ملكه و سلطانه و افاض
على العالمين و زاد حسابه

In the days of the government of the Khaqan of the Age Abu'l-Ghazi Bahadur Khan, may God the Exalted perpetuate his kingship and his domination, and add to his years, and may his status increase.

The third frieze, in miniature 11, repeats the first one, shorn of the last three words "and his domination".

The wording of all three inscriptions makes it clear that the manuscript was not commissioned by the ruler, nor by officials in charge of the Royal Library.

In a manuscript commissioned by the Royal Library, the royal protocol would be introduced by the formula "By order of the Library of the Khaqan of the Age", etc. (*be rasm-e Ketabkhane-ye Khaqan oz-zaman*), etc. The wording used here is that which occurs on monuments, objects or manuscripts commissioned *under the rule of a Sultan*, but *not by him*.[10] Indeed, the introduction to the *Anthology* makes it plain that the initiative came from the author of the text. This is said in one long sentence beginning on the verso of Folio 4 and running on to the recto of Folio 5. Two poetic quotations, one of a quatrain, the other from a *ghazal*, are introduced as an "off" commentary to break it up:

باعث بر تمهيد مقدمات و ترتيب و تزيين اين
حكايات آنكه محرر زعمهاى كهن و مصور اين
داستان سخن كوهكن كوههاى بلا و مجنون بيابان
عشق و ابتلا هيمهٔ آتش شوق و محبت پروانهٔ
شمع محفل درد و محنت گداختهٔ شام هجران
سوختهٔ فراق و حرمان غريق بحر گناه اميدوار
برحمت اله نعمت الله المشتهر بخليفة بندهٔ
نيكخواه و دعاگوى و دولتخواه بى اشتباه
حضرت خان جم جاه انجم سپاه معدلت دستگاه
شجاع دوران حاتم زمان السلطان بن السلطان و
الخاقان بن الخاقان ابولغازى عبدالله بهادرخان
خلدالله تعالى ظلال اشفاقه على روس العالمين
خصوصاً اين بندهٔ كمين كه از اوان صبى و عنفوان
شباب و هم سرى با طوبى قامتان طوبى لهم و
حسن مآب

The cause of the preparation of these prolegomena and of the ordaining and adorning of these narrative poems is that the copier [*moharrer*] of these ancient tales and the illustrator [*mosavver*] of these romances; the Stonehewer [*Farhad*] of the mountains of misfortune; the Majnun of the desert of love and attachment; the fuel of the fire of ardent passion; the butterfly of the candle in the gathering of pain and suffering; the one who burns in the night of estrangement; the one

consumed by separation and deprivation; the one
drowning in the ocean of guilt; the one hoping for the
mercy of God, Ni'matullah known as Khalifa, the
servant who wishes well, raises his prayers and wishes
faultless good fortune for His Majesty the Khan
endowed with the splendour of Jam[shid], with armies
as numerous as the stars, with the apparatus of Justice,
the hero of our time, the Hatem [Tayi] of the age, the
Sultan son of the Sultan and the Khaqan son of the
Khaqan Abu'l-Ghazi 'Abdullah bahadur Khan – may
God the Exalted perpetuate the protective shadows of
His piety over the heads of the knowledgeable, in
particular this insignificant servant who, since the time
of his boyhood and the prime of his youth, in the
company of those as slender as the Tree of Tuba and
endowed with grace [*hosn*],

[here comes the quatrain]

در بیت الحزان درد و غم و در بیابان محنت و الم
همواره پر سراب و آتش و پیوسته افتان و خیزان
در کشاکش از بیوفائی خوبان مهوش دمی
بی مشقت ایشان نمی غنود و زبان حالش دایم
بدین مقال مترنم می بود

in the mourning house of pain and grief and in the
desert of difficulty and suffering, always full of
mirages and fire and continually falling and rising in
the turmoil, as a result of the unfaithfulness of the
moonlike beauties, did not slumber one moment
without suffering from them, and, in the language
appropriate to the spiritual circumstance, sang these
words:

[here comes the ode]

و جهت خاطر حزین و دل اندوهگین صبح و شام
بلکه علی الدوام درین اندیشه و خیال اوقات می
گذرانیده که از نفحات انفاس اکابر دین و صاحب و
دوکتان راه یقین حکایات عاشقانه در حسب حال
پند و در بیان مقال خود ترتیب نماید تا بر صفحهٔ
روزگار ازین خاک ز یادگار ماند شاید بنظر ارباب
دین و دولت رسد و پسند خاطر کیمیا اثر ایشان
گردد الحق مجموعهٔ آمده بلکه گلستانی ترتیب
یافت که چشم ایام چون آن ندیده و هیچ گوشی
تعریف مثلش نشنیده اگر فاضلان و هنرمندان
دوران سبحه وار دست بدستش گردانند رواست و اگر
خوبان زمان از گلشن لطافتش حال و مقال نامرادان
ملاحظه فرمایند سزاست
و من الله العصمة و التوفیق

and, by reason of the sorrow in his grieving mind and
his sorrowful heart from morning till night, constantly
spent his time thinking that, out of the breath exhaled
by the grandees of religion and by the master of the
ship on the path to certainty, he would ordain stories
of love to serve as parables and to explain his
discourse, so that, with these, the dust of memory
would remain on the page of our time. Perhaps they
may come to the attention of the masters of religion
and the state, and will become agreeable to their
efficacious minds.

Verily, an anthology has come [out of it], nay a
"*Golestan*" [Sa'di's work is meant here] has been
ordained such as the eyes of the world have not seen,
and praise the like of which no ear has [yet] heard. If
the eminent men [here: literati] and the artists of the
age make it pass from hand to hand it is legitimate,
and if the beauties of this period observe the spiritual
frame of mind and the discourse of the unfortunate
ones in the rosebed of its subtleties, it is appropriate.
"And from God cometh protection and success" [in
Arabic]

The stylistic prowess, bombastic and florid when rendered in mod-
ern prose, has great charm in the original. In phrases rhythmically
matched in twos (*qarine*) and harmoniously rhyming, it is a masterly
exercise in "adorned prose" (*nasr-e mozayyan*) even if what it says
boils down to these simple facts: Ni'matullah known as Khalifa com-
piled the anthology at his own initiative and saw it as a new *Golestan*.
The light-hearted tone does not suggest an author nurturing
great ambitions nor even one expecting a material reward. The writer
is remarkably discreet about his own past. From childhood on he
lived in the court milieu of "the beautiful ones" and notes that
its members can be treacherous.

Such self-effacement coupled with a tone of authority points
to an exalted Sufi figure. Ni'matullah betrays his awareness of his
own stature. With striking boldness, he had his own name inscribed
in a blue and white frieze in miniature 11, in the same form and
in the same cursive script as the Sultan's own name and titles which
are calligraphed in another blue and white frieze in the miniature.
The only concession to royal precedence is that the Sultan's
name and title appear at the top of the palace. Ni'matullah's
name is written over the entrance gate leading into the building. But
that is none too modest. It is a way of saying that the gateway of the
master's anthology leads into the Palace of Kingship. Ni'matullah's
name and title, given in precisely the same form as in the intro-
duction, are ushered in by the set formula, in Arabic *sahibuhu*,
which can be understood both as "its owner [is]" and "its author".
The manuscript was clearly intended for the writer's own use:

صاحبه نعمت الله المشتهر بخليفة

Its owner/author is Ni'matullah known as "The Khalifa".

Khalifa, in mystical language, describes him who has attained the spiritual station of *Khelafat*,[11] or proximity to God. It could point to a Sufi allegiance. This, however, requires independent confirmation.

Fortunately, the *'Abdullah-Nama*, written by Hafiz Tanish al-Bukhari, supplies essential information about the author of the anthology. "Ni'matullah known as Khalifa" loomed large in the emirate of Bokhara as a statesman of princely stock and as a spiritual figure. In 966, two years after 'Abdullah Khan had seized power in Bokhara, a considerable architectural programme was undertaken in the city at the request of the Sufi master *Khwaja* Juybari.[12] A descendant of Abu Bakr-e Sa'd, the master wanted to have a *khanqah*, a mosque and a *madrase* erected at the top of the grounds of his ancestor's tomb. These were to be surrounded by parks (*baghha*), gardens (*basatin*) and beautifully decorated constructions (*bana'-e khosh arayesh*).

Khalifa was at the heart of the project in his capacity of Holder of the Privy Seal. In the words of Hafiz-i Tanish:

اینچنین ارکان دولت و اعیان آن حضرت مانند
امیرخلیفة که آنزمان [ب]منصب عالی مهرداری
مفوض بود و در اتمام عمارات مذکوره اهتمام تمام
بذل فرمود و امیر با اقتدار جانگیلدی بی و
امیرزاده با اعتبار ولیجان میرزا و جولتای بی
باین ترتیب و آئین چمنها و بساتین در غایت
تکلف و تزیین گرد بر گرد مزار فیض آثار بنا
کردند

Thus, the pillars of the state and the most favoured supporters [*a'yan*] of His Majesty, such as Amir Khalifa, who at that time was graced with the exalted position of Holder of the Privy Seal and had given his fullest attention to the completion of the buildings in question, the powerful Amir Jangildi Bay, the eminent son of an Amir, Valijan Mirza, and Jultay Bay ordained in accordance with this project lawns [*chamanha*] and gardens [*basatin*], with lavish embellishments and decorations all round this graced mausoleum.

Khalifa is shown here in no uncertain terms to have been part of the ruler's innermost circle. He found himself in direct contact with masters (*ostadan*) and painter-designers (*naqqashan*), which may have inspired him later with the idea of having his *Anthology* illustrated in the royal studio. Hints at his Sufi involvement are discreetly dropped.

Further down, his powerful position at court is made clear once again. This time his deep commitment to Sufism is stated in explicit language. The passage describes 'Abdullah Khan's desire to find a suitable consort which he expressed in that same year, 966. The Sufi master *Khwaja* Juybari sent off two men on a spouse-searching mission to Marv, the capital from which another branch of the Shaybanid house ruled Khorasan. One was the master's own successor designate Khalaf *Khwaja* Kalan and the other was Khalifa, chosen in preference to all other *amir*s by virtue of his seniority in the employ of the court:

جهت استدعای حضرت صاحب قران، جناب ولایت
مناب هدایت نساب حقیقت اکتساب طریقت انتساب
مرشد کامل کامل [کذا] مکمل حضرت باری امامنا
و مخدومنا خواجه جویباری خلف با عز و شرف
خویش یعنی مخدوم زاده جهان و جهانیان نور چشم
عالم و عالمیان حضرت خواجه کلان طال عمره را بمرو
پیش پاینده محمد سلطان بن دین محمد خان روان
فرمود؛ و جناب امارت ایاب ایالت انتساب رکن
الدوله و مؤتمن السلطنه نظام الدین امیر نعمة الله
المشهور بمیر خلیفه را که بنا بر سابقیت خدمت
درگاه آن حضرت رقم امتیاز از سایر امرا برصفحهٔ
ایام می نگاشت و از خلوص طویت و کمال خلاص و
عقیدت خود را در سلک مریدان و معتقد ایشان
میداشت در ملازمت خواجه زاده ارسال نمود.

In order to put forward the request of His Majesty the Master of the Conjunction ['Abdullah Khan], His Eminence enjoying Divine Friendship [*velayat*], favoured with kinship to the Prophetic Guidance, holder of [esoteric] truth, descendant of the spiritual path [*tariqat* or Sufi community], the perfect and accomplished guide [*morshed* or Sufi master], His Majesty the ruler, our Imam, our lord *Khwaja* Juybari bade his successor designate, glorious and noble, that is: the scion of the lord of the world and all humans, the light of the eyes of the universe and all creatures, *Khwaja* Kalan, long life to him, proceed to Marv and call upon Payanda Muhammad Sultan b. Din Muhammad Khan; and dispatched in deferential company to the scion of the Excellency [=son of Juybari] his eminence the transmitter of sovereignty [*emarat-eyab*] descended from the clan, pillar of the state, the repository of royal trust, Nizam ud-Din Amir Ni'matullah known as Mir Khalifa who, by virtue of the seniority of his service at His Majesty's court, wrote down on the page of time the paraph of privilege

over all the Amirs, and who, as a result of the purity of his designs and the perfection of his integrity and creeds, followed the path of the aspiring [disciples – *moridan*] and shared their creeds."

The eulogistic titles which introduce Khalifa's *laqab* Nizam ud-Din show him to have been deeply trusted by the ruler. Khalifa is characterized as the *mu'tamin us-saltana* ("the repository of Sultanic power"). This powerful man was a Sufi and one who lived in accordance with the principles of detachment and asceticism such allegiance implies. "He followed the path of the aspiring disciples" (*dar salk-e moridan*), as Hafiz-Tanish puts it. The historian specifies that the supreme master *Khwaja* Juybari sent Khalifa "in deferential company" (*dar molazemat*) to his successor-designate *Khwaja* Kalan despite his high rank as an *amir* at court. Khalifa thus deferred to the spiritual hierarchy. The fact that he was dispatched on such a highly important mission as seeking the hand of an Uzbek princess for the sultan 'Abdullah Khan says everything about the trust that was put in Khalifa by the monarch and the Sufi hierarchy alike. The mission was entirely successful. *Khwaja* Kalan and Khalifa returned to Bokhara accompanied by Princess Sultanim loaded with presents, notably gems, from the Marv court.

In the lapse of time separating Khalifa's mission to Marv in 966 and the composition of the *Anthology* in 972, the Sufi prince appears to have suffered a reverse of fortune at court. The tone of the introduction and indeed of the whole make-up of the manuscript points to a man aware of his high status, which gives him the confidence to take liberties in a playful manner with a much younger ruler, as well of a rift between himself and the Sultan, which fills him with regret. This much is first intimated in the introduction by a quatrain in the manner of Jami whose author I have not yet identified. The place of the short poem in the sentence indicates that it is meant as an allusion to the circumstances of the writer of the introduction, that is, Khalifa himself [*Hazaj*]:

تا آنکه (ا)ز تاب دل غم پرور او
شد همچو درخت پر شکوفه سر او
غیر از گل درد هیچ چیزی نشکفت
جز میوهٔ غم نبود حاصل بر او

Until, by the searing torment in his heart full of grief
His head became like a tree full of blossoms
No plant blossomed except the flower of pain
No yield came for him except the fruits of grief

Making allowances for the *précieux* style and some rhetorical exaggeration, the quatrain points to some bitter experience.

The second and much longer quotation, likewise intended as an allusion to the writer's circumstances, is taken from one of Jami's preludes to the romance of *Yusof and Zoleykha* and is titled "The palm-

trees of the excellence of sealing the bonds of love and the twig of connecting with it the beginning of this versified book".[13] Khalifa does not identify Jami's romance by title since it is too well known to any cultivated Persian readership to require such identification. These are famous lines from the romance most admired in Eastern Iranian Sufi circles. Both indicate that Khalifa identifies with Jami, the greatest mystical poet in the Naqshbandi path of Sufism. They further tell us that the author of the *Anthology* is a follower of that path (*Hazaj*):

بحمدالله که تا بودم در این دیر
براه عاشقی بودم سبک سیر
چو دایه مشک من بی نافه دیده
بتیغ عاشقی نافم بریده
چو مادر بر لبم پستان نهاده
به خونخواریِ عشقم شیر داده
اگرچه موی من اکنون چو شیر است
هنوز آن ذوق سرّم در ضمیر ست
بپیری و جوانی نیست چون عشق
دهد برمن دمادم این فسون عشق
که جامی چون شدی در عاشقی پیر
سبک روحی کن و در عاشقی میر

Praise be to God that as long as I was in this [ruined] hermitagee
I stood on the path of [mystical] love, travelling swiftly
As my nurse saw my musk without a musk bag
She cut off my umbilical cord with the sword of mystical love
Like a mother she laid her breast on my lips
The bloodthirstiness of my love, she quenched with her milk
Although my hair is now [white] as milk
The ardour of that secret knowledge still lingers in my consciousness
In old age or youth, there is nothing like love
Love every moment whispers to me this incantation:
Jami since you became old in mystical love
Lighten your spirit and die a mystical lover[14]

If Jami's lines are anything to go by, Ni'matullah was an old man by the time he compiled the *Anthology*, albeit one as ardent as ever in the path of mystical love.

This is hinted at in the first miniature (pl. 1) which comes as a visual counterpoint to the preface in a rectangular panel fitted below the concluding lines. Three clerics are seated. One is identified by his white beard as the master (*pir*, "old man"). He faces the other two, shown three-quarters, their arms crossed in an attitude of deferential attention. With his left hand, the master lightly touches a book, no doubt the *Anthology* itself. The scene is probably intended

to echo the line in the text above it that describes how "the literati [*fazelan*] and artists [*honarmandan*] of the age turn it around like a rosary." The two categories are represented by one man each, facing Ni'matullah.

PART TWO:
The Make-up of a Master's Book of Initiation

Indeed, the imprint of a Sufi master can be detected in every aspect of the book. It accounts for its make-up as well as a host of details, literary and visual.

Ni'matullah was not content with selecting texts that were the most admired in the Eastern Iranian Sufi circles of his time. The illustrations accompanying the parables are composed and arranged in relationship to the text in such a way that each story can be read as a parable referring to the master. In each miniature, the figure of a master appears in the traditional guise of the "old man" (*sheykh* in Arabic, *pir* in Persian). In some, the presence of a master is not explicitly required by the text. In others, it has no justification whatsoever in the narrative and is obviously added for its own sake.

Even more revealing is the occurrence at intervals of a miniature composed as a diptych, with the master facing one or several disciples. I am not aware of any parallel for this idea. The cycle of illustrations begins, as has been said, with the master touching his book in front of two listeners, and it ends with the master seated with a book lying in front of him as a young man listens (the Shah, i.e. 'Abdullah Khan). From start to finish, the book is thus designated as an instrument of initiation at the hands of a master.

1. 'Attar's parable of Master San'an

The book begins with a parable by *Sheykh* Farid od-Din 'Attar, perhaps the most highly regarded of Sufi mystics in the Eastern Iranian world, particularly in Mavara an-Nahr. Dowlatshah in his famous "Biographies of Poets" (*Tazkerat osh-Sho'ara*), completed on 18 Shawwal 892/7 October 1487, calls *Sheykh* 'Attar the "Sultan of Mystics" (*Sultan ul-'Arifin*).[15]

The parable drawn from the "Discourse of the Birds" (*Manteq ot-Teyr*) is the longest and most dramatic in 'Attar's book. In contrast to the other excerpts in the *Anthology*, this one is not identified in any heading. The parable starts on folio 5b with the first two words by which the story is known (*Hazaj*):

شیخ صنعان پیر عهد خویش بود

در کمالش هرچه گویم بیش بود

Sheykh San'an was the master of his time
Anything I may say about his perfection, he surpassed it[16]

The story is about mystics who delude themselves with the illusion that they have attained spiritual perfection. Among other things, they stand in danger of allowing their intense emotions, which are at the source of their passionate love for God, to be deviated.

One night, the "master of his time" dreams that after accomplishing the pilgrimage to Mecca, he suddenly sets out for Greece. Anxious to unravel the meaning of this dream, the *Sheykh* leaves for Greece, accompanied by four hundred disciples. They travel all over the land. As they pass by a magnificent palace, they see a beautiful Christian maiden. The *Sheykh*, love-stricken at first sight, spends the whole day gazing at the palace. When they realize what has happened, the disciples are first dumbfounded and then distraught. This is the moment illustrated by the first miniature relating to the parable. In the top corner left, the verses read (pl. 2):

سر بسر در کار او حیران شدند

سرنگون رفتند و سرگردان شدند

All of them were amazed at his predicament
They went about dropping their heads and became distraught[17]

The miniature shows the master standing at the foot of a two-storeyed structure. This is the inner courtyard of a palace, the only place where it might have been remotely conceivable, in sixteenth-century Bokhara or in any other city of the Iranian world, for a passing stranger to catch a glimpse of a princess looking out of a window. The royal titles of Sultan Abu'l-Ghazi Bahadur Khan appearing at the top (see above p. 153) transform the supposed "Anatolian" (Rumi, i.e. Byzantine) palace into a metaphor of a contemporary Bokharan palace.

The master shown standing in the bottom corner left, looking up at the façade, is therefore "the master (*sheykh*) of the age" in contemporary Bokharan guise. The four clerics on the right stand for the "four hundred" disciples in the parable. As in all Iranian book painting, the characters of the past are shown here in contemporary garb and set in locations matching in style those from the painter's own time. The past is a metaphor of the present in Iranian art as in literature. 'Attar's *Sheykh* San'an is simultaneously perceived as a mid-sixteenth-century Sufi master, in other words as the metaphorical persona of *Sheykh* Ni'matullah "known as the Khalifa", a title here to be understood as "head of a *tariqat*".

The second miniature illustrating the story of *Sheykh* San'an leads to the same conclusion (pl. 3). The disciples try, in vain, to persuade their master to return to the path of those who are true to the faith. After a month, the *Sheykh* becomes ill. As she sees him wandering about the street on which the palace stands, the Christian maiden understands the nature of his condition. She presses the *Sheykh* to drink wine. He is taken to a "Magian hermitage" (*deyr-e Moghan*) where wine can be drunk.[18] His disciples look for him in despair, only to find him in the midst of a gathering (*majles*) — a party where poetry is chanted and improvised, music played, and

wine drunk – hosted by a dazzling beauty, the Christian maiden. The miniature illustrates this moment, described in the verses running over the cusp of the vaulted hall (eyvan) in the "Rumi" palace and continuing in two cartouches arranged vertically on the sides:

ذرهٔ عقلش نماند و هوش هم

درکشید آنجایگه خاموش دم

جام می بستد ز دست یار خویش

نوش کرد و دل برید ازکار خویش

چون یکجا شد شراب و عشق یار

عشق آن ماهش یکی شدصدهزار

Not an atom of reason nor lucidity remained in him
 He kept silent for a while in this place
From the hands of his companion he took the cup filled with wine
 Drank it and cut off his heart from his own doings
As wine and love for his companion combined
 His love for that [radiant] moon was multiplied a hundred fold[19]

In the painting, however, the Sheykh is not shown in anything like the "Magian hermitage" mentioned in the poem, but seated with the Rumi woman. They are shown together as a royal couple might be, in a feast with wine and music held in the garden spreading in front of the palace. Female court attendants appear in pairs on either side, as they might in the service of a princess. Two musicians play the tambourine (daf) and the harp (chang) while two other women pour out wine, one holding a Chinese porcelain decanter and a cup, the other respectfully presenting a large bowl. Two disciples, dropping their heads in distress, sit in the lower corner left. At the top of the palatial eyvan the monumental inscription in blue and white ceramic reminds the viewers that the scene is set "In the days of the rule of the Khaqan of the Age, Abu'l-Ghazi 'Abdullah Bahadur Khan". Once again, Sheykh San'an is presented as the model of a Sheykh of the Bukharan court, who may be presumed to be Ni'matullah.

Long passages follow without any illustration. As his passion gets exacerbated, the Sheykh finally converts to Christianity. Gradually, the woman in turn develops feelings for the Sheykh. Contemplating marriage, she requests him to do the unthinkable by way of giving her a dowry, which as a destitute dervish the Sheykh could never afford to pay. He must tend her herd of pigs for a year. Now driven to despair, the disciples go to the Ka'ba. In Mecca, they meet a friend of the Sheykh and ask him for guidance. The friend blames the disciples. They abandoned their master in spiritual peril when it would have been their duty to stay with him, even to convert to Christianity and share his plight to save him. Rather than complain to God about their misfortune, they should have been praying in the master's presence.

The disciples go back to Greece. The friend, while praying in his cell in Mecca, sees the Prophet in a dream. As he implores God to save the Sheykh, he hears that the master has found the way to salvation. The friend, the disciples and the master are reunited and all is joy. It is the turn of the Christian woman to be deeply tried. She converts to Islam. Realizing her own solitude, she sets out in search of the master. An inner voice informs the Sheykh of these changes. He returns to Greece, telling his incensed disciples of the change that has occurred in her. They go back in search of the Christian woman and find her lying on the road, dishevelled, her clothes in tatters, exhausted. On seeing the Sheykh, she regains strength and begs him to show her the true path. The Sheykh explains the meaning of Islam, stirring profound emotions in her. They are all overjoyed. But the elation she experiences in discovering faith is too much for her. As life ebbs away, she tells the Sheykh the words written in the third miniature (pl. 4):

می روم زین خاکدان پر صداع

الوداع ای شیخ عالم الوداع

I am departing from this bowl of dust filled with anguish
 Adieu, O Sheykh of the world, adieu[20]

In the miniature, the woman is crumpled up in the dust, her head in the Sheykh's lap as four clerics (the "four hundred disciples") look on. The subject presumably bears no connection to the Ni'matullah of 972/1564–5.

But the last page of the excerpt almost certainly does (pl. 5). It faces the image showing the master with the dying woman. The last eleven distichs in the parable are calligraphed in two columns above two square panels each enclosing two of the four disciples. The first four lines conclude the story. The next six spell out maxims. Each one of these sounds like a punchline which could be uttered by the man who commissioned the manuscript to his disciples:

چون مرا کوتاه خواهد شد سخن

عاجزم عفوم کن و سختی مکن

این بگفت آن ماه ودست ازجان فشاند

نیم جانی داشت بر جانان فشاند

گشت پنهان آفتابش زیر میغ

جان شیرین زو جدا شد ای دریغ

قطرهٔ بود او و در این بحر مجاز

سوی دریای حقیقت رفت باز

جمله چون بادی ز عالم میرویم

او برفت و ما همه هم میرویم

اینچنین افتد بسی در راه عشق

این کسی داندکه هست آگاه عشق

هرچه می گویند در ره ممکن است

رحمت نومید و مکر و ایمن است

در چنین ره چابکی باید بسی

بو که بتوان ساختن از خود کسی

نفس این اسرار نتواند شنود

بی نصیبی گوی نتواند ربود

یعنی این از جان ودل باید شنود

نی بنفس آب و گل باید شنود

جنگ دل با نفس هر دم سخت شد

نوحهٔ در ده که ماتم سخت شد

Since my words will be cut short
 I am helpless, forgive me,[21] do not blame me
Thus spoke this radiant moon, and then she gave up life
 She was half alive and this half she shed over her beloved one
The sun of her splendour went under a cloud
 Her sweet soul was separated from her the pity of it
She was but a drop in this ocean of metaphors
 She returned to the sea of truth
We all go from this world fast as the wind
 She went and we too will go
Thus[22] it often happens in the road to love
 This much he understands, he who knows about love
Anything they say on the road is possible
 It is compassion without hope, tricks and faith
On such a road, great swiftness is required
 Perchance it will be possible to make a person of you[23]
The whiff of this secret knowledge cannot be smelt
 The ball at the polo game cannot be stolen without a mallet[24]
This certainty must be heard by the heart and soul
 It must not be heard by the form of clay and water[25]
The war of the heart with breath gets harder every moment
 Utter a dirge for the checkmate was hard on me

2. *The Selections from Sa'di's* Bustan

The next excerpt is from Sa'di's "Garden of Scents" (*Bustan*). Introduced by the Arabic formula "From the Garden of Scent" (*'an il-Bustan*), it starts on folio 22b with the opening lines of Chapter One, "On Justice and Foresight".[26]

The first miniature (pl. 6) relates to a parable which comes under the heading:

حکایت در تدبیر پادشاهان [و] تأخیر کردن در سیاست

Story about rulers planning and deferring punishment

The parable begins at the top of folio 25b from which a narrow strip, probably damaged at a very early stage, was cut out some time in the sixteenth or seventeenth century. A man who has travelled the world, full of experience, learned and vigorous but destitute and wearing tattered clothes, arrives in a land whose ruler is well-disposed towards ascetics. After taking him to a public bath, royal servants lead him into the palace and introduce him to the king. The ruler wishes to know the ageing dervish's reasons for coming to his kingdom. In the early manuscripts of Sa'di's work, the questions asked by the king are not spelled out. They are made implicit by the traveller's words to the king. In the later versions of the text, three additional distichs formulate these questions, as is the case in the *Anthology*. Owing to the insertion of the strip of paper, the top part of the miniature has been cut out. The two bands of text surviving on either side of the *eyvan*, or vaulted hall, include the end of one distich and the beginning of another:

[شهنشاه گفت از کجا آمدی]

چه بودت که نزدیک ما آمدی

چه دیدی درین کشور ازخوب و زشت

[بگو ای نکو نام نیکو سرشت]

[The King of Kings said: where did you come from?]
 What induced you to come to us?
What have you seen in this country, good or ugly?
 [Tell me, you who are good by repute and good by nature][27]

Impressed by the ascetic's wisdom and dignified demeanour, the king makes him his vizier. The jealousy of the ascetic's predecessor knows no bounds. The former vizier accuses the new one of having become enamoured of one of the king's beautiful pages. A retainer of his, the old vizier assures the king, overheard the two as they were embracing each other. Incensed, the king starts observing his new vizier's moves more closely. One day he sees him wistfully gazing at a page who in return gives the ascetic a look of understanding. The enraged king summons the dervish, tells him of what he stands accused and on hearing his firm denial, says how he himself saw the ascetic looking wistfully at the page. The ascetic explains that envious people are hardly to be listened to when they throw out accusations. As for the wistful look, this expressed the feeling that he, the ascetic, had when remembering how he too was once young, fair-faced and slender. On hearing these words, the king sees his error and further confirms the ascetic in his powerful position.

Could this parable be fraught with autobiographical allusions? This is a tempting thought, but one that cannot be substantiated until the details concerning the relationship of Ni'matullah with 'Abdullah Khan over the years come to light.[28]

The second story from the "Garden of Scents" to be illustrated is found in Chapter Two, excerpts of which begin on folio 32a under the heading "Chapter Two: On displaying Kindness" (*Bab-e dovvom Dar Ehsan*).[29] The story appears on folio 33a under a one-line head-

ing in white lettering on gold ground:

گفتار اندر احسان کردن با سگ

Discourse on displaying kindness to dogs.[30]

The story is told in just these distichs, the last of which is written inside the miniature (pl. 7):

یکی در بیابان سگی تشنه یافت

برون از رمق در حیاتش نیافت

کله دلو کرد آن پسندیده کیش

چو حبل اندرویست دستار خویش

بخدمت میان بست و بازو گشاد

سگ ناتوان را دمی آب داد

Someone found a thirsty dog in the desert
He found but the last breath of life in him
This man of pleasing morals made his hat into a bucket
He fastened it with his turban, using it as a rope
He got ready to help and extended his arm
He gave water for a while to the exhausted dog[31]

The miniature illustrates the second distich in traditional fashion.

The third story occurs half way through Chapter Four "On Humility". A one-line heading introduces it at the bottom of folio 35b:

حکایت ملک صالح با درویشان در دشت

The story of Malek Saleh and the dervishes in the open country[32]

King Saleh of Syria goes out one day, accompanied by an officer, to wander about the market and the surrounding streets, his face half-veiled "according to Arab custom" [i.e. nomad custom]. He finds two destitute men lying in a mosque distraught after a sleepless night, and overhears what they say. In the *Anthology* the story begins abruptly with their words:

گر این پادشاهان گردن فراز

که دلهو و عیشند و با کام و ناز

درآیند با عاجزان در بهشت

من از گور سر برنگیرم زخشت

بهشت برین ملک و مأوی ماست

که بند غم امروز بر پای ماست

همه عمر از اینان چه دیدی خوشی

که در آخرت نیز زحمت کشی؟

اگر صالح آنجا بدیوار باغ

برآید بکفشش بدرم دماغ

If these proud rulers
Who live idly for pleasure, indulging in comfort
Enter Paradise with [us] the helpless ones
I will not raise my head from the brick in my tomb
Paradise is our Kingdom and our refuge
Today the shackles of sorrow trammel our feet
What good have you seen from them in all our lives
That you should also suffer in the other world?
If Saleh comes here to the garden wall
I will smash his face with my shoe[33]

Such an abrupt beginning would be meaningless to an ordinary patron. It makes sense to a teacher thoroughly acquainted with the text and making selections in order to remember without fail the passages he intends to quote. The emphasis on the beggar's revolutionary words, which challenge and indeed threaten the legitimacy of established authority, is typical of the fundamental orientation of Sufi movements and their deep roots in the poorer classes. It adds one more touch to the portrait of Ni'matullah.

King Saleh, beating a prudent retreat, continues his nightly walk through the city until sunrise. Then, as the two distichs in the vertical panel of the miniature in pl. 8 note,

دوان هر دو کس را فرستاد و خواند

بهیبت نشست و بحرمت نشاند

بریشان بباربد باران جود

فرو شستشان گرد ذل از وجود

He dispatched a messenger to these two and summoned them
Enthroned in splendour, he had them seated in honour
He poured out over them the torrent of his generosity
He washed off the dust of misery from their existence[34]

The miniature on folio 36b shows the beggars as they are led to the King, wearing scented clothes. It refers to the precise moment when one of the beggars asks the King a question:

یکی گفت ازینان ملک را نهان

که ای حلقه درگوش حکمت جهان

پسندیدگان در بزرگی رسند

ز ما بندگانت چه آمد پسند؟

One of them asked the King in private
O you to whose decrees the world stands in bondage
Those that pleased you attain high positions
But from us your servants what pleasure did you incur?[35]

The beggar who addresses the King holds up both hands in the gesture which signifies rhetorical wonder and entreaty in the body lan-

guage of Iranian conversation. His friend listens with both arms crossed in deferential attention. Once again, one suspects that the beggar who has challenged the king might be intended as the metaphorical alter ego of Ni'matullah himself.

3. *A Passage from Nezami's* Khosrow and Shirin

After Sa'di, the author of the *Anthology* turns to Nezami's romance of royal love, *Khosrow and Shirin*. The selection, introduced by a heading within a cartouche in white lettering on gold ground with green scrolling motifs on folio 37b, recounts the meeting of the King and the Armenian beauty. Interestingly, the most famous scene has not been chosen for illustration, possibly because it did not relate in any way to Ni'matullah's own situation. The first scene to which the author of the illustrative programme gave attention is announced on folio 48b by a one-line heading in white gouache on a gold ground:

عاشق شدن فرهاد بر شیرین

Farhad falls in love with Shirin

Prince Shapur has just told Shirin about a sculptor called Farhad. Both he and Farhad were born in Chin, i.e. Eastern Turkistan,[36] where they studied under the same master. Shapur then takes the sculptor to Shirin's palace (*shadorvan*). The miniature on folio 37a illustrates their arrival (pl. 9):

در آمد کوهکن مانند کوهی
کزو آمد خلایق را شکوهی

The Mountain-Hewer arrived like a mountain [on the move]
From which the splendour descends upon humans[37]

Could Farhad, who appears in Nezami's poem as an ascetic character totally dedicated to his art, be intended as yet another metaphorical reference to Ni'matullah? As before, the lack of detailed information about Ni'matullah's life makes any speculation on the subject hopeless.

The next passage copied contains Farhad's verbal joust (*monazere*) with Khosrow. Defeated, the irate emperor takes the sculptor to faraway Bisotun where he carves out of the rock a portrait of Shirin. But surprisingly that scene traditionally depicted by book painters is not illustrated. The two distichs which describe Farhad executing in similar fashion a portrait of Khosrow mounted on his horse Shabdiz have been altogether omitted from the excerpt. Therefore this equally famous subject is not shown either. Instead, the designer of the book chose as a subject for his image a string of metaphors which conclude Nezami's story. The relevant lines read (pl. 10):

اگر دنبه بر گرگان تله بست
بدنبه شیر مردی زان تله رست
چو پیه از دنبه زان سان دید یاری
تو بر دنبه چرا پی می گذاری
مکن کین میش دندان تیز دارد
بخوردن دنبهٔ دلگیر دارد

If a tail slammed the trap shut on the wolves
By that tail [of deceit], a lion [=a king] escaped from the trap
Since the tallow [of his vanity] thus received help from the tail of deceit
Why would you press your foot over the tail of deceit?
Do not, for if this ram [=the world] has sharp teeth
For eating, it has an inviting tail[38]

Thus the miniature, instead of illustrating a narrative scene, represents the literary motifs used in the metaphors. In one square panel, a wolf stands for the courageous and lonely Farhad, and in the next panel two sheep are shown. Far from being an illustration, it elaborates, by visual means, on the thoughts developed by the poet. Big as the wolf may be, the sweet-looking sheep can trick it and bite back: courage and force find their limits, just as sweetness and weakness can conceal unsuspected fighting resources. More than ever, the manuscript gives the impression of having been conceived in a highly unconventional way, for teaching purposes. I know of no parallel for such image selection or for its use as a kind of additional commentary in visual footnote fashion.

4. *The parables of Jami*

Jami, the great Sufi poet who became initiated into the Naqshbandi congregation, comes next. He is given more space than any other author in the *Anthology*, nor should this come as a surprise. The founder of the Naqshbandi path, 'Obeydollah, known as *Khwaje-ye Ahrar*, the "Eminent of the Spiritually Free", taught in Bokhara. It is to him that Jami dedicated "The Present of the Spiritually Free" (*Tohfat ol-Ahrar*), and it is with an excerpt from that romance that the selections of Jami's oeuvre begin on folio 54b. The first is found in the "The Seventeenth Discourse hinting at the delicate beauty [*hosn*] of those who are good and the resplendent beauty [*jamal*] of the loved ones who are the most attractive flowers in this springtime garden, and the most patiently drawn patterns in this gallery of figures". In the manuscript, the title plate [*'onvan*] merely states "From the *Tohfat ol-Ahrar*". The opening lines are a lyrical celebration of God to Whose Existence every flash of beauty bears witness:

نقش سراپردهٔ شاهیست حسن
لمعهٔ خورشید الهی است حسن
حسن که در پردهٔ آب و گلست
تازه کن از عهد قدیم دل است

Delicate beauty is the motif in the royal tent
Delicate beauty is the flash of the divine
Delicate beauty that is under the veil of [the human form] of clay and
water
Make it new, it is from an ancient pact of the soul[39]

No illustration accompanies these excerpts from the *Tohfat ol-Ahrar*, although it includes three parables. The first one is "The story of the black man [*zangi*] who saw his face in a mirror unstained by rust [*zang*, sending back a punning echo to *zang-i*, "the rusted one"] and was pleased with the mirror for the reflection it gave him of his face" starts on folio 56a. It may have been selected by Ni'matul-lah as a self-incriminating allusion. This is taken from "The Seventeenth Discourse" which begins on folio 56b. It is introduced by a long title on folio 57b:
"Story of the mystical lover ['*asheq*], who, in the presence of his Beloved One, opened his eyes to look at another object of love and who, on account of this wrongful eyeing, fell from the consideration of his Beloved One".

This appears to echo the estrangement of Ni'matullah from 'Abdullah Khan, to which reference is made here and there. The third story is taken from the "Ninth Discourse" which unexpectedly comes on folio 60b, *after* the seventeenth discourse. The long title of this discourse, given in full, seems to echo Ni'matullah's thoughts about his own career:
"Ninth Discourse alluding to muteness as the means of salvation and the ornament that elevates position".

The story goes back to *Kalila wa Dimna* and is about a tortoise befriended by two ducks. The tortoise agrees to accompany them on a trip by biting on a stick which the two will hold in their beaks. In contrast to a *Tohfat ol-Ahrar* copied within a few years of the *Anthology* by Mir Hoseyn al-Hoseyni, known as Mir Kolangi,[40] the story is not illustrated. This seems to bear out the very personal character of the choice of miniatures in the volume.

After the *Tohfat ol-Ahrar* come some passages "From the Rosary of the Pious" (*min Subhat ul-Abrar*), as the calligraphy on gold ground specifies in the title plate. The first one, starting on folio 61a, is from the "The nineteenth necklace on love that is the inclination of the soul through the study of the perfection of the attributes, and the attraction of the spirit to witnessing the radiant beauty of the essence".

Conditions must be met prior to treading the path that leads to the contemplation of God's beautiful attributes. The point is made by Jami in "The Story of that Stooping Master Who Did Not Lay Down a Straight Mould on the Road to Love and Who by Virtue of his Oblique Approach Fell Out of the Consideration of the Straight-Seeing Beloved One".[41]

A miniature illustrating its final episode is the most important one as a clue to the patron who commissioned the manuscript (pl. 11). It appears on folio 63b. A beautiful fourteen-year-old stand-ing on the edge of a terraced roof was parading his attractions. A white-haired man with a stoop was seduced. He came up to him, declaring himself to be overcome by love at first sight. The youth recognized the ancient master's condition but, failing to detect the "perfume of sincerity" in his heart:

گفت کای پیر پراکنده نظر
رو بگردان بقفا باز نگر
که در آن منظره گلرخساریست
که جهان از رخ او گلزاریست
او چو خورشید فلک من ماهم
من کمین بندۀ او و او شاهم
عشق بازان چو جمالش نگرند
من که باشم که مرا نام برند
پیر بیچاره چو آن سو نگریست
تا ببیند که در آن منظره کیست
زد جوان دست و فکند از بامش
داد چون سایه بخاک آرامش
که آنکه با ما ره سودا سپرد
نیست لایق که دگرجا نگرد
هست آئین دوبینی ز هوس
قبلۀ عشق یکی باشد و بس

He said: O scatter-eyed Master
Go, turn around and look back
In this palace is a rose-faced one
By whom the world is turned into a rose bed
He is like the sun in the sky and I am its moon
I am his merest slave and he is my King
When those who practise the art of love gaze at his beauty
Who am I even to be mentioned?
When the poor master looked in that direction
To see who was in that palace
The youth struck out and threw him off the roof
He laid him to rest in the earth like a shadow
He who practises black treachery with us
Is not worthy to look anywhere
The custom of looking in opposite directions stems from self-indulgence
Love prays in one direction, and no more[42]

The last three distichs are written in a vertical rectangle inserted in the top corner left in the fashion of calligraphic panels mounted in *moraqqa'* pages. The youth standing on the terraced room bends slightly forward over the low crenellated parapet to look at the wretched master who is falling head down, legs wriggling. A companion seated to the right on the same terrace also looks at the falling man. And so does a third character intended as "the beauty in the palace". The youth and the beauty both bite their forefingers, in the

traditional gesture conveying amazement, while on ground level, a young man with knitted eyebrows, indicating concern, has just opened the long window. There is a vivid irony about it all. It is multiplied and made devastatingly self-incriminating by the inscriptions. Under the parapet runs the third monumental inscription reminding the reader that this took place "In the days of the rule of the Khaqan of the Age Abu'l-Ghazi 'Abdullah Bahadur Khan". Below, in a panel set over the ground floor window in what is represented as a structure placed ahead of the palace, the only inscription to be seen within any miniature aside from those honouring the rule of 'Abdullah Bahadur Khan says that "its owner is Ni'matullah known as The Khalifa". It is close to the head of the falling man as if to suggest that Ni'matullah himself is the foolish, duplicitous master precipitated to his death. The self-deprecating touch here turns to withering irony, aimed at the man who commissioned the manuscript obviously on his own behalf.

The excerpt ends on folio 69a with the prayers concluding the twenty-first "necklace" which is called "On Jealousy that Consists of Protecting the Love of Him that Travels the Path by Cutting Off Any Linkage Other Than to the Beloved One or Cutting off the Perception of the Beloved One from Anything Else".

The eight distichs singled out to be calligraphed on folio 69a are fundamental statements celebrating God as the sole object of human love. They are uttered by Jami, with whom Khalifa clearly identifies:

در همه کون و مکان غیر تو کو

تا کسی بر تو برد غیرت از او

گرد گشتیم درین خانه بسی

نیست غیر تو درین خانه کسی

هرکسی جسته بغیری پیوند

کرده دل را بغم غیر تو بند

جامی از غیر تو بر دوخته چشم

وز خیال تو برافروخته چشم

چشمش از طلعت خود روشن ساز

بردلش کن در آن گلشن باز

رو بگردان ز در دورانش

هجرت آموز ز مهجورانش

سوز او ساز فزون روزبروز

ز آتش غیرت غیریت سوز

وادی بعد برو کوته کن

بسراپردهٔ قربش ره کن

In the entire universe who is there aside from You
 That anyone could be more jealous of than You
We went around many times in this house
 There is no one in this house aside from You
Whoever sought ties to anyone else

Fettered his heart in the grief of being with others
Jami averted his eyes from any one else
 And with the idea of You illuminated his eyes
Make his eyes bright with [the vision of] Your visage
 To his heart open the door of this rose bed
Go whirl away from the door of his age
 Learn about the [Prophet's] exile from those exiled from His presence
Make the burning yearning for Him increase by the day
 With burning jealousy about Him, burn out the idea of being without others
Go, make the ford to the hereafter short
 To the royal tent of closeness to Him prepare the way[43]

At the bottom of the column, two square panels illustrate notions that would seem to be well beyond the realm of illustration (pl. 12). In one, the kneeling master is seen, head bent, eyes ecstatically opened, matching the line "Make his eyes bright" etc. Facing him, a dervish whirls.

This is followed by excerpts from Jami's most admired and most frequently copied romance announced in a rectangular heading at the top of folio 69b, "From Yusof and Zoleykha". The opening lines are those describing the dream of Zoleykha in which she sees Joseph for the second time: "Happy is the heart in which love sets up its residence".[44] Once again the abrupt beginning, making the selection incomprehensible to someone unfamiliar with the story, shows that the *Anthology* was conceived by a reader thoroughly at home with his classics, perhaps as a memento for recitation.

The first illustration, on folio 78b (pl. 13), relates to lines halfway through the episode in which Zoleykha sends off Yusof to the park. The first two lines appear at the bottom of folio 78a; the next two lines are in the vertical cartouches inside the miniatures while the last two lines are skipped on folio 79a, where the text continues:

میان آن دو حوض افراخته تختی

برای همچو یوسف نیک بختی

بترک صحبتش گفتن رضا داد

بخدمت سوی آن باغش فرستاد

بگل مرغ چمن زد داستانی

که خوش باغی و نیکو باغبانی

چو باشد باغ و بستان جنت ایوان

نشاید باغبان جز حور و رضوان

صد از زیبا کنیزان سمنبر

همه دوشیزه و پاکیزه گوهر

چو سرو ناز قایم ساخت آنجا

پی خدمت ملازم ساخت آنجا

Between those two pools she set up a throne
　　For such a fortunate one as Yusof
She resigned herself to parting company with him
　　She sent him off on his duty to that park
The nightingale told its story to the rose
　　Saying: what a lovely garden you are, what a good gardener you
　　　　are[45]
When the park and the garden are the palace of Paradise
　　No gardener is suitable other than the Huri and Rezvan[46]
One hundred beautiful maidens with jasmine-scented bosoms
　　All of them virgins of pure nature
She established there like graceful cypress trees[47]
　　Attached to his service she established them there

Only one pool is visible in the image in which the panels of cal-
ligraphy enclose the second and third distichs. The throne is, as
usual in a garden, a high platform ("throne" renders Persian *takht*
meaning, literally, "platform"). The maidens stand or sit about,
some dropping their heads in demure reverie, and one standing as
she bites her finger to signify surprise.

The second image on folio 82b (pl. 14) fits into the first
intensely dramatic episode in the story. Having heard about Zoleykha's
passionate love for Yusof, the Egyptian women taunt her. Zoleykha
ordains a banquet of royal splendour and begs Yusof to attend it.
She presents him with a magnificent outfit including a crown stud-
ded with gems (*taj-e morassa'*), pointed shoes covered with rubies and
gems – the shoelaces made from strands of pearls.[48] Then:

بـــدســـتــش داد زریّــن آفـــتـــابـــه
کنیزی از پیش زرین عصابه

یـکـی طـشـتـش بـکـف از نـقـرهٔ خـام
بـــســان ســایــه او را گــام بــر گــام

...　......　........　.......
...　......　......　......

ز خـلـوتـخـانـه آن گـنـج نـهـفـتـه
بــرون آمــد چــو گــلــزار شــکــفــتــه
زنــان مـصـر کـان گـلـزار دیـدنـد
ز گـلـزارش گـل دیـدار چـیـدنـد
بـیـک دیـدار کـار از دسـتـشـان رفـت
زمــام اخـتـیـار از دسـتـشـان رفـت
ز زیـبـا شـکـل او حـیـران بـمـانـدنـد
ز حـیـرت چـون تـن بـیـجان بـمـاندنـد
چـو هـریـك را در آن دیـدار دیـدنـد
تـمـنّـا شـد تـرنـج خـود بـریـدنـد
نـدانـسـتـه تـرنـج از دسـت خـود بـاز
ز دسـت خـود بـریـدن کـرد آغـاز

She handed him a golden ewer
　　A maiden behind him with a golden head dress
Holding a basin made of pure silver
　　Following in his steps like his shadow
　　...　...　...　...　...
From his retreat that hidden treasure
　　Came out like a blossoming rose bed
As they saw that rose bed the Egyptian women
　　Plucked the rose of his appearance out of his rose garden
With but one glance, the affair got out of hand
　　The reins of free choice slipped from their hands
They were amazed at his comely shape
　　Amazement left them like lifeless bodies
As they saw each other absorbed in that contemplation
　　Their ardent desire came out: they cut their oranges
Unaware that the oranges in their hands were cut open
　　They began to cut them with their own hands[49]

Closely following the text, the miniature illustrates two succes-
sive moments in the narrative. Yusof first appears at the left,
wearing the crown and the pointed shoes. He holds up a golden ewer
(*aftabe*) and is followed by the servant woman who carries a silver
basin (the silver paint is now oxidised). A moment later, the women
crush the oranges which they hold in one hand and, unconscious
of their own actions, prepare to cut them again with the knife
they hold in the other hand. The painter has added a detail: one
woman has passed out, overcome by the emotion which Yusof's sud-
den appearance has induced in her.

The third miniature, like all images concluding a story, takes
the form of a diptych (pl. 15). It occurs on folio 86a at the end
of one of the last episodes in Jami's story: "Yusof is overcome by
love for Zoleykha and builds a house of worship for her".[50]

In the six distichs written above the image, Yusof invites Zoleykha
to take her seat in the house and to thank God. The image refers
essentially to the line at the top of the page:

درو بـنـشیـن پـی شـکـر خـدائـی
کـزو داری بـهـر مـوئـی عـطـائـی

Take your place in it seeking to thank God
　　From Whom you received a gift in every portion of your being[51]

Each of the characters appears under an arch, Yusof holding out his
hand in a gesture of peaceful conversation.

5. Selections from 'Arefi's The Ball and the Mallet

The fifth author from whom Ni'matullah borrowed short pas-
sages is 'Arefi, literally "of the mystic type", as the famous ninth/fif-
teenth-century Sufi mystic called himself.[52] His best-known text,

"The Ball and the Mallet" (*Guy va Chowgan*), enjoyed immense popularity in the ninth/fifteenth and tenth/sixteenth centuries.

The text begins on folio 86b under an illuminated heading enclosing the title of the work. It is a poem fraught with intricate symbolism about a shah and a dervish. That again suggests that it is intended to be read as an allegorical allusion to the close relationship between 'Abdullah Khan and Khalifa. This impression is reinforced by the fact that at the beginning of the story of which the excerpt appears in the *Anthology*, the first distich mentions a *shahzade-ye Chin*, "a prince of Eastern Turkistan" – if Chin is understood in the sense it retained until the first half of the sixth/twelfth century, at least in Khorasan and Mavara an-Nahr.[53] As a metaphorical allusion of a *recherché* order, it would have been highly suitable.

The first miniature on folio 88b deals with the frequently illustrated theme of a *darvish* watching a shah playing polo (pl. 16). This refers to the second day of the shah's game. The king catches sight of the ascetic, rendered distraught by the passion he has conceived for him, and makes a great display of his graceful and deft gamesmanship, supposedly to cheer up the dervish:

گو[ئی] به کرشمه سویش انداخت
وانگاه بناز بر سرش تاخت
[زان بی سرو پای گوی خود جست
برجست چو گوی از زمین چست]
بر خاک نشسته بود درویش
وانداخته سر چو صولجان پیش

With a wink he threw the ball towards him
 And then gracefully rushed on above him
[He jumped away from that loose ball
 He nimbly vaulted away like a ball]
The darvish sat on the ground
 His head bent forward like a mallet[54]

An additional character has been plausibly added – he is a polo caddy holding a mallet in reserve for those who break theirs. The polo ground is curiously rendered as hilly terrain.

The second and last miniature on folio 91a relates to the last two verses of a passage that sums up the meaning of 'Arefi's poem (pl. 17):

زین حال که گفتمت نشانی
گر عاشق عارفی بدانی
آنرا که به عشق اهتمام است
در عشق همین قدم تمام است

Of this spiritual condition that I told you about, you shall
 Recognise a sign if you are a mystical lover
To him whose concern is mystical love
 This [very] step is the sum total of it in mystical love[55]

Underneath, a distich concludes the excerpt as usual. In the right-hand column, a white-bearded sage stands by a tree, his head bent slightly forward. With his arms crossed and his hands tucked into his long sleeves, he contemplates a young man in princely garb. The prince also stands, as he reads from an open book. The visual metaphor is almost too obvious to bear a commentary. The old *darvish* is Khalifa facing a young king, 'Abdullah Khan, as the latter looks at Khalifa's *Anthology*, the "Selections from the Treasure of Kindness".

6. *Hatefi's* Leyla and Majnun

The next excerpt, which starts on folio 91b, strikes a markedly different note. As specified in the illuminated heading, it is borrowed "from Leyla and Majnun". As is usual in the *Anthology*, the author's name is not mentioned. This is not Nezami but Hatefi-ye Jami who wrote a *masnavi* (romance) on the same theme. Like 'Arefi and Jami, his father-in-law, Hatefi lived in Harat.[56] The preference given to his version of *Layla and Majnun* over Nezami's is typical of the Eastern Iranian world's literary inclinations. Hatefi's work does not have the profound resonance and complexity of Nezami's verses. It is written in limpid, fluid lines that are to Persian poetry what Heine is to German literature. The section chosen by Khalifa describes the companions setting out in search of Majnun. The first miniature, on folio 92b, shows the distraught Majnun among wild beasts in the desert where he has sought refuge (pl. 18). It illustrates the moment described in the six lines of slanting calligraphy which appear in the top corner right, once again in the fashion of a leaf mounted in a *moraqqa'*:

کرده به درندگان وطن را
او نیز دریده پیرهن را
از ظلم فراق و جور اندوه
بگرفته بداد دامن کوه
یاران چو به پیش او رسیدند
یاران دد و رام در رمیدند

He had established his residence among the [beasts] who tear up
 He too had torn up his shirt
The injustice of separation and the tyranny of grief
 He had taken to the tribunal of the mountain foot
When the companions arrived in front of him
 His companions, wild and tame, galloped away[57]

The bare-breasted Majnun, looking skeletal, is seated by a brook, feeding a gazelle. Facing him, a turbanned *sheykh* sits back on his heels while another *sheykh* weeps. They are "the companions" whose caravan has arrived. A boy tends to the two camels who have just been tethered.

The second miniature appears to relate to the chapter titled in white on gold: *Raftan-e Majnun be-tamasha-ye Leyla* ("Majnun goes to gaze at Leyla") which begins on folio 94b. It occurs on folio 95 (pl. 19). Majnun has been taken to the encampment of his beloved one. He catches sight of Leyla as she looks out of her tent:

بنمود رخ این ز جعد پرتاب
او داد ز دور چـــــشـــم را آب
افروخته این چو شمع پر نور
او سوخته چون سپند از دور

This one showed her face between her scattered jet black [hair]
 He from afar had his eyes filling with tears
This one was ablaze like a candle throwing light
 He was burning like wild rue in the distance[58]

Majnun, still bare-breasted and dishevelled as a sign of deep despair, is seen in the bottom corner right, talking to a turbanned man in charge of the women's quarters. The "encampment" has the appearance of a royal tent in a garden with ladies of the court standing about. The turbanned man's knitted eyebrows indicate concern and objection to unreasonable behaviour – a bare-breasted man has no business moving about this area. The third miniature, on folio 97b (pl. 20), shows Majnun retreating into the mountains. This is the only descriptive scene composed as a diptych in the excerpt. It appears under three distichs which say:

بـــر دل ز فــراق کـــوه انـــدوه
گردیـد روان بـجـانـب کـوه
بـا حسرت و درد از عدد بیـش
میرفت بـرنج خانهٔ خویـش
بـا خـود غم و درد بـی عدد برد
آورد یـکی بـخویش و صد برد

On his heart grief weighed heavy as a mountain
 He started walking towards the mountains
With immeasurable regret and sorrow
 He walked towards his house of suffering
With him he took his immeasurable grief and sorrow
 For one that he brought with him, he took away a hundred more[59]

As far as may be judged, no direct allusion is intended to Ni'matullah Khalifa's life in this passage. But it might be a metaphorical comparison – the love-stricken Ni'matullah, taking to a solitary retreat.

7. *Helali*, The Shah and the Beggar

With the last piece, by the latest poet,[60] on the contrary, allusions to Khalifa's relationship with 'Abdullah Khan are again much in evidence. The very title of the romance sums up what the whole point of the *Anthology* appears to be driving at, when seen in terms of personal experience: "The Shah and the Dervish" (*Shah va Darvish* is the alternative title given to the romance; in *Shah va Geda*, "The Shah and the Beggar", the title retained in the *Anthology*, *Geda*, literally "Beggar", is to be understood in its meaning "dervish").

Of all the excerpts, this is the only one that is introduced by what may be called a frontispiece, on folio 98a (pl. 21). A page divided in two columns as it would be for the text is in fact occupied by a miniature in the form of a diptych. A princely figure, wine cup in hand, stands in a palace facing a young page. The page sits back on his heels as he respectfully holds up the metallic tripod tray on which he has just presented the wine cup. The young prince 'Abdullah Khan is thus discreetly brought in.

The excerpt begins on folio 98b with an evocative distich significantly borrowed from the section headed in Helali's complete text "Divulging the secret and blaming the common run" (*Khafif*):

بـاز چـون مـهـر از فـلـك سـر زد
مـهـر شـاه از درونه سـر بـر زد
دل پـر از مـهر و لـب پر از خنده
سـوی درویـش رفت شـرمنـده

When the sun brought out its head into the sky once again
 The warm feelings of the Shah came out from deep within
His heart full of warmth and his lips full of smiles
 He walked shyly towards the darvish[61]

Substantial differences separate the *Anthology* version from the printed text, of which a critical edition has yet to see the light of day.[62] Whether they were introduced deliberately to adjust the text more closely to the actual relationship between 'Abdullah Khan and Ni'matullah Khalifa cannot be determined until a systematic collation of tenth/sixteenth century copies of the text is undertaken.

The attraction of the ageing dervish and the young prince meets with the disapproval of the common run and the dervish, forced to leave court, retreats to the desert.

Long sections are skipped before the excerpt resumes with two maxims in the middle of folio 99a, followed by the account of the succession of the young Shah:

پبیش جوهرشنـاس گوهر سنج
هـست عالم چو عرصهٔ شطرنج
کـه بـه بـازیـچـه هر زمان [شا]هی
سوی این عرصه می کند راهی
شـاه چـون جانشین خسرو شد
رسـم آئیـن خـسـروی نو شد

In the eyes of him who knows the essence and evaluates gems
 The world is like a chess board:
With his chessmen a shah at all times
 Makes way towards this chessboard
When the shah became the successor of Khosrow [the Sasanian ruler]
 The tradition of Khosrovian celebrations became new again[63]

Here the allusion to current circumstances in Bokhara seems transparent. Ni'matullah refers to the succession of 'Abdullah Khan as a very young king. "The Khosrovian celebrations" refer to traditional Iranian celebrations, in particular to Nowruz, which was greeted, among other things, with royal banquets and solemn ceremonial wine-drinking steeped in ancient esoteric symbolism, as I have shown recently. This single line is echoed in what I have called the frontispiece – the young prince is standing, wine cup in hand, observing the "Khosrovian" rite of wine libations (pl. 21).

This leads up to the section which describes the "Arrival of the *Darvish* at court". It is accompanied by the only narrative miniature found in the excerpt from "The Shah and the Beggar [Dervish]".

The section begins with a word which gives the key to the title of the "Selections from the Treasure of Kindness" (*Montakhab-e Ganjine-ye Letafat*).

چون ز الطاف شاه نیك اندیش
خبر آمد بعاشق درویش
زود برجست و رو براه نهاد
قدم اندر حریم شاه نهاد

When of the kindness [altaf] of the pure-minded Shah
 News reached the darvish filled with mystical love
He promptly rose to his feet and set out on his way
 He stepped inside the private enclosure of the Shah[64]

The dervish manages to show the seal that the king had given him in the past to one of the ruler's confidants. The young Shah is advised by him that an ageing *darvish* has arrived, whereupon he:

گفت بیرون رو و ز راه ادب
خاتم آرنده را درون بطلب

Said: step outside and as polished usage requires
 Bid the man carrying the seal to step inside[65]

This distich is inscribed in the two vertical panels within the frame enclosing the miniature (pl. 22). The scene shows the young king on his gem-studded throne turning towards the confidant who kneels in front of him as he presents an invisible object (the seal) on a band of silk laid across his hands.

On the last folio, 105a, according to the Arabic pagination (but, in fact, 103a) the story is concluded with the last two lines in the

section which, in Helali's romance, is headed "On the unfaithfulness of life":

فی المثل عمر نوح اگر یابی
چون بطوفان رسی خطر یابی
آنکه جاوید بود و هست یکیست
احد واجب الوجود یکی است

If, by way of an allegory, you find the life of Noah
 As you come to a tempest, you find danger
He who was and is eternal is One
 The Unique who causes His own existence is One[66]

However old you may live to be, the last distich but one reminds the reader, you run into spiritual danger. After that comes the fundamental metaphysical statement of Islam which serves as a concluding line to the string of stories that make up the *Anthology*. Symmetrically, at the end of the colophon described earlier in these pages (pl. 23) the last words in the book call for God's grace to descend upon the Prophet. The careful composition of the entire work is verified here for the last time.

Below the colophon, the twenty-third and last miniature once again takes the form of a diptych at the end of a chapter. At the left, Khalifa, the old Uzbek prince, has a flowing beard and a turban which designate him as a master (*sheykh/pir*). He is turned three-quarters to the right, his book (the *Anthology*) laid in front of him. Facing Khalifa, a young princely disciple stands for 'Abdullah Khan. He is turned three-quarters to the right, respectfully clutching his right wrist with his left hand. This is the centuries-old gesture of deferential attention. Here, the gesture has an added meaning. In the living Sufi tradition, it symbolizes the *lam-alif*, which are the first two letters in the Supreme Koranic profession, the *Shahada*, "There is no god but God".[67]

PART THREE:
The Bokhara Royal Atelier in the 970s

No other instance of a manuscript so clearly interwoven with the thread of a patron's life story has yet been published, even if others, yet to be identified, are surely in existence.

One other manuscript produced by the royal atelier in Bokhara under 'Abdullah Khan's rule is similarly dedicated to a patron other than the ruler. The volume is apparently without a colophon – none is discussed by Diakonov.[68] But in two miniatures illustrating the text of Sa'di's "Rose Garden" (*Golestan*), monumental inscriptions calligraphed in blue and white friezes name the patron precisely as one such inscription does in the *Anthology* of Khalifa.[69] The longer of the two inscriptions reads, in Arabic, followed by a terse Persian sentence:

في الدولة الخاقان الاعدل الاكرم اشجع خواقين الدوران
الخاقان بن الخاقان ابن الخاقان ابوالغازى عبدالله
بهادرخان خلد الله تعالى ملكه و سلطانه جهة جناب
وزارت مآب مقرب الحضرت الخاقانى خواجه كمال الدين
حسين زاد قدره باتمام رسيد ٩٧٤

In the days of the rule of the Khaqan most just and most endowed with God's grace, the most valiant of the Khaqans of our time, the Khaqan son of the Khaqan son of the Khaqan Abu'l-Ghazi 'Abdullah Bahadur Khan. May God the Exalted eternize his Kingship and Sultanic rule, for his eminence invested with ministerial status from the close Khaqanid circle, Khwaja Kamal ud-Din Husayn, may his weight increase. Came to completion 974.

The second inscription, for which room was limited, merely says, in Persian:

جهة جناب وزارت مآب مقرب الحضرت الخاقانى خواجه
كمال الدين حسين ٩٧٤

For his Eminence invested with ministerial status, from the close Khaqanid circle Khwaja Kamal ud-Din Husayn 974.

Not much is known about this minister except for what appears to be a passing reference to his execution more than two decades later when Shah 'Abbas recaptured Astarabad.[70] The importance given to the ministerial dedication in the second miniature at the expense of the mention of the King's titles and names is noteworthy. Like Ni'matullah's *Anthology*, it points to the power that members of the inner circle enjoyed.

That would seem to have been the case in the Uzbek Emirate throughout much of the tenth/sixteenth century. The earliest evidence available of such power is provided by a miniature in a *Yusof and Zoleykha*, in which the patron's name, prominently calligraphed, has so far gone unnoticed (pl. 24). Basil Robinson was the first to draw attention to this splendid volume, as he did to so many others.[71] The eminent scholar cites it as part of a group of manuscripts bearing the "ex-libris" of Sultan 'Abd ul-'Aziz. "Ex-libris" is not quite the term. In one of the miniatures, two monumental inscriptions name first Sultan 'Abd ul-'Aziz, under whose reign it was done, and, secondly, the patron *for whom* it was done. The first inscription, calligraphed in the *reqa'* script, is written in Arabic. Broken up in two sections, it runs at the top of a palatial structure and goes on over the opening of a projecting cella:

في ايام الدولت الخاقان العادل الفاضل ابوالغازى
عبدالعزيز بهادرخان خلدالله تعالى ملكه و سلطانه

In the days of the rule of the Khaqan, equitable and eminent, Abu'l-Ghazi 'Abd ul-'Aziz/Bahadur Khan,

may God the Exalted perpetuate his kingship and domination."

The second inscription, in a fine *solos* script, has remained unread to this day. Written in Persian, it is calligraphed on the lintel over the arched door leading into the palatial grounds:

جهت مملكت پناهى امارت دستگاهى تنيش بى

For him that is attached to the Refuge of the Kingdom and to the Apparatus of Government Tanish Bey.

Tanish Bey, who commissioned the volume of *Yusof and Zoleykha*, is the very same Hafiz Tanish who wrote the *'Abdullah-Nama*. Tanish is designated here in a terser mode of address than the complete literary identification Tanish b. Mir Muhammad al-Bukhari.

Not the slightest difference in quality or conception can be detected between the manuscripts that were thus commissioned by the inner circle and those made for the Sultan's library.

Together, the *Montakhab-e Ganjine-ye Letafat* copied for the Sufi prince Ni'matullah in 972, the pages from the *Yusof and Zoleykha* illuminated in 973 "by order of the Library" of 'Abdullah Khan, and the *Golestan* with two miniatures commissioned in 974 by *Khwaja Kamal ud-Din Husayn*, the Vizier of 'Abdullah Khan, all show that the Harat model prevailed in the royal atelier of Bokhara as late as the 970s. The artistic fascination with Harat reflects the broader admiration for Khorasan, the jewel in the crown of the Uzbek sultanate, and its Iranian culture which the Uzbeks unreservedly shared. Ni'matullah, an authentic eastern Turk as was the ruling family, thought and wrote in purely Persian terms, as did historically all literate Eastern Turks, until the nineteenth-century Russian occupation.

In the *Anthology*, the Harat imprint is particularly striking because the text is so richly illustrated. From the miniature showing Sheykh San'an gazing at the Rumi beauty (pl. 2), to the miniature illustrating the two beggars who have been given scented clothes (pl. 8), the Harat reference is obvious in the compositional schemes.

It is equally apparent in many conceits. Architectural motifs such as the brick pattern in the *Sheykh* San'an image (pl. 2), blossoming trees appearing behind the wooden railings isolating gardens from the natural setting beyond, as in the miniature illustrating the fall of the dervish (pl. 11), can easily be traced to their earlier Khorasan models.

And yet, the *Anthology* reveals a new factor at work. Western Iranian influence was slowly coming in. This is suggested by the stylization of the faces of men and women in a number of miniatures (women: pls. 3, 9; men: pls. 5, 6, 8 etc.). The figures are bigger in relation to the scene than is usual in the Harat school.

Moreover, the *Anthology* shows that some highly original developments were taking place. Most striking is the tendency to break

up the image into its individual components. This is perceptible in some of the elaborate scenes – mostly in pl. 9, but also in pl. 11. There, the components are juxtaposed, without being organically linked. In pl. 9, the architectural elements have been applied like pieces picked up from a child's construction game. In pl. 9, motifs normally used to illuminate margins or title plates incongruously break into the architectural decorative patterns. The escutcheons under the cusped arch do not really belong there. Nor do the half-escutcheons in the spandrels on either side of it. It is as if the cut-outs used for decorating the margins had influenced the painter's approach to miniature painting.

This break-up repeatedly resulted in the composition of diptychs for which there is no necessity inherent in the text. It is as if the painter found himself more at ease in contemplating his scenes in fragmented form, each part being carefully boxed in its own frame. Only once (pl. 1) does he refrain from dividing the tableau that concludes a section into symmetrical sections – in this case, the introduction. There too, however, the group of four figures, the master and his disciples, looks like a close-up taken from a larger image.

This double tendency towards the fragmented image and the close-up view continued until the end of 'Abdullah Khan's reign. In the manuscript of Jami's *Yusof and Zoleykha* copied in 973/1565, one of the two miniatures illustrates Yusof standing on the banks of the Nile and drying himself.[72] The rectangular sail of the boat in the distance is decorated with various escutcheons borrowed from manuscript illumination. These include two half-escutcheons at the top, on either side of the sail, where they are used much in the same way as in the decoration of the *eyvan* in pl. 9.

The tendency reached its peak with the margins of the beautiful volume of Jami's *Salaman and Absal* now preserved in Saint Petersburg, which was copied in Moharram 989/February 1581.[73] Single figures, seen as head and shoulders like close-ups, are framed in escutcheons appearing as insets on the illuminated margins. It

should be stressed, however, that it would be a mistake to take it for granted that fragmentation was merely an aesthetic development. It is likely to have matched a conceptual trend as well. That assumption can only be proved or disproved after a greater number of manuscripts from the Bokhara atelier in the second half of the tenth/sixteenth century have been studied in their entirety, each miniature being examined in relationship to the text.

Among other items a manuscript of Jami's *Yusof and Zoleykha* copied by 'Ali Reza, which is now in Jerusalem, would justify a closer examination. Rachel Milstein, who first drew attention to it, mentioned pairs of figures which she said were "decorative". One may ask if these might not in fact have been used in the same way as the paired figures in the present manuscript. Here our knowledge of the patron's name and some information about his background make it possible to reach certainty. With the Jerusalem manuscript, this may or may not be so. But on the analogy of Mir Khalifa's *Anthology*, a cautious approach seems advisable, to put it mildly.

The truth is that the study of Persian manuscripts is still in its infancy. An admirable recording enterprise has been started by scholars such as Basil Robinson whose catalogues of several British libraries will remain for decades invaluable tools for any researcher. The stage is set for the next development.

The most urgent task is probably a systematic examination of the main manuscripts, each one analysed as a whole, on which we rely for using such denominations as "The Tabriz School", "The Qazvin School", etc. within different periods. Closer attention must be paid to the nature of the link between image and text (merely identifying the theme simply will not do any more). It can vary a lot, as any reader of Persian manuscripts is aware.

Much might be learnt that does not merely concern images, but the entire world perception of one of the most complex cultures of the East.

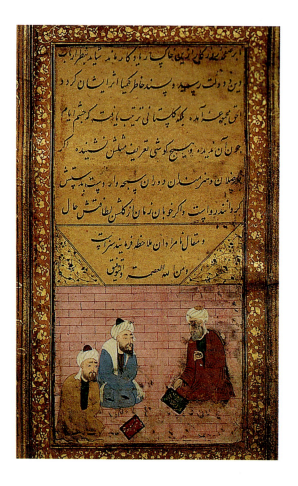

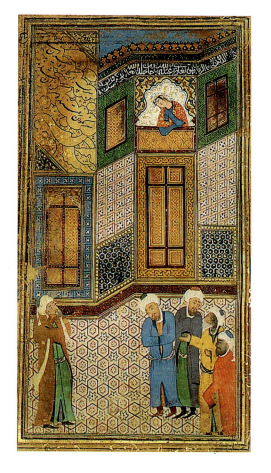

1. Ni'matullah Khalife, as a Sufi master, presenting his book to the literati of the age.

2. 'Attar, *Manteq ot-Teyr*. Sheykh San'an sees a Greek beauty in a palace – inscribed to 'Abdullah Khan.

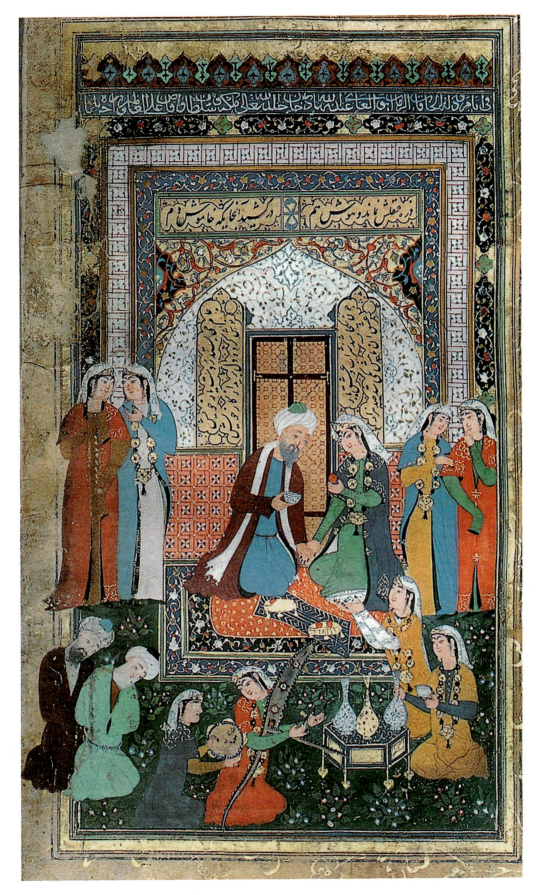

3. 'Attar, *Manteq ot-Teyr*.
Sheykh San'an attends a party given by the Greek
beauty. 'Abdullah Khan is named in the frieze.

4. 'Attar, *Manteq ot-Teyr*.
The Greek beauty expires in the presence
of Sheykh San'an and his disciples.

5. 'Attar, *Manteq ot-Teyr*.
Sheykh San'an's disciples watch the
scene depicted in fig. 4.

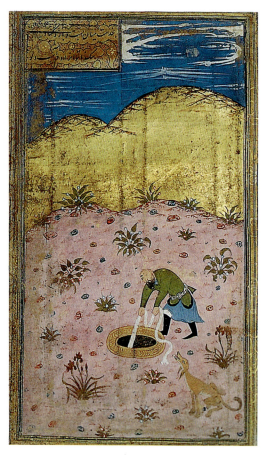

6. Sa'di, *Bustan*.
A travelling dervish is led to the king. His arms
in the *lam-alif* position identify him as a Sufi.

7. Sa'di, *Bustan*.
A compassionate man who found a
thirsty dog in the desert pulls up water.

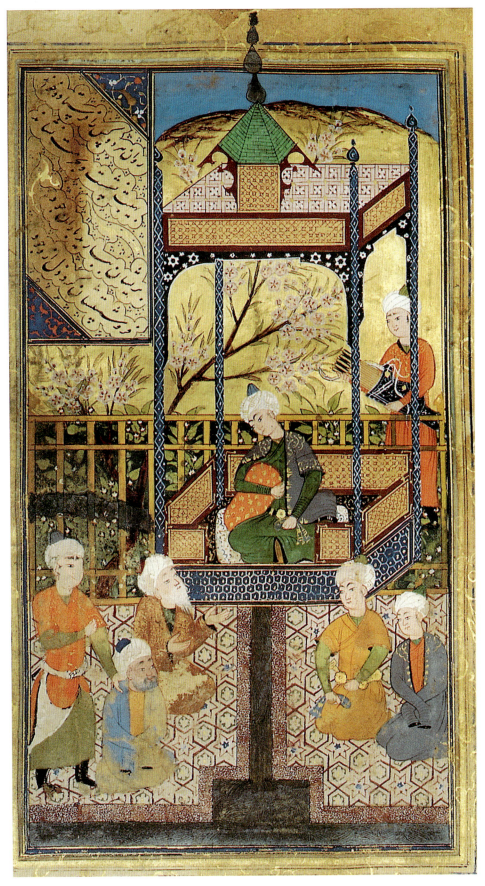

8. Sa'di, *Bustan*.
One of two beggars, whose disparaging remarks King Saleh overheard,
addresses the ruler.

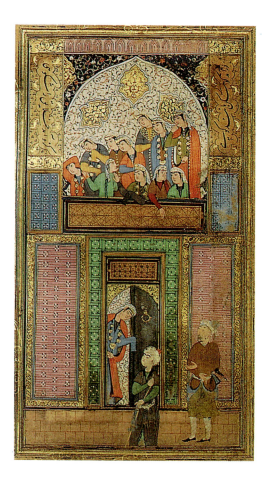

9. Nezami, *Khosrow va Shirin*.
Farhad is taken by emperor
Shapur to Shirin's palace.

10. Nezami, *Khosrow va Shirin*.
A proverb about the wolf's tail
is illustrated in rebus form.

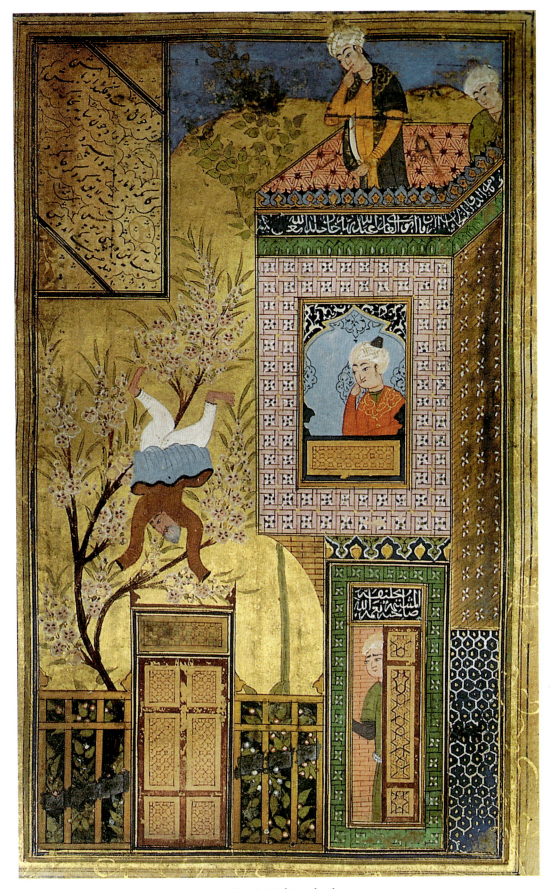

11. Jami, *Tohfat ol-Ahrar.*
The dervish thrown off the roof of a palace is named over the door:
this is Ni'matullah Khalifa.

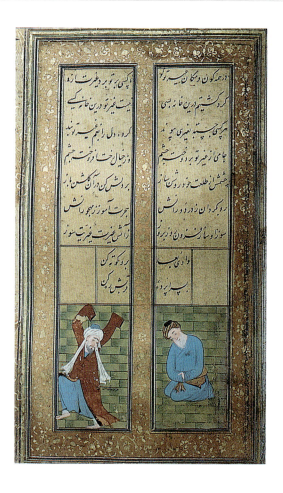

12. Jami, *Tohfat ol-Ahrar*.
The two figures relate to Jami's
verses celebrating God as an
object of human love.

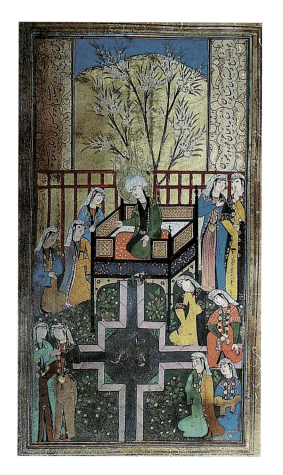

13. Jami, *Yusof va Zoleykha*.
Zoleykha sends Yusof off to the
park. Only one pool is visible,
instead of the two in the story.

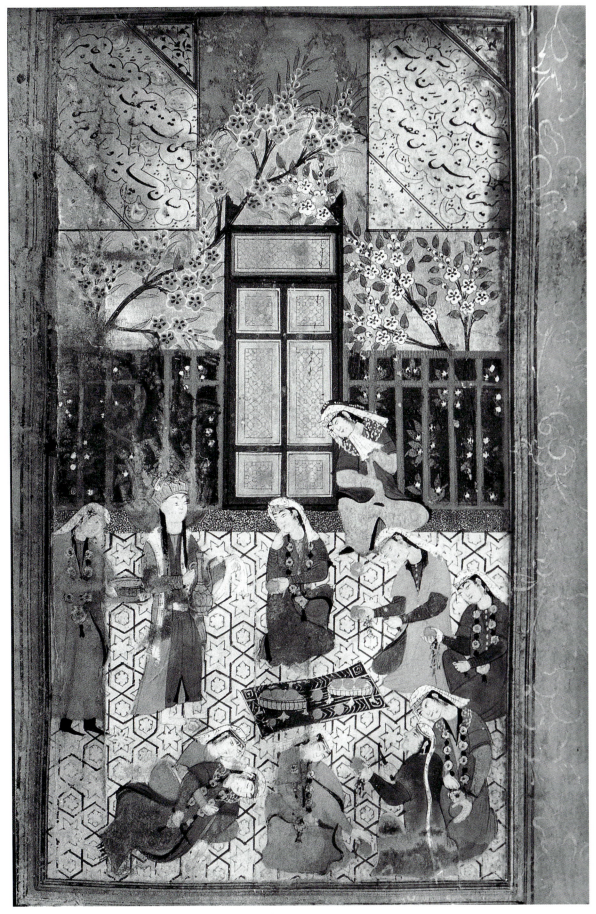

14. Jami, *Yusof va Zoleykha*.
Yusof receiving a ewer and the Egyptian women raving about his beauty.

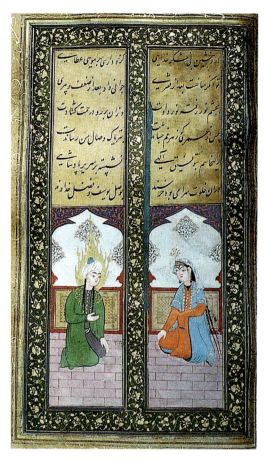

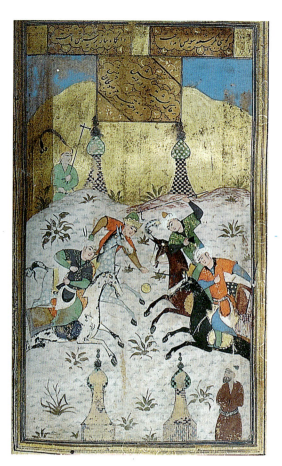

15. Jami, *Yusof va Zoleykha*.
Yusof invites Zoleykha to take her place
in a house of worship and thank God.

16. 'Arefi, *Guy-o Chowgan*.
A young king becomes aware that a
dervish is attracted by his good looks.

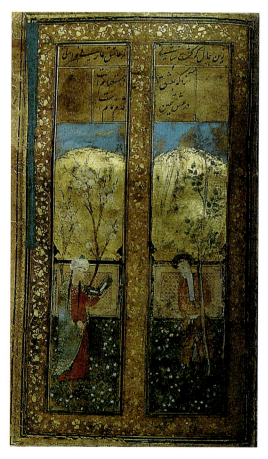

17. 'Arefi, *Guy-o Chowgan*.
The king holds a book (the *Anthology*)
facing a dervish, meant here as
Ni'matullah.

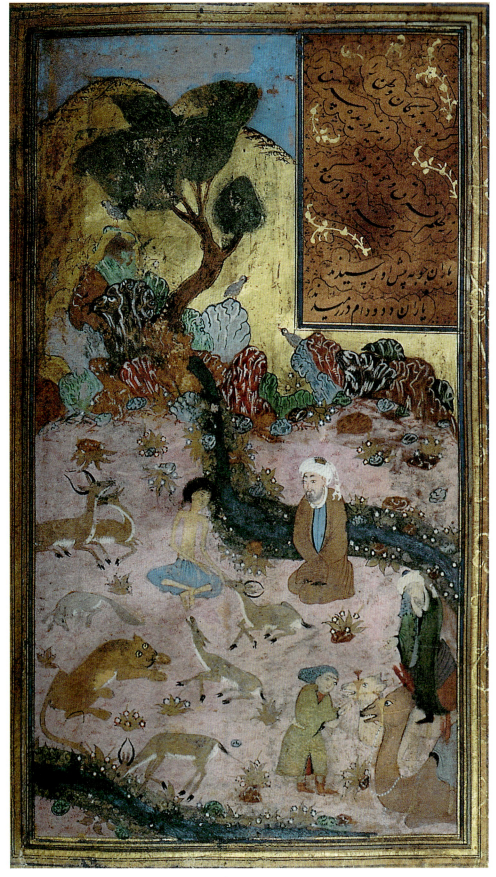

18. Hatefi, *Leyla va Majnun*.
Majnun sits in the desert amidst wild beasts, as his companions
approach his retreat.

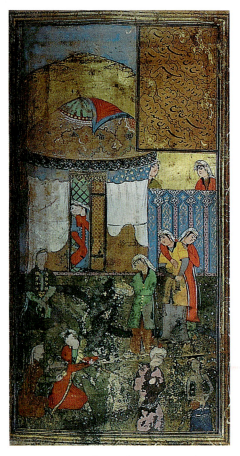 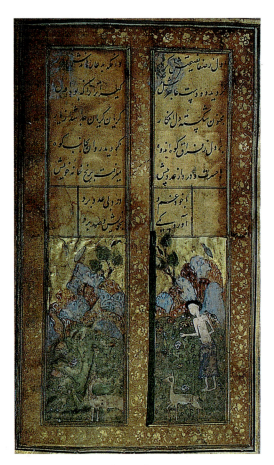

19. Hatefi, *Leyla va Majnun*. Majnun, taken to the encampment of Leyla, sees her peeping out of a tent.

20. Hatefi, *Leyla va Majnun*. Majnun retreats to the mountains. Paradoxically, the image is composed as a dyptich.

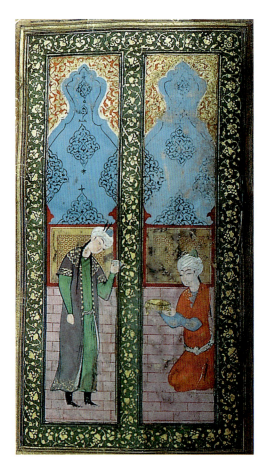

21. Helali, *Shah va Darvish*. A servant hands the king a seal that he had given to the dervish.

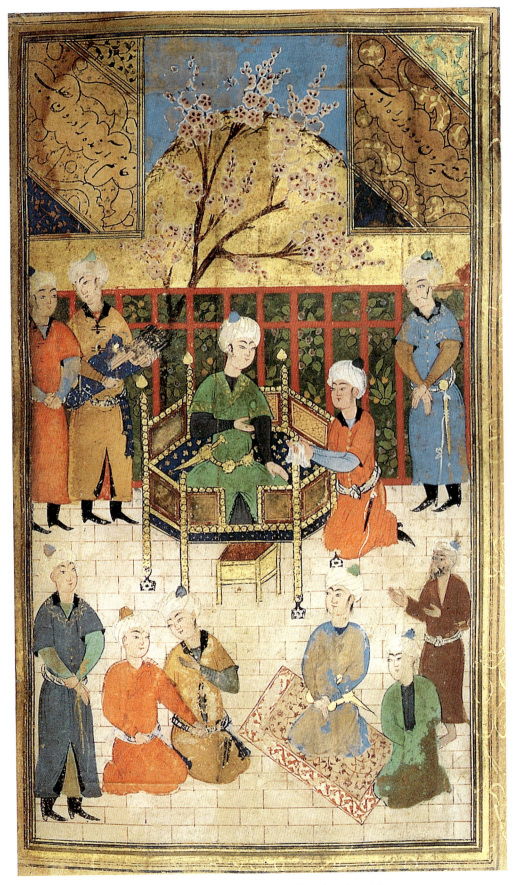

22. Helali, *Shah va Darvish*. The dervish
arrives at the royal precinct and the King receives a seal.

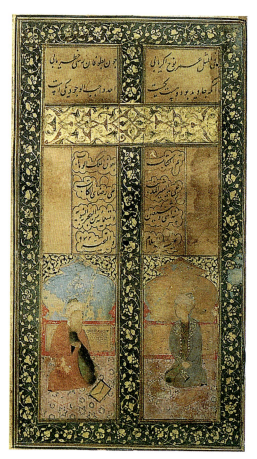

23. The young prince makes the *lam-alif* gesture, suggesting his Sufi allegiance to Ni'matullah.

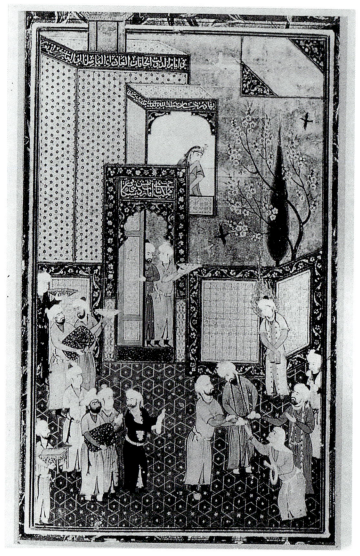

24. Jami, *Yusof va Zoleykha*. Note the inscription over the arched door mentioning Tanish Bey.

Notes

1 Hotel Drouot. Ader Tajan, *Art Islamique*, Paris, 16–17 November 1992, 69, lot 293, attributed to the "École de Qazwin".

2 On Sultan Abu'l Ghazi 'Abdullah Bahadur Khan, known to Persian chroniclers, including his own, as 'Abdullah Khan, see the short account given by Hasan Beg Rumlu, *Ahsan ot-Tavarikh*, ed. 'Abd ol-Hosayn Nava'i, Tehran 1349/1970 and 1357/1978 (2 vols), II, 513. Important complements in Chahryar Adle, ed. and trs. *Siyaqi-Nezam Fotuhât-e Homâyun, "Les victoires augustes", 1007/1598. Relation des évènements de la Perse et du Turkestân à l'extrême fin du XVI e s.* Thèse du 3ème Cycle, Paris, 1976 (2 vols), I, 275–308 (on his military campaigns) and II, 569–585 (on 'Abdullah Khan's biography).

3 The best manuscript is briefly described by Hermann Ethé, *Catalogue of Persian Manuscripts in the Library of the India Office*, Oxford 1903, 229 under no. 574. A critical edition in facsimile based on the Saint Petersburg manuscript is currently in press: Hafiz-i Tanish b. Mir Muhammad Bukhari, *Sharafnama-yi Shahi*, ed. M.A. Salahuddin(ov), Moscow 1983 (vol. I), 1989 (vol. II). My friend and colleague Chahryar Adle was the first to draw attention to the source in his study of the *Fotuhat-e Homayun* (see note 2) II, 595, note 5; 814 under "Hafez-Tanis '(Tânes)'". He pointed out to me the more convenient manuscript in the India Office. The Saint Petersburg original seems good, but the facsimile printing often blurs the text.

4 See *Divan-e Kamel-e Jami*, ed. Hashem Razi, Tehran n.d., preface, 95–97. The Naqshbandi movement was founded by *Khwaje* Baha od-Din 'Omar Bokhari (ob. 791). Jami was initiated to the Naqshbandi path while studying in Samarqand and Harat. He dedicated his romance *Tohfat ol-Ahrar* to his second master, *Khwaje* 'Obeydollah, known as *Khwaje-ye Ahrar*, "The Master of the Spiritually Free."

5 9 August 1564–28 July 1565. *Min al-hijriya an-nabawiya* must presumably be understood as leaving out the word *ash-shohur*: "from [the months of] the Prophet's *hijra*". The formula, very clearly calligraphed, is found in the work of the best calligraphers at ease in Arabic, such as Mahmud b. Ishaq ash-Shehabi. See the colophon of the manuscript of *Yusof and Zoleykha* copied in Bokhara in the following year (973): Abolala Soudavar, *Art of the Persian Courts*, New York 1992, 215, pl. 80f.

6 Mehdi Bayani, *Ahval va Asar-e Khoshnevisan*, Tehran 1345/1966–1358/1979 (4 volumes), vol. II, 464–66. Bayani overstates the difficulty. According to his observations in the form of working notes, which unfortunately the great scholar did not live to edit himself and see through the press, the earliest dates to the 930s (the date is given in garbled form and remains uncertain) and the latest to 1024, which would be too late for one man. It would be necessary to compare the colophons, if only in photographic plates, as yet unavailable. Leaving aside the earliest thoroughly established date (940) and the two latest dates (1023 and 1024), this leaves a body of dated and signed manuscripts covering a 20-year period which can reasonably be assumed to be the work of one calligrapher signing himself 'Ali Reza *al-katib*/'Ali Reza-ye *kateb*, whom I shall refer to, for convenience' sake, as 'Ali Reza of Bokhara. They are remarkably consistent as a reflection of literary texts by Sufi authors, and with a marked Sufi slant: 1. [Helali?] *Shah va Darvish*, end of Rabi' II 963; 2. Sa'di, *Golestan*, end of Rabi' II 969; 3. Amir Shahi, *Divan*, end of Sha'ban 970; 4. Hatefi, *Leyla va Majnun* "in the city of Bokhara, middle of Jumida [*sic*] 972"; 5. [Helali?] *Shah va Darvish* in the months of 979; 6. Jami, *Baharestan*, in the months of 983. On the particular type of mysticism in Amir Shahi see *Divan-e Amir Shahi-e Sabzevari*, ed. Sa'id Hamidiyan, Tehran 1348/1969, 25–7. It is interesting to note that, excepting Amir Shahi who did not write romances (his one *masnavi* does not qualify as one), all these are represented in the *Anthology*. To these manuscripts three more, also dated and signed by 'Ali Reza *al-katib*, may be added: 1. A *Teymur-Name* by Hatefi signed 'Ali Reza *kateb* in 976/1568, in the Institute for Oriental Studies, Tashkent, Uzbekistan (Olympiada Galerkina, *Mawarannahr Book Painting*, Leningrad 1980, colour plate 1 [frontispiece]); 2. A manuscript of *Yusof va Zoleykha* signed by 'Ali Reza *al-katib* in 980 (Rachel Milstein, *Islamic Painting in the Israel Museum*, Jerusalem 1984, 60–63; Na'ama Brosh and Rachel Milstein, *Biblical Stories in Islamic Painting*, Jerusalem 1991, 78–9, no. 21); 3. Another manuscript of *Yusof va Zoleykha* dated "in the months of 981" (Sotheby's, *Oriental Manuscripts and Miniatures*, London 19 October 1994, 80, lot 107); the marginal decoration in this closely compares with the *Anthology* margins. The other calligrapher called 'Ali Reza signs himself 'Ali Reza 'Abbasi and, from what I have seen, writes in such a different ductus that the possibility of confusion seems remote, e.g. Soudavar, *op. cit.*, 286–7, where his more sophisticated signing formula betrays a superior knowledge of Arabic. He is presumably the same calligrapher as 'Ali Reza Tabrizi, whose very successful career is recounted by Qazi Mir Ahmad Monshi Qomi, *Golestan-e Honar*, ed. Ahmad Soheyli Khwansari, Tehran 1352/1973, 124–6. A second 'Ali Reza mentioned by Ahmad Monshi Qomi, 91–92, who spent some time in Mashhad, appears to have lived much earlier and was beyond any possible doubt a different artist (perhaps the calligrapher active in the 930s? See above in this note.)

7 *Khoshnevisan*, 465–6.

8 Assadullah Souren Melikian-Chirvani, *Islamic Metalwork from the Iranian World (8–18th centuries)*, London 1982, 17 (see Index I for several specific examples).

9 Noted by Rumlu (see note 2).

10 E.g. the two miniatures in the manuscript of *Yusof va Zoleykha* by Jami, copied by Mahmud b. Ishaq ash-Shehabi al-Heravi in the months of 973/29 July 1565–18 July 1566 "by order of the Library of the Khaqan of the Age" etc. in Soudavar, *op. cit.*, 214, pls. 80c and 80d.

11 Dr *Sayyed* Ja'far Sajjadi, *Farhang-e Loghat va Estelahat va Ta'abirat-e 'Erfani*, Tehran 1354/1975, 199, defines *khelafat* as "the spiritual station [*maqam*] following the elimination of distance between self and God, as a result of inner purification and transfiguration."

12 'Abd ul-Mu'min, successor of 'Abdullah Khan, later destroyed the structures erected by the latter between Bokhara and Samarqand. These cities may also have been affected. See Adle, *Fotuhât-e Homâyun*, II, 624.

13 Jami, *Masnavi-e Haft Owrang*, ed. Morteza Modarres Gilani, Tehran 1337/1958. Reprint n.d., 593.

14 Jami, *Haft Owrang*, 594.

15 Dowlatshah Samarqandi, *Tazkerat osh-Sho'ara*, ed. Mohammad 'Abbasi, Tehran 1337/1958, 207; on the date, see 610. Admiration for *Sheykh* 'Attar as a Sufi master is maintained to this day. See the views expressed by the editor of the *Mokhtar-Name*, Mohammad Reza Shafi'i Kadekani, Tehran 1358/1979, preface, 21.

16 *Sheykh* Farid od-Din Mohammad 'Attar-e Neyshaburi, *Manteq ot-Teyr*, ed. Dr *Sayyed* Sadeq Gowharin, Tehran 2536 sh/1977, 67, l. 1185, where the more common "San'an" is restored to its original form "Sam'an".

17 *Manteq ot-Teyr*, 70, l. 1235.

18 On the "Magian Hermitage" and the "Master of the Magians" motifs and their distant esoteric origin, see Assadullah Souren Melikian-Chirvani "The Wine Bull and the Magian Master", in *Studia Iranica, Cahier 11/Recurrent Patterns in Iranian Religions from Mazdaism to Sufism*, Paris, 1992, 101–34.

19 *Manteq ot-Teyr*, 76, l. 1354–6.

20 *Ibid.*, 88, l. 1583.

21 In the printed text, 88, l. 1584, 'afvi replaces 'afvam.

22 *Inchenin*, "thus", in the manuscript seems preferable to the printed z'inchenin (88, l. 1589), which makes no sense.

23 This distich is omitted in the printed text.

24 *Nasibi* in the manuscript, *nasibe* in the printed text: 88, l. 1591.

25 Translates the Koranic words *ma'wa tin*, "(of) water and clay," i.e. the bodily envelope.

26 *Bustan-e Sa'di*, ed. Gholamhoseyn Yusofi, Tehran 1363/1984, beginning 42, l. 218.

27 These verses are missing in Gholamhoseyn Yusofi's edition, where they properly belong on p. 46 between distichs 319 and 320. They are, however, included in the manuscripts used by H. Wilberforce Clarke, *The Bustan*, repr. London 1985, 41, ll. 133–4.

28 While this essay was in press, a new manuscript commissioned by Ni'matullah turned up at auction; the Uzbek prince's name remained unread. I hope to publish it shortly. A vast amount of documentation about the Uzbek prince probably lies dormant in libraries.

29 *Bustan*, 79. The tone is that of an exemplary story [*hekayat*] in the manner of Sa'di.

30 *Bustan*, 85: the title is not found in Yusofi's critical edition, which has *hekayat*, "story".

31 *Bustan*, 85, ll. 1279–81. Only spelling differentiates the manuscript from the printed version.

32 *Bustan*, 127. This title again is not found in Yusofi's critical edition, which merely reads *hekayat*, "story", as before (see note 29).

33 *Bustan*, 127, ll. 2298–2302.

34 *Bustan*, 127, ll. 2305–6. Note the inversion *har do kas ra* instead of *har do ra kas*

35 *Bustan*, 128, ll. 2309–10.

36 In early poetry, the *Shah-Name* included, and early chronicles, Chin unambiguously describes Eastern Turkistan, not China. Qadar Khan is referred to as the *padeshah-e Chin* by chroniclers and panegyrists alike, and so are the Qarakhanids as late as the 6th/12th century. See my forthcoming "The Turks from Chin."

37 Nezami, *Khosrow va Shirin*, ed. Hasan Vahid Dastgerdi, Tehran 1313/1934, offset reprint, n.d., 218 11.1.

38 *Khosrow va Shirin*, 237, l. 8–238 ll. 1–2. The

printed text reads *dandan-e pir darad* in the third distich which gives it a different nuance (i.e. it has an old man's teeth and therefore likes tender food such as sheep's tail). Hoseyn Pazhman Bakhtiyari, *Khosrow va Shirin*, Tehran 1343/1964, 153, follows Vahid Dastgerdi.

39 Jami, *Masnavi-e Haft Owrang*, ed. Morteza Modarres Gilani, Tehran, 1337/1958, 432.

40 *Mawarannahr Painting* (see note 2), pl. 34.

41 *Haft Owrang*, 515.

42 *Haft Owrang*, 516.

43 *Haft Owrang*, 522.

44 *Haft Owrang*, 611.

45 *Haft Owrang*, 668. The printed text reads *ke khosh bagh* (*ke* = colon).

46 Rezvan, the gardener of Paradise.

47 *Sarv-e naz*, "the graceful/enticing cypress" is the image of the irresistible young beauty.

48 *Haft Owrang*, 691.

49 *Haft Owrang*, 692.

50 *Haft Owrang*, 728.

51 *Haft Owrang*, 730.

52 Information on 'Arefi is so scanty as to lead one to infer that the mystic deliberately drew a veil of secrecy around himself. What Dowlatshah Samarqandi has to say in the *Tazkerat osh-sho'ara*, 496 (see note 15) runs to three and a half lines, none of it of a biographical character: "He wrote many panegyrics...was skilled in the art of the *masnavi*. He also wrote fine *ghazals*." The authors of major anthologies, such as Amin Ahmad Razi in his *Haft Eqlim* completed in 1010, do not even mention 'Arefi which, given the popularity enjoyed by his *masnavi*, "The Ball and the Mallet", is astounding. 'A. Khayampur, *Farhang-e Sokhanvaran*, Tabriz 1340/1961, 369, merely records the fact that the poet was "alive" in 842, when "The Ball and the Mallet" was completed.

53 There is some reason to believe that awareness of past geographical designations was greater in Khorasan including Harat. On Chin, see note 36.

54 ['Arefi], R.S. Greenshields, ed. & tr. *The Book of Ecstasy by Arifi of Herat*, repr. London 1980, 27, l. 8–10.

55 'Arefi, 29, ll. 15–16, where the text reads *qadar* not *qadam*, "this much" not "this step".

56 Khwandamir, *Habib os-Siyar*, ed. Jalal od-Din Homa'i, Tehran, 1333/1954 (4 volumes), IV, 354–5, is the first Persian writer to yield basic information on the poet who, he says, was the nephew of 'Abd or-Rahman Jami and died in Moharram 927/12 December–10 January 1521.

57 Hatefi Heravi, *Leyla va Majnun*. Two manuscripts are quoted here: B.N. Pers. 357,

folio 34b ll. 4–6 on this manuscript see Edgar Blochet, *Catalogue des Manuscrits Persans*, Paris 1905–34 (4 volumes), II, 1513; Br. Mus. Add. 10,586, folios 53b–54a, where the first distich quoted here is missing. On this manuscript see Charles Rieu, *Catalogue of the Persian Manuscripts in the British Museum*, (3 volumes), London 1879–83, II (1881), 652B–653A.

58 Br. Mus. Add. 10,586, folio 57A.

59 Br. Mus. Add. 10,586, folio 58B.

60 In the *Divan-e Helali-e Chaghata'i*, ed. Sa'id Nafisi, Tehran 1337/1958, the editor gathers all the available primary sources on Helali's life and sets out (preface, pp. 20–1) the combined cogent reasons which lead him to accept 936/5 September 1529–24 August 1530 as the year when the poet died.

61 *Helali*, 234–5, ll. 3367–8.

62 See for example the significant variants in the second and fourth hemistichs in the lines that have just been quoted:

> When the sun brought out its head into the sky once again
> The Shah raised his head from his graceful sleep
> His heart full of warmth and his lips full of smiles
> Ashamed of past reproaches

63 Helali, 266, ll. 4103–4 and 267, l. 4107.

64 Helali, 267, ll. 4124–5.

65 Helali, 268, l. 4129. The particle ba in baraw, pronounced in modern usage boro(w) was inadvertently left out by the calligrapher.

66 Helali, 272, ll. 4239–40. In the printed text, the hemistichs in line 4240 are reversed. In the second hemistich (i.e. the first one as it stands in the manuscript), the order of the verbs has been reversed.

67 Verbal communication from the Iranian scholar Mehdi Hojjat.

68 N.V. Diakonov, *Sredneaziatiske Miniaturi XVI–XVIII vv*, Moscow 1964, 22–5. The first page discussed in the book appears under no. 11.

69 Diakonov, pls. 12 and 16 respectively. See preface, 12, and text, 23 no. 12. The original text of the monumental inscription is not printed, but merely translated into Russian. The Arabic words *zada qadruhu* "may his weight increase", were apparently misread as the name of the month *zu'l-qa'da*, nowhere to be seen.

70 *Khwaja* Kamal od-Din Husayn is briefly mentioned by Siyaqi-Nezam in the *Fotuhat-e Homayun*. See Adle, *Fotuhât-e Homâyun*, Persian text, I, 429, l. 6 corresponding to the India Office manuscript Ethé 537, folio 113a. French translation II, 512, l. 11.

71 Basil W. Robinson, "A Survey of Persian

Painting (1350–1896)" in Chahryar Adle, ed., *Art et Société dans le Monde Iranien*, Paris 1982, p. 63. Miniature reproduced fig. 33, p. 63.

72 Soudavar 213, pl. 80b.

73 Diakonov, pls. 30–1. See now the superb facsimile and monographic study by Kamal S. Aini and Muqaddema Ashrafi, *Salaman wa Absal/Salaman i Absal/Salaman and Absal of Abd-al-Rahman Jami* (in Persian, or so-called "Tajik", Russian and English) Dushanbe 1977. Manuscript copied by Mohammad b. Molla Mir al-Hoseyni in Moharram 989/5 February–6 March 1581: see colophon on folio 51a. The authors consider the miniatures in the margins to have been painted in Qazvin, but that is hardly obvious. See Muqaddema Ashrafi's Russian preface, 17.

14

The Chester Beatty
Süleymânnâme[1] Again

MICHAEL ROGERS

DESPITE THE FACT THAT SCARCELY ANY OF THE SPACES LEFT for illustration were filled, the *Süleymânnâme* of Firdevsî Burûsevî (Uzun Firdevsî),[2] dedicated (f. 6a) to Bayazid II (1481–1512), hence datable pre-1512, almost accidentally includes an important document for early Ottoman painting.[3] By Firdevsî Burûsevî's own account of his work he drew on two *Süleymân-nâme*s, one written in Syriac by Luqman al-Hakim and one translated into Persian by Aflatun (both either apocryphal or pseudographic) and upon a certain [unnamed] work which had come his way at Niksar, pointed out to him by the *shaykh* of the *tekke* of Melik Gazi Danişmend there. But he was very probably also indebted to less fictitious early Ottoman versions of the Solomon Romance.[4] His text is in 20 books, divided into a hundred scenes or chapters (*meclis*), though the author states that it was originally to consist of 360 books and 1836 *meclis*.[5] Perhaps fortunately, no such complete text is known. The identifiable sources are highly eclectic – Koranic *qisas* material, doubtless after a compilation like al-Kisa'i's or al-Tha'alibi's *Qisas al-Anbiya*;[6] *tafsir, hadith* and sayings of the Imams; Biblical material,[7] from Genesis, Kings and possibly the Apocrypha too, drawn directly or via the Midrash scholia; the Alexander Romance; and Persian epic, that is the heroes of the *Shahname* of Firdawsi of Tus from Gayumarth to Rustam. The beginning of the narrative is basically Old Testament, with the Creation sequence and demonomachy, but with Gayumarth introduced as one of Adam's sons. There follows, anticipating Wagner as it were, a series of wars between the Prophets or patriarchs and the demons for the possession of a ring, given to Adam by God but forfeited on the Fall, which was to give Solomon his power over all the orders of Creation. Solomon himself appears on the scene relatively late (his birth: folios 158b–159a); thereafter the narrative of his exploits differs considerably from the Old Testament story.[8]

The double frontispiece (folios 1b–2a) has not previously been described in the detail it deserves. Both folios have been cut down somewhat. On folio 1a (plate 1) Solomon is shown as an elderly man, seated cross-legged in a domed pavilion with cylindrical side-towers, pointed turrets and a creeper growing up it. To either side is a gathering of fowls, with a pelican, a dodo-like *simurgh* or phoenix, and less specific raptors, waders and passerines in the background. Behind the throne is a crowd of crowned angels or peris with their wings springing from their shoulders. The moulding between the two tiers of the throne is irregularly decorated with repeating letter-forms most probably derived from Hebrew uncial characters. Below the throne are six registers.

(i) Eleven seated turbanned figures, evidently Solomon's viziers, on high stools with low backs; the central part of the register is occupied by the arcaded base of Solomon's throne, with joggled bicoloured (*ablaq*) voussoirs, significantly Moorish in appearance, two blue and white flasks in chalice-shaped stands, and a step-ladder (fig. 1). The architecture of the throne is, for example, rather similar to that of the depiction of Jerusalem in the Sarajevo Haggadah, an Aragonese manuscript, probably written and illuminated in Barcelona and datable c. 1350–1400.[9]

(ii) Eleven seated male figures with two standing youthful attendants.

(iii) Fifteen seated figures, six definitely male and the rest either youths or women, with two standing attendants: all but the attendants are crowned, not turbanned.

(iv) Eight animal-headed demons, partly in profile and partly full face, one with a Phrygian cap; two seated demons, one with a flanged mace and one with a bull-headed mace; and a group of seated helmeted soldiers and two standing attendants at the extreme right.

(v) A group of animal-headed demons, looking inwards; a giant demon on a high stool with two horned heads and the head of a fanged horse holding a horse's fore-leg in its right hand, addressing a bird-headed demon on a lower stool; and angels standing or enthroned, with two standing attendants. The various groups are separated by columns of irregular height (fig. 2).

(vi) A series of nine compartments, some illegible but some clearly with planet figures. There are also a pair of closed panelled doors; the protome of a lion or gryphon in a broken arch; a curious reminiscence of St. George and the dragon scene with a pair of wyverns and a female head looking through an opening in the wall behind; a fountain basin on a hexagonal base; and gazelles.

Folio 2a shows the court of the Queen of Sheba, Bilqis, but in a six-register composition (plate 3).

(i) Phalanxes of standing male angels with the attributes of emirs, including cup, axe, sword, mace, bottle and napkin, flank the throne. Their wings have a feathery base and long pinions.

(ii) The Queen of Sheba is shown in the centre on a low throne framed by a rounded arch with pilasters under a ribbed dome on a porphyry transitional zone and with a trefoil finial. Above that is the base of an upper dome with deep casements, the shutters of which are open, surmounted by a dome with spiralling ribs. To either side of the throne are female attendants, some bearing flasks, cups and napkins (fig. 3).

(iii–v) Three rows of standing demons, thirty-six in all, those on rows (iv) and (v) having standing attendants. Those demons with several heads mostly have different heads, though relatively few of them are human; some of their tails have animals' heads too. One of the demons is ithyphallic, but the others when naked have no genitals. Virtually all have stomach musculature in spirals or concentric circles. Their jewellery is gold torques or rings at the ankles. Row (iv) includes an acephalous demon.

(vi) Two panels of a groom with a pair of saddled horses, and with an intrusive gazelle's or deer's head. On the right are various animals, including a lion couchant, a seated lion or dog, a lamb with tail curling upwards, and a boar.

The backgrounds of folios 1b and 2a all make considerable use of imitation marble or breccia panelling.

Solomon's throne, which was an integral element of his glory, is mainly known from the Judaic sources. It was a mechanical contraption, plated with gold, jewelled and with rich marble inlay.

On each of its six steps were pairs of eagles and lions confronted with, in addition, on the first step an ox and a lion; on the second, a wolf and a lamb; on the third a leopard and a goat; on the fourth an eagle and a peacock; on the fifth a falcon and a cockerel; and on the sixth a hawk and a sparrow. At the summit of the throne was a dove subduing a hawk. Above the throne were golden candlesticks and gold lamps, pomegranates, chains and lilies, and above that was a roof trellis of twenty-four interlaced vines.[10] While the throne depicted in the Chester Beatty manuscript is not precisely an illustration of this, the details more or less coincide. It is possible also that the animals identifiable in the lowest register of the Bilqis page are a further reminiscence of Solomon's mechanical menagerie.[11]

The principal illustrated Muslim source for the natural history of demons, largely derived from versions of al-Kisa'i's or al-Tha-'alibi's Qisas al-Anbiya,[12] is the 'Aja'ib al-Makhluqat of Zakariya Qazwini, the earliest known copy of which is dated 678/1279–80 (Munich, Bayerische Staatsbibliothek, Cod. ar. 464). The illustrations of demons[13] there differ, however, markedly from those in the small number of earlier extant illustrated magical manuscripts, notably the Seljuk Turkish Kitab Daqa'iq al-Haqa'iq of Nasir al-Din Siwasi.[14] The demons of the Süleymânnâme are not, however, in the 'Aja'ib al-Makhluqat tradition at all, not even of those later fourteenth century manuscripts which show Western European, probably Southern Italian, influence.[15] In fact, the most detailed account of demons before Solomon's throne in any Qazwini manuscript is in a very late copy of c. 1700,[16] by which time the text could easily have been contaminated by the Süleymânnâme itself, or by yet another manuscript of the Testamentum Salomonis.

Pictorially speaking, the most important demons are the thirty-six figures in rows (iii) to (v) (fig. 4) of the Bilqis page which are evidently the Decan demons of the Egyptian zodiac; these made their way principally into mediaeval Western astrology,[17] via the later medieval versions of the Testamentum Salomonis,[18] a Greek text which seems to be an early Christian reworking of a Judaic compilation of c. 100 AD and an illustrated version of which incidentally formed part of the personal library of Mehmed the Conqueror.[19] The thirty-six Decans, the cosmocrators of the Testamentum Salomonis, who figure there as principles of evil, rather like personified microbes or viruses, are given much less importance in the Qisas al-Anbiya, and their attributes in the Chester Beatty Süleymânnâme frontispieces suggest that few of them are illustrating any particular demons described there.[20] The demon with its head beneath its shoulders, the akephalos daimon of the Testamentum Salomonis, is a type which goes as far back as Herodotus,[21] while the enormous ears of other demons, which draw ultimately on Indian demonology, go back to the Karnaprávarana of the Mahábhárata, literally, "people who cover themselves with their ears", who were taken to typify the barbarian tribes of the epic period in India. These are widely represented in medieval European illustration, for exam-

ple, in the *Speculum Historiale* of Vincent de Beauvais or the Western Alexander Romance.[22] The musculature of the *Süleymânnâme* demons' stomachs, moreover, recalls the concentric ovals of European Romanesque drapery and limbs. Dog-headed demons, *cynocephaloi*, are also conspicuous in the frontispieces: these originated in the Hellenistic tradition, and spread, possibly through Byzantine painting, to the East, though in the West they were supposed to be giants, hence the common representation of St. Christopher as a dog-head.[23]

However generally early Ottoman in style these two pages may appear to be, not only are the demons and other details strongly reminiscent of later Gothic manuscript illustration; the composition is also Western European. No other representations of Solomon and the Queen of Sheba arranged in successive registers are known in Islamic painting, while paintings of other subjects arranged in this way are also practically unknown. European medieval manuscript illustrations organised in this way, though rather localised, fall into three groups. The first group includes copies of the early encyclopaedia of Hrabanus Maurus (eg. MS Monte Cassino, cod. 132, folio 16b, Italian, c. 1063)[24] but also Catalan manuscripts of the Commentary of Beatus of Liébana on the Apocalypse, for example that made for Ferdinand I of Castile and León in 1047, (Madrid, Biblioteca Nacionál, MS vit. 14–2, with a double page showing the adoration of the Lamb).[25] The composition in registers for the Beatus manuscripts was doubtless no invention since, for clarity and convenience, Last Judgements in both European and Byzantine painting, for example, the well-known Last Judgement at Torcello, have conventionally been depicted in registers. In subject matter, however, the *Süleymânnâme* frontispieces have nothing in common with such eschatological subjects. The second group includes earlier mediaeval English or French manuscripts, for example a copy of St. Augustine's *De civitate Dei* (probably Canterbury, c. 1120), with the City of God shown as an edifice with Christ in a mandorla and rows of angel-musicians, saints and martyrs below,[26] and a drawing by Ingelard, c. 1030–60, showing the celestial hierarchies.[27] Though the subject matter of this last is more pertinent it is also improbably early in date and, like the others, it appears to have given rise to no copies later than 1200, and it is difficult to see how such manuscripts could have come the way of Firdevsî or his illustrator.

The third group of Western manuscripts is, however, more promising. Like the earlier Beatus manuscripts they are mostly southern Spanish, but in addition mostly have strong Jewish connexions, though up to the present no illustrated manuscript of the *Testamentum Salomonis* from this milieu has come to light. Both the "Golden Haggadah" (British Library, MS Add. 27210), made probably in Barcelona c. 1310–25, which shows striking resemblances to thirteenth-century Mesopotamian *Maqamat* manuscripts,[28] but is not relevant here, and a "Hispano-Moresque" Haggadah of c. 1310–20 (British Library, MS. Or. 2737) are, interestingly, archaising in style

and recall Catalan miniature painting of the 10th–11th centuries – hence, up to a point, the Beatus compositions (cf. plate 2). These include a 14th-century Castilian historical manuscript, *Cronica de los Reyes de Judea e de los Gentiles,* with kings shown enthroned in Gothic aedicules (plate 3);[29] and the Bible of the House of Alba, a translation (Toledo, 1422–30) from Hebrew into Spanish by Rabbi Moses de Arragél of Guadalajara, for Luís de Guzmán, twenty-fifth Master of the Order of Calatrava (plate 4).[30] The frontispiece shows a knightly figure enthroned in an elaborate Gothic aedicule with a hemispherical ribbed dome, with representations of the works of corporal mercy in rows below and Dominicans, Franciscans and members of the order of Calatrava. The fact that the parallels adduced here are all from manuscripts which never left Europe means that the present argument is from types rather than specific prototypes, but many other resemblances of detail could easily be traced.

The Spanish connexion is particularly important because of the Hebrew manuscripts which evidently reached Turkey soon after the expulsion of the Sephardim following the fall of Granada in 1492. Some of these have been identified in the libraries of Europe and the Near East, though unfortunately relatively few collections of Hebrew manuscripts have been completely catalogued and the mass of material may still be in private hands. To judge from Michel Garel's exemplary study of Hebrew manuscripts in French collections,[31] they reached Istanbul in considerable numbers. Of the present total of about 650 manuscripts over three quarters of them were already in French collections by the year 1650, and a very substantial proportion of these were from the Ottoman empire, including 250 Hebrew manuscripts bequeathed to the Paris Oratory in 1620 by Achille Harley de Sancy, who acquired them in Istanbul during his time as French ambassador there. Two Hebrew manuscripts acquired by E.N. Adler indicate how relevant they might be. One was a finely written Hebrew Massoretic bible begun in Toledo for the Rabbi Jacob Aboáb in April 1492 and completed, possibly for a Karaite patron, in Constantinople in 1497.[32] The second is a book on fevers, translated probably from the Arabic, written in 1486 by Abraham, son of the Spanish Rabbi Isaac b. Risus at Makesia [?sc. Manisa] at the orders of Yusif ha Cohen, physician to Bayazid II.[33] Though Yusif's name does not occur in Landau's *Geschichte der jüdischen Aerzte*[34] he is very probably to be identified with the Granada physician, the father of Moses Hamon,[35] who found his way to Bayazid's Court and became his physician and who received a substantial gratuity in the *in'âmât defter* of Bayazid for Şevvâl, 909:[36] 3000 *akçe* and a mohair *cübbe* trimmed with fine woollen cloth. Such works illustrate well the type of Jewish scholars welcomed at the Ottoman Court – theologians (hence competent also in the Talmud, the Midrash and Old Testament exegesis), scribes, physicians and druggists, all most probably with some extra-curricular interests in astrology[37] too, though that would not have been welcomed by the Muslim astrologers already established at Court.[38] Perhaps rivalry of that sort was a factor in the rejection of the draft of the *Süleymânnâme*.

The remarkably diverse elements of the *Süleymânnâme* frontispiece relate to numerous different episodes in the Solomon Romance – including his viziers, his power over the birds, the visit of the Queen of Sheba, the subjugation of the demons whom he set to building his Temple, and his horses. Doubtless, much else would also have been immediately recognisable to any contemporary familiar with the *Qisas al-Anbiya*, or the *Testamentum Salomonis*.[41] In short, though to say so obviously begs the question of the parallelism envisaged between text and illustrations, so crammed with detail is the double frontispiece that it could almost have been intended as an epitome of the illustrations as a whole.[42]

Because, it would appear, the frontispieces were intended as a sort of advertisement for the *Süleymânnâme* the relative importance of Firdevsî's textual sources may well be reflected in their pictorial themes. There appears to be no text of al-Kisa'i which could account for all the elements depicted, so that we may confidently assert that a text like the *Testamentum Salomonis* was also used, and may even have been used exclusively.[39] This is all the clearer in that while double-page frontispieces showing Solomon and Bilqis are not uncommon in sixteenth-century Shiraz painting – and the fashion for this subject may have appeared there even earlier – they are scarcely comparable either in subject matter or in arrangement.[40]

The chronology of the composition of the *Süleymânnâme* is to some extent determinable from internal evidence.[43] It was begun at Balıkesir in the reign of Mehmed II and by the time of his death in 1481 had reached part 7.[44] It was then continued at Bayazid II's command on his accession. Later Firdevsî appears to have joined the suite of Şehzade Korkud, since in Meclis 281 he writes that it was finished at Manisa in 904/1498 where Korkud was at that time in residence. It is highly possible that both Mehmed II and Bayazid gave Firdevsî money to cover the expenses of transcribing this first draft, which may have run[45] to 330 or even 380 books. The circumstances of its presentation are also recorded in the *in'âmât* defters of Bayazid II, registers of honoraria, gratuities, rewards and occasional Palace expenses.[46] A grant of 3000 *akçe* to a lame poet (*veled-i leng*[47]) holder of a fief (*merd-i timâr*) who presented a *Süleymânnâme* which he had composed himself (*te'lîf-i hûd*), with, twenty days later,[48] the rest of the gratuity when he read it out aloud (*ki-kitâb-i Süleymânnâme gûfte*) – doubtless only selected extracts: 2000 *akçe* cash and a medallion brocade (*benek*) robe of honour valued at 3000 *akçe*. Compared to rewards to other poets, particularly those established in Court circles, such a reward was lavish, though it is more characteristic of rewards to outsiders offering kasides who subsequently may or may not have been taken on to the permanent strength of the *müşâhereborân* (recipients of monthly emoluments). Thereafter, at roughly 6-monthly intervals, between 20 Cemâzilâhir 912/16 November 1506 and 8 Şevvâl 914/31 January 1509, he is recorded as *Firdevsî müellif-i Süleymânnâme*,[49] receiving on these occasions 3000 *akçe* and a medallion brocade robe of hon-

our, but with no indication that he offered anything further. Nor is he listed together with the six to twelve poets who were evidently *müşâhereborân*. whose names continue to appear regularly long after he disappears.

This chronology, and Firdevsî's outsider status, goes some way to explain why, apart from the frontispiece, none of the other illustrations was executed, for had he been one of the *müşâhereborân* that would surely have given him access to the palace scriptorium to transcribe his fair copy and illustrate it fully. It would, moreover, not have required an excessive amount of reworking to make it presentable to Selim I. Why did Firdevsî not present it to him? At this point we should review the information on Firdevsî's career given by the 16th-century *tezkereci*, Latîfî.[50] Latîfî states that Firdevsî began the *Süleymânnâme* at Bayazid's command, though on a much reduced scale: the Sultan selected a mere eighty out of the three hundred and sixty books he had composed.[51] When, however, the revised draft was submitted to Bayazid, the Sultan – far from graciously accepting the dedication – was so displeased that Firdevsî had no recourse but to flee to Khurasan, where he may have died. Since the *in'âmât* defters of the latter part of Bayazid II's reign show that he continued to receive gratuities at least up to 1509, Latîfî's report must concern a reworked text submitted in that year or thereabouts. For, following the submission of the first draft in 1504, Firdevsî completed the *Şatrançnâme-i kebîr*, a treatise on chess composed at Balıkesir in that same year,[52] and a revised translation dated 914/1508–1509, of the *Câmeşûynâme* or "Book of the Launderer", on dyes and dyeing, attributed to the 13th century Persian polymath, Nasir al-Din Tusi.[53] Bayazid's displeasure, it goes without saying, would have been an effective barrier to a Royal subvention to complete the illustration of the *Süleymânnâme*.

Even if Latîfî's report that the work was begun at Bayazid's command is correct this does not necessarily mean that the original idea was Bayazid's. Ottoman court poets were, as poets at other courts and other times have also been, to some extent parasites, earning their keep by rewards for the works they offered to their royal patrons, and many suggestions for patronage must have been prompted by them, even if it later suited them, or the patron's panegyrists, to pretend that the initiative was his, not theirs.[54]

To return once more to the manuscript. The script is workmanlike but not the work of a fine calligrapher and may well be Firdevsî's autograph. Such illumination as it contains is certainly attractive but it is untypical of the well-documented production of Bayazid's palace scriptorium in style, technique and even quality and must therefore have been commissioned outside by Firdevsî himself. The frontispieces, which can be seen as a virtual epitome of the narrative, suggest that they may have been commissioned from an erudite friend, perhaps even one of Bayazid's court painters working on the side, with access to manuscripts brought from Spain by Sephardic refugees, as an explanation of the narrative for Bayazid's benefit.

This draft would then have been presented to him for his approval, with the hope that he would then commission and pay for the rest of the illustrations and reward Firdevsî accordingly. When that hope was not fulfilled the draft was abandoned. Further work on the progress of manuscript illustration from conception to presentation will doubtless show that this was far from being an isolated occurrence.[55] Could it have been that the crowded detail of the frontispieces put Bayazid off, as the Emperor Joseph II complained to Mozart, "Too many notes, my dear Mozart"? Perhaps its strongly astrological content brought accusations of heterodoxy from Bayazid's jealous Court astrologers.[56] Or perhaps, Firdevsî had to be punished for ignoring Bayazid's instructions to compose a work in the 80 books he had selected.

Curiously, despite this damaging set-back, which could have led to the total disappearance of the work, later copies of Firdevsî's *Süleymânnâme* are known.[57] There is also a mention of Firdevsî's romance in the *Bibliothèque Orientale*[58] of Bartélémi d'Herbelot (d. 1695), possibly pointed out to him by Antoine Galland, who was in Istanbul in 1672–73, though, not knowing of Firdevsî Burûsevî's existence, he misattributes the work to Firdawsi of Tus. The subsequent history of the Chester Beatty manuscript is, however, difficult to trace. Köprülü[59] states that he had seen an illustrated version of the *Süleymânnâme* in Istanbul some years before he wrote: that may well have been it.

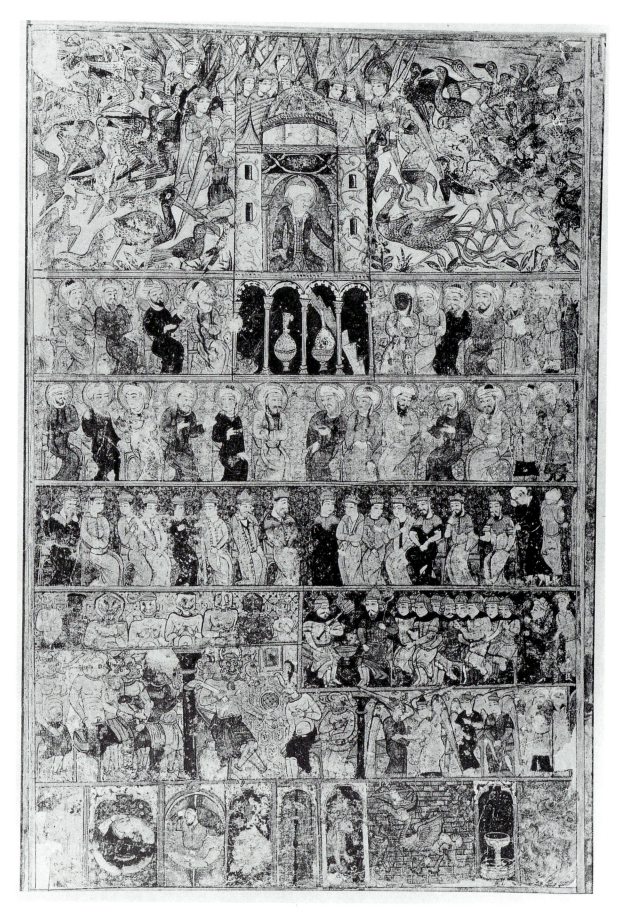

I. SOLOMON ENTHRONED, Firdevsî Burûsevi, *Süleymânnâme*, c. 1505–12,
Dublin, Chester Beatty Library MS 406, f. 2b.

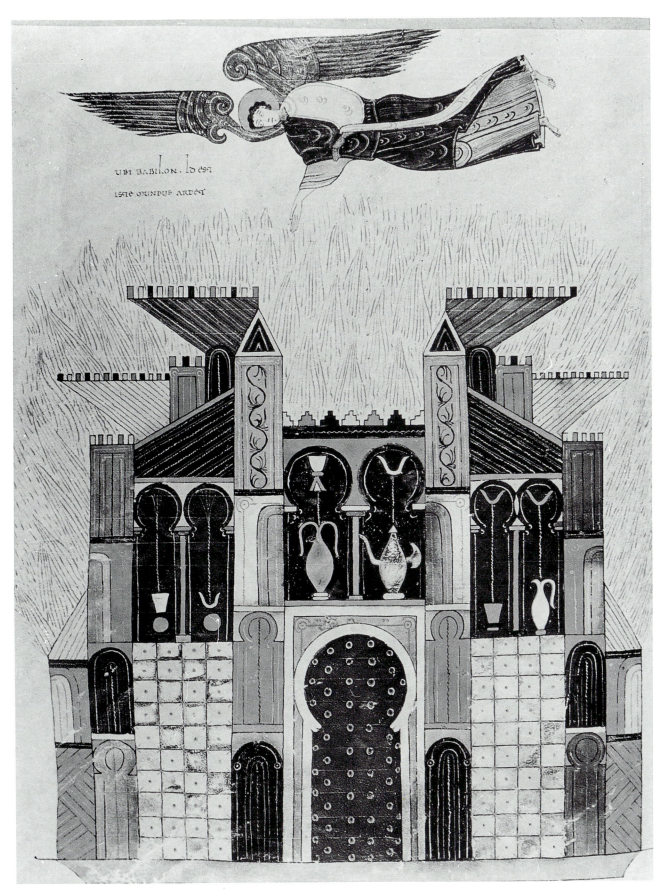

UBI BABILON. Id est
iste oundus ardet

2. THE ANGEL POURING THE VIALS OF WRATH ON THE CITY OF BABYLON/THE RUIN OF BABYLON,
Beatus of Liébana. *Commentary on the Apocalypse*, made for Ferdinand I of Castile and León, 1047, Madrid, Biblioteca Nacionál, vit. 14–2, folio 234a.

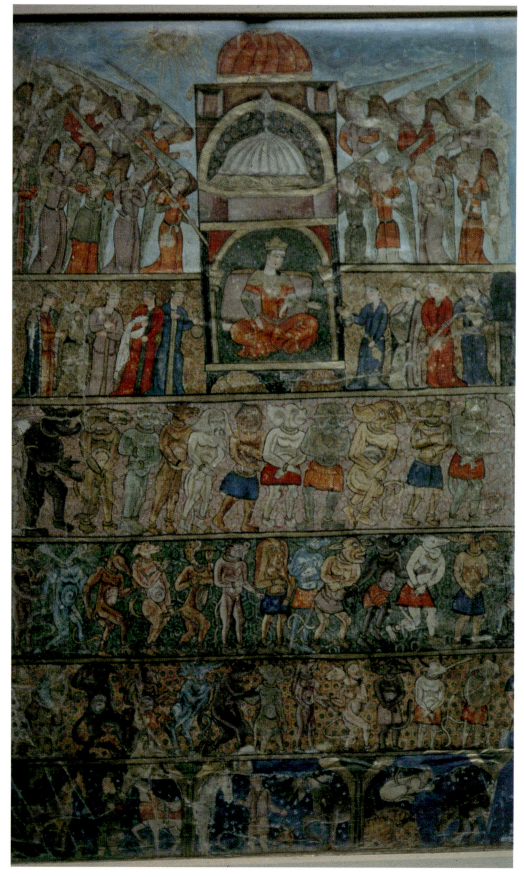

3. Firdevsî Burûsevi, *Süleymânnâme* THRONE OF BILQIS,
Dublin, Chester Beatty Library. MS. 406, f. 2a

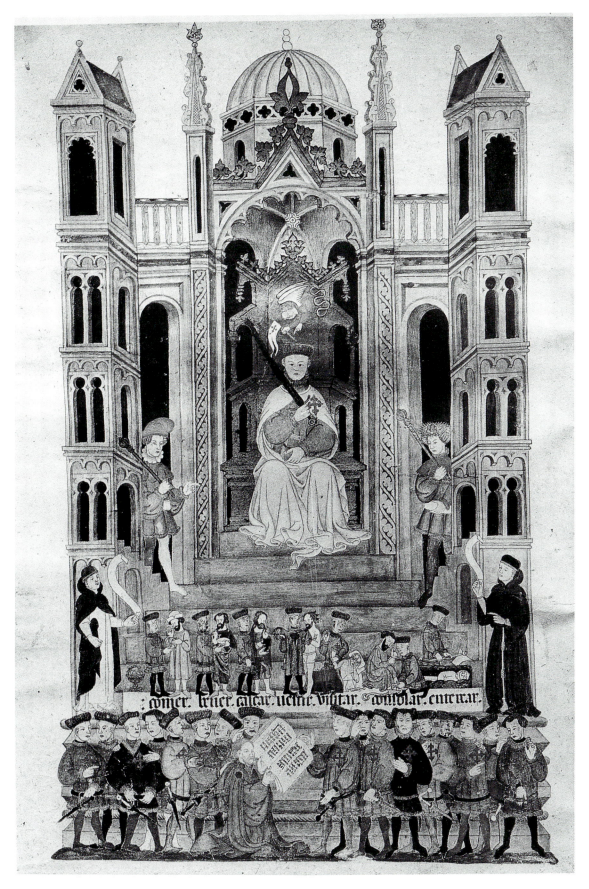

4. Luis de Guzman,

25th Master of the Order of Calatrava, Bible of the House of Alba, Toledo, 1422–30. Madrid, Palacio de livia vit. 1.

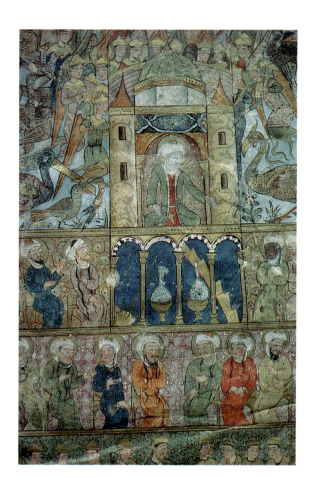

Fig. 1. Firdevsî Burûsevi, *Süleymânnâme*,
THRONE OF SOLOMON.
Dublin, Chester Beatty Library, MS. 406, f. 1b.

Fig. 2. Firdevsî Burûsevi, *Süleymânnâme*,
THRONE OF SOLOMON.
Dublin, Chester Beatty Library, MS. 406, f. 1b (detail).

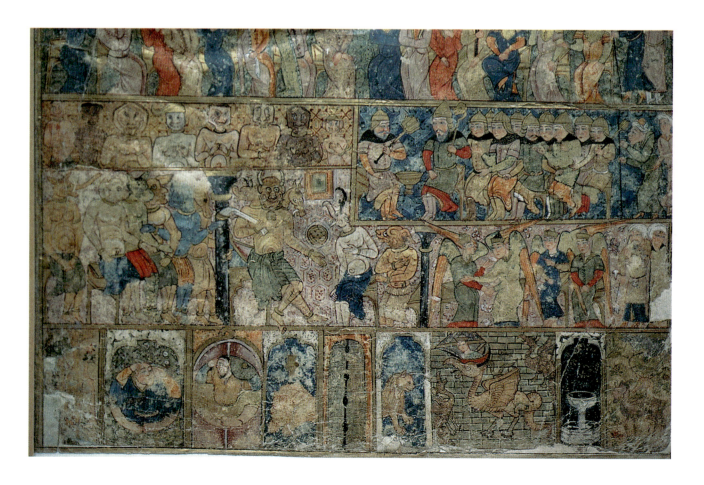

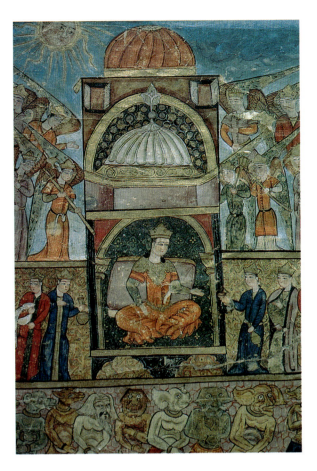

Fig. 3. Firdevsî Burûsevi,
Süleymânnâme,
THRONE OF BILQIS.
Dublin, Chester Beatty Library, MS.
406, f. 2a.

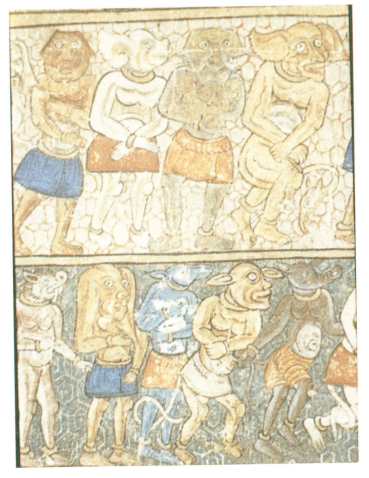

Fig. 4. Firdevsî Burûsevi,
Süleymânnâme,
DEMONS BELOW THE
THRONE OF BILQIS.
Dublin, Chester Beatty Library,
MS. 406, f. 2a.

Notes

1 Vladimir L. Minorsky, *The Chester Beatty Library. A catalogue of the Turkish manuscripts and miniatures* (Dublin, 1958), 9–10. *Süleymânnâme* (the Solomon Romance), by Şerefüddin Musa, known as Firdevsî Burûsevî (b. 855/1453). 332 folios, mottled cream polished paper, *naskhi*, possibly autograph, mostly 39 lines to the page, sometimes in five columns; some pages are blank. Double frontispiece (folios 1b–2a) showing Solomon and the Queen of Sheba (Bilqis) enthroned. The Preamble (folios 2b–3a) with decorated borders bears dedications to Bayazid II in gold *naskhi* above and below. 44.3cm. x 31 cm. Dublin, Chester Beatty Library, MS 406. The volume is a large folio with illuminated headpieces and margins for the preamble and to each of the chapters. The chapters end with verses and invocations to Solomon and were evidently written separately, though none appears to have a colophon or date. The (later) rubricated inscriptions are in a bold hand with many illegible flourishes.

2 M. Atâ Çatîktaş, "Türk Firdevsî'si ve Süleymanname-i Kebir", *Türk Dünya Araştırmaları* 25, (1983), 169–78; Barbara Flemming *et al.*, *Verzeichnis der orientalischen Handschriften in Deutschland. Türkische Handschriften* I (Wiesbaden, 1968), 36–40. Hüseyin Akkaya, *The Prophet Solomon in Turkish literature and the Süleymaniye of Şemseddînn Sivâsî* (Harvard University, 1977), 30–1. The fullest survey of Firdevsî's works is to be found in Fatma Büyükkarcı, *Firdevsî-i Tavîl and his Da'vet-nâme* (Harvard University, 1985), 1–8.

3 E.J. Grube, "Two paintings in a copy of the 'Süleymânnâme' in the Chester Beatty Library", in *Seventh International Congress of Turkish Art. Proceedings*, ed. Tadeusz Majda (Warsaw, 1990), 133–40, which includes a full bibliography of previous discussions.

4 M. Fuad Köprülü, "Firdevsî. Firdavsî (1453–?)", *Islâm Ansiklopedisi*.

5 Estimates of the full length given by later writers vary – but they were doubtless not speaking from the experience of having read it and counted the chapters.

6 T. Nagel, "al-Kisa'i, sahib Kisas al-Anbiya"; "Kisas al-Anbiya", *Encyclopaedia of Islam*, 2nd edition.

7 This eclecticism actually extends (cf. Georg Salzberger, *Der Salomo-Sage in der semitischen Literatur* [Berlin, Nikolassee, 1907]) to the account of Solomon in the Old Testament, Kings I, which is a compound of "historical"

fact, reworking by the Deuteronomists with praise of Solomon's piety and even more strongly idealising post-Exilic additions.

8 "Sulaymān b. Dā'ūd", *Encyclopaedia of Islam*, 2nd edition.

9 National Museum, Sarajevo, folio 32b. Cf. Elisheva Revel-Néher, "L'alliance et la promesse: Le symbolisme d'Eretz-Israel dans l'iconographie juive du Moyen Âge", *Jewish Art* 12–13 [*Festschrift Bezalel Narkiss*], (1986–87), 135–46, and C. Roth, *La haggadah de Sarajevo*, facsimile (Grenoble, 1963), who argues that since the style of illumination is very conservative it could well be even later than that. While it evidently left Aragon on the expulsion of the Jews in 1492, it was not conveyed directly to the Balkans, for it bears a note of sale in Hebrew dated 25 August 1510 in an Italianate hand. It doubtless reached Venice whence it could easily have reached Dubrovnik and then Sarajevo.

10 Louis Ginzberg, *The legends of the Jews*, translated Henrietta Szold, 6 volumes (Philadelphia, 1913–28), IV, 150 ff; VI, 277–303. It is worth remark (cf. Serpil Bağcı, "A new theme of the Shirazi frontispiece miniatures: The divan of Solomon", *Muqarnas* 12 (1995), 101–11) that the description in H.1231, folios 123b–124a (Fehmi Edhem Karatay, *Topkapı Sarayı Müzesi Kütüphanesi Türkçe yazmalar kataloğu* [Istanbul, 1961], no.1019, actually vols. 74–76 of the Süleymânnâme) tallies neither with the Midrash nor with the Chester Beatty Library frontispiece. Briefly, it was surrounded on all sides by palm trees, olives and lemon trees, all of gold with leaves and fruits of precious stones. On the palm trees were perched a pair of gold peacocks with ruby crowns and two Egyptian vultures also of gold. The seven steps of the throne were all of different precious stones. At the sides were gold lions with movable jaws and tails and a pair of silver dragons, lashing their tails and spouting fire. And the canopy of solomon's throne was surmounted by a cockerel made of a single pearl inlaid with jewels which crowed hourly.

11 The illustrations to the two-volume translation of Firdawsi's *Shahname* by Sharif (identified by Barbara Flemming, "Şerif, Sultan Ğavri und die 'Perser'", *Der Islam* 45, [1969], 81–93, with Husayn b. Hasan b. Muhammad al-Husayni al-Hanafi, the *shaykh* of the mosque of al-Mu'ayyad in Cairo, who may well have come from Amid/Diyarbekir), made for the Mamluk

Sultan, Qansuh al-Ghawri, Topkapı Saray H. 1519 (Nurhan Atasoy, "1510 tarihli Memlûk Şehnamesinin minyatürleri", *Sanat Tarihi Yıllığı*, [Istanbul, 1966–68], 44–69; E. Atıl, "Mamluk painting in the late fifteenth century", *Muqarnas* 2 [1984], 159–71, show architectural pavilions which are in many respects comparable. The frontispiece to a contemporary *diwan* of Qansuh al-Ghawri (Ms Staatsbibliothek Preussischer Kulturbesitz or. oct. 3744, cf. Barbara Flemming *et al.*, *Verzeichnis der orientalischen Handschriften in Deutschland. Illuminierte islamische Handschriften* [Wiesbaden 1971], no. 111) shows, moreover, a pavilion with an enthroned figure which is strikingly similar to that in which Bilqis in the *Süleymânnâme* sits. Both volumes of al-Ghawri's *Shahname* bear the seal of Selim I and must have been acquired by him on the conquest of Egypt, so they can scarcely have had any direct influence on the *Süleymânnâme* frontispieces. Esin Atıl (*art. cit.*, 159–71) considers these Mamluk architectural representations to be an indigenous Cairene development, but it is possible that they also were influenced by the diaspora of Sephardic Jewry from Spain.

12 Cf. T. Nagel, cited note 5 above.

13 Also compare the group of illustrated astrological miscellanies typified by the *Kitab al-Bulhan* in the Bodleian Library. Cf. Stefano Carboni, *Il Kitab al-Bulhan di Oxford* (Turin, 1988).

14 Paris, Bibliothèque Nationale, persan 174, cf. Marianne Barrucand, "The miniatures of the *Daqa'iq al-Haqa'iq*. A testimony to the cultural diversity of medieval Anatolia", *Islamic Art* IV, (1992), 113–42. The author rightly concludes that the illustrations are of various dates and that the date of compilation may give the terminus. As far as Nasir al-Din Siwasi's own contributions are concerned, however, I would judge that they are limited to the line drawings, which, regrettably, she ignores. The later reworkings mean, in fact, that its documentary value for mediaeval demonology may be insignificant.

15 Notably, Paris, Bibliothèque Nationale, supp. pers. 332, dated 1388, cf. H. Massé, *Le livre des merveilles du monde* (Paris 1944), though this is not otherwise relevant here.

16 Cf. G. Salzberger, *op. cit.*, 103, 108, citing Ahlwardt Pm 627, 160 ff.

17 The comparative iconographic tables of Decan demons given by W. Gundel, (*Dekane und Dekansternbilder, Studien der Bibliothek Warburg no.*

191 [Hamburg-Glückstadt], 1936, 160–74) show up considerable differences. In the Western Middle Ages many are crowned; many are shown in human, not demonic form, as in the text of the *Testamentum Salomonis*; quite a lot of them, for example, the three Decans of Virgo, are female; and they are mostly clothed. He adduces (*ibid.*, 374–83) a number of Hermetic manuscripts in Greek (Paris, Bibliothèque Nationale, grecque 2256, 2502) and in Latin (British Library, Harleian 3731) which are closer, though those which are shown have far more distinguishing attributes. The discrepancies suggest that, whatever the actual source of the *Süleymânnâme* Decan-demons, they are more appropriate to a text like the *Testamentum Salomonis* which introduces many of them by name but gives few of their individual forms. Cf. also "Pre-Talmudic demonology", *Jewish Encyclopaedia*, IV, 518.

18 Chester Charlton McCown, *The Testament of Solomon* (Leipzig-New York, 1922); G. Salzberger, *op. cit.*; F.C. Coneybeare, "The testament of Solomon", *Jewish Quarterly Review* XI, (1898), 15–45.

19 G. Deissmann, *Forschungen und Funde im Serai. Mit einem Verzeichnis der nicht-islamischen Handschriften im Topkapu Serai zu Istanbul* (Berlin-Leipzig, 1933), no. 17, Greek, 15th century, in an oriental binding with the flap to the right of red brocade with leather doublures. Cf. also Th. Uspensky, *La bibliothèque du Serail et ses manuscrits grecs* (text in Russian), (Sofia, 1907). The illustrations are line drawings, of talismans, human figures and demons, but show nothing comparable to the ambitious composition of the *Süleymânnâme* frontispieces.

20 It is beside the point that seven of the Decans mentioned in the *Testamentum Salomonis*, in the form of deadly females and clearly a reminiscence of the baleful Pleiades, are ignored in the *Süleymânnâme* illustration, since they are ignored also in the text when the full complement of Decans is discussed.

21 cf. Pauly-Wissowa, *Real-Enzyklopädie zur klassischen Altertumswissenschaft*, XXII, c. 2346.

22 R. Wittkower, "Marvels of the East. A study in the history of monsters", *Journal of the Warburg and Courtauld Institutes* V, (1942), 159–97; D.J.A. Ross, *Illustrated medieval Alexander-Books in Germany and the Netherlands. A study in comparative iconography*, (Cambridge, 1971), Fig. 404, showing Alexander fighting against the headless men, from a French 14th-century manuscript of the Alexander Romance based on a version of the *Historia de Proeliis*, Brussels, Royal Library, 11040, folio 73b. Also relevant is a Miscellany (North-West France, c. 1277,

Malibu, J. Paul Getty Museum, Ludwig MS XV 4), including treatises by Hugo of Fouilloy and an (anonymous) treatise on the *Mirabilia Mundi* based on Pliny the Elder or else on C. Julius Solinus (3rd century AD), with figures of the monstrous races. Cf. *Ornamenta Ecclesiae*, exhibition catalogue (Schnütgens-Museum, Cologne, 1985) I, A 29. They were also known to Shakespeare:
"And of the Cannibals that each other eat, The Anthropophagi, and men whose heads Do grow beneath their shoulders. This to hear Would Desdemona seriously incline." (*Othello*)

23 F. Macler's study of Armenian magical and demonological texts, *L'enluminure arménienne profane* (Paris, 1928) shows that these also were strongly influenced by European prototypes, but there appears to be no evidence for their direct influence on the *Süleymânnâme*.

24 Walter Goldschmidt, "Früh-mittelalterliche illustrierte Enzyklopädien", *Vorträge der Bibliothek Warburg* (Hamburg, 1923–24).

25 W. Neuss, *Die Apokalypse des Hl. Johannes in der alt-Spanischen Bibel-Illustration*, (Münster-in-Westphalen, 1931); Luis Vazquez de Parga Iglesias and Umberto Eco, *Beato di Liébana: Miniature del Beato de Fernando I y Sancha* (Franco-Maria Ricci, Parma, 1973); Giulia Bologna, *Illuminated manuscripts. The book before Gutenberg* (London, 1988), 98.

26 Florence, Laurenziana, MS Plut. 12.17, folio 2b; cf. Bologna, *op. cit.*, 94.

27 Paris, Bibliothèque Nationale, MS Lat. 11751, folio 59b; cf. Dorothy Miner, "More about medieval pouncing", in *Homage to a bookman. Festschrift H.P. Kraus* (Berlin, 1967), 87–108. The parallel was first noted by David James, *Islamic masterpieces of the Chester Beatty Library*, exhibition catalogue, (London, Leighton House, 1981), no. 31.

28 Bezalel Narkiss and Cecil Roth, *Hebrew illuminated manuscripts*, (Jerusalem, 1969), Plate 9.

29 Madrid, Biblioteca Nacionál, MS 7415; cf. Bologna, *op. cit.*, 127.

30 Madrid, Palacio de Livia, vit. 1; cf. Bologna, *op. cit.*, 140.

31 *D'une main forte. Manuscrits hébreux des collections françaises*, exhibition catalogue, (Bibliothèque Nationale, 1991). Reviewed by the present author, *Burlington Magazine*, February 1993, 151–2.

32 Adler, "Spanish exiles at Constantinople", *Jewish Quarterly Review* XI, (October, 1898), 526–9. This he acquired in Istanbul from the widow of the Karaite Chief Rabbi. The present locations of this and the following manuscript are not known to me.

33 Adler, *ibid.*, acquired in Teheran in 1896. The date given in the colophon of the manuscript, 5246 of the Jewish indiction [1486], poses a problem since the scribe states that his father was of the Spanish *exile* so, like Yusif ha Cohen, must have arrived in Istanbul some time after the fall of Granada in 1492. Perhaps the date given is that of the colophon of the work he translated.

34 (Berlin, Karger, 1895).

35 Uriel Heyd, "Moses Hamon, Chief Physician to Sultan Süleyman the Magnificent", *Oriens* XVI, (1963), 152–70.

36 Ö.L. Barkan, "Istanbul saraylarına ait muhasebe defterleri", *Belgeler* IX, (1979), 296–380, no. 362.

37 Lájos Blau, *Das altjüdische Zauberwesen* (Strasburg, 1898).

38 The gratuities paid to an astrologer, Mevlânâ Seyyid, in the 909 *in'âmât defter* of Bayazid II (Barkan, *art. cit.*, 296–380, nos. 280, 358), 7000 *akçe* in Şa'bân with a *cübbe* of mohair trimmed with sable; and 1500 *akçe* in Şevvâl of the same year with a *benek* robe too, show how extremely lucrative such a position could be. The gratuities were over and above his monthly stipend as a member of the *cemâ'at-i müşâheherân* (those receiving a monthly emolument) and could have been rewards for occasional, especially successful predictions.

39 Though for many individual details, notably the birds, the *Qisas al-Anbiya*, possibly reworked into a later version of the *'Aja'ib al-Makhluqat*, could have been an adequate source. In terms of demon numbers al-Kisa'i is less relevant than the *Testamentum Salomonis*, for he states that the demons assembled before Solomon were in four hundred and twenty groups, each with a different religion, and that they differed in colour, as well as in their theriomorphic features.

40 Serpil Bağcı, "A new version of the Shirazi frontispiece miniatures: The *Divan* of Solomon", *Muqarnas* 12 (1995), 101–11.

41 Why certain figures appear on one of the pages rather than the other must, of course, have been partly determined by the need to balance the two compositions – though the arrangement in registers lends itself to visual padding – and certain elements suggest deliberate antithesis; but the reason why Bilqis rather than Solomon has the thirty six Decan-demons parading before her in rows could well be that it is a reminiscence of the *Testamentum Salomonis* where the "Queen of the South", who is not otherwise named there, is explicitly stated to be a witch (*goēs*).

42 It is pertinent to note E.J. Grube's observation

(art. cit.) that the two illustrations are considerably smaller not only than the folios but also than the format of the written text, which suggests that they were executed separately and were mounted subsequently on folios 1b and 2a.

43 Ibrahim Olgun and Ismet Parmaksızoğlu, eds., *Firdevsî-i Rûmî'nin 'Kutbname'*, (Ankara, 1980), xi–xxvi. The *Kutbnâme* was a versified panegyric of Bayazid II's Mediterranean campaigns of 1499–1503.

44 *Süleymânnâme*, Meclis 81, line 15a, Fatih Millet Kütüphanesi, Ali Emiri 317.

45 Ibrahim Olgun, "Uzun Firdevsî ve türkçeciliği", in *Ömer Asin Aksoy Armağanı*, eds. Mustafa Canpolat, Semih Tezcan and Mustafa Şerif, (Ankara, 1978), 195–200. Meclis 82 actually begins with praise of Sultan Selim. "Sultan", however, was a title held by Şehzades as well as by the reigning monarch, so could well predate his accession as Sultan very considerably. Olgun (*art.cit*) gives no grounds for supposing that the passage was interpolated in Istanbul after 1512.

46 Ömer Lutfî Barkan, "Istanbul saraylarına ait muhasebe defterleri". *Belgeler* IX/13 (1979), 296–380.

47 *Ibid.*, 351 no.317, dated 9 Ramazân 909/25 February 1504. Barkan interprets *Leng* as a patronymic, but the name is rare in Ottoman Turkey.

48 *Ibid.*, 359 no.346, dated 29 Ramazân 909/16 March 1504.

49 Ismail E. Erünsal, "Türk edebiyatı'nın arşiv kaynakları I. II. Bayazid devrine ait bir in'âmât defteri", *Tarih Enstitütüsü Dergisi* 10–11 (Istanbul, 1979–80), 301–42; idem, "Türk edebiyatı tarihine kaynak olarak arşivlerin değeri", *Türkiyat Mecmuası* XIX, 1977–9 (Istanbul, 1980), 213–22. The defter is in the Atatürk Kitaplığı, Istanbul, Muallim Cevdet O.71.

50 M.F. Köprülü, "Firdevsî. Firdavsî", *Islâm Ansiklopedisi*; Mustafa Isen, *Latîfî tezkeresi* (Istanbul, 1990), 180–2.

51 In fact Hüseyin Akkaya observes (*op. cit.*, 30–1) that there are at least *eighty-one* volumes of this presumably abbreviated version in various libraries and manuscript collections.

52 M. Atâ Çatıktaş, "Firdevsî-i Rûmî'nin *Şatrancnâme-i Firdevsî'si*", *Türk Dünya Araştırmaları* 37, (1985), 186–98.

53 I have not been able to locate any manuscript either of Nasir al-Din Tusi's original or of Firdevsî's revision. It need not have been a direct commission by Bayazid II and should, therefore, probably be discounted in the present context.

54 They must also often have sympathised with Dr. Johnson's view of the patron as "commonly a Wretch who supports with insolence and is rewarded with flattery", but they seem to have been wise enough not to say so.

55 Cornell H. Fleischer (*Bureaucrat and intellectual in the Ottoman empire. The historian Mustafa Âli* [Princeton, 1986], 105–10) provides the interesting parallel of Mustafa 'Âli's *Nusretnâme* which, in an attempt to gain the favour of Murad III, he had had illuminated and illustrated by local painters at Aleppo for presentation to the Sultan. The text was copied in Rebî' II 990/April–May 1582 and the work was probably presented on his visit to Istanbul in 1583, together with a note apologising for the poor quality of the workmanship and a plea that painters from the palace atelier should be set to work on the production of a palace copy (now Topkapı Saray, Hazine 1365). This was agreed and the work was completed, under Mustafa 'Âli's supervision, in Receb 992/July 1584. His ulterior motive, of course, was somehow to break into the charmed circle of the palace scriptorium, dominated at the time by Murad III's historiographer Seyyid Lokmân, and like so many of Mustafa 'Âli's démarches it was attended by only moderate success.

56 Also attributed to Firdevsî is the *Da'vetnâme*, a translation of a Persian work on the occult sciences, completed at Balıkesir in 893/1487–88. Cf. Büyükkarcı, *op. cit.* This suggests that astrology was a long-standing preoccupation with him.

57 Barbara Flemming *et al.*, *Türkische Handschriften* I, 36–40, no. 52. In the library of the Topkapı Saray there are various volumes of a set copied in 951/1544–5, possibly for Süleyman the Magnificent (H.1523–37 and K.892; cf.Fehmi Edhem Karatay, *Topkapı Sarayı Müzesi kütüphanesi Türkçe yazmalar kataloğu* (Istanbul, 1961), nos.2780–93). This includes volume 77.

58 *S.v.*, "Soliman Ben Daoud".

59 *Art. cit., Islâm Ansiklopedisi.*

15

The Illustrated Manuscripts
of Athar al-Muzaffar:
A History of the Prophet

KARIN RÜHRDANZ

URING THE SECOND HALF OF THE SIXTEENTH CENTURY Persian manuscript painting, earlier dominated by the illustration of classical epics, experienced some important changes. One of these developments resulted in the separation of miniature painting from textual background, thereby giving it the additional role of album picture. Another led to the incorporation of a new range of themes into the set of texts selected for illustration. For the first time, poems or prose works dealing with the history of Muhammad and other prophets, with the deeds of the Shi'ite Imams and famous Sufis were chosen for illustration in sizeable numbers. This phenomenon reflects complex social and cultural changes which might become better known by analysing artistic developments in the second half of the sixteenth century, a task which can only be undertaken after all the relevant illustrated manuscripts have been examined.

From the beginning the visual exploitation of the new range of themes reveals several thematic preferences and different stylistic starting points. Without ignoring the manifold stylistic sources it can be said that the essential role was played by northern Iranian miniature schools. In the illustrated copies of the poem *Athar al-muzaffar* to be discussed here, attention will be concentrated upon two stylistic groups which were both first recognized and characterized by B.W. Robinson: the Khurasan style[1] and the Astarabad style.[2] Thus this paper is particularly indebted to the immense research output of B.W. Robinson which has decisively shaped current

ideas about the development of Persian miniature painting.

The *masnavi* poem *Athar al-muzaffar* was composed in 1516 by Nizam al-Din Astarabadi for Khvaja Saif al-Din Muzaffar Bitikchi.[3] The *History of the Prophet* was embedded in explanations designed to justify the Safavid claim to rule, and served in some sense as a proto-history of the new dynasty. There is no illustrated copy from the period immediately following the compilation of the text, but the possibility that such a copy existed cannot be ruled out completely. Around the year 1526 miniatures were added to another pro-Safavid text, the *Ahsan al-kibar*[4] written by Muhammad al-Varamini which had been copied earlier. But the three known illustrated manuscripts of the *Athar al-muzaffar* were all produced during the third quarter of the sixteenth century.

One of these manuscripts is preserved in the library of the Topkapi Saray Museum (H. 1233).[5] The calligrapher Muhyi al-Haravi[6] completed the copy in the month of Dhu'l-Qa'da of the year 975 (April–May 1568). It can be supposed that the calligrapher Muhyi al-Haravi was active mainly in Harat during the second half of the sixteenth century. The manuscript comprises 7 miniatures to which at least one detached illustration, now in the Pozzi Collection in Geneva,[7] must be added.[8]

A single work produced by Muhyi al-Haravi between the fifties and the eighties of the sixteenth century bears the name of the place where it was written, Harat, and elsewhere he is described as a calligrapher from Khurasan.[9] This Khurasani connection would

be supported by the style of most of the illustrations in his copy of the *Athar al-muzaffar*. Six of the eight miniatures (including the detached one in Geneva) are clearly to be attributed to the Khurasan style,[10] though not all of them can be called typical specimens of that style.

The miniatures are characterized by an economical use of figures and elements of landscape, but the components were chosen carefully and purposely according to the subject, so as not to repeat the same standard repertory again and again. Likewise, ornamental decoration was employed sparingly and placed deliberately. Strongly coloured areas contrast with subtly differentiated monochrome surfaces. In the same way figures stand out against the background. Clothed in monochrome undecorated garments, they appear like a solid block, thereby focussing our attention on their gestures and facial expressions.

From the description given above it becomes evident that the miniatures differ from the average Khurasan-style painting. Not surprisingly, they lack some of the idiosyncrasies of that style, for instance, the round childish faces and the thin long necks. The range of colours is less limited, although subdued colours prevail and a preference for the combination of gold and brown with blue or green can be detected.

The distinction between this and average, and often mediocre, Khurasani production should be understood, in the first instance, as a difference in quality. But the artist who painted most of the illustrations in the Istanbul *Athar al-muzaffar* proved his competence in the visual interpretation of unusual subject matter too. He hit on uncomplicated, but illuminating and sometimes original pictorial solutions. The reduced compositions, while concentrating on the main event, leave space for secondary scenes too, usually in the lower part of the miniature. These complementary scenes are carefully selected to fit the principal subject, but at the same time they reveal an interest in the representation of everyday life. With their liveliness and realistic presentation they balance the more solemn and less realistic tenor of the representations of the Prophet. Where these elements are lacking, the composition becomes more flat and the picture looks somehow sterile.

This is the case with the miniature now preserved in Geneva, the subject of which is a conversation between Gabriel and Muhammad. The angel tells the Prophet that he should give his daughter Fatima in marriage to 'Ali b. Abi Talib and recognize his son-in-law as his *wali*. The painter depicted the situation precisely, but laconically, stressing the special position of the Prophet, who is in touch with an envoy from God, by isolating the two figures in the mosque. The two men outside the building are, however not sufficient to offset the impression of immobility and lifelessness.

For the story of how the monk Bahira met Muhammad the painter found a more interesting solution (fol. 33a).[11] The subject chosen for illustration is the moment just before Bahira speaks out about his insights about the future prophet. The composi-

tion closely follows the text on the page with the illustration, which describes the miracle of the dead tree suddenly breaking into leaf again, and the monk's reaction to this. The tension inherent in this moment is only partly conveyed in the painting by the figure of the monk rushing to the scene whereas the calm attitude assumed by Muhammad and the merchants sitting at the left of the painting counteracts any feeling of suspense. But it may have been intended to present the miracle as an event in which there was no element of accident or disturbance. In contrast to this the complementary scene showing the servants of the merchants at work introduces that connection with everyday life which was denied to the main subject. At the same time, together with other stylistic means, like the low horizon and the view of a spring behind the hills, it promotes the feeling of space.

A similar function is fulfilled by the depiction of the slaughter of a camel in the first illustration (fol. 13b). 'Abd al-Muttalib, the grandfather of the Prophet, had vowed to sacrifice the son specified by lot. To save the life of 'Abdallah, the future father of Muhammad, an old woman advised him to cast lots again to discover whether God might not also accept camels in exchange for the boy. Once the number of camels offered for sacrifice was big enough, the lot fell against them.[12] Again, the scene of everyday life is not merely some additional embroidery, but an essential part of the composition. Moreover, by this means two successive stages of the story are represented in one picture, thus mirroring the course of events as given in the text.

The inclusion of such secondary scenes into the composition is itself enough to indicate, independent of other criteria, how far the artist is indebted to the Qazvin/Mashhad style. The way he was developing his compositions while following the text as closely as possible seems to indicate that he was breaking new ground. The way that he managed to fit familiar elements of composition to a new context which differed from their original purpose indicates his ability to devise a visual realization of uncommon subjects.[13]

The daring which was part of this approach can also be seen in a battle scene, the only one he is known to have painted (fol. 96b). The text demands that 'Ali should be the main actor in the centre of the composition. But the introduction of angels, not only fully armed but even (in two cases) fighting on horseback is a more original idea. Whether it was he too who introduced the careful depiction of armour which later became popular in Khurasani painting cannot be decided. But this is certainly an element the artist did not owe to the Qazvin/Mashhad tradition.

When one compares these six miniatures with other first-rate Khurasani work from the seventies, for instance with the illustrations in a copy of Maulana Haidar's *Makhzan al-asrar* formerly in the Vever Collection,[14] it becomes evident that the differences setting them apart from average Khurasani painting are not merely a matter of artistic quality. The ties connecting them with the main

I. THE SACRIFICE OF ʿABD AL-MUTTALIB, 1568

Istanbul, Topkapi Saray Museum, H. 1233, fol. 13b

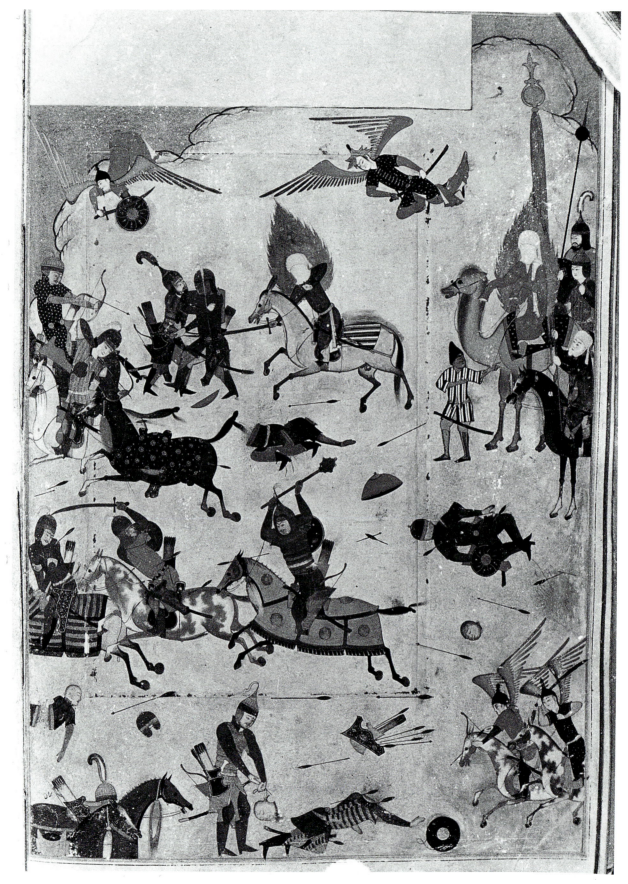

2. MUHAMMAD UND ʿALI DURING THE BATTLE OF BADR, 1568

Istanbul, Topkapi Saray Museum, H. 1233, fol. 96b

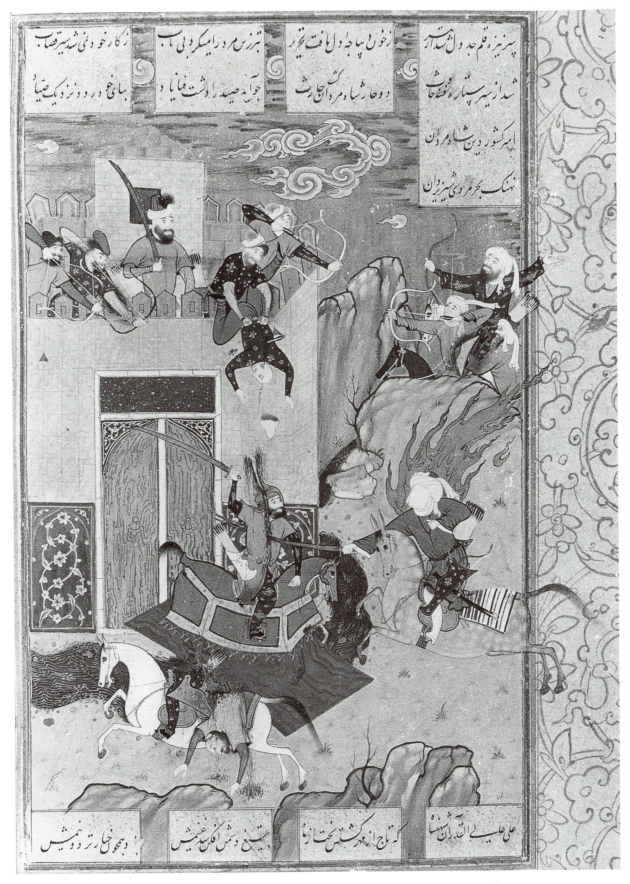

3. 'ALI FIGHTING TO TAKE THE FORTRESS OF QAMUS, 1568

Istanbul, Topkapi Saray Museum, H. 1233, fol. 158b

line of development of the Qazvin/Mashhad style are still readily to be recognised. Characteristics that, a little later, will stand out as specific traits of the Khurasan style, here seem rather to be a response to the idiosyncrasies of the subject matter and the result of personal ideas. Thus, it looks quite possible that these paintings are the starting point of the Khurasan style.[15] The date in the Istanbul manuscript places the execution of the miniatures between the completion of the famous *Haft Aurang* (dated 1556–1565)[16] and the shifting of the centre of artistic activity back to Qazvin in the middle of the seventies.[17] This would be a plausible moment for the formation of a separate line of stylistic development growing into a provincial style. In all probability, this happened in Harat, which, at least in the 1570s,[18] played a major part in the development of the Khurasan style.

Two other, but stylistically different, illustrations in the Istanbul manuscript (foll. 114b and 158b) seem to suggest connections with the Qazvin/Mashhad style. These miniatures, which present heroic exploits of 'Ali, are obviously painted by another hand and belong to that style. They are of fine quality but they offer no surprises. These battle scenes continue the tradition of epic illustration, and simply replace the main hero by 'Ali, complete with veil and nimbus.

Another illustrated manuscript of the *Athar al-muzaffar* is preserved in the Chester Beatty Library in Dublin (Pers. 235).[19] This copy was completed on 1 Rajab 974/12 January 1567; no further information is given. The manuscript now contains only three miniatures: the destruction of the idols of the Ka'ba (fol. 55a), 'Ali's heroic feat at the taking of the fortress of Qamus (fol. 132a) and Muhammad proclaiming 'Ali his *wali* near Ghadir Khumm (fol. 152a).[20] It seems likely that this was not the original number of illustrations.[21] At least two detached miniatures should be added. One in the former Vever collection shows Muhammad preaching after the Battle of the Ditch[22] and the other, formerly in the Kevorkian Collection, shows the reception near a city gate of a veiled person provided with a halo.[23] This miniature has been cut out and placed on a text not related to it. It might represent the entry of Muhammad into Mecca.

The five miniatures all belong to the Qazvin/Mashhad style. But again, they cannot be called typical specimens of this style. Since they were painted only a few years later than the illustrations of the already mentioned *Haft Aurang* manuscript in the Freer Gallery, a comparison with those miniatures suggests itself. Not surprisingly, the paintings in the *Athar al-muzaffar* are more modest. The smaller picture area alone denied the development of panoramic compositions. Instead, a concentration on the figures determines the direction of stylistic development. The positions and gestures of the figures are almost the only means of expression. Landscape and architectural background have hardly any share in elucidating the message. They offer some information about the scene of action, but not enough to recognise the subject of the detached miniature from the Kevorkian Collection, for instance.

The number of figures that are big in relation to the picture space is relatively high, but they never appear as an indistinguishable mass. With the exception of the veiled main actors, it is precisely in the varied representation of the individual figures and the skilful rendering of the different poses that the strength of these miniatures lies. On the other hand, they lack the remarkable delicacy and courtly elegance which characterizes even the more modest paintings of the Qazvin/Mashhad style.[24] At least in part, this seems to result from the special quality of the subject matter, the "display of holiness", which transformed the style. The obligation to develop an adequate visual expression of events of immediate religious importance in turn gives the paintings a certain heaviness.

All the miniatures display a tendency to discard the complicated arrangement of figures common to the works of the Qazvin/Mashhad style in favour of variants on a design of two staggered rows. A row of figures in the lower part of the picture is supplemented by another row in the upper part, mainly spectators from behind hills or on rooftops. Occasionally, important actions take place in this upper area. Often a connecting diagonal between the two levels is accentuated.

The step-by-step transformation of the style can be traced in the slight differences between the individual miniatures. In the three illustrations preserved in the manuscript, as distinct from the other illustrations, the painter seems to have gone a step farther in departing from the Qazvin/Mashhad style. Thus the participation of two different hands cannot be excluded. For instance, the illustration showing the event near Ghadir Khumm clearly has the same compositional model as the representation of Muhammad preaching after the battle of the ditch. It is distinguished from the latter by the enlargement of the figures, not in the sense of coarsening but rather in that more attention is paid to details of faces and clothing. Therefore it should not be seen as a loss in quality but as a shift of emphasis proper to a new genre.

The relationship between the miniatures of the Dublin *Athar al-muzaffar* and the two illustrations in the Istanbul manuscript which belong to the Qazvin/Mashhad style likewise demonstrates the way the Dublin paintings depart from the main line of stylistic development. This impression may of course be affected by the circumstance that the two Istanbul miniatures are battle scenes, and as such are more exposed to the impact of epic illustration, including its stylistic influence. To highlight the problem, one may compare the only battle scene among the Dublin miniatures – 'Ali fighting to take the fortress of Qamus (fol. 132a) – with the last illustration in the Istanbul manuscript, H. 1233 (fol. 158b), which depicts the same story even if it does not represent the same moment. As is to be expected (notwithstanding the date in the colophon) the Istanbul miniature illustrates the earlier stage of development. This is underlined by the way that the content of the text is reflected by the painting. The Istanbul miniature presents

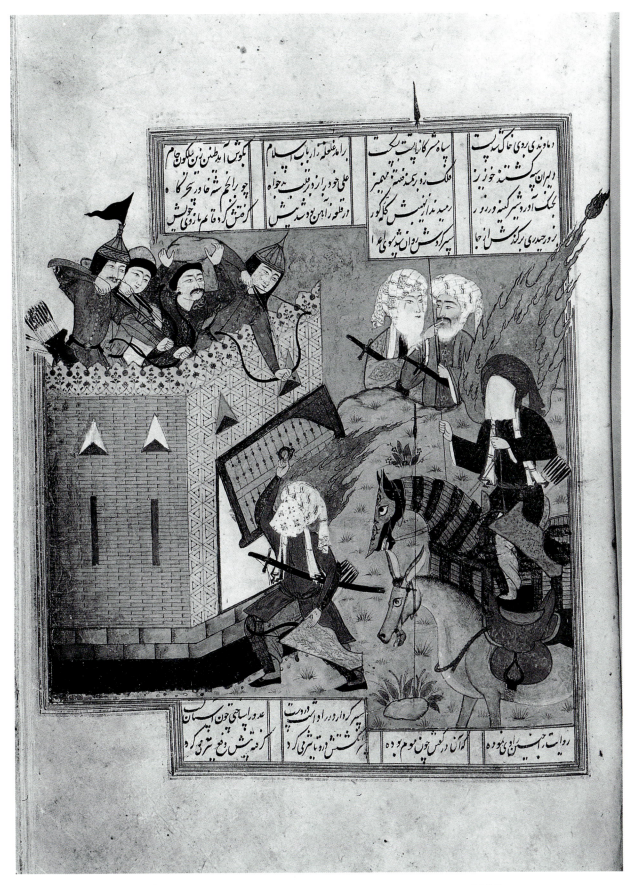

4. 'ALI FIGHTING TO TAKE THE FORTRESS OF QAMUS, 1567

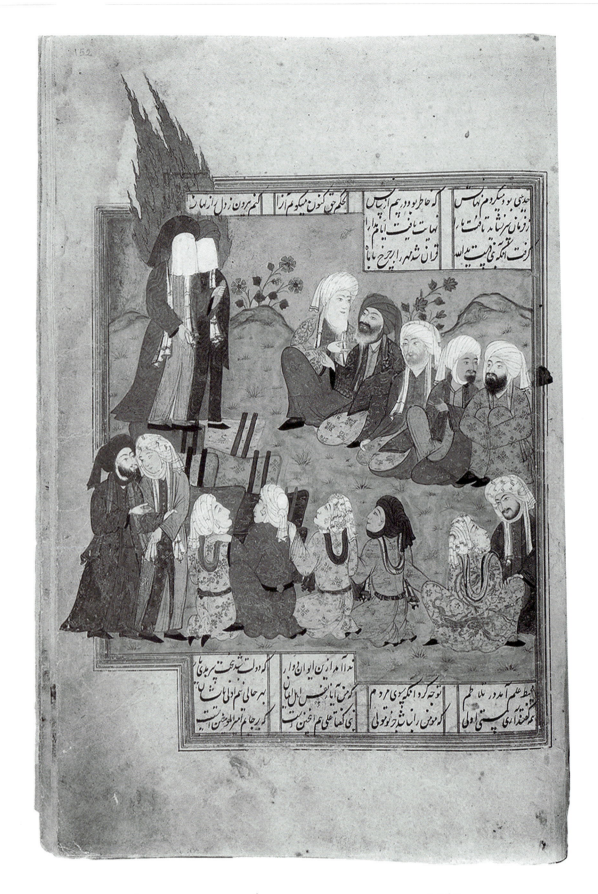

5. MUHAMMAD AND 'ALI NEAR GHADIR KHUMM, 1567

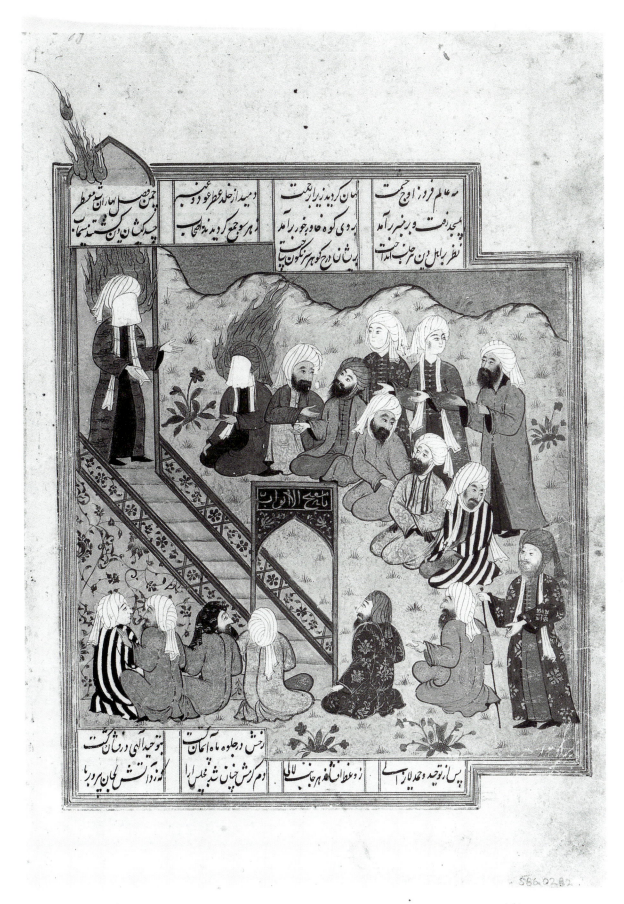

6. MUHAMMAD PREACHES AFTER THE BATTLE OF THE DITCH, 1567

Opaque watercolour, ink, and gold on paper, S1986.282. Courtesy of the Arthur M. Sackler Gallery, Smithsonian Institution, Washington, D.C.

'Ali as a warrior hero comparable to the protagonists of the *Shah-nama*. The Dublin illustration, which shows the Prophet watching the heroic deed of his son-in-law, emphasizes the divine mission which 'Ali is fulfilling. This is an obvious deviation from the traditional battle scene in favour of the requirements of the new genre.

Thus, in the case of the Dublin miniatures an important impulse to stylistic change was given by the subject matter. And again the question arises: where can one detect the beginnings of a new stylistic development? The notional borderline was, it seems, reached by the three illustrations still in the Dublin manuscript, whereas the two dispersed miniatures remain a step behind. But what kind of stylistic direction was this, and where did it lead to? There is no illustrated manuscript from the following decade which represents the further development of this direction.[25] This may explain why these ideas have not yet attracted scholarly attention. However, it seems obvious enough that this whole development merges with the Baghdad school[26] during the 1580s, which means that it had left Safavid territory by that time.

The third copy of the *Athar al-muzaffar* belongs to the State Public Library in Saint Petersburg (Dorn 456).[27] It was copied in the year 981/1573–4 by the calligrapher Khvaja Mir b. Shams al-Din Muhammad Munshi Astarabadi[28] and comprises 11 illustrations. The miniatures belong to the Astarabad style[29] with its much simplified flat compositions and the characteristic range of colours including not only violet, green and light-blue, but also red and orange as background colours. Details of armour and the decoration of clothing and caparisons are minutely executed whereas the scene itself is presented somewhat laconically. It is limited to the iconographic core of the subject, being arranged symmetrically and dominated by the two main actors. Additional repetitive figures are distributed in a loosely symmetrical fashion. Within the landscape background, which is usually reduced to a minimum, bizarre rock formations occasionally catch the eye; they are reminiscent of Turkman or of early Safavid models.

Although the pictorial cycle seems to be complete, the reduced iconography allows only limited conclusions. Muhammad is presented in direct contact with the supernatural, for instance when Gabriel approaches him (fol. 29b) or when he is saved from his persecutors by a miracle (fol. 50b). Later he acts as a leader, with 'Ali as his warrior hero. When 'Ali is fighting the enemies of the Prophet, Muhammad himself is present in two cases (foll. 70b and 80b). Two other miniatures show 'Ali engaged in single combat without any reference to the Prophet's presence (foll. 98a and 115b). Of course, these paintings are the least inventive because standard models of battle scenes were reused. Other ideas are more interesting, like Gabriel suspended horizontally in mid-air above the sleeping Prophet. There is originality too in representing the miracle of the successful flight of Muhammad by showing his pursuers standing baffled in front of the cave and being misled by the spider's web and by the bird's nest in the tree

which blocks the entrance to the cave.[30] But these ideas were realized in a way which could hardly inspire a later artist to take them up again.

As to principles of composition, figure painting, ornamental details or range of colours, the illustrations are characterized by such a degree of uniformity that they must all be the work of the same artist. They are closely related to the miniatures of the London copy of the poems of Hilali which was finished in 1574.[31] Very likely, both manuscripts were illustrated by the same painter, who may earlier have participated in the paintings of the 1565 *Shahnama* too. It seems, however, that he had no prior experience of illustrating the subject-matter of the *Athar al-muzaffar*.

Because of the difficulties that faced the illustrator it is surprising that the manuscript was illustrated at all. The volume catalogued as Dorn 456 was presented as *waqf* to the shrine in Ardabil, but this can hardly be accepted as the reason for producing the manuscript. Besides, Dorn 456 comprises two more manuscripts.[32] They were probably assembled for the purposes of the donation only and their illumination was still unfinished at this point.[33] One factor speaks for a connection between all three manuscripts: they were all copied within a short period of less than two years, which in turn suggests that there was a plan behind their production. Nevertheless, it seems that a manuscript copied by a scribe from Astarabad and illustrated in the Astarabad style must have been commissioned in or brought from Astarabad. A commission from outside might explain why a provincial workshop should have undertaken such a difficult task. Thus, notwithstanding its connection with the other two manuscripts, the Saint Petersburg *Athar al-muzaffar* stands out as the isolated product of a provincial school.

As far as it can be judged at present, the pictorial cycles of the *Athar al-muzaffar* manuscripts are not related to each other. These separate approaches did not result in the formation of a representative set of illustrations connected with the text, but they did play a part in the gradual visual transformation of subjects from the history of the Prophet and the first Imam of the Shi'a. Stylistically, all three approaches are connected with branches of Persian miniature painting which developed during the third quarter of the sixteenth century – partly in close contact with the centre in Qazvin – in the northern and north-eastern part of the country. All three manuscripts seem to have been produced outside royal ateliers, but in two cases with the participation of artists who were linked to the main stream of artistic development. Nevertheless, the impression produced by the Istanbul and the Dublin manuscripts is dominated by the new stylistic developments, which offered the most interesting iconographic solutions. We should be aware of the possibility that, together with iconographic models, stylistic peculiarities may have been transmitted when the illustration of religious subjects gained popularity, and that this occurred outside the Safavid realm as well.

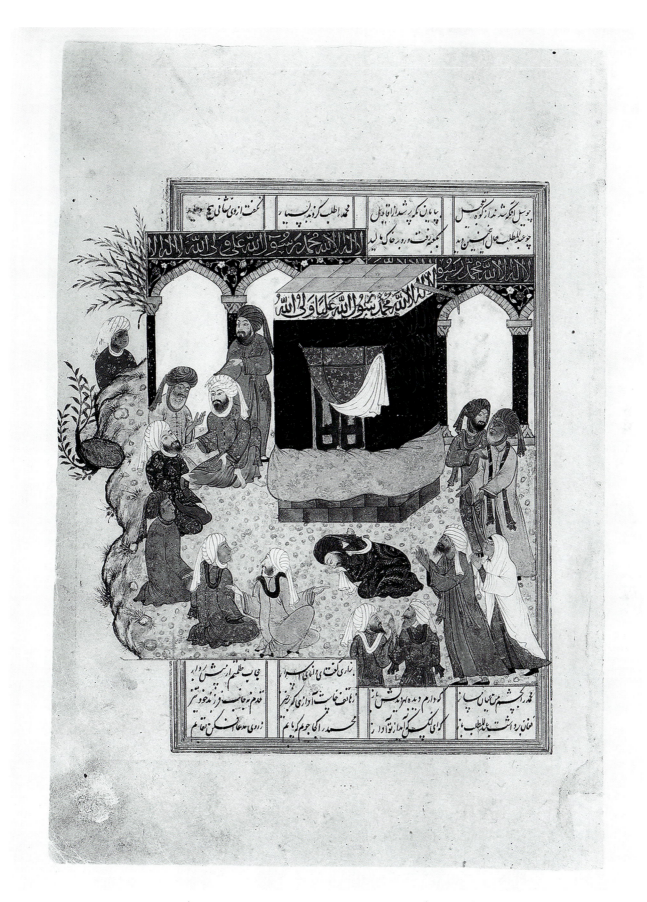

7. 'ABD AL-MUTTALIB PRAYING AT THE KA'BA, 1567

Courtesy of the Pierpont Morgan Library, New York (G. 72b)

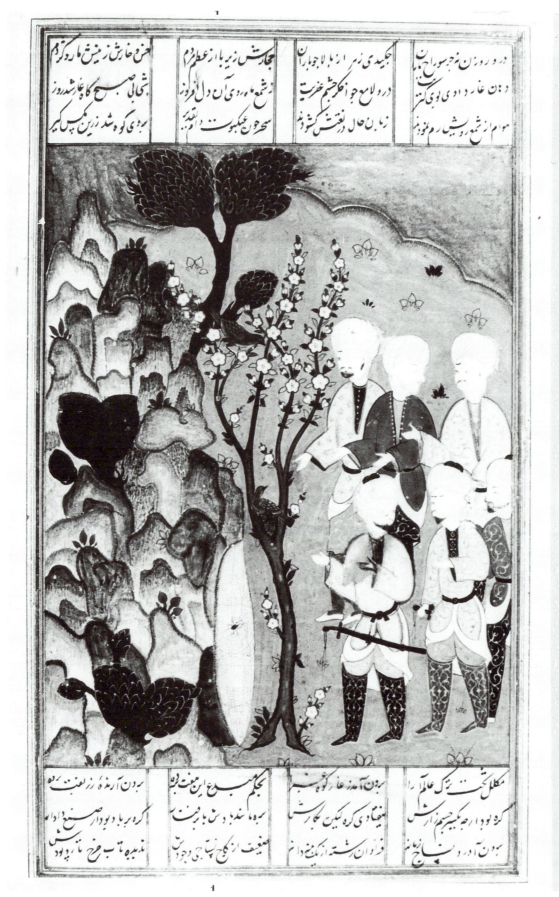

8. THE PURSUERS OF MUHAMMAD BEING DECEIVED, 1573/74
St. Petersburg, Russian National Library, Dorn 456, fol. 50b

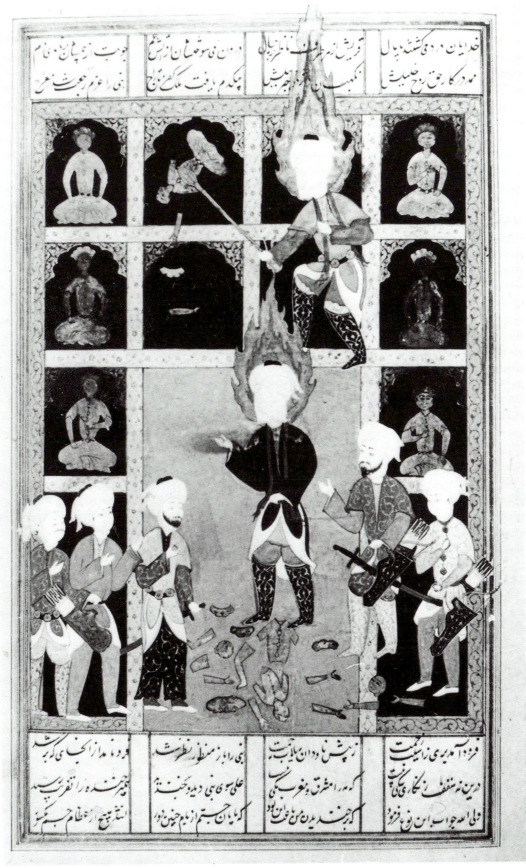

9. 'ALI DESTROYING THE IDOLS, 1573/74

St. Petersburg, Russian National Library, Dorn 456, fol. 124a

Note

After the completion of this paper, news about a fourth illustrated copy of the *Athar al-muzaffar* was brought from India by Barbara Schmitz, to whom I am most thankful for the information. The manuscript, which is preserved in the Raza Library in Rampur (RRL 4187), contains not only the text of the *Athar al-muzaffar* but also a *qasida* in praise of Muhammad and his family by the same author. This copy of the *Athar al-muzaffar* was completed in 974/1566–7 and decorated with 40 miniatures. These were executed in the same style as those of Dorn 456 in St. Petersburg.

With the appearance of the Rampur manuscript it becomes likely that the connection of the author and his patron with Astarabad was one reason for the *Athar al-muzaffar* being copied and illustrated in that town. Although the output of the workshop(s?) active there during the 1560–1580s was larger than had at first seemed to be the case, the preference for a text like *Athar al-muzaffar* is difficult to explain. On Khvaja Saif al-Din Muzaffar Bitkchi Astarabadi, his important political and cultural role in supporting Safavid power in Harat, and his eventual return to his native town, see Aubin, J.: "Révolution chiite et conservatisme. Les Soufis de Lahejan, 1500–1514, Études safavides II", *Moyen Orient et Océan Indien*, 1 (1984), 16–19; Szuppé, M.: *Entre Timourides, Uzbeks et Safavides, Studia Iranica*, 12.

Another illustrated page from the Dublin manuscript of the *Athar al-muzaffar* was discovered in the Pierpont Morgan Library, New York (G 72). It shows 'Abd al-Muttalib praying at the Ka'ba. As Barbara Schmitz has demonstrated, it should be placed between foll. 20 and 21 of the Dublin manuscript (for the dispersed leaf, see her forthcoming catalogue of Islamic manuscripts in the Pierpont Morgan Library).

Notes

I would like to thank the Library of the Topkapi Saray Museum, Istanbul, and the State Public Library, St. Petersburg, for giving me access to the manuscripts and providing me with photographs, and also the libraries in Dublin, Geneva and Washington for sending photographs.

1　Robinson, B.W.: *A Descriptive Catalogue of the Persian Paintings in the Bodleian Library*, Oxford 1958, 138, 151f.

2　Robinson, B.W.: *Persian Miniature Painting from Collections in the British Isles*, London 1967, 113f., Nos. 182–184.

3　Stori, C. A. (Storey, Ch. A.): *Persidskaja Literatura. Biobibliograficeskij obzor*, tr. Iu. A. Bregel', Moscow 1972, I, 574f., No. 428; III, 1482. See also A.J. Arberry, *et al.*: *The Chester Beatty Library. A Catalogue of the Persian Manuscripts and Miniatures*, III, Dublin 1962, 13f.

4　Saint Petersburg, GPB, Dorn 312, cf. Kostygova, G.I.: *Persidskie i tadzhikskie rukopisi Gosudarstvennoi Publichnoi Biblioteki im. M.E. Saltykova-Shchedrina*, I, Leningrad 1988, 5f., No. 12; D'iakonov, M.M., Iu. S. Dashevskii: "Pozdnie miniatiury Kasima Ali v rukopisi Gosudarstvennoi Publichnoi Biblioteki im. M.E. Saltykova-Shchedrina v Leningrade", *Izvestiya otdeleniya obshchestvennykh nauk AN Tadzh. SSR*, 5, Stalinabad 1954, 29–41; Stchoukine, I.: "Qasim ibn 'Ali et ses peintures dans les Ahsan al-Kibar", *Arts Asiatiques*, XXVIII (1973), 45–62.

5　Karatay, F.E.: *Topkapı Sarayı Müzesi Kütüphanesi Farsça Yazmalar Kataloğu*, I, Istanbul 1961, 260f., No. 756.

6　Bayani, M.: *Ahval u athar-i khushnavisan*, 3–4, Tehran 1363, 895f., No. 1339. The earliest work by his hand is a copy of Jami's *Divan* (Paris, Bibliothèque Nationale, pers. 226) dated 961/1554, cf. Richard, F.: *Catalogue des manuscrits persans*, I, Paris 1989, 233f. His last known work is part of a copy of Rumi's *Masnavi*, written 1003–05/1594–97 in Balkh, cf. Schmitz, B.: *Miniature Painting in Herat 1570–1640*, New York University, Institute of Fine Arts, 1981 (Ph.D dissertation), 385f. In Muharram 977/June to July 1569 he completed the copy of a text by Sana'i in Harat (Rampur, Raza Library, RRL 3932).

7　Robinson, B.W.: "Catalogue des peintures et des calligraphies islamiques léguées par Jean Pozzi au Musée d'art et d'histoire de Genève", *Genava*, XXI (1973), 127, No. 60, pl. p. 113.

8　This was already established by Z. Tanındı, cf. Tanındı, Z.: *Siyer-i Nebi*, Istanbul 1984, 6.

9　Bayani, *op. cit.*, 895.

10　Robinson, *Descriptive Catalogue*; Schmitz, *op. cit.*, 110–118.

11　For the story cf. Bahira, *Shorter Encyclopaedia of Islam*, eds.: H.A.R. Gibb, J.H. Kramers, Leiden, London 1961, 53f. For more concerning this miniature, including the reproduction, see my contribution to the symposium *Rezeption in der islamischen Kunst*, Bamberg, June 1992 (forthcoming).

12　Ibn Ishaq: *Das Leben des Propheten*. Aus dem Arabischen übertragen und bearbeitet von G. Rotter, Tübingen and Basel 1976, 24–26.

13　On this point cf. the aforementioned paper read at the symposium *Rezeption in der islamischen Kunst* (note 11).

14　Washington, Arthur M. Sackler Gallery, S86.0054, cf. Lowry, G.D., and M.C. Beach: *An Annotated and Illustrated Checklist of the Vever Collection*, Washington 1988, 133–135, No. 167.

15　Illustrated manuscripts from Khurasan which can be placed in the first half of the 1560s with a high degree of certainty because of their date, and which represent an artistic level somewhat below the court atelier production, lack the pronounced idiosyncrasies of the Khurasan style which became typical in the 1570s. This is indicated by the miniatures of a copy of Hilali's *Laila va Majnun*, dated 969/1561, Manchester, John Rylands Library, Ryl Pers 907, cf. Robinson, B.W.: *Persian Paintings in the John Rylands Library. A Descriptive Catalogue*, London 1980, 270–274, Nos. 801–803; likewise a copy of Jami's *Haft Aurang*, dated 971/1564, Bombay, Prince of Wales Museum, cf. Skelton, R.: "An illustrated manuscript from Bakharz", *The Memorial Volume of the Vth International Congress of Iranian Art and Archaeology*, II, Teheran 1972, 198–204. (Both copies are the work of the same calligrapher, Muhammad b. 'Ala al-Din from Raza (Zarra), Vilaya of Bakharz. In the last-mentioned manuscript Raza is given as the place of completion of the copy.)

16　Washington, Freer Gallery of Art, 46.12, cf. Welch, S.C.: *Persian Painting. Five Royal Safavid Manuscripts of the Sixteenth Century*, New York 1976, 24–27, 31, pls. 34–48; Simpson, M.S.: "The Production and Patronage of the *Haft Aurang* by Jami in the Freer Gallery of Art", *Ars Orientalis*, 13 (1982), 93–119.

17　Qazvin court painting in the middle of the 1570s is best represented by the dispersed ilustrations of the *Shahnama* of Shah Isma'il II;

cf. Robinson, B.W.: "Isma'il II's Copy of the *Shahnama*", *Iran*, XIV (1976), 1–8; on artistic developments during the last decade of the reign of Shah Tahmasp cf. Welch, A.: *Artists for the Shah*, New Haven and London 1976, 157f.

18　For a differentiation of the Khurasan style as supposedly practised in Harat from a tendency more closely following the Mashhad tradition cf. Schmitz, *Miniature Painting*, 110–125.

19　*The Chester Beatty Library, Catalogue*, III, 13–15.

20　*Ibid.*, pl. 11.

21　In default of examining the manuscript itself, this idea is based on the evidence of the detached miniatures only.

22　Washington, Sackler Gallery, S86.0282, Lowry/Beach, *Checklist*, 268, No. 316; the description of the list given there seems somehow contradictory. If the information about the written surface is accepted the measurement of the width of the illustration should be corrected.
Judging from the published photograph the miniature should be as high as it is wide (c. 14.3 cm). There is enough space for 20 lines of text, too, as can be found in the Dublin manuscript.

23　*Sotheby's Catalogue of Highly Important Oriental Manuscripts and Miniatures. The Property of the Kevorkian Foundation. Day of Sale: 7.12.1970*, 22f., Lot 50; apart from the general impression produced by the miniature the only indication of a relation to the Dublin manuscript is the measurements of the illustration (14.3 cm x 13 cm). The part of the frame at the upper and lower edges cannot be original. The stepped layout of the miniature proves the former inclusion of some lines of text which have been cut away.

24　It is noticeable that, of the small number of illustrated manuscripts which can be attributed to the Qazvin/Mashhad style between 1565 and 1575, nearly all are characterized by an individual "flavour" which makes it difficult to establish a notional main line of development. To give just two examples of those manuscripts which are dated and which might be reckoned among the typical but less ambitious works:
(1) a copy of the poems of Hilali, dated 1568: Lisbon, Gulbenkian Foundation, cf. Kühnel, E. and B. Gray: *Oriental Islamic Art*, Lisbon 1963, No. 127;
(2) Jami's *Yusuf u Zulaikha*, dated 1569: Oxford, *Bodleian Library*, 140f., pls. XXVII–XXVIII. The remarks above apply to a

copy of Jami's *Haft Aurang*, Istanbul, Topkapi Saray Museum, H. 1483, dated 1570; cf. Çağman, F., Z. Tanındı, J.M. Rogers: *The Topkapi Saray Museum. The Albums and Illustrated Manuscripts*, Boston 1986, pls. 113–118. Some of its more idiosyncratic illustrations seem somehow to be related to those in the Dublin manuscript, apart from the connections which are due to the common affiliation of both manuscripts to the Qazvin/Mashhad style.

25 The now dispersed copy of the *Shahnama* produced for Shah Isma'il II comprises some paintings which reveal the tendency towards simplification of composition, further accentuation of the individual figure at the expense of its role in the composition as a whole and limitation of details in landscape representation, as is demonstrated by the miniature "Rustam lassoing Kamus", formerly Collection of Dr and Mrs. Schott, Gerrards Cross, cf. Welch, Artists, 23. Fig. 1. These paintings are stylistic variants within the Qazvin/Mashhad style.
 Miniatures painted in the 1580s occupy an artistic level below that of the court atelier; they include the illustrations of a *Shahnama* dated 1586: London, British Library, Add. 27302, which show this tendency even more pronounced in fashion. Cf. Titley, N.M.: *Persian Miniature Painting and its Influence on the Art of Turkey and India*, London 1983, 100, pl. 16, and 109. The chronological gap between the London and Dublin manuscripts and the differences in figure painting and range of colours, however, make a connection rather unlikely.

26 Milstein, R.: *Miniature Painting in Ottoman Baghdad*, Costa Mesa 1990.

27 Dorn, B.: *Catalogue des manuscrits et xylographes orientaux de la Bibliothèque Impériale publique de St. Pétersbourg*, St Pétersbourg 1852, 387; Kostygova, *op. cit.*, 2f., No. 5.

28 This copyist is also responsible for an undated copy of three poems by Amir Khusrau Dihlavi, now in the Majlis Library in Teheran, Ms. No.

235 (according to information given to me by O.F. Akimushkin, whom I would like to thank for it). Another work by his hand is a copy of Jami's *Yusuf u Zulaikha*, dated 970/1562/63, preserved in the Columbia University Library in New York (Smith Ms. 432). Interestingly, it comprises miniatures which seem to be stylistically related to the illustrations of the St. Petersburg *Athar al-muzaffar* (information kindly made available to me by R. Milstein whom I also wish to thank).

29 More than two decades after the first discussion by Robinson (*Persian Miniature Painting*, 113–4), our knowledge of the Astarabad style can be solidly based upon a number of illustrated manuscripts. For the early stage, namely the third quarter of the 16th century, the following mss. are the most important:
 (1) Firdausi's *Shahnama*, London, British Library, Or. 12084–86, completed 972/1565 in Astarabad; cf. Titley, N.M.: *Miniatures from Persian Manuscripts. A Catalogue and Subject Index of Paintings from Persia, India and Turkey in the British Library and the British Museum*, London 1977, 52f., Nos. 123–25, pl. 19;
 (2) Three poems by Hilali, London, British Library, Or. 5601, copied 982/1574 by Nasir Astarabadi; cf. *ibid.*, 61f., No. 186;
 (3) Firdausi's *Shahnama*, Istanbul, Topkapi Saray Museum, H. 1493, copied by Sharif Munshi b. Khalifa Maulana Miran b. Maulana Mu'in al-Din al-Tuni, known as 'Alama, in the year 973/1566 in Astarabad; cf. Karatay, 134, No. 359;
 (4) Amir Khusrau Dihlavi's *Khamsa*, dated 970/1562/63, formerly Vever Collection, now Washington, Sackler Gallery, S86.0056; cf. Lowry/Beach, *CheckList*, 173, No. 204.
 Thus both manuscripts copied by Khvaja Mir b. Shams al-Din Muhammad Munshi Astarabadi and dated 1562/63 and 1573/74 respectively fit well into the period defined by the above-mentioned data. Together with the style of the illustrations, that would be

sufficient proof of their origin in Astarabad.

30 Horten, M.: *Die religiöse Gedankenwelt des Volkes im heutigen Islam*, Halle 1917, 36.

31 Cf. note 29.

32 The text of the *Athar al-muzaffar* (foll. 1b–140b) is followed by a copy of the *Shahnama-yi Tahmasp* by Qasimi Junabadi (foll. 142b–213a). Cf. Dorn, *op. cit.*, 387f.; Kostygova, *op. cit.*, II, Leningrad 1989, 10f., No. 735, and another work by the same author, named *Zubdat al-ash'ar* (foll. 215b–272a), cf. Dorn, *op. cit.*, 388; Kostygova, *op. cit.*, 244f., No. 692. Both were obviously copied by the same calligrapher, who called himself Muhammad b. Ruhallah al-Tabib at the end of the *Shahnama-yi Tahmasp* which he finished in Safar 982/May to June 1574 and Muhammad only in the colophon of the other text completed in the month of Dhu'l-Qa'da 982/February to March 1575. We do not know much about this calligrapher but it seems that he was connected with Qazvin. Most probably, his father was the famous physician Mir Ruhallah Qadi Jahani who died during the reign of Muhammad Shah in Qazvin and who was also a calligrapher of note, cf. Eskandar Beg Monshi: *History of Shah 'Abbas the Great*, tr. by R.M. Savory, Boulder 1978, 265f.; the brother of Mir Ruhallah was most famous as a calligrapher, cf. *ibid.*, 267f. There is another manuscript copied by Muhammad b. Ruhallah, a *Divan* of Bana'i, dated 983/1576, Dublin, Chester Beatty Library, Pers. 243. It comprises three illustrations which belong to the Qazvin/Mashhad style, cf. *The Chester Beatty Library Catalogue*, III, 21, pl. 16.

33 Apart from the unfinished illumination of both manuscripts copied by Muhammad b. Ruhallah al-Tabib there are spaces left empty for illustration in the *Shahnama-yi Tahmasp*. Their layout is similar to that of the miniatures in the just mentioned *Divan* of Bana'i in the Chester Beatty Library and unlike the layout of the Astarabad miniatures.

A Reconstruction and Preliminary Account of the 1341 Shahnama

With Some Further Thoughts On
Early *Shahnama* Illustration

MARIANNA SHREVE SIMPSON

I N THE YEAR 741 OF THE HIJRA, CORRESPONDING TO 1341
A.D., Qawam al-Daula wa'l-Din Hasan, vizier to the Inju gov-
ernor in Fars province, commissioned an illustrated copy of Fir-
dausi's *Shahnama*. By the year 1919 A.D. the vizier's manuscript
had made its way out of Iran and into the hands of the dealer Dikran
Kelekian, who proceeded to sell its leaves throughout Europe and
North America.[1] Recently it has been possible to track down a
significant percentage of the manuscript's dispersed folios and to
reconstruct their original order.[2] This reconstruction is presented
here in appendix form, along with a listing of the known folios by
collection.

The dispersal of the 1341 *Shahnama* during the early twenti-
eth century, however regrettable from our present perspective, did
result in its becoming familiar to a wide scholarly audience. By
the 1930s the manuscript had begun to receive considerable
attention and folios from it were included in the major exhibi-
tions of Persian painting held in London (1931) and Paris (1938).
Over the past six decades the manuscript has figured in virtually
all studies of fourteenth-century Persian painting and in numer-
ous surveys and collection and exhibition catalogues.[3]

Most references to the 1341 *Shahnama*, particularly in sur-
vey-type publications, appear within discussions of the so-called Inju
school or atelier of Shiraz.[4] The half-dozen or so illustrated man-
uscripts attributed to Inju Shiraz share a very similar painting style.

This is characterized by a rather slapdash technique featuring strong
but often hastily-drawn contours and paint applied in uneven and
thin washes of colour; flat, planar compositions with an additive
arrangement of forms; tall, rather stiff personages usually with over-
size heads and unfocused eyes; long-legged and sometimes dappled
horses and an occasional elephant with ears like wet drapery; and
schematic landscape features including mountains rendered as sharp
pointed vertical peaks of bright colour. Perhaps the most distinc-
tive aspect of the Inju or Shiraz style – often commented upon as
a kind of hallmark – are the predominately red and ochre backgrounds
against which figures, animals and landscape elements are silhou-
etted. As has been frequently noted, the association of this painting
style with Shiraz, capital of the Injus in Fars province, was first made
by Ivan Stchoukine who based his attribution on the patron of
the 1341 *Shahnama*.[5] Thus the manuscript occupies a position of
historiographical – as well as historical – significance within the
study of early Persian painting.

In addition to the dispersed 1341 *Shahnama* the group of Inju-
style manuscripts comprises two intact and nowadays well-known
Shahnama volumes: one dated 731/1330 in the library of the Top-
kapi Saray Museum, Istanbul (H. 1479) and the other dated 733/1333
in the National Library of Russia, St. Petersburg (Dorn 329).[6]
Besides sharing formal characteristics, this troika of closely-dated
*Shahnama*s takes a similar approach to the illustration of the Persian

national epic – an issue that will also be addressed here, picking up an old line of investigation and expanding upon it with the assistance of the newly-reconstructed 1341 *Shahnama*.[7]

Documentation

It may be helpful to begin this preliminary account of the 1341 *Shahnama* by clarifying a point about its internal documentation that has become somewhat muddled in the scholarly literature. The descriptive catalogue of the 1931 Burlington House exhibition mentions that the manuscript contains a colophon dated 741 and a dedication to the vizier al-Hasan Qawam al-Daula wa'l-Din.[8] In his 1936 *Peinture Iranienne* Stchoukine briefly describes "une rosace enluminée," then in the collection of Henri Vever, with an inscription stating that the manuscript was finished in 741 A.H. for the library of Qawam al-Din Hasan, vizier of Fars.[9] While these early references are not wrong, neither one is complete or totally accurate. As finally determined upon the "re-emergence" of the Vever collection and its acquisition and publication by the Arthur M. Sackler Gallery, Washington, the 1341 *Shahnama* has a pair of eight-lobed rosettes on facing folios (AMSG S1986.110, verso and S1986.111, recto: pls. 1–2). These contain a two-part inscription specifying that the manuscript was made by order of the *kitabkhana* of the great

lord, honourable minister, chief vizier of glorious Fars etc., etc., the venerable Hajji Qawam al-Daula wa'l-Din Hasan (right rosette) at the end of the auspicious month of Ramadan, the year seven hundred and forty-one (left rosette).[10] In addition to this dedication, which appears within the manuscript's preliminary matter, the 1341 *Shahnama* does contain a colophon, as mentioned in the Burlington catalogue. This comes at the end of the epic text on the manuscript's last surviving folio, now in the collection of Sadruddin Aga Khan (SAK IR.M. 6/I, verso: pl. 3).[11] The triangular colophon is followed by a finispiece published as Shah Mahmud of Ghazna enthroned, but more accurately a generic enthronement scene. Although the colophon text is badly damaged and partly rewritten, enough of the original inscription remains to confirm that the manuscript was copied by the scribe Hasan ibn Muhammad ibn 'Ali ibn (?) Husaini, known as al-Mausili, and completed on the twentieth day of the month of Dhu'l-Qa'da. Unfortunately, the year has been scratched out,[12] but it has been generally assumed that it would have read 741. Yet given that 20 Dhu'l-Qa'da 741 (corresponding to 7 May 1341) comes only forty-nine days after the end of Ramadan 741 (corresponding to mid-March 1341), which is the date given in the dedicatory rosette, it may be necessary to consider the possibility that the now-obliterated colophon year would

pls. 1–2
1341 *Shahnama*, folios [5b–6a]: Dedicatory rosette
Courtesy, Arthur M. Sackler Gallery, Smithsonian Institution, Washington, D.C. (S1986.110, verso and S1986.111, recto)

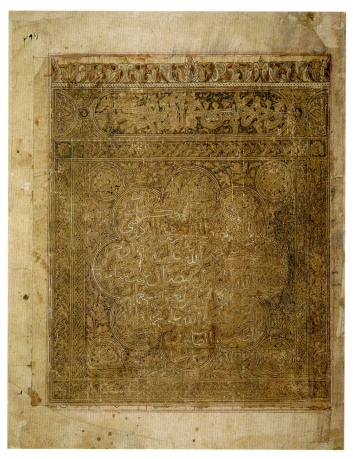
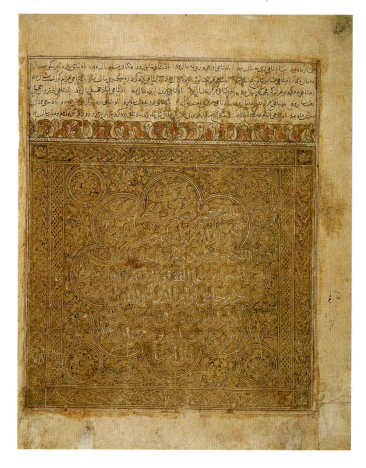

pl. 3
1341 *Shahnama*, folio [321/322b]: Colophon and finispiece
Collection of Prince Sadruddin Aga Khan, Geneva (IR.M.6/I, verso)

have read 742 (or even 740, given the possibility that the text could have been transcribed and dated before the dedicatory inscription was written and dated.) In any event, the key point here is that the *Shahnama* made for Qawam al-Daula contains both a dated ded-

ication at the beginning and a dated colophon at the end.[13] The manuscript was thus doubly documented – which may make it a *unicum* in the recorded corpus of fourteenth-century Persian illustrated manuscripts.[14]

pl. 4
1341 *Shahnama*, folio 317a: *Shahnama* text
Worcester Art Museum, Worcester, Massachusetts (1953.21, recto)

pl. 5
1341 *Shahnama*, folio 317b: Sa'd-i Vaqqas slays General Rustam
Worcester Art Museum, Worcester, Massachusetts (1953.21, verso)

Material form and preliminary matter

In its original form the 1341 *Shahnama* would have contained approximately 325 folios, of which well over one-half is extant.[15] The known folios consist of medium-weight paper, dark cream or light beige in colour and unpolished. Most are quite worn and stained, with creased surfaces and ragged edges, and many have been trimmed. The average sheet dimensions are 37 x 30 cm; the written surface measures 28 x 24 cm. The standard page consists of 30 lines of text written in six columns, with three *Shahnama* verses per line, or ninety verses per page. The columns are defined by two pairs of tomato red lines, and the written surface enframed with a pair of tomato red lines and a single grey line, now quite faded.[16] The two central text columns are regularly punctuated by rubric panels that "displace" two or three lines of text and are defined top and bottom by a pair of red lines (pls. 4–5).

The text is written in black ink in clear and measured *naskh*. The rubrics are in *tawqi* and in a variety of colours, including burgundy, tomato red and green ink with black vocalization signs as well as black with red vocalization.

The manuscript opens with a double-page frontispiece depicting a hunting scene on the right and an enthronement on the left

(AMSG S1986.113, side 2 and S1986.112, recto: pls. 6–7).[17] Both paintings feature quite standardized iconography, symmetrical compositions, thinly-painted forms and abraded surfaces.

The hunt takes place in a mountainous landscape of tall multi-coloured peaks. A pair of mounted horsemen face each other in the foreground, attended by two smaller figures on horseback on a slightly higher plane. A large quadruped, resembling an onager, gazes upwards from the centre of the mountains, while two archers on foot take aim at four other animals above and at the left side. The presence of a number of unusual or anomalous features, such as the odd chicken-like creature between the two principal horsemen, and the illuminated heading pasted on at the top, suggest that this painting has been reworked.[18]

The enthronement that constitutes the left half of the frontispiece seems to have survived more or less in its original state, including the surrounding fret design in gold (also present around the hunt scene) and an outer frame of "layered" petals, highlighted in gold, orange and grey and punctuated in the centres and corners by roundels with gold blossoms. The composition itself is quite crowded, with over twenty-five figures disposed in three

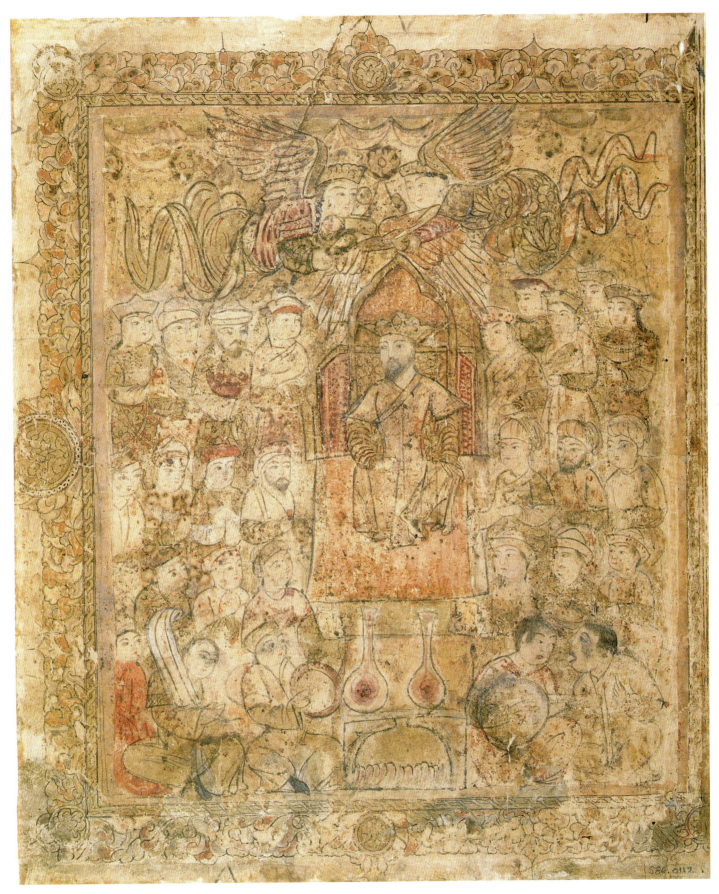

pls. 6–7
1341 *Shahnama*, folios [1b–2a]: Double frontispiece
Courtesy, Arthur S. Sackler Gallery, Smithsonian Institution, Washington, D.C. (S1986.113, side 2 and S1986.112, recto)

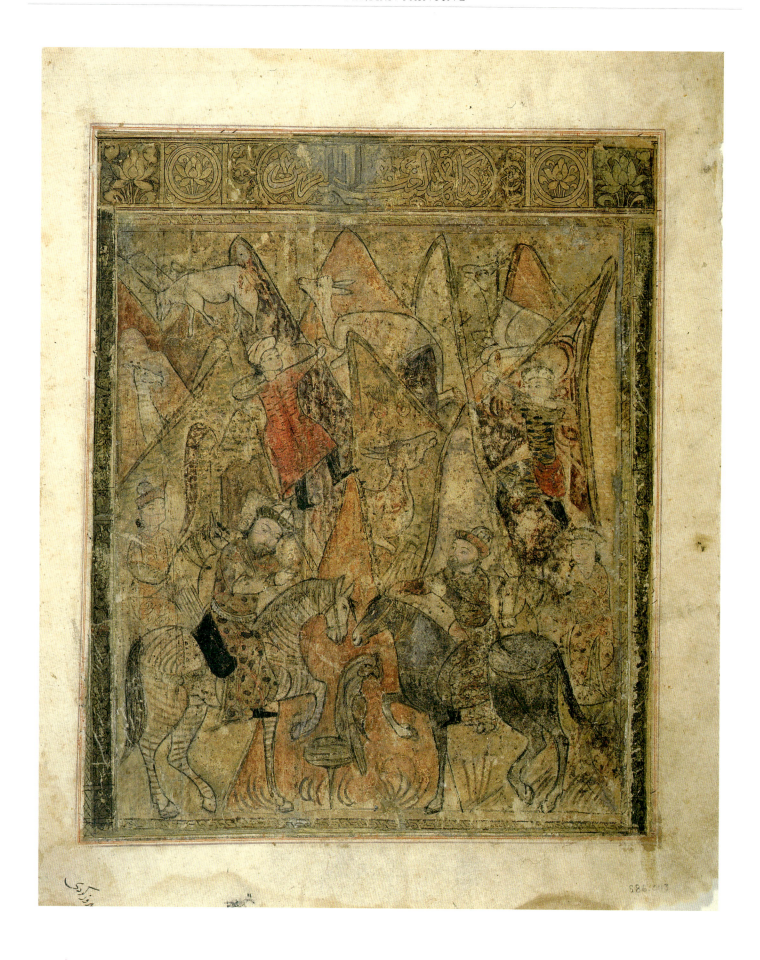

rows around the crowned and enthroned central figure, plus two angels hovering overhead. Of particular note is the figure in the lower right who seems to be singing (or at least speaking) loudly to his lute-player companion. Other than this bit of interaction, the scene is completely static, with virtually all participants facing in towards and/or looking at the king, who himself stares off towards the left. The sense of stasis is capped by the angels, who fly together in tandem, their torsos, wings and streamers fixed at practically the same angle. The symmetry of the scene is further enhanced by the carefully-parted white curtain above the angels and the two tall-necked bottles, filled with red liquid, that rest on the table in the centre foreground. All in all, this enthronment subscribes completely to the Islamic tradition of highly structured, at the same time somewhat theatrical, frontispieces, as represented, for instance, by the painting at the beginning of volume seventeen of the *Kitab al-Aghani*.[19]

The verso of the enthronement frontispiece contains the beginning of the prose text of the so-called old preface to the *Shahnama* (AMSG S1986.112).[20] The text on the initial prefatory page and on its mate on the facing recto (CB 110.1) is set within an illuminated frame of matching design (pls. 8–9). This includes two pairs of rounded panels with inscriptions and flanking floral medallions joined at top and bottom by a vertical band of gold basket weave.

The four panels are inscribed in Arabic with the *bismilla* (top right), followed by the first verse of sura I (*Fatiha*) of the Qur'an (top left), and praises to God and the Prophet Muhammad (bottom right and left). All four sections of text are written in white letters outlined in black and reserved within gold contour panels. The surrounding interstices are filled with gold blossoms and leaves on curving stems. A pair of small roundels, each enclosing a single gold blossom, link the inscription panels to a half medallion filled with a vertical design of split palmettes in gold against a darker gold ground. The spaces between the panels, roundels and medallions contain double floral scrolls in gold.

After this double-page illumination, the old preface continues for several more folios of prose text.[21] The penultimate folio in the sequence includes, at the bottom, a small composition depicting Firdausi and the three court poets of Ghazna (SAK IR.M. 56, verso: pl.10). The author of the *Shahnama* sits cross-legged on the left, facing 'Unsuri, Farrukhi and Asjadi who each hold beakers. While this scene is familiar enough today, in fact it does not appear in any other early *Shahnama* manuscript – making its appearance here possibly something of a first.

The final folio of the prose preface, reconstructed here as folio 5, contains on its recto four illuminated rubrics giving the length

pls. 8–9
1341 *Shahnama*, folios [2b–3a]: Double folios with beginning of old preface to *Shahnama*
right half: Courtesy, Arthur M. Sackler Gallery, Smithsonian Institution, Washington. D.C. (S1986.112, verso)
left half: Chester Beatty Library, Dublin (MS 110.1, recto)

pl. 10

1341 *Shahnama*, folio 4b: Old preface and illustration
of Firdausi and the court poets of Ghazna

Collection of Prince Sadruddin Aga Khan, Geneva (IR.M. 56, verso)

pl. 11

1341 *Shahnama*, folio [5a]: Old preface

Courtesy, Arthur M. Sackler Gallery, Smithsonian Institution,

Washington, D.C. (S1986.110, recto)

of the Pishdadian, Kayanian, Ashkanian, and Sassanian dynasties (AMSG S1986.110: pl. 11). Like the *bismilla* and related invocations at the start of the preface, the text here is written in white ink with black outlines and reversed in gold contour panels. The interstices are filled with gold leaves set against a silver (line 1), gold (lines 2 and 4), and green background.[22]

The last few lines of the prose preface, enumerating the reigns of the Sassanian kings, appear on the verso of reconstructed folio 5 just above the first half of the manuscript's two-part dedication. As previously mentioned, the dedication is enclosed in a pair of matching eight-lobed rosettes (pls. 1–2). Each rosette contains nine lines of text, written in white and outlined in black. The lines are reserved in bright gold contour panels and the interstitial spaces filled with gold leaves against a darker gold ground. The ground immediately around the rosettes is filled with leafy floral sprays and four large lotus roundels that square off the central field. This area is set within a double frame composed of inner bands of gold braid on the left and right sides and outer bands of split palmette interlace on all four sides, punctuated at the corners by small blossoms. The illumination on folio 5 verso is further separated from the lines of text above by a thin white band with black

checks and a row of petals, with one blossom in the centre and two half-blossoms at the ends, similar in form and palette to the motifs in the border around the frontispiece enthronement (folio 2a). The facing rosette is surmounted by an inscription panel, virtually identical to those at the beginning of the prose preface on reconstructed folios 2b and 3a. The inscription is a fragment of Arabic poetry: "And the best companion of all time". The best companion here seems to refer to a book; thus this poetic excerpt evidently was meant to pay homage to the *Shahnama*.[23] Of further note is the knotted tail of the *ya* in the word *fi*; such epigraphic elaboration is unique in the 1341 manuscript. This panel is capped by a slightly larger version of the petal band found above the first rosette.

The actual text of Firdausi's *Shahnama* begins on the verso of reconstructed folio 6 (AMSG S1986.111). Both this folio and the facing recto of folio 7 (AMSG S1986.109) are surrounded by an illuminated frame that forms a double composition (pls. 12–13). The illumination consists of four rectangular inscription panels, with the text treated similarly to the inscriptions at the beginning of the old preface. The inscriptions here consist of praises to God in Persian: "In the name of Him by whose command existence came into being [top right]. The heavens gained their motion,

pls. 12–13
1341 *Shahnama*, folios [6b–7a]: Beginning of the *Shahnama*
Courtesy, Arthur M. Sackler Gallery, Smithsonian Institution, Washington, D.C. (S1986.111, verso and S1986.109, recto)

the earth its stability from Him [top left]. The exalted is God, one without equal [bottom right] whom lords call Lord [bottom left]."[24] Each of the inscription panels is flanked by a square enclosing a large gold lotus blossom and tripartite leaves. The top and bottom panels are linked together by a band of superimposed fleur-de-lys encased in a pair of split palmettes against a ground of alternating colours (gold, green and white). These illuminated frames feature additional motifs in the side margins: a scalloped medallion in the centre filled with a lotus blossom and sprays and edged with a row of petals, and two small floral roundels at the top and bottom that resemble mirrors and include a winged outer edge (most clearly visible on AMSG S1986.109, recto). Each of these facing folios also contain a pair of illuminated rubrics with the text written in white, reserved in a gold contour panel and surrounded with gold leaves against either a silver or gold ground. Although the illumination on these folios is to all intents and purposes identical and forms a mirror-image composition, there are subtle differences in detail, such as the size and treatment of the fleur-de-lys and the colour of the ground around the inscriptions, that suggest an artistic concern to avoid mechanistic replication of standard forms.

What is even more interesting about the preliminary matter in the 1341 *Shahnama* is that while the contents of the initial folios are comparable to those in the 1330 and 1333 *Shahnama*s, the arrangement of the constituent parts is quite distinctive. The 1330 *Shahnama* in Istanbul, for instance, opens with an illuminated rosette (TKS H. 1479, folio 1a), now enclosing an obviously rewritten and only partly legible inscription that originally might have constituted a dedication. This is immediately followed by the old preface (folios 1b–4a), with the first pair of facing folios set within an illuminated frame. Next comes a double frontispiece, depicting an audience-cum-enthronement scene (folios 4b–5a), and then Firdausi's text, with an illuminated frame around the initial verses (folios 5b–6a). This was evidently the same order used in the 1333 *Shahnama* in St. Petersburg, as can best be judged from its initial fragmentary folios (National Library of Russia, Dorn 329, fols. 1a–2b).[25] The 1341 *Shahnama* thus switches the position of the frontispiece and dedicatory rosette, suggesting that what might have seemed like a fixed sequence for the opening folios of a *Shahnama* manuscript made in Shiraz was actually quite flexible.

Pictorial programme

One hundred and four of the folios surviving from the 1341 *Shahnama* are illustrated; this figure includes the illustrated frontispiece and finispiece, seven text folios with pasted-on illustrations

and four folios with multiple illustrations.[26] On the basis of the reconstruction, and especially the lacunae between surviving folios, it may be deduced that the original manuscript contained between 30 and 50 more illustrated folios. Altogether this makes for 105 surviving text illustrations and perhaps as many as 140 originally, plus the frontis- and finispiece. The manuscript was thus much more heavily illustrated than either of its intact counterparts from Shiraz: the 1330 volume has 92 extant text illustrations and the 1333 manuscript only 49.[27]

Like other fourteenth-century paintings for the *Shahnama*, the known illustrations in the 1341 volume vary greatly in size and shape. Approximately half of the picture planes are rectangular, cutting across the full width of the written surface and occupying the equivalent of nine to eleven lines of text. A small handful occupy the middle four columns of text. Over 40 compositions are "stepped" with their upper, and sometimes even lower, sections taking up a decreasing number of text columns in width. These paintings step up and down in the centre or at the sides, creating a variety of often unusual pyramidal shapes. The representation of Mihrak's

daughter conversing with Shapur at the well (HUAM 1960.192), for instance, steps up at one end and down one column width in the centre, thereby creating discrete spaces for the two principal figures, a waiting horse, and the well (pl. 14). Quite a number of other illustrations make the same conscious use of stepped picture planes.[28] Although the configuration of these particular compositions may have been determined by the iconography of the scenes, other much more generic illustrations, such as enthronements and battles, also occupy stepped compositions, suggesting that the format may have been dictated as much by aesthetic as iconographic considerations.

In general the illustrations in the 1341 *Shahnama* subscribe to the stylistic conventions associated with painting in Shiraz during the Inju period. More specific features include double lines delineating forms (that is, outlines that have been drawn twice) and red pentimenti visible beneath the typically thin washes of paint. Human proportions are frequently lanky and positions awkward; heads often come right up to the edge of the picture plane as if trying to push out of the composition. Women are defined by

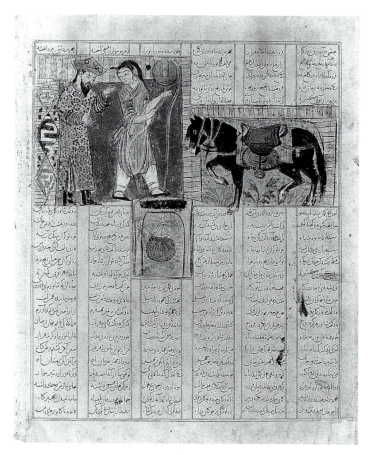

pl. 14
1341 *Shahnama*, folio [216a]: Mihrak's daughter
converses with Shapur at the well
Courtesy of The Arthur M. Sackler Museum, Harvard University Art
Museums, Cambridge, Massachusetts. Bequest of Abby Aldrich Rockefeller
(1960.192)

pl. 15
1341 *Shahnama*, folio [187b]: Rustam and Isfandiyar
meet and parley
The Metropolitan Museum of Art, New York. The Cora Timken Burnett
Collection of Persian Miniatures and Other Persian Objects, Bequest of
Cora Timken Burnett (57.51.36)

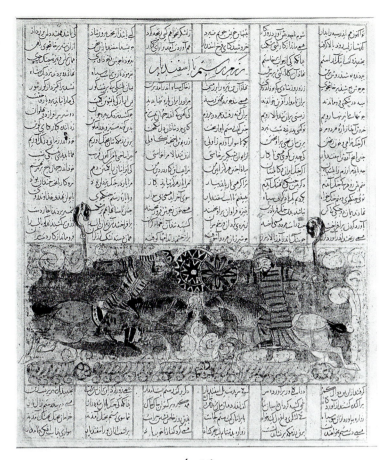

pl. 16
1341 *Shahnama*, folio [191a]: Rustam and Isfandiyar
test each other

Albright-Knox Art Gallery, Buffalo, New York, Sherman S. Jewett Fund
(35:15.2)

pl. 17
1341 *Shahnama*, folio [59a]: Fire ordeal of Siyavush

McGill University Libraries, Montreal, Department of Rare Books and
Special Collections (1977.4)

two long locks of hair hanging from beneath pleated wimples, while men appear in two standardized facial types: round faces without beards and long faces with pointed beards. Horses are large-boned and rangy, and sometimes lower their heads to graze at inappropriate moments, such as battles. Landscapes usually lack any ground plane; at most *terra firma* is indicated by a single clump of grass. Clouds appear more frequently, usually as horizontal bands with "tails" that trail down the background (pls. 15–16). While the overall style of the 1341 illustrations seems quite uniform, there are a few paintings that differ from the norm with smaller compositions and shorter, squatter figures (pl. 17).[29] These works suggest that the manuscript was illustrated by more than one artist or artistic team – a not unlikely situation given the projected size of the original pictorial programme.

Shahnama *illustration in Shiraz*

Much of the recent and ongoing scholarship on *Shahnama* illustration during the first half of the fourteenth century concerns the rate of illustration in individual volumes and the significance of the distribution and choice of scenes in terms of a manuscript's purpose and meaning. In an earlier phase of investigation of the pattern of *Shahnama* illustration, I observed that the rate of illustration and distribution of paintings in the Shiraz manuscripts – and at that time I was able to discuss only the 1330 and 1333 volumes – was

uneven and unpredictable.[30] Sometimes seven, eight or even more folios go by without a single painting, only to be followed by a close succession of illustrated folios. The recent reconstruction of the 1341 *Shahnama* reveals this same general pattern, although the greater number of illustrations in the third of the Inju *Shahnama* troika results in a higher overall ratio of illustrated to unillustrated folios than in two other volumes. For instance, the unbroken sequence of twenty folios between folios 169 and 189 in the 1341 codex starts with three text folios, then an illustrated folio, then three text folios, then three illustrated folios, then one text folio, then a folio with two illustrations followed by a folio with one illustration, then five text folios, then an illustrated folio, a text folio, an illustrated folio, a text folio and an illustrated folio. Similarly, the 32 surviving and reconstructed folios between 210 and 242 go: one illustrated folio, two text folios, one illustrated folio, two text folios, one illustrated folio, nine text folios, two illustrated folios, one text folio, two illustrated folios, six text folios, one illustrated folio, four text folios and one illustrated folio.

Many other examples could be enumerated, but the point is clear: the distribution of illustrations in the 1341 *Shahnama* is variable, and the pictorial programme is based on some principle or scheme other than that of regular alternation of text and illustration. Obviously the manuscript's illustrator (or illustrators) was

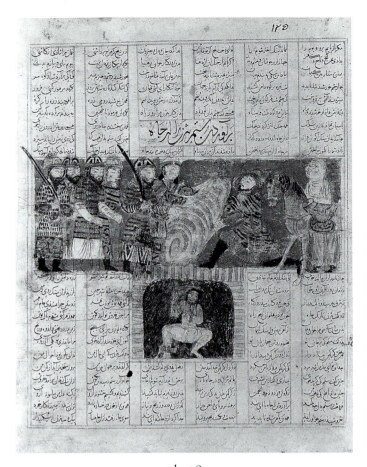

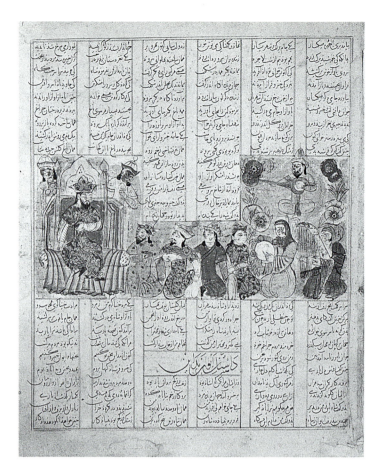

pl. 18
1341 *Shahnama*, folio 125a: Rustam rescues Bizhan
from the pit

Courtesy, Freer Gallery of Art, Smithsonian Institution, Washington, D.C. (45.7)

pl. 20
1341 *Shahnama*, folio [310/311]: Musician Barbad
plays for Khusrau Parviz

Art and History Trust Collection, courtesy of the Arthur M. Sackler
Gallery, Smithsonian Institution, Washington, D.C.

under no requirement to produce an evenly-paced visual narra-
tive. Rather, what we seem to have here is a pictorial programme
that allowed for the illustration of selective scenes wherever they
might fall within the manuscript. Thus the cycle of Bizhan and Man-
izha and the cycle of Rustam and Isfandiyar are heavily illus-
trated (that is, they have a high illustration to text ratio), while those
of Siyavush and Iskandar have relatively few images.

In the study of other traditions of manuscript illustration it
might be argued that the choice of scenes was determined by the
available models. In the case of the 1341 *Shahnama* such models could
have been the 1330 and/or 1333 codices, and indeed, about half
of the miniatures surviving from the 1341 manuscript appear in
one or the other or both of the two earlier volumes. These shared
images include a number of by now quite familiar scenes such as
Rustam rescuing Bizhan from the pit and the musician Barbad play-
ing for Khusrau Parviz (pls. 18–21).[31] As it happens, not only
the iconography, but also the composition of these scenes is
often quite similar, suggesting that the artist(s) of the 1341 manu-

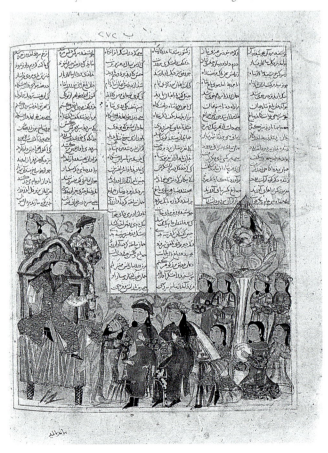

pl. 21
1330 *Shahnama*, folio 272b: Musician Barbad plays
for Khusrau Parviz

Topkapi Sarayi Müzesi, Istanbul (H. 1479)

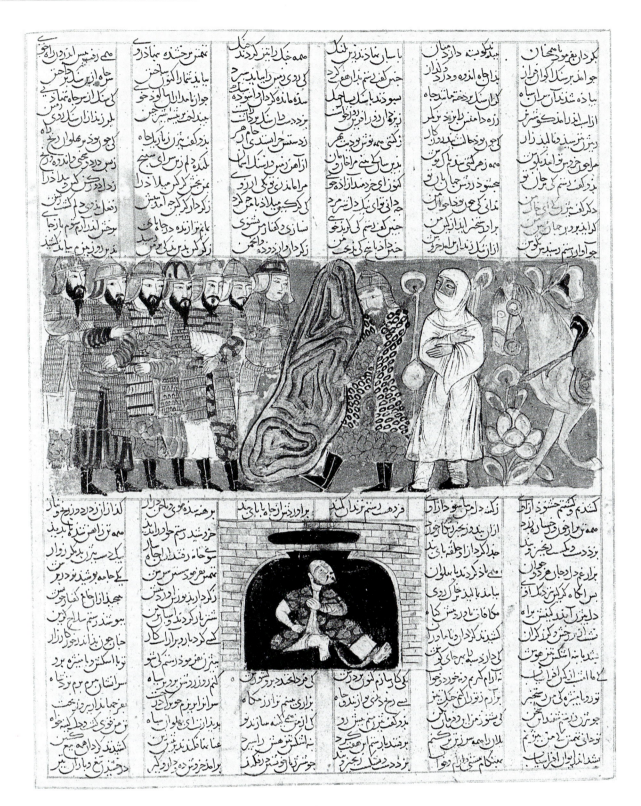

pl. 19
1330 *Shahnama*, folio 91b: Rustam rescues Bizhan from the pit
Topkapi Sarayi Müzesi, Istanbul (H. 1479)

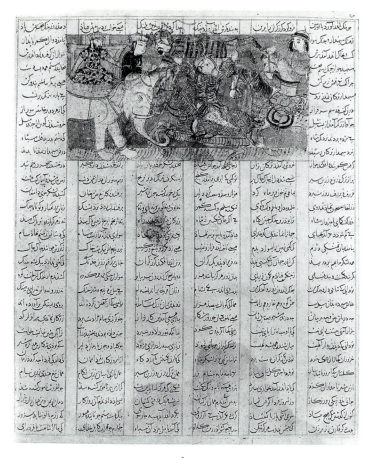

pl. 22
1341 *Shahnama*, folio 37a: Rustam catches Afrasiyab
by the belt and lifts him from the saddle

pl. 23
1330 *Shahnama*, folio 28a: Rustam catches Afrasiyab
by the belt and lifts him from the saddle

script may very well have been copying from or were inspired by the earlier illustrations. On the other hand, there are instances of considerable divergence, particularly involving the illustration of specific narrative moments within the same episode, as in the shared representations of Rustam lifting Afrasiyab from the saddle, which suggests pictorial creation rather than cribbing (pls. 22–23).

That the illustrations in the 1341 *Shahnama* resulted from an artistic process that allowed for invention and variation is suggested by the impressive number of its unique illustrations. The manuscript contains twenty-one illustrations that are not found in either the 1330 or 1333 volumes, including such scenes as Tahmina coming to Rustam's chambers (KEIR III.4) and Bizhan hunting wild boar (MET 29.160.22), and another 34 that do not appear in any other fourteenth-century *Shahnama* (e.g. pl. 24). Thus fully half the extant compositions in the 1341 manuscript may have been selected and formulated quite independently of any existing models, Shiraz or otherwise. Admittedly many of the singular paintings reflect what by the fourth decade of the fourteenth century must have been standard iconographic typolo-

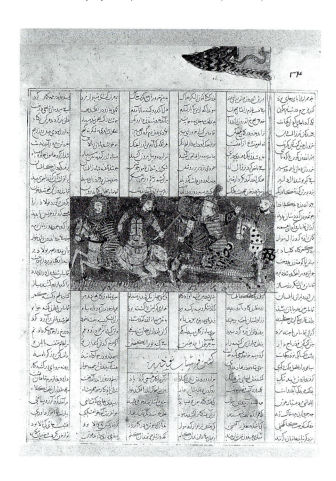

pl. 24
1341 *Shahnama*, folio 34a: Zal joins Mihrab in
battling Turanians

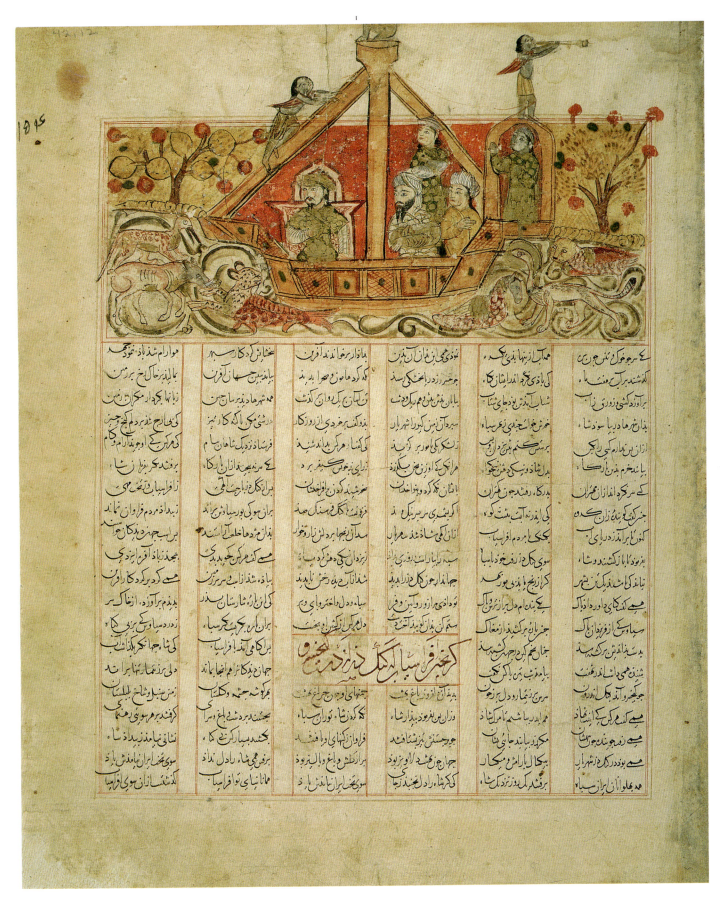

pl. 25

1341 *Shahnama*, folio 154a: Kay-Khusrau sees marvels of the sea

gies for scenes such as enthronments, banquets, battles, pursuits, executions and hunts. There are some illustrations, however, that reveal an imaginative interpretation of the *Shahnama* text, as when Kay Khusrau sees the marvels of the sea (FGA 42.12) where the fantastic creatures, including a winged horse, a sea lion and a half-fish/half-leopard amalgam, convey the very essence of Firdausi's verses (pl. 25).

All that being said, unique illustrations are by no means peculiar to the 1341 *Shahnama* alone. Both the 1330 and the 1333 *Shahnama*s also contain a number of scenes that are not found in any of the other illustrated *Shahnama*s of the period. As in the 1341 manuscript, some of these are quite typological and others more original. The 1330, 1333 and 1341 manuscripts also share other pictorial characteristics, including compositions that exhibit a close text-image relationship (that is, they are placed in the middle of the episodes they illustrate), and that, in all but a few cases, derive their iconography directly from the nearest verses. Furthermore, to reiterate the initial point about the distribution of illustrations, the paintings in these *Shahnama* manuscripts appear at irregular and unpredictable intervals throughout the epic text. In short, all three manuscripts contain pictorial programmes that combine the routine and the unexpected.

In my previous work on the 1330 and 1333 *Shahnama*s I suggested that one explanation for their illustrative character might lie in their cultural milieu, namely Inju Shiraz.[32] As is well known, Shiraz was the centuries-old capital of Fars province, nucleus of the ancient Achaemenid kingdom of Persia and locus of its mother tongue. Unlike other parts of Iran, Shiraz had been left relatively unscathed during the Mongol invasions and had retained its native Iranian population and native Iranian governors who in the Mongol period came from the ranks of those called Injus, or administrators of the properties of the Il-Khans.[33] During the thirteenth and fourteenth centuries Shiraz was home to many celebrated poets, historians and critics, as well as active patrons of arts and letters. Prominent among these was Qawam al-Daula wa'l-Din Hasan, who served as grand vizier to two successive Inju governors from the mid-1330s through to the mid-1350s (Jalal al-Din Mas'ud Shah, r. 1336–42 and Abu Ishaq, r. 1344–56). It may be assumed that all the high officials-cum-art patrons of the Inju clan in Shiraz would have been thoroughly familiar with the great classics of Persian literature, and especially with the *Shahnama* with all its references to historical events that actually transpired in that region. Undoubtedly Qawam al-Daula had his favourite sections of Fir-

dausi's epic, and may have directed the painter(s) of his *Shahnama* to concentrate on cycles such as Bizhan and Manizha and Rustam and Isfandiyar (both of which are heavily illustrated relative to their total number of folios) and to skip over or go easy on others, such as Siyavush and Iskandar.

Further research on Inju patronage is likely to clarify the extent to which the selective nature of the illustrative cycles in the 1330, 1333 and 1341 *Shahnama*s resulted from or reflected the literary tastes, artistic interests and/or ideological concerns of their patrons.[34] In the meanwhile, there are some general hypotheses and conclusions that may be drawn from the newly-reconstructed 1341 *Shahnama* together with its earlier sister manuscripts. First of all, the high number of compositions projected for this volume suggests that the rate of *Shahnama* illustration did not steadily decline, as one might presume on the basis of the 1330 and 1333 manuscripts, to end inexorably in sparsely-illustrated manuscripts such as the *Shahnama* of 1370 (Topkapi Saray Museum Library, H. 1511). It is possible, of course, that the heavily illustrated 1341 *Shahnama* is a temporary reversal in an otherwise downward trend, but the greater likelihood is that it signifies the continued evolution of *Shahnama* imagery. Secondly, the 1341 *Shahnama* confirms what previously has been proposed for the 1330 and 1333 volumes, namely that the development of the pictorial *Shahnama* in the first decades of the fourteenth century was marked by at least two distinct phases, or historical generations: the first represented by the so-called small *Shahnama*s with their very regular series of illustrations and the second by the Shiraz *Shahnama*s with their much more selective sequences.[35] Coming finally to a broad historiographical point, it seems to remain the case that the study of the intact 1330 and 1333 volumes and now the reconstructed 1341 *Shahnama* does not necessarily bring us any closer to what in other areas of manuscript studies would be called the *Ur*, or original, text from which all subsequent copies derived. The illustration of *Shahnama* manuscripts depended far more on the motivation and needs of their time and place of origin than on mechanistic procedures involving the copying of one illustrated codex from another. This is not to say that the first illustrated *Shahnama* will never be identified or hypothesized, but simply that the earliest known dated volumes – those of 1330, 1333 and 1341 – suggest a mode of manuscript illustration and illumination still in the process of formation, one with a simultaneously dynamic and pragmatic artistic attitude and approach towards the Iranian national epic.

Notes

I am grateful to Oya Pancaroglu for assistance with the organization of materials pertaining to the 1341 *Shahnama* and the final preparation of the manuscript's reconstruction, and to Sharon Littlefield for work on Appendix II and related bibliographic citations. I also would like to acknowledge the very helpful contributions of Marjan Adib and Wheeler Thackston. My thanks also to Eleanor Sims for information about folios in the Khalili collection as well as others sold at London auctions.

1 Some of the leaves are stamped with different seals which may document the names of owners before the manuscript left Iran (e.g., FGA 48.15, verso). Most of the seal impressions are no longer easily legible, although one of them reads Ikhlas ibn Muhammad ibn Ikhlas Khan and is dated 1001/1689–90. See Arthur J. Arberry, Edgar Blochet, Basil W. Robinson and James V.S. Wilkinson, *The Chester Beatty Library: A Catalogue of the Persian Manuscripts and Miniatures* vol. 1 (Dublin: Hodges and Figgis, 1959), p. 26. The registrar's files of the Freer Gallery of Art contain considerable correspondence concerning the 1341 *Shahnama*, including a letter of 8 September 1938 from Dikran Kelekian stating that the manuscript was brought from Tehran in 1919 by a Dr. Raffy. The provenance appears more complicated in a letter of 15 June 1942 from H.S. Andonian, a Kelekian associate. This letter suggests that Dr. Raffy supplied Kelekian with two separate but similar *Shahnama* manuscripts, the first in 1919 and the second "a few years later." The association between Dr. Raffy (or Raffi) and a *Shahnama* manuscript appears from time to time in the scholarly literature. See, for instance, Eric Schroeder, "Ahmed Musa and Shams al-Din: A Review of Fourteenth Century Painting," *Ars Islamica* 6 (1939): 114 n. 6; *idem*, *Persian Miniatures in the Fogg Museum of Art* (Cambridge, MA: Harvard University Press, 1942), p. 29 n. 7.
It is possible that at some point the 1341 manuscript was bound in more than one volume; the large number of non-sequential folios belonging to the Chester Beatty Library (MS. 110), for instance, are contained within a fourteenth-century binding. I have found no physical corroboration, however, to support the assertion that Kelekian was selling folios from two separate *Shahnama* manuscripts. Schroeder's comment (*Fogg Museum*, p. 29 n. 7) concerning

the difficulty in distinguishing miniatures from the *Shahnama* made for Qavam al-Din (as the Inju patron was then called) from those in the dispersed "Raffi" *Shahnama* is understandable, since the paintings actually all once belonged to the same (possibly two-volume) codex. The art dealer Charles Vignier also seems to have played a role in the manuscript's dispersal: see Glenn D. Lowry and Milo C. Beach, with Roya Marefat and Wheeler M. Thackston, *An Annotated and Illustrated Checklist of the Vever Collection* (Washington, D.C.: Arthur M. Sackler Gallery in assoc. with University of Washington Press, 1988), pp. 77 and 402; Basil W. Robinson, *Jean Pozzi: L'Orient d'un collectionneur* (Geneva: Musée d'art et d'histoire, 1992), p. 106.

2 The methodology used in the preparation of this reconstruction is identical to that employed to reconstruct the so-called small *Shahnama*s (Marianna Shreve Simpson, *The Illustration of an Epic: The Earliest Shahnama Manuscripts* [New York: Garland Publishing Inc., 1979]) and the Demotte *Shahnama* (Sheila S. Blair and Oleg Grabar, *Epic Images and Contemporary History. The Illustrations of the Great Mongol Shahnama* [Chicago and London: The University of Chicago Press, 1981]). The text on all known folios has been identified on the basis of the Bertels edition of the *Shahnama* (E.E. Bertels, ed. *Firdausi Shakh-Name: Kriticheskii Tekst.* 9 vols. [Moscow: Nauka, 1960–71] and the sequence of folios ordered accordingly. In this process the subjects of the illustrations are confirmed and lacunae in the text determined. The reconstruction of the 1341 *Shahnama* was assisted by the presence of numbers in the margins of many of the surviving folios. For more on this point, see note 15.

3 Selected bibliography (listed chronologically; see Appendix II for additional references to specific folios): Laurence Binyon, J.V.S. Wilkinson, and Basil Gray. *Persian Miniature Painting* (London: Oxford University Press, 1933), cat. no. 24; Rudolf M. Riefstahl, *Catalog of an Exhibition of Persian and Indian Miniature Paintings from the Private Collection of Dikran Khan Kelekian* (New York: The Gotchnag Press, 1933), pp. 10–12, cat. nos. 5–9; Ivan Stchoukine, *La Peinture iranienne sous les derniers 'Abbasides et les Il-Khans* (Bruges: Imprimerie Sainte Catherine, 1936), pp. 93–94, ms. no. XIX; Kurt Holter, "Die islamischen Miniaturhandschriften vor 1350," *Zentralblatt für Bibliothekswesen* 44 (1937): p. 19, no. 49 (with

previous references); Henri Corbin *et al.*, *Les Arts de l'Iran, L'Ancienne Perse et Bagdad* (Paris: Bibliothèque Nationale, 1938), p. 21, cat. no. 21; Ernst Kühnel, "Book Painting. C. History," in *A Survey of Persian Art*, Arthur U. Pope and Phyllis Ackerman, eds. (London and New York: Oxford University Press, 1938–39), 5: 1834 and 9: pls. 833–34; Arberry, *et. al.*, *Catalogue* 1: 23–26, ms. no. 110; Ernst J. Grube, *Muslim Miniature Paintings from the XIII to XIX Century* (Venice: Neri Pozza Editore, 1962), pp. 31–32; Basil W. Robinson, *Persian Miniature Painting from Collections in the British Isles* (London: Her Majesty's Stationery Office, 1967), p. 85, cat. no. 105; Anthony Welch, *Collection of Islamic Art: Prince Sadruddin Aga Khan* (Geneva: Château de Bellerive, 1972), 1: 67–85; Basil W. Robinson et al., *The Keir Collection: Islamic Painting and the Arts of the Book* (London: Faber and Faber Limited, 1976), p. 135, cat. nos. III.4–III.5; Robert Hillenbrand, *Imperial Images in Persian Painting* (Edinburgh: Scottish Arts Council, 1977), cat. nos. 64, 136–138, 207; Ernst J. Grube, *Persian Painting in the Fourteenth Century: A Research Report* (Naples: Istituto Orientale di Napoli, 1978), p. 15 n. 43; Hans-Caspar Graf von Bothmer, *Die islamischen Miniaturen der Sammlung Preetorius* (Munich: Staatliches Museum für Völkerkunde, 1982), p. 24, cat. no. 3; Lowry and Beach, pp. 69–77, cat. nos. 74–85; Abolala Soudavar, *Art of the Persian Courts: Selections from the Art and History Trust Collection* (New York: Rizzoli, 1992), pp. 43–44, cat. no. 14; Robinson, *Pozzi*, pp. 106–07, cat. nos. 5–11.

4 Sheila R. Canby, *Persian Painting* (London: British Museum Press, 1993), pp. 34–38; Corbin *et al.*, pp. 138–39; Basil Gray, *Persian Painting* (Geneva: Editions d'Art Albert Skira, 1961), pp. 57–58; Maurice Dimand, *A Handbook of Muhammadan Art* (New York: The Metropolitan Museum of Art, 1958), pp. 33–35; Grube, *Fourteenth Century*, pp. 15–16; Grube, *Muslim Miniature Paintings*, pp. 21–22; Ernst J. Grube, *The World of Islam* (London: Paul Hamlyn, 1966), p. 62; Ernst J. Grube and Eleanor Sims, "Painting," in *The Arts of Persia*, Ronald W. Ferrier, ed. (New Haven and London: Yale University Press, 1989), p. 204; Kühnel, p. 1834; Basil W. Robinson, *A Descriptive Catalogue of the Paintings in the Bodleian Library* (Oxford: The Clarendon Press, 1958), p. 1; Basil W. Robinson, "A Survey of Persian Painting," in *Art et Société dans le Monde Iranien*,

Chahryar Adle, ed. (Paris: Editions Recherche sur les Civilisations, 1982), p. 18; Robinson, *Persian Miniature Painting*, p. 84; Robinson, *Pozzi*, pp. 115–116; Robinson *et al.*, *Keir Collection*, pp. 132–33; Schroeder, *Fogg*, pp. 29–34; Marianna Shreve Simpson, *Arab and Persian Painting in the Fogg Art Museum* (Cambridge, MA: Harvard University, 1980), p. 23; Norah M. Titley, *Persian Miniature Painting and its Influence on the Art of Turkey and India: The British Library Collection* (London: The British Library, 1983), pp. 38–39; Welch, I: 59–60.

5 Stchoukine, *Peinture iranienne*, p. 93.

6 The 1330 *Shahnama* has never been fully published. For a recent discussion see: J. Michael Rogers, ed., *The Topkapi Saray Museum. The Albums and Illustrated Manuscripts* (Boston: Little Brown and Company, 1986), p. 51. The 1333 manuscript has been published by Adel T. Adamova and Leon T. Giuzalian, *Miniatiury rukopisi poemu "Shakhname," 1333 goda* (Leningrad: Iskusstvo, 1985). The Shiraz *Shahnama* trio may actually be a quartet if one includes the so-called Stephens *Shahnama*. This manuscript has a rosette inscribed in a much later hand with the date of 740/1339–40. A few individual leaves are in public collections; the bound volume itself was sold at Sotheby's (29 April 1998, lot 41) and aquired by Mr and Mrs Farhad Ebrahimi. It is currently on deposit at the Arthur M. Sackler Gallery, Smithsonian Institution, Washington, D.C. (LTS 1998.1.1).

7 Marianna S. Simpson, "The Pattern of Early *Shahnama* Illustration," in *Studia Artium Orientalis et Occidentalis* 1 (1982): 43–53.

8 Binyon, Wilkinson and Gray, cat. no. 24.

9 Stchoukine, p. 933. As previously mentioned, it is the reference to the manuscript's patron that gave Stchoukine the clue to the Shiraz origin of the 1341 manuscript, and others of analogous style.

10 The complete inscription was first published by Lowry and Beach, cat. no. 76 and 77, and is repeated here with one minor change:

> For the flourishing library of the great lord, honorable minister, chief vizier of glorious Fars, possessor of generosity, source of liberality and virtue. The second Hatem, lover of the righteous, refuge to the poor and humble, glory of pilgrims to the house of God, the venerable Hajji Qawam al-Daula wa'l-Din Hasan. May God prolong his greatness, and may he have divine guidance for good deeds and mercy upon his ancestors. Mercy of God upon a servant

who proves trustworthy.
(right-hand rosette; AMS S1986.110, verso)

The book of *Shahnama*. From the sayings of the king of wisdom, the sultan of poets, Abu'l-Qasim Muhammad al-Firdausi al-Tusi, peace be unto him. At the end of the auspicious month of God, Ramadan, may its glory extend to all, the year seven hundred and forty-one of the *hijra*. Mercy and peace of God upon Muhammad and his family, the good and pure, all of them.
(left-hand rosette; AMS S1986.111, recto)

11 Welch, p. 83.

12 Kelekian claimed that the damage was done by a certain Dr. Raffy who previously owned the manuscript and brought it to Europe from Iran. This tidbit appears in a letter of 16 October 1944 from Kelekian to Richard Ettinghausen, then curator of Islamic art at the Freer, as part of a lengthy correspondence concerning the Freer's possible acquisition of this folio. The letter specifies that Dr. Raffy thought that the fourteenth century was not early enough for such a rare book and insisted that it dated from the eleventh century.

13 Both the colophon folio and the dedicatory rosette seem to have been exhibited at the Bibliothèque Nationale in Paris in 1938; at least the accompanying catalogue contains an entry for both a "Feuillet du colophon portant la date à laquelle fut terminée la copie" (Corbin *et al.*, cat. no. 21.1) and a "Rosace enluminée portant la dédicace au vizier Qawam al-Din" (Corbin *et al.*, cat. no. 21.2). In the 1988 catalogue of the Vever collection number 21.1 of the 1938 Paris exhibition is identified as another folio from the 1341 *Shahnama* (now AMSG S1986.109; see Lowry and Beach, cat. no. 78 and p. 403). The continued conflation of or confusion between the dedication and colophon is reflected, for instance, in Robinson, *Pozzi*, p. 106 and Soudavar, p. 43.

14 The 1330 *Shahnama* in Istanbul also opens with an inscribed rosette and concludes with a colophon (folios 1a and 286a, respectively). The rosette inscription, however, has been rewritten, making it impossible to determine if it originally contained a dedication.

15 As previously mentioned (note 2), the sequence of the surviving folios was established on the basis of their text according to the Bertels edition of the *Shahnama*. This sequence automatically reveals the textual lacunae between folios and leads in turn to a

determination of the number of folios that once filled what are now gaps. (Each full folio of text contains 180 verses.) The folio numbers, also mentioned above, have been of some use in estimating the manuscript's length, although they are not totally reliable as they seem to have been added at a subsequent moment in the manuscript's history, after some of the folios had been shuffled and others possibly removed. Some folios also seem to have been skipped in the numbering process. Others have two sets of numbers: AMSG 1986.117, for instance, contains the numbers 15 and 147 on its recto. To complicate matters further, some folios are composites, and consist of a written surface cut out of its original margins and joined to numbered margins from a completely different part of the manuscript. CB 110.54, for instance, consists of text from the Iskandar cycle towards the end of the *Shahnama* joined to a margin numbered 50 falling into the Suhrab cycle towards the beginning of the epic. The extent to which the manuscript seems to have been misnumbered from the outset is revealed in a sequence of four successive text folios (that is, no textual gaps) from the Iskandar cycle (CB 110.53, .54, .55 and BMFA 10.1841). Both the first and fourth of this set are numbered 203 and 204, respectively. Evidently the two intervening folios were simply not counted. These are listed as 203 (B) and 203 (C) in the appended reconstruction. The penultimate surviving folio from the manuscript bears the number 317 (WAM 1935.21: pl. 4). Quite a bit of Firdausi's text – enough to occupy four or five folios – comes between this folio and the colophon folio. It is on the basis of this reckoning – plus the addition of several uncounted or miscounted folios – that I have come up with the original folio count for the manuscript – which, of course, could be more, but probably not less, than the estimate of 325.

At present I am able to account for 180 folios. This figure includes twelve folios documented only by their numbered margins, which have been attached to other written surfaces (folios 31, 36, 50, 57, 65, 66, 80, 199, 206, 297, 298, 299 and 300), seven folios documented by illustrations cut out of their original written surfaces and pasted onto other folios (folios 75, 127, [134a], 137, 164, 181, 250), and one folio documented by a fragmentary text passage pasted onto another folio (folio [77b]). The largest portion of the surviving folios is in the Chester Beatty Library, Dublin (CB MS 110; eighty-five folios). The rest is

located in thirty-odd private or public collections or known from sale catalogues (see Appendix II).

16 The pair of columnar dividers are separated by a space of .8 cm; each line of the pair is .1 cm apart. A space of 3 cm separates the red inner rulings and the grey outer ruling. This ruling may originally have been another colour, such as blue.

17 Each scene measures 25 x 21.5 cm.

18 The illumination consists of several elements pasted together: a central inscription cartouche flanked by a pair of medallions with lotus blossoms and a second pair of larger lotus blossoms at the end. The text in the central cartouche reads "Lughat al-Fars," suggesting that it belongs to a manuscript of that important dictionary by Abu-Mansur 'Ali b. Ahmad Asadi. I know of one folio with *Lughat al-Fars* text and a finispiece painted in Shiraz Inju style (Musée du Louvre, AA49). It may be that the heading on AMSG S1986.113, side 2 comes from a *Lughat al-Fars* manuscript to which the Louvre folio also once belonged. The other side of the 1341 hunting scene (AMSG S1986.113, side 1) consists of a text page that originally would have come towards the end of the volume (folio 253 in the appended reconstruction). Obviously the first folio in the 1341 *Shahnama* has suffered considerable refurbishment.

19 Richard Ettinghausen, *Arab Painting* (Geneva: Editions d'Art Albert Skira, 1977), p. 65.

20 The order of the folios with the old preface has been reconstructed by comparing their text with that of the old preface in the fragmentary *Shahnama* of 614/1217 (Florence, Biblioteca Nazionale Centrale, MS Cl.III.24, folios 2a–3a) and the intact *Shahnama* of 731/1330 (Topkapi Saray Museum Library, H. 1479, folios 1b–4a), as well as two secondary sources: V. Minorsky, "The Older Preface to the *Shah-nama*," in *Studi orientalistici in onore di Giorgio Levi Della Vida* (Rome: Istituto per l'Oriente, 1956), 2: 159–79; Davoud Monchi-Zadeh, *Topographisch-historische Studien zum iranischen Nationalepos* (Wiesbaden: Steiner, 1975), 1–15. One folio of the preface in the 1341 volume (CB 110.2) presents a problem: its recto text concerns Muhammad's dynasty and includes a geneaological chart; the verso text concerns Iranian dynastic reigns and includes a chart of Pishdadian rulers, followed by a brief mention of the Kayanians. The later passages overlap the text on another prefatory folio (CB 110.1). Although acquired as part of the large lot of 1341 folios belonging to the Chester Beatty Library and similar to them in calligraphic style and page layout, it is possible that CB 110.2 was not originally part of the same manuscript. The illumination of its recto rubric, for instance, features a lotus that differs slightly from those found elsewhere in the manuscript's preliminary matter (discussed below). In any event, this problematic folio is listed in the reconstruction as folio 3 bis. In addition to this possible anomaly, the 1341 *Shahnama* lacks a longish text passage found in the preface to the 1330 manuscript (Topkapi Saray Museum Library, H. 1479, fol. 2b, line 30 – fol. 3a, line 16). I am most grateful to Marjan Adib for assistance in checking the old preface folios.

21 As discussed in the previous note, one of the folios of the old preface included within the present reconstruction may not actually belong to the 1341 manuscript. Therefore, it is uncertain if the manuscript's preface originally consisted of the equivalent of three or four full folios of text.

22 Rubrics 1, 2 and 4 have been overwritten in the same text in red ink, which appears original, but is now quite rubbed.

23 The fact that the line begins with *wa* suggests that this is the second part of a verse. The first part presumably would have appeared on the facing folio (AMSG S1986.110, verso), had not the space above the dedicatory rosette been taken up with the final lines of the old preface. I am grateful to Wheeler Thackston for his translation and comments.

24 Translations by Wheeler Thackston. Like the rubrics on folio 5a, parts of the inscription are overwritten in red. It is worth noting that the bottom inscriptions are identical to those incorporated into the illumination that enframes the opening verses in the 1330 *Shahnama* (Topkapi Saray Museum Library, H. 1479, folios 1b–2a).

25 Adamova and Giuzalian, pp. 14, 42–44, 159. Due to the manuscript's condition, there is no way of telling if it opened with a dedicatory rosette.

26 Folios that now contain pasted-on illustrations (that is, cut out from other parts of the manuscript and pasted over unrelated text): 75b, 127a, [134a], 137a, 164b, 181a/b, 250b. Folios illustrated on recto and verso: 126a–b, 180a–b. Folios with two or three illustrations on the same side: 39/40 (3 illustrations), 140a (2 illustrations).

27 But possibly not as many as the 190 which Sheila Blair has projected for the great Mongol (a.k.a. Demotte) *Shahnama*. See Sheila S. Blair, "On the Track of the 'Demotte' *Shahnama* Manuscript," in *Les Manuscrits au Moyen-Orient: Essais de codicologie et de paléographie*, F. Déroche, ed. (Istanbul and Paris: Institut Français d'Etudes Anatoliennes and Bibliothèque Nationale, 1989), pp. 125–31.

28 E.g., folios 21a (KNM LNS 36 MS), 24b (BMFA 20.1840), 46a (SAK IR.M. 6/B), [91] (SOTH 15.X.97, lot 38), 113a (HUAM 1960.195), 125a (FGA 45.7), [137a] (CMA 44.479), [152a] (KEIR III.5), 195b (AIC 34.117), 208a (DC 13/1990), 213b (CB 110.60), [310/311] (AHT, cat. no. 14).

29 E.g., folios [13/14a] (HAA 4100.I), 57a (SAK IR. M. 6/I), 59a (MCG 1977.4), 127a (UOMA 64:20.2), [268/271] (PET).

30 Simpson, "Pattern," p. 49.

31 Rustam rescuing Bizhan from the pit
 1330 *Shahnama*, folio 91b
 1333 *Shahnama*, folio 137a (Adamova and Giuzalian, pp. 81–83)
 1341 *Shahnama*, folio 125a (FGA 45.7)
Musician Barbad playing for Khusrau Parviz
 1330 *Shahnama*, folio 272b
 1330 *Shahnama*, folio 352b (Adamova and Giuzalian, pp. 150–51).
 1341 *Shahnama*, folio [310/311]
Other familiar scenes that appear in all three of the Shiraz *Shahnama*s include: Fire ordeal of Siyavush, Kay Khusrau's paladins die in the snow, Iskandar building the wall against Gog and Magog, Nushirvan executes Mazdak and his followers, Bahram Chubina wears women's clothes, and Bahram Chubina slays the lion-ape.

32 Simpson, "Pattern," p. 51.

33 A succinct and extremely helpful discussion of the Injus appears in the 1992 catalogue of the Art and History Trust Foundation (Soudavar, p. 43).

34 The 1330 and 1333 manuscripts predate Qawam al-Daula's vizierate, which leaves the field open for other possible patrons without, however, entirely precluding Qawam.

35 Simpson, "Pattern," pp. 49–51.

APPENDIX I

RECONSTRUCTION OF THE 1341 *SHAHNAMA*

FOLIO	COLLECTION	CYCLE	TEXT REFERENCE	ILLUSTRATION
[1a]				
[1b]	AMSG S1986.113, side 2			Frontispiece: Hunting scene
[2a]	AMSG S1986.112, recto			Frontispiece: Enthronement
[2b]	AMSG S1986.112, verso		Old preface	Illuminated frame
[3a]	CB 110.1, recto		Old preface	Illuminated frame
[3b]	CB 110.1, verso		Old preface	
[3 bis a]	CB 110.2, recto		Old preface	
[3 bis a]	CB 110.2, verso		Old preface	
4a	SAK IR.M. 56, recto		Old preface	
4b	SAK IR.M. 56, verso		Old preface	Firdausi and court poets of Ghazna
[5a]	AMSG S1986.110, recto		Old preface	
[5b]	AMSG S1986.110, verso		Old preface/dedication	Illuminated rosette
[6a]	AMSG S1986.111, recto		Dedication	Illuminated rosette
[6b]	AMSG S1986.111, verso	Preface	I, 12, 1-14, 37	Illuminated frame
[7a]	AMSG S1986, 109, recto	Preface	I, 14, 38-17, 74	Illuminated frame
[7b]	AMSG S1986, 109, verso	Preface	I, 17, 75-22, 151	
[8a]	MAH 1971-107/5, recto	Preface/Kayumars	I, 23, 154-29, 11	
[8b]	MAH 1971-107/5, verso	Kayumars	I, 29, 12-32, 67	Kayumars and Hushang fight the Black Div
12	KHALILI MS 1019.1	Zahhak	I, 63, 205-66, 269	Kava the blacksmith at Zahhak's court
[13/14a]	HAA 4100.1, recto	Zahhak	I, 75, +425-78, 470	
[13/14b]	HAA 4100.1, verso	Faridun	I, 79, 1-80, 14	Faridun enthroned
[16a]	MSM 77-11-394, recto	Faridun	I, 95, 26 -100, 356	
[16b]	MSM 77-11-394, verso	Faridun	I, 100, 357-104, 418++	Tur kills Iraj as Salm looks on
19a	SAK IR.M. 6, recto	Faridun	I, 123, 750-128, 823++	
19b	SAK IR.M. 6, verso	Faridun	I, 129, ++824-130, 858++	Manuchihr and Qaran fight Salm
[20a]	KHALILI MS 679	Manuchihr	I, 131, 859-136, 26	Manuchihr besieges the fortress in which Salm has taken refuge
21a	KNM LNS 36 MS, recto	Manuchihr	I, 142, 102-145, 139	Sam recognizes his son Zal in the Simurgh's nest
21b	KNM LNS 36 MS, verso	Manuchihr	I, 145, 140-150, 218	
24a	BMFA 20.1840, recto	Manuchihr	I, 171, 548-175, 603	
24b	BMFA 20.1840, verso	Manuchihr	I, 175, 604-180, 692	Zal meets Rudaba
[26a]	SAK IR.M.6/A, recto	Manuchihr	I, 193, 891-194, 897	Manuchihr informed of romance of Zal and Rudaba
[26b]	SAK IR.M.6/A, verso	Manuchihr	I, 196, 923-201, 1000	

The reconstruction is based on E.E Bertels, ed., *Firdausi Shakh-Name: Kriticheskii Tekst.* 9 vols. Moscow, 1960–71.

Key

[] = reconstructed folio number or text citation

+ = additional verses not in Bertels edition

++ = folio contains additional verses not visible in reproduction

Collection abbreviations are given in Appendix II.

27a	CB 110.3, recto	Manuchihr	I, 201, 1001-207, 1084	
27b	CB 110.3, verso	Manuchihr	I, 207, 1085-213, 1178	
[29/30]	KHALILI MS 1019.2	Manuchihr	I, 246, 1601-1624 I, 264, 1-267, 54	Rustam kills the white elephant
31	MSM 77-11-394, verso		original margin numbered 31 (no original text)	
34a	WAG 10.677d, recto	Nauzar	II, 31, 379-36, 446	Zal joins Mihrab in battling Turanians
34b	WAG 10.677d, verso	Nauzar	II, 36, 447-42, 535	
35a	BM 1925-2-20-01, recto	Nauzar/Zav; Tahmasp/Garshasp	II, 42, 536-49, 22	
35b	BM 1925-2-20-01, verso	Garshasp	II, 49, 23-54, 82	Zal and Rustam converse (repainted)
36	AMSG S1986.115, recto		original margin numbered 36 [II, 54, 83-65, 44]	
37a	FGA 52.35, recto	Kay-Qubad	II, 65, 45-69, 114	Rustam catches Afrasiyab by the belt and lifts him from the saddle
37b	FGA 52.35, verso	Kay-Qubad	II, 69, 114-75, 202	
[38]	CHR 15.X.96, lot 125	Kay-Ka'us & Mazandaran	II, 91, ++282-93, 315++	Rustam's first feat: Rakhsh kills the lion while Rustam sleeps
[39/40a]	MAH 1971-107/369, recto	Kay-Ka'us & Mazandaran	II, 98, 412-101, 468	Rustam's fourth feat: he cleaves the witch; Rustam hit on the head by Aulad's herdsman as he sleeps while Rakhsh grazes; Rustam's fifth feat: he lassoes Aulad
[39/40b]	MAH 1971-107/369, verso	Kay-Ka'us & Mazandaran	[II, 101, 469-106, 559]	
43a	MAH 1971-107/332, recto	Kay-Ka'us & Mazandaran	[II, 114, 709-120, 799]	
43b	MAH 1971-107/332, verso	Kay-Ka'us & Mazandaran	II, 120, 800-132, 868+	While battling Rustam, king of Mazandaran turns himself into a rock
46a	SAK IR.M.6/B, recto	Kay-Ka'us & King Hamavaran	II, 152, 395-155, 438+	Kay-Ka'us airborne
46b	SAK IR.M.6/B, verso	Kay-Ka'us & King Hamavaran	[II, 155, +438-160, 508]	
47a	CB 110.4, recto	Kay-Ka'us & King Hamavaran	II, 160, 509-165, 580	
47b	CB 110.4, verso	Kay-Ka'us & King Hamavaran	II, 165, 581-168, 622	Battle of seven warriors (repainted to depict Firdausi presenting *Shahnama* to Shah Mahmud)
[48a]	KEIR III.4, recto	Kay-Ka'us & KingHamavaran/ Suhrab	II, 168, 623-174, 62	
[48b]	KEIR III.4, verso	Suhrab	II, 174, 63-177, 108	Tahmina comes to Rustam's chambers
50	AMSG S1986.110, recto	Suhrab	original margin numbered 50 [II, 183, 165-188, 255]	

51a	CB 110.5, recto	Suhrab	II, 196, 345-199, 374+	Rustam before Kay-Ka'us
51b	CB 110.5, verso		II, 200, 378-204, 432	
[56]	CHR 15.X.96, lot 126	Siyavush	III, 9, 61-13, 116	Siyavush brought before Kay-Ka'us by Rustam
57	SAK IR.M.6/I, recto	Siyavush	original margin numbered 57 (no original text)	
[59a]	MCG 1977.4, recto	Siyavush	III, 34, +475-37, 527	Fire ordeal of Siyavush
[59b]	MCG 1977.4, verso	Siyavush	III, 36, ++54-40, 584	
60a	CB 110.6, recto	Siyavush	III, 40, 588-45, 666	
60b	CB 110.6, verso	Siyavush	III, 45, 667-50, 743	
61a	CB 110.7, recto	Siyavush	III, 50, 744-55, 827	
61b	CB 110.7, verso	Siyavush	III, 55, +828-57, 904	
62a	CB 110.8, recto	Siyavush	III, 59, +905-64, 985	
62b	CB 110.8, verso	Siyavush	III, 64, 986-69, 1066	
63a	CB 110.9, recto	Siyavush	III, 69, +1067-73, 1133	
63b	CB 110.9, verso	Siyavush	III, 73, 1134-79, 1216	
[64a]	MET 57.51.35, recto	Siyavush	III, 78, 1214-84, 1284	
[64b]	MET 57.51.35, verso	Siyavush	III, 84, 1285-87, 1341+	Siyavush plays polo with Afrasiyab
65	CB 110.54, recto		original margin numbered 65 (no original text)	
66	CB 110.55, recto		original margin numbered 66 (no original text)	
[71a]	CHR 15.X.96, lot 123	Siyavush	III, 114, 1746-1779++	Piran visits Siyavushgard and is entertained at home of Farangis
[72b]	KHALILI MS 1019.3	Siyavush	III, 122, 1874-125, 1926	Murder of Siyavush (illustration not related to text)
73a	CB 110.10, recto	Siyavush	III, 125, 1927-130, 2004	
73b	CB 110.10, verso	Siyavush	III, 130, 2005-135, 2090	
74a	CB 110.11, recto	Siyavush	III, 135, 2091-140, 2164	
74b	CB.110.11, verso	Siyavush	III, 140, 2167-144, 2225++	
75a	KEIR III.6, recto	Siyavush	III, 145, 2229-150, 2313++	
75b	KEIR III.6, verso	Siyavush	III, 152, 2334-155, 2377	illustration pasted over text (Isfandiyar kills Simurgh)
[77b]	SAK IR.M.6/C, verso (middle)	Siyavush	III, 169, 2579-170, 2599+ [III, 170, 2600-175, 2676]	
[78a]	AG, recto	Siyavush	III, 175, 2677-179, 2729+	Faramarz unseats Surkha
[78b]	AG, verso	Siyavush	III, 179, 2731-184, 2810	
79a	FGA 42.11, recto	Siyavush	III, 184, +2810-189, 2889	
79b	FGA 42.11, verso	Siyavush	III, 189, +2899-191, 2920	Rustam slays Pilsam
80	AMSG S1986.109, verso	Siyavush	original margin numbered 80 (no original text)	
86a	HUAM 1960.194, recto	Siyavush/Kay-Khusrau	III, 249, 3764- IV, 11, 48	
86b	HUAM 1960.194, verso	Kay-Khusrau	IV, 11, 49-14, 105	Rustam and Zal greet Kay-Khusrau
[91]	SOTH 15.X.97, lot 38, verso	Farud Siyavush	IV, 64, 883-68, 931	Tur and Iranians mourn Farud and Jarira who has committed suicide over her son's body

96a	CB 110.12, recto	Farud Siyavush/	IV, 110, 1588-116, 13	
		Kamus Kashani		
96b	CB 110.12, verso	Kamus Kashani	IV, 116, 14-121, 88	
98a	SAK IR.M.6/D, recto	Kamus Kashani	IV, 131, 250-134, 301	Tus battles Human
98b	SAK IR.M.6/D, verso	Kamus Kashani	IV, 134, 302-139, 369	
99a	WAG 10.677c, recto	Kamus Kashani	IV, 139, 370-142, 427	Iranians under command of Tus fight the Turanians after Ruhham killed the sorcerer
99b	WAG 10.677c, verso	Kamus Kashani	IV, 142, 428-147, 504	
100a	CB 110.13, recto	Kamus Kashani	IV, 147, 505-151, 567+5	
100b	CB 110.13, verso	Kamus Kashani	IV, 151, 568-157, 642	
101a	CB 110.14, recto	Kamus Kashani	IV, 157, 643-159, 685 IV, 351, 1-317, 41	
101b	CB 110.14, verso	Kamus Kashani	IV, 317, 44-318, 69++ IV, 160, 692-162, 740+6	
102a	CB 110.15, recto	Kamus Kashani	IV, 163, 743-186, 834	
102b	CB 110.15, verso	Kamus Kashani	IV, 168, 835-173, 915	
103a	MMFA 54.Ea.1, recto	Kamus Kashani	IV, 173, 919-177, 972	Iranians versus the Turanians
103b	MMFA 54.Ea.1, verso	Kamus Kashani	IV, 177, 973-182, 1063	
104a	CB 110.16, recto	Kamus Kashani	IV, 182, 1064- 187, 1140	
104b	CB 110.16, verso	Kamus Kashani	IV, 187, 1141-192, 1222	
[105a]	BM 1933.9.29.02, recto	Kamus Kashani	IV, 192, 1223-197, 1305	
[105b]	BM 1933.9.29.02, verso	Kamus Kashani	IV, 197, 1306-200, 1368	Rustam slays Ashkabus and his horse
106a	CB 110.17, recto	Kamus Kashani	IV, 200, 1369-205, 1444	
106b	CB 110.17, verso	Kamus Kashani/ Khaqan of Chin	IV, 205, 1445-209, 20	Rustam captures Kamus with lasso and kills him
108a	CB 110.18, recto	Khaqan of Chin	IV, 220, +185-225, 255	
108b	CB 110.18, verso	Khaqan of Chin	IV, 225, 256-231, 335	
109a`	CB 110.19, recto	Khaqan of Chin	IV, 231, 336-236, 421	
109b	CB 110.19, verso	Khaqan of Chin	IV, 236, 422-241, 510	
111a	BMFA 20.1839, recto	Khaqan of Chin	IV, 252, 679-256, 730	
111b	BMFA 20.1839, verso	Khaqan of Chin	IV, 256, 731-261, 817	Rustam pulls Khaqan of Chin from his elephant by lasso and takes him prisoner
113a	HUAM 1960.195, recto	Khaqan of Chin	IV, 272, ++969-275, 1023	Rustam attacks Kafur's citadel called Bidad
113b	HUAM 1960.195, verso	Khaqan of Chin	IV, 275, 1024-280, 1111	
114a	CB 110.20, recto	Khaqan of Chin	IV, 280, 1112-285, 1175+	
114b	CB 110.20, verso	Khaqan of Chin	IV, 285, +1176-290, 1252	
118a	MET 29.160.22, recto	Bizhan & Manizha	V, 10, 60-14, 133	
118b	MET 29.160.22, verso	Bizhan & Manizha	V, 14, 134-18, 171++	Bizhan hunts wild boar
[120/121]	SOTH 6.XII.67, lot 11	Bizhan & Manizha	text not available	Div Akvan flings Rustam into the sea
123a	CB 110.21, recto	Bizhan & Manizha	V, 53, +758-55, 805	Kay-Khusrau fêtes Rustam and asks him to rescue Bizhan
123b	CB 110.21, verso	Bizhan & Manizha	V, 56, 806-60, 890	
125a	FGA 45.7, recto	Bizhan & Manizha	V, 70, 1058-72, 1110	Rustam rescues Bizhan from the pit
125b	FGA 45.7, verso	Bizhan & Manizha	V, 72, 1110-77, 1185	

[126a]	OF	Bizhan & Manizha	V, 79, 1217-80, 1230 (partial text) [V, 77, 1186-81, 1246]	Rustam defeats Afrasiyab's army after he rescues Bizhan from the pit
[126b]	OF	Bizhan & Manizha	[V, 81, 1246-84, 1304]	Rustam returns to Kay-Khusrau
127a	UOMA 64:20.2, recto	Bizhan & Manizha/ 12 Rukhs	V, 84, 1305-90, 78	illustration pasted over text (battle scene; specific subject unidentified)
127b	UOMA 64:20.2, verso	12 Rukhs	V, 90, 79-95, 170	
131a	SAK IR.M.6/E, recto	12 Rukhs	V, 124, 695-130, 782	
131b	SAK IR.M.6/E, verso	12 Rukhs	V, 130, 783-133, 837	Bizhan decapitates Human
132a	AMSG S1986.119, recto	12 Rukhs	V, 133, 838-136, 891	Bizhan slays Nastihan
132b	AMSG S1986.119, verso	12 Rukhs	V, 136, 892-141, 980	
[134a]	KHALILI MS 1019.4	12 Rukhs	V, 151, 1160-156, 1247	illustration pasted over text (combat scene; specific subject unidentified)
135a	CB 110.22, recto	12 Rukhs	V, 161, 1378-166, 1422	
135b	CB 110.22, verso	12 Rukhs	V, 166, 1423-171, 1508	
136a	CB 110.23, recto	12 Rukhs	V, 171, 1509-176, 1591	
136b	CB 110.23, verso	12 Rukhs	V, 176, 1592-179, 1648	Giv battles Lahhak and Farshidvard
137a	CMA 44.479, recto	12 Rukhs	V, 179, 1649-185, 1735	illustration pasted over text (Piran escapes Gudarz but is later killed)
137b	CMA 44.479, verso	12 Rukhs	V, 185, 1736-189, 1814	
139a	AMSG S1986.115, recto	12 Rukhs	V, 193, 1871-195, 1897+	Faruhil pierces Zangula with arrow Rahham kills Barman
139b	AMSG S1986.115, verso	12 Rukhs	[V, 195, +1897-197, 1919]	
[140a]	Gillet, recto	12 Rukhs	V, 197, 1920-199, 1954	Barta kills Kuhram with sword Zanga and Akhast fight on horseback [possibly originally illustrated: Piran
[140b]	Gillet, verso	12 Rukhs	[V, 199, 1955-204, 2050]	escapes Gudarz but is later killed, CMA 44.479]
141a	AMSG S1986.99, recto	12 Rukhs	V, 204, 2051-210, 2142	
141b	AMSG S1986.99, verso	12 Rukhs	V, 210, 2143-216, 2229	Lahhak and Farshidvard before Afrasiyab (repainted)
147a	AMSG S1986.117, recto	Great War	V, 267, 534-272, 614	
147b	AMSG S1986.117, verso	Great War	V, 272, 615-276, 671	Kay-Khusrau kills Shida
148a	CB 110.24, recto	Great War	V, 276, 672-281, 758	Kay-Khusrau fights three Turanians
148b	CB 110.24, verso	Great War	V, 281, 759-284, 816	
149a	CB 110.25, recto	Great War	V, 284, 817-289, 901	
149b	CB 110.25, verso	Great War	V, 289, 902-293, 980	
150a	CB 110.26, recto	Great War	V, 293, 980-298, 1063	
150b	CB 110.26, verso	Great War	V, 298, 1064-303, 114	
151a	CB 110.27, recto	Great War	V, 303, 1142-308, 1229	
151b	CB 110.27, verso	Great War	V, 308, 1230-313, 1314	
[152a]	KEIR III.5, recto	Great War	V, 314, 1317-317, 1375	Persians capture Gang-Behesht, Afrasiyab's fortress
[152b]	KEIR III.5, verso	Great War	V, 317, 1376-322, 1460	
153a	CB 110.28, recto	Great War	V, 323, 1461-327, 1545	
153b	CB 110.28, verso	Great War	V, 327, 1546-332, 1633	
154a	FGA 42.12, recto	Great War	V, 351, +1978-354, 2031	Kay-Khusrau sees marvels of sea
154b	FGA 42.12, verso	Great War	V, 355, 2032-360, 2119	

156a	WAG 10.677b, recto	Great War	V, 370, 2269-375, 2349	
156b	WAG 10.677b, verso	Great War	V, 375, 2350-378, 2406	Kay-Khusrau slays Afrasiyab while Garsivaz watches
157a	CB 110.29, recto	Great War	V, 378, 2407-383, 2493	
157b	CB 110.29, verso	Great War	V, 393, 2494-388, 2576	
160a	CB 110.30, recto	Great War	V, 396, 2716-401, 2798	
160b	CB 110.30, verso	Great War	V, 401, 2799-405, 2879	
161a	CB 110.31, recto	Great War	V, 405, 2880-409, 2962	
161b	CB 110.31, verso	Great War	V, 409, 2963-414, 3045	
[162a]	MET 36.113.2, recto	Great War	V, 414, 3046-417, 3093+	Kay-Khusrau's paladins die in snow
[162b]	MET 36.113.2, verso	Great War [/Luhrasp]	V, 417, 3094+-418, 3107 VI, 8, 1-12,63	
164a	AMSG S1986.116, recto	Luhrasp	VI, 21, 226-27, 312	
164b	AMSG S1986.116, verso	Luhrasp	VI, 27, 313-32, 400	illustration pasted over text (execution of a prisoner, specific subject unidentified)
165a	FGA 48.15, recto	Luhrasp	VI, 32, 401-38, 483	
165b	FGA 48.15, verso	Luhrasp	VI, 38, 486-42, 545	Gushtasp slays the dragon
166a	CB 110.32, recto	Luhrasp	VI, 42, 546-47, 630	
166b	CB 110.32, verso	Luhrasp	VI, 47, 631-53, 715+	
167a	CB 110.33, recto	Luhrasp	VI, 53, 716-58, 797+	
167b	CB 110.33, verso	Luhrasp	VI, 58, 800-63, 885	
168a	CHR 15.X.96, lot 124 recto	Luhrasp/ Gushtasp	VI, 63, 886-67, 37	Gushtasp enthroned wirh Zardukht
169a	CB 110.34, recto	Gushtasp	VI, 72, +111-76, 171++	
[169b]	[CB 110.34, verso]	Gushtasp	[VI, 76, 172-81, 241]	
170a	CB 110.35, recto	Gushtasp	VI, 81, 242-86, 307	
170b	CB 110.35, verso	Gushtasp	VI, 86, 308-91, 378	
171a	CB 110.36, recto	Gushtasp	VI, 91, ++379-96, 449	
171b	CB 110.36, verso	Gushtasp	VI, 96, 450-101, 523	
[172a]	CB 110.37, recto	Gushtasp	VI, 101, 524-106, 590+	
[172b]	CB 110.37, verso	Gushtasp	VI, 106, ++591-109, 635	Biderafish fights Zarir
173a	CB 110.38, recto	Gushtasp	VI, 109, 636-113, 707+	
173b	CB 110.38, verso	Gushtasp	VI, 113, 708-118, 776	
174a	CB 110.39, recto	Gushtasp	VI, 119, 777-124, 850	
174b	CB 110.39, verso	Gushtasp	VI, 123, 851-128, 916	
175a	CB 110.40, recto	Gushtasp	VI, 129, 917-133, 984+	
175b	CB 110.40, verso	Gushtasp	VI, 133, 985-137, 23	
[176a]	MET 36.113.1, recto	Gushtasp	VI, 137, 24-142, 103	
[176b]	MET 36.113.1, verso	Gushtasp	VI, 142, 104-145, 158	Arjasp flees from Gushtasp in combat
[177a]	CB 110.41, recto	Gushtasp	VI, 145, 159-150, 283	
[177b]	CB 110.41, verso	Gushtasp	VI, 150, 239-154, 291	Isfandiyar released from his chains by Jamasp
[178a]	SOTH 6.XII.67, lot 12, recto	Gushtasp	[VI, 154, 292-158, 370]	
[178b]	SOTH 6.XII.67, lot 12, verso	Gushtasp	VI, 158, 371-162, 434	Isfandiyar lassoes Gurgsar
179a	CB 110.42, recto	Gushtasp/Trials of Isfandiyar	VI, 162, 434-167, 14	
179b	CB 110.42, verso	Trials of Isfandiyar	VI, 167, 15-171, 95	

[180a]	SAK IR.M.6/F	Trials of Isfandiyar	VI, 171, 96-175, 149	Isfandiyar's second exploit: he kills two lions
[180b]	SAK IR.M.6/G	Trials of Isfandiyar	VI, 175, 151-178, 215	Isfandiyar's third exploit: he kills the dragon
[181a/b]	KEIR III.6	Trials of Isfandiyar	[VI, 178, 216-185, 322]	Isfandiyar's fifth exploit: he kills the Simurgh (illustration pasted over earlier text: see folio 75b)
182a	CB 110.43, recto	Trials of Isfandiyar	VI, 185, 323-190, 409	
182b	CB 110.43, verso	Trials of Isfandiyar	VI, 190, 410-194, 496	
183a	CB 110.44, recto	Trials of Isfandiyar	VI, 195, 497-199, 580	
183b	CB 110.44, verso	Trials of Isfandiyar	VI, 199, 581-204, 666	
184a	CB 110.45, recto	Trials of Isfandiyar	VI, 204, 667-209, 746	
184b	CB 110.45, verso	Trials of Isfandiyar	VI, 209, 747-214, 836	
185a	CB 110.46, recto	Trials of Isfandiyar /Rustam & Isfandiyar	VI, 214, 837-220, 56	
185b	CB 110.46, verso	Rustam & Isfandiyar	VI, 221, 60-227, 152	
186a	CB 110.47, recto	Rustam & Isfandiyar	VI, 227, 60-227, 152	
186b	CB 110.47, verso	Rustam & Isfandiyar	VI, 232, 247-237, 33	
[187a]	MET 57.51.36, recto	Rustam & Isfandiyar	VI, 238, 334-243, 423	
[187b]	MET 57.51.36, verso	Rustam & Isfandiyar	VI, 243, 424-247, 488	Rustam and Isfandiyar meet and parley
188a	CB 110.48, recto	Rustam & Isfandiyar	VI, 247, 487-252, 583	
188b	CB 110.48, verso	Rustam & Isfandiyar	VI, 253, 584-257, 680	
[189a]	MET 29.160.21, recto	Rustam & Isfandiyar	VI, 257, 681-264, 768	
[189b]	MET 29.160.21, verso	Rustam & Isfandiyar	VI, 264, 769-267, 827	Rustam and Isfandiyar vaunt their valour
[191a]	AKG 35.15.2, recto	Rustam & Isfandiyar	VI, 278, 1005-282, 1061	Rustam and Isfandiyar test each other
[191b]	AKG 35.15.2, verso	Rustam & Isfandiyar	no text available	
195a	AIC 34.117, recto	Rustam & Shaghad	[VI, 323, 26-328, 115]	
195b	AIC 34.117, verso	Rustam & Shaghad	VI, 328, 116-331, 170	Rustam slays Shaghad and then dies
196a	CB 110.49, recto	Rustam & Shaghad	VI, 331, 171-338, 279	
196b	CB 110.49, verso	Rustam & Shaghad/ Bahman Isfandiyar	VI, 338, 280-343, 10	
197a	CB 110.50, recto	Bahman Isfandiyar	VI, 343, 11-350, 126	
197b	CB 110.50, verso	Bahman Isfandiyar/ Hamai Chahrzad	VI, 350, 127-356, 33	
198a	CB 110.51, recto	Hamai Chahrzad	VI, 356, 34-361, 122	
198b	CB 110.51, verso	Hamai Chahrzad	VI, 361, 123-366, 214	
199	CB 110.41		original margin numbered 199 (no original text)	
[201a]	Gillet, recto	Dara	VI, 387, +105-390, 161	Iskandar goes as ambassador before Dara
[201b]	Gillet, verso	Dara	VI, 390, 162-395, +245	
202a	CB 110.52, recto	Dara	VI, 395, +245-400, 331	
202b	CB 110.52, verso	Dara	VI, 400, 332-405, 420	
203(A)a	CB 110.53, recto	Dara/ Iskandar	VI, 405, 421-406, 453+33 VII, 6, 1-6, 11+	
203(A)b	CB 110.53, verso	Iskandar	VII, 6, 12-12, 97	

[203(B)a]	CB 110.54, recto	Iskandar	VII, 12, 98-17, 182	
[203(B)b]	CB 110.54, verso	Iskandar	VII, 17, 183-21, 274	
203(C)a	CB 110.55, recto	Iskandar	VII, 21, 275-26, 364	
203(C)b	CB 110.55, verso	Iskandar	VII, 26, 365-32, 457	
204a	BMFA 20.1841, recto	Iskandar	VII, 49, 780-52, 834	Iskandar with Queen Qaidafa
204b	BMFA 20.1841, verso	Iskandar	VII, 52, 835-57, 925	
205a	CB 110.56, recto	Iskandar	VII, 57, 926-63, 1021	
205b	CB 110.56, verso	Iskandar	VII, 63, 1021-67, 1111	
206	CB 110.37		original margin numbered 206	
			(no original text)	
207a	CB 110.57, recto	Iskandar	VII, 77, 1299-82, 1386	
207b	CB 110.57, verso	Iskandar	VII, 82, 1387-86, 1471	
208a	DC 13/1990	Iskandar	VII, 87, 1472-90, 1529	Iskandar builds wall against Gog and Magog
[210a]	MCG 1977.5, recto	Iskandar	VII, 106, 1805-108, 1856	Iskandar mourned
[210b]	MCG 1977.5, verso	Iskandar [/Ashkanians]	[VII, 108, 1857-114, 29]	
211a	CB 110.58, recto	Ashkanians	VII, 114, 30-119, 115	
211b	CB 110.58, verso	Ashkanians	VII, 119, 116-124, 206	
212a	CB 110.59, recto	Ashkanians	VII, 124, 207-128, 294	
212b	CB 110.59, verso	Ashkanians	VII, 128, 295-133, 384	
213a	CB 110.60, recto	Ashkanians	VII, 133, 385-137, 470	
213b	CB 110.60, verso	Ashkanians	VII, 137, 471-141, 530	Haftvad's daughter finds the worm
215a	CB 110.61, recto	Ashkanians/Ardashir	VII, 151, 717-156, 27	
215b	CB 110.61, verso	Ardashir	VII, 156, 28-161, 114	
[216a]	HUAM 1960.192, recto	Ardashir	VII, 161, 115-166, 201	
[216b]	HUAM 1960.192, verso	Ardashir	VII, 166, 203-170, 261	Mihrak's daughter converses with Shapur at the well
217a	CB 110.62, recto	Ardashir	VII, 170, 262-175, 349	
217b	CB 110.62, verso	Ardashir	VII, 175, 350-180, 445	
218a	CB 110.63, recto	Ardashir	VII, 180, 446-185, 531	
218b	CB 110.63, verso	Ardashir	VII, 185, 532-190, 617	
219a	CB 110.64, recto	Ardashir/Shapur	VII, 190, 618-198, 48	
219b	CB 110.64, verso	Shapur/Hurmuzd	VII, 198, 49-204, 56	
220a	CB 110.65, recto	Hurmuzd/Bahram Hurmuzd/Bahram Bahram/Bahram Bahramian	VII, 204, 57-213, 6	
220b	CB 110.65, verso	Bahram Bahramian/ Narsi Bahram/Hurmuzd Narsi	VII, 213, 7-219, 12	
221a	CB 110.66, recto	Shapur Dhu'l-Aktaf	VII, 220, 13-225, 102	
221b	CB 110.66, verso	Shapur Dhu'l-Aktaf	VII, 225, 103-229, 190	
222a	CB 110.67, recto	Shapur Dhu'l-Aktaf	VII, 229, 191-234, 281	
222b	CB 110.67, verso	Shapur Dhu'l-Aktaf	VII, 234, 282-239, 371	
223a	CB 110.68, recto	Shapur Dhu'l-Aktaf	VII, 240, 372-244, 462	
223b	CB 110.68, verso	Shapur Dhu'l-Aktaf	VII, 245, 463-249, 554	
224a	CB 110.69, recto	Shapur Dhu'l-Aktaf	VII, 249, 555-255, 646	
224b	CB 110.69, verso	Shapur Dhu'l-Aktaf/ Ardashir Good/Shapur Shapur/Bahram Shapur	VII, 255, 647-263, 23	
225a	CB 110.70, recto	Bahram Shapur/ Yazdigird	VII, 263, 24-267, 80	
225b	CB 110.70, verso	Yazdigird	VII, 267, 81-273, 169	

[226a]	SAM 52.41, recto	Yazdigird	VII, 274, 170-277, 224	Bahram Gur's mount tramples Azada
[226b]	SAM 52.41, verso	Yazdigird	VII, 277, 225-281, 311	
227a	CB 110.71, recto	Yazdigird	VII, 281, 312-285, 370	Yazdigird killed by a white demon horse
227b	CB 110.71, verso	Yazdigird	VII, 285, 371-291, 485	
229a	CB 110.72, recto	Yazdigird/Bahram Gur	VII, 302, 671-305, 31	Bahram Gur enthroned
229b	CB.110.72, verso	Bahram Gur	VII, 305, 32-310, 116+	
[230a]	MAH 1971-107/336, recto	Bahram Gur	VII, 310, 116+-316, 209	
[230b]	MAH 1971-107/336, verso	Bahram Gur	VII, 316, 210-320, 268	Bahram Gur hunts the lion and the lioness
231a	CB 110.73, recto	Bahram Gur	VII, 320, 269-326, 352	
231b	CB 110.73, verso	Bahram Gur	VII, 326, 354-331, 442	
232a	CB 110.74, recto	Bahram Gur	VII, 331, 443-335, 528	
232b	CB 110.74, verso	Bahram Gur	VII, 335, 529-340, 615	
233a	CB 110.75, recto	Bahram Gur	VII, 340, 616-345, 706	
233b	CB 110.75, verso	Bahram Gur	VII, 345, 707-351, 799	
234a	CB 110.76, recto	Bahram Gur	VII, 351, 800-356, 887	
234b	CB 110.76, verso	Bahram Gur	VII, 356, 888-360, 972	
236a	CB 110.77, recto	Bahram Gur	VII, 370, 1153-372, 1242	
236b	CB 110.77, verso	Bahram Gur	VII, 372, 1243-380, 1325	
237a	WAG 10.677a, recto	Bahram Gur	VII, 380, 1326-384, 1393	Bahram Gur at the peasant's house
237b	WAG 10.677a, verso	Bahram Gur	VII, 384, 1394-389, 1479	
239a	CB 110.78, recto	Bahram Gur	VII, 398, 1648-403, 1730	
239b	CB 110.78, verso	Bahram Gur	VII, 403, 1737-408, 1821	
240a	CB 110.79, recto	Bahram Gur	VII, 408, 1821-413, 1908	
240b	CB 110.79, verso	Bahram Gur	VII, 413, 1909-418, 1994	
[241a]	CAM 1947.500, recto	Bahram Gur	VII, 418, 1995-421, 2050	Bahram Gur wrestles before Shangul
[241b]	CAM 1947.500, verso	Bahram Gur	VII, 421, 2051-426, 2137	
242a	AMSG S1986.114, recto	Bahram Gur	VII, 426, 2138-429, 2196	Bahram Gur kills the dragon
242b	AMSG S1986.114, verso	Bahram Gur	VII, 429, 2197-434, 2284	
243a	CB 110.80, recto	Bahram Gur	VII, 434, 2285-441, 2397	
243b	CB 110.80, verso	Bahram Gur	VII, 441, 2398-447, 2485	
245a	CB 110.81, recto	Yazdigird	VIII, 10, 73-16, 167	
245b	CB 110.81, verso	Yazdigird	VIII, 16, 168-21, 255	
246a	BMA 86.227.133, recto	Yazdigird	VIII, 21, 256-24, 314	Khushnavaz battles Sufaray
246b	BMA 86.227.133, verso	Yazdigird	VIII, 24, 315-31, 35	
247a	CB 110.82, recto	Qubad	VIII, 31, 36-36, 125	
247b	CB 110.82, verso	Qubad	VIII, 36, 126-42, 216	
[248a]	MAH 1971-107/340, recto	Qubad	[VIII, 42, 217-47, 305]	
[248b]	MAH 1971-107/340, verso	Qubad	VIII, 47, 306-50, 363	Nushirvan executes Mazdak and five of his followers
[249a]	LACMA M.73.5.18, recto	Qubad/Kisra Nushirvan	VIII, 50, 364-54, 30	Nushirvan enthroned
[249b]	LACMA M.73.5.18, verso	Kisra Nushirvan	VIII, 55, 31-59, 113++	
250a	SAK IR.M.6/C, recto	Kisra Nushirvan	VIII, 59, 116-64, 206	illustration pasted over text (battle scene; specific subject unidentified)
250b	SAK IR.M.6/C, verso	Kisra Nushirvan	VIII, 65, 223-70, 315	
253	AMSG S1986.113, side 1	Kisra Nushirvan	VIII, 86, 590-92, 679	

256a	SAK IR.M.6/H, recto	Kisra Nushirvan	VIII, 120, 1203-131, 1299	
256b	SAK IR.M.6/H, verso	Kisra Nushirvan	VIII, 131, 1300-134, 1359	Nushirvan's third banquet for Buzurgmihr
[268/271]	PET	Kisra Nushirvan	VIII, 255, 3471-259, 3543	Nushirvan sends a servant to give Buzurgmihr a message in prison
274a	CB 110.83, recto	Kisra Nushirvan	VIII, 301, 4229-303, 4255	Caesar's envoys before Nurshirvan
274b	CB 110.83, verso	Kisra Nushirvan	VIII, 303, 4256-307, 4335	
[281/282]	BIN	Hurmuzd	VIII, 366, 869-367, 879 (partial text)	Bahram Chubina defeats and kills Sava
284a	CB 110.84, recto	Hurmuzd	VIII, 399, 1394-402, 1453	Bahram Chubina wears women's clothes sent by Hurmuzd
284b	CB 110.84, verso	Hurmuzd	VIII, 402, 1454-408, 1536	
286a	CB 110.85, recto	Hurmuzd	VIII, 420, 1711-425, 1791	
286b	CB 110.85, verso	Hurmuzd	VIII, 425, 1792-428, 1849+	Ayin Gushasp murdered
[292a]	MINN 51.37.23, recto	Khusrau Parviz	IX, 58, 807-61, 876	Bahram Chubina enthroned
[292b]	MINN 51.37.23, verso	Khusrau Parviz	IX, 61, 877-67, 966	
295a	MET 36.113.3, recto	Khusrau Parviz	IX, 86, 1312-90, 1379	
295b	MET 36.113.3, verso	Khusrau Parviz	IX, 90, 1380-94, 1434	Kharrad in the presence of Caesar's talisman
297	AG, recto		original margin numbered 297 (no original text)	
298	MCG 1977.4, recto	Khusrau Parviz	original margin numbered 298 (no original text)	
299	AMSG S1986.111, recto	Khusrau Parviz	original margin numbered 299 (no original text)	
300	AMSG S1986.118, recto	Khusrau Parviz	original margin numbered 300 (no original text)	
302	CHR 15.X.96, lot 122	Khusrau Parviz	IX, 149, 2364-151, 2395++	Bahram Chubina slays the lion-ape
[304/305a]	MINN 51.37.8, recto	Khusrau Parviz	IX, 173, 2781-176, 2844	Gurdiya speaks with Tuvurg
[304/305b]	MINN 51.37.8, verso	Khusrau Parviz	IX, 176, 2845-180, 2930	
[310/311]	AHT, recto	Khusrau Parviz	IX, 227, 3639-231, 3699	Musician Barbad plays for Khusrau Parviz
[316a]	AMSG S1986.118, recto	Farrukhzad/ Yazdigird	IX, ++309, 8-310, 5 IX, 311, 1-312, 20++	Yazdigird enthroned
[316b]	AMSG S1986.118, verso	Yazdigird	IX, 313, 22-317, 99	
317a	WAM 1935.21, recto	Yazdigird	IX, 317, 100-325, 188	
317b	WAM 1935.21, verso	Yazdigird	IX, 325, 189-331, 244	Sa'd-i Vaqqas slays General Rustam
[321/322a]	SAK IR.M.6/I, recto	Yazdigird	IX, 373, 761-379, 831+	The miller assassinates Yazdigird
[321/322b]	SAK IR.M.6/I, verso	Yazdigird	IX, 379, 832-382, 865	Finispiece: Enthronement

APPENDIX II

1341 *SHAHNAMA*: LIST OF COLLECTIONS

(with selected references)

AG Alex Gallery, New York
1 folio
Important Persian and Mogul Miniatures
(New York: Alex Gallery, 1993),
plate 1.

AHT Art and History Trust Collection,
courtesy of the Arthur M. Sackler
Gallery, Smithsonian Institution,
Washington, D. C.
1 folio
Abolala Soudavar, *The Art of the Persian
Courts: Selections from the Art and History
Trust Collection* (New York: Rizzoli,
1992), cat. no.14.

AIC Art Institute of Chicago
1 folio: 34.117

AK Albright-Knox Gallery, Buffalo
1 folio: 35:15.2
From the World of Islam (Part 1)
(Keuka Park, NY: Fox-Richmond
Gallery, Keuka College, 1970),
cat. no. 1.

AMSG Arthur M. Sackler Gallery,
Washington, D.C.
12 folios: S1986.99, .109, .110,
.111, .112, .113, .114, .115, .116,
.117, .118, .119
Glenn D. Lowry and Milo Cleveland
Beach with Roya Marefat and
Wheeler M. Thackston, *An Annotated
and Illustrated Checklist of the Vever
Collection* (Washington, D.C.: Arthur
M. Sackler Gallery in Association
with the University of Washington
Press, 1988), cat. nos. 74–85.

BIN formerly collection of Edwin Binney
3rd
1 folio
Edwin Binney 3rd, *Islamic Art from the
Collection of Edwin Binney 3rd*

(Washington, D.C.: Smithsonian
Institution, 1966), cat. no. 23.

BM British Museum, London
2 folios: 1925 2-20.01, 1933 9-
29.02
Robert Hillenbrand, *Imperial Images in
Persian Painting* (Edinburgh: Scottish
Arts Council, 1977), cat. no. 64
(1925 2-20.01); Sheila R. Canby,
Persian Painting (London: British
Museum Press, 1993), fig. 20
(1933 9-29.02).

BMA Brooklyn Museum of Art
1 folio: 86.227.133
*The Collector's Eye: The Ernest Erickson
Collection at the Brooklyn Museum* (New
York: The Brooklyn Museum,
1987), cat. no. 183.

BMFA Museum of Fine Arts, Boston
3 folios: 20.1839, .1840, .1841
Museum of Fine Arts Bulletin (Boston)
21 (August 1923): 51.

CAM Cincinnati Art Museum
1 folio: 1947.500
Oleg Grabar, *Persian Art Before and
After the Mongol Conquest* (Ann Arbor,
MI: University of Michigan Museum
of Art, 1959), cat. no. 132.

CB Chester Beatty Library, Dublin
85 folios: MS. 110
Arthur J. Arberry, Edgar Blochet,
Basil W. Robinson, and James V.S.
Wilkinson, *The Chester Beatty Library: A
Catalogue of the Persian Manuscripts and
Miniatures* (Dublin: Hodges, Figgis
and Co. Ltd., 1959) 1: cat. no. 110
and plates 18 and 19.

CHR Christie's, London
5 folios: 15.X.96, lot 122, lot 123,

lot 124, lot 125, lot 126
*Islamic Art and Indian Miniatures and
Rugs and Carpets* (London: Christie's,
17 October 1996), lots 122–126.

CMA Cleveland Museum of Art, Cleveland
1 folio: 44.479
A. Upham Pope and Phyllis
Ackerman, eds., *A Survey of Persian Art*
(London and New York: Oxford
University Press, 1938–39) 9: pl.
834A.

DC David Collection, Copenhagen
1 folio: 13/1990
Kjeld von Folsach, *Fabelvaesener fra
Islams Verden* (Copenhagen: Davids
Samling, 1991), cat. and fig. 75;
Oriental Manuscripts and Miniatures
(London: Sotheby's, 12 October
1990), lot 157.

FGA Freer Gallery of Art, Washington,
D.C.
5 folios: 42.11, 42.12, 45.7, 48.15,
52.35
Esin Atil, *Exhibition of 2000 Years of
Persian Art* (Washington, D.C.:
Smithsonian Institution, 1971),
plate 10 (42.12); Grace D. Guest,
"Notes on a Thirteenth Century
Beaker," *Ars Islamica* 10 (1943), fig.
17 (45.7).

GIL Gillet Collection, Lyons
2 folios
Pope and Ackerman, plate 834B.

HAA Honolulu Academy of the Arts
1 folio: 4100.1
Don Aanavi, *Islamic Arts* (Honolulu:
Academy of Arts, 1974), cat. no. 1.

HUAM Harvard University Art Museums,
Cambridge

3 folios: 1960.192, .194, .195
Marianna S. Simpson, *Arab and Persian Painting in the Fogg Art Museum* (Cambridge, MA: Fogg Art Museum 1980), cat. nos. 54–56.

KEIR Keir Collection, Richmond, Surrey
3 folios: III.4, .5, .6
Basil W. Robinson, "Persian and Pre-Mughal Indian Paintings" in *Islamic Painting and the Arts of the Book: The Keir Collection* (London: Faber and Faber, 1976), cat. nos. III.3, III.4, III.5 and plates 14 and 15.

KHALILI Collection of David Khalili, London
5 folios: MS 679, MS 1019.1, MS 1019.2, MS 1019.3, MS 1019.4
Jean Soustiel, *Objets d'art de l'Islam*, 2 (1974): 18, no. 14 (MS 1019.2); *Fine Oriental Miniatures, Manuscripts and Persian Lacquer, part two* (London: Sotheby's, 23 November 1976), lot 256 (MS 1019.3). All these folios are to appear in a forthcoming catalogue of the Khalili painting collection by Eleanor Sims.

KNM Kuwait National Museum
1 folio: LNS 36 MS
Marilyn Jenkins, ed., *Islamic Art in the Kuwait National Museum: The al-Sabah Collection* (London: Sotheby Publications by P. Wilson Publishers, 1983), cat. no. 98.

LACMA Los Angeles County Museum of Art
1 folio: M.73.5.18
Pratapaditya Pal, ed., *Islamic Art: The Nasli M. Heeramaneck Collection* (Los Angeles: Los Angeles County Museum of Art, 1973), cat. no. 189.

MAH Musée d'art et d'histoire, Geneva
5 folios: 1971-107-5, -332, -336, -340, -369
Basil W. Robinson, *Jean Pozzi: L'Orient d'un Collectionneur* (Geneva:

Musée d'art et d'histoire, 1992), cat. nos. 5–11.

MCG McGill University Libraries, Montreal
2 folios: 1977.4, .5
Grabar, cat. nos. 129 and 131.

MET Metropolitan Museum of Art, New York
7 folios: 29.160.21, .22; 36.113.1, .2, .3; 57.51.35, .36
Maurice S. Dimand, "Three Persian Miniatures of the XIVth Century," *Bulletin of the Metropolitan Museum of Art* 32 (January 1937): 13 (36.113.1, .2, .3); Marie G. Lukens, *Islamic Art* (New York: Metropolitan Museum of Art, 1965), fig. 29 (57.51.35).

MINN Minneapolis Institute of Arts
2 folios: 51.37.8, .23
Eleanor Sims, "Persian Miniature Painting in the Minneapolis Institute of Arts," *The Minneapolis Institute of Arts Bulletin* 62 (1975): 55.

MMFA Montreal Museum of Fine Arts
1 folio: 54.Ea.1
Hillenbrand, cat. no. 137.

MSM Staatliches Museum für Völkerkunde, Munich
1 folio: 77-11-394
Hans-Caspar Graf von Bothmer, *Die islamischen Miniaturen der Sammlung Preetorius* (Munich: Karl M. Lipp, 1982), cat. no. 3.

OF Olsen Foundation, Bridgeport
1 folio
Binney, cat. no. 24.

PET Galerie Georges Petit, Paris
1 folio: 3-5.VI.31, lot 94
Catalogue des tableaux anciens, objets d'art et de haute curiosité européens et orientaux . . . la collection de M. Gustave Homberg (Paris: Galerie Georges Petit, 3–5

Juin 1931), lot 94 and plate 48.

SAK Collection of Prince Sadruddin Aga Khan, Geneva
11 folios: IR.M.6, .6/A, .6/B, .6/C, .6/D, .6/E, .6/F, .6/G, .6/H, .6/I; IR.M.56
Anthony Welch, *Collection of Islamic Art: Prince Sadruddin Aga Khan* (Geneva: Château de Bellerive, 1972–8) 1: 67-85, cat. nos. IR.M.6-.6/I; 3: 44, cat. no. IR.M.56.

SAM Seattle Art Museum
1 folio: 52.41

SOTH Sotheby's, London
1 folio: 15.X.97, lot 38
Oriental Manuscripts and Miniatures (London: Sotheby's, 15 October 1997), lot 38.

2 folios: 6.XII.67, lot 11, lot 12
Highly Important Oriental Manuscripts and Miniatures: The Property of the Kevorkian Foundation (London: Sotheby's, 6 December 1967), lots 11-12.

UOMA University of Oregon Museum of Art
1 folio: 64:20.2

WAG Walters Art Gallery, Baltimore
4 folios: 10.677a, b, c, d
Ernst Grube, *Muslim Miniature Painting* (Venice: Neri Pozza Editore, 1962), cat. nos. 25 and 26 (10.677a-b).

WAM Worcester Art Museum
1 folio: 1935.21
Perry B. Cott, "Recent Accessions of Near Eastern Miniature Paintings," *Worcester Art Museum Annual* 1 (1935–36): 32.

Ghiyath al-Din 'Ali-yi Naqshband and an Episode in the Life of Sadiqi Beg

ROBERT SKELTON

DURING THE REIGN OF HIS PATRON SHAH 'ABBAS I AND for some time after, in the lands penetrated by Iranian culture, the remarkable silk weavings of Khvaja Ghiyath al-Din-i Naqshband were greatly sought after. Yet, by the time his name became known to historians of the decorative arts in Europe, he was virtually forgotten by his compatriots – for whom the history of the material arts was still of comparatively little significance. Anyone who wished to seek his name in works of traditional Iranian scholarship could only refer to those invaluable quarries of diverse information known as *tazkirat* – biographical notices of poets and men of learning. Since many of these men often combined the writing of verses with other attainments, *tazkirat* are often valuable for the light they shed on what were considered to be less noteworthy fields of artistic endeavour than verse.

It was from one such text that H. Blochmann, translator of that valuable compendium of Mughal administration, the *A'in-i Akbari*, was able to supplement the author, Abu'l-Fazl's, brief reference to a reduction in the price of silks made by "the famous Ghiyas-i Naqshband" with an amusing anecdote that Blochmann had found in the *Tazkira* of Tahir Nasrabadi.[1] From this source he discovered that Ghiyath came from Yazd and had written verses, of which a few were quoted by Nasrabadi.

Although this anecdote has become well-known through Blochmann's note, Nasrabadi's original text appears not to have been consulted by subsequent writers on Ghiyath. For Blochmann's version, brought to the attention of art historians by Phyllis Ackerman in 1933,[2] differs slightly from that in the printed edition of the *Tazkira* itself.[3] In her article, Ackerman tacitly connected Nasrabadi's story with a particular silk, formerly in the Kelekian col-lection, which she illustrated on the same page. Another piece of the same silk is in the Textile Museum, Washington D.C. (pl.I). According to Nasrabadi "It is well-known that he (Ghiyath) had made a figured gold-brocade, on which, in some trees, was pictured the figure of a bear, which he presented to the king residing in paradise, the late Shah 'Abbas. After seeing the brocade, Abu Qardash, who was full of merriment, praised the bears. The Khwaja at once responded with the impromptu couplet:

The gentleman looks mostly at the bear
Each person sees the image of himself."

Blochmann underlines the point of the response by quoting the Iranian proverb "A bear on a hill is an Avicenna, i.e. a fool among bigger fools is a philosopher".

The story appears again in a much longer account of Ghiyath, discovered by Farajollah Bazl in the *Jami'-i Mufidi*, a well-known history of Yazd by Muhammad Mufid Mustaufi ibn Najm al-Din Mahmud Bafqi-yi Yazdi.[4] Thus only a year after her initial article appeared Ackerman was able to publish a large part of Mufidi's informative entry on Ghiyath in a translation made by Bazl in collaboration with Arthur Upham Pope.[5] With this new data Ackerman revealed that Ghiyath was respected as a distinguished personality with many excellent qualities and came from a respectable background which included a well-known calligrapher as one of his immediate ancestors. He achieved high rank as a favourite courtier of Shah 'Abbas and was noted for his skill in the composition of amusing verses. In his youth he enjoyed wine and the company of attractive women but eventually repented, whereupon the Imam 'Ali

appeared to him in a dream and reinforced his intention to give up alcohol. In several verses quoted by Ackerman Ghiyath proclaims his allegiance to 'Ali. His skill as a textile designer is praised highly by Mufid, who states that his productions were in great demand by the rulers of India, Turkestan and Turkey.[6] As a result of this commercial success Ghiyath became the owner of countless luxury objects, books, furniture and lands and built himself a fine residence in Yazd which had evidently been visited by the Shah. He lived there until his death, leaving behind him six sons, of whom at least one, Mu'izz, followed his father's profession.[7] Finally, Ackerman told her readers that some of Ghiyath's grandsons were still living in Yazd when Mufidi wrote his account in 1082 A.H./1671 A.D.

This second article has provided textile historians with the fullest account of Ghiyath that has so far been published in English but the relevant section of Mufid's text presented there is not actually complete. Certain passages, such as a nearly identical version of the anecdote about Abu Qardash,[8] are left out or are quoted out of their original sequence, and verses by Ghiyath have been omitted where they seemed not to be of direct biographical interest. No further enquiries into the weaver's life and personality appear to have been carried out and subsequent publications simply deal with textiles from his workshop in the context of Ackerman's earlier research.[9]

The present writer's attention was drawn to the possibility of more light being shed on Ghiyath in 1976, when Anthony Welch published his illuminating study of the soldier/painter/court librarian Sadiqi Beg in his *Artists for the Shah*[10] and quoted a passage from Sadiqi's *Majma' al-Khavass* that clearly refers to the celebrated weaver.[11] Thanks to the delightful ambiguity of Persian, Welch read *"fann-i naqshbandi wa sha'rbafi"* as "art of illuminating and writing poetry" (i.e. *shi'rbafi*)".[12] Ghiyath was indeed a poet; but the term *sha'rbafi* applies as much to the weaving of silk cloth as to the composition of verses, while *naqshbandi* embraces various arts that depend on the drawing or painting of designs.[13]

Sadiqi does not present many new facts about Ghiyath, but, unlike Nasrabadi and Mufid, who made their compilations many years later, he was both a contemporary and an intimate associate, speaking from personal knowledge as one who entered the service of Ghiyath in the early 1680s and stayed for a while in his employer's house. Thus when he tells us that this Yazdi was of Shirazi descent and from no less a personage than the great poet Sa'di, it is clear that this was claimed, whether justly or wrongly, by Ghiyath himself. Sadiqi also reveals that Ghiyath was without equal in his strength, agility and skill in archery but was at the same time very gentle and kind. His generosity was such that if he had no guest on a particular day, food and drink would not be agreeable to him – a passion for hospitality that Ghiyath himself alludes to in a verse quoted by Sadiqi (see appendix C).

Within a year of this brief pen-portrait by Sadiqi being published in translation, further confirmation of this episode in the

artist's life was found in the form of a tinted drawing partly based on an engraving of the Annunciation in a collection on loan to the Fogg Art Museum (pl.2).[14] On the face of it, from what we know of the virtuosity of Sadiqi's style in its calligraphic phases,[15] this drawing would not be recognised as coming from his brush; but an inscription provides a very firm link with his remarks on Ghiyath al-Din 'Ali-i Naqshband in the *Majma' al-Khavass*. It reads: "These two figures are in the manner of the Frankish masters: drawn while in the service of the one giving asylum to those seeking the right path, the Wonder of the Age, Khvaja Ghiyath Naqshband. Written by the servant [of God] Sadiqi, the Librarian".[16] In view of the fact that Sadiqi made this drawing soon after 1580, it is interesting that he was following an engraved source of about a century earlier. The precise model has not been identified but the figure of the angel clearly relates to one from an Annunciation by the Netherlandish engraver known as the Master of the Banderoles, who worked in the Low Countries and perhaps for a while in north-western Germany until about 1470–5 (pl.3).[17]

Perhaps the first commercial engraver, this master almost invariably copied the work of others or else combined motifs from more than one source. As in the Banderoles Master's Annunciation, the Virgin of Sadiqi's drawing is shown on the left and bears some resemblance to the Virgin in prints by Israel van Meckenem (c. 1445–1503), who also copied earlier engravings.[18] Nevertheless, there are significant differences and it is possible that the engraver followed by Sadiqi had been influenced by similar sources.

Although the Virgin occupies a significant place in Islamic hagiography, there is no indication in the inscription that she was recognised as such by Sadiqi and we have no evidence as to why this subject was copied by the artist at this time. It seems not unlikely that the original engraving may have been in the possession of Ghiyath rather than the artist and it may simply have attracted Sadiqi's attention on an occasion when he may have been browsing through Ghiyath's collection.[19] Certainly one would expect a designer-craftsman such as Ghiyath to have gathered together an archive of visual reference material, and in view of Sadiqi's testimony it may be reasonable to suspect that other artists were lured by Ghiyath's reputation as a host to enjoy the delights of the Yazd household in exchange for examples of their work. That Sadiqi himself may have executed other drawings in the context of textile design is suggested by a flower study (pl. 4) inscribed *'amal-i Sadiqi*, sold by Sotheby's in 1978 (9 October, lot 10). Its handwriting resembles that on other works by Sadiqi. Sadiqi Beg was not the only contemporary of Ghiyath to leave a brief notice of him in a *tazkira*. We can also find a shorter entry in the *Haft Iqlim*, a biographical encyclopaedia arranged, as its title implies, according to celebrities' towns or countries. Its author, Amin-i Ahmad-i Razi, the son of a favourite of Shah Tahmasp, later moved to India, where he finished his book in 1002 A.H./1593–4 A.D. Amin-i Ahmad does not have a lot to say about Ghiyath, and he evidently liked the less edifying

of Ghiyath's poems (appendix D), but his use of the present tense suggests that Ghiyath was still alive in 1593–4. He also provides us with the significant but unsurprising fact that Ghiyath had been appointed to be the *muqaddam*, or leader, of the Guild of Weavers of Yazd, an official position that carried with it a number of responsibilities.[20] The appointment was one that had to be ratified by the Shah in the case of the capital, or by the local governor in provincial cities. It was perhaps in this role that Ghiyath came up against a certain Ghazi Beg, a *wazir* who at first rose high in the favour of Shah 'Abbas and was appointed as governor of Yazd, but who was subsequently disgraced as a result of corrupt and tyrannical activities. These were brought to the attention of the Shah by a trustworthy person, who backed up his report by quoting this *qit'a* composed by Ghiyath:

> Oh Shah, the Giver of Justice
> Never forgive a tyrant, whoever he may be,
> Especially that Ghazi, in the town of Yazd,
> From whose tyranny there is grief in every household.
> It is good to have clemency but not to him
> For clemency towards him is injustice to others.[21]

Perhaps it was the occasional stress of his responsibilities as leader of the guild that prompted a quatrain in which Ghiyath al-Din's normal mood of self-congratulation regarding the advantages bestowed on him was replaced by one of regret.

> Miserable is the one whose home town is Yazd
> More miserable is the one whose art is *naqshbandi*
> Worse than these two is the one who is eloquent.
> Helpless is he, who, like me, has all three.[22]

The personality who emerges from such poems and from the observations made about him by others was clearly a multi-faceted character of outstanding artistic talent in his chosen profession. His skill as a weaver and designer was accompanied by an evident entrepreneurial flair, generosity, ready wit and an agreeable disposition in relation to his fellows. Some may think that these many positive aspects of his personality do not match well with his "facetious" verses (*hazliyat*) or those which express an interest in beardless youths (see Appendices C & D). An example of somewhat unkind wit appears in Mufid's account of Majd-i Hamgar (d. 686A.H./1287–8 A.D.), the panegyrist of the Atabek of Fars, Sa'd b. Abu Bakr b. Zangi. Majd was a native of Shiraz residing in Yazd. On leaving that city for Isfahan he left his aged wife behind, but to his dismay she followed him to Isfahan and when her arrival was reported to him he made a very ungenerous comment. The story was commemorated by Ghiyath in two couplets describing this virtuous but ill-favoured lady:

> The jewel casket of her mouth was empty of pearls
> The cypress of her form was bent double like a weeping-willow.

> To cast amorous glances she required eye-glasses
> And to walk gracefully she needed the help of a stick.[23]

With regard to his interest in pre-pubescent youths, it will be remembered that weavers in the East still do employ young children. Indeed in view of the fineness of silks from Ghiyath's workshop it is difficult to imagine their manufacture without the intervention of such nimble fingers. Judging from the verses it is tempting to suppose that the handsomeness of certain employees could easily impinge upon the feelings of a man whose aesthetic sensibility was as finely tuned as his. Nevertheless the topic, including the metaphors used for the appearance of facial hair, belongs to a long-established convention, and there is a parallel convention in the *shahr-ashub* literature, which celebrates the disturbing presence within urban communities of virtually all possible types of craftsmen. That weavers could be imagined to excite such sentiments is indicated by the *Sifat-i Sha'r baf* from the *Divan-i Rizvan* of Mirza Tahir Vahid:

> My heart is captive to the brocade weaver
> In whose hand every thread is a noose.
> Like a piece of brocade I made his shop my abode,
> And since that time my skirt is in course of being filled with roses.[24]

Apart from the new evidence regarding Ghiyath al-Din's life and character already noted above there is also more evidence in Mufid's account of him than has been noticed previously.

We know for example from Amin-i Ahmad that Ghiyath held an official position as *Muqaddam* or *Bashi* of the weavers' guild in his native city; but, in view of his recognised pre-eminence as a manufacturer of luxury fabrics, the question remains whether or not he held any office within the hierarchy of the royal *karkhanajat* in Isfahan. We have an indication that this may be the case from a statement made by the Mughal Emperor Akbar's minister and historian, Abu'l-Fazl, with reference to the important embassy sent by Shah 'Abbas with the envoy Manuchihr Beg, who arrived at Lahore in October 1598 with gifts including "300 pieces of brocade – all woven by the hands of noted weavers – and fifty masterpieces of Ghias Naqshband".[25] Abu'l-Fazl's remark is interesting in that it singles out the work of Ghiyath from that of other noted craftsmen and also in its unconscious assumption that it was the status of these highly regarded weavers which underlined the value of the gift. However, it also hints at an answer to the question as to whether Ghiyath had a role in the running of the royal workshops. The fact that a significant batch of his output was included among diplomatic gifts rather suggests that Ghiyath was involved in this important branch of state (*buyutat-i saltanati*) at an official level. This is further suggested by a quatrain cited by Mufid in which Ghiyath tactfully reminded the Shah that he had not yet been paid last year's salary (*mavajib*). The receipt of a

salary implies an official position, though it is not absolutely clear whether this applied only to those employed in workshop administration at the capital.[26]

Another question concerning Ghiyath which remains to be settled is the chronology of his working life. On the evidence of Amin-i Ahmad he was still alive in 1002 A.H./1593–94 A.D. and this is supported by the use of the present tense by Sadiqi Beg in the *Majma' al-Khavass*, near the end of which is a chronogram for the circumcision of Safi Mirza in 1003 A.H.[27] Judging from his respectful tone when speaking of Ghiyath, Sadiqi was probably a little younger than his employer, who would thus have been over fifty when Sadiqi stayed in Yazd in or soon after 988 A.H./1580 A.D.[28] On this assumption Ghiyath may, therefore, have been born in about 930–40 A.H. and would have been aged between sixty-five and seventy-five in 1002–3 A.H./1593–5 A.D. when he was still known to be alive. Shortly before his death Ghiyath wrote a quatrain which sheds further light on the matter:

> Alas the harvest of life has gone with the wind.
> Oh where is the time of youth – Oh where?
> Oh old dotard! don't you recall
> That the commerce (of life) ceases between sixty and seventy?

This implies that Ghiyath may not quite have reached the age of seventy before he died, in which case the date of his birth can be narrowed down still further to about 936 A.H./1529–30 A.D.

The only further information provided by Mufidi concerns close relatives of Ghiyath. The verse listing his six sons clearly suggests that they were the offspring of two mothers, of whom the first gave birth to four and the second to two. Another relative, whose exact relationship is not defined, appears also to have been a talented weaver, named Saif al-Din, who enjoyed the favour of Shah Safi and was thus working during the first half of the following century (see Appendix F). Saif al-Din was also deeply attached to the Imam 'Ali and sought the permission of the Shah to reside at Najaf. It seems very possible, therefore, that he was the Saifi-yi 'Abbasi who signed a brocade silk in the possession of the shrine of Najaf.[29] In that case, his *laqab* or honorific title shows that he was already working and esteemed by the court before the death of 'Abbas I in 1629. This raises the possibility that Saif al-Din was apprenticed to his kinsman, Ghiyath, and grew up in his workshop.

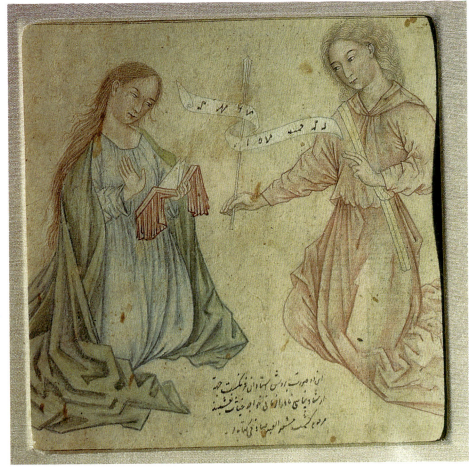

1. LAILA AND MAJNUN IN THE DESERT WITH BEARS SEATED ON ROCKS.

Satin lampas signed: 'amal-i Ghiyath. Yazd or Isfahan, late 16th century. Courtesy of the Textile Museum, Washington (TM3.312)

2. THE ANNUNCIATION TO THE VIRGIN.

Watercolour on paper signed by Sadiqi Beg. Yazd, c.1580–5. PRIVATE COLLECTION ON LOAN TO FOGG ART MUSEUM 418.1983

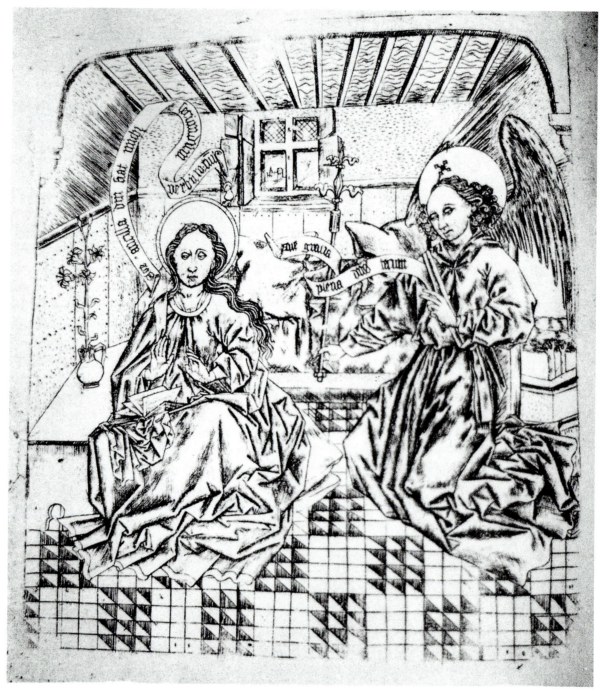

3. THE ANNUNCIATION TO THE VIRGIN.

Engraving on paper by the Master of the Banderoles.

Flemish, c.1450–70.

After Lehrs. *Kritischer Katalog.*

4. STUDY OF A ROSE MOUNTED WITH CALLIGRAPHY.
Watercolour on paper inscribed "Work of Sadiqi".
Isfahan or perhaps Yazd, c.1580–1609.
PRESENT WHEREABOUTS UNKNOWN.

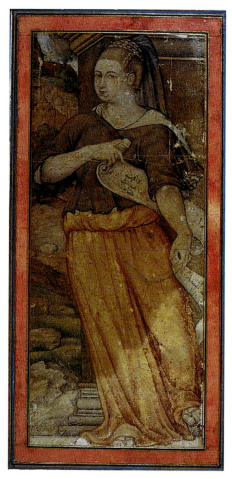

5. A SYBIL.

Watercolours on paper. Signed by Sadiqi Kitabdar.

Isfahan, 1609 A.D. Present whereabouts not known.

6. TWO SYBILS.

Engraving on paper. By Goltzius after Polidoro da Caravaggio, 1592.

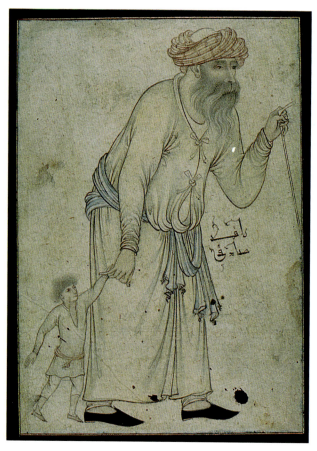

7. OLD MAN AND CHILD.

Ink and watercolours on paper. Signed by Sadiqi. Isfahan, early 17th
century. By courtesy of the Chester Beatty Library, Dublin.

8. DERVISH LEADING A DOG.

Ink and watercolours on paper. Signed by Sadiqi. Isfahan, early 17th century.
By courtesy of the Walters Art Gallery, Baltimore.

Appendices

In May 1951 I was beginning to assist B.W. Robinson in his preparation for the exhibition of *Persian Miniature Paintings from British Collections*, which was held in the old building of the Indian Section of the Victoria & Albert Museum. On the 26th of that month, Robbie loaned me a copy of *Written and Spoken Persian*, written by E.M.N. Hawker for staff of the Anglo-Iranian Oil Company with the recommendation that "Persian poetry had much to commend it". Despite some slight later aquaintance with more advanced manuals the recipient of this kind loan has never become competent to deal with the complexities of Safavid literary expression, which even an admirer admits to be "caught in a web of complex rhetorical devices and cannot extricate itself" ending "in contrived artificiality and in puzzle-like constructions".[30] Consequently in addition to thanks to Robbie for so much more than just the loan of Hawker's book, the deepest gratitude must also be expressed to several Iranian friends: Mrs. Afsaneh Wogan, who shed much light on several of the texts at an early stage, Dr. Manijeh Bayani for going through subsequent crude attempts and correcting many errors and Mr. Mohsen Ashtiany for offering advice on two or three of the most inscrutable passages. The faults which remain are mine alone, and – following the excuse of Ghiyath to Shah 'Abbas - *kh(v)aham ki bi pushand zi-karam 'aib-i mara*.

APPENDIX A

Extract from the *Tazkira* of Mirza Muhammad Tahir Nasrabadi Isfahani.

KHWAJA GHIYATH

Khwaja Ghiyath is from (one of) the districts of Yazd. For as long as the Weaver of the Firmament has been weaving day and night from the warps of sunshine and the wefts of shooting stars there has been no weaver nor designer like him. Furthermore, in this art he had a fine talent and correct taste. It is well known that he (Ghiyath) had made a figured gold-brocade, on which, in some trees, was pictured the figure of a bear, which he presented to the king residing in paradise, the late Shah 'Abbas. After seeing the brocade, Abu Qardash, who was full of merriment, praised the bears. The Khwaja at once responded with the impromptu couplet:

The gentleman looks mostly at the bear
Each person sees the image of himself.

On one occasion he completed a coat of gold-brocade, along the edge of which which was woven this quatrain of his own composition:

Oh King, your greatness equals the sky and your face, the sun.
I wish the coat could last throughout your life.
For one such as you my gift is inadequate
(Though) I hope that you may wear it in clemency for my fault.

The Shah replied "I shall wear it with pleasure".
Among the verses that have reached the poor man are these:

(*Couplet*):
With feet of ambition (clogged) in mud and the hand of regret on his head
A man of free spirit becomes one of the captive ones here.[31]

(*Ruba'i*):
Your incipient beard bears heavily on my heart.
In this spring comes the scent of autumn.
I don't care if the fire within bursts out in fiery words.
Whatever is in the heart comes eventually to the tongue.

(*Ruba'i*):
Oh Spirit of the Time disturbed by your tumult!
And oh Field of Combat caused by desire of you!
The complaint has become fixed in my mind
Neither is my mind broad nor your situation narrow.

(*Ruba'i*):
I am the precious pearl not the oyster-shell
I am the favourite son of the world mother
I am above the angels in rank, dignity and honour
Indeed I am the guard dog at the shrine of the King of Najaf (i.e. 'Ali).[32]

APPENDIX B

Extract from the *Jami'-i Mufidi* of Muhammad Mufid Mustaufi ibn Najm al-Din Mahmud Bafqi Yazdi.

The nightingale of the rose-garden of eloquence and sweet sounds and the parrot of the sugar plantation of eloquent and sweet speech, Khvaja Ghiyath al-Din 'Ali Naqshband of Yazd.

He was praised for his eloquence of expression and fluency of speech, sharpness in understanding and delicacy of character. In attaining excellence and perfection in the achievement of greatness and good fortune he achieved favour and approbation among the men of his time. That honourable man was one of the grandsons of Maulana Kamal, the calligrapher known as 'Assar, "the oil-presser"[33] who was the Yaqut of the age and the Sairafi[34] of his time.

And the honourable Ghiyath al-Din 'Ali was always a favourite of Kings and decree-dispensing Emperors; and, at the time of the Emperor who seized and governed the world, the late Shah 'Abbas, he became a favourite of that Majesty; [chosen by alchemy?] he became one of the circle of intimates of the King and one of the Lords of the heaven-resembling court. With his increasing proximity to the King he achieved high rank and eminence in the royal assembly and was raised to the peak of honour and the summit of preferment. He wrote clever and amusing verses and presented his petititons to the King in the form of poems. Thus he made a request for his salary in this quatrain:

> *Oh (Shah), source of light to my blood-weeping eye,*
> *Untie with a glance the knot of my affairs.*
> *Oh problem-solver of the Kingdom of Iran*
> *Grant me, this year, last year's salary*

It is well known that he had made a figured gold-brocade, on which was pictured the figure of a bear, which he presented to the world-conquering Emperor. After seeing the brocade, Abu Qardash, who was full of merriment, praised the bear that had been woven into it. Khvaja Ghiyath at once responded with the impromptu couplet:

> *The gentleman sees more in the bear:*
> *Each person sees the image of himself.*

On one occasion he completed a coat of gold-brocade, along the edge of which was woven this quatrain of his own composition:

> *Oh King, whose greatness equals the sky and whose face, the sun.*
> *I wish the coat could last throughout your life.*
> *For one such as you my gift is faulty*
> *I hope that you may wear[35] it in clemency for my fault.*

In reply the Shah replied "I shall wear it willingly".[36] At the beginning of his life and in the freshness of youth he enjoyed drinking wine that cheered the spirits, and the company of beautiful girls of Venus-like charms; and he considered it useless to spend his life without the life-enhancing liquor of red wine, and joined the heaven-like assembly of the world-seizing Emperor. Every morning when the gilded cup of the sun shone in the assembly of heaven he sought delectable wine from the cupbearers of sun-like countenance at the resplendent banquet; and every evening, when the silver bowl of the new moon started moving in the assembly of the fixed stars and planets, he drew from the hand of the lovely-cheeked one of moon-like appearance the cup of the companion wine until by the Divine grace of the Eternal God he began to utter the words "Repent to Allah" and, with pure heart, showed repentance of all his sins.

The cause of his repentance was that one night, overcome with regret and contrition, he prayed for the grace of repentance from the Pardoner of sins. And the arrow of his prayer reached the target of consent. In that same night he had a dream in which he saw the Commander of the Faithful and Imam of the Pious, the Victorious Lion of God, 'Ali son of Abi Talib – the blessings of Allah and peace be upon him – and from that auspicious hand he was honoured with repentance, and wrote these words concerning this:

(Masnavi)
> *One night in trepidation for the omission of acts of devotion*
> *I fell to the earth and prayed*
> *Oh Absolver (of sins) by the truth of the King of Valour ('Ali)*
> *Cleanse me from this impurity*
> *When my tongue exposed the sincerity of my heart*
> *He granted that which I had requested.*
> *On that same night by good fortune I saw in a dream*
> *The King, the Victor of Khaibar, facing the mihrab.*
> *The awakened heart imitated him*
> *And behind him said two parts of the prayer.*
> *When that Ocean of Truth finished praying*
> *He honoured me with advice and admonition.*
> *With this counsel he opened the door of grace*
> *And ordered me to renounce the drinking of wine.*

And these few quatrains were also born of the inspiration of that nightingale of the sugar plantation of eloquence:

> *Today make me victorious over my enemies*
> *And in seeking the truth make me studious.*

Tomorrow when I raise my head from the grave
Leave my resurrection to 'Ali ibn Abi Talib.

Also:

I am the precious pearl, not the oyster-shell.
I am the favourite son of the world mother.
I am worth a hundred times more than angels in rank and honour[37]
In that I am the guard dog at the shrine of the King of Najaf (i.e. 'Ali).

Also:

In the world of love 'Ali is our harvest
And this rose, which has blossomed from eternity, is from our water and soil.

As long as blood runs in the veins of Ghiyath, and soul in (his) body,
The love of 'Ali and his descendants is in my heart.

Khvaja Ghiyath al-Din 'Ali was unrivalled in the art of textile design. He continually drew marvellous things and wondrous forms on the pages of time with a thoughtful brush and completed exquisite textile fabrics. Such was the renown of his high achievement in this art that the mighty kings and rulers of India, Turkestan and Turkey sent him precious gifts asking for textiles from the workshops of his genius.

His magnificent furnishings, precious pieces of porcelain, books, lands and enclosed properties reached such an extent that the accountant confessed that he was unable to quantify them. That great man built for his residence in this mortal world a lofty mansion of particular extravagance in the garden called Dar al-Shifa-yi Sahibi[38] and this ode which was the fruit of his genius was inscribed (there) in gold:

(Ghazal)

Our house, by which the basis of sorrow is laid waste,
Is endowed to the impoverished haunter of taverns.
The mouth of Khizr's spring is dry from envy of its pure waters.
Vexed is the Garden of Paradise from the effect of its virtues.
Do you know why its climate is so pleasant?
It results from the blessing of the King of Iran's footprints
That World-bestowing Emperor, from whose justice
The hovel of the indigent is the envy of Paradise.
Happy is the man who resides in it
Because this night-halt is the abode of men without care.
Do not disturb anyone in this place if you desire
The Garden of Paradise, which is the refuge of the untroubled.
The intention is for the comfort of friends and not for Ghiyath
That his heart has desires for palaces and porticoes.
Eight couplets boasting of the eight paradises
His Houri is a virgin, his speech beautiful, his slaves are his handwriting.

And Ghiyath spent his life residing there and since durability and permanence in the world, which ends in affliction, are not possible for any mortal, he too followed those who went before him, shed the clothes of life and freed the guest of the spirit from the abode of the body.

(Hemistich)

Eternal life is not possible.

Some time before he set out on his last journey he uttered this quatrain:

Alas the harvest of life has gone with the wind.
Oh where is the time of youth — Oh where?
Oh old dotard! don't you recall
That the commerce (of life) ceases between sixty and seventy?

And from that fine personage were left six sons. As pointed out by that parrot of sugar-scattering speech:

Oh cypress-like lord of the wise
Hear the circumstances of us and our sons.
I, who, in Yazd, am the envy of Iran,[39]
Chosen by God to be equipped with artistic skills.
On top of a hundred thousand sorts of gift
God has given six silver coins from two jewel caskets,[40]
Afzal, Akmal, Rafi' and Mu'izz,
Whose decline may I never see.
Asghar and the young Abu'l-Faza'il,
Pure in disposition though ill-favoured in appearance.
Out of generosity Oh Munificent (Lord), resolve my difficulties.
(Oh) Creator, without a partner, of the earth and heavens,
Make them all excellent in art,
Make them famous in perfections and accomplishment.

And at the time of writing this discourse — two years from the year eighty and one thousand of the *hijra* (1082/1671–72 A.D.) — some of the grandsons and kin of that honourable man are still living in great esteem in the pleasant garden of Yazd and the most noble and best of them is the Asylum of Wisdom, the Galen of the Age, Mirza Muhammad Mufida, son of the Refuge of Mercy, Mu'ina Muhammada, the physician, who is adorned with the quality of piety, obedience and service to God as well as goodness of disposition. In curing diseases and removing their causes he displays clearly the signs of the life-bestowing breath of Christ. With great willingess and equanimity and with a cheerful countenance he does his utmost in healing the poor and needy. Without pomp and ceremony, the high and low of that land can enjoy and profit from his auspicious and healing breath.

APPENDIX C

Extract from the Persian translation of the *Majma' al-Khavass* of Sadiqi Beg Kitadbar.

KHVAJA GHIYATH-I NAQSHBAND

Khvaja Ghiyath-i Naqshband is of the people of Shiraz and descended from Shaikh Sa'di (may his grave be hallowed!). He has many skills. Firstly in the art of designing and making silken fabrics he can be called the phoenix of the age and the unique one of his time. The kings and princes of Iran and Turkestan are seekers after the silk cloths of his contriving. In agility, strength and archery he has no equal and with all this he is very gentle and kind. After the defeat at Astarabad I entered his service in Yazd and as well as close friendship with him I had the honour of staying in his house. If he had no guest on any day then food and drink were not agreeable to him. Because too much praise may be thought to be exaggeration I am content to give an account of his poetry, pious works and religious devotion. He composes all types of poetry and he has such a flair for composing impromptu verses that he can recite a hundred of them in quick succession without the listeners realising that it is impromptu. He is one who stays awake all night in prayer.

These couplets are his:

I, who in Yazd am the envy of my contemporaries
Am chosen by God in artistic skills.

There is no skill (hunar) like eloquence
Yet I am an artist-craftsman as well as being a poet.

Indeed, in the polishing of literary conceits
I am the adornment of Iran, and the envy of Turkestan.

I do not speak of it, for on that account
I am a thorn in the eyes of rivals.

In truth give me relief from stupidity
For I am dying from its oppression.

What else can I do in return
But move my lips in reproach.

With barley bread, marjoram and vinegar
I don't need Khizr and the water of life.[41]

Kinsmen and strangers alike receive a portion
According to their need from the table of my hospitality.

My table-cloth of hospitality has never been folded up
In the face of others.

I have freed a hundred hearts from imprisonment
Even though I remain in the jail (of life).

During the daytime I am busily engaged in making decorative designs
At night in the companionship of prayer and the Qur'an.

Among the prominent men of my city
I am a roaring lion and sharp-bladed sword.

But with those of humble station
I am a feeble ant, not a writhing snake.[42]

Do you know where I have acquired all these virtues?
From being one of the slaves of the King of Valour ('Ali).

* * * * * *

What happy days when there was no tarnish on your mirror (cheeks) face
And the tulip-bed (lips) not yet edged with violets.[43]

Without daily water[44] your beautiful cheek was a rose without thorns.
In these regions there was no cypress (boy) to match your proud demeanour

There were none who were not intoxicated by the wine of your beauty
Nor was there anyone who was not drowsy from its effect.

Now that the bird of your beauty has flown on the wings of a beard
The letters[45] in naskh script (the beard) are written on your face.

See how the Ka'ba of your face is now a place for infidels
Caught in its beard, your face, of Yusuf-like beauty,[46] is a prisoner in jail.

The pleasure-dome of your face is now the highway of ants[47]
The flower of the Angel's garden is trodden by the foot of Satan.

A thousand hearts are distracted by your disturbance.
The morning of your youth is over: for you, evening now has its turn.
When you see two people conversing like a pair of scissor-blades
It is the old story of reproach over the growth of beard.

In short, the boat of your beauty sinks in the sea of mortality
So there is no time for obstinacy, pride, capriciousness or indifference.

Your momentary beauty diminishes and the beard increases.
It's time to cease your coquettish glances: for a beard and coquetry don't mix.
Now that (tarnished?) silver can be put right by the elixir of noura (a depilatory)
You delude yourself if you think that you are still marketable.

Be patient, humble and self-abasing.

Because (now) it is your turn to carry loads or work with clay.

APPENDIX D

Extract from the *Haft Iqlim* of Amin-i Ahmad-i Razi[48]

KHVAJA GHIYATH AL-DIN-I NAQSHBAND

He is the foremost of skilled craftsmen and the *muqaddam*[49] of the weavers of silken fabrics, and from time to time, when he is in a good mood, a verse comes to be uttered by him. Most of his verses are facetious and witty such as the examples transcribed:

Oh cuckold, do not rebel against the *mim* of censure (*malamat*)[50]
When you place the finger of the penis in the cleft of the vulva.
For meanness, poverty, vileness and altercation
Are placed by the hand of fate in that fissure.

Filthy are the people of pure Khurasan
At night the washers of corpses and at dawn plundering the dead.
At the table of the distinguished they occupy the place of honour
At the bottom of the bowl (i.e. at heart), the friend[51] of the footman.
Wherever the handle of the spoon is stirred
(There) like a fly in the soup is a woman of ill repute.

APPENDIX E

Extract from *Tazkira-i Sukhanvaran-i Yazd* of 'Abd al-Husain Ayati Tafti:[52]

GHIYATH YAZDI

Khvaja Ghiyath-i Naqshband was one of the skilled crafts-men. He created silken cloths. He hastened to the court of Shah 'Abbas and received honour from that art-loving king and gradually rose in his profession. He became one of the wealthiest of the first degree in Yazd. He constructed various buildings, some of which still stand[53] in the street of the Dar al-Shifa. In his youth he was addicted to intox-icating drinks, the harp and rebec (*rabab*) and at the end of his time he was a sincere penitent and opened his lips to reprimand others. In one of his *mathnawi*s he has said:

He (i.e. 'Ali) ordered me to repent from drinking wine.

Ruba'i:

Miserable is the one whose home town is Yazd
More miserable is the one whose art is naqshbandi[54]
Worse than these two is the one who is eloquent.
Helpless is he, who, like me, has all three.[55]

APPENDIX F

Extract from the *Jami'-i Mufidi* of Muhammad Mufid Mustaufi ibn Najm al-Din Mahmud-i Bafqi-yi Yazdi.[56]

THE LATE FORTUNATE KHVAJA SAIF AL-DIN MAH-MUD-I NAQSHBAND

That honoured person was related to that nightingale of the orchard of eloquence and sweet discourse, Khvaja Ghiyath al-Din 'Ali-yi Naqshband of Yazd. In various kinds of talents and skill and ingenuity he was unique in his time and alone in the ages. In finding solutions, in experience and in dexterity in the business of designer craftsmanship he had no like nor equal. Consequently, awareness of his fine qualities was circulated by word of mouth and favourable reports. Something of that came to the notice of the Emperor of the Age and the Land, the Best of the great Sultans, Abu'l-Muzaffar Shah Safi, the deceased Safavi resembling Moses, who bestowed a decorated dress of honour on him in the group of his servants; and from that favour the basis of his worth and dignity and excellency increased.

In a short while he acquired a quantity of property and lands and founded gardens (resembling) paradise; and, having set up a farm (or hamlet?) in Farahshah, he caused that fine effort to be given precedence. And in the district of Khairabad in Aharistan he founded a garden patterned on the Garden of Paradise containing excellent buildings for the sake of recompense in the other world. And he added a further supply of water to the *qanat* of Salghurabad to please the landlords, half for the proprietors and another half for the houses and gardens of the district of Mal-i Amir and the Old Fort. And he made a pool in the great Congregational Mosque as deep as the thought of the wise and as broad as the men of liberality so that the servants of the Compassionate (i.e. Allah) became favoured with much water, and in the vicinity of the old fort he made a good public bath house.

In the meanwhile he sought permission to stay in Holy Najaf and the devout Padshah (Shah Safi) gave it. In that blessed place, the fortress of those possessing necessities and the abode of prayers, he turned the face of humility to that pure soil. And for the period of several years he displayed uprightness and zeal, praying night and day, and he brought out the hand of favour from the sleeve of liberality.

Notes

1 H. Blochmann, *The Ain i Akbari by Abul Fazl 'Allami, translated from the original Persian*, vol. I, Calcutta, 1873, pp. 88, 616–7.

2 Phyllis Ackerman, "Ghiyath, Persian Master Weaver" *Apollo*, XVIII, No. 106 (Oct., 1933), p. 255.

3 *Tazkira-i Nasrabadi*, Armaghan Press, Tehran, 1316–17 S./1937–8, pp. 49–50 (see appendix A). On the basis of the British Library MS., C. Rieu insists that Tahir's birthplace should be rendered Nasirabad (*Catalogue of the Persian Manuscripts in the British Museum*, London, 1879, I, pp. 368–9) but this is disputed by the editor of the printed edition, who found descendants still living in the village of Nasrabad near Isfahan.

4 Muhammad Mufid Mustaufi Bafqi, *Jami'-i Mufidi*, vol. 3, Tehran, 1340 S., pp. 426–431 (see appendix B), p. 494 (see appendix F).

5 Phyllis Ackerman, "A biography of Ghiyath the weaver", *Bulletin of the American Institute for Art and Archaeology*, III/7 (1934), pp. 9–13.

6 Ackerman has "India, Turkey and Byzantium", *ibid.*, p. 10.

7 Ackerman here refers to the figured silk by Mu'izz in the Victoria and Albert Museum (*The Burlington Magazine*, XXXVII, [1920] p. 243).

8 Although the two versions of the story are nearly identical, there are one or two minor differences, particularly Nasrabadi's use of the plural *ta'rif-i khirsha* "praised the bears", which shows his awareness that individual motifs in such stuffs formed a part of repeat patterns, as in the Textile Museum silk. Mufid's text, started in Basrah in 1082/1671 and completed in Multan in 1090/1679, is not likely to have been seen by Nasrabadi, who remained in the vicinity of Isfahan, after starting his *tazkira* a year later in 1083/1672–3. Probably both were following a common source.

9 Schmidt, J.H. "Persische Stoffe mit Signaturen von Ghiyas", *Jahrbuch der Kunsthistorischen Sammlungen in Wien*, Neue Folge VII (1933), pp. 219–227; Reath, N.A. & Sachs, E.B., *Persian Textiles and their Technique from the Sixth to the Eighteenth Centuries Including a System for General Textile Classification*, New Haven, 1937, pp. 34, 39, 111, 117, 126, pls.65, 74, 85; Pope, A.U. and Ackerman, P., eds. *A Survey of Persian Art from Prehistoric Times to the Present*, London and New York, 1938–9, vol. III, pp. 2094–2101, 2108, pls.1036–1040; Aga-Oglu, M., *Safavid Rugs and Textiles: The Collection of the Shrine of Imam 'Ali at al-Najaf*, New York, 1941, pp. 45–7; Spuhler, F., *Islamic Carpets and Textiles in the Keir Collection*, London, 1978, pp. 164, 169–172, 174–5, 177; *Woven from the Soul, Spun from the Heart. Textile Arts of Safavid and Qajar Iran 16th–19th Centuries*, ed. C. Bier, Washington, 1987, pp. 188–9, 192–3; Spuhler, F., "Carpets and Textiles", in *Islamic Art in the Keir Collection*, ed. B.W. Robinson, London, 1988, pp. 90–1.

10 Yale University Press, New Haven and London, 1976.

11 Welch, *op. cit.*, p. 65. Sadiqi Kitabdar, *Majma' al-Khavass*, Persian translation of the Chagatai text by 'Abd al-Rasul Khayampur, Tabriz, S.1327/1948–9, pp. 187–8. I am indebted to Professor P. Soucek for helping me to obtain a copy of this text.

12 The comparison between weaving and writing poetry is discussed by Jerome Clinton in his essay in Bier (ed.), *op. cit.*, pp. 8–9.

13 Ghiyath himself alludes with pride to this dual role in the second *bait* of the first poem cited by Sadiqi: *ham hunarmand u ham sukhandanam* "I am an artist-craftsman as well as a poet". See also a *ruba'i* quoted in the *Tazkira-i Sukhanvaran-i Yazd*, (appendix E).

14 I am grateful to Mr. S.C. Welch for providing a transparency. While working on this paper I learned from Mr. Welch that this and another drawing were to be published in a forthcoming issue of *Oriental Art* by Mr. Gauvin Bailey, whose conclusions were similar to my own, apart from a later dating based on an alternative interpretation of *az jehat-i* as "for" instead of "in the service of". On the point of sending this for publication, I learn that Bailey's article has appeared in a mutilated form (*Oriental Art*, XL/4 [1994/5], pp. 29–34). In consequence we have agreed that the excised part of his paper should replace the concluding section of my own (see Bailey, *Supplement*, pp. 260–1 below).

15 For example the famous drawing in the Boston Museum of Fine Arts; Welch, A., *Shah 'Abbas & the Arts of Isfahan*, Asia House Gallery, New York, 1973, p. 24, No. 2.

16 Sadiqi's appointment to the post of Librarian followed the accession of Shah 'Abbas in 995 A.H./1587 A.D. The inscription was therefore added after that date. The original reads: *in do surat beravish-i ustadan-i farang ast jihat-i irshad panahi nadir al-zamani khvaja ghiyath-i naqshband marqum gasht mashaqqahu al-'abd sadiqi kitabdar.*

17 I am grateful to Mr. Ronald Parkinson and Dr. Hans Buijs for helping me to identify this source (see Hollstein, F.W.H., *Dutch and Flemish etchings engravings and woodcuts ca. 1450–1700*, Vol. XII, Amsterdam, 1949–(nd). The engraver is discussed in Vollmer, H., *Allgemeines Lexikon der Bildenden Künstler von der Antike bis zur Gegenwart*, Leipzig, 1950, vol. 37, p. 33.

18 E.g., *The Illustrated Bartsch*, 9, "Early German Artists", ed. Fritz Koreny, New York, 1981. I am grateful to Dr. Michael Kauffmann for drawing my attention to this possibility. It is usual for the Virgin to be shown on the right, but compositions are often reversed when a pounced tracing has been used.

19 The subject of the Virgin Mary was not unknown in contemporary Iranian textiles, as shown by her appearance in a velvet believed to have been presented by Shah 'Abbas to the Doge Mario Grimani in 1603, see Ackerman, P., "Islamic Textiles" in Pope and Ackerman, *op. cit.*, III, p. 2119 (pl.1061B).

20 The status and duties of the *muqaddam*, or *bashi*, as the office was often known in Savafid times, are outlined by Mehdi Keyvani in his *Artisans and Guild Life in the later Safavid period, Contributions to the social-economic history of Persia*, (Islamkundliche Untersuchungen, Band 65), Berlin, 1982, p. 79 ff. Lutf 'Ali Azar (d. 1195 A.H./1781 A.D.) in his *Atash kada* refers to Ghiyath as the *bashi* of the weavers of Yazd (Keyvani, *op. cit.*, p. 42, thus confirming Amin-i Ahmad's statement).

21 *Jami'-i Mufidi*, p. 178.

22 Quoted by 'Abd al-Husain "Ayati" in his *Tadhkira-i Sukhanvaran-i Yazd* (see Appendix E).

23 *Jami'-i Mufidi*, p. 422.

24 Keyvani, *op. cit.*, Appendix 2. An obvious reference to the *Muqaddima* of Sa'di's *Gulistan* (*The Gulistan or Rose Garden of Sa'di*, tr. E. Rehatsek, London, 1964, p. 59) is combined with a description of flower-patterned brocade.

25 *The Akbar nama* of Abu'l-Fazl, tr. H. Beveridge, vol. III, p. 1113.

26 This is not made clear in the Safavid administrative manual *Tadhkirat al-Muluk* (tr. V. Minorsky, London, 1943, pp. 48–50). Keyvani, *op. cit.*, p. 82 states that in Timurid times the chiefs of the guilds of Herat received remuneration from the guild members, but cites instances in the Safavid period where *bashis* were paid by the government. The fact that Ghiyath applied directly to the Shah rather than the provincial governor may suggest that he also held office at the centre.

27 Storey C.A., *Persian Literature. A. Bio-bibliographical Survey*. London, 1972, vol. I, part 2, p. 1335. Welch, *op. cit.*, p. 70 places its composition between 1006 A.H./1597–8 A.D. and 1010 A.H./1601–2 A.D.

28 Sadiqi was born in 940 A.H./1533 A.D. and was thus about 48–50 at the time.

29 Aga Oglu, *op. cit.*, p. 47, No. 8.

30 Yar-Shater, E., "Safavid Literature: progress or decline", in *Iranian Studies*, VII, part 1, 1974, p. 242.

31 Ghiyath is perhaps referring to difficulties encountered as leader of the silk weavers' guild in Yazd.

32 This *ruba'i* is also quoted by Mufid. The metaphor of the dog is discussed by A. Schimmel, *A Two-Coloured Brocade*. Chapel Hill, 1992, pp. 195–6.

33 Ackerman, *op. cit.*, p. 9 read his pen name as "Gissar". According to Mehdi Bayani, *Ahval wa athar-i khushnavisan*, Tehran, 1363 S., III, p. 1133, Kamal worked in the 9th–10th century of the Hijra and gave his name on a page in the Punjab Museum as Kamal b. Shihab al-'Assar.

34 'Abdullah Sairafi of Tabriz was a calligrapher and tile-maker noted for his inscriptions on buildings in Tabriz during the time of Sultan Abu Sa'id ibn Uljaitu.

35 Evidently a pun, since *pushidan* to "wear-conceal" can also convey the meaning of concealing or overlooking a fault.

36 Both this and the preceding anecdote appear in the same sequence with minor variations in the *Tazkira-i Nasrabadi* (see Appendix A). As Nasrabadi and Mufid were writing contemporaneously in different cities, it is likely that they were both indebted to a third source.

37 The wording but not the essential meaning of this line differs slightly from the quatrain as quoted by Nasrabadi (seee Appendix A).

38 *Dar al-Shifa* = a hospital: presumably so named because of the curative nature of the climate and water commented upon in the following verse.

39 A variation of this couplet, cited by Sadiqi in the *Majma' al-Khavass*, reads *aqran* "peers or contemporaries" for *Iran*.

40 Ghiyath evidently had two wives of whom the first gave birth to four sons and the second to two.

41 For a discussion of Khizr and the water of life see Schimmel, *op. cit.*, pp. 71–3. Ghiyath is here indicating that his own wants are those of a simple ascetic life.

42 The ant (*mur*) is often contrasted with the snake (*mar*), *ibid.*, pp. 196 & 403, note 28.

43 *Ibid.*, p. 231.

44 *Ab-i ruz* – evidently another metaphor for down or stubble.

45 *Ibid.*, p. 167.

46 Joseph, the archetype of beauty, was cast into prison after refusing Zulaikha's advances, *Qur'an*, XII, 30–35.

47 Ants are a common simile for facial down (Schimmel, *op. cit.*, pp. 75, 156, 403).

48 *Haft-Iqlim. The Geographical and Biographical Encyclopaedia* of Amin Ahmad Razi, ed. A.H. Harley and Khan Bahadur Maulavi 'Abdul Muqtadir, Bibl. Indica 215, fasc. 2, Calcutta, 1927, pp. 184–5.

49 The *muqaddam* was the head man of a guild, more usually designated the *bashi* during Safavid times (see Keyvani, *op. cit.*, pp. 79–80).

50 The removal of *mim* from *malamat* "reproach or censure" results in *lamat* (Arabic *la'amat*) "baseness or sordidness". An additional *double entendre* may be intended since *lamat* "your *lam*" implies something bent or crooked by contrast with *alif*.

51 Presumably a pun: *vali* "friend" also "but", with the alternative meaning that the person is "nothing but a footman".

52 'Abd al-Husain "Ayati" Tafti, *Tadhkira-i Sukhanvaran-i Yazd*, ed. Ardeshir K. Khaze, Bombay, 1963, p. 228. I am grateful to Dr. Manijeh Bayani for drawing my attention to this *Tazkira*, whose late 19th-century author relied on the *Jami'-i Mufidi* as his main source.

53 Ayati died in Yazd in 1332 A.H./1913–14 A.D.

54 *Naqshbandi* can mean a range of arts requiring skill in drawing and design. With regard to textiles, Steingass defines it as "embroidery", but it can also mean brocade weaving. The *Burhan-i Qati'* equates the verb *naqsh bastan* with *afridan* – "to create".

55 This is in contrast to the self-congratulatory mood of a verse quoted by Sadiqi Beg in which Ghiyath claims to be envied in Yazd for his possession of both poetic and artistic skills (See Appendix C).

56 Muhammad Mufid Mustaufi Bafqi, *Jami'-i Mufidi*, Tehran, 1340 A.H./1921–2 A.D., vol. 3, p. 494.

Supplement:
The Sins of Sadiqi's Old Age[1]

GAUVIN ALEXANDER BAILEY

IN A RECENT ARTICLE, I PUBLISHED A DRAWING BY THE SAFAVID painter Sadiqi Beg Afshar (1533–1610) after an engraving by the Flemish Master of the Banderoles that showed the former to be a pioneer of the Europeanate style in Safavid painting. The drawing bears a remarkable inscription which describes it as being "in the manner of the Frankish masters" (*bi ravish-i ustadan-i farang*) and relates it to the weaver Ghiyath Naqshband, but I was unable to date it any more precisely than c.1587–1610. Since then, I have come across another signed Sadiqi study of a European engraving that not only allows a more precise dating for the Fogg drawing to the last years of Sadiqi's life, but enables us to identify a group of drawings by the same artist which has long been attributed to the Mughal school.

The picture appears as lot 125 in the Sotheby's catalogue *Oriental Manuscripts and Miniatures* (27 April 1994) (pl.5), and bears an incomplete inscription in an archaic Kufic script: "Sadiqi the Librarian painted it...Isfahan, A.D. 1609" (*raqimuhu sadiqi kitabdar...isfahan 1018*).[2] It depicts a female allegorical figure with plaited hair in a flowing gown and veil, holding a scroll in front of an architectural setting and European townscape. Its model is a Dutch engraving of the late sixteenth century, i.e. a hundred years more recent than the Master of the Banderoles (active 1450s–70s) and contemporary with Sadiqi himself. It is very similar to a print by Hendrik Goltzius of 1592 (pl. 6) depicting two sibyls which was adapted from a lost fresco by Polidoro da Caravaggio (1492–1543).[3] This same engraving also served as the model for a later seventeenth-century Mughal miniature painting.[4]

If the Goltzius print is the model, Sadiqi has blended features from both sibyls: the body belongs to the figure holding the

banderole (naturally!), complete with the extended knee, billowing waistline and bare forearms; and the head derives from the other sibyl, since it is depicted in three-quarter view, a position favoured by Sadiqi.[5] The Sotheby's picture has close stylistic affinities with the Fogg Annunciation, and is a finished piece of comparable quality.[6] The pouty mouth and double chin betray the work of the same hand, as does the treatment of the hands and drapery – this time a study of the Italianate style of the sixteenth century. Unlike the Fogg drawing, it does not depict a Christian scene and its symbolism is more acceptable to a Muslim audience.

The Kufic inscription leads us to a drawing by Sadiqi in the Musée Guimet, showing a mullah astride a mule in a hybrid European/Persian landscape, which has been attributed to the Mughal school by Stchoukine and Okada.[7] There was no Mughal painter named Sadiqi, and despite its European townscape, naturalistic face and hint of chiaroscuro, this picture is very linear and Persian in style, with its Safavid turban, tufts of grass, and embracing trees. The treatment of the hands and face also relate this work to the Fogg and to the Sotheby's picture.

Stchoukine and Okada have misread the inscription to say "Sadiqi Mosavvir" (Sadiqi the Painter), whereas it actually reads *raqimuhu sadiqi* ("Sadiqi painted it"), which is identical to the signature on the Sotheby's picture.

A reversed version of the same picture in Baltimore is executed more in the style of Riza-yi 'Abbasi.[8] Although some shading is suggested around the mule's limbs and the man's chin, it is a much more linear drawing, and, despite the almost exact correspondence between the figures in this and the Paris drawings, the landscape elements are completely different. The trees in the Baltimore picture are direct

quotations of Riza's manner, with their distinct triangular leaves, and the tear-shaped grass relates to Riza's work as well.[9] Details of drapery, particularly in the waistband, also echo the younger master's agitated brushstroke. Here is proof that Sadiqi was capable of working in two very different modes concurrently. This ability is consistent with his known skill as an imitator.

A tinted drawing of a horse and groom in Moscow is similarly shaded, although here the background is blank.[10] Again attributed to the Mughal school, this work has Sadiqi's signature (Sadiq) in a quasi-Kufic script on the animal's rump (the location is not as disrespectful as it might appear, since it was meant to suggest a brand). The pattern of the groom's sash is very close to the turban of the Paris mullah, as are the details of his face and hands. Another drawing from this group at the Chester Beatty Library depicts an old man leading a child by the hand, and is signed *raqimuhu sadiqi* in a particularly flowery Kufic script (pl.7).[11] Again, the background is blank, and the figures combine a very linear, calligraphic style of drapery reminiscent of Riza-yi 'Abbasi with a hint of European-inspired shading in the facial features. A more traditional treatment of drapery also characterizes a drawing of a dervish

leading his dog (in the Walters Art Gallery, Baltimore) which bears the same pseudo-Kufic signature by Sadiqi (pl. 8). Here the ascetic's trusty companion is a heavily-shaded European hunting hound of a type common in Flemish engravings of the later sixteenth century.[12]

This unusual group of drawings represents Sadiqi's last great experiment, an attempt to introduce elements of the "Frankish" style into Persian painting. At first he adapted images directly from engravings, although always infusing them with his own personality. His next step was bolder; he imposed Western techniques of modelling and perspective upon the quintessentially linear style of Riza-yi 'Abbasi. These "sins of his old age", painted in the closing years of his life by an artist whose style was always sensitive to change, demonstrate a continued commitment to innovation that reflects contemporary developments in Mughal painting yet anticipates the Europeanizing style in Persian painting by several decades. These works also show that an individual artist sometimes worked in different modes of painting at the same time — even antiquarian ones — thus forcing us to review traditional methods of attribution.

Notes

1 This was originally the second half of an article on Sadiqi Beg, the first half of which is already published: Gauvin A. Bailey, "In the Manner of the Frankish Masters", in *Oriental Art* XL, No. 4 (Winter 1994/1995), pp. 29–34.

2 This drawing also appeared in an earlier Sotheby's sale of *Important Oriental Manuscripts and Miniatures*, 4 July 1976 (lot 103): information from Robert Skelton.

3 Walter Strauss, ed., *Hendrik Goltzius: The Complete Engravings and Woodcuts*, New York, 1977, vol. II, No. 297. Copies were made that show this image in reverse, and Sadiqi's picture suggests that he worked from one of those. The Goltzius figures do not have the

distinctive braids of the Sadiqi copy, so I hesitate to make an unequivocal identification with this model. He was probably familiar with a variety of prints.

4 Sotheby Parke Bernet, New York, *Fine Oriental Miniatures, Manuscripts, Islamic Works of Art and 19th Century Paintings*, Friday, 14 December, 1979 (lot 24).

5 For example, Bailey (1994–5), figs 1 and 7.

6 As I have not seen this picture except in a black-and-white photograph, I cannot comment on the colours used.

7 Ivan Stchoukine, *Miniatures Indiennes du Musée du Louvre*, Paris, 1929, pl.X; and Amina Okada, *Miniatures de l'Inde impériale, les peintres de la cour*

d'Akbar, Paris, 1989, no. 46.

8 Ernst Grube, *Miniature Islamiche*, Venice, 1962, pl.108. Robert Skelton directed me to this image.

9 Compare to Grube (1962), pl.111, which is signed by Riza-yi 'Abbasi.

10 Tyulayev, S.I. *Indian Art in Soviet Collections*, Moscow, 1955, pl.18. Robert Skelton directed me to this image.

11 Chester Beatty Library, Dublin: Pers. 260 (viii). Robert Skelton directed me to this image.

12 Walters Art Gallery, f. 69a. Robert Skelton directed me to this image and Dr. Ellen Smart kindly assisted in obtaining a photograph.

18

The Ann Arbor Shahnama and its Importance

PRISCILLA P. SOUCEK

THE FOCUS OF THIS CONTRIBUTION IS A MANUSCRIPT WHICH exemplifies many of the questions which have been of interest to B.W. Robinson during his long involvement with Persian paintings. It is a copy of Firdausi's *Shahnama*, now in the collection of the University of Michigan Museum of Art, which was catalogued by Mr. Robinson when it formed part of the Hagop Kevorkian collection and on which he has also commented in later publications.[1] Paintings from it have also been published by E. Grube and by the present author.[2] The manuscript has been dated to the 1450s or 1460s and has been associated with the patronage of Pir Budaq Qaraqoyunlu.

Despite these various publications, the Ann Arbor *Shahnama*'s distinctive features have not yet been delineated in detail, nor has its importance been recognized in full. Here the analysis will have two different goals: to provide a rationale for its attributed date and provenance, and to establish its place among illustrated versions of Firdausi's epic. This double approach is suggested by the character of the Ann Arbor manuscript, distinctive for the manner in which it mingles the ordinary and the unusual, the typical and the idiosyncratic. Each facet can serve to advance our understanding. The unique or unusual aspects can help us to define the circumstances surrounding the manuscript's production, and its more generic features can be used to examine broader questions such as how variations in *Shahnama* illustrations may be linked to historical transformations in Persian manuscript illustration.

Let us first establish the basic features of this manuscript (for a list of its illustrations see below, Appendix I). At present it contains 562 folios but it clearly was once somewhat longer, probably by four folios. The folio missing from the first gathering would have contained the initial illumination of the preface, and about 18 lines of its text as well any medallions, stamps or inscriptions identifying the manuscript's patron or owners. The text at present ends abruptly and about 220 verses are missing. Since each folio contains no more than 100 *bayt*s this probably means that three folios are needed to provide space for the completion of the text and its colophon.[3]

Many manuscripts lack initial and concluding folios, a situation which can be due to normal wear and tear, but it is possible that these pages were removed from the Ann Arbor manuscript to conceal the identity of its previous owner(s). This must have been the motive behind the excision, from the lower margin of folio 4, of a seal or owner's mark, leaving behind an irregular hole. The missing pages must have been removed before a note was written in 1926 enumerating the manuscript's folios as 562, its paintings as 32, and its illuminations as two.

This census, however, undercounted the paintings and illuminations, each by one, for the manuscript actually contains 33 illustrations and three illuminated headings. Although colophons are preserved on folios 4a at the end of the preface and 269a at the end of the text's first half, they contain neither a date nor the signature of a calligrapher. Any conclusions about the manuscript's origin must, therefore, be derived from comparative analysis.

Fortunately its thirty-three paintings can be paralleled in a number of other *Shahnama* manuscripts as well as in other illustrated texts, a range of examples which ensures that its examination offers a vantage point for studying the development of painting in Iran during the fourteenth and fifteenth centuries. Here six of the Ann Arbor paintings will be considered in depth in order to estab-

lish that manuscript's artistic and historical pedigree. This approach requires a consideration of its place within the broader history of Persian manuscript illustration.

A notable distinction between most fifteenth-century manuscripts and those of the previous century is that although they have fewer illustrations, their paintings achieve greater individual prominence through an increase in size and compositional complexity. The shift from numerous small illustrations to a few prominent ones appears to be the result of the convergence of several factors.

In the last decades of the fourteenth and the first decades of the fifteenth century there was a general decrease in the proportion of width to height of manuscript pages resulting in a narrower, taller format. The written surface in many fourteenth-century manuscripts has a width to height ratio of approximately 3:4, whereas during the fifteenth century proportions of 2:3 are more common; in the second half of the century even 1:2 ratios gain popularity, especially in Shiraz.

As the written surface was narrowing, paintings also came to fill a greater proportion of the page's area. Thus, compositions which in fourteenth-century *Shahnama* manuscripts were often horizontal in format, and occupied no more than one-third of the height of a page, were often transformed in fifteenth-century copies into vertically oriented scenes occupying one-half to two-thirds of the space reserved for the text. This new format was often accompanied by, and perhaps even stimulated by, a greater concern for the spatial relationship between figures and their landscape or architectural setting. These preferences for a vertical format and for greater spatial complexity can also be linked to the creation of new illustrative themes, a factor which will be considered below in the discussion of individual paintings.

Larger paintings also created new tasks for the calligrapher. A major challenge was to integrate the space reserved for a painting within the design scheme of the page as a whole. Illustrations were customarily placed immediately after the verses which describe an event. Thus as paintings came to dominate the page, it was often necessary to alter the number of verses on the preceding page or pages in order to ensure that the picture's location would be textually appropriate and visually satisfactory. Most of the illustrations in the Ann Arbor manuscript are preceded by a page with a reduced verse count.

The creation of manuscripts illustrated with a smaller number of more prominent paintings must have increased pressure to standardize both text format and illustrative cycles. Most of the stories depicted in the Ann Arbor *Shahnama* had a long-standing popularity and were illustrated in both fourteenth- and fifteenth-century manuscripts. A group of manuscripts from the 1440s to the 1460s are especially close to it in both the subjects depicted and the compositions used. They include a copy dated to 1444 now in the Royal Ontario Museum, Toronto,[4] the undated copy from

the 1440s made for Muhammad Juki now in London,[5] one of 1457 now in the collection of the Aga Khan, Geneva,[6] and H. 1496 dated to 1464 now in the Topkapi Museum, Istanbul.[7] A fragmentary, poorly published and undated manuscript of ca.1460 from the Public Library, St. Petersburg, appears also to be closely related to the Ann Arbor copy.[8] Three copies from the 1480s illustrated in the "Turkman" style have more distant links with the Ann Arbor manuscript: two dated to 885/1480 in Dublin, C.B. Persian Mss. 157 and 158,[9] and another dated to 887/1482–3 in Istanbul, H. 1489.[10]

Two manuscripts are strikingly similar to the Ann Arbor copy in the themes illustrated – that in Geneva, and H. 1496 in Istanbul. Parallels between the three are particularly strong among illustrations to the *Shahnama*'s first half. The Geneva manuscript, which contains 53 paintings, shares twenty subjects with the Ann Arbor copy, including 15 of the 18 illustrations in the latter's first half. H. 1496 in Istanbul contains only 28 illustrations, but 20 of them are closely related to compositions in the Ann Arbor copy (for a list of shared themes see Appendix I).

In general, connoisseurs of Persian painting have tended to divide fifteenth century manuscripts into two categories – those produced in or near Shiraz (most of which are considered to have been produced "for the trade"), and those connected with Timurid court patronage, principally linked with the city of Herat, but deriving from a tradition probably developed in the late fourteenth century under Jalayirid patronage in Baghdad. Romantic epics such as those by Nizami Ganjavi or Khwaju Kirmani epitomize the literary taste of this period. Manuscripts of these texts illustrated with courtly themes were produced for both Jalayirid and Timurid patrons, in Baghdad, Tabriz, Shiraz and Herat.[11]

One of the features of the Ann Arbor manuscript is that its paintings blend elements found in manuscripts from both the "Shiraz" and "Timurid-court" groups of the 1430s and 1440s. In addition to this hybrid or eclectic approach which characterizes the majority of its 33 paintings, five or six of the Ann Arbor paintings are executed in a distinctive style widely used in Shiraz during the second half of the fifteenth century and often labelled as "Turkman".[12] Here attention will be focused on the eclectic group of illustrations.

Two compositions drawn from the Ann Arbor manuscript's early sections, the "Murder of Iraj" and "Tahmina enters Rustam's Chamber," demonstrate the range of sources with which its compositions can be compared. The "Murder of Iraj" provides a useful introduction to how the Ann Arbor illustrations relate to those used in manuscripts associated with Shiraz which range in date from the 1440s to the 1480s. It depicts the instant before Iraj's assassination when Tur is poised to thrust a dagger into his brother's breast (fig. 1). The golden stool with which Tur had previously struck Iraj lies on the ground near the latter's head. This particular moment in the brothers' confrontation is the one most commonly depicted in fifteenth-century Shiraz manuscripts.

I. TUR KILLS IRAJ
The University of Michigan,
Museum of Art, 1963/1.41,
fol. 22.

Major compositional elements in the Ann Arbor painting are also used in other illustrated *Shahnama*s such as the one dated to 1444 now in the Royal Ontario Museum, Toronto, that of 1457 in the collection of the Aga Khan, Geneva, and that of 1464 now in Istanbul, H. 1496; yet none is an exact copy of the others.[13]

The numerous variants of a given theme found in Shiraz illustrations from the 1440s to the 1460s stand in contrast to the more uniform compositions used in manuscripts of a later date. Illustrations in H. 1496 often appear close to the prototype for scenes contained in copies from the 1480s. For the "Murder of Iraj", Chester Beatty P. 157 of 885/1480 and H. 1489 of 887/1482–3 in Istanbul contain simplified versions of the H. 1496 composition.[14]

These links suggest that the H. 1496 composition resembles a *tarh* or master composition used in Shiraz. The existence of such a model is also suggested by parallels between the H. 1496 and the Ann Arbor illustrations in the positioning of Iraj and Tur as well as in the backdrop of a tent and two canopies. These features appear in the Ann Arbor and H. 1496 scenes in a mirror reverse configuration (pls. 1, 2).

These two paintings differ, however, in the placement and role of spectators. In the Ann Arbor painting people crowd around the murder scene with little visible reaction to the horror before their eyes, whereas the one in H. 1496 differentiates between Salm's acquiesence in his brother's murder and the shocked reactions of

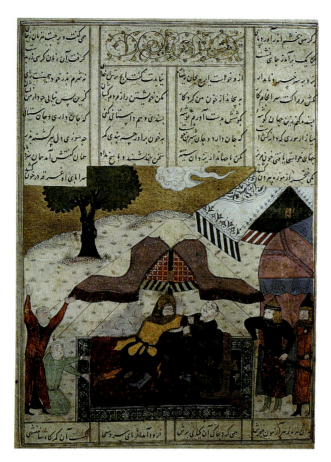

2. TUR KILLS IRAJ
Istanbul, Topkapi Sarayi Museum, H. 1496, fol. 30b.

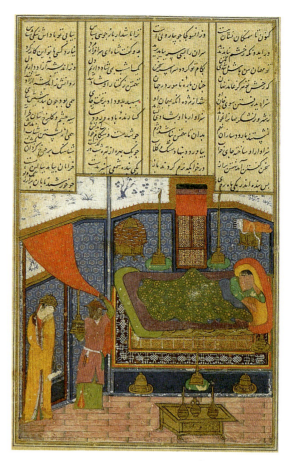

3. TAHMINA ENTERS RUSTAM'S CHAMBER
The University of Michigan, Museum of Art, 1963/1.46, fol. 81a.

others, a distinction which reminds a viewer of the moral of the story. These paintings also differ in their text location: the H. 1496 example is placed correctly, whereas the Ann Arbor illustration is situated in a passage describing how Tur strikes Iraj with a golden *kursi* or stool, an earlier incident which had been illustrated in the fourteenth century.[15] The incongruous location of the Ann Arbor painting may reflect a lack of coordination between the manuscript's calligrapher and its illustrators.

The "Murder of Iraj" demonstrates not only the degree to which the compositions in the Ann Arbor manuscript have links to Shiraz manuscripts ranging in date from the 1440s to the 1480s, but also its especial closeness to those from the 1450s and 1460s, particularly to that of 1464 in Istanbul, H.1496, and that of 1457 in Geneva. Several other Ann Arbor compositions also display broad similarities to those in various fifteenth-century Shiraz manuscripts. These include the "Mourning of Suhrab" which is virtually identical with paintings in several Shiraz manuscripts of the 1440s,[16] or the "Birth of Rustam" which is reflected in Shiraz manuscripts from the 1460s to the 1480s such as H.1496 and its descendant, Dublin C.B. P. 157.[17]

The second Ann Arbor painting to be analysed, "Tahmina enters Rustam's chamber," shows another facet of this manuscript's heritage, because its composition appears to be more closely con-

nected to schemes popularized in Jalayirid Baghdad and later used in Timurid Herat than to paintings from Shiraz. The Ann Arbor composition captures a specific moment in Firdausi's narrative: a servant holding a candle enters Rustam's room and, as he lifts the door-curtain with his other hand, a beautiful young woman appears in the passageway behind him (pl. 3).[18] This composition is so similar to an isolated painting owned by Harvard University in the placement and gestures of its figures as well as in details of its setting that both must derive from a common tradition (pls. 3 & 4).[19] Features shared by these paintings include their architectural setting, the placement and gestures of figures, and even a use of colour. In each, Tahmina stands to the left, under a red curtain held by a youth in Mongol dress who carries a lighted candle in his right hand. Her face is partially hidden in the collar of her yellow robe.[20] Rustam, wearing green and reclining on a bed with a gold-patterned green spread, watches them, with his head resting on his left hand.

The setting of the two paintings is similar in the division of its parts but different in their proportion. In both, Rustam's bed is situated in the raised alcove of a room; his weapons and accoutrements are placed on two short stands behind and above him; and a table bearing three objects rests on the floor below. Rustam's chamber in the Harvard painting differs, however, from that of the

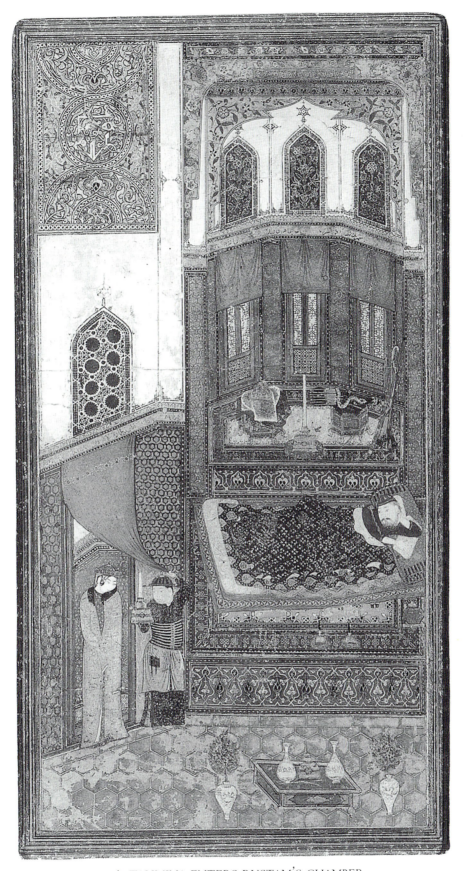

4. TAHMINA ENTERS RUSTAM'S CHAMBER
Harvard Art Museums (Arthur M. Sackler Museum), gift of Mrs. Elsie Cabot Forbes and Mrs.
Eric Schroeder and purchase from the Annie S. Coburn Fund, 1939, 225.

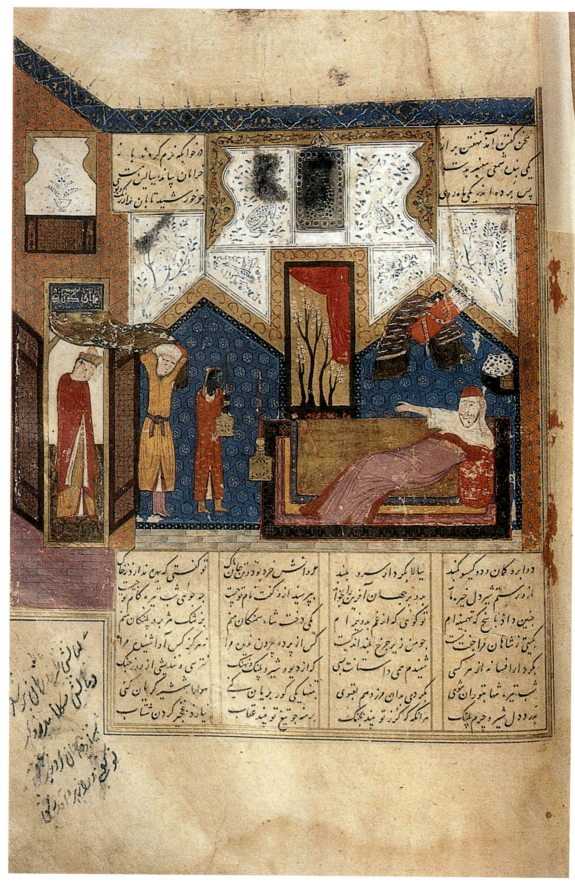

5. TAHMINA ENTERS RUSTAM'S CHAMBER
Geneva, Château de Belle Rive, fol. 85a.

Ann Arbor manuscript in its richer architectural detail and greater spatial coherence. The increased verticality of its picture field also provides a sense of space around the figures.

The Harvard and Ann Arbor compositions include the same gestures of lifting a curtain to reveal a figure poised on a threshold; this gesture is also used in the depiction of a wedding celebration from the Khwaju Kirmani manuscript of 1396. In that painting a young woman with a candle in one hand lifts a curtain with the other as the groom leaves the bridal chamber.[21] The use of the same gestures in these three paintings probably reflects long-standing Islamic court protocol governing the lifting of curtains which separated one room from another and gave access to important persons.[22] The concern with a depiction of movement through space in these paintings is also reminiscent of painting competitions held in Fatimid Egypt where artists sought to portray figures moving into or out of a niche.[23]

The Harvard painting has been attributed to both Shiraz and Herat and dated from ca. 1410 to ca. 1440 on the basis of varied reading of its inscriptions.[24] Whatever its date or time of execution, it manifests features associated with thematic and pictorial trends which gained prominence in the Jalayirid-Timurid court tradition of the late fourteenth and early fifteenth century: an increased verticality of the picture space combined with a greater spatial clarity in the rendering of architectural and landscape settings, and the depiction of romantic themes in a decidedly courtly environment.

Those illustrations have been described as resembling a "fairytale" but some appear to contain accurate depictions of court ceremonial and also to reflect concrete features of palatial architecture.[25] The new literary and artistic climate of the late fourteenth century with its emphasis on romantic epics such as Nizami's *Khusraw u Shirin* and Khwaju Kirmani's *Humay u Humayun* probably also had a significant effect on *Shahnama* illustrations. These trends may explain features often encountered in fifteenth-century *Shahnama* manuscripts such as an increased use of compositions with a courtly setting, as well as various thematic shifts.[26]

The hypothesis presented here, that the Harvard and Ann Arbor paintings reflect a composition invented in a court milieu around the turn of the fifteenth century, is strengthened by the widespread use of a simpler and probably older composition which also depicts a different moment in the story – the conversation of Rustam and Tahmina after she had entered his room. In these scenes Tahmina, accompanied by a female attendant, addresses a recumbent Rustam. Usually his chamber is depicted in a single plane as a flat wall. These features appear in the only known fourteenth-century illustration of the story, a page from the "Second Small Shahnama" now in the Keir collection in which the standing figures of Tahmina and her attendant frame a reclining Rustam.[27] Manuscripts associated with fifteenth-century Shiraz, such as the *Shahnama* of Ibrahim Sultan in Oxford, or the "Hakim" *Shahnama*,

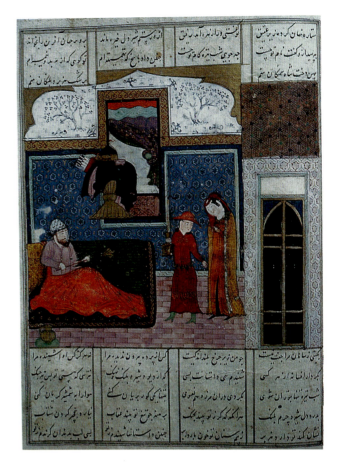

6. TAHMINA INTRODUCES HERSELF TO RUSTAM
Istanbul, Topkapi Sarayi Museum, H. 1496, fol. 103a.

follow the general scheme of the Keir painting by showing Tahmina inside Rustam's chamber accompanied by a female attendant.[28]

Shiraz manuscripts from the 1450s onward often excerpt the figural group used in the Harvard and Ann Arbor paintings but combine it with more archaic elements. The Geneva *Shahnama* of 1457 presents an idiosyncratic variant of the entry scene which includes a female attendant carrying a candle (pl. 5).[29] Most later Shiraz illustrations, however, such as those in H.1496 from 1464 and C.B.P. 157 of 1480, portray the conversation of Rustam and Tahmina in a flat architectural setting, but the postures of Tahmina and her attendant echo those in the entry scene (pl. 6).[30]

The continued popularity in Shiraz of a composition depicting the conversation of Rustam and Tahmina rather than her entry into his chamber may reflect both a conservatism among calligraphers and a preference among painters for its simpler architectural scheme. H.1496 and CB P. 157 were copied by the same calligrapher, and situate the scene after the same verse.[31] The appearance of figures modelled on Tahmina and her Mongol attendant in those Shiraz paintings does suggest, however, that the Ann Arbor illustration helped to transmit this new compositional feature.

The role of the Ann Arbor manuscript as a link between the Jalayirid-Timurid court style of the late fourteenth and early fif-

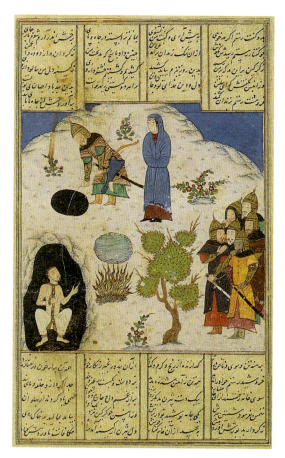

7. RUSTAM THROWS A ROPE TO BIZHAN
The University of Michigan, Museum of Art, 1963/1.54, fol. 202b.

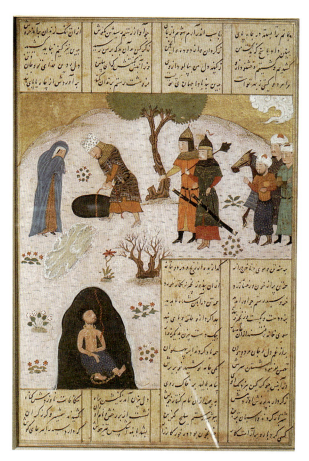

8. RUSTAM THROWS A ROPE TO BIZHAN
The Chester Beatty Library, Persian Ms. 157, fol. 214b.

teenth centuries and Shiraz manuscripts from the second half of the fifteenth century is also demonstrated by the analysis of another composition, Rustam's rescue of Bizhan from the pit in which he had been imprisoned by order of the Turanian ruler, Afrasiyab (pl. 7). It depicts the moment when Rustam lowers a rope into Bizhan's pit to pull him to safety.[32] Bizhan's lover, Manizha, stands to the right of Rustam, and the Iranian heroes who accompanied Rustam on his expedition to Turan are clustered in the lower right corner. The painting's left side is dominated by Bizhan's pit, of which the mouth is shown as if from above, and the cavity proper is drawn in cross-section. The stone which had been used to seal the pit and the bonfire lit by Manizha to guide Rustam are placed between the cavity and a large tree.

The Ann Arbor illustration differs both thematically and compositionally from most earlier depictions of this story, which focus on two different moments: Rustam's removal of the stone from the mouth of Bizhan's pit, and Rustam's interrogation of Bizhan.[33] The stone used to seal Bizhan's prison is described by Firdausi as the one which had been used by Akvan when he flung Rustam into the sea. Later, retrieved, it was given to Afrasiyab, a link which underscores the latter's demonic alliances.[34]

Rustam's removal of this stone, which had resisted the combined strength of seven Iranian heroes, provides confirmation of his

miraculous power and of his role as a bulwark against demonic forces allied to the Turanians.[35] After removing the stone, Rustam interrogates Bizhan and extracts from him a promise to forgive Gurgin his various acts of treachery. Only then does Rustam agree to rescue Bizhan by lowering a rope into the pit, the incident depicted in the Ann Arbor painting.[36]

These three sequential incidents in the story of Bizhan's rescue differ both in their significance for Firdausi's text and in the demands they place on a painter's skill in the representation of space. Rustam's removal of the stone reinforces a major theme of the *Shahnama* and is used in the earliest surviving depictions of this story on the "Freer Beaker" and in the *Shahnama*s of 1330, H. 1479 in Istanbul, and that of 1333, G.P.B. 329 in St. Petersburg.[37] In these compositions the pit is shown either as a chimney-like projection rising above the ground line or as a flat area located beneath it, often inset into the text panel below the image. The compositions' two levels do not form a spatial continuum.

Depictions of Rustam's conversation with Bizhan and the latter's rescue were probably prized for their visual novelty rather than for the moral message they conveyed.[38] In conversation scenes, which were particularly popular at Shiraz, illustrators experimented with various methods of linking its two levels – the mouth of the pit where Rustam stands, and its cavity were Bizhan is impris-

oned. In H.1511, dated to 1370, Bizhan's pit appears as an appendage below the main landscape level. In the *Shahnama* of Ibrahim Sultan a section of the text separates Rustam and Manizha from Bizhan in his pit.[39] Even the manuscripts in Geneva and Istanbul, which are normally the closest to the Ann Arbor text, have illustrations without a depiction of Bizhan's pit from two directions.[40] This Ann Arbor scheme is widely used, however, in Shiraz manuscripts of the 1480s such as C.B.P. 157 and H.1489. Their paintings do suggest that the Ann Arbor composition became part of the Shiraz repertoire (pl. 8).[41]

Although the Ann Arbor composition is in striking contrast to most Shiraz illustrations executed before the 1480s, it does have parallels among "Jalayirid-Timurid" court manuscripts. The Ann Arbor painting's figural scheme is closely related to that used in Muhammad Juki's *Shahnama*, but the smaller space provided to the Ann Arbor painter has resulted in a compression of the painting's vertical and horizontal axes. Thus, the Ann Arbor scene lacks the delicately drawn night landscape which dominates the upper level in the latter illustration.[42]

The manner in which the pit is integrated into its setting in the Ann Arbor and Muhammad Juki paintings probably derives from compositions used to illustrate *Kalila va Dimna*, a text which contains numerous stories about people or animals falling into, or being rescued from, wells and pits. In manuscripts of the thirteenth or fourteenth century these pits are presented as projections above the ground or rendered in a schematic manner.[43] During the course of the fourteenth century painters experimented with various methods of integrating pits or wells into the landscape as a whole.[44]

Landscape paintings in which a well or pit is seen simultaneously from above and in cross-section appear in illustrations of "The Perils of Life" used in two copies of *Kalila va Dimna*, one from Baghdad dated to 1392, the other an undated fragment of ca. 1410 preserved in a Herat manuscript of 1431.[45] Another illustration, the "Rescue of the Treacherous Goldsmith," from the *Kalila va Dimna* of ca. 1410, offers an even closer analogy for the manner in which Rustam lowers a rope to Bizhan in the rescue scene and could well have provided a visual model for the Muhammad Juki and Ann Arbor *Shahnama* depictions.[46]

Thus, a consideration of the Ann Arbor composition of Bizhan's rescue leads to conclusions very similar to those reached about that manuscript's "Tahmina enters Rustam's Chamber" – both link the "Jalayirid-Timurid Court Tradition" of the late fourteenth and early fifteenth centuries with the simpler Shiraz manuscripts of the second half of the fifteenth century. The latter often echo Ann Arbor compositions, albeit in a reduced and simplified form.

As was noted above, however, another group of the Ann Arbor illustrations appear to be in the mainstream of Shiraz painting, for they have not only close affinities to compositions used in manuscripts of the 1440s but also close ties to those produced in the 1450s and 1460s (see Appendix 1). The logical conclu-

sion to draw from these analogies is that the Ann Arbor manuscript was produced in Shiraz between ca. 1457 and ca. 1464. This hypothesis does not, however, explain its particular affinity with the Jalayirid-Timurid court tradition, nor does it examine whether historical circumstances encouraged its unusual pictorial synthesis.

Two final examples from the Ann Arbor manuscript help to clarify these questions. Both have unusual subjects, and both appear to be the work of a single painter: "Ardashir mounts the Throne in Baghdad", and "Buzurjmihr advises Khusrau Anushirvan". Both are illustrated with variants of a single composition which shows a youthful enthroned ruler flanked by figures to the left and right (pls. 9, 10, 11).

The first painting, "Ardashir Mounts the Throne", shows the founder of the Sassanian dynasty delivering a moral discourse to guide his subjects after ascending the throne. Firdausi describes how Ardashir began his life as the ruler of Istakhr and gradually consolidated his power until he defeated Ardavan and entered the latter's capital of Ctesiphon, anachronistically identified in the *Shahnama* as "Baghdad". This theme, which marks the effective foundation of the Sassanian dynasty, is rarely illustrated.[47]

The other Ann Arbor painting which shows a royal audience, "Buzurjmihr advises Anushirvan", concerns the search for an intruder

9. ARDASHIR MOUNTS THE THRONE IN BAGHDAD
The University of Michigan, Museum of Art, 1963/1.67, fol. 367a.

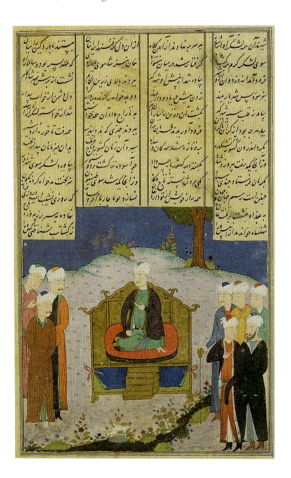

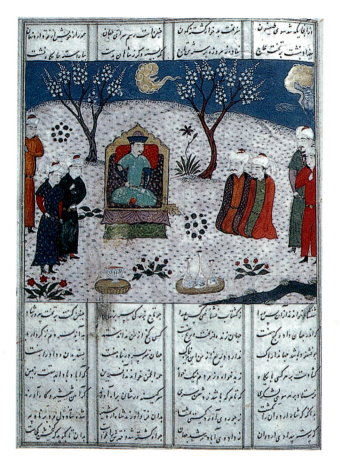

10. ARDASHIR MOUNTS THE THRONE IN BAGHDAD
Istanbul, Topkapi Sarayi Museum, H. 1496, fol. 459a.

in the royal harem and is the climax of an episode which began with the ruler's dream that a wild boar was sitting on his throne and drinking from his cup.[48] After none of his advisors could explain this vision Anushirvan ordered them to search his kingdom for a person able to interpret it. One of them discovered the youthful Buzurjmihr near the city of Merv and brought him back to the royal capital.[49]

When Buzurjmihr is taken before the Shah, he interprets the dream as an allusion to a youth who is hiding in Anushirvan's harem disguised as a woman. As a remedy, he suggests that the court women be brought before them so that the intruder may be discovered. When the women appear unveiled before the ruler and Buzurjmihr, the youth's identity is revealed.[50] The Ann Arbor painting shows Anushirvan flanked on the left by his court women and on the right by a grey-bearded man (pl. 11).

When viewed from the perspective of Firdausi's text, these two illustrations present anomalies. "Ardashir enthroned at Baghdad" is a rarely depicted incident of little significance for Firdausi's narrative, and "Buzurjmihr advises Anushirvan" differs in an important detail from Firdausi's text. The narrative repeatedly stresses Buzurjmihr's youth, whereas in the Ann Arbor painting he appears as a grey-bearded man.

12. BURZUYAH BEFORE ANUSHIRVAN
Tehran, Gulistan Palace Library.

11. BUZURJMIHR
ADVISES ANUSHIRVAN
The University of Michigan,
Museum of Art, 1963/1.71,
fol. 440b.

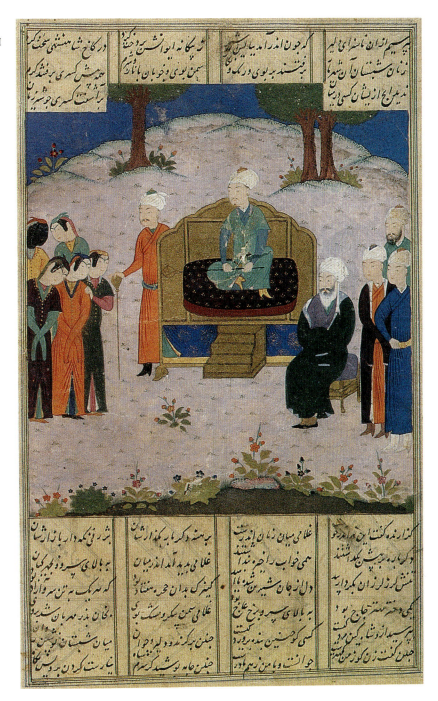

An explanation for the discrepancy between Firdausi's char-
acterization of Buzurjmihr and the Ann Arbor painting can prob-
ably be derived from that illustration's model. Its closest parallel
is a scene of the sage Burzuyah before Anushirvan from a copy of
Kalila va Dimna in Tehran (pl. 12).⁵¹ The two paintings share sev-
eral important features: the placement and posture of both the ruler
and his seated advisor, and the two groups of standing figures flank-
ing the throne. The posture of both the ruler and his standing atten-
dants in "Ardashir Enthroned" also echo those in the Tehran
composition (pls. 10, 12).

In view of the many kindred features between the Ann Arbor
paintings and those in the Tehran manuscript, it is logical to assume
that they are closely connected. It has been proposed that the Tehran

manuscript was produced under the patronage of the Qaraqoyunlu
prince Pir Budaq, and in either Shiraz or Baghdad.⁵²

A review of the circumstances of Pir Budaq's life may serve
to clarify the possible link between the Ann Arbor manuscript
and that prince's patronage. Four dates help to define his activity as
a manuscript patron: his installation as the ruler of Shiraz in the
autumn of 1452, his expedition to Herat in the autumn of 1458,
his expulsion from Shiraz and transfer to Baghdad in the spring and
summer of 1460, and his assassination in June 1467.⁵³

These events divide Pir Budaq's fifteen years of rule into
two segments: 1452–1460 in Shiraz, and 1460–1467 in Baghdad.
For this prince's patronage of the arts, his visit to Herat in 1458
seems to have been of critical importance. On his return he

appears to have been accompanied by a calligrapher, Shaykh Mahmud, and probably also by other skilled craftsmen including at least one painter. By the summer of 1459 Shaykh Mahmud had copied a manuscript for Pir Budaq notable for its exquisite binding and illumination and now preserved in Istanbul.[54] Pir Budaq's expulsion from Shiraz in the spring of 1460, and his transfer to Baghdad in the fall of that year, must have led some of the calligraphers and painters in Shiraz to transfer their workshop to Baghdad. Between 1461 and 1466 numerous manuscripts were copied in Baghdad, including a few with illustrations.[55]

The depiction of Ardashir's enthronement at Baghdad in the Ann Arbor *Shahnama* probably indicates that the manuscript was produced in that city during the 1460s. The closely related *Shahnama*, H. 1496, copied in 868/1463–4, also includes an illustration of this unusual theme, suggesting that it too was produced in Baghdad during Pir Budaq's residence there (pl. 10).[56]

The artistic relationship of the Tehran *Kalila va Dimna* with the Ann Arbor *Shahnama* may go beyond the borrowing of a compositional scheme. The former manuscript has recently been shown to contain paintings which replicate compositions from the late fourteenth or early fifteenth centuries, raising the possibility that it is, at least in part, a mid-fifteenth-century copy of an earlier manuscript.[57]

The presence in the Ann Arbor manuscript of compositions which probably originated n the late fourteenth century (such as "Tahmina enters Rustam's Chamber", and "Rustam rescues Bizhan") suggests that they too may reflect the impact of a Herat-trained painter working in Baghdad during the 1460s who was also the transmitter of compositions which had originated several decades earlier. This hypothesis would provide a rationale for the Ann Arbor *Shahnama*'s combination of themes derived from the "Shiraz" and "Jalayirid-Timurid" traditions and help to explain its role as a link between different generations of painters.

This essay on the Ann Arbor *Shahnama* also provides evidence that the pictorial tradition in Persian manuscripts defies simple categorization, and that many factors contributed to its dynamic evolution. Even the illustration of a text as central to Persian culture as the *Shahnama* could be affected by wider currents of artistic and literary taste, so that its illustrative cycle was constantly evolving, reflecting the mood of a period as well as the skill of its painters in addition to the special demands of particular patrons.

APPENDIX I

Ann Arbor *Shahnama* compared to Geneva & Istanbul Mss.:

AA *Shahnama*		Geneva *SN*	H. 1496	
8a.	Gayumars enthroned		10b.	12b.
22a.	Tur kills Iraj		26a.	30b.
36a.	Zal visits Rudaba	–	–	
47a.	Birth of Rustam	–	60a.	
49a.	Rustam slays the White Elephant	50b.	62a.	
69a.	Rustam kills the White Div	72a.	87a.	
81a.	Tahmina visits Rustam	85a.	103a.	
91b.	Rustam recognizes wounded Suhrab	95a.	–	
98a.	Fire Ordeal of Siyavush	102b.	126b.	
107b.	Siyavush plays polo	111b.	138a.	
131a.	Kay Khusrau crosses the Oxus	–	169a.	
165b.	Rustam slays Ashkabus	169a.	212a.	
175a.	Rustam unseats the Khaqan	178b.	223b.	
185b.	Akwan hurls Rustam into the sea	187b.	–	
202b.	Rustam rescues Bizhan	200b.	255a.	
226b.	Gurgin leads Andariman's Horse	–	283b.	
241b.	Kay Khusrau throws Shida	238b.	–	
260a.	Kay Khusrau kills Afrasiyab	256b.	–	
267b.	Luhrasp Enthroned	–	331b.	
274a.	Gushtasp slays the Wolf	271b.	–	
290a.	Gushtasp shackles Isfandiyar	–	–	
298a.	Isfandiyar battles the Dragon	–	–	
320a.	Rustam pierces Isfandiyar's Eyes	320a.	–	
325b.	Rustam shoots Shaghad from a Pit	325b	409a.	
337b.	Iskandar and the Dying Dara	337b.	–	
346a.	Iskandar visits the Ka'ba	–	423a.	
354b.	Iskandar builds a wall	–	444a.	
367a.	Ardashir Enthroned in Baghdad	–	459a.	
388b.	Bahram's Camel Tramples Azada	–	482a.	
397b.	A Shoemaker rides Bahram's Lion	–	494a.	
416a.	Bahram kills a Dragon	416b.	–	
440b.	Buzurjmihr advises Anushirvan	–	–	
463b.	Talhand dies in Battle with Giv	–	–	

Notes

1 B.W. Robinson, *The Kevorkian Collection: Islamic and Indian Illustrated Manuscripts, Miniature Paintings and Drawings* (unpublished typescript, New York, 1953), p. 22, no. XIX; *idem*, "The Turkman School to 1503", in *The Arts of the Book in Central Asia*, ed. B. Gray, Paris, 1979, pp. 216–217; *idem*, "Persian Painting and the National Epic", *Proceedings of the British Academy, London*, vol. LXVIII, 1982, fig. 10.

2 E. Grube, *The Classical Style in Islamic Painting*, [n.p.], 1968, a "provincial center of the Timurid realm," "1430–1450," pp. 28–29, 188–189, nos. 26–30; P.P. Soucek, "Illustrated Manuscripts of Nizami's *Khamseh*", Ph.D. dissertation, New York University, 1971, vol. 2, pp. 452–453, Baghdad, 1460's; *eadem*, "Islamic Art", in *Eighty Works in the Collection of the University of Michigan Museum of Art: A Handbook*, ed. H.W. Woodward, Ann Arbor, 1979, no. 29.

3 *Shahnama-yi Firdausi*, critical ed., Moscow, Akademiia Nauk, (editors vary), vol. IX, 1981, p. 363, "Yazdigard":645.

4 R.O.M. 963.315.3, formerly in the Kevorkian Collection (Robinson, *Kevorkian Collection*, no. XXV, pp. 25–26).

5 B.W. Robinson, "The Shahnama of Muhammad Juki", *The Royal Asiatic Society and its Treasures*, ed. S. Simmonds and S. Digby, London, 1979, pp. 83–102.

6 A. Welch, *Collection of Islamic Art, Prince Sadruddin Aga Khan*, Geneva, 1978, vol. 4, Ms. 11, pp. 12–15.

7 F.E. Karatay, *Topkapi Sarayi Müzesi Kütüphanesi Farsça Yazmalar Kataloğu*, Istanbul, 1961, no. 336, p. 128; P. Soucek, "Illustrated Manuscripts of Nizami's *Khamseh*," vol. 2, p. 454.

8 GPB no. 332, L.T. Giuzalian and M.M. Diakonov, *Rukopisi Shakh-name v Leningradskikh sobraniiakh*, Leningrad, 1934, no. 5, pp. 19–21; *eidem*, *Iranskie miniatiury*, Leningrad, 1935, pp. 45–48, pls. 10–13.

9 M. Minovi *et al.*, *The Chester Beatty Library: A Catalogue of the Persian Manuscripts and Miniatures*, vol. II, Dublin, 1960, pp. 9–13, pls. 2–7.

10 Karatay, *Farsça Yazmalar*, no. 337, p. 128.

11 Notable examples are the British Library, Add. 18113, Khwaju Kirmani, *Divan*, Baghdad, 1396 (T.W. Lentz and G.D. Lowry, *Timur and the Princely Vision: Persian Art and Culture in the Fifteenth Century*, Washington, 1989, cat. no. 13, pp. 53–55, 330–331), British Library Add. 27261, *Anthology*, Shiraz, 1410–11, (*ibid.*, cat. no. 35, pp. 17–118, 336), and Freer Gallery of Art, 31.29–37, Nizami, *Khusrau u Shirin*,

12 Tabriz ca. 1420, (M. Aga-Oglu, "The Khusraw wa Shirin Manuscript in the Freer Gallery," *Ars Islamica*, vol. IV, 1937, pp. 479–81).

12 Folios 241b, 260a, 274a, 290a, 298a and possibly 267b which is somewhat damaged (for topics illustrated, see Appendix I).

13 Toronto, R.O.M. 963.315.3, fol. 21a; Geneva, Ms.11. fol. 26a, Istanbul, T.S.M., H. 1496, 30b.

14 Istanbul, TSM H. 1496, fol. 12b; Dublin, C.B. P. Ms. 157, fol. 25b; Istanbul, TSM H. 1489, 33b.

15 The Ann Arbor painting is placed after "Faridun": 497 whereas in R.O.M. 963.315.3, H. 1496, C.B.P. 157 and H. 1489 paintings are placed after "Faridun": 507 (Abu'l-Qasem Ferdowsi, *The Shahnameh*, ed. D. Khaleghi-Motlagh, New York, 1988, vol. I, pp. 120–121): H. 1496 and C.B.P. 157 copied by the same calligrapher at a sixteen-year interval (1464 versus 1480) are also similar in the arrangement of verses on the page. For a fourteenth-century illustration of the earlier incident see A.T. Adamova and L.T. Giuzalian, *Miniatiury Rukopisi Poemy "Shakhname" 1333 Goda*, Leningrad, 1985, pp. 48–49.

16 Paris, BN Pers. 493 dated to 1441, fol. 89a (I. Stchoukine, *Les Peintures des Manuscrits Timurides*, Paris, 1954, pl. XXXIII); Toronto, R.O.M. 963.315.3 dated to 1444, fol. 105a; Manchester, John Rylands Pers. Ms. 9, fol. 105b (B.W. Robinson, *Persian Painting in the John Rylands Library*, London, 1980, fig. 440).

17 Istanbul, H. 1496, 60a; Dublin, C.B.P. MS. 157, fol. 49b.

18 "Suhrab": 64–65, *Shahnama-yi Firdausi*, vol. II, Moscow, 1966, p. 174.

19 Lentz and Lowry, *Timur*, cat. no. 45, pp. 130, 338. The illustration of this incident in the *Shahnama* of Muhammad Juki, a Herat manuscript of ca. 1440 now in London, contains a similar figural ensemble in a mirror reverse configuration (J.V.S. Wilkinson, *The Shah-namah of Firdausi*, Oxford, 1931, pl. V).

20 This colour scheme may reflect court usage. For the same combination of red furnishings and a woman in court dress wearing yellow see *A Mirror for Princes from India*, ed. E.J. Grube, Bombay, 1991, fig. 95. Yellow garments were especially popular with some Islamic rulers; (M. Lombard, *Les Textiles dans le Monde Musulman*, Paris, 1978, pp. 129–130).

21 Lentz and Lowry, *Timur*, cat. no. 13, pp. 55, 330–331.

22 On the role of curtains in court ceremonial, see D. Sourdel, "Questions de Cérémonial

23 'Abbaside," *Revue des Études Islamiques*, vol. 28, 1960, pp. 123–124, 132, 140–142.

23 T.W. Arnold, *Painting in Islam*, New York, 1965, pp. 21–22.

24 M.S. Simpson, *Arab and Persian Painting in the Fogg Art Museum*, Cambridge, 1980, pp. 35–38.

25 Lentz and Lowry, *Timur*, pp. 53, 55; the spatial divisions of the wedding celebration (B.L. Add. 18113, fol. 45b) can be paralleled in the traditional houses of Baghdad.

26 Themes more prominent in fifteenth- than fourteenth-century *Shah-namahs* which may reflect the growing popularity of Nizami's *Iskandar-nameh* include "Iskandar and the Dying Dara" and "Iskandar visits the Ka'ba."

27 B.W. Robinson *et al.*, *Islamic Painting and the Arts of the Book*, London, 1976, Part III: 2 pp. 133–134, pl. 13; The "Stephens *Shah-nama*" is also said to contain an illustration of this incident, but its composition is unpublished (Sotheby Parke Bernet & Co., *Important Oriental Manuscripts and Miniatures*, 12 April, 1976, lot 190:122, p. 82).

28 Stchoukine, *Peintures des Manuscrits Timurides*, pl. XXIII; "Hakim" *Shah-nama*, fol. 91b.

29 Located after "Suhrab":65; Welch, *Collection of Islamic Art*, vol. 4, p. 13, Ms. 11, fol. 85a.

30 H. 1496, fol. 103a, C.B. P. Ms. 157, fol. 85b.

31 Both are copied by Muhammad b. Muhammad known as "Baqqal" (the Grocer). The paintings are placed after "Suhrab":71 (*Shahnama-yi Firdausi*, vol. II, p. 175).

32 "Bizhan u Manizha": 1105, (*Shahnama-yi Firdausi*, Moscow, 1967, vol. 5, p. 72). The whole episode occupies verses 1070–1118 (*ibid.*, pp. 70–73).

33 The removal of the stone ("Bizhan u Manizha": 1085–1086, *ibid.*, p. 71) is followed by a conversation between Bizhan and Rustam ("Bizhan u Manizha": 1087–1105, *ibid.*, pp. 71–72).

34 "Bizhan u Manizha": 414–416 & 1078, *ibid.*, pp. 32, 71.

35 "Bizhan u Manizha": 1078–1083; Rustam prays for strength before moving the stone: 1085 (*ibid.*, pp. 70–71).

36 "Bizhan u Manizha": 1093–1105, *ibid.*, p. 72.

37 M.S. Simpson, "The Narrative Structure of a Medieval Iranian Beaker," *Ars Orientalis*, vol. XII, 1981, figs. 9 and 12; J.M. Rogers, trans. and ed. *The Topkapi Saray Museum: the Albums and Illustrated Manuscripts*, Boston, 1986, p. 51, fig. 42; Adamova and Giuzalian, *Shakhname*, no. 19, pp. 81–83.

38 A tenth-century painter gained fame for his depiction of Joseph in the well (Arnold,

Painting in Islam, pp. 106–107).

39 Fol. 105a (Aga-Oglu, "Preliminary Notes on some Persian Illustrated Mss. in the Topkapu Sarayi Müzesi-Part I," *Ars Islamica*, vol. I, 1934, p. 191, fig. 40; Ousely Add. 176, fol. 186a (Stchoukine, *Peintures des Manuscrits Timurides*, pl. XXV).

40 MS. 11, Geneva, fol. 200b shows Rustam conversing with Bizhan after his rescue and the pit is not depicted. H. 1496, fol. 255a shows Bizhan emerging from the mouth of the pit, but its lower section is not shown.

41 Istanbul, TKS H. 1498, fol. 196a, Dublin, C.B.P. 157, 214b.

42 Wilkinson, *The Shah-namah of Firdausi*, pl. XI.

43 *A Mirror for Princes from India*, ed. E.J. Grube, Bombay, 1991, figs. 7–10, 61, pp. 20–21, 66.

44 *Ibid.*, figs. 10a, 40, 50, 62–63, pp. 21, 45, 56, 66.

45 *Ibid.*, pp. 66, 81, figs. 64, 82.

46 *Ibid.*, fig. 92, p. 87.

47 The painting is located after "Ardashir": 1, 3 (*Shahnama-yi Firdausi*, Moscow, 1968, vol. VII, p. 155). The story of Ardashir's rise to power occupies "Ashkaniyyan": 754–777, "Ardashir": 1–14 (*ibid.*, pp. 153–156). The *Preliminary Index of Shah-nameh Illustrations*, ed. J. Norgren and E. Davis, Ann Arbor, 1969, (s.v.), mentions only two other manuscripts illustrated with this theme – dated to 1549 and 1602.

48 "Anushirvan": 972–975 (*Shahnama-yi Firdausi*, Moscow, 1970, vol. VIII, p. 110).

49 "Anushirvan": 991–1022 (*ibid.*, pp. 111–113).

50 "Anushirvan": 1022–1042 (*ibid.*, pp. 113–115). The painting is located after "Anushirvan": 1032 (*ibid.*, p. 114).

51 B.W. Robinson, "The Tehran Manuscript of *Kalila wa Dimna*: a Reconsideration," *Oriental Art*, N.S., vol. IV, 1958, p. 110, fig. 2.

52 Soucek, "Nizami's *Khamsa*", pp. 451–52; B.W. Robinson, "The Turkman School," p. 217.

53 Abu Bakr-i Tihrani, *Kitab-i Diyarbakriyya*, ed. N. Lugal and F. Sümer, Ankara, 1964, vol. II, pp. 327–8; 'Abd al-Razzaq Samarqandi, *Matla' al-Sa'dayn*, Fatih 4370, fols. 682b–683b; Tihrani, *K-i D*, II, pp. 362–366; *ibid.*, pp. 371–373 and 'Abd al-Razzaq, *M.S.*, Fatih 4370, fol. 705a–705b.

54 T.I.E.M. 1986, a *Divan* of Qasim al-Anvar, dated to the end of Jumada II 863 or early May 1469; Lentz and Lowry, *Timur*, cat. no. 139, pp. 248–249, 357; M. Aga-Oglu, *Persian Bookbindings of the Fifteenth Century*, Ann Arbor, 1935, pls. XVIII–XIX.

55 Calligraphers active in Baghdad include Fakhr al-Din Ahmad al-Haravi, 'Abd al-Rahim al-Khvarazmi, and 'Abd al-Rahman al-Khvarazmi as well as Shaykh Mahmud (Soucek, "Nizami's *Khamsa*", pp. 426–548).

56 H. 1496, fol. 459a.

57 *A Mirror for Princes*, pp. 62–63, 89–91, figs. 56–58, 94–95.

19

Habib Allah

MARIE L. SWIETOCHOWSKI

THE METROPOLITAN MUSEUM RECENTLY ACQUIRED A FINE painting of a dappled blue stallion (1992.51), signed by the artist Habib Allah. Signed works by this late sixteenth-early seventeenth century artist are relatively rare, so that the Museum is particularly fortunate to have also the painting of "The Assembly of the Birds" in the manuscript of the *Mantiq al-Tair* (63.210.11), similarly signed. This essay, very much a preliminary study of the artist, will concentrate on Habib Allah's signed works and others closely related to them. All but two of these are single figure studies, either human or animal, and two are manuscript illustrations.

What I shall attempt to do is to fill in briefly the historical background of the artist and his patrons and present those of his works that are accessible to me,[1] even if only, in some cases, in black and white photographs.

What is known of Habib Allah's life and career is based almost exclusively on the words of Qazi Ahmad in his treatise *Calligraphers and Painters*, translated by V. Minorsky. He writes:

> Maulana Habibullah of Sava lived in Qum. For the skill of his hands he was one at whom men point their fingers and with regard to art he became a ravisher of the souls of his contemporaries. Every day he makes more progress. [*H*. p. 71: "Navvab Husayn-khan Shamlu, governor of Qum, had attached him to his person when he went to Herat, but the felicitous Prince ('Abbas I?) took him away from the khan, and now he is in the capital, Isfahan, employed by the court department (*sarkar-i humayun*) as a painter"].[2]

In the Introduction to the treatise B.N. Zakhoder writes:

> "To Qum, as a haven of refuge, often came artists and master calligraphers who had been disappointed in life or who had no success in court workshops or institutions. Such were [so and so, etc.] and the painter Habibullah of Sava.[3]

The difficulty in reconstructing Habib Allah's career is that so much can only be speculation. For example, it is plausible to suppose that the artist had sought patronage at the Safavid court at Qazvin, and that, like so many others, with the accession of the almost blind Muhammad Khudabanda in 985/1578 and the break-up of the royal atelier, had left Qazvin, and, in his case, gone off to Qum. In his detailed history of Shah 'Abbas, Iskandar Beg Munshi first mentions Habib Allah's patron, Husain Khan Shamlu, in the year 1000/1591–92, as Governor of Qum.[4] Since Habib Allah was by this time a painter of repute, it was probably not long before Husain Khan Shamlu became his patron.

Because the relationship between Husain Khan Shamlu and Shah 'Abbas Habib Allah's ultimate patron, was so close, a short summary of relevant historical events might prove helpful. 'Abbas Mirza was born in Herat on 27 January 1571. 'Aliquli Khan Shamlu was appointed governor of Herat by Isma'il II, with orders to put to death his nephew, but because of the close family relationship to Sultan Muhammad Khudabanda, and the fact that 'Aliquli's mother was midwife at the birth of 'Abbas Mirza and his foster-mother, he procrastinated, and on 13 December 1577, received news of Isma'il's murder. Muhammad Shah then mounted the Safavid throne at Qazvin. Because of his defective eyesight and the minority of the princes, his wife Mahd-i 'Ulya actually governed the realm.[5]

'Aliquli Khan (the father of Husain Khan Shamlu, the future governor of Qum and later Herat) was ordered to return 'Abbas

Mirza to Qazvin, but, with the backing of other Khurasani emirs, refused, (having the justifiable fear of an Uzbek invasion if a royal presence was not maintained in Khurasan). After two fruitless missions from Qazvin, his father, Sultan Husain Khan, the acknowledged leader of the Shamlu tribe at court, was sent to Herat to bring the errant 'Aliquli Khan into line. He also was unsuccessful, and only dared to return to court after the murder of Mahd-i 'Ulya, when in any case it was decided that 'Abbas Mirza should stay in Herat.[6]

In the year 991/1583 'Aliquli Khan's erstwhile ally, Murshidquli Khan, managed to establish his power base at Mashhad. This move was the beginning of a rift that ultimately led to an armed conflict in 992/1584. 'Aliquli Khan lost sight of 'Abbas Mirza in the battle, and Murshidquli Khan seized the opportunity offered, bearing 'Abbas Mirza off to Mashhad. 'Abbas Mirza had grown very fond of his guardian and was dismayed at this abrupt change in his life. 'Aliquli Khan's sons must have been the young prince's playmates and certainly Husain Khan remained close to Shah 'Abbas all his life.[7] 'Abbas Mirza remained in Mashhad with his new guardian until the murder of the heir apparent, Hamza Mirza, on 4 December, 1586 led to Murshidquli Khan's successful bid to put his charge on the Safavid throne at Qazvin in the late summer of 995/1587.

In 997/1588–89 the Uzbeks captured Herat, 'Aliquli Khan was killed, the Shamlu tribe massacred, and Khurasan overrun. It was not until 1006/1597–98 that Shah 'Abbas was in a position to consider the recovery of Khurasan. That year he sent Husain Khan Shamlu and two other emirs in order, among other assignments, to collect military intelligence from all parts of Khurasan. "The emirs carried out their orders to the letter, and Hoseyn Khan Samlu returned to court and was received with honor by the Shah".[8] This is not the only instance of mention of the presence of the governor of Qum at court, so he clearly maintained a trusted and close relationship with the Shah.

The following year, 1007/1598–99, saw the reconquest of Khurasan by the Safavid forces, and Husain Khan Shamlu was awarded the governorship of Herat and position of *amir al-umara* of Khurasan.[9] In 1010/1601–2 Shah 'Abbas was back in Khurasan, where he spent the winter months in Mashhad and came to Herat briefly in the spring of 1010/1602, summering at Badghis near Herat while mustering troops for his disastrous campaign against Balkh. Retreating to Herat, the army was decimated by heat and dysentery. "The effects of this campaign were not dissipated during the two or three weeks the Shah spent at Herat".[10]

In the fall of 1607, the Shah made a pilgrimage to Mashhad, where he was received by Husain Khan Shamlu and other Khurasani emirs,[11] but by this time Habib Allah must already have moved to Isfahan (see note 2). When Husain Khan Shamlu died in 1017/1608–9 Shah 'Abbas ordered his burial within the precincts of the shrine at Mashhad, in recognition of his many years of faithful service.[12]

What then are the possible dates that Habib Allah could have left Husain Khan Shamlu's service for the Shah's? It was presumably after the artist took up duties in Herat in 1007/1598–99, because he could have been called to the royal atelier from Qum at any time, but was not. They could have met during the few weeks the Shah stayed in Herat after the reconquest, settling military and administrative affairs, or later in the same year when the Shah was at Mashhad for a month, since we do not know when the artist made his pilgrimage there. They may also have met in the year 1010/1601–2, either when 'Abbas was wintering in Mashhad or in the spring in Herat or during the summer months in Badghis, not far from Herat.

We shall now turn to the works of Habib Allah and list them according to category, that is: single figures, animals, and manuscript illustrations, beginning with signed works, roughly in the order of their first appearance or mention in publications, followed by related works.

H1. *Young Hunter Carrying his Musket*

Signed, to the left of the flower in the lower right, *"Mashhadi Habib Allah"*. Staatliche Museen, Berlin; opaque colours and gold on paper; 82 x 9.5 cm. Published: Schulz, Walter, *Die persisch-islamische Miniaturmalerei*, Leipzig, 1914, vol. II, pl.167, left; Kühnel, Ernst, *Miniaturmalerei im Islamischen Orient*, Berlin, 1922, ill. p. 87; Sakisian, A.B., *La Miniature persane*, Paris and Brussels, 1929, pl.CIII, fig. 185; Robinson, B.W., *Persian Drawings*, New York, 1965, fig. 3 (hereafter Robinson); Grube, E., "The Language of the Birds: The Seventeenth century Miniatures", in *The Metropolitan Museum Bulletin*, May, 1977, fig. 3, taken from Sakisian (hereafter Grube, MMA).

In discussing the signature on this painting Abolala Soudavar writes: "The signature on the latter bears the epithet Mashhadi, one that a pilgrim to Mashhad would proudly use...The term is to be used before the name, much like the epithet Haji; thus the correct reading of his signature would be "Mashhadi Habibollah" and not "Habibollah-e Mashhadi"...This reading is also justified by the order of the writing: "Mashhadi" at the bottom "Habib" in the center and "Allah" at the top".[13]

In his comments on the works of Habib Allah, Ivan Stchoukine finds the provincial style of the work apparent. "Elle garde encore des traits de l'époque précédente: les lignes sont plus calmes et les courbes moins accentuées que dans l'art de la capitale; la silhouette du personnage accuse une légère raideur".[14] While I do not agree with Stchoukine that the work is provincial, or the figure a little stiff (unlike the second "Young Huntsman Loading a Matchlock", see no. H9), I do agree with the rest of his comments and suggest that this painting was made before Habib Allah came to work in the royal atelier in Isfahan sometime between 1598 and 1606 (the date of Qazi Ahmad's treatise).

H2. *Young Huntsman Loading a Matchlock*

Inscribed, along stock of gun: "'*amal Habib Allah*"; drawing in ink, touches of colour and gold. Topkapi Saray Library, H. 2165, fol. 54v. Unpublished. For a painting in a Sotheby sale's catalogue similar to this one, see H9.[15]

The young man's face is in tones of pinkish beige. His outsized turban is of pale blue with gold stripes, and has a black and blue plume attached with a green turban ornament; his sash and trousers are of the same colour, with the folds of the sash in black. His leggings are black with gold bindings and his boots beige, drawn with great detail and touches of black, green and red. His sword and powder horn are of gold, the one with a green hilt, the other with green rim and tip. His matchlock is black with blue and gold markings.

The letters of the inscription seem too angular to be a signature, but the ascription is probably correct. The youth's features seem consistent with other works of the artist, with a softening of the brows where they meet, the straight nose and the slight smile noted before. The folds of his garments, turning over at the bottom of his *jama*, bunched at the wrist with a slight peak in the centre, and sharp at the edges of the sash are all characteristics of Habib's style. The relaxed stance of the figure relates him to the Berlin huntsman, although the dandyish turban and full soft face point to this as a product of his Isfahan years, dating to the early seventeenth century, somewhat later than the Berlin huntsman, in spite of similarities of background. One peculiarity noticeable in the reproduction is that the tip of the sword is painted on top of the blue border, so that one wonders whether it was cut off when mounted and repainted at a later date.

H3. *A Seated Young Lady in an Orange Dress and Green Mantle*

Signed, on the book she is holding: "*Habib Allah naqqash*" (the *h* is smudged and thus indecipherable, and the rest of the inscription on the book is too faint to make out); Painting in ink, colours and gold. Topkapi Saray Library, H. 2165, fol. 54v (see also note 15). Unpublished.

The young lady is seated on a hexagonal stool decorated with tiles, with gold borders, pricked. She wears a green jacket decorated with gold, with a black fur collar edged with a band of gold arabesques on a black ground; she wears an orange dress and striped trousers, green slippers and a peaked headdress with a black plume in front. Her right knee is crossed over her left and in her gloves or tattooed hands she holds a flat book of anthology shape. The clouds and plants of the landscape in which she sits seem to have been added later as they overlap the border and her knee.

This young lady, called a princess by Sakisian, the first scholar to have mentioned her in print (see note 15), is very elegant and aristocratic, and like H2 seems to belong to the Isfahan phase of the artist's career. The delicate line, facial features (not so full as the type favoured by Riza and his followers), elegant hands and attention to detail, such as the striped sash with its very long fringe looped through her narrow waist sash, as well as a characteristic treatment of

garment folds, similar to those described in H2, all confirm the ascription to (or signature of) Habib Allah.

H4. *Seated Lady*

Signed *"raqimahu Habib Allah"* (?) (the signature is very faint); ink and wash, 15.5 x 8.5 cm. Private collection, London.

Published: Robinson, B.W., *Persian Drawings*, New York, 1965, p. 136 and pl.50, colour.

Robinson writes: "The drawing shows Habiballah's mastery of delicate, yet firmly flowing line, only a little inferior to that of Aqa Riza. It seems difficult to accept the view recently put forward that his style was provincial and little influenced by the new trends in the capital." One can only agree with these words.

H5. *Young Man with a Bow*

Signed *"raqimahu Habib Allah"*; ink and light colour on paper, 14.5 x 6.8 cm.; collection of Abolala Soudavar.

Published: Sotheby's Sale Catalogues, 8 July 1980, lot 210, ill.; Soudavar, Abolala, *Art of the Persian Courts*, New York, 1992, no. 89.

Soudavar dates it to the fourth quarter of the sixteenth century. For all but the last two years of that quarter Habib Allah was working in Qum. Soudavar points out that the youth seems to be a musician rather than a warrior, as witness the little bells attached to the bow, and cites other examples of similar figures. He compares the dress and hairstyle to those found in "a contemporary tinted drawing attributable to Muhammadi" of masqueraders and suggests that itinerant groups of entertainers wandered the Khurasani countryside. B.W. Robinson gives further information on the Muhammadi drawing, namely, that it is dated 1012/1604, and that it has the seal of the Ardabil Shrine.[16] Habib Allah, in the development of his style, judging by his few signed works, seems to have been influenced firstly by the court style practised at Qazvin. It is probable, though unproven, that Habib Allah actually sought patronage to Qazvin. Where else but to the capital would a talented young artist from nearby Sava have gone? Habib Allah seems, secondly, to have been influenced by Muhammadi. While he does not try to reproduce the spare, round-headed figures of Muhammadi, such as the "Young Darvish with Book and Spear",[17] the "Young Man with a Bow" seems indebted to such figures. Not only do the two figures have similar slight smiles and an aura of inner joy, but also the superb handling of line, delicate yet sure, somewhat more firmly fluid in the case of Habib Allah, who was not immune to the mesmerizing influence of Riza-yi 'Abbasi. While Habib Allah may well have travelled to the capital, Qazvin, during the several visits there of his patron, Husain Khan Shamlu, between 1590 and 1598, and so become aware of the artistic luminaries of the day, it is very unlikely that he became aware of Muhammadi's work until his arrival in Herat in 1598–99, particularly if Robinson is correct in his surmise that Muhammadi never left Herat.

H6. *Youth with a Spade*

Signed *"mashq-i Muhammadi"*, drawing, 18 x 13cm., in the India Office Library. Published: Robinson, B.W.,

"Muhammadi and the Khurasan Style", in *Iran*, XXX, 1992, M26, pl. Xb.

Robinson finds the signature "more than doubtful". The drawing is, however, similar in many respects to the "Young Man with a Bow". The youth's stance is almost identical except for the necessity of leaning into the spade. The clothing is the same except for the lacing of the upper part of the garment. The sash is wrapped and tied in exactly the same manner, and the folds of

the garment fall and flow in similar rhythms, also comparable to those of the "Seated Lady".
Oddly enough, if the "Youth with a Spade" might be attributed to Habib Allah, it has pulled
slightly further away from the influence that the "Young Man with a Bow" owed to Muhammadi
and become more attuned to the calligraphic line of Riza, suggesting a slightly later date,
perhaps the turn of the century.

H7. *Portrait of a Girl Holding a Sprig of White Flowers*

Colours and gold on paper, 13.5 x 6.4cm.; in the Kraus Collection. Published: Sotheby's Sales Catalogue, 1 December
1969, lot 82 (the comment reads: "A fine drawing in the style of Habiballah of Meshad"; Grube, E., *Islamic Paintings
from the 11th to the 18th Century in the Collection of Hans P. Kraus*, New York, n.d., pl. XXXVII (in colour), no. 152.

Included in Grube's catalogue entry are these words: "The painting is of exquisite quality... It is
a fine example of the Isfahan School at its height, when Rida-i 'Abbasi was directing it... Even
though the painting is not signed there can be little question that it was done by one of the
major painters of the school if not by Rida himself." I believe that the writer of the Sotheby's
catalogue was correct. Everything about the painting, from the quality of the firm yet fluid line,
more delicate and less calligraphic than Riza's, to the shape of the face as well as the features
and expression, and the way the drapery folds fall and turn and produce sharp angles where
bunched, points to the hand of Habib Allah. Although fully coloured, this figure is still very
close to the "Seated Lady", H4, signed by Habib Allah, and is probably slightly earlier in date,
from the closing years of the sixteenth century.

H8. *A Woman with a Spray of Flowers*

Colours and gold on paper, 14.9 x 7.2 cm.; in the Arthur M. Sackler Gallery, Washington, D.C. Published: Lowry,
G.D., and Beach, M.C., *An Annotated and Illustrated Checklist of the Vever Collection*, Washington, D.C., Seattle and London,
1988, no. 359.

This painting is very close to H7 in subject and style. One may note the same little flower stuck
into the head-band of each young lady, and both hold a similar sprig of flowers. The position of
the hands reflects those of the "Seated Lady", H4. H7 and H8 would appear to be of the same
date, and, if so, may have been painted in Qum, where influences from the court of Qazvin were
sure to have been felt, or in Herat, before Habib Allah was transferred to Isfahan. If one can
accept that H7 is the work of Habib Allah, then so is H8.

H9. *A Young Man Loading a Matchlock*

Colours and gold on paper, 17.3 x 9.4 cm. Published: Sotheby's Sale Catalogue, 1 December 1969, lot 73, and
identified as being "In the style of Habib Allah of Mashhad".

Certainly it is difficult not to associate this painting with the "Young Huntsman" in Berlin, H1,
to which it is stylistically very close. It is, however, a copy of the drawing in Istanbul, H2,
although, in spite of being called in the Sotheby catalogue a tinted drawing, it is described there
as being in full colour, unlike the one in Istanbul. It lacks some of the detail of that drawing, as
in, for example, the boots. The figure seems a little stolid compared to the Berlin huntsman.

H10. *A Young Man with his Falcon*

Colours and gold on paper, 16.2 x 7.8 cm. From the "Album of the Emir of Bukhara" in The Pierpont Morgan Library, M.386.a. Published: Grube, E.J., *Muslim Miniature Paintings*, Venice, 1962, no. 102; Grube, E.J., *The Classical Style in Islamic Painting*, Edizioni Oriens, n.p., 1968, no. 87.

Barbara Schmitz, working on a catalogue of the Islamic paintings in the Morgan Library, believes this to be a copy of a Habib Allah painting, presumably by a follower or student. It is certainly close in style to Habib Allah's work in type of figure, facial features and drapery folds, but perhaps lacks the finesse of the artist himself.

H11. *A Young Man Playing a Lute*

In the British Museum. Published: Martin F.R., *The Miniature Painting and Painters of Persia, India and Turkey*, London, 1912, pl.119.

This has been added here because such an eminent art historian as Stchoukine suggested, in his short entry on Habib Allah, that this painting should be attributed to that master.[18] The attribution seems doubtful.

H12. *A Chained Dromedary*

Signed: "'*amal Habib Allah*", just behind the front border of the saddle cloth; mounted on an album leaf; in the Medelhavsmuseet, Stockholm (Inv. no. NM/1917/385). Published: Ådahl, Karin, *Islams Varld*, Stockholm, 1968, p. 19, no. 33; she dates it ca. 1600.[19]

This painting appears to be a copy of a painting in the Freer Gallery of Art with an attribution to Bihzad written in cartouches above the camel and his keeper, who is walking away from the animal, but looking back over his shoulder, holding a spindle in one hand and a long thread in the other. Even if it is not by Bihzad himself, it is probably after a painting by him. The dromedary is alone in the Stockholm painting. Except for a differently decorated saddle-cloth and girth, an extra rope, and the camel's thicker mane in Habib Allah's version, the two are very close. A drawing of a camel fight in the Metropolitan Museum of Art, of about the same date as this drawing, was copied after a camel fight by Bihzad, of which there are several subsequent versions.[20] This practice attests to both the lasting esteem in which the work of Bihzad was held and to the popularity of camels with late Timurid and Safavid artists. For example, Sakisian published an image of a chained camel with keeper in which the position of the chained forelegs and the stump confirm that it is another variant of the composition.[21]

H13. *A Caparisoned Camel with a Small Bearded Figure behind Handling a Spindle*

Signed on the animal's haunch "*Habib*" and faintly in gold in the lower left hand corner "'*amal-i faqir qulash Habib naqqash*"; seal impression of Fathallah dated A.H. 1240/A.D. 1825, another seal obliterated; 10.1 x 17 cm. Published: Sotheby's Sales Catalogue, 26 April 1990, lot 106, illustrated in colour, and attributed there to Isfahan, c.1600.

The catalogue entry tells us that: "This painting derives from a Bihzadian original, and may be compared to Habiballah's work in the Bihzadian manuscript of *Mantiq al-Tayr* in the Metropolitan Museum of Art, New York. According to Anthony Welch Shah Abbas was keen on reviving the Timurid style, and commissioned Habiballah, whom he had known since he was a young prince at Herat, to refurbish the manuscript." See A. Welch, *Artists for the Shah*, London,

1976, p. 184. The entry ends with: "A miniature of similar composition with an attribution to Bihzad was sold in these rooms 26th March 1973, lot 37". It is of interest that the camel here and in H12 should derive from Bihzadian originals, but it has already been remarked that copying former revered masters was not an uncommon practice. However, the theory of a Timurid revival promoted by Shah 'Abbas is, in my opinion, without foundation, as will be discussed below, and we now know that a historical misunderstanding suggested to A. Welch a contact between Habib Allah and 'Abbas Mirza in Herat years earlier than it actually took place (see note 12).

A camel's keeper working a spindle has been referred to in regard to H12. Another example is the well-known painting in the Freer Gallery of Art of the keeper before a chained Bactrian camel signed by Shaikh Muhammad and dated A.H. 994/A.D. 1556–67.[22] The significance of a camel keeper with a spindle has, to my knowledge, never been explained. Were camel keepers drawn from nomadic tribes and were they traditionally weavers of camel hair?

In this picture the dromedary appears to be a more serene beast than the one in H12 and the others cited in that entry, which, like Shaikh Muhammad's camel, combine fierceness with hauteur. In any case the two camel paintings ascribed to Habib Allah share certain characteristics such as an emphasis on the mane and ruff of the camel, his saddle cloth and girth, brush strokes creating an almost tactile impression of hair, and the sure but gentle line. Stylistically these two camel paintings seem to relate to the Qazvin court tradition before the dominance of Riza and his style and may well date from the Qum years under the patronage of Husain Khan Shamlu.

H14. *Portrait of a Stallion*

Signed (in front of the stallion at knee level) "*raqim-i Habib Allah*"; opaque watercolour and gold on paper; page: 20.3 x 30.1 cm, painting: 12.7 x 19.7 cm.; effaced collector's stamp in lower right corner; mounted on an album page with coloured and marbled border; verso: *nasta'liq* calligraphy signed by "the miserable servant Shah Muhammad al-Katib al-Mashhadi".

Published: *The Metropolitan Museum of Art Bulletin*, Fall 1992, "Recent Acquisitions: A Selection, 1991–1992", p. 15, ill. in colour.

The dappled blue stallion stands alone against a gold background scattered with characteristic plants and clouds, also in gold. He is bridled and has a saddle cloth with a leaf and floral scroll pattern in gold on a gold ground. The chest flap is folded back, revealing its rose-coloured underside, and is tucked into the girth, which is surmounted by a gold finial topped with a hair ball and a pair of plumes. The stallion is placed off centre almost as if to leave space for the figure of a groom, who was not, in the end, included, the artist rightly being satisfied with his picture as it was. Habib Allah's fluid, unfaltering yet delicate line is very evident here. The dappling of the horse's coat is subtle and harmonious, soft shades of blue contrasting with the rich gold of the saddle and being perfected by the finishing touch of colour in the lining of the saddle cloth.

In a society in which the nobility spent much of its active life on horseback, travelling, fighting, hunting or playing polo or other sports demanding equestrian skill and agility, it is not surprising that pictures of horses, whether portraits or more often idealized representations, were extremely popular from the sixteenth century on, more often than not pictured with a groom in attendance. There is a picture of a young prince holding a falcon while riding a dappled horse which has an inscription identifying the subject as Shah 'Abbas, illustrated in a Sotheby Sales Catalogue of 1 December 1969, lot 72.[23] It is entirely possible that the young Shah had a favourite dappled horse and that Habib Allah painted such an idealized portrait of it to celebrate or commemorate it.

The style of the painting seems more reflective of the court art of Qazvin as rooted in the Tabriz style than the forward-looking Isfahani style. Actually the closest prototype for this horse can be found in the painting "Gushtasp slays the Dragon of Mount Saqila", folio 402r of the *Shah-nama* of Shah Tahmasp. As S.C. Welch states in regard to this painting: "Gushtasp's steed belongs at court rather than on the battlefield". Welch attributes the painting to Mirza 'Ali.[24] The delicacy and fluidity of line seen here become prime characteristics of Habib Allah's drawing style. Since Habib Allah's rocks in the "Assembly of the Birds" in the *Mantiq al-Tair* (see H15) are close to the rocks of this *Shah-nama* painting, one wonders if Habib Allah may not have been a pupil of Mirza 'Ali, an artist who had apparently died by 1576 but who was active during Habib Allah's formative years.

H15. *The Assembly of the Birds*

Signed (on a rock on the edge of the stream between the ducks and geese) *"raqim-i Habib Allah"*, in a manuscript of Farid al-Din 'Attar's *Mantiq al-Tair*, copied by the calligrapher Sultan 'Ali al-Mashhadi in Herat in A.H. 891/A.D. 1486; The Metropolitan Museum of Art, 63.210.11r.

Published: Grube, E.J., "The Language of the Birds: the Seventeenth Century Miniatures" in *The Metropolitan Museum of Art Bulletin*, May 1967, fig. 4, colour; Swietochowski, M.L., "The Historical Background and Illustrative Character of the Metropolitan Museum's *Mantiq al-Tayr* of 1483" in *Islamic Art in the Metropolitan Museum of Art*, New York, 1972, pp. 43–72, fig. 3; *The Metropolitan Museum of Art Bulletin*, Fall, 1978, frontispiece, colour.

Four of the eight illustrations in this manuscript are contemporary with the colophon date, while the other four were added by the order of Shah 'Abbas, who had the manuscript refurbished with new margins of different coloured gold-flecked paper and new illumination for the double-page frontispiece. In 1609 he donated the manuscript to the family shrine in Ardabil. This is one of only two manuscripts known to have an illustration signed by Habib Allah.

The "Assembly of the Birds" is certainly the finest of the four added miniatures. That it is not in the "current" Isfahan style is evident, but to say that it was deliberately painted in the Timurid style is misleading, even with the removal of the obviously Safavid hunter with his gun of a type only introduced at the end of the sixteenth century.[25] The treatment and colouring of the rocks, full of animated faces, is close to the Safavid court style, as exemplified by several paintings in the *Shah-nama* of Shah Tahmasp. In a specific instance, the tree in this painting is far closer to Riza's tree in the painting "Faridun spurns the ambassador from Salm and Tur" in the 1587–97 *Shah-nama* made for Shah 'Abbas than it is to Timurid trees.[26]

In questioning whether any of the other later paintings in the *Mantiq al-Tair* could also be the work of Habib Allah, the answer would seem to be "no" in the case of "Shaikh San'an and the Dying Christian Maiden". The landscape elements, for example, with the heavily outlined, mottled rocks, the heavily outlined tree-trunk and stiff leaf patterns are very different from the soft shading of rocks and delicate outlines of the signed painting. This, the most typically Isfahani of the four later paintings, is not very adept in composition, with the attendant figures in pairs standing stiffly in a landscape they overwhelm by their scale.

As to the other two later paintings, the mixture of seemingly Timurid elements with some figures in Isfahani style could well be the result of the later artist or artists having to work within a Timurid framework already mapped out in unfinished pictures, rather than any deliberate attempt to archaize. An attribution to a particular artist must await further study.[27]

H16. *A Pastoral Scene where Melons are Weighed and a Pair of Oxen are Ploughing*

Signed *"Habib Allah"*,[28] fol. 1v. in a manuscript of the *Timur-nama* of Hatifi, copied by Pir 'Ali al-Jami in the early
16th century, with the three added miniatures attributed to Isfahan, ca. 1600, ms.: 28 x 17 cm.
Published: Sotheby's Sales Catalogue, 17 December 1969, lot 284, fol. 18v only illustrated.

In the Sales Catalogue we read: "The right half of the frontispiece is a reversed version of a miniature on folio 49 of a manuscript of Farid al-Din Attar's *Mantiq al-Tayr* now in The Metropolitan Museum of Art, New York…" It must be predicated that the *Timur-nama* paintings were added to the manuscript after Habib Allah had added his illustration to the *Mantiq al-Tair*. The ploughing scene, the melon-weighing and the lohan figure, separately or together, became a popular subject, as, for example, Muhammadi's celebrated drawing in the Musée Guimet,[29] which may well have inspired Habib Allah to copy this particular composition.

<p style="text-align:center">✳ ✳ ✳ ✳ ✳ ✳ ✳</p>

In conclusion, Habib Allah was an artist of considerable talent, a traditionalist rather than an innovator. He was a superb draughtsman, a master of fine line and equally fine brushwork as well as a sensitive colourist. There are few facts known about his life other than the meagre information provided by Qazi Ahmad: that he was from Sava, that he lived in Qum, that the governor of that city, Husain Khan Shamlu, took the painter with him to Herat when he was appointed governor of that city, that Shah 'Abbas took him from the Khan, and that, at the time Qazi Ahmad wrote this edition of his chronicle (1606), Habib Allah was working at the court in Isfahan. That he made a pilgrimage to Mashhad at some point may also be postulated.

None of his signed work is dated, but stylistically Habib Allah was a man of his time, working in the transitional period between the predominance of the Qazvin court style, which evolved from the Tabriz court style, and the new style of Isfahan fashioned under the influence of Riza-yi 'Abbasi. Habib Allah's style would seem to have been formed by the younger generation of Shah Tahmasp's artists, particularly Mirza 'Ali, and later, probably in Herat, he was influenced by Muhammadi's work, and finally by Riza's. There is no evidence of a Timurid revival in Habib Allah's work, nor is there any evidence that Shah 'Abbas ever dictated an artist's style. Habib Allah's work is free of the mannerisms of the Ibrahim Mirza circle, and, perhaps due to his absence from court, seems to adhere to the aesthetic of a slightly earlier tradition than that of Shah 'Abbas's court at Qazvin, until he, too, was seduced by the style of Riza. His work was, in my opinion, never provincial and equal in quality to the best of his peers. He deserves further study.

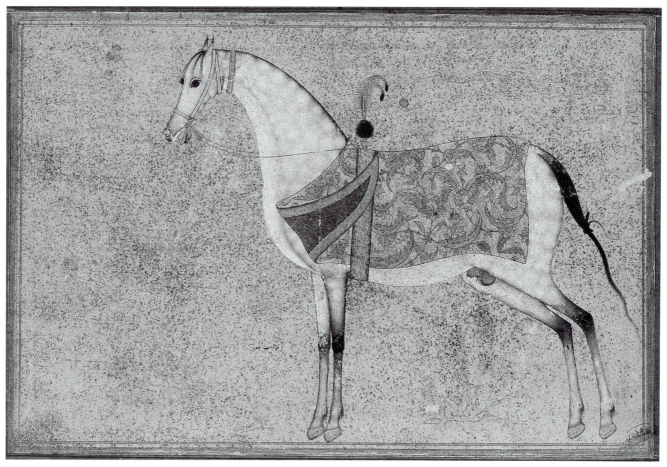

I. A STALLION

The Metropolitan Museum of Art, New York. 1992.51 (H14)

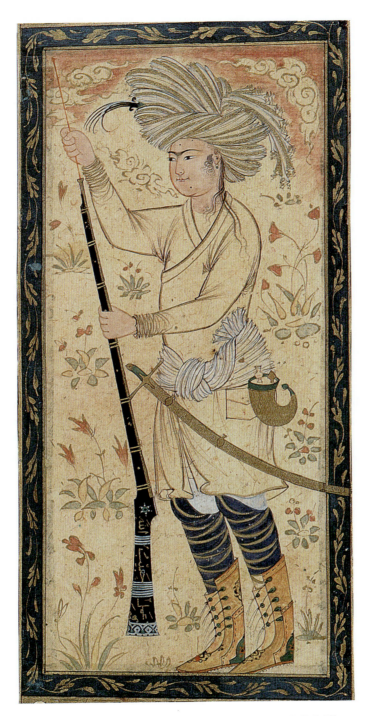

2. YOUNG HUNTSMAN LOADING A MATCHLOCK
Topkapi Saray Museum Library, Istanbul, H. 2165, fol. 54b. (H2)

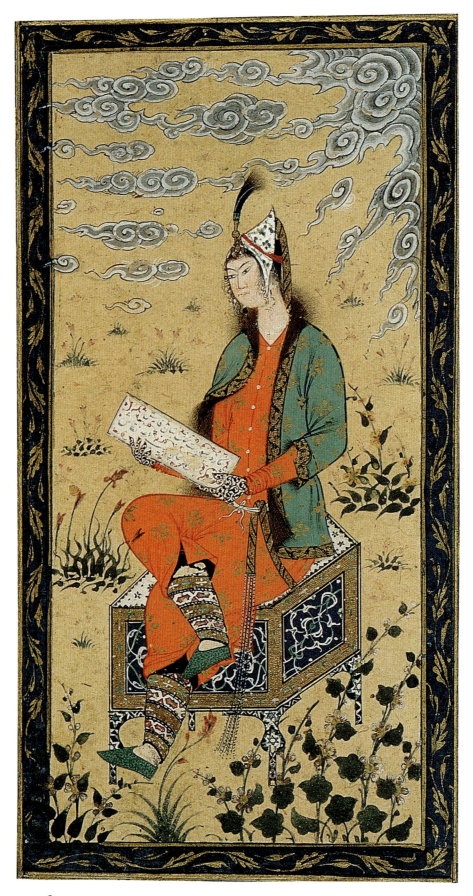

3. A SEATED LADY IN AN ORANGE DRESS AND GREEN MANTLE
Topkapi Saray Museum Library, Istanbul, H. 2165, fol. 54v. (H3)

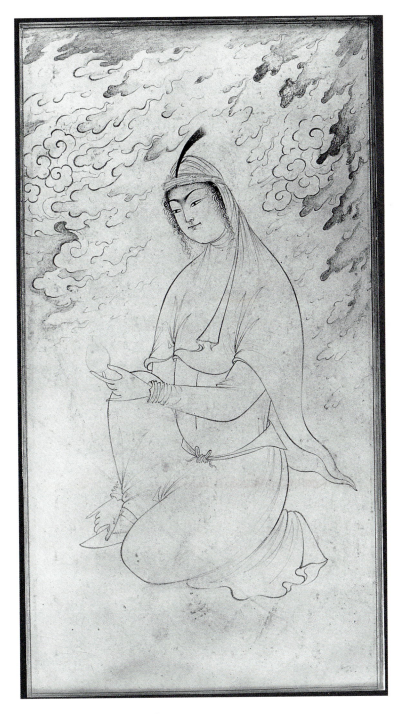

4. A SEATED LADY
Private Collection, London (H4)

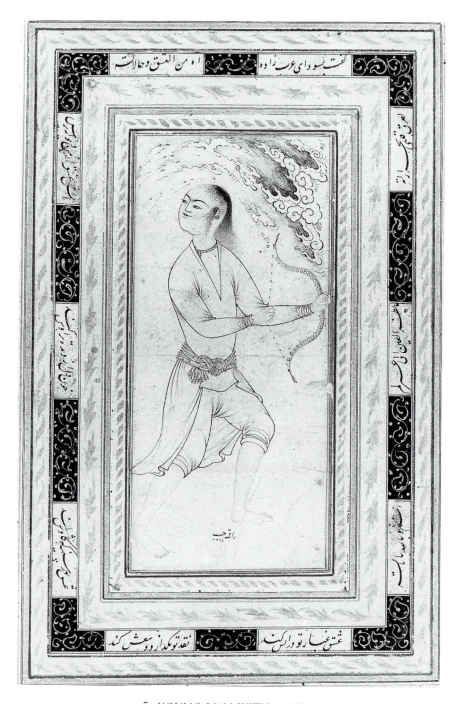

5. YOUNG MAN WITH A BOW
Art and History Trust Collection, courtesy of the Arthur M. Sackler Gallery, Smithsonian
Institution, Washington, D.C.

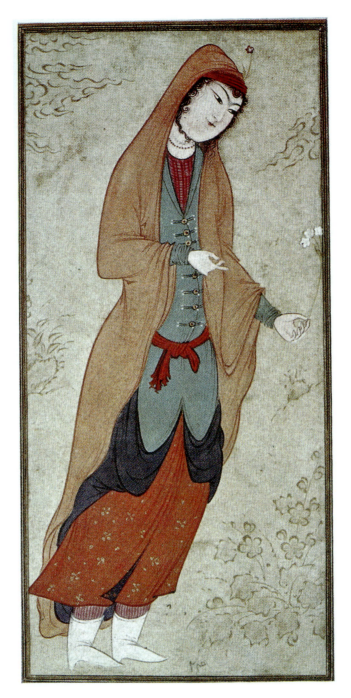

6. A YOUNG LADY HOLDING A SPRIG OF WHITE FLOWERS
The Hans P. Kraus Collection, New York (H7)

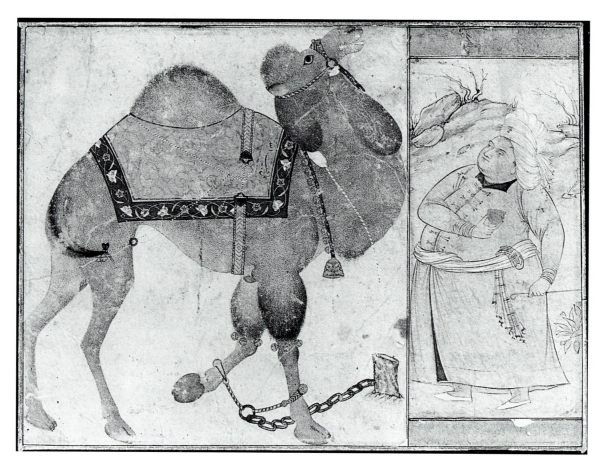

7. A CHAINED DROMEDARY
The Medelhavsmuseet, Stockholm (H12)

Notes

1 Of the two historians who have worked the most on Habib Allah see Anthony Welch, "Painting and Patronage under Shah 'Abbas I" in *Iranian Studies*, vol. VII, 1974, pp. 458–507 and in *Artists for the Shah*, New Haven and London 1976 (hereafter Welch, *Artists*), and Barbara Schmitz, *Painting in Herat*, a doctoral dissertation completed at the Institute of Fine Arts of New York University in 1984. Habib Allah is not the main focus of Welch's study, while Schmitz has studied the artist in considerable depth. For example, she discusses a *Shah-nama* manuscript now in Teheran, apparently made in the *Dar al-Saltanat* in Herat in April 1600, and she attributes 25 illustrations to the style of Habib Allah, pp. 331–333. The manuscript is unpublished and the illustrations are not clear enough for me to take a position on this subject, although I have the greatest respect for Dr. Schmitz' scholarship. She also attributes to this artist two paintings of bear cubs and a leopard with cubs, in a ms. of the *Nuzhat-nama-i 'Ala'i*, copied in Qum and dated 17 Rajab 1007/13 February 1599, now in the Chester Beatty Library, ms. no. P.255, not illustrated. See Schmitz, pp. 160–161.

2 Minorsky, V., trans., *Calligraphers and Painters, a Treatise by Qadi Ahmad, son of Mir Munshi (circa A.H. 1015/A.D. 1606)*, Washington, D.C., 1959, p. 191; on pp. 36–37 Minorsky explains that *H* refers to a ms. in the Nawab Salar Jung Bahadur Library in Hyderabad which is a later version of the text remodelled by the author. Instead of being dated to 1005/1596 (with the last event quoted in 1003/1594), as are other manuscripts of the text, this edition refers to events as late as 1015/1606.

3 *Ibid.*, pp. 29–30.

4 Eskandar Beg Monshi, *History of Shah 'Abbas the Great (Tarik-e 'Alamara-ye 'Abbasi)*, translated by Roger Savory; Persian Heritage Series, no. 28, Boulder, Colorado, p. 614; while Iskandar Beg entered the Shah's secretariat in 1001/1592–93 (p. 628), he never mentions the artist Habib Allah, either in Herat or in Isfahan. The first two books of his history were completed in 1616, and the third in 1629 (p. xxiv).

5 *Ibid.*, pp. 362–363, 368.

6 *Ibid.*, pp. 365–366, 372, 375.

7 *Ibid.*, pp. 425, 427, 435–437.

8 *Ibid.*, pp. 483–486, for murder of Hamza Mirza; pp. 502–514, for 'Abbas Mirza's accession to the throne; pp. 557–560, for fall of Herat and death of 'Aliquli Khan; p. 712 for the quotation about Husain Khan Shamlu.

9 *Ibid.*, pp. 760–764. Unfortunately Iskandar Beg Munshi does not confirm that Husain Khan Shamlu was among the royal troops that repossessed Herat, but it seems inconceivable that he was not, given his military record, experience of Khurasan, and trusted position with the Shah. However, whether he took up his new duties immediately, sending for his retainers from Qum, whether he returned to wind up his affairs and returned to Herat with his entourage, or whether Habib Allah had accompanied him during the campaign remains a matter of speculation, as must the exact date of Habib Allah's arrival in Khurasan. We do know that Shah 'Abbas spent several days on the battlefield taking an inventory and settling claims, and several more seeing to administrative matters in Herat, before going off to Mashhad for a month, where he involved himself in the affairs of the shrine of the Imam Riza.

10 *Ibid.*, p. 826.

11 *Ibid.*, p. 947.

12 *Ibid.*, p. 1163. It has seemed necessary to put events in order here, as well as the relationship between Habib Allah's patrons, Husain Khan Shamlu and Shah 'Abbas, because of the misunderstanding caused by A. Welch's mistakenly mixing up 'Aliquli Khan's father, Sultan Husain Khan Shamlu, and his son, Husain Khan Shamlu, Governor of Qum and Herat (see Schmitz, footnote 12). Therefore Habib Allah was not "in the service of one of the great qizilbash lords" in 1576, as Welch states, a year when Husain Khan Shamlu could have been only six years old at the most. Also Welch mistakenly has 'Abbas Mirza being carried off to Mashhad by Murshidquli Khan "apparently with Habibullah in tow" in 1581 instead of 1584, when Habib Allah was living in Qum. See Welch, A., "Painting and Patronage Under Shah 'Abbas I", pp. 482–483, and *Artists*, pp. 66, 173, 179, 190.

13 Soudavar, Abolola, *Art of the Persian Courts*, New York, 1992, p. 227.

14 Stchoukine, Ivan, *Les Peintures des Manuscrits de Shah 'Abbas Ier à la Fin des Safavis*, Paris, 1964, p. 47.

15 Sakisian, p. 142, is the first scholar to mention the two paintings in the Topkapi Saray Library. Stchoukine cites Sakisian, see note 13. See also Welch, A., "Painting and Patronage under Shah 'Abbas", footnote 61. Since this footnote refers to the man loading the musket and Welch makes no mention of the "princess", I am not sure whether or not she is mounted on the same folio. However, since they are mounted identically the assumption is that they are. I am very grateful to Filiz Çağman for sending me slides of these two paintings. It is odd that the sword of the huntsman goes over the blue margin, and one wonders if the tip was not cut off in the mounting and repainted. The figure seems a little too large for the space into which he is now fitted.

16 Robinson, B.W., "Muhammadi and the Khurasan Style" in *Iran*, XXX, 1992, no. M30.

17 *Ibid.*, M5, ill. in colour in Robinson, B.W., *Persian Paintings in the India Office Library*, London, 1976, pl.V.

18 Stchoukine, *op. cit.*, p. 47.

19 I am grateful to Michael Berry for bringing this picture to my attention as well as the Freer camel, and for giving me the catalogue reference. I am grateful to Karin Ådahl for sending me a photograph of the dromedary and for permission to publish it. Stchoukine, *op. cit.*, p. 47, says that Kühnel, in *Arbeiten des Reza*, p. 130, mentions a signed painting of a chained camel in the Museum of Stockholm. For the Freer camel, see Sakisian, *op. cit.*, pl. XLIX (top).

20 For the camel fight see Swietochowski, M.L., and Babaie, S., *Persian Drawings in The Metropolitan Museum of Art*, New York, 1989, no. 18, with reference to other camel pictures.

21 Sakisian, *op. cit.*, pl.XCVIII.

22 Atil, Esin, *The Brush of the Masters*, Washington, D.C., 1978, no. 16A.

23 The miniature is attributed tentatively to Shiraz, ca. 1590, on the basis of Stchoukine's remarking on a large hunt at Shiraz in 1590 in which Shah 'Abbas took part; see Stchoukine, *op. cit.*, p. 135–136. However, since there are many references to Shah 'Abbas hunting in many parts of the realm, undue weight should not be given to this particular hunt.

24 Dickson, M.B., and Welch, S.C., *The Houghton Shah-Nama*, Cambridge, Mass. and London, 1981, I, pl.16, and p. 140.

25 Grube, E.J., "The Language of the Birds: The Seventeenth Century Miniatures", in *The Metropolitan Museum of Art Bulletin*, May 1967, p. 344; Welch, *Artists*, p. 184.

26 Dickson and Welch, *op. cit.*, I, pls.6,13,14,16, for Shah Tahmasp's *Shah-nama*; Welch, *Artists*, p. 184.

27 See H15 under "Published" for illustrations of these paintings.

28 Barbara Schmitz, *op. cit.*, p. 162, gives the information that the painting was signed "Habib Allah"; in Chapter IV, footnote 8, she states that the signature appears on a rock in the centre of the composition and that Toby Falk told her of the signature, which even at that time was very faint; from this we do not know whether the name stood alone or with "signed by".

29 For notes on this and where it is illustrated see Robinson, "Muhammadi", *op. cit*, M2.

Worldly and Otherworldly Love in Safavi Painting

ANTHONY WELCH

My heart, sad hermit, stains the cloister floor
With drops of blood, the sweat of anguish dire;
Ah, wash me clean, and o'er my body pour
Love's generous wine! The Worshippers of fire
Have bowed them down and magnified my name,
For in my heart there burns a living flame,
Transpiercing Death's impenetrable door.[1]

HAFIZ

Pictures of listless beautiful people abound in later Safavi paint-ing (pl.1),[2] a visible shift from earlier heroic and literary ideals of Iranian painting. These graceful dandies make smaller claims on hero-ism than their predecessors: they embark on no adventures, exter-minate no dragons, achieve no notable exploits. Quietly self-centred and deliberately content, they exist in stillness, and action is beyond or beneath them. Not only are they a different type, they also exist in a different visual environment, for they do not illustrate manuscripts, and they belong to the art of the precious album (*muraqqa'*) rather than the art of the precious text. Unlike con-temporary paintings and drawings that bear the names of those por-trayed, they do not seem to show real individuals but rather to represent ideal types lifted in isolation from earlier paintings of more populated court entertainments or love stories of individuals like Layla and Majnun, Zulaykha and Yusuf, and Shaykh San'an. Their very abundance is puzzling, since they are not identified as partic-ular individuals, since they do not function as part of a literary work, and since they do not belong to the category of naturalistic genre pictures that are also plentiful in this period. Past art-historical schol-arship, including my own, has associated them with the alleged over-

refinement and effete sophistication of the later Safavi period after the death of Shah Tahmasp in 1576, but this categorization is based on little more than the taste of the writers using these terms. At first glance these pictures appear to be secular images, created for the delectation of connoisseurs, but many of them are accom-panied by inscriptions that suggest other definitions.

A turbaned young man sits with his arms crossed and looks towards a spot slightly in front of his left foot (pl.2). His cloth-ing suggests that he is well-off. The work of a lesser associate of the Safavi artist Riza, the drawing should date to about 1620. Four lines of poetry border the picture:

In the king's cup your moon-like face
Gives to the sun of victory a new ascent.
All that Iskandar desired and the world did not give him
Is one sip of the pure wine of your life-enhancing cup.[3]

While the verses may have been appended to the drawing at a later time, as the careful indentation for the youth's big toe may indicate, their meaning suggests that they were regarded as adding something other than calligraphic association. The "moon-like face" inspires the sunrise: therefore, it is presumably love that moves the cosmos. Though Iskandar's search for the water of life was bitterly unsuccessful, the immortality he sought can be found in a single sip from the beloved's cup. One of the most poignant sym-bols of the searcher for enlightenment, Iskandar is linked here with the beloved's cup, its wine, and by implication the Cup of Jamshid. The youth in the picture therefore suggests not only the person admired by the poet but is also an intimation of the divine.

These are standard verities and frequent metaphors in Iranian poetry, and, even if the image is not illustration in a traditional sense, it does serve as a visual complement to the verse.

Datable to about 1595 and also bearing Riza's name, another drawing shows a round-faced young woman, left hand at the waist and right hand holding a chain of beads (pl.3).[4] It is bordered by mystical verses:

> O beloved, concerning the desires of the soul and the universe:
> The universe is visible, but the soul is hidden.
>
> I have learned from you, and I speak to you
> Who are the best of the enlightened ones.
>
> Of this mystery I know but one aspect,
> But all the aspects of which I speak precede the existing world.
>
> Your munificence has overwhelmed the humble ones;
> Through your magnificence the beggar has become honourable.
>
> He was enlightened by the splendour of the light of your face
> And was renowned because of the perfection of your qualities.
>
> Her cheek in her veil is mine.
> May each person tell her to raise the veil.

Bare-faced but pious, form visible but soul hidden, she is the visual "translation" of the poem, particularly its final verse, and represents the beloved who instructs the lover's soul in spiritual enlightenment.

Other images of this type have a more prosaic meaning. Here another young person (pl.4) sits under a wind-blown sky and gazes to the left. The couplet metaphorically alludes to the transience of youth and beauty and suggests that the drawing was intended to be offered as a precious gift:

> O you branch of spring, how nicely you sway.
> May the torment of time (and breeze) never upset you.[5]

This drawing of a seated princess bears the name of the Safavi artist Sadiqi and was done about 1575 (pl.5). Against a superb illuminated background is written a quatrain:

> No living being has ever found your favour disappointing;
> For he whom you accept enjoys nothing but good fortune.
> And any particle joined to your favour for even one instant
> Glows with a brightness greater than one thousand suns.[6]

The poem depends upon a double meaning long established in Iranian poetry: earthly beauty is an intimation of the immortal beauty of the divine. While the quatrain itself speaks almost solely of the divine and does not specifically mention an earthly beloved, the visual image presents, of course, only the earthly beloved. Thus the two elements — verbal and visual, immortal and mortal — complement each other and themselves establish the relationship between "two worlds" that is so common in Persian mystical poetry.

In another line drawing, done about 1590, a young man contemplates a portrait drawing of a young woman (pl.6).[7] Though he holds no wine vessel, she does. Twelve *bayts* on the sides of the page are from Jami's *Yusuf u Zulaykha* and specifically describe Yusuf's beauty and his father Ya'qub's great affection for him: the young man is evidently meant to depict that paragon of beauty and virtue. The drawing is, however, an album page and was not designed to be part of a manuscript of Jami's romance: instead, the story was so widely known and carried such potent associations in the Islamic world that the portrait in Yusuf's hands has to be of Zulaykha, holding a cup and flask of wine indicative of the passion that lifts her beyond herself.

There are many implicit representations of these separated lovers, and in a painting done about 1575 a young woman (pl.7) reads a small book: it seems reasonable to assume that it contains the words in the two panels at the left:[8]

> Although your lovely face is a garden of roses,
> The thorns of your sorrow are the sadness of my heart.
>
> Each day your beauty is a bazaar,
> Not just on market day.
>
> O, my Yusuf, name your own price.
> For all that I own, there is a buyer.
>
> We have not sinned, O saint!
> The price of a wicked heart is not high.
>
> What price is that of your beauty?
> Alas! The nightingale is caught in the snare!

Yearning for Yusuf, Zulaykha must be reading not only these verses describing her plight but also those in the smaller panel that add a poignant message of time's passing:

> Before me such a flower of beauty disappears;
> Hastening toward eternity, it disappears.
> Even today, full of anger, it disappears;
> So too my life, even it, disappears.

Although we are not privileged to see exactly what Zulaykha is reading, a number of drawings and paintings are more explicit. In figure 8 a young man reads a piece of fine calligraphy:[9]

I am near death from longing for you.
Approach from afar for a moment.

DRAWN BY RIZA

The content of the poem continues the basic message of love and identifies this youth as the one inspiring it. The signature is a complicated pun: the calligraphy is signed by Riza, who is thereby also implicitly identified as the maker of the image of the youth, the writer of the letter to the youth, and the one who is himself suffering from longing.

A similar pun with signature is found in a *circa* 1650 painting by one of Riza's principal students, Muhammad Qasim Musavvir (pl.9).[10] Indeed, the two works are so close in posture and pun that it is fair to assume that the student is faithfully emulating his master, as he did in other instances. This sumptuously dressed fashion plate holds a book of calligraphy that uses established mystical metaphors as a panegyric for the painting's owner:

He is (Allah).

May the world fulfil your wishes from three lips —
The lips of the beloved, the lips of a stream, and the lips of a cup.
May you remain in this world so long
That you pray on the grave of the firmament
— the humblest of your worshipful subjects, Muhammad Qasim
Musavvir.

The metaphor of the "three lips" is frequent in Iranian mystical poetry and equates the beauty of the beloved with the beauty of the garden stream and with the beauty of the wine cup; the pious invocation at the top of the page underscores the two levels of meaning: longing for the earthly beloved is an intimation of the soul yearning for God. The picture partially complements the words: we see the lips of the beloved, the stream, but not the cup.

Whether these figures are aimless or drinking or reading, such images of love should not be understood simply as admired physical specimens. They share with their poetry the qualities of elegant refinement around a traditional theme, one that abounds in different guises in Safavi art.

A young woman seems about to accept a cup of wine proffered by a young man in pl.10.[11] Whether in sufi poetry or in court poetry using sufi metaphors, the image implies the initiation into the search for *fana'* (annihilation of the self), for their mortal love is a distant reflection of the soul's yearning for God, most notably illustrated in Sultan Muhammad's celebrated tavern scene from the c. 1527 *Diwan* of Hafiz for Sam Mirza (pl.11),[12] where inebriation through wine, music, and dance are metaphors for the seeker's transcendence of self. A somewhat more veiled reference is found in a small drawing (pl.12),[13] datable to about 1635–40, that shows a hunter carrying a small gazelle he has killed. He is a simple man,

unlike the monarchs, officers, and youthful aristocrats who are more usually included in depictions of the hunt. Above and below the drawing are two lines of poetry, and their meaning expands and alters the picture's meaning:

When you shoot something with your arrow, look after your arrow.
Look how the poor victim gives up its soul.

The responsibility of the beloved for the wounded lover is a major theme of Iranian poetry, often represented by images of two young lovers, but presented here in terms of the hunt.

An early seventeenth-century steel mirror (pl.13)[14] bears an inlaid gold quatrain:

Tell the mirror-maker: "Don't bother polishing it!"
The mirror will become unclouded when you look in it.
You have loaned your face to the mirror.
How else could it show your visage?

As God unclouds the understanding of mystics who search for the divine, the beloved's face clears the mirror, and this message is paralleled in one of Riza's latter paintings, where a woman looks in a mirror while she leans on a pillow figured with the lively image of a devoted lover who is pouring wine (pl.14).[15]

Numerous paintings and drawings of *darvishes* and hermits also occur in sixteenth- and seventeenth-century art for the Ottomans, Safavis, and Mughals, as this image of a humble *darvish* carrying an appropriately simple *kashkul* (beggar's bowl) over his shoulder and behind his left arm demonstrates (pl.15).[16] These works reflect not only patrons' taste but also a broader social interest that brought *darvish* paraphernalia into aristocratic circles, sometimes also in the form of elegantly crafted and eleborately inscribed *kashkul*s.

An aristocratic penchant for mystical imagery, whether sincerely felt or merely so much rhetorical gloss, not only explains the preponderance of images of youthful, idyllically handsome people but also offers an explanation for the large number of *darvish* images in later Safavi painting. This infusion of sufi image and metaphor into court life makes possible an explication of the next picture, which does not have an accompanying inscription (pl.16).[17] A well-turned-out young man gazes listlessly to the left. At his feet are three pomegranates, and we should remember that a pomegranate tree grew from the axe with which the hapless but devoted Farhad killed himself when he heard of his beloved Shirin's death. This reference to a lover's devotion is strengthened by the curious object which the young man holds in his left hand. It is a cotton or paper cylinder, burning at one end, with which the youth has inflicted two wounds on his right forearm (such a burn mark was known as a *dagh*, and the process of making such burns was called *dagh kardan* or *dagh sokhtan*). What might seem at first glance to be masochism is, in fact, a widespread practice with important social and religious impli-

cations made more intelligible by other comparisons.

The pious *darvish* in pl.17[18] has a *kashkul* and other belongings identifying him as a sufi. 'Ali's name is written across his chest, his arms are scarred by wounds presumably inflicted during Muharram in memory of the Shi'ite martyrs, and his arms show numerous healed and fresh burns, too regularly and ostentatiously distributed to be the marks of disease.[19] After their recapture runaway slaves were also marked with a brand (*dagh-i ghulami*).

Thus the youth in pl.17 is identifying himself through these "love-burns" as one who is *dagh del* (love-sick) and a slave to love. Like many of his contemporaries in Safavi Iran he has appropriated sufi practice to demonstrate his part in the interplay of worldly and otherwordly love. Being consumed in or by the fire of love so that one becomes a *fani* (someone who has achieved annihilation) has other important manifestations in Iranian poetry, such as the metaphor of the moth drawn ineluctably to the fire that will destroy it; this is often found on inscribed candlesticks.[20]

The meaning behind this custom among the aristocracy becomes more evident in a 1056/1646 painting by Afdal al-Husayni (pl.18).[21] Both man and woman are consummate examples of ideal moon-faced Safavi beauty. They are also sumptuously dressed, and there are other signs of their loving activity besides their looks: a jug and cup of wine rest near his feet, and his right arm lies on a cushion that – like the cushion in pl.14 – is decorated with love, in this case two courting birds (in sufi poetry, whether the *Diwan* of Hafiz or the *Mantiq al-Tayr* of Farid al-Din 'Attar, birds are frequently metaphors for the human soul, yearning to be free of the snares of this world). In her left hand the young woman holds a cloth cylinder, its burning end turned for the moment away from the young man's arm that bears three blackened *dagh* marks. The two lovers are singularly impassive and seem to be beyond any emotional response. In his memoirs the Iranian diplomat Ulugh Bek, who accompanied Anthony Sherley's 1599–1604 embassy from Isfahan to Spain and who deserted his diplomatic mission, became a Roman Catholic, took the name Don Juan of Persia, and remained in Spain, describes this custom for his European readers:

> A Persian youth who wishes to pose as a faithful lover must behave in a very extraordinary way; indeed, so strangely that it were impossible for its very extravagance to pass the matter over in silence. The lover who would prove that his love is sincere must painfully burn himself in various parts of his person with a slow match made of linen stuff, that in effect acts exactly like the caustic which, with us in Spain, the surgeons apply for opening issues such as may be needful in the legs and arms. Then the lover displays himself in the sight of his lady, he being a very Lazarus for the number of his sores: whereupon she will send him cloths, napkins and bandages of silk or

holland, with which to bind his wounds, and those he wears until they are cured. Later, he who can show most signs of these cauteries is the one most beloved of the fair dames, and most promptly will come to matrimony.[22]

Another traveller, a young Venetian named Ambrosio Bembo (1651–1705), spent a number of weeks in the summer of 1674 in the Safavi capital of Isfahan, and also remarked on this custom:

> They say that some young men send verses to the women they love. As a sign of love, they say they are wounded, and they receive from their ladies cloths to heal the wounds.[23]

Thus these Safavi images of young and beautiful people partake of a visual context and a metaphoric content that would have been as obvious to viewers as was the language of contemporary Iranian poetry. Whether expressed in verbal or visual terms, sufi love imagery is ubiquitous in Safavi culture. Some of these images may be allegories at some distance, and some of them seem to be "rote" metaphors, frequent, repetitive, and expected. They are unified by the mystical or quasi-mystical allegories of love, suffering and yearning for the beloved that abound in Iranian poetry. While there is no evidence that they served overtly iconic purposes, or instructed the faithful in doctrine, or inspired piety and reverence for prophets and saints, they did refer to a more general mystical religious theme that was of central importance in Safavi Iran.[24]

It is clear from the fact that some of these pictures bear royal seals that they were part of visual culture at the highest levels of society, where presumably these depictions of evanescent youths were tacitly understood as connected with sufi allegory. They may also have been regarded as objects for contemplation in their own right: through their aesthetic power the observer might even achieve a kind of transcendence, like Zulaykha consumed by Yusuf's beauty or like Yusuf enthralled by a picture of Zulaykha (pl.6). The goal of *fana'* could, after all, be approached by many paths, and, appropriately, images of beautiful youths often contain explicit reference not only to the *darvish* life and to love, but also to wine and music (pl.19).[25]

That the *dagh*/love burn and the *kashkul* were appropriated from *darvishes* shows that it was not only the visual ideal of beautiful youth that had appeal, and there are other instances indicating that the *darvish* life was a powerful image among the aristocracy, as the long poem, *Shah u Darvish*, by Hilali (d. 935/1528–29) demonstrates and as do the numerous Safavi pictures of rulers conversing with *darvishes* and hermits. The sufi orders had been one of the most important sources of support for the Safavi regime, which owed its origins to the loyalties that Shaykh Safi al-Din (650–735/

1252–1334) had inspired in and around Ardabil. The sufi underpinning of the Safavi ascent to power found one of its most powerful expressions in the well-known mystical-political poetry of Shah Isma'il I (r. 907–930/1501–1524). But during the reign of Shah Tahmasp (930–984/1524–1576) this militant sufism became suspect and was viewed as a threat to established order and bureaucracy, so that many of the most extreme orders were savagely suppressed. Likewise, Shah 'Abbas I (996–1038/1588–1629) rejected this earlier power base in favour of regular armed forces drawn from other groups. Therefore the *darvish*es whom we see in these pictures do not represent the fanatic devotees of Shah Isma'il's time but instead are the milder, more self-centred believers whose search eschews politics and is entirely inward. It was a traditional

Shi'ite teaching that an aspirant should strive for personal sanctity through imitation of the lives of saints and martyrs. Thus these images imply a social relationship of great importance and can be seen as a statement of adherence to a religious ideal, even if it is a little vague and attentuated: they supply visual documentation that some well-dressed and well-fed Safavi aristocrats considered themselves or wished to be seen as "sufis at heart" who through artefacts, stigmata, poetry, and pictures sought to emulate the examples set for them by saints and *darvish*es. Though these distantly sufi images, midway between entertainment and instruction, were not intended to be iconic or devotional or even blatantly didactic, they were consciously allegorical and could serve as oblique reminders of the ideal.

1. Harvard University Art Museums, Alpheus Hyatt Fund, 1952.7.

2. Collection of Prince Sadruddin Aga Khan, Ir. M. 81.

3. Museum of Fine Arts, Boston, 14.614.

4. Collection of Prince Sadruddin Aga Khan.

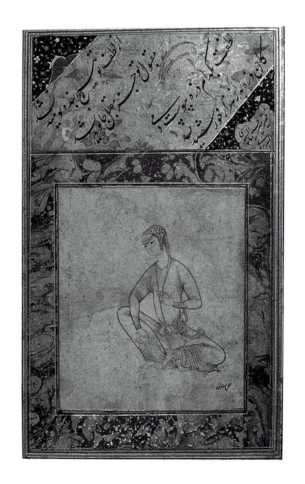

5. Collection of Prince
Sadruddin Aga Khan,
M. 193.

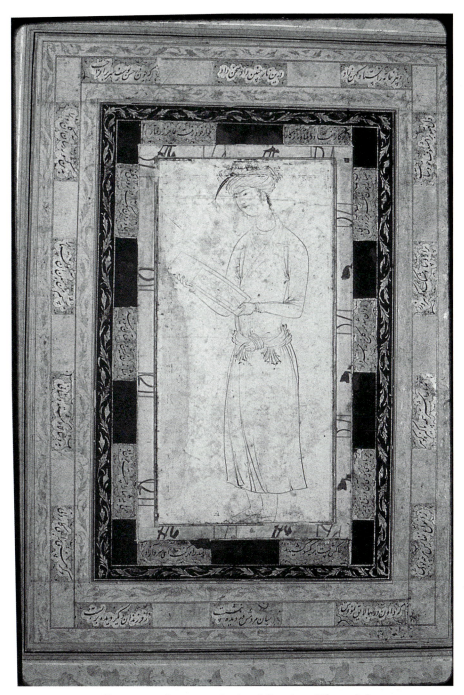

6. Collection of Prince Sadruddin Aga Khan, M. 109.

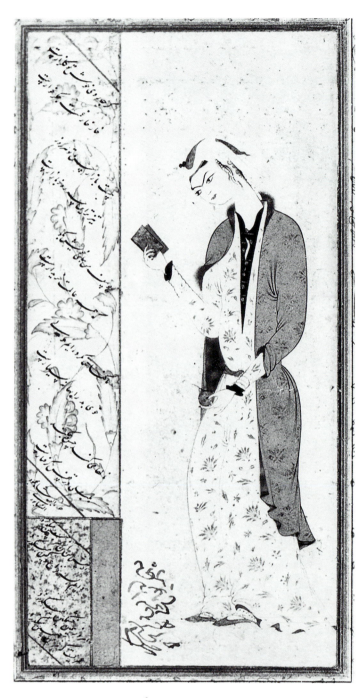

7. Museums of Fine Arts, Boston, 14.495.

8. Istanbul University Library.

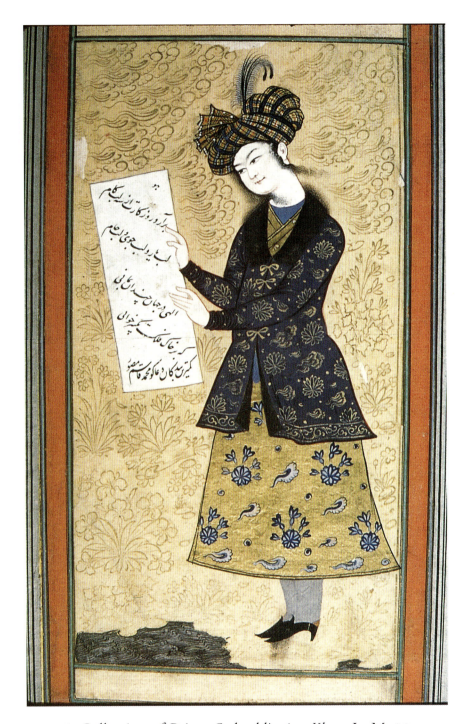

9. Collection of Prince Sadruddin Aga Khan, Ir. M. 91.

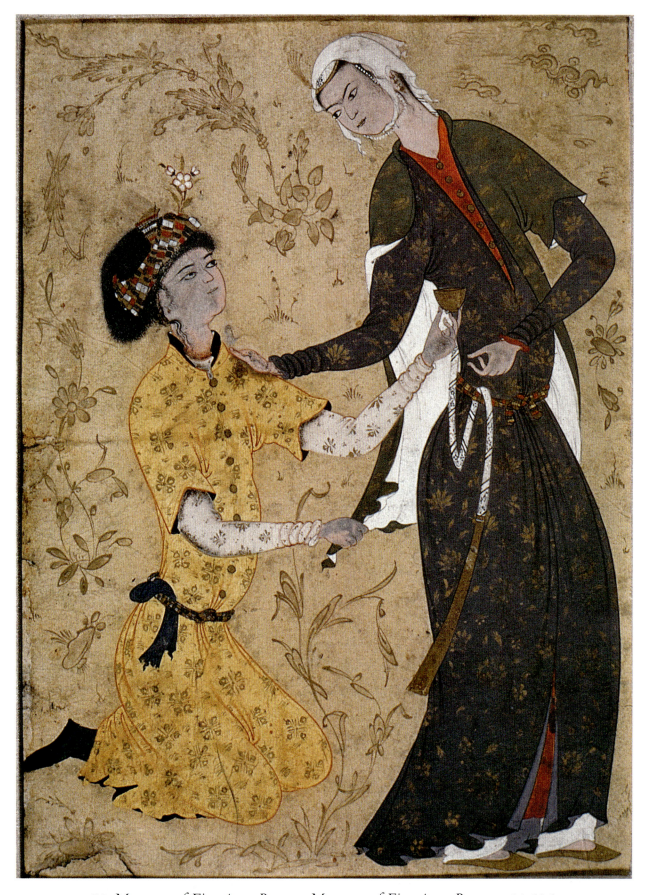

10. Museum of Fine Arts, Boston, Museum of Fine Arts, Boston, 14.595.

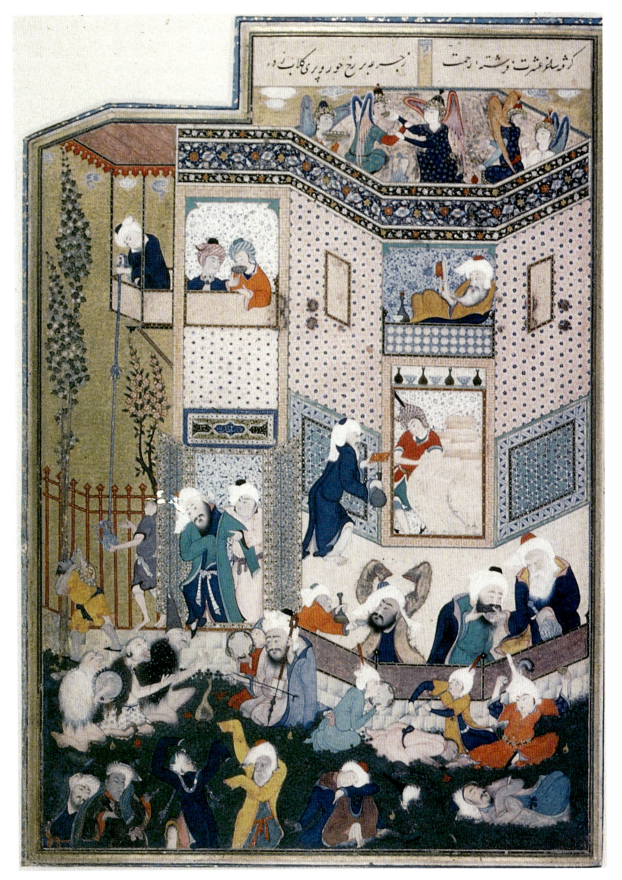

11. Private Collection.

نظاره جانی در جوین سکری کنی

12. Collections of Prince Sadruddin Aga
Khan, Ir. M. 77.

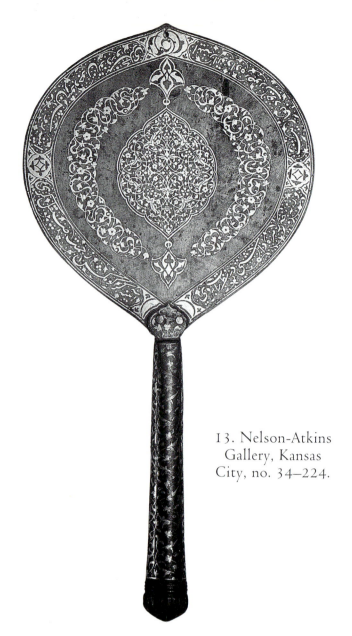

13. Nelson-Atkins
Gallery, Kansas
City, no. 34–224.

14. Institute of
Art, Detroit,
44.274.

15. Musée Guimet.

16. Private Collection.

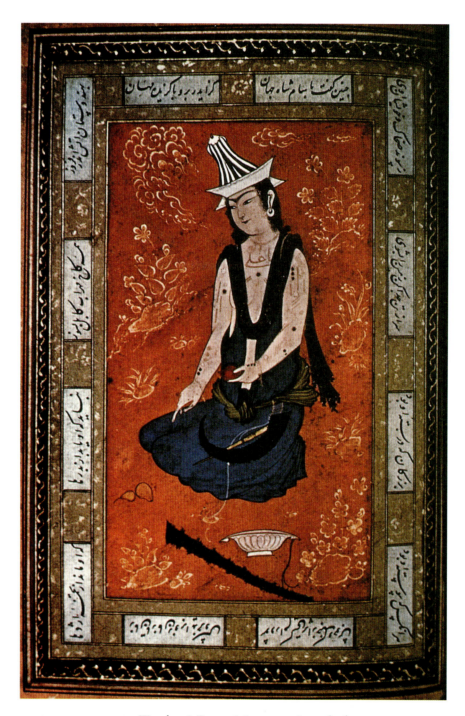

17. Topkapi Saray Museum, Istanbul.

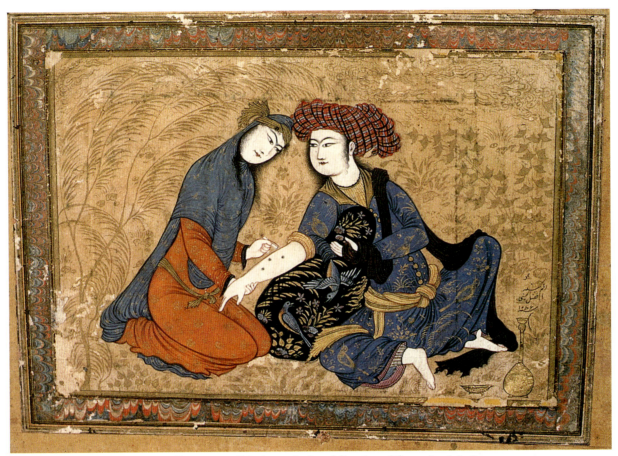

18. Collection of Prince Sadruddin Aga Khan, Ir. M. 89.

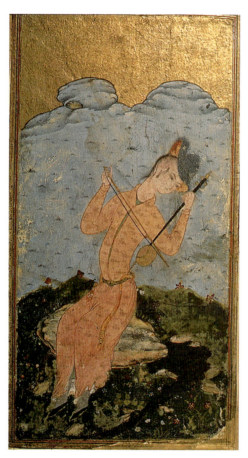

19. Collection of Prince Sadruddin
Aga Khan, Ir. M. 71.

Notes

Anyone investigating the history of Iranian painting owes much to B.W. Robinson for painstaking scholarship and indispensable publications over many years. But I particularly wish to express another kind of indebtedness to Robbie, a person of great warmth and kindness, whose hospitality, good humour, and unfailing generosity of spirit have been extended so often to so many of us. Thank you, Robbie.

1 *Poems from the Diwan of Hafiz,* transl. by Gertrude Lowthian Bell (Heinemann, London, 1897), Poem XIII, p. 82.

2 Harvard University Art Museums, Alpheus Hyatt Fund, 152.7. Published in A. Welch, *Shah 'Abbas and the Arts of Isfahan* (Asia Society, New York, 1973), p. 30, no. 7, and *idem, Artists for the Shah: Late Sixteenth Century Painting at the Imperial Court of Iran* (Yale University Press, New Haven and London, 1976), fig. 29 and attributed to Aqa Riza; and M.S. Simpson, *Arab and Persian Painting* (Fogg Art Museum, Harvard University, Cambridge, Mass., 1980), no. 30.

3 Collection of Prince Sadruddin Aga Khan. Published in A. Welch, *Collection of Islamic Art, Prince Sadruddin Aga Khan* (Geneva, 1978), vol. 3, Ir. M. 81, pp. 122-123. Translations are by the author, unless otherwise identified.

4 Museum of Fine Arts, Boston, 14.614, published in Ananda K. Coomaraswamy, *Les Miniatures Orientales de la Collection Goloubew au Museum of Fine Arts de Boston, Ars Asiatica,* vol. III (Paris and Brussels, 1929), No. 80, pl. XLVI; Eric Schroeder, *Persian Miniatures in the Fogg Museum of Art* (Harvard University Press, Cambridge, Mass., 1942), p. 124; Ernst J. Grube, *Muslim Miniature Painting* (Fondazione Giorgio Cini, Venice, 1962), no. 100; Ivan Stchoukine, *Les peintures des manuscrits de Shah 'Abbas I à la fin des Safavis* (Librairie Orientaliste Paul Geuthner, Paris, 1964), p. 106; A. Welch, *Shah 'Abbas,* No. 9, pp. 31 and 64. In the lower left is a later owner's seal ('Abdullah Abu Talib, 1154 [1741–42]).

5 Collection of Prince Sadruddin Aga Khan. Translation by Annemarie Schimmel (slightly modified), published in A. Welch and S.C. Welch, *Arts of the Islamic Book: The Collection of Prince Sadruddin Aga Khan* (Asia Society and Cornell University Press, Ithaca and London, 1982), pp. 105–107.

6 Collection of Prince Sadruddin Aga Khan.

Published in A. Welch, *Shah 'Abbas,* no. 1 and pp. 22 and 63, where the calligrapher, Mir Husayn al-Sahvi al-Tabrizi, and the painter, Sadiqi, are discussed; and *idem, Artists for the Shah,* fig. 18.

7 Collection of Prince Sadruddin Aga Khan. The figural artist may have collaborated with a calligrapher to create this album page for a patron particularly fond of Jami's tale.

8 Museum of Fine Arts, Boston, 14.595. Published in P.W. Schulz, *Die persisch-islamische Miniaturmalerei,* 2 vols. (Verlag von Karl W. Hiersemann, Leipzig, 1914), pl. 140; and Coomaraswamy, *op. cit.,* No. 46, pl. XXV, and pp. 33–34.

9 Istanbul University Library. Published in Stchoukine, *op. cit.,* pl. XXXVI.

10 Collection of Prince Sadruddin Aga Khan, Ir. M. 91. On the reverse are several *hadiths.* Published in Laurence Binyon, J.V.S. Wilkinson, and Basil Gray, *Persian Miniature Painting* (Oxford University Press [Humphrey Milford], London, 1933), no. 294; Phyllis Ackerman, *Guide to the Exhibition of Persian Art* (The Iranian Institute, New York, 1940), p. 240, no. 32; Anthony Welch, *Collection,* vol. 3, Ir. M. 91, pp. 148–152; *idem, Calligraphy in the Arts of the Muslim World* (University of Texas Press, Austin and London, 1979), no. 63, pp. 152–53; and A. Welch and S.C. Welch, *Arts of the Islamic Book,* no. 35, pp. 110–111. This wording may indicate that the owner was the painter's sovereign, Shah 'Abbas II (1642–1666).

11 Museum of Fine Arts, Boston, 14.595; attributed to Mirza 'Ali about 1575 and published in A. Welch, *Artists for the Shah,* fig. 19; Coomaraswamy, *op. cit.,* No. 47, p. 34 and pl.XXVI; Ernst Kühnel, *Die Miniaturmalerei im islamischen Orient* (Bruno Cassirer Verlag, Berlin, 1923), pl.67; F.R. Martin, *Miniature Painting and Painters of Persia, India, and Turkey,* two volumes (Bernard Quaritch, London, 1912), pl.140; and Schulz, *op. cit.,* pl.140.

12 Private collection. Published in S.C. Welch, *Persian Painting: Five Royal Safavid Manuscripts of the Sixteenth Century* (Braziller, New York, 1976), pl.18.

13 Collection of Prince Sadruddin Aga Khan, Ir. M. 77. Published in A. Welch, *Collection,* vol. III, No. Ir. M. 77, pp. 112–113.

14 Nelson-Atkins Gallery of Art, Kansas City,

Mo.; Nelson Fund. Published in A. Welch, *Shah 'Abbas,* No. 44, pp. 56 and 71.

15 Institute of Art, Detroit, No. 44.274.

16 Musée Guimet, Paris.

17 Private collection.

18 Topkapi Saray Museum. Published in Wilfrid Blunt, *Isfahan, Pearl of Persia,* (Elek, London, 1966), p. 66. Walter Andrews and Dana Bates have told me that the *dagh* is a common motif in Ottoman poetry.

19 This practice is also found in other drawings and paintings of the period where *darvishes* have burned their arms. See B.W. Robinson, *Miniatures persanes: Donation Pozzi* (Musée d'art et d'histoire, Geneva, 1974), no. 76, where a young and a middle-aged *darvish* sit at an outdoor meal: beside them are two pomegranates and a *kashkul,* and there are many identical burns on their arms and legs.

20 For an example of a Safavi candlestick inscribed with mystical love verses similar to those in these drawings and paintings, see A. Welch, *Shah 'Abbas,* no. 43, pp. 57 and 71.

21 Collection of Prince Sadruddin Aga Khan, Ir. M. 89. Published in A. Welch, *Collection,* vol. III, Ir. M. 89, and *idem* and S.C. Welch, *Arts of the Islamic Book,* No. 36 and pp. 112–114.

22 *Don Juan of Persia. A Shi'ah Catholic 1560–1604,* translated and edited with an introduction by Guy Le Strange (Broadway Travellers, New York and London, 1926), pp. 54–55.

23 From *The Travels and Journal of Ambrosio Bembo.* I have recently completed an English edition of this hitherto unpublished text for publication. In 1671, at the age of nineteen, Bembo left Venice on a journey that took him to Crete, Cyprus, Syria, Iraq, Iran, and India. He returned to Venice in 1675. His book is a major new source for seventeenth-century history.

24 For a discussion of more straightforward religious imagery in Iranian painting see Michael Rogers, "The Genesis of Safawid Religious Painting," *Iran,* VIII (1970), pp. 125–140.

25 Collection of Prince Sadruddin Aga Khan, Ir. M. 71. Attributed to Mirza 'Ali and published in A. Welch, *Collection,* vol. III, Ir. M. 71; Martin B. Dickson and Stuart Cary Welch, *The Houghton Shahnamah,* vol. 1, fig. 208; and A. Welch and S.C. Welch, *Arts of the Islamic Book,* No. 27B, pp. 24–28.

Two Eminences Observed:

A Drawing by Mirza-'Ali[1]

STUART CARY WELCH

NATURE AND ART OCCASIONALLY MEET UNEXPECTEDLY. One day a few months ago, while visiting friends near Boston, I entered their downstairs bathroom in response to a "call of nature." Turning right during this brief interruption to stimulating conversation, I sighted something not usually associated with the decor of W.C.s, a fine Safavi drawing [fig. 1].[2] "Mirza-'Ali!" thought I. Closer inspection confirmed this instant attribution. One by one, the great sixteenth-century master's characteristics of style flocked to mind and were found.

But before defending the attribution, we must remind the reader of Mirza-'Ali's background, artistic personality, and work.[3] He was the son of Sultan-Muhammad, who is usually ranked with Bihzad among Persian painters, and whom we have described as an "artist-saint". Mirza-'Ali was reared in Tabriz, capital of the connoisseurly second Safavi Shah Tahmasp (r. 1524–76). His nursery and playground were – in effect – the royal ateliers. Painting was in his blood, particularly as represented by the brilliant work of his father. One of the royal Safavi atelier's senior artists, Sultan-Muhammad was born and trained in the area of Herat, where he joined the royal Safavi studios early in the sixteenth century after being recruited during the eastern campaigns of Shah Isma'il I (r. 1502–1524), founder of the Safavi state. Brought by his new patron from Khurasan to Tabriz, he received access to the royal library, where he saw and was thrilled by the visionary art of the Aq-Qoyunlu Turkmans. These miniatures, drawings, and manuscript illustrations, many of which are now in the Library of the Topkapi Saray Museum, had been taken along with Tabriz itself by the enterprising young shah. If for Shah Isma'il, who was related to the Aq-Qoyunlu royal family, these vital pictures aflame with dragons, wild men, and other soul-stirring motifs, were familiar, they were a fresh revelation to the artist. Their Chinese-inspired cloudbands, gnarled trees, and rocks alive with grotesqueries caught his fancy, and changed his style.[4] Because his work in Turkmanish mode with its fervent spirit and vivid palette was precisely keyed to the taste and personality of the still young Shah Isma'il, Sultan-Muhammad served as his artistic amanuensis for more than two decades. For him he painted many of the most exciting pictures in Persian art.[5]

The founding Safavi Shah's tendencies to other-worldliness, expressed in heretical verse as well as in art patronage, eventually calmed, reflecting the stability born of his political and military successes. Gradually, the cultural ethos shifted from extremism towards orthodoxy. Documents were forged to support Safavi dynastic claims, protocol gained rigidity, and the rhythms, colouring, and mood of his pictures mellowed into harmony. His – and Sultan-Muhammad's – espousal of Turkman art adjusted to the subtle realism of later Timurid art in Herat, where the Shah's eldest son, Prince Tahmasp (b. 1514), grew up in the highly refined court until recently ruled by another great patron, Sultan Husayn Bayqara ("The Eagle") (r. 1469–1506). Prince Tahmasp's artistic tastes, therefore, were shaped by contacts with formerly Timurid poets, musicians, philosophers, and artists who remained in Herat after their patron's defeat and death. The precocious Prince Tahmasp met and admired Master Bihzad, who was every bit as gifted a painter as Sultan-Muhammad. When, in 1522, the calligraphy- and picture-loving prince returned to his father's court, Bihzad was put in charge of the Safavi academy of painting. Shortly thereafter, at the behest of both the shah and the crown prince, the visionary Turkman/Safavi mode of Tabriz blended with the earlier finesse of Timurid Herat.

Sultan-Muhammad, encouraged both by his patrons and by Master Bihzad – now an aged mentor rather than an active artist – painted a series of pictures in which the two strains met and merged. Timurid spatial logic, extreme fineness of brushwork, accuracy of human and animal proportion, and scrupulously observed psychological portraiture blended with the mystical style adapted by Sultan-Muhammad from his Aq-Qoyunlu forbears. A major and marvellous new artistic synthesis had been born.[6]

Mirza-'Ali was apprenticed to the Safavi ateliers during this period of artistic ferment. His earliest recognized pictures, painted for a great *Shahnama* initiated in the early 1520s for Shah Isma'il, exemplify the coming together of styles under the two great men usually ranked as Persia's supreme masters of painting. In these miniatures, little effort is required to identify and sort out the two stylistic flavours in the youthful Mirza-'Ali's ambitious, energetic, but somewhat unharmonious "visual fruitcakes". Just as candied lemons and cherries can be differentiated from pistachios and walnuts, so can the elements derived from his visionary father be separated from the restrained elegances borrowed from Bihzad.[7]

Already, however, Mirza-'Ali's personal style emerged from the amalgam. Although influenced by Master Bihzad's minutely detailed observations of the court and its myriad personalities, the more dashing portrayals by his father were not forgotten. To Bihzad's penetratingly balanced physiognomies he added Sultan-Muhammad's usually benevolent but rougher ones, brushed with a breadth of humour verging on caricature. Mirza-'Ali grouped these together in wry vignettes of court life, immediate as today's newspaper. Soon, they had become so accurate – and so comical – that the shah and his inner circle must have awaited them with slightly anxious amusement. The artist's sharp ear – and eye – for gossip and his "insider"'s awareness of court behaviour bring to mind such spirited students of the *haut monde* as the Duc de Saint-Simon, Marcel Proust, and Evelyn Waugh. His painted drawing-room comedies [he managed to avoid tragedies] provide the fullest record known to us of early Safavi society. No one more perceptively or gently characterized smug young bloods, effete dandies, or delicate littérateurs. Nor did any other artist take more pleasure in portraying every form of womankind. Mothers, nurses, scullery maids, crones and princesses – all are paraded before us in almost photographic detail. If Mirza-'Ali specialized in depicting the polished sophisticates of his own second Safavi generation, he also aimed his pricking reed pen and brushes at their elders. We sense his enjoyment in satirizing the pot-bellied old fogies of the *kizilbash* (or Redheads), cantankerous windbags whose bravery had enabled Shah Isma'il to defeat not only the Aq-Qoyunlu Turkmans but to take over Timurid Herat and to challenge the mighty Uzbeks. Occasionally, influenced by the roundness of form and carefully recorded folds of flesh and wrinkles known to him from European art, he portrayed Safavis with astonishing illusionism.[8] If Mirza-'Ali's horses, camels, cats, and dogs might be less animated than those painted by

his father and by Mir Sayyid-'Ali, who felt more at ease with them than with people, no one outshone him as the portrayer of children, from infancy through to adolescence.

Mirza-'Ali's earliest works already reveal his technical prowess, delightful awareness of human quirks, and inventiveness as composer, colourer, and deviser of arabesques. Moreover, his logical handling of space and mastery of sinuously calligraphic line equal his gift as court reporter. His pictures are the most explicit sources of information about everything from facades to balconies, fences, courtyards, gardens, carpets, costume, cooking pots, blue and white crockery, and food. His enthusiastically recorded still lifes of sweets concocted from clotted cream, sugar, and nuts are mouth-wateringly delicious.

In *The Houghton Shahnameh*, we have traced the development of this delightful artist's style and personality from precocious apprenticeship through decades of masterfulness, and on to the final period, when his vision was further enriched by the encouragement of a second patron, Shah Tahmasp's nephew, son-in-law, and boon companion, Sultan Ibrahim Mirza. This engaging young patron liberated elements of Mirza-'Ali's style and personality that had been constrained by Shah Tahmasp's increasing insistence upon strict behaviour. Following a series of upsettingly moralistic nightmares, the shah had renounced many of his former pleasures. Music, dance, hashish, and wine were banned. And with them went most painting and painters.[9] Also banished from court was the shah's closest companion, Sultan Ibrahim Mirza, a lover of art, music, polo, literature, and grand master of pleasurable follies. He was effectively exiled by being appointed governor of distant Mashhad, a post made somewhat pleasanter by his access to many of the now stern Shah's former court artists. One of these was Mirza-'Ali, who was now urged to concentrate upon life studies of the more eccentric denizens of Sultan Ibrahim's court.

Most of Mirza-'Ali's major miniatures of the later period are contained in The Freer Gallery of Art's copy of poems by Jami, created between 1556 and 1565 for Sultan Ibrahim Mirza.[10] Although the earliest of these pictures retains the sobriety of the artist's work for Shah Tahmasp, the mood soon changed. Landscapes, burgeoning with prancing trees framed by pastel-hued *glissando* rocks, nearly dance from the paper; and Mirza-'Ali's people begin to look odd, gaining or losing inordinate quantities of weight, becoming *very* tall or *very* short, and losing stability. Unlike the artist's earlier figures, whose anatomy is treated logically and clearly and whose feet are more solidly grounded than those by any other Safavi artist, those of his Mashhad, or mannerist, period stagger. Legs weaken, trunks attenuate and twist, necks become elongated cones, and fingers metamorphose into over-elegant spaghetti. Animals, too, undergo curious personality deformations. Horses develop madcap graces and fiery eyes: hares assume lion-hearted bravado. Trees, flowers, landscapes, and streams hark back to the churningly "baroque" forms known from the artist's ambitious "apprentice pieces" for the

Shahnama. But there are differences. Youthful, innocent ebullience has been replaced by somewhat world-weary amusement verging on frenzy.

Mirza-'Ali's drawing, *Two Eminences Observed*, returns us to normality. In it, two figures courteous as Ming Dynasty Chinese scholars are scanned from the horizon by a peeping youth [fig. 1]. He drew the two men, like most of the others in his pictures, in a conversational duet. One of the *causeurs*, at left, appears to listen, his head slightly bowed and his arms crossed at the wrists. He is respectful, humbling himself before his more active and talkative companion, who has a portfolio tucked into his robe and a vessel (containing something to drink or eat?) under his left elbow. He extends both arms entreatingly, as though beseeching a small favour. "Would you be so kind as to read this letter, or poem, or taste the delicious contents of this jar?" Both figures stand sturdily, just beyond a gently curving stream bordered by flowers and pleasing rocks, at least one of which appears to be smiling. The gesturing figure wears an immaculately tied turban of a sort unique to Mirza-'Ali. Resembling the shell of a tortoise in outline, it is tied around the Safavi baton, which might suggest that its wearer – unlike his

scholarly friend, with batonless headgear and long sleeves – belongs to the knightly wing of the court. A strong clue for our attribution is the right-hand figure's long, fox-clever face with pointed beard, one of Mirza-'Ali's stock characters.[11] The moon-faced young man observing them from behind a hillock, left, is another constant in the artist's work, identifiable in pictures from every phase of his career.

This drawing can be ascribed to ca. 1535–40, during Mirza-'Ali's mature period. The mood is formal, with few suggestions of the artist's mannerist phase, when Sultan Ibrahim Mirza encouraged him to avoid dreary middle-aged intellectuals in favour of over-elegant "cut-ups". Everyone in the drawing exudes the dignified respectability of Shah Tahmasp's court after the royal nightmares. Details of setting confirm our dating. Overhead, clouds knot and unknot, like dragons in a measured oriental dance honouring Sultan-Muhammad. Silent, soft Bihzadian trees and flowers bask in the tranquil garden. To hear the gurgles of the placid stream we must prick our ears. Hints of turbulent sinuosities to come, alas, are hard to find.

I. A drawing by Mirza-'Ali.

Notes

1 This article is dedicated to B.W. Robinson, a greatly valued friend since the early 1950s. We envision this most generous man as a human cornucopia, ever flowing with kindness, hospitality, generous advice, specialized learning, and lively music – from the rounds and madrigals of the Catch Club to New Orleans jazz. We look forward to many more years with "Robbie" and Oriel, to conversations about Sultan-Muhammad, to performances of the Bishop of Rochester's merry songs, and to flagons of lager from a kitchen cubbyhole noted both for the deliciousness of its production and for occasional liquid explorations.

2 Drawn with reed pen in black ink on paper; size of borders: 6" x 9⅝"; size of drawing: 4¼" x 6⅝". We are grateful to its discerning owner, a Boston private collector, for permission to publish this attractive and important work of art, which was acquired by its owner many years ago from Charles Kelekian. A trimmed inscription at the lower edge, perhaps a signature or attribution, is illegible. The pinkish-tan border contains twelve panels of unrelated verses written in *nasta'liq* script, set against a faded pinkish-tan ground adorned with arabesque in gold.

3 For an illustrated, fuller account of this artist's style, life, and work, see M.B. Dickson and S.C. Welch, *The Houghton Shahnameh*, Cambridge, Massachusetts, 1981, I, pp. 129–151. For less detailed treatments of the artist, see: S.C. Welch, *Wonders of the Age, Masterpieces of Early Safavid Painting, 1501–1576*, Cambridge, Massachusetts, 1979, pp. 48–49, 88–89, 92–93, 114–115, 148–149, 158–161, 182–185, 200–201, 208–211, 214–217.

4 See Dickson and Welch, *op. cit.*, I, figs. 9–20.

5 See especially Dickson and Welch, *op. cit.*, I, fig. 90, and II, pl. 7.

6 For Sultan-Muhammad's newly synthesized style, see particularly Dickson and Welch, *op. cit.*, II, pls. 17, 20, and 24.

7 See Dickson and Welch, *op. cit.*, II, pls. 6, 169, 176, 191, 243, and 258.

8 See, for example, the man standing in the entranceway, left foreground, in *Barbad Playing Before Khusrau*, in the British Library's *Quintet* of Nizami (Or. 2265), dated between 1539 and 1543, Dickson and Welch, *op. cit.*, I, fig. 180; Welch, *Wonders*, p. 158.

9 Aqa-Mirak and 'Abd al-'Aziz stayed on at the Shah's court, where they painted large pictures for Shah Tahmasp's copy of the *Falnama*, or Book of Divination.

10 For illustrations, see S.C. Welch, *Persian Paintings: Five Royal Safavid Manuscripts of the Sixteenth Century*, New York, 1976.

11 His first fully-fledged appearance is in the *Shahnama* of ca. 1522–ca. 1540. See Dickson and Welch, *op. cit.*, II, pl. 243, *Nushirvan Receives an Embassy from the Ray of Hind*.

Index

INDEX OF PROPER NAMES

The following index relates to the text and appendices of the preceding articles. Although it includes the names of specific works cited in the text, it does not include the titles of the individual paintings or scenes which they contain.

A'in-i Akbari 249
Abaqa 129
'Abbas Mirza 283–84, 289
'Abd al-Husain Ayati Tafti 261
'Abd al-Muttalib, 202, 214
'Abd al-Razzaq ibn Mawlana Jalal al-Din
 Ishaq 3
'Abdallah, father of the Prophet Muhammad
 202
'Abdullah-Nama 151, 155, 168
'Abdi Şaban 60
'Abdullah b. Ibrahim Sultan 124
'Abdullah Karahisari 58
Abraham see 'Ibrahim'
Abu Bakr-e Sa'd 156
Abu Haritha 133
Abu Hayyan al-Tawhidi 75–6
Abu Ishaq 232
Abu Ishaq ibn Ahmad al-Sufi al-Samarqandi
 123
Abu Qardash 249–50, 257
Abu Talib b. Nizam al-Din 13
Abu Turab 87
Abu Turab Ghaffari 84, 87
Abu'l-Faza'il 259
Abu'l-Fazl 249, 251
Abu'l-Hasan (Sani al-Mulk) Ghaffari 83,
 84–7
Abu'l-Hasan Thalith Ghaffari see 'Yahya
 (Abu'l-Hasan Thalith) Ghaffari'
Abu'l-Hasan-i Avval Ghaffari 83–4
Achaemenid 232
Ackerman, Phyllis 249–50
Adam 187
Adamova, Ada, 3–4, 10–11
Adler, E.N. 189
Afdal al-Husayni 304
Afif al-Din Muhammad ibn Mansur ibn
 Muhammad ibn Bumuya al-Qashi 149
Aflatun 187
Afrasiyab 230, 274
Afzal 259
Agha Bala 85
Agha Mirak 84
Aharistan 261
Ahmad-i Jami 12
Ahmed I 59

Ahmed Karahisari 57–61, 67, 70
Ahmed Karahisari Qur'an 57–61
Ahmedi 124
Ahsan al-Kibar 201
'Aja'ib al-Makhluqat 188
Akbar 4, 98, 251
Akmal 259
Akvan 274
Alexander Romance 187, 189
'Ali see "Ali b. Abi Talib'
'Ali Akbar Khan, Muzayyan al-Dawla 86
'Ali b. Abi Talib 20, 132–35, 204, 206, 210,
 249, 252, 257–64, 304
'Ali Çelebi 59–60
'Ali Quli Khan 20–2
'Ali Reza al-Katib 152–3, 169
'Ali Reza *katib* see "Ali Reza al-Katib'
'Aliquli Khan Shamlu 283–4
Amin-i Ahmed-i Razi 250–62, 261
Amir Ahmad u Mahsati 49
Amir Jangildi Bay 155
Amir Khusrau Dihlavi 101, 120
Anahita 98
Annunciation, The 250
Anthology of Prose Texts of Ibrahim Sultan 101,
 113–4, 123
Anushirvan 276–7
Anvar-i Suhayli 113
Apocalypse 189
Aq-Qoyunlu 319–20
Aqa Khan Nuri 83
Ardabil 305, 210
Ardashir 275, 278
Ardavan 275
'Arefi 152, 164–5
Arran 148
"Art of the Armourer" exhibition 1
Artists for the Shah 250
Asadallah Ghaffari 84
Asadullah Kirmani 57
Ashkanian dynasty 224
Asjadi 223
'Assar 258
Astarabad 168, 201, 210, 214, 260
'Ata'i 53
Athar al-muzaffar 201–2, 206, 210, 214
Atil, E. 20
Averincev, S. 98
Avesta 98
Avicenna 249
Azarbaijan 147

Babaie, S. 22
Babylon 131

Bactria 98
Badghis 284
Baghdad 131, 147, 268–9, 277–8
Bahira 132, 202
Bakara Sura 57
Balkesir 190
Balkh 284
Baltimore 2604
Baltimore, Walters Art Gallery 41, 265
Barbad 228
Barcelona 187, 189
Barkhurdar ibn Mahmud Turkman Farahi 3,
 12
Barrett, Douglas 4
Basholi 4
Battle of the Ditch 206
Bayani, Mehdi 152
Bayazid al-Tabrizi 120
Bayazid II 57, 187, 189–90
Baysunghur 101, 119, 120–1, 123–4, 127
Baysunghur Anthology 119–20
Bazil 12
Bazl, Farajollah 249
Beatus manuscripts 189
Beatus of Liébana 189
Bembo, Ambrosio 304
Berlin *Anthology* 120–2
Berlin State Museums 119
Berlin, Staatsbibliothek 13, 53
Bible 98, 187, 189
Bibliothèque Orientale 191
Bihzad 76, 98–9, 288–9, 319–20
Bilqis 49, 188–90
Biruni, al- 129–31, 132–3
Bisotun 161
Bizhan 228, 230, 232, 274–5
Blochmann, H. 249
Bokhara 4, 99, 151–3, 155, 157, 161, 167,
 169
Book of the Launderer 190
Boston, Museum of Fine Arts 20
Buddha 98
Buniyatov, Diya M. 147–8
Buraq 9, 47
Burlington House Exhibition 218
Burzuyah 277
Bustan of Sa'di 152, 154, 159
Buzurjmihr 276–7
Byzantine 189

Ca'fer Agha Tekke 57
Ca'fer Nakkaş 59–60
Calatrava, Order of 189
Calligraphers and Painters 283

Câmesûnâme 190
Canterbury 189
Caravaggio, Polidoro da 264
Cemal Halife 57
Central Asia 4, 98–9
Chaghatai 5
Chahar Maqala 123
Chenab 4
Chin 161, 165
Christ 259
Christians of Najran 133–4
Churchill album 84
Cleveland Museum of Art 124
Colombari, F. 84
Constantinople 127, 189
Copenhagen, Royal Library 13
Corbin, H. 98
Cowen, J.S. 39–42
Cronica de los Reyes de Judea e de los Gentiles 189
Ctesiphon 275

d'Herbelot, Bartélemi 191
Daneshvari, 'Abbas 40
Dar al-Funun 85–6
Darvish Khan 153
Dastan-i Jamal u Jalal 5
Daulatshah 119–20
Daumier 84
De Civitate Dei 189
de Beauvais, Vincent 188–9
de Guzmán, Luís 189
de Hell, Hommaire 84
de Sancy, Achille Harley 189
Deccan 53
Delhi 122
Dhu'l-Faqar 132
Diakonov 167
Dictionary of Nasta'liq Calligraphers 152
Din-i Ilahi 98
Divan of Amir Khusrau Dihlavi 120
Divan of Farid al-Din 'Attar 47
Divan of Hafiz 10–3, 16
Divan of Hidayat 46
Divan of Shams-i Tabrizi 98
Divan of Sultan Ahmad 46
Divan-i Rizvan 251
Diwan of Hafiz 303–4
Dominicans 189
Don Juan of Persia 304
Dorn 460 210, 214
Dowlatshah 157
Dublin 209–10, 270
Dublin, Chester Beatty Library 40, 46–7, 50, 53, 188, 191, 206, 265, 269
Duc de Saint-Simon 320
Edinburgh, University Library 129–30
Edirne, Selimiye Mosque 58
Egypt 122, 273
Ehl-i Hiref 57–60
Emperor Joseph II see 'Joseph II, emperor'
Enderun 59
Ettinghausen, Richard 40
Europe 83–4
Evliya Çelebi 58

Farashah 261
Farhad 47, 161, 303
Farid al-Din 'Attar 47, 151, 157, 291, 304
Farrukhi 223
Fars 101, 217–8, 232, 251
Fath 'Ali Shah 84, 152
Fatiha Sura 57
Fatima 133–4
Fatimid 273
Ferdinand I of Castile and Léon 189
Firdausi 12–3, 101, 120, 127, 187, 191, 2173, 223–6, 267, 270, 274–5, 276–7
Firdevsî Burûsevî (Uzun Firdevsî) 187, 189–91
Firuz Shah 41
Flandin, Eugène 84
Flemming, B. 13
Fogg Art Museum 250
Furughi 86–7

Gabriel, angel see 'Jibra'il'
Galland, Antoine 191
Garel, Michel 189
Gayumarth 98, 187
Geneva, Aga Khan collection 268–9
Geneva, Pozzi Collection 201
Geschichte der jüdischen Aertze 189
Ghadir Khumm 134–5, 206
Ghaffari family 83–7
Ghazan 130
Ghazi Beg 251
Ghazna 223
Goetz, H. 4
"Golden Haggadah" 189
Golestan 152, 154, 170
Goltzius, Hendrik 264
Goya 84
Granada 189
Gray, Basil 4, 20, 148
Greece 157–8
Grek, T. 3–4, 10–11
Grube, Ernst 24, 123, 267, 287
Grundy, Mrs. Hull 1
Gul va Nauruz 101
Gushtasp 42, 121
Guy va Chowgan 152, 164–5

Habib Allah 283–91
Hadiqat al-Uns 20
Hafiz 10–3, 16, 303–4
Hafiz Tanish al-Bukhari 155–6
Haft Aurang 206, 152
Haft Iqlim 250, 261
Haft Owrang see 'Haft Aurang'
Haft Paikar 46
Haggadah 187, 189
halife-nakkaşin 60
Hamla-yi Haidari 12–3, 16
Hamza Mirza 284
Harat see 'Herat'
Hari see 'Hauma'
Hariri, al- 40
Harvard University 270
Has Oda 59

Hasan b. 'Abdullah Karahisari see 'Abdullah Karahisari'
Hasan b. Ahmed Karahisari see 'Ahmed Karahisari'
Hasan Çelebi 58, 61
Hasan ibn Ahmad 87
Hasan ibn Muhammad ibn 'Ali ibn (?) Husaini al-Mausili 218
Hasan Khan ibn Allahyar Khan 12, 16
Hasan, al- 131, 134
Hatefi-ye Jami 152, 1615
Hatem Tayi 154
Hauma 98
Hebrew 187, 189
Helali 152, 166
Herat 21, 46–7, 84, 120, 124, 151–2, 165, 168, 201, 206, 214, 268, 270, 273, 275, 277–8, 283–4, 286–7, 291, 319–20
Hidayat 46
Hikmat al-ishraq 98
Hilali 12, 210, 304
Hillenbrand, Robert 39, 42
Hindu 98
Hirka-i Saadet 57–8
History of the Prophet 201
History of the Zand Dynasty 83
Hommaire de Hell see 'de Hell, Hommaire'
Hôtel Drouot 151
House of Alba 189
Hrabanus Maurus 189
Huizinga, J. 97
Hulegu 129
Humay u Humayun 273
Husain Khan Shamlu 283–4, 286, 289, 291
Husayn, al- 131–4
Hyderabad, Salar Jang Museum 46

I'timad al-Saltana 87
Ibn al-Bawwab 40
Ibn al-Fuwati al-Shibani al-Hanbali 147–8
Ibn al-Kutubi 129
Ibn al-Muqaffa' 116, 127
Ibn Hisham 132
Ibn Ukhuwwa 99
Ibrahim 98
Ibrahim Mirza 291
Ibrahim Sultan 101, 113–4, 119–23, 127, 275
Ilkhanids 129–30, 132–3
Illumination of the Pious 152
India 4, 20, 46, 98–9, 129, 188, 214, 250, 259
Indus 4
Ingelard 189
Inju 47, 217, 226–7, 232
Iqbal-Nama 13
Iraj 269–70
Iran 4, 20, 46, 84, 98–9, 129, 147, 258, 260, 267, 304
'Isa 98, see also 'Jesus'
Isfahan 20, 81, 84, 251, 264, 283, 285, 287, 291, 304
Isfandiyar 47, 228, 232

Iskandar 43, 46, 228, 232, 301
Iskandar Beg Munshi 283
Iskandar Sultan 120–1
Iskandar Sultan ibn 'Umar Shaykh 101, 122
Iskandar-Nama 13, 43, 124
Istakhr 275
Istanbul 189, 191, 210, 225, 270, 278
Istanbul, Süleymaniye Library 101, 122
Istanbul, Topkapi Saray Museum Library 13,
 19, 53, 57–9, 201, 217, 268, 319
Istanbul, Topkapi Sarayi Kütüphanesi see
 'Topkapi Palace Museum Library'
Istanbul, Türk ve Islam Eserleri Müzesi 152
Istanbul, University Library 41
I'timad al-Saltana 85

Jahangir 20
Jahangir Album 53
Jalal al-Din Mas'ud Shah 232
Jalal al-Din Rumi see 'Rumi'
Jalayirid 124–5, 268, 270, 273, 275, 278
Jami 10–1, 12–3, 152, 156, 161–3, 169,
 302, 320
Jami' al-Sahih 120
Jami' al-Tawarikh 41, 129–30, 132–3, 135,
 147–8
Jami'-i Mufidi 249, 258, 261
Jamshid 154, 301
Jani 81
Jarring, Professor Gunnar 5
Jerusalem 169, 1873
Jesus 130, 132–3, see also 'Isa'
Jibra'il 49, 202, 210
John the Baptist 132
Joseph II, emperor 191
Juki *Shahnama* 44
Jultay Bay 155
Juvayni 123

Ka'ba 206, 214, 260
Kaempfer, Engelbert 81
Kalila va Dimna see 'Kalila wa Dimna'
Kalila wa Dimna 41–2, 44, 46, 53, 101,
 1013–4, 121–3, 1562, 275, 277–8
Kamal al-Mulk Ghaffari see 'Muhammad
 (Kamal al-Mulk) Ghaffari'
Kara Mehmed 60
Kara Memi 59–60
Karahisar 57
Karim Khan Zand 83
Karnaprávana 188
Kashan 83
Kashmir 3–6, 10–2, 16, 17 n.16
Kay Khusrau 232
Kayanian dynasty 224
Keir collection 4, 273
Kelekian collection 249
Kelekian, Dikran 217
Ker Porter, Sir Robert 84
Kevorkian collection 206, 267
Khairabad 261
Khalaf Khwaja Kalan 155
Khamsa of Amir Khusrau Dihlavi 101

Khamsa of Nizami 4, 10, 46, 120, 124
Khaqanid 167–8
Khizr 260
Khorasan see 'Khurasan'
Khosrow 161
Khurasan 98, 155, 165, 201–2, 261, 284,
 319
Khurshid Khanum 86
Khurshid va Jamshid 101
Khusrau Parviz 228
Khusrau u Shirin 273
Khusraw and Shirin 152, 161
Khusraw Khan Kirmani 86
Khuyi, al- 40
Khvaja Ghiyath al-Din-i Naqshband 249–52,
 257–61, 264
Khvaja Mir b. Shams al-Din Muhammad
 Munshi Astarabadi 210
Khvaja Saif al-Din Muzaffar Bitikchi 201,
 214
Khvaju Kirmani see 'Khwaju Kirmani'
Khwaja Juybari 155–6
Khwaja Kamal ud-Din Husayn 167–8
Khwaje-ye Ahrar 161
Khwaju Kirmani 42, 101, 270, 273
Khwandamir 119, 123
Kisa'i, al- 187–9
Kitab al-Aghani 223
Kitab al-Diryaq 39, 41
Kitab Daqa'iq al-Haqa'iq 188
Klimburg-Salter, D. 46
Köprülü 191
Kubbealti Vizier 59
Kulliyyat-i Ahli Shirazi 46
Kuniyoshi Exhibition 1

Lahore 251
Laila and Majnun see '*Layla and Majnun*'
Last Judgement 189
Latîfî 190
Laurens, Jules 84
Layla and Majnun 10, 152, 165–6, 301
Life of the Prophet 132–3
Light of Muhammad see 'nur al-Muhammadi'
Lisbon *Anthology* 120–1
Lisbon, Gulbenkian Foundation 120
London, British Library 4, 6, 11–3, 41, 43,
 46, 49, 53
London, British Museum 4, 75
London, Royal Asiatic Society 13
London, Victoria and Albert Museum 1–2
Losty, Jeremiah 4, 7, 11
Low Countries 250
Luft, P. 13
Lund Nava'i 5–6, 9–10, 13
Lund, University Library 5, 13
Luqman al-Hakim 187
Lütfi 'Abdullah 60

Ma'athar va'l-Athar 85
Mahábhárata 184
Mahbub al-Qulub 3, 12–3
Mahd-i 'Olya 283

Mahmud al-Husayni 120
Mahmud of Ghazna 218
Majd-i Hamgar 251
*Majma' al-adab al-murattab 'ala al-asma' fi muj'am
 al-alqab* 143
Majma' al-khavass 250, 252
Majnun 10, 152–3, 165–6, 301
Makesia 189
Makhzan al-asrar 202
Mamluk 124
Manchester, John Rylands Library 47
Mani 78
Manichaeans 98
Manisa 189–90
Manizha 228, 232, 274–5
Manteq ot-Teyr see '*Mantiq al-Tayr*'
Mantiq al-Tair see '*Mantiq al-Tayr*'
Mantiq al-Tayr 49, 283, 287, 290–1, 304
Manuchihr Beg 251
Maqamat 40, 131, 189
Maragha 129, 147
Marv 155–6, 276
Marzuban-Nama 101, 113–4, 123
Mas'ud Ghaffari 84
Mashhad 284, 291, 320
Masnavi of Jalal al-Din Rumi 86
Masnavis of Khwaju Kirmani 42
Masnavi of Yahya (Abu'l-Hasan Thalith)
 Ghaffari 87
Master Ca'fer Nakkaş 59–60
Master of the Banderoles 250, 264
Mathnavi see '*Masnavi*'
Matla' al-Sa'dain wa Majma' al-Bahrain 3
Maulana Haidar 202
Maulana Kamal ('Assar) 258
Mavara an-Nahr 98, 151, 153, 157, 165
Mawarannahr see 'Mavara an-Nahr'
Mawlana Nazar-Muhammad Farghani 3
Mecca 60, 157–8, 206
Mehmed II 190, 124
Mehmed III 58, 61
Mehmed the Conqueror 188
Mehmet II see 'Mehmed II'
Melik Gazi Niksar Danişmend 187
Melikian-Chirvani, A.S. 4
Merv see 'Marv'
Mi'rajnama 47, 130
Michelangelo 86
Midrash 187, 189
Mihrak 226
Milstein, Rachel 169
Minorsky, V. 283
Mir 'Ali Shir Nava'i 3, 5, 16
Mir Ghulam 'Ali Khan Azad 13
Mir Hoseyn al-Hoseyni 162
Mir Kolangi 162
Mir Sayyid 'Ali 320
Mir Sayyid Ahmad 76
Mir Sayyid Riza 12
'Mirror for Princes' 123
Mirza 'Ali 290–1, 319
Mirza Buzurg Ghaffari 84
Mirza Qasim Malik 85

Mirza Tahir Vahid 251
Mirza-'Ali 319–21
Miscellany of Iskandar 43, 46
Mitra 98
Mongol(s) 129–30, 147, 232, 270, 273
Montakhab-e Ganjine-ye Letafat 151, 165, 167–8
Moscow 265
Moses see 'Musa'
Moses Hamon 189
Mozart 191
Mu'in 12
Mu'in Musavvir 78
Mu'ina Muhammada 259
Mu'izz 259
Mu'izz ibn Badis, al- 75–7
Mughal 249, 251, 264–5
Muhammad (Kamal al-Mulk) Ghaffari 84–7
Muhammad 'Ali 22
Muhammad A'zam 12
Muhammad al-Varamini 301
Muhammad Asafi 5
Muhammad Ghaffari 83, 85
Muhammad Juki 270, 275
Muhammad Mufid Mustawfi ibn Najm al-Din Mahmud Bafqi-yi Yazdi 249–52, 258–9, 261
Muhammad Qasim 21–2, 25
Muhammad Qasim Musavvir 303
Muhammad see 'Prophet Muhammad'
Muhammad Shafi' 'Abbasi 79–81
Muhammad Shah 83–4
Muhammad Yusuf 22
Muhammad Zaman 47, 79, 81
Muhammadi 20–22, 291
Muhyi al-Haravi 201
Munich, Bayerische Staatsbibliothek 188
Murad III 58, 61
Murshidquli Khan 284
Musa 98, 1304, 261
Musailima 131–2, 134–5
Mustafa 'Ali 119
Mustafa Jawad 147–48
Mustafa Müzehhib 59–60
Mustafa Nakaş 59, 67
Müstakimzade 57–8
Muzayyan al-Dawla 86

Nadir Shah 4, 83
Najaf 252, 257, 261
Nakkaş 'Ali Çelebi 60
Nakkaş Hasan 69–60
Nakkaşbaşi Lütfi 'Abdullah 60
Nasir al-Din 83
Nasir al-Din Shah 83, 84–6
Nasir al-Din Siwasi 188
Nasir al-Din Tusi 147, 190
Nasr al-sultani 120
Nasr Allah 101, 123
New York, Metropolitan Museum of Art 22, 79, 283, 288, 291
New York, Pierpont Morgan Library 214
Ni'matullah Khalifa 151–2, 154–9, 161–9
Niksar, *tekke* of Melik Gazi Niksar

Danişmend 187
Nizam al-Din Astarabadi 201
Nizami 4, 10, 13, 41–2, 46–7, 120, 124, 152, 161, 165, 268, 273
Nizamiyya Palace 83, 86
Noah 167
Nowruz 166
Nur al-Muhammadi 98
Nusratnama 53

'Obeydollah *Khwaje-ye Ahrar* 161
Okada, Amina 264
Oljeitu 135
Oman, C.C. 1
One Thousand and One Nights 83, 85–6
Ottoman 50, 53, 57–8, 124, 187
Oxford, Bodleian Library 120, 123, 127

Paris 264
Paris, Bibliothèque Nationale 5–6, 12–3, 16, 40, 129
Paris, Louvre Museum 22
Paris, Musée Guimet 21, 264, 291
Payanda Muhammad Sultan b. Din Muhammad Khan 155
Pemnem 53
Persepolis 120
Persian Miniature Exhibition 1
Philosophy of Light see '*Hikmat al-ishraq*'
Pir Budaq Qaraqoyunlu 46, 267, 277–8
Pir Muhammad 43
Pishdadian dynasty 224
Polo Ball and the Mallet 152, 164–5
Pope, Arthur Upham 249
Pope-Hennessy, Sir John 2
Present of the Spiritually Free 152
Princess Sultanim see 'Sultanim, Princess'
Prophet Muhammad 46–7, 98, 129–35, 158, 167, 201–2, 206, 210, 214, 223
Proust 320
Punjab, Punjabi 4, 11
Qadi Ahmad 75–6, 119
Qairawan 131
Qajar 10, 12, 83
Qamus 206
Qaraqoyunlu 267, 277
Qawam al-Daula wa'l-Din Hasan 217–9, 232
Qazi Ahmad 283, 285, 291
Qazvin 20, 22, 25, 151, 206, 210, 283–4, 286–7, 289–906
Qisas al-Anbiya 187–8, 190
Queen of Sheba 188–90
Qum 283–4, 286, 289, 291
Qur'an 5, 40, 57–61, 98, 119–20, 223, 260
Quraysh 132
Qutluqbuga 147–8

Rabbi Isaac b. Risus 189
Rabbi Jacob Aboáb 189
Rabbi Moses de Arragél of Guadalajara 189
Rafi' 259
Rajaur 11–3, 18 n.31
Rampur 42, 214

Rampur, Raza Library 214
Raphael 86
Rashid al-Din 129–30, 135, 147–8
Rezvan 164
Richard, Jules 85
Rida 77–9
Rigveda 98
Riza-yi 'Abbasi 20, 22, 24, 264–5, 285–7, 289, 291, 301–3
Robinson, Basil 1–2, 19, 21, 24, 39, 43, 46–7, 50, 75, 83, 119–20, 122–4, 168–9, 201, 257, 267, 286, 317, 321 n.1
Rome 131
Rosenthal, F. 147
Rousseau, Douanier 86
Rumi 86, 98, 120
Rustam 42, 187, 228, 230, 232, 270, 273, 274–5
Ruznama 84, 86
Ruznama Dawlat-i 'Aliya-yi Iran 84

Şehzade Kurkud 190
Sa'd al-Din al-Varavini 105, 123
Sa'di 12, 152, 159, 250, 260
Sa'd b. Abu Bakr b. Zangi 251
Sadiqi Beg Afshar 22, 24, 75, 250, 252, 264–5, 302
Safavid(s) 12, 19–20, 76–7, 79, 84–5, 113, 152, 201, 210, 214, 264, 283–4, 288, 301–5, 319–21
Saif al-Din 252
Sairafi 258
Salaman and Absal 169
Salm 269
Salman Savaji 101
Sam Mirza 303
Samarqand 43, 153
Sani' al-Mulk Ghaffari see 'Abu'l-Hasan (Sani' al-Mulk) Ghaffari'
Sanskrit 129
Sarajevo Haggadah 187
Sassanian(s) 161, 224, 275
Şatrançnâme-i Kebîr 190
Sava 283, 291
Sayyidbeily, Mariam G. 147–8
Schmitz, Barbara 283
Selections from the Treasure of Kindness 151, 165, 167–8
Selim I 57, 190
Selimiye Mosque 58
Shabdiz 161
Shah 'Abbas I 19–22, 24, 168, 249, 251, 257–8, 261, 283–4, 288–91
Shah and the Beggar 152, 166–7
Shah Isma'il I 305, 319–20
Shah Isma'il II 283
Shah Rukh 120, 122
Shah Safi 252, 261
Shah Tahmasp 77, 84, 250, 290–1, 301, 304, 319–21
Shah u Darvish 304
Shah va Geda 148, 166–7

Shahnama 12–3, 19, 40–3, 47, 77, 101,
120–4, 127, 187, 210, 217–20, 223–8,
230, 232, 267–9, 273–5, 278, 290,
321
Shahsavan tribe 16
Shaikh al-Mufid 133–5
Shaikh Muhammad 289
Shams al-Din Daqa'iqi 123
Shams al-Din Muhammad al-Daqa'iqi al-
Marvazi 101
Shapur 161, 226
Sharaf 84
Sharaf al-Din 'Ali Yazdi 122
Sharafnama 43, 46
Shaybanids 152–3, 155
Shaykh Mahmud 278
Shaykh Muhammad 20
Shaykh Safi al-Din 304
Shaykh San'an 301
Shaykhi 21
Sherley, Anthony 304
Shi'ism, Shi'ite 20, 129, 132–5, 152, 201,
210, 304
Shihab al-Din Suhrawardi 98
Shiraz, Shirazi 4, 7, 9–10, 21, 43, 101, 113,
119–24, 190, 225–7, 230, 232, 251,
260, 268–70, 273–5, 277–8
Shirin 161, 303
Shonfort, Dr. George 87
Sifat-i Sha'r baf 251
Simpson, Shreve 20
Sims, Eleanor 24
Sindbad-Nama 101, 113–4, 123
Sira 132–3
Siyah Qalam 21
Siyar-i Nebi 130–1
Siyavush 22, 228, 232
Skelton, R. 4
Sobhat ol-Abrar 152
Sohrweide, H. 13
Solomon Romance 187
Solomon see 'Sulayman'
Soltykoff, Alex 84
Soucek, P. 4
Soudavar, Abolala 284, 286
Soudavar collection 42
Spain 190, 304
Speculum Historiale 188
Srinagar 4, 16
St. Augustine 189
St. Christopher 189
St. Petersburg 3, 10, 148, 169, 214, 225
St. Petersburg, Hermitage 4, 22
St. Petersburg, National Library of Russia
217
St. Petersburg, State Public Library 24, 210
Stchoukine, I. 13, 20–2, 217–8, 264, 285,
288
Stockholm, Royal Library 5
Sulayman (prophet) 49, 187–90
Süleyman b. Mehmed 60

Süleyman the Magnificent 57–9, 61
Sultan 'Abd ul-'Aziz 168
Sultan 'Ali al-Mashhadi 76
Sultan Abu'l-Ghazi 'Abdullah Bahadur Khan
151–5, 157–9, 162–39, 165–9
Sultan Ahmad 46
Sultan Ahmed I see 'Ahmed I'
Sultan al-Ghauri 124
Sultan Bayazid II see 'Bayazid II'
Sultan Husayn Bayqara 319
Sultan Ibrahim Mirza 320–1
Sultan Khalil 46
Sultan Mehmed III see 'Mehmed III'
Sultan Mehmet II see 'Mehmed II'
Sultan Muhammad 84, 303
Sultan Muhammad Khudabanda 283
Sultan Murad III see 'Murad III'
Sultan Mustafa 57
Sultan Selim I see 'Selim I'
Sultan Zain al-'Abidin 4
Sultan-Muhammad 319–21
Sultanim, Princess 156
Suluk al-Talibin 13
Sunnism 152
Sütlüce 57
Sütlüce, Ca'fer Agha Tekke 57
Suz u Gudaz 50
Swietochowski, M.L. 22
Syria 160

Ta'rikh-i Jahan Gushay 123
Tabriz 84, 148, 268, 319
Tahir Nasrabadi 249–50
Tahmina 230, 270, 273
Talbot Rice, David 148
Talkhis majma' al-adab fi mu'jam al-alqab 147
Talmud 189
Tarikh-i Uljaytu 148
Tash'irsazi 97
Tashkent 10, 12
Tazkerat osh-Sho'ara 157
Tazkira-i Sukhanvaran-i Yazd 261
Tehran 277
Tehran, Gulistan Palace Collection 85–6
Tehran, Royal Library 152
Testamentum Salomonis 188–90
Tha'alibi, al- 187–8
The Chronology of Ancient Nations 129
The Houghton Shahnameh 320
Timur 43, 122
Timur-Nama 3, 291
Timurid 101, 119–24, 268, 270, 273, 275,
278, 288–90, 291, 319
Titley, N. 4, 11–2
Togan, Z.V. 148
Tohfat ol-Ahrar 161–2
Tohfe-ye Ahrar 152
Tokharistan 98
Toledo 189
Torcello 189
Toronto, Royal Ontario Museum 268–9

Tour du Monde 87
Travels in Africa 87
Tuba Tree 154
Tur 269–70
Turan 274
Turkestan 250, 259–60
Turkey 250, 259
Turkman 210, 268, 319

Ulugh Beg 120, 304
Ulugh Bek see 'Ulugh Beg'
'Umar 135
'Unsuri 223
Uppsala, University Library 5
Uzbek(s) 17, 151, 156, 167–8, 284, 320

Vahsi Bafqi 87
Valijan Mirza 155
van Meckenem, Israel 250
Vaqi'at-i Kashmiri 12
Varqa u Gulshah 40–1
Vasilchikov, Grigorii Borisovich 25
Vatican City, Vatican Museum 86
Vever Collection 202, 206, 218
Virgin, the 250
Vishnu 98

Waqfnama of Rashid al-Din 147–8
Washington D.C., Sackler Gallery 40, 47,
218
Washington D.C., Textile Museum 249
Washington D.C., Freer Gallery of Art 206,
288–9, 320
Waugh, Evelyn 320
Welch, Anthony 20–1, 250, 288–9
Welch, Stuart Cary 290
World History of Rashid al-Din see 'Jami' al-
Tawarikh'
Wright, Elaine 120, 127

Yahya (Abu'l-Hasan Thalith) Ghaffari 83,
85–7
Yahya Khan Ghaffari 84
Yahya Safi 57
Yaqut 258
Yazd 43, 114, 249–82, 257–71
Yusuf 98, 260
Yusuf and Zoleykha see 'Yusuf and Zulaykha'
Yusuf and Zulaikha see 'Yusuf and Zulaykha'
Yusuf and Zulaykha 10–11, 12–13, 152, 156,
163–4, 168–9, 301–12, 304, 314–15
Yusuf ha Cohen 189
Yusuf u Zulaikha see 'Yusuf and Zulaykha'

Zafar-Nama 101, 122–4
Zakariya Qazwini 188
Zij-i Ilkhani 129
Zoroaster 98
Zvenigorodsky, Andrei Dmitrievich 25

SUBJECT INDEX

ablaq 187
ahl al-bait see '*ahl al-bayt*'
ahl al-bayt 132–4
'*aks-sazi* 97
aloe 77
alum 77
angels 47, 49, 53, 98, 187–8, 202, 223, 257, 260
animals 41–2, 113–4, 122, 131–2, 161–2, 165, 188, 202, 217, 220, 232, 249, 257–8, 265, 284, 288–9, 291, 320
ansae 40
Arab painting 39–40, 113, 131, 189
arabesque 97
architecture 6–7, 39–40, 99, 153, 155, 162–3, 168, 188, 206, 268, 273
artists' materials 59, 68–72, see also 'paper', 'pigments'
artists' wages 58–60, 67, 70–1, 190, 251–2
'*ashara* 57, 60
Astarabad style 201, 210
astrology 188–9, 191
astronomy 129

Baghdad school 210
bazm u razm 121
binders, binding 60–1, 71, 278
birds 41–2, 79–80, 114, 162, 187–8, 210, 260, 288, 290, 304
boats 169
bodhisattvas 98
brush(es) 76, 80–1, 259
Buddhist painting 4
Bukhara school 153
Byzantine painting 189

calligraphers 57, 201, 210, 215 n.25, 216 n.32, 249, 268, 278
calligraphy 40–2, 58, 80, 120, 123, 152–4, 158, 162, 167–8, 183 n.5, 201, 224,

302–3, 319
carpenters 61
carpets 47, 50
Catalan manuscripts 189
celi-muhakkak 58
celi-sülüs 58
Chinese influence 5, 40–2, 133, 319
chinoiserie 120
Christian influence 132
Christians 157–8
clouds 42–3
colophon 57, 121, 123, 152–3, 217–9, 267
costs of manuscript production 59, 67–72
costume see 'dress'
cüz 57, 60

dagh 303–4
darvish 151, 163, 165–6, 303–5
demons 188–90, see also '*divs*'
dervish see '*darvish*'
divine light 97–9
divs 42, 46, 113, see also 'demons'
dress 9, 24, 49, 98, 131–3, 188–90, 270, 285–6

embassies 24–5, 132, 251, 304
European influence 9, 22, 79, 81, 84–6, 188, 250, 264–5
European travellers 83–4, 87
ex-libris 119, 168
eyvan 157, 159, 169

farr, farrah, farn 98
fasting 131
firman 20
frontispiece 57, 59, 121, 124, 223–6

gallnut 76–7, 79
gardens 7, 121, 155, 259, 261
ghazal 153

gilding, gold 5, 59, 70–2, 78, 97–9, 127, 160–2, 198 n.1, 202, 220, 223–4, 290
golden vegetation 188
Gothic painting 189
gul-duzi 97
gum arabic 76–7
hadith 187
haloes 39–40, 98, 131–2, 134
hashiyya 120
henna 59, 70, 72
Herat school 168
Hindu influence 4, 11
Hindu manuscripts 4, 16, 53
houris 9, 164, 259
hwarna 98

idolatry 131
illumination 4–5, 19, 39, 59–61, 72, 120, 129, 224–5, 267, 278, 290
Indian elements 7, 9
Indian manuscripts 4, 11, 16, 24, 53
indigo 77
Inju school 42
ink 76–80, 220
inkwell 78
intercalation 131
Isfahan school 287
Isfahan style 290–1
ishraq 98
iwan see '*eyvan*'

jadwal 116
Jalayirid painting 120–1
Jewish painting 187, 189

kashkul 303–4
ketkhüda 59–60
khateme 152
khatima 133
Khurasan style 201–2, 206

kitabkhana 218
kitre (gum tragacinth) 59, 70
kufic 264–5

lacquer 5, 12, 17 n.6
lalah 21
lamp 131, 188
landscape 7, 12, 40, 87, 99, 121, 134–5, 202, 206, 220, 227, 268, 320
lapis lazuli 59, 70, 72
leather 5, 57
light 50, 98, 166
lithography 83

Mamluk painting 124
Mashhad style 202, 206
mastar 5
matn 120
minbar 131
moraqqa' see '*muraqqa''*
mosque 131, 155, 160
mücellidbaşi 60
Mughal painting 4, 7, 9–10, 53, 264–5
muhakkak 57
muraqqa' 19, 20, 24, 162, 165
müsenna 58
musk 77
müzehhib 59

nakkaş 59
nakkaşbaşi 59–60, 70, 83, 78, 148
Naqshbandi sufism 151, 156, 161
naqshbandi 250–1, 261
Nasiri painting 85
naskhi 101, 123, 198 n.1, 220, 260
nasta'liq 5, 12, 76, 152
neft dudesi 59, 70–1
nesih 57, 60
nur al-anwar 97

opium 87
Ottoman painting 7, 124, 187

padash 85
paper 5, 17 n.16, 22, 43, 57–9, 70–1, 77–8, 82 n.23, 97, 198 n.1, 220, 290
pens 59, 75–6, 81
peris 187–8
photography 83–5
pigments 59, 70–2
pilgrimage 130–1
pir 156–7
porcelain 7, 44, 160, 259
portraits 84, 86
prophets 98, 130, 187, 201, 304

qadi 42
Qajar painting 10, 83
qalam 75–6, 80
Qazvin school 151, 169
Qazvin style 202, 206, 291
qisas 187
Qur'an 119–20, 223, 260

reqa' 168
reyhani 57
rosewater 77

Safavid painting 6, 9–10, 76–7, 79, 301
saffron 59, 70, 72, 77
sarlauh see '*sarlawh*'
sarlawh 5, 97, 120
sati 50
scripts 57–8, 101, 123, 264
seals 167, 304, see also '*tugra*', '*firman*'
shahr-ashub 251
shams 97
shamsa 101, 119–20, 123–4
signatures 20–21
silk 249–52, 261

simurgh 47, 187
soot 59, 70–1, 76–7, 79
starch 77
stucco 40
sufis, sufism 97–8, 151–2, 155–7, 161, 164, 167, 201, 303–5
sülügen 59, 71
sülüs 57
sürh 59
Tabriz school 169
Tabriz style 290–1
tafsir 187
takht 164
tamarisk 76
taswir, al- 148
tazkira, tazkirat 249–50
textiles 79
throne 164, 187–8
tilavet 57
Timurid painting 122
tomb 155
tugra 59
Turkman art 319
Turkman manuscripts 46, 124
Turkman style 268

'unwan 5, 40, 97, 120
ustad 21, 148
ustadh see '*ustad*'
üstübeç 59, 71

vitriol 76–7
waqf 210
wells 42
wine 22, 87, 249, 258, 261, 301–4, 320
zamin-duzi 97
zar-duzi 97

zodiac 188